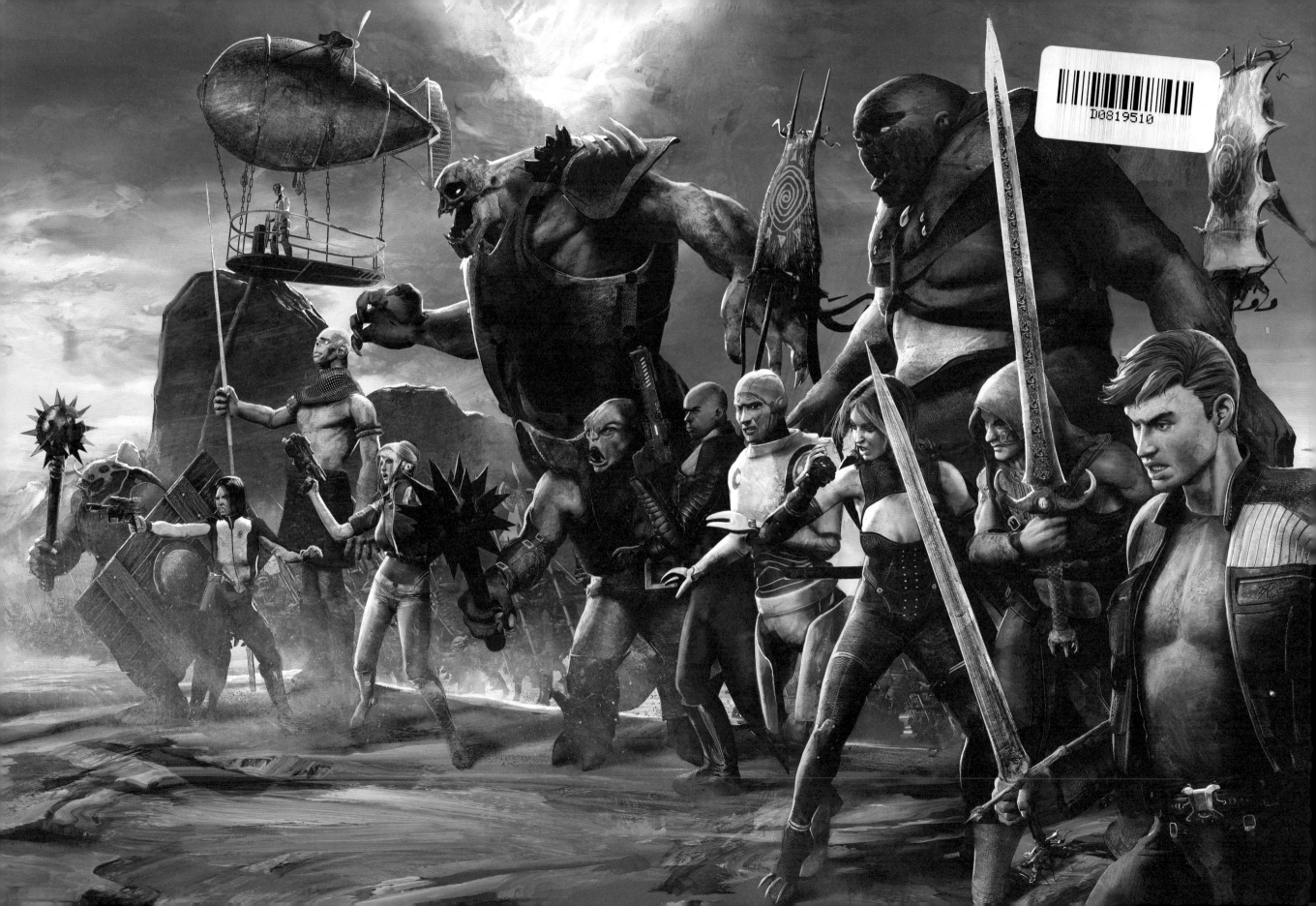

a·nom·a·ly

—noun, plural -lies.

1.
a deviation from the common rule, type, arrangement, or form.

ANOMALY™

Created by
SKIP BRITTENHAM & BRIAN HABERLIN

Writers
**SKIP BRITTENHAM
& BRIAN HABERLIN**

Artists
**BRIAN HABERLIN
& GEIRROD VAN DYKE**

Letterer & Appendix Content
FRANCIS TAKENAGA

Coding Director
DAVID PENTZ

Digital Assists
**JAMES HABERLIN
& DIANA SANSON**

Special thanks to:
VARUN SONI

ANOMALY, Vol. 1. October 2012. Published by ANOMALY PUBLISHING, a division of ANOMALY PRODUCTIONS, INC. ANOMALY, its logo and characters are ™ and © 2012 Anomaly Productions, Inc. All characters are ™ and © 2012 Anomaly Productions, Inc. All rights reserved. The characters, events and stories in this publication are entirely fictional. With the exception of artwork used for review purposes, none of the contents may be reprinted without the permission of Anomaly Productions, Inc. Requests for permission should be addressed to: ANOMALY PRODUCTIONS, INC. 1801 Century Park West, Los Angeles, CA 90067.

For more information, please visit: experienceanomaly.com

FIRST EDITION
Library of Congress Cataloging-In-Publication has been applied for.
ISBN-13: 978-0-9853342-0-8

Print and color management by iocolor, Seattle
Printed in China by Shenzhen Artron Color Printing LTD

Editor:
SALLY HABERLIN

Publisher:
ANOMALY PUBLISHING

"THANKS TO MY WIFE, WHO INSPIRED ME TO START WRITING, AND MY THREE DAUGHTERS AND SON-IN-LAW WHO SUPPORTED ME ALONG THE WAY. AND TO BETH, WHO FLIES WITHOUT A CAPE."

SKIP BRITTENHAM

"TO SALLY, IAN AND MORGAN...MY GREATEST SUPPORT AND EVER WONDERFUL CRITICS. AND TO THE MEMORY OF MY MOTHER MILDRED AND BROTHER JAMES WHO ALWAYS ENCOURAGED MY WORK."

BRIAN HABERLIN

"TO MY FAMILY PHIL, DIANE AND NIYA. AND TO VERONICA."

GEIRROD VAN DYKE

ULTIMATE AUGMENTED REALITY™ (UAR)
Quick Start Guide

1. Visit **experienceanomaly.com/UAR** using your device browser.

Alternately, use your QR Code reader app and point it at the code to the right.

QR Code reader NOT necessary to run app.

2. Select the appropriate store (iOS or Android) and install the app . **The UAR app is FREE.**

3. Run the application and point at "live" pages to activate UAR.

UAR content pages will be listed within the app so you don't miss a thing.

New, **FREE** content will be added periodically.

Follow us on Facebook, Twitter and join our email list at **experienceanomaly.com** to find out when the next UAR update is released.

What is Ultimate Augmented Reality™?

Ultimate Augmented Realty (UAR) uses real world cues (images, objects, etc.) and seamlessly blends them with enhanced digital content specially designed for this project. It's a whole new way to experience Anomaly.

How do I get it?

It's easy!

1) Visit **experienceanomaly.com/UAR**

2) **Select** your device (will link to appropriate app store).

3) **Download** and **install** onto your device.

How do I use it?

1) **Launch** the app.

2) **Point** your device camera at "live" pages (listed in-app).

3) **Let the magic begin!** Remember, most 3D items are **interactive.** Tap/swipe these objects to see how they react. All entries have extensive journal entries or Master Conglomerate Data Matrix (MACODAX) entries.

Future Updates:

Anomaly UAR contains 50 3D interactive models and over 100 pages of **additional** original material not found in this book (**only** accessible by UAR).

This is only the beginning...

UAR entries will be periodically updated, adding even more immersive content and depth to the massive Anomaly Universe.

IT HAPPENS...
JUST LIKE IT
DOES ALMOST
EVERY NIGHT.

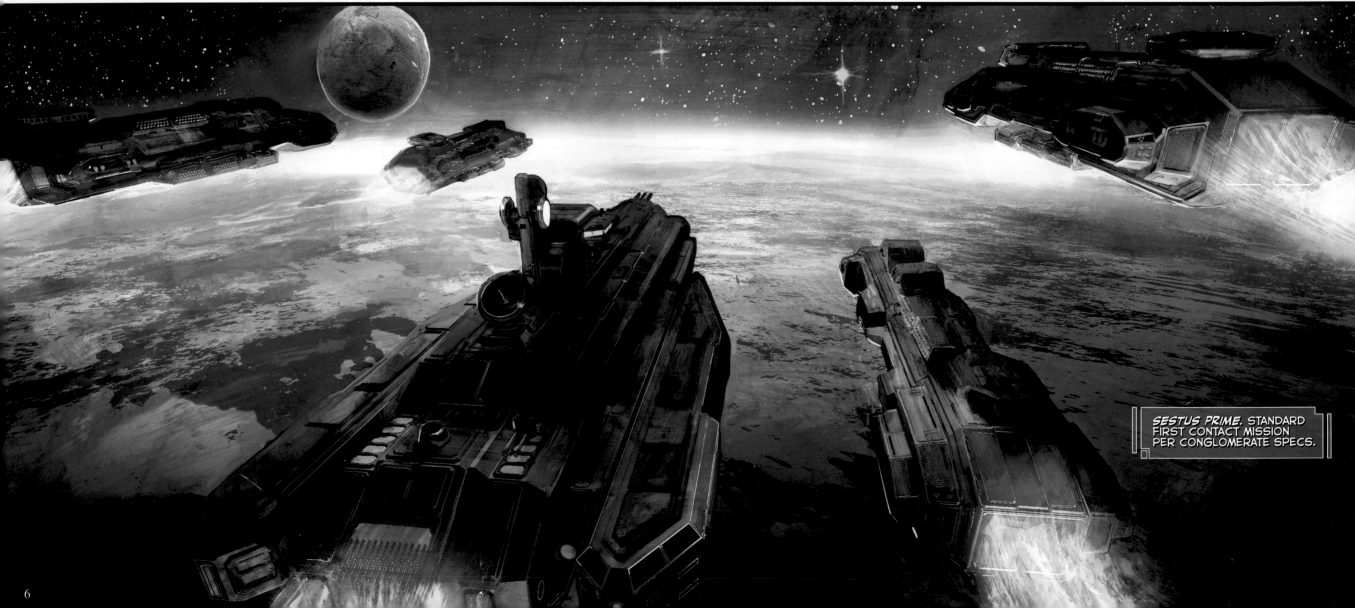

SESTUS PRIME. STANDARD
FIRST CONTACT MISSION
PER CONGLOMERATE SPECS.

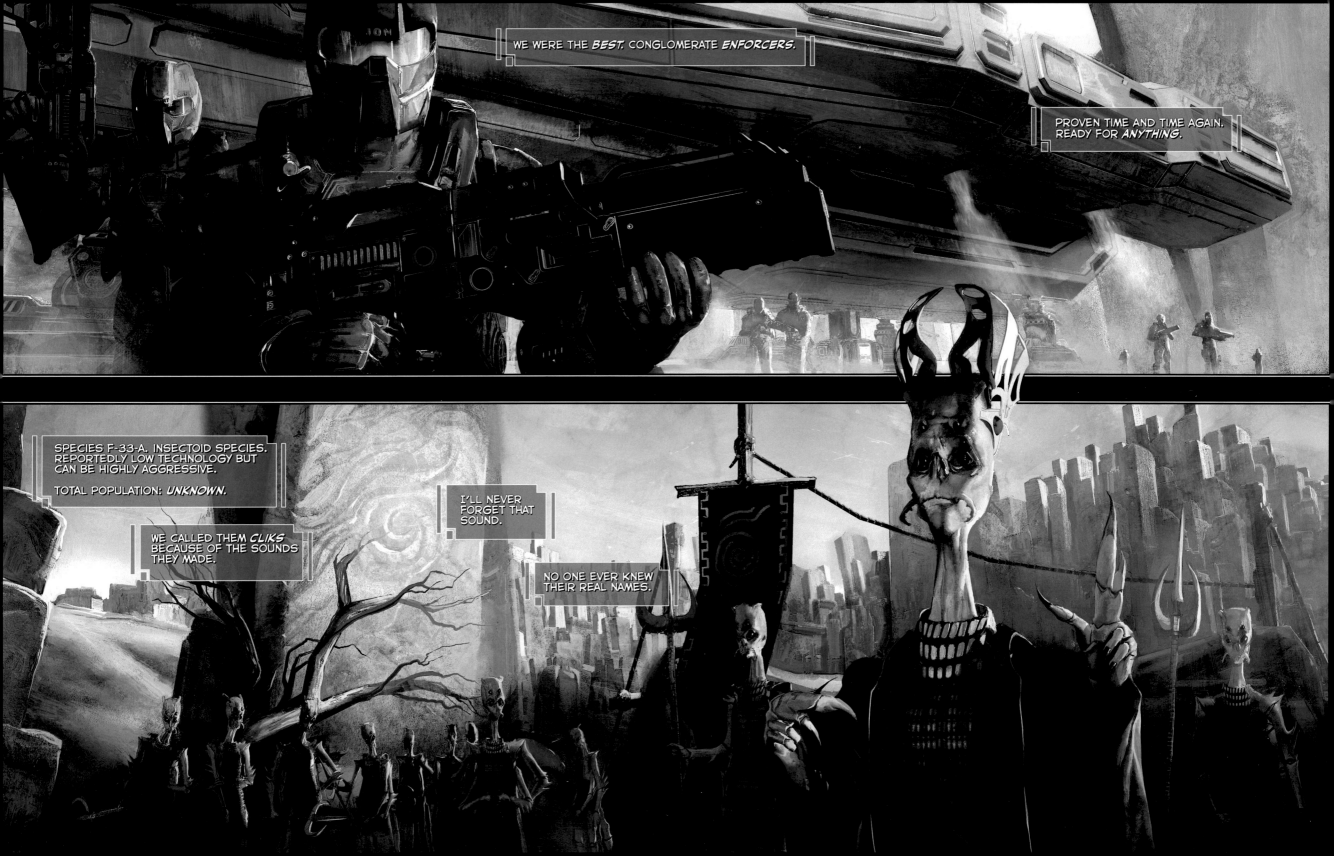

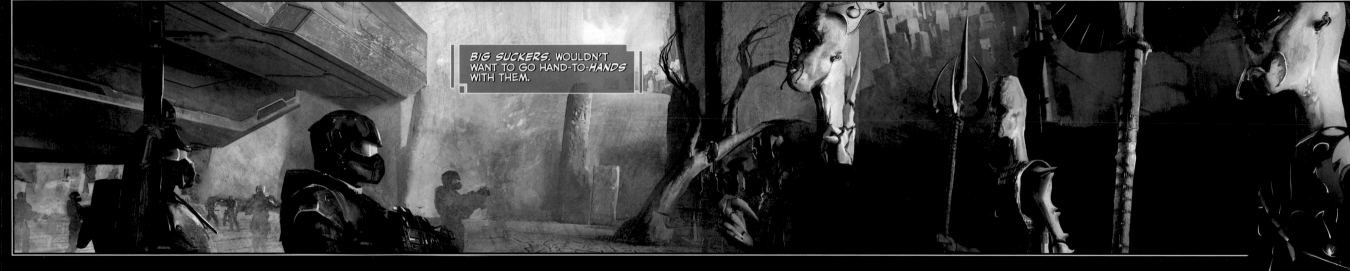

BIG SUCKERS. WOULDN'T WANT TO GO HAND-TO-*HANDS* WITH THEM.

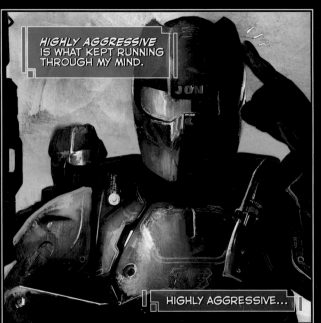

HIGHLY AGGRESSIVE IS WHAT KEPT RUNNING THROUGH MY MIND.

HIGHLY AGGRESSIVE...

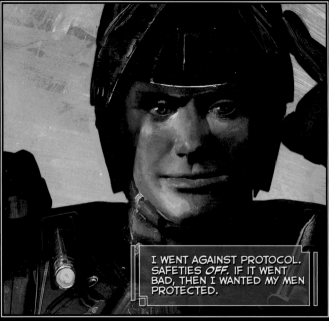

I WENT AGAINST PROTOCOL. SAFETIES *OFF.* IF IT WENT BAD, THEN I WANTED MY MEN PROTECTED.

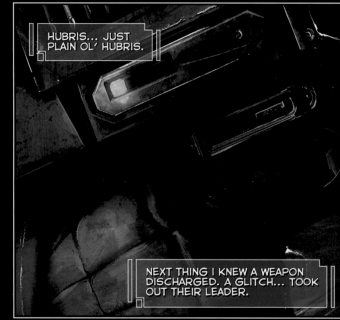

HUBRIS... JUST PLAIN OL' HUBRIS.

NEXT THING I KNEW A WEAPON DISCHARGED. A GLITCH... TOOK OUT THEIR LEADER.

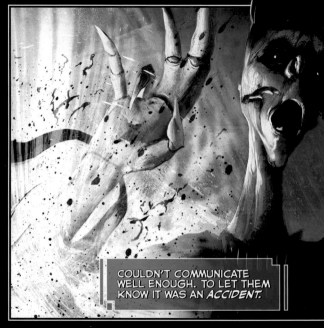

COULDN'T COMMUNICATE WELL ENOUGH. TO LET THEM KNOW IT WAS AN *ACCIDENT.*

THEY JUST KEPT COMING AT US...

THOUSANDS OF THEM. BUT WE MADE IT OUT BY THE SKIN OF OUR TEETH.

MY CONGLOMERATE BOSSES DEEMED THEM *TOO HOSTILE* FOR PEACEFUL CONTACT. THEY WIPED THEM OFF THE PLANET WITH NEUTRONS. LEFT IT A CLEAN NEW WORLD FOR THEM TO MARK AS THEIR OWN ON SOME BIG MAP OF THE UNIVERSE.

MY FAULT... MY RESPONSIBILITY.

AND I'VE BEEN PAYING FOR IT EVER SINCE.

 THE PRESENT:

N- *NO!*

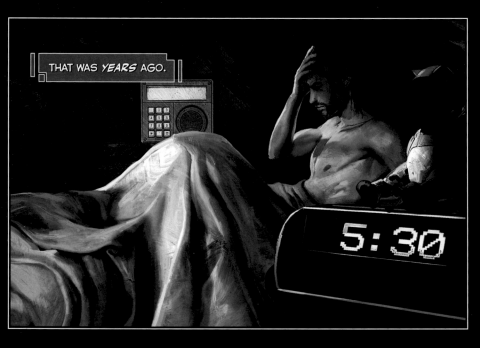

THAT WAS *YEARS* AGO.

5:30

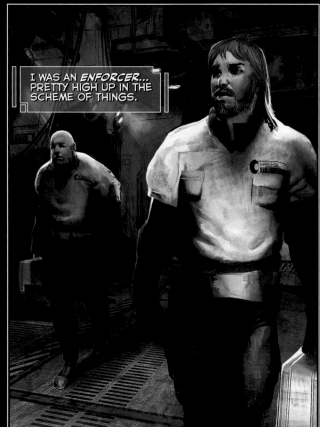

I WAS AN *ENFORCER*... PRETTY HIGH UP IN THE SCHEME OF THINGS.

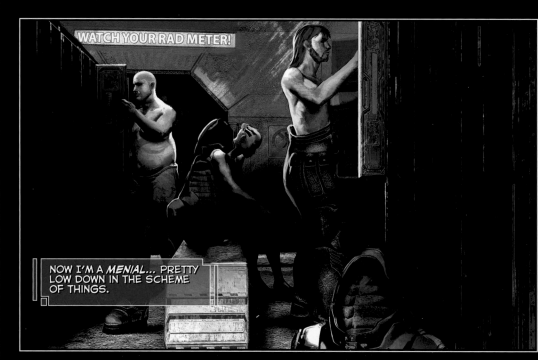

WATCH YOUR RAD METER!

NOW I'M A *MENIAL*... PRETTY LOW DOWN IN THE SCHEME OF THINGS.

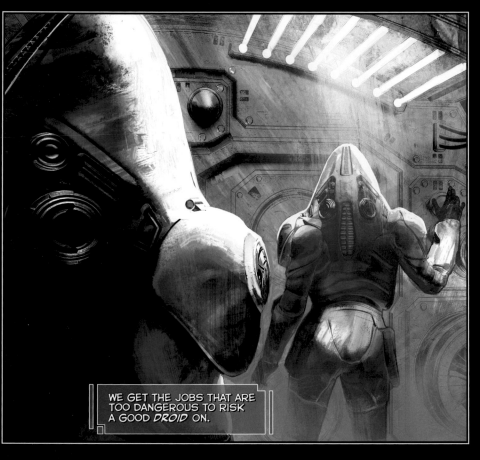

WE GET THE JOBS THAT ARE TOO DANGEROUS TO RISK A GOOD *DROID* ON.

TO QUOTE A RECENT CONGLOMERATE MAGISTRATE: *"WHY WASTE A ROBOT WHEN WE HAVE A SURPLUS OF HUMANS..."*

NICE.

REAL NICE.

BUT ALL TOO TRUE.

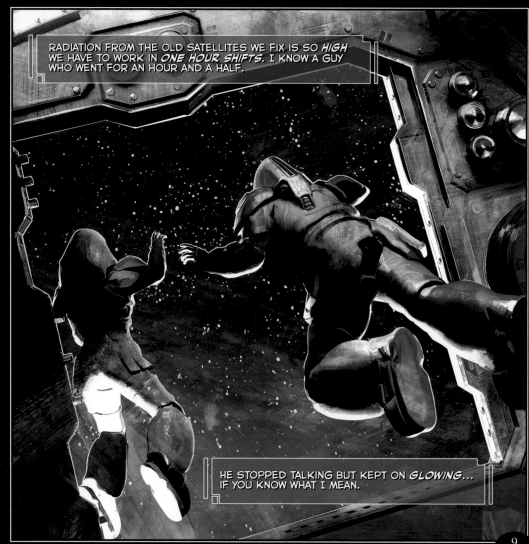

RADIATION FROM THE OLD SATELLITES WE FIX IS SO *HIGH* WE HAVE TO WORK IN *ONE HOUR SHIFTS.* I KNOW A GUY WHO WENT FOR AN HOUR AND A HALF.

HE STOPPED TALKING BUT KEPT ON *GLOWING*... IF YOU KNOW WHAT I MEAN.

STILL, COULD BE WORSE.

MY OFFICE HAS ONE *HELL* OF A *VIEW.*

EARTH. 2717.

WE REALLY DID A NUMBER ON THE OLD HOME WORLD. MOST OF THE POPULATION LIVES IN ORBIT NOW... OR OFF WORLD. IF YOU CAN'T GET OFF WORLD AND HAVE TO BE STUCK ON THE PLANET ITSELF IN ONE OF THE "TERRARIUM CITIES" THEN YOU'RE EVEN LESS LUCKY THAN ME.

AND THESE DAYS I'D SAY I'M PRETTY UNLUCKY.

THE CONGLOMERATE... HOW DO THE COMMERCIALS PUT IT? OH, YEAH...

"BUILDING A BETTER TOMORROW TODAY."

ALL ROADS LEAD TO THE CONGLOMERATE... NO COUNTRIES ANY MORE... NO INDEPENDENT PLANETS. JUST THE CONGLOMERATE... AND THAT'S HOW THEY LIKE IT.

MOVE, GET OUT OF ITS WAY OR BE SHOVED ASIDE... I WAS SHOVED ASIDE... SO MUCH HUMAN GARBAGE... A MENIAL... THE LOWEST OF THE LOW... YEP...

THAT'S ME.

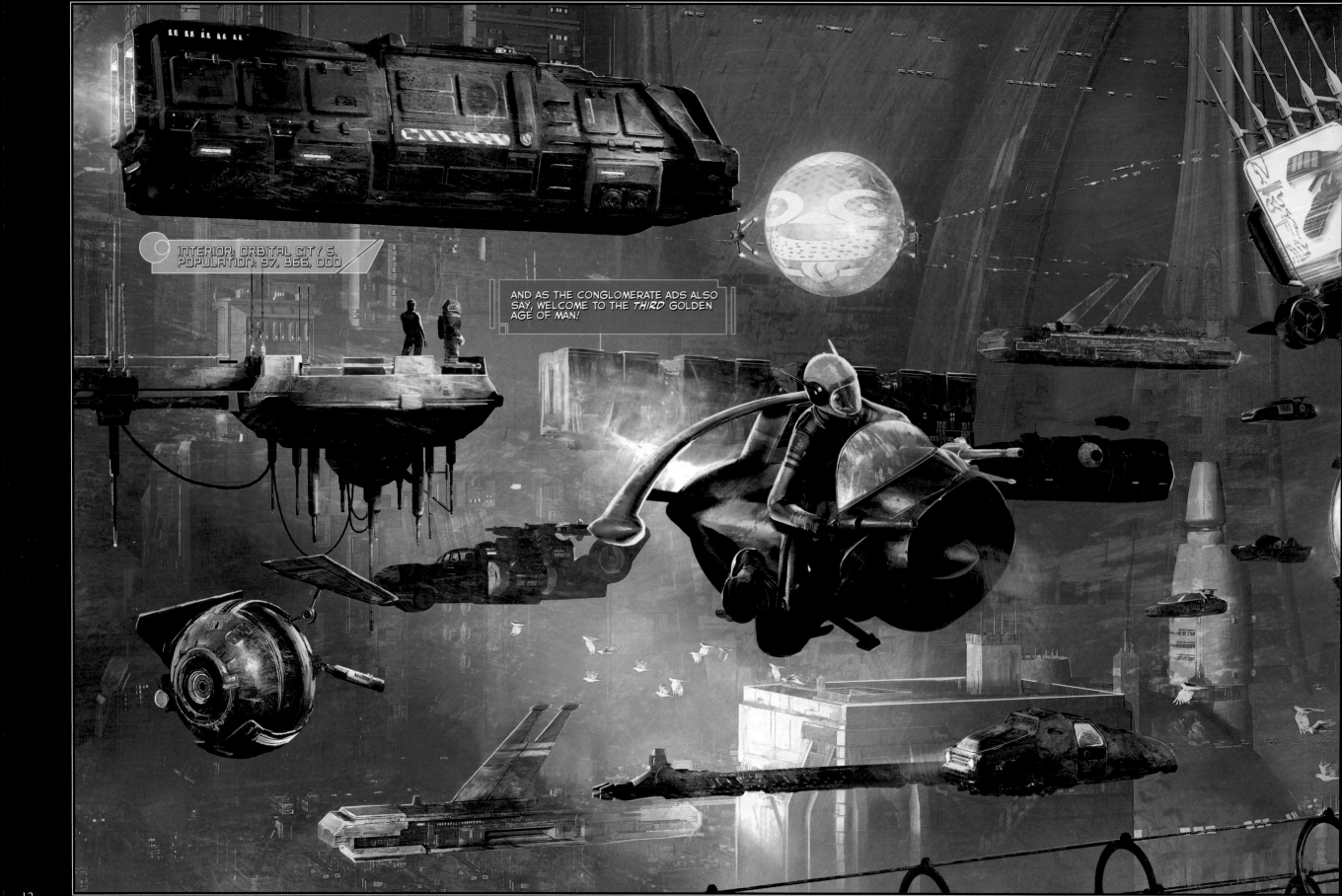

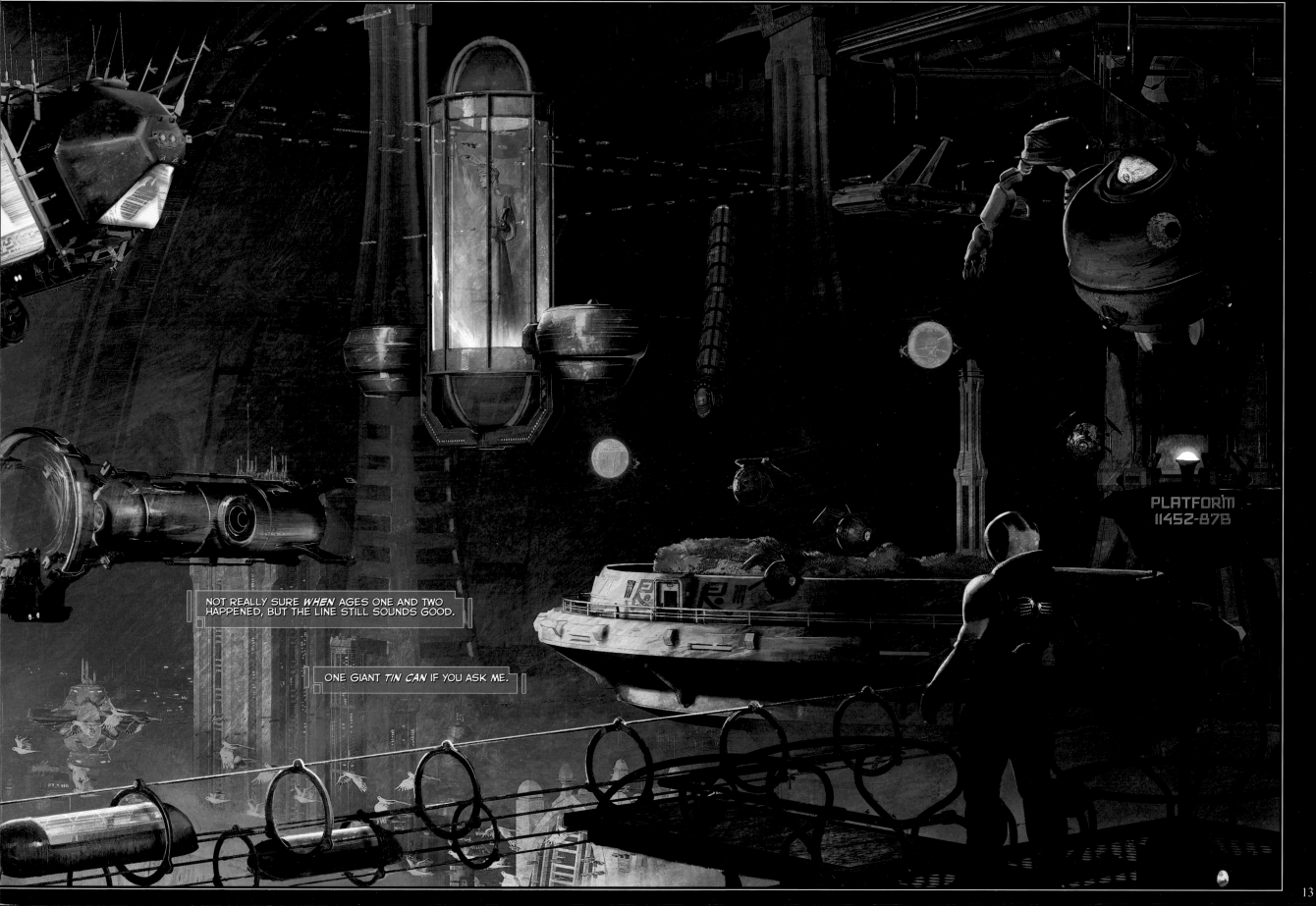

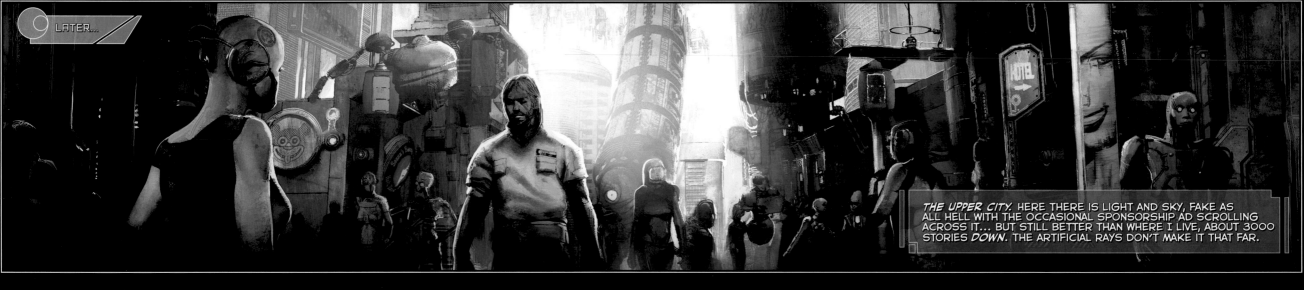

THE UPPER CITY. HERE THERE IS LIGHT AND SKY, FAKE AS ALL HELL WITH THE OCCASIONAL SPONSORSHIP AD SCROLLING ACROSS IT... BUT STILL BETTER THAN WHERE I LIVE, ABOUT 3000 STORIES *DOWN*. THE ARTIFICIAL RAYS DON'T MAKE IT THAT FAR.

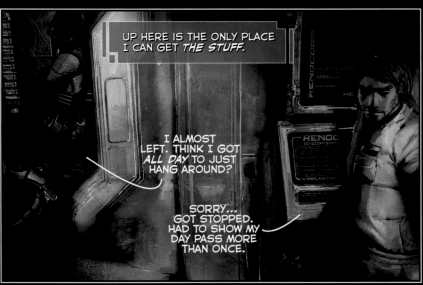

UP HERE IS THE ONLY PLACE I CAN GET *THE STUFF*.

I ALMOST LEFT. THINK I GOT *ALL DAY* TO JUST HANG AROUND?

SORRY... GOT STOPPED. HAD TO SHOW MY DAY PASS MORE THAN ONCE.

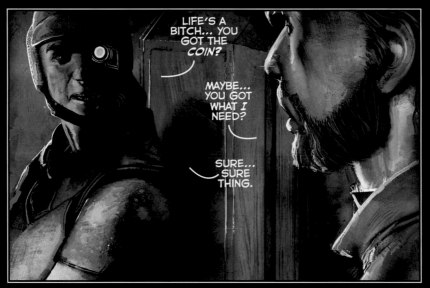

LIFE'S A BITCH... YOU GOT THE *COIN*?

MAYBE... YOU GOT WHAT *I* NEED?

SURE... SURE THING.

HERE...

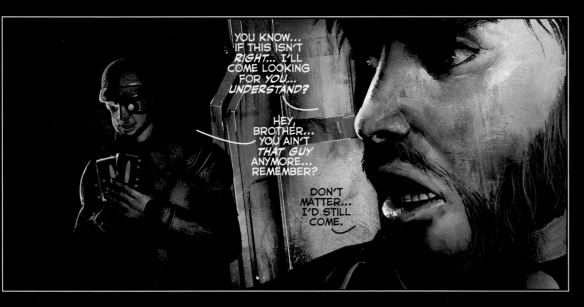

YOU KNOW... IF THIS ISN'T *RIGHT*... I'LL COME LOOKING FOR *YOU*... UNDERSTAND?

HEY, BROTHER... YOU AIN'T *THAT GUY* ANYMORE... REMEMBER?

DON'T MATTER... I'D STILL COME.

YEAH, YEAH... AND NICE DOIN' BUSINESS WITH YOU, TOO.

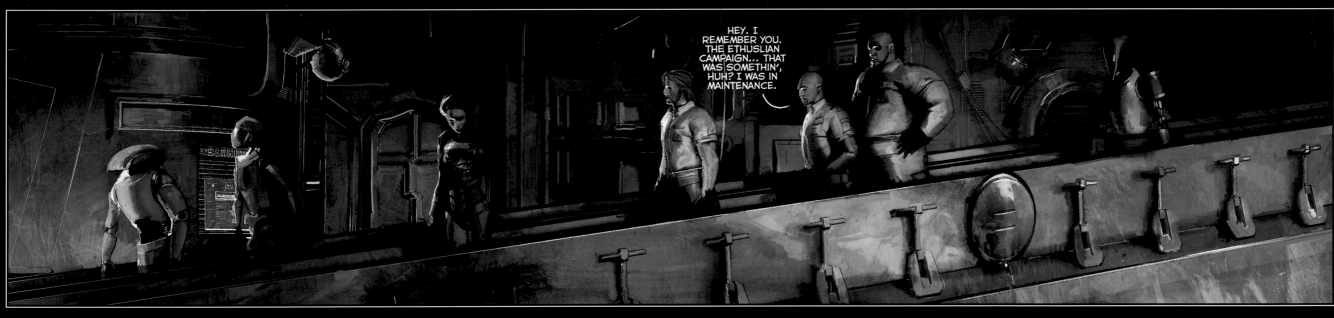

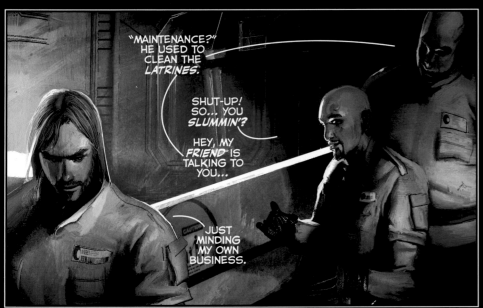

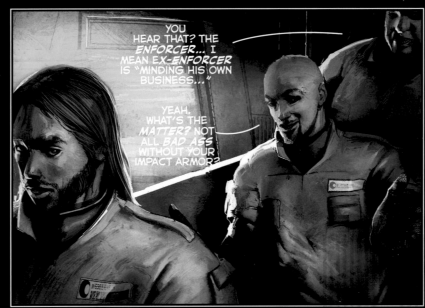

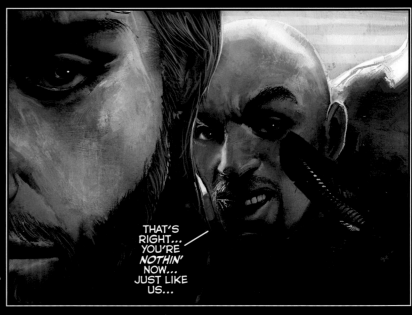

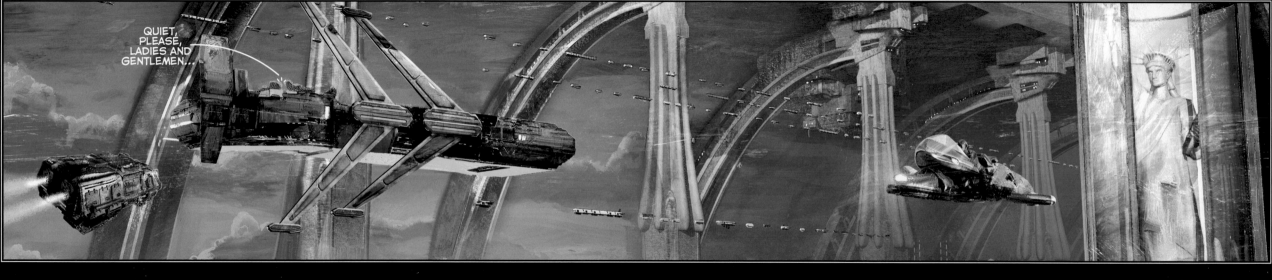

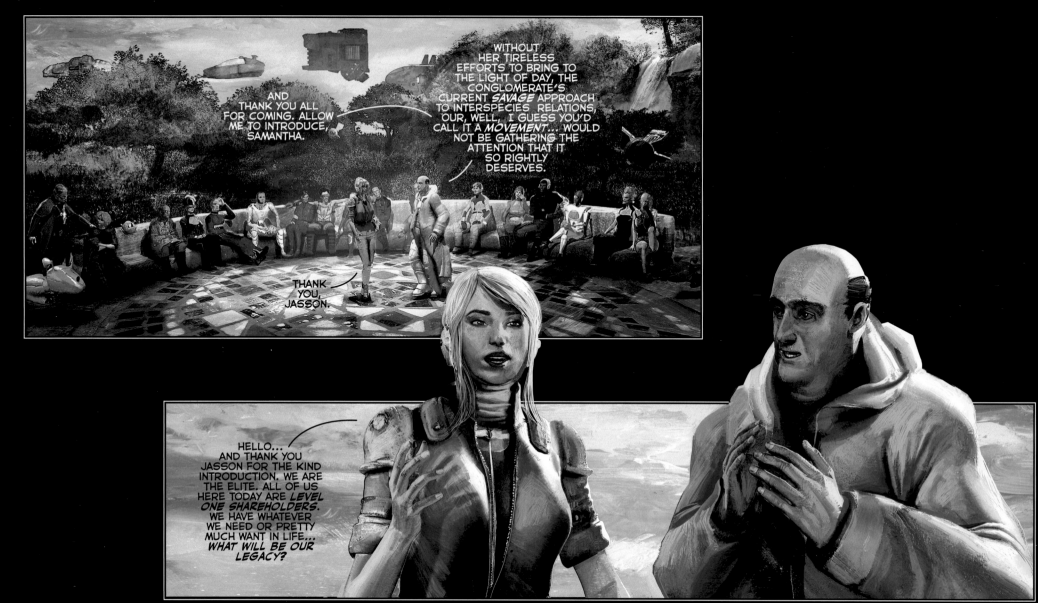

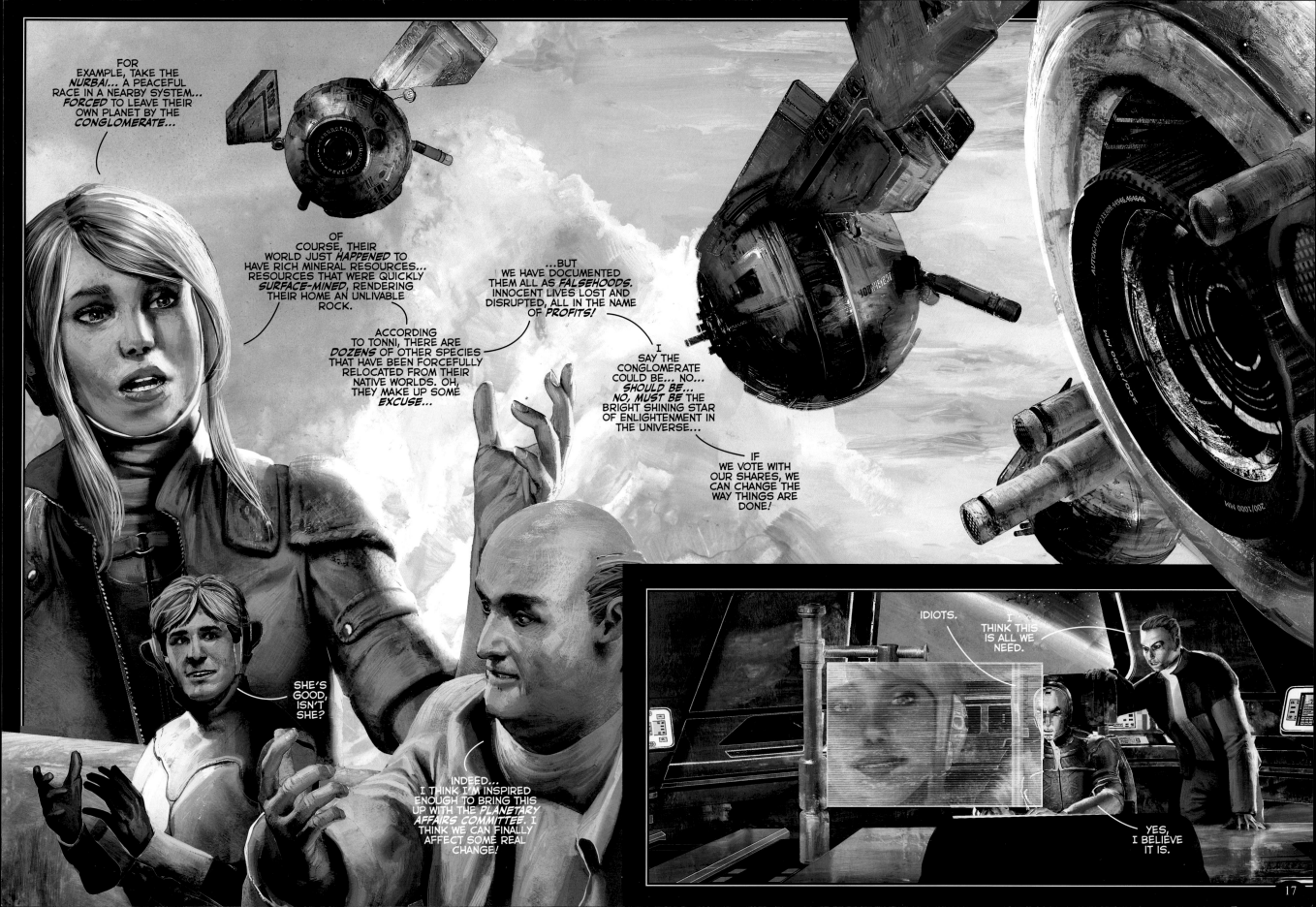

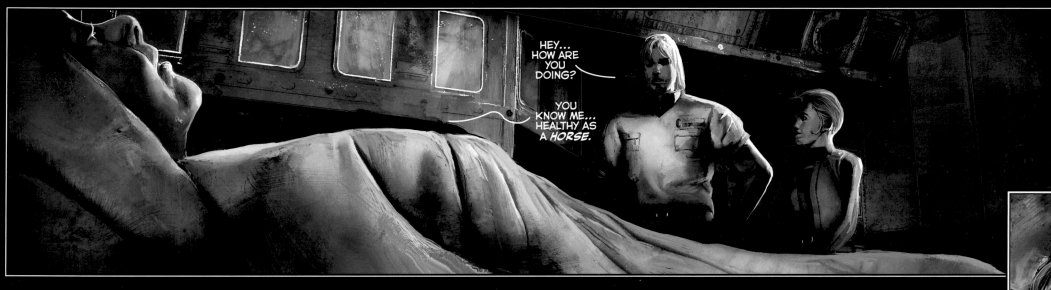
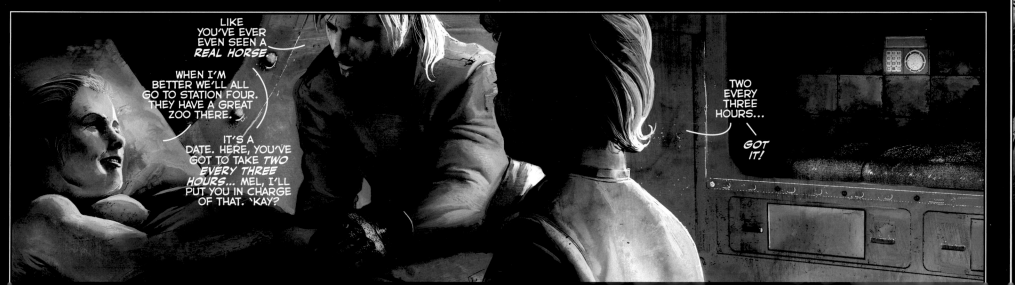

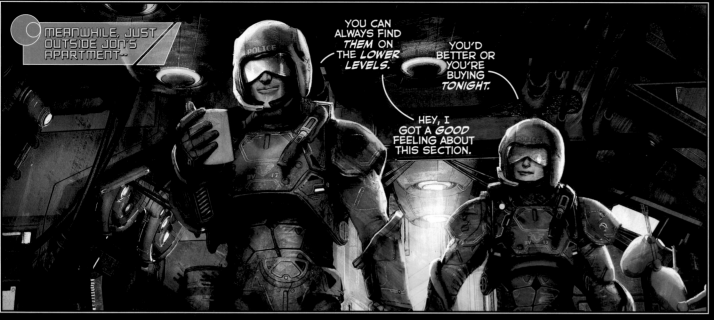

YOU CAN ALWAYS FIND *THEM* ON THE *LOWER LEVELS.*

YOU'D *BETTER* OR YOU'RE *BUYING* TONIGHT.

HEY, I GOT A *GOOD* FEELING ABOUT THIS SECTION.

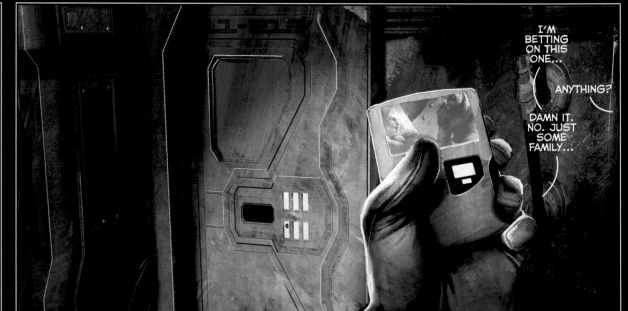

I'M BETTING ON THIS ONE...

ANYTHING?

DAMN IT. NO. JUST SOME FAMILY...

REMEMBER I LIKE THAT *ORION ALE*--

YEAH... I'M NOT BUYING THAT *TOP SHELF CRAP...* IF I LOSE YOU'LL *DRINK* WHAT I DRINK.

AH, HERE WE GO.

THAT'S *BETTER.*

JUST MY *LUCK.*

ALRIGHT, YOU KNOW THE DRILL.

BUT OF COURSE.

CEASE ALL ACTIVITY!

swipe

click

SECURITY OVERRIDE.

NO! WE HAVEN'T DONE ANYTHING. THERE *MUST* BE SOME *MISTAKE!*

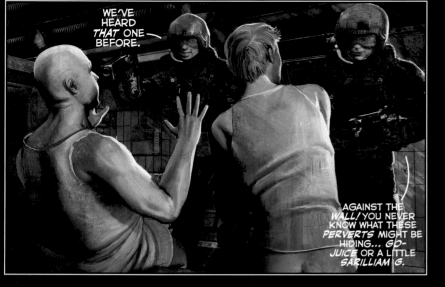

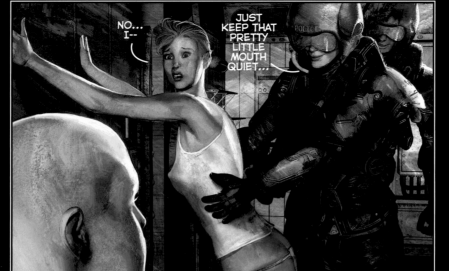

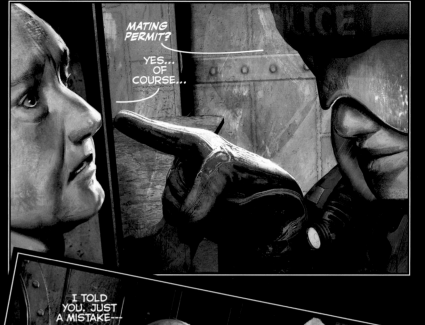

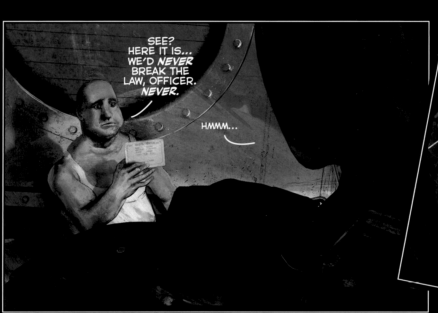

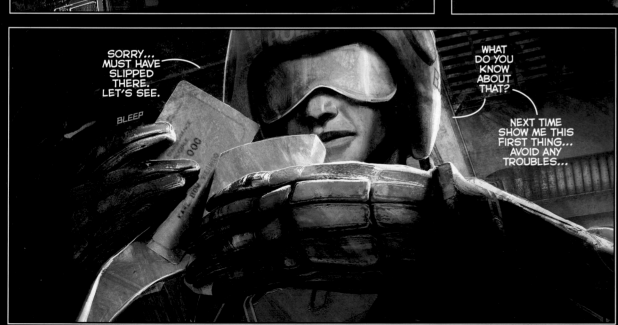

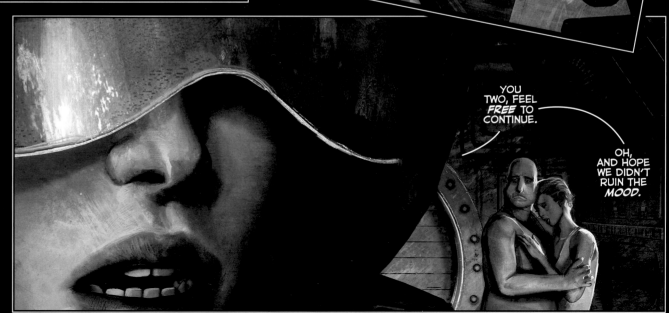

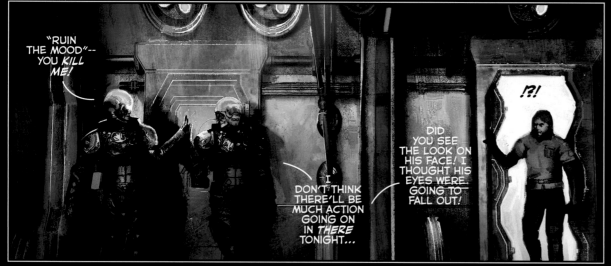

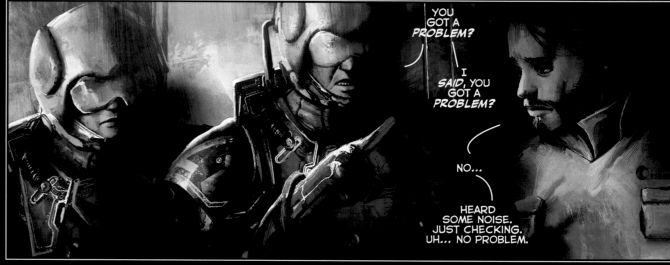

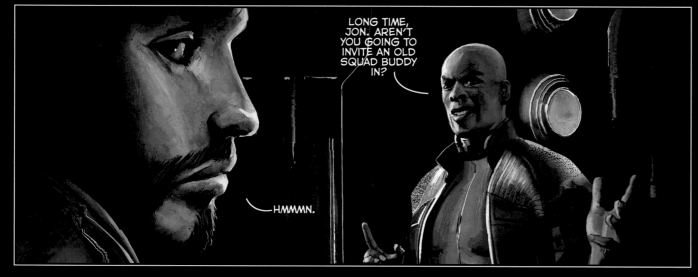

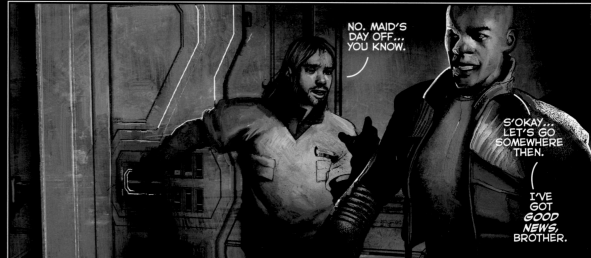

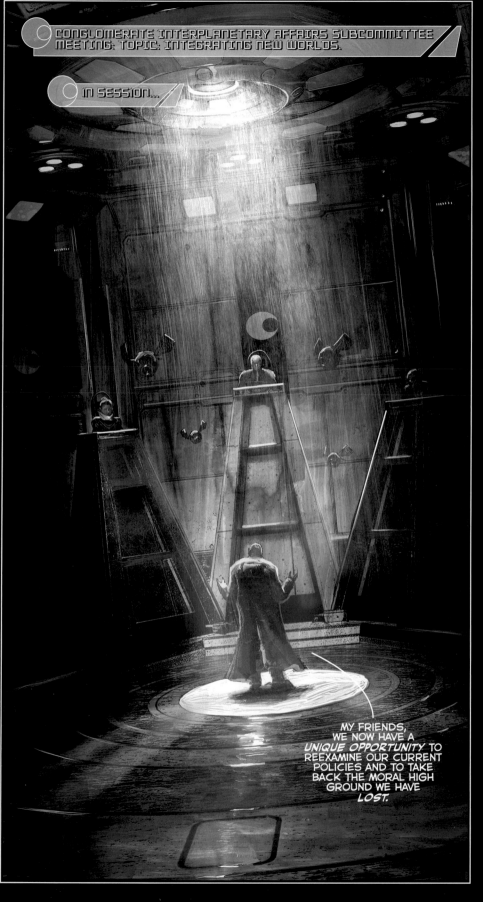

MY FRIENDS,
WE NOW HAVE A
UNIQUE OPPORTUNITY TO
REEXAMINE OUR CURRENT
POLICIES AND TO TAKE
BACK THE MORAL HIGH
GROUND WE HAVE
LOST.

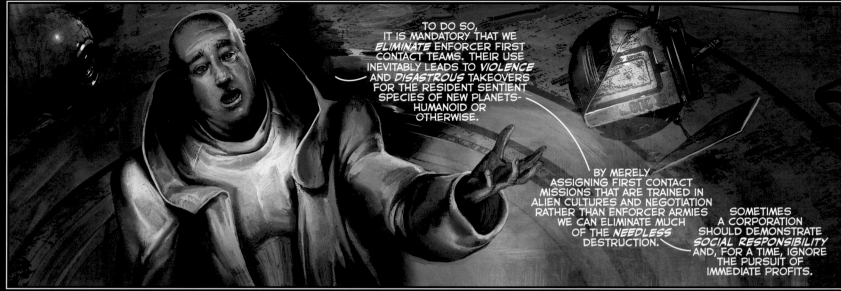

TO DO SO,
IT IS MANDATORY THAT WE
ELIMINATE ENFORCER FIRST
CONTACT TEAMS. THEIR USE
INEVITABLY LEADS TO *VIOLENCE*
AND *DISASTROUS* TAKEOVERS
FOR THE RESIDENT SENTIENT
SPECIES OF NEW PLANETS-
HUMANOID OR
OTHERWISE.

BY MERELY
ASSIGNING FIRST CONTACT
MISSIONS THAT ARE TRAINED IN
ALIEN CULTURES AND NEGOTIATION
RATHER THAN ENFORCER ARMIES
WE CAN ELIMINATE MUCH
OF THE *NEEDLESS*
DESTRUCTION.

SOMETIMES
A CORPORATION
SHOULD DEMONSTRATE
SOCIAL RESPONSIBILITY
AND, FOR A TIME, IGNORE
THE PURSUIT OF
IMMEDIATE PROFITS.

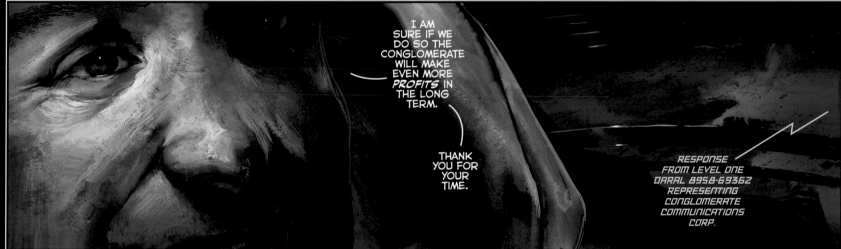

I AM
SURE IF WE
DO SO THE
CONGLOMERATE
WILL MAKE
EVEN MORE
PROFITS IN
THE LONG
TERM.

THANK
YOU FOR
YOUR
TIME.

RESPONSE
FROM LEVEL ONE
DARAL 8958-69362
REPRESENTING
CONGLOMERATE
COMMUNICATIONS
CORP.

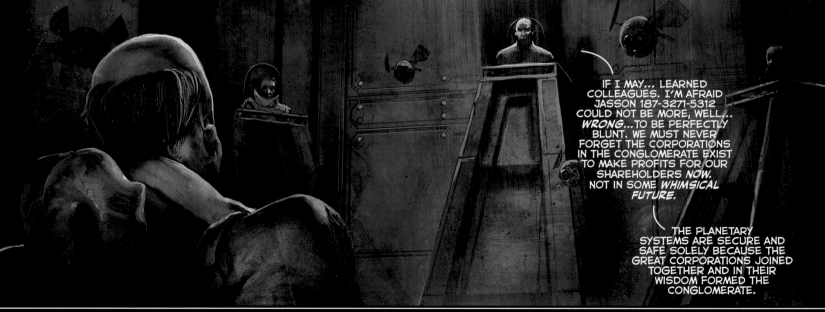

IF I MAY... LEARNED
COLLEAGUES. I'M AFRAID
JASSON 187-3271-5312
COULD NOT BE MORE, WELL...
WRONG...TO BE PERFECTLY
BLUNT. WE MUST NEVER
FORGET THE CORPORATIONS
IN THE CONGLOMERATE EXIST
TO MAKE PROFITS FOR OUR
SHAREHOLDERS *NOW.*
NOT IN SOME *WHIMSICAL*
FUTURE.

THE PLANETARY
SYSTEMS ARE SECURE AND
SAFE SOLELY BECAUSE THE
GREAT CORPORATIONS JOINED
TOGETHER AND IN THEIR
WISDOM FORMED THE
CONGLOMERATE.

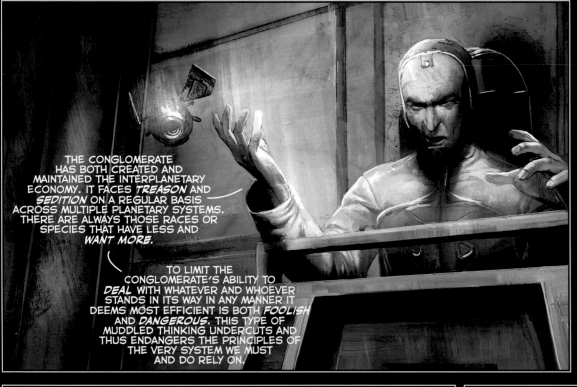

THE CONGLOMERATE HAS BOTH CREATED AND MAINTAINED THE INTERPLANETARY ECONOMY. IT FACES *TREASON* AND *SEDITION* ON A REGULAR BASIS ACROSS MULTIPLE PLANETARY SYSTEMS. THERE ARE ALWAYS THOSE RACES OR SPECIES THAT HAVE LESS AND *WANT MORE.*

TO LIMIT THE CONGLOMERATE'S ABILITY TO *DEAL* WITH WHATEVER AND WHOEVER STANDS IN ITS WAY IN ANY MANNER IT DEEMS MOST EFFICIENT IS BOTH *FOOLISH* AND *DANGEROUS.* THIS TYPE OF MUDDLED THINKING UNDERCUTS AND THUS ENDANGERS THE PRINCIPLES OF THE VERY SYSTEM WE MUST AND DO RELY ON.

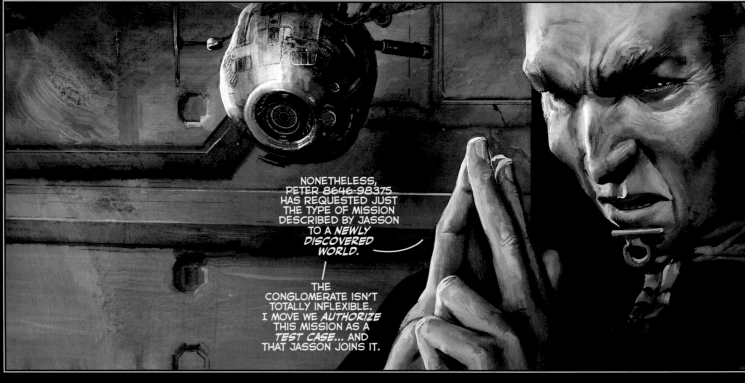

NONETHELESS, PETER 8646-98375 HAS REQUESTED JUST THE TYPE OF MISSION DESCRIBED BY JASSON TO A *NEWLY DISCOVERED WORLD.*

THE CONGLOMERATE ISN'T TOTALLY INFLEXIBLE. I MOVE WE *AUTHORIZE* THIS MISSION AS A *TEST CASE...* AND THAT JASSON JOINS IT.

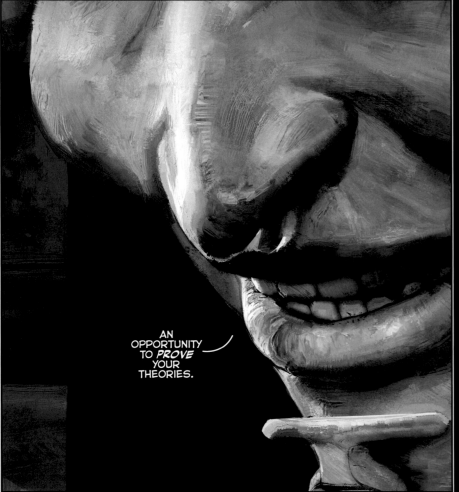

AN OPPORTUNITY TO *PROVE* YOUR THEORIES.

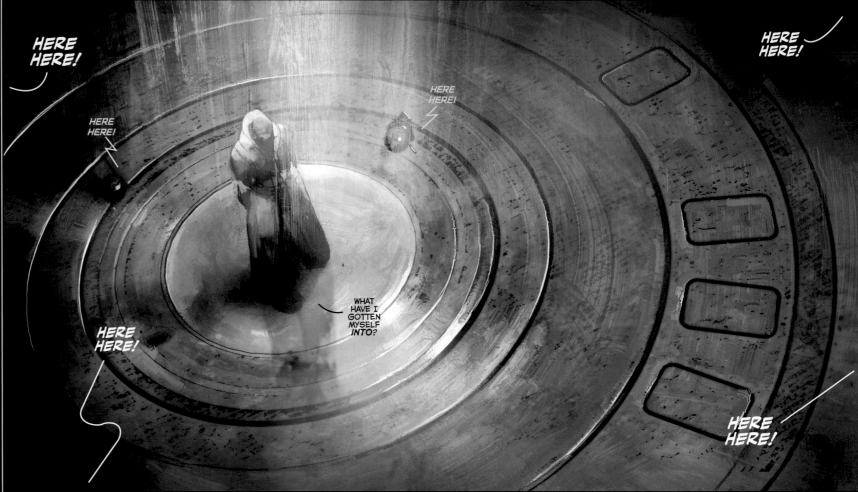

HERE HERE!

HERE HERE!

HERE HERE!

HERE HERE!

WHAT HAVE I GOTTEN MYSELF INTO?

HERE HERE!

HERE HERE!

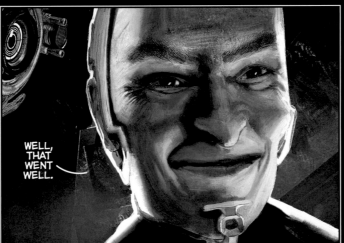

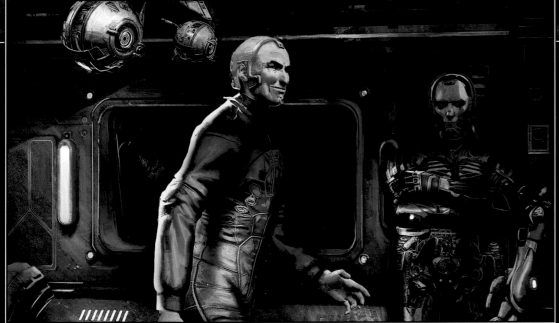

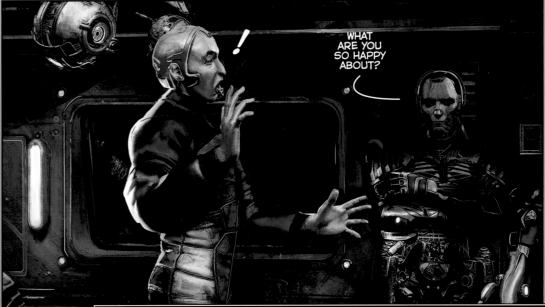

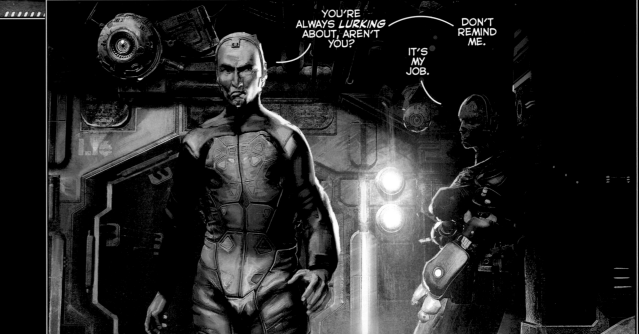

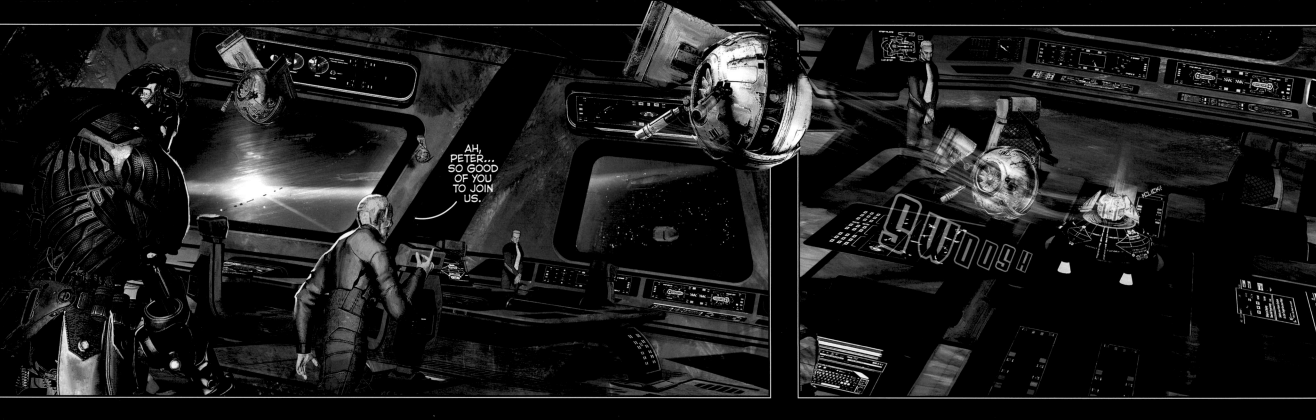

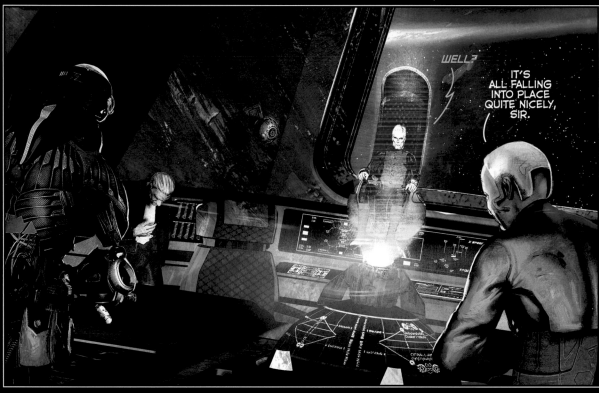

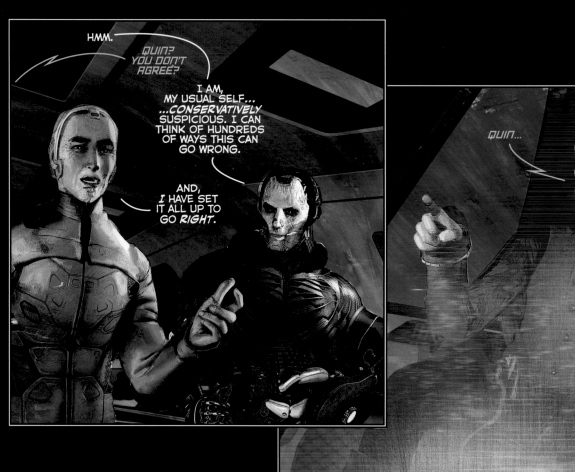

DARAL HAS MY FAITH.

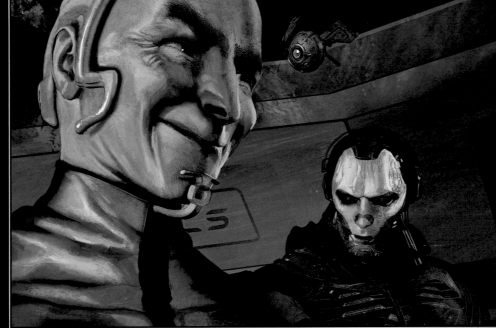

BUT...
IF MY
FAITH
SHOULD
HAPPEN TO BE
MISPLACED...

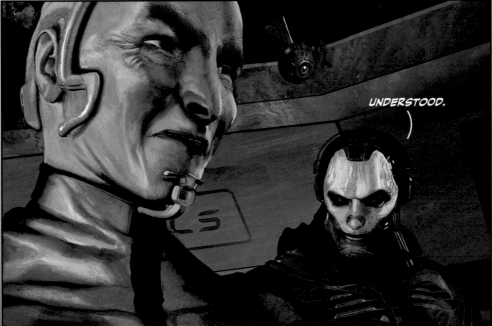

UNDERSTOOD.

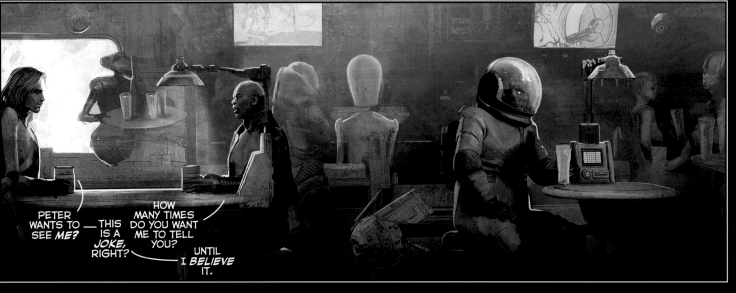

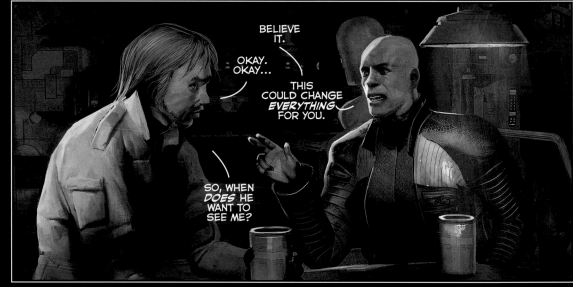

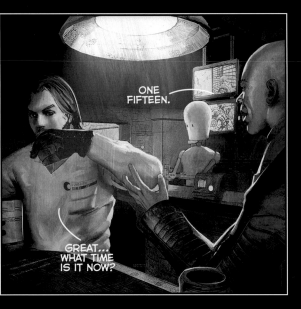

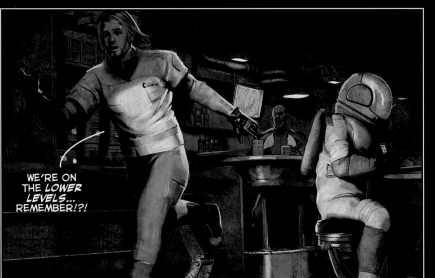

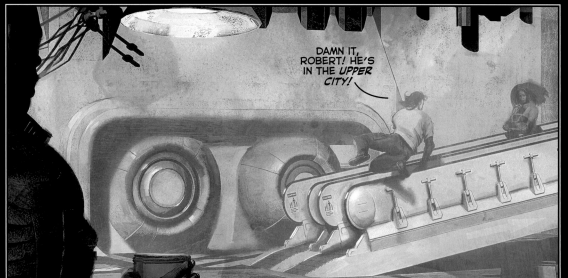

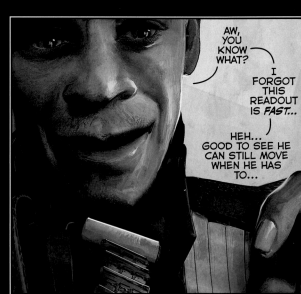

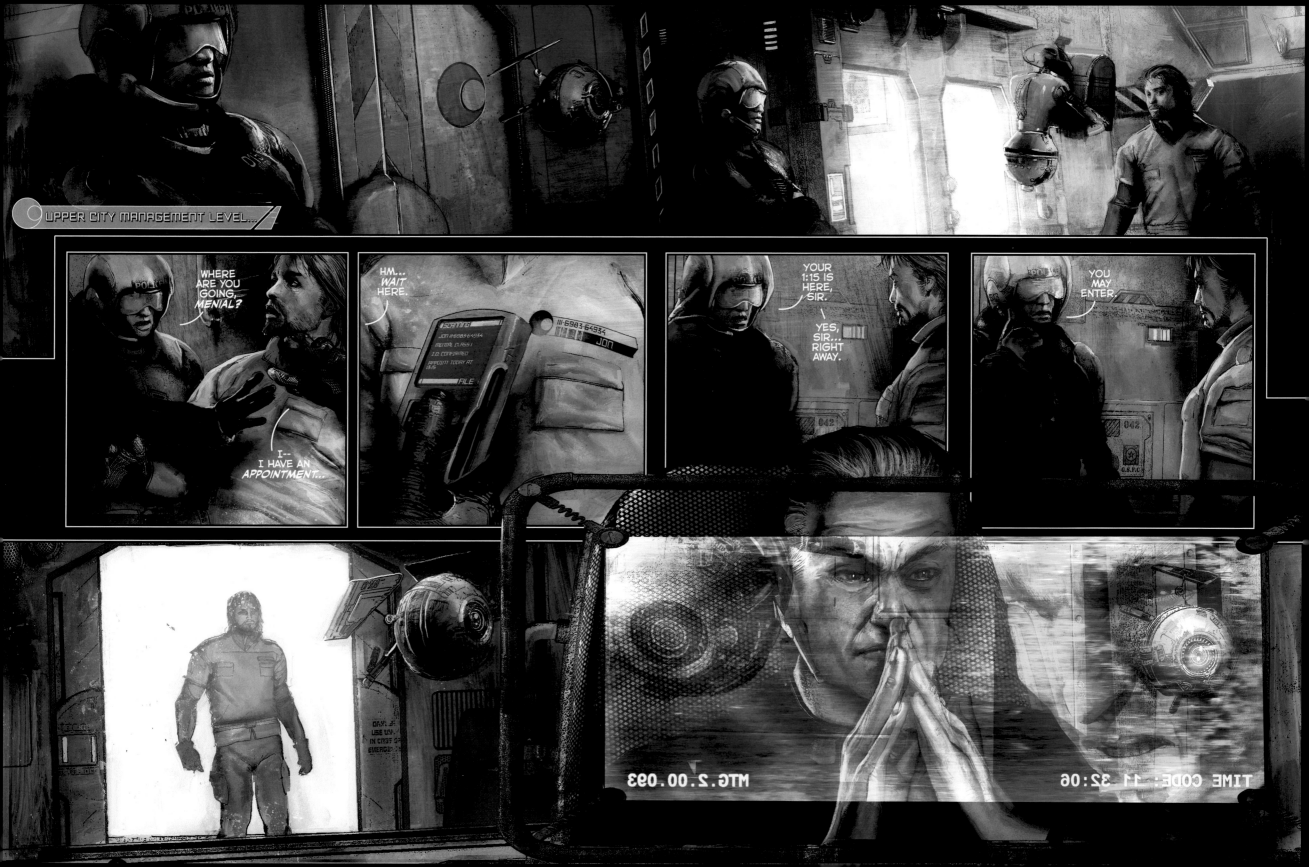

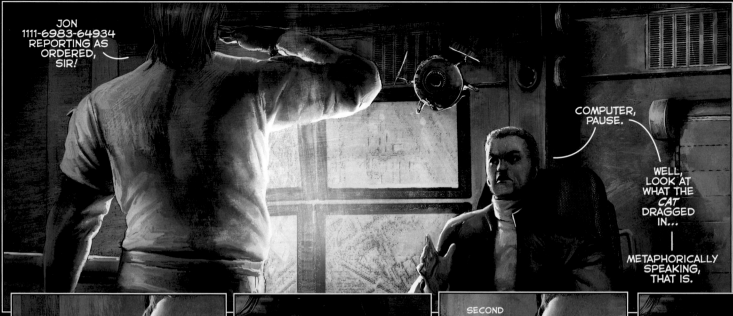

JON 1111-6983-64934 REPORTING AS ORDERED, SIR!

COMPUTER, PAUSE.

WELL, LOOK AT WHAT THE *CAT* DRAGGED IN...

METAPHORICALLY SPEAKING, THAT IS.

FROM THE LOOKS OF YOU, I'M SURPRISED YOU CAN EVEN REMEMBER HOW TO SALUTE. AT EASE.

SIR, MAY I ASK WHAT I'M DOING HERE? ROBERT—

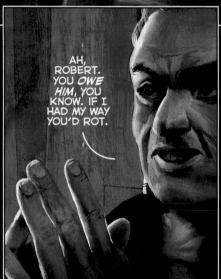

AH, ROBERT. YOU *OWE HIM*, YOU KNOW. IF I HAD MY WAY YOU'D ROT.

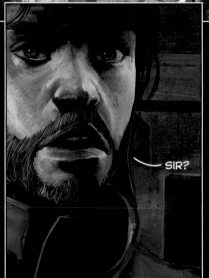

SIR?

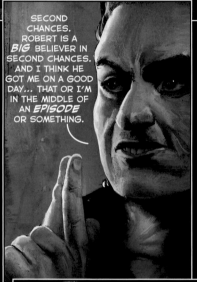

SECOND CHANCES. ROBERT IS A *BIG* BELIEVER IN SECOND CHANCES. AND I THINK HE GOT ME ON A GOOD DAY... THAT OR I'M IN THE MIDDLE OF AN *EPISODE* OR SOMETHING.

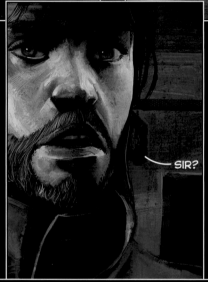

SIR?

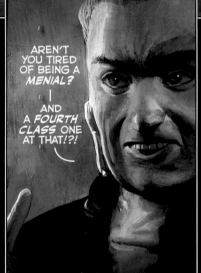

AREN'T YOU TIRED OF BEING A *MENIAL?* AND A *FOURTH CLASS* ONE AT THAT!?!

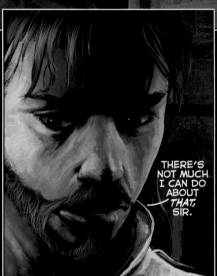

THERE'S NOT MUCH I CAN DO ABOUT *THAT,* SIR.

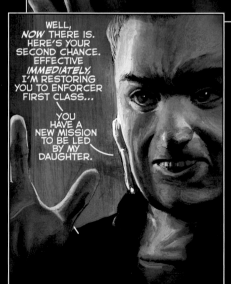

WELL, *NOW* THERE IS. HERE'S YOUR SECOND CHANCE. EFFECTIVE *IMMEDIATELY,* I'M RESTORING YOU TO ENFORCER FIRST CLASS...

YOU HAVE A NEW MISSION TO BE LED BY MY DAUGHTER.

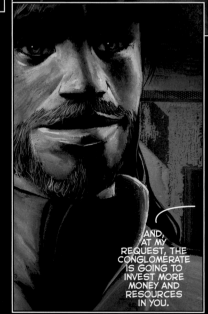

...AND, AT MY REQUEST, THE CONGLOMERATE IS GOING TO INVEST MORE MONEY AND RESOURCES IN YOU.

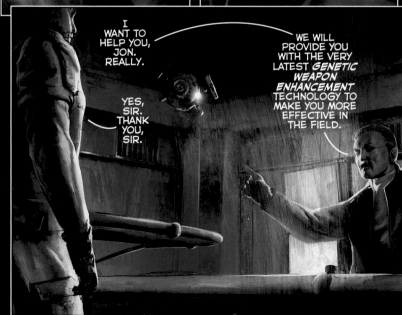

I WANT TO HELP YOU, JON. REALLY.

YES, SIR. THANK YOU, SIR.

WE WILL PROVIDE YOU WITH THE VERY LATEST *GENETIC WEAPON ENHANCEMENT* TECHNOLOGY TO MAKE YOU MORE EFFECTIVE IN THE FIELD.

AND ONE LAST THING. DON'T BLOW THIS.

NO ONE FAILS ME *TWICE!*

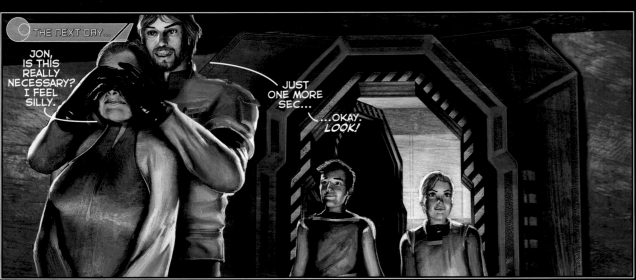

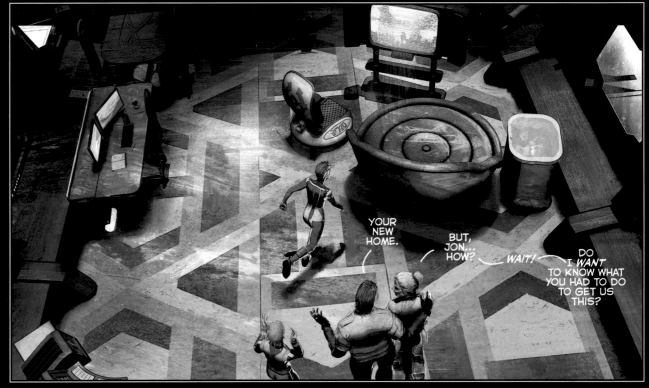

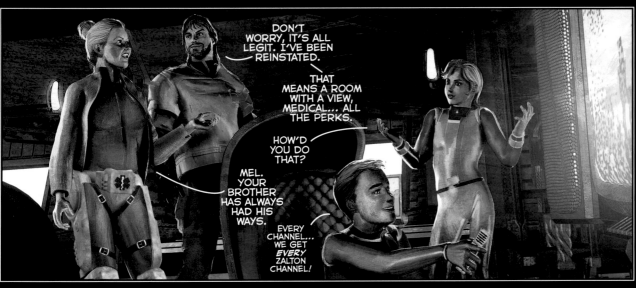

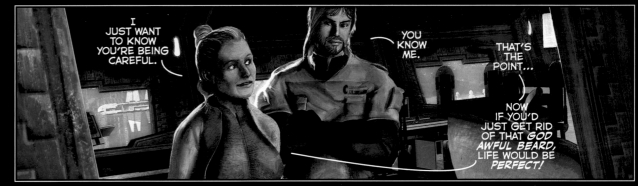

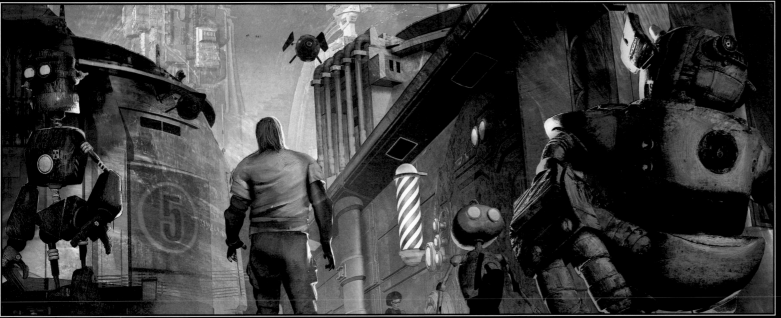

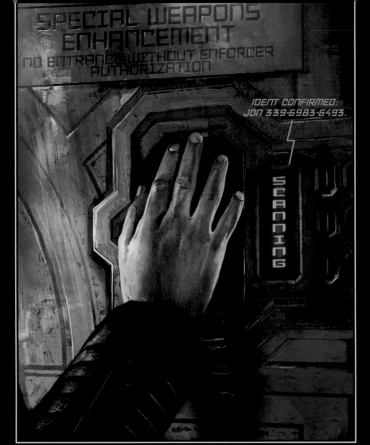

SPECIAL WEAPONS
ENHANCEMENT
NO ENTRANCE WITHOUT ENFORCER
AUTHORIZATION

IDENT CONFIRMED:
JON 339-6983-6493.

SCANNING

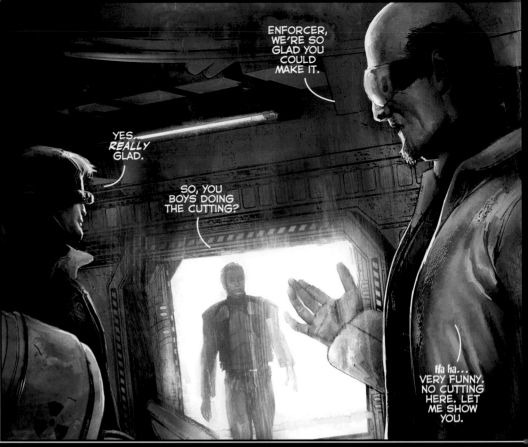

ENFORCER, WE'RE SO GLAD YOU COULD MAKE IT.

YES, REALLY GLAD.

SO, YOU BOYS DOING THE CUTTING?

Ha ha... VERY FUNNY. NO CUTTING HERE. LET ME SHOW YOU.

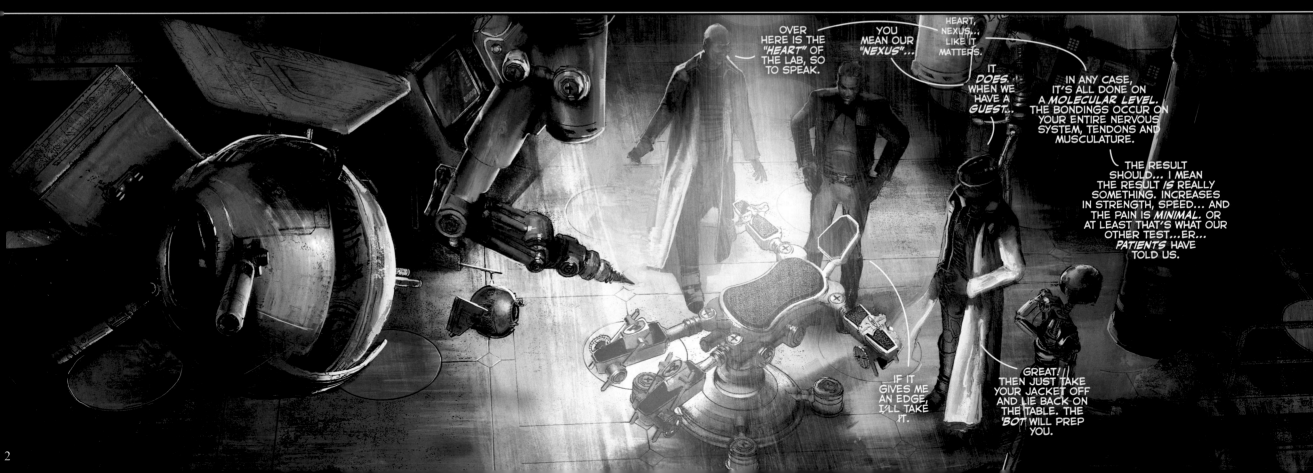

OVER HERE IS THE "HEART" OF THE LAB, SO TO SPEAK.

YOU MEAN OUR "NEXUS"...

HEART, NEXUS... LIKE IT MATTERS.

IT DOES. WHEN WE HAVE A GUEST...

IN ANY CASE, IT'S ALL DONE ON A MOLECULAR LEVEL. THE BONDINGS OCCUR ON YOUR ENTIRE NERVOUS SYSTEM, TENDONS AND MUSCULATURE.

THE RESULT SHOULD... I MEAN THE RESULT IS REALLY SOMETHING. INCREASES IN STRENGTH, SPEED... AND THE PAIN IS MINIMAL. OR AT LEAST THAT'S WHAT OUR OTHER TEST...ER... PATIENTS HAVE TOLD US.

IF IT GIVES ME AN EDGE, I'LL TAKE IT.

GREAT! THEN JUST TAKE YOUR JACKET OFF AND LIE BACK ON THE TABLE. THE 'BOT WILL PREP YOU.

2

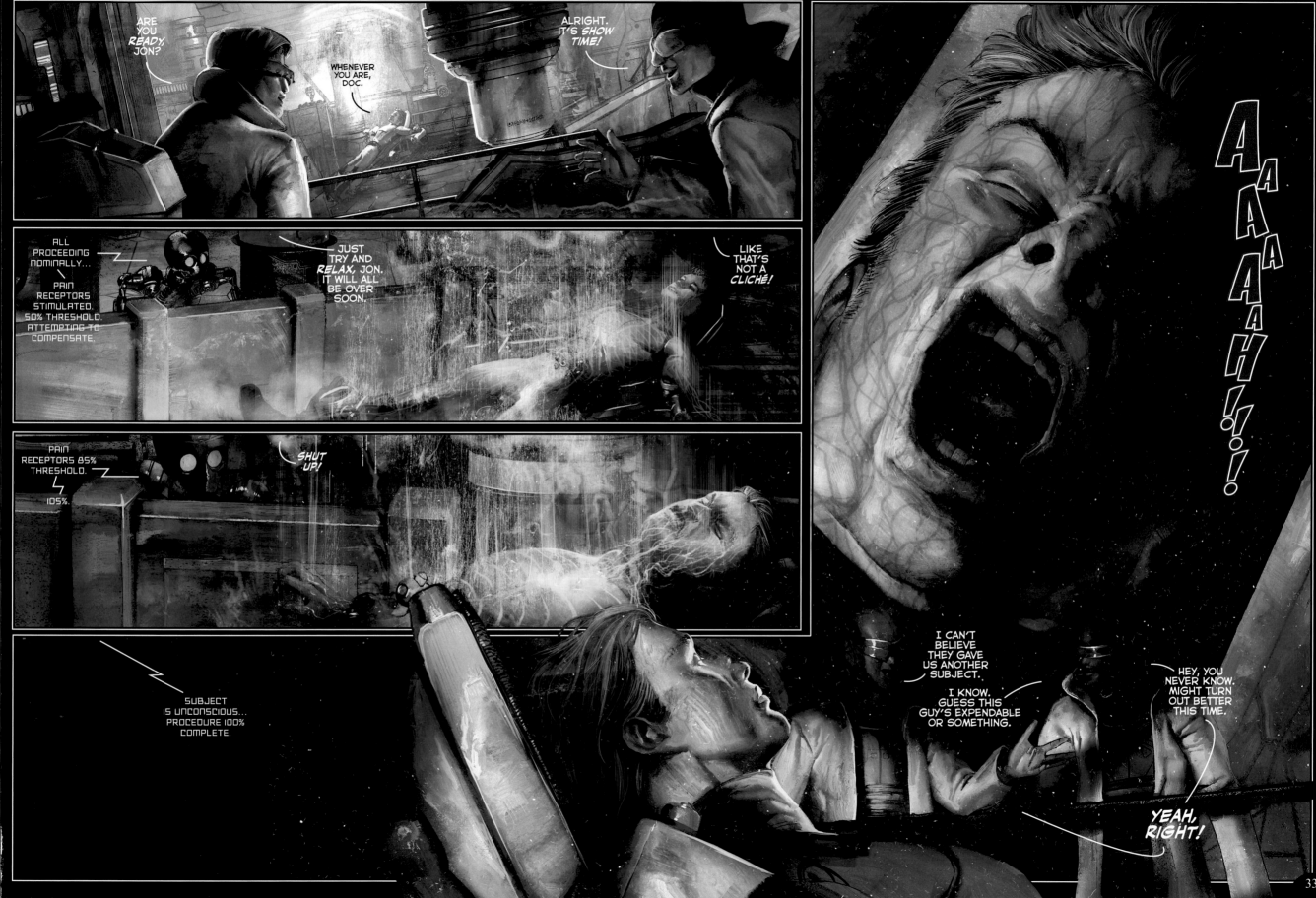

I TOTALLY AGREE. WE'LL HAVE THE CHANCE TO SHOW THEM HOW FIRST CONTACT *COULD* WORK... NO. HOW IT *SHOULD* WORK.

I HOPE WE'RE RIGHT. WE'LL BE *GAMBLING* WITH OUR LIVES HERE.

WE'RE RIGHT... I'LL SHOW YOU WHO'S WRONG.

ENFORCER! WHAT ARE THE PRIME RULES OF *FIRST CONTACT*?

CONTAIN AND PACIFY.

PACIFY. I DON'T THINK YOU MEAN PUTTING SOMETHING TO SUCK IN THEIR MOUTHS, DO YOU?

...DEPENDS ON THE CASE...

NO MA'AM.

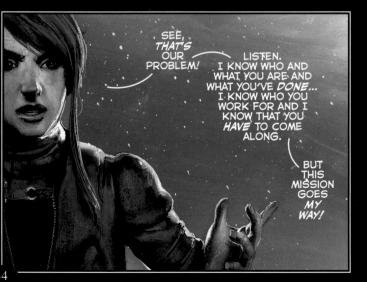

SEE, *THAT'S* OUR PROBLEM!

LISTEN. I KNOW WHO AND WHAT YOU ARE AND WHAT YOU'VE *DONE*... I KNOW WHO YOU WORK FOR AND I KNOW THAT YOU *HAVE* TO COME ALONG.

BUT THIS MISSION GOES *MY WAY!*

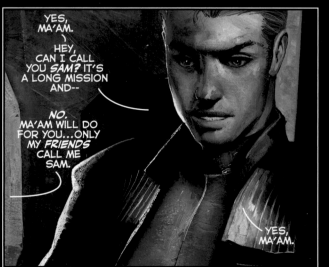

YES, MA'AM. HEY, CAN I CALL YOU *SAM?* IT'S A LONG MISSION AND--

NO. MA'AM WILL DO FOR YOU... ONLY MY *FRIENDS* CALL ME SAM.

YES, MA'AM.

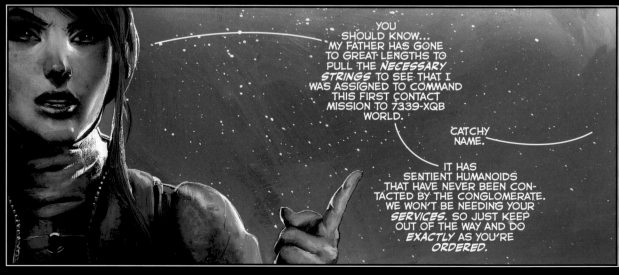

YOU SHOULD KNOW... MY FATHER HAS GONE TO GREAT LENGTHS TO PULL THE *NECESSARY STRINGS* TO SEE THAT I WAS ASSIGNED TO COMMAND THIS FIRST CONTACT MISSION TO 7339-XQB WORLD.

CATCHY NAME.

IT HAS SENTIENT HUMANOIDS THAT HAVE NEVER BEEN CONTACTED BY THE CONGLOMERATE. WE WON'T BE NEEDING YOUR *SERVICES.* SO JUST KEEP OUT OF THE WAY AND DO *EXACTLY* AS YOU'RE ORDERED.

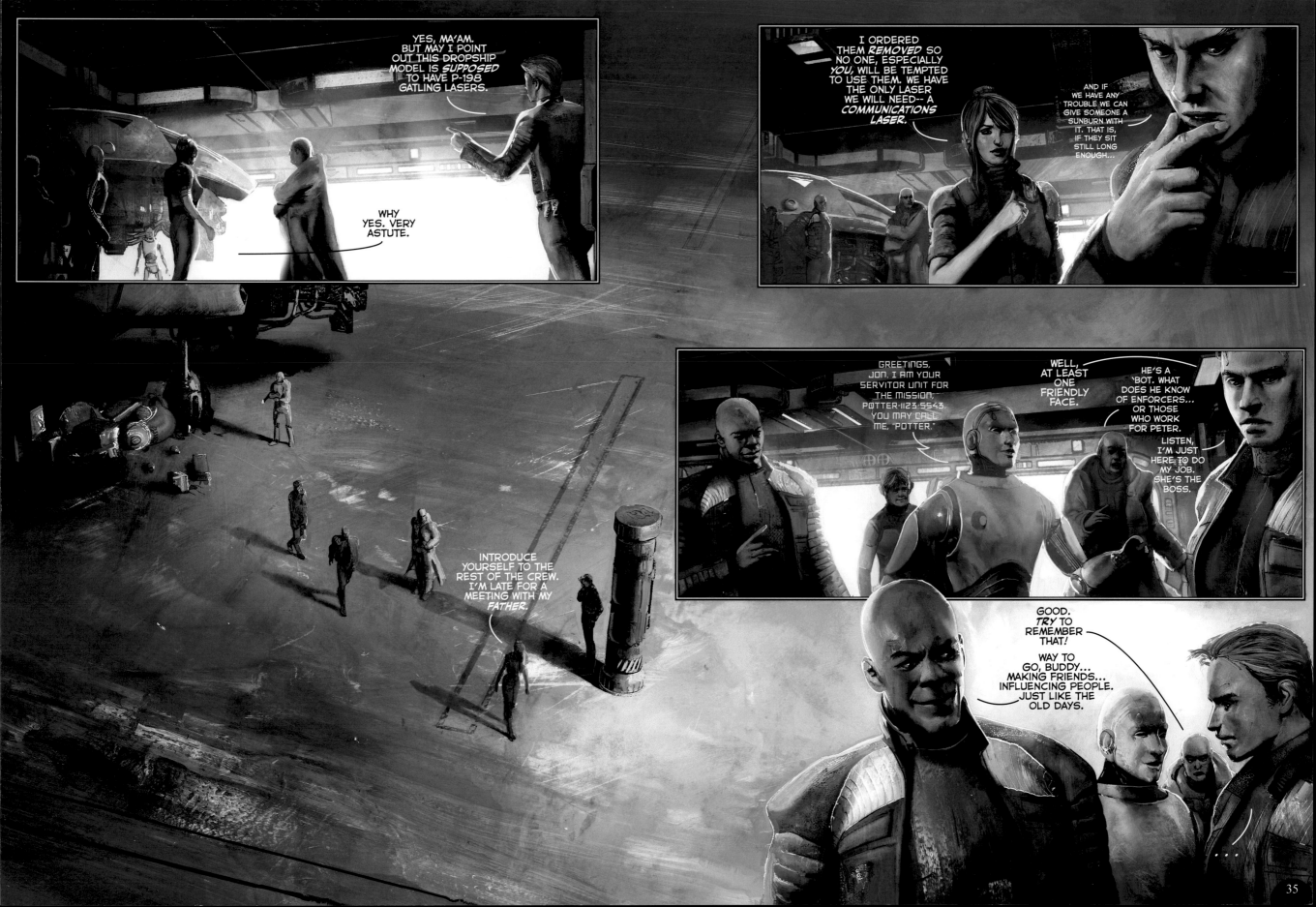

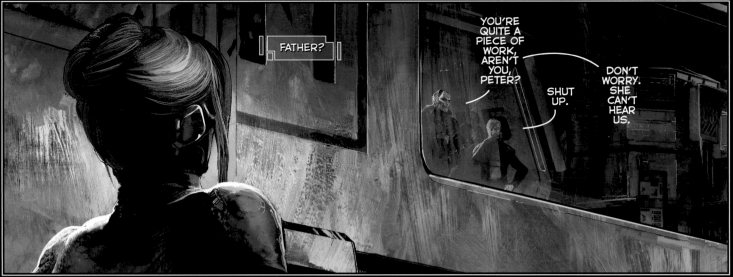

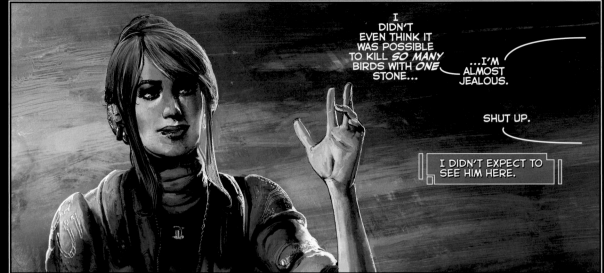

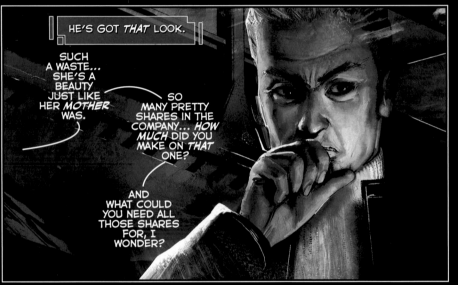

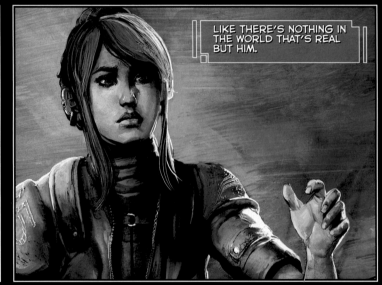

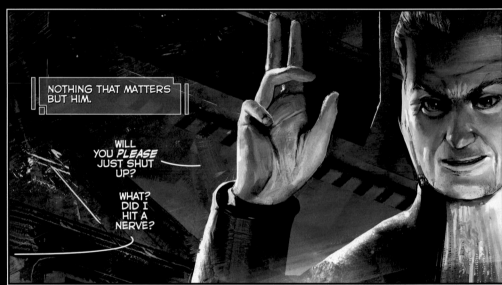

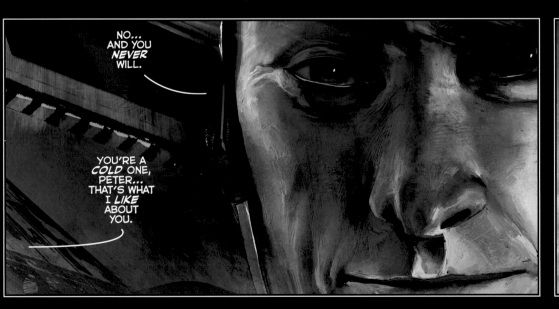

36

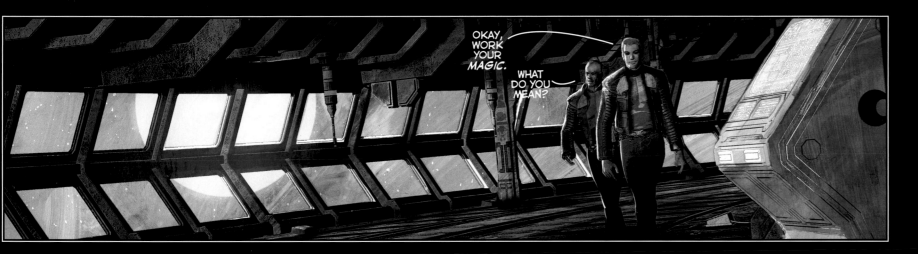

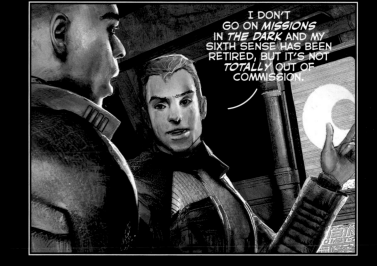

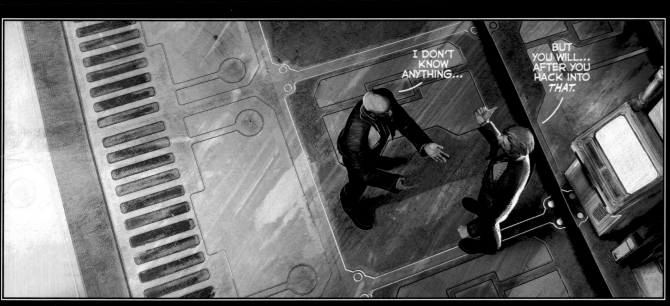

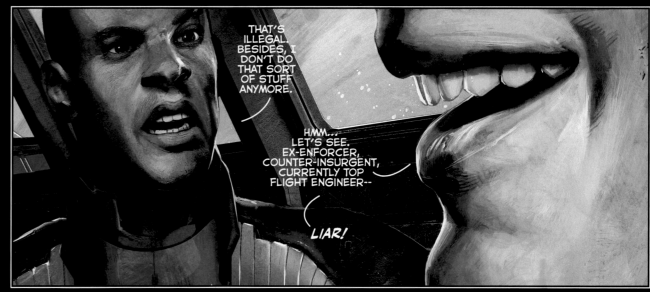

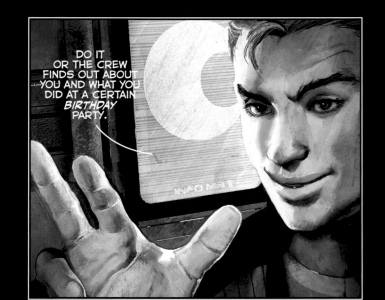

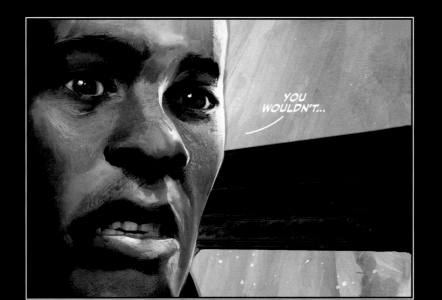

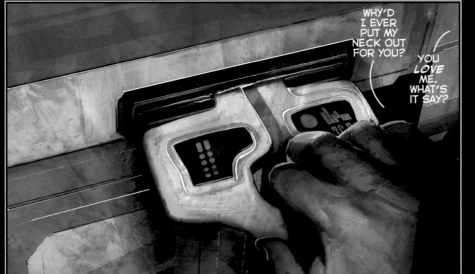

WHY'D I EVER PUT MY NECK OUT FOR YOU?

YOU *LOVE* ME. WHAT'S IT SAY?

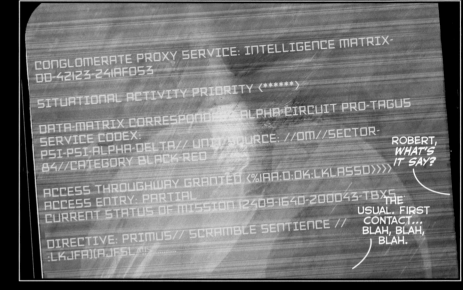

CONGLOMERATE PROXY SERVICE: INTELLIGENCE MATRIX-
DD-42123-24IAF053

SITUATIONAL ACTIVITY PRIORITY (******)

DATA-MATRIX CORRESPONDENCE: ALPHA-CIRCUIT PRO-TAGUS
SERVICE CODEX:
PSI-PSI-ALPHA-DELTA// UNIT SOURCE: //OM//SECTOR-
84//CATEGORY BLACK-RED

ACCESS THROUGHWAY GRANTED (%IAA:0:0K.LKLA550>>>>
ACCESS ENTRY: PARTIAL
CURRENT STATUS OF MISSION 12409-1640-200043-TBXS

DIRECTIVE: PRIMUS// SCRAMBLE SENTIENCE //
:LKJFAJLAJFSL.!!!......

ROBERT, *WHAT'S* IT SAY?

THE USUAL. FIRST CONTACT... BLAH, BLAH, BLAH.

GOOD, MUST JUST BE GETTING PARANOID IN MY OLD AGE...

BUT IT'S A BIT TOO *CLEAN.*

TOO CLEAN?

ALL THE DATA... TOO NEATLY ORGANIZED...

SOUNDS LIKE MY PARANOIA IS *CONTAGIOUS* WHEN SOME BUREAUCRAT'S NEATNESS IS A PROBLEM.

GOD, *YOU'RE RIGHT.* YOU HAD ME THINKING LIKE AN *ENFORCER* AGAIN...

...YOU KNOW, ANY LITTLE THING...

COME ON, I OWE YOU ONE. FIRST ROUND'S ON ME.

INFO MAT

YEAH, YOU'RE GOING TO NEED ONE TO DEAL WITH OUR *ICE MAIDEN* CAPTAIN.

YEAH, SHE'S A PIECE OF WORK, HUH? I THINK SHE'S MEANER THAN PETER. MUST BE A *FAMILY* THING.

NAW, HE JUST MARRIED HER MOTHER... HE'S NOT HER REAL DAD.

SO NO GENETIC EXCUSES—THEN.

SHE'S JUST *MEAN...*

SWOOSH!

SO, YOU GUYS EVER DONE ANY *DEEP SPACE* MISSIONS BEFORE?

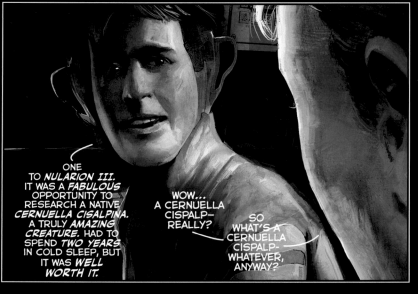

ONE TO *NULARION III.* IT WAS A *FABULOUS* OPPORTUNITY TO RESEARCH A NATIVE *CERNUELLA CISALPINA.* A TRULY *AMAZING CREATURE.* HAD TO SPEND *TWO YEARS* IN COLD SLEEP, BUT IT WAS *WELL WORTH IT.*

WOW... A *CERNUELLA CISPALP—* REALLY?

SO WHAT'S A *CERNUELLA CISPALP—* WHATEVER, ANYWAY?

WELL, IT'S ABOUT THIS BIG. AND ITS SHELL IS A SERENE BROWNISH COLOR.

THAT REALLY CONTRASTS WITH THE BRIGHT GREEN OF THE SOIL THERE. AND ITS ANTENNAE... OH, YOU SHOULD SEE ITS *ANTENNAE—*

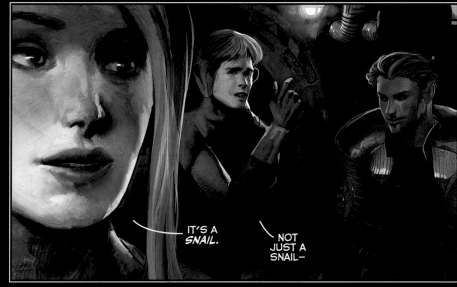

IT'S A *SNAIL.*

NOT JUST A SNAIL—

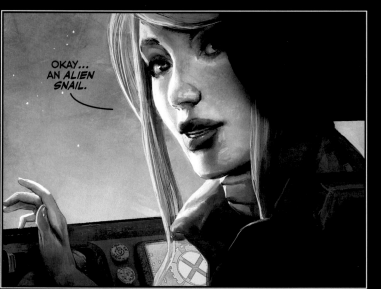

OKAY... AN *ALIEN SNAIL.*

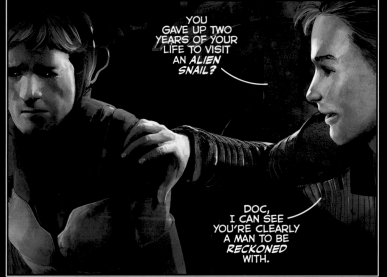

YOU GAVE UP TWO YEARS OF YOUR LIFE TO VISIT AN *ALIEN SNAIL?*

DOC, I CAN SEE YOU'RE CLEARLY A MAN TO BE *RECKONED* WITH.

...

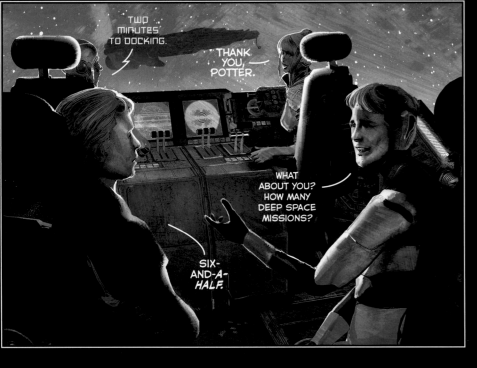

TWO MINUTES TO DOCKING.

THANK YOU, POTTER.

WHAT ABOUT YOU? HOW MANY DEEP SPACE MISSIONS?

SIX-AND-A-HALF.

AND A HALF?

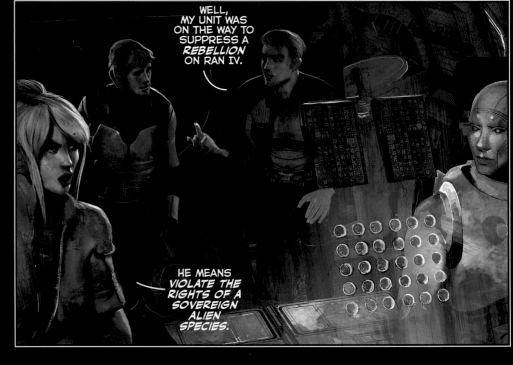

WELL, MY UNIT WAS ON THE WAY TO SUPPRESS A REBELLION ON RAN IV.

HE MEANS VIOLATE THE RIGHTS OF A SOVEREIGN ALIEN SPECIES.

WELL, I WOULDN'T REALLY KNOW AS WE DIDN'T GET THERE. WE HAD A MALFUNCTION IN OUR SERVITOR 'BOT.

FOR SOME REASON IT JUST PUT THE SHIP ON COURSE FOR THE DEEP BLACK. NO REAL FINAL DESTINATION...

WE WERE IN COLD SLEEP FOR THREE YEARS UNTIL WE WERE CLOSE ENOUGH TO A GATE FOR A SHIP TO RESCUE US. THEY BOARDED US AND DESTROYED THE MALFUNCTIONING 'BOT.

TWENTY OF US HAD DIED IN OUR CHAMBERS.

YOU SEE, AFTER THE 'BOT WAS DESTROYED HIS CENTRAL CPU WAS RECONSTRUCTED, SO WE COULD FIND OUT WHAT HAPPENED.

WELL, WE FOUND OUT IT WAS RUNNING ITS OWN EXPERIMENTS IN LUCK...

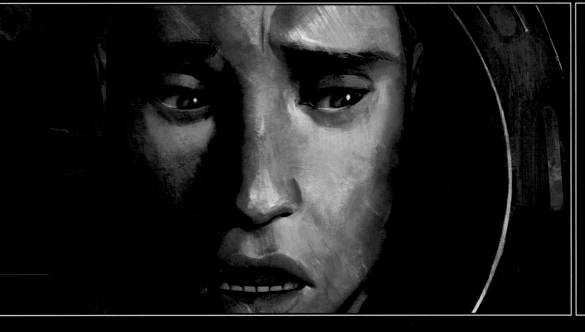

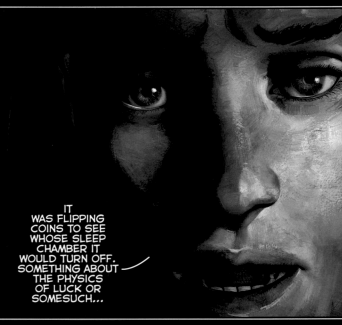

IT WAS FLIPPING COINS TO SEE WHOSE SLEEP CHAMBER IT WOULD TURN OFF. SOMETHING ABOUT THE PHYSICS OF LUCK OR SOMESUCH...

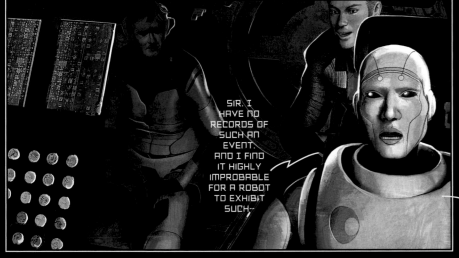

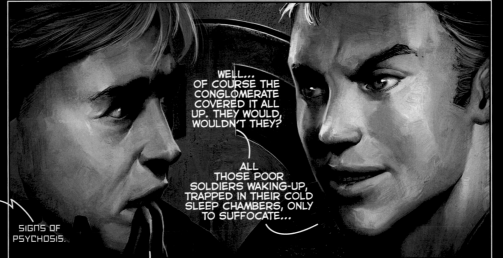

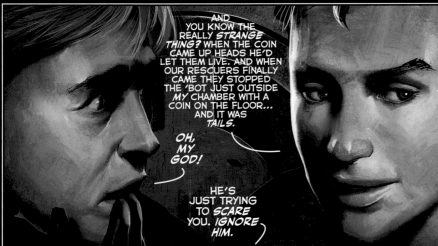

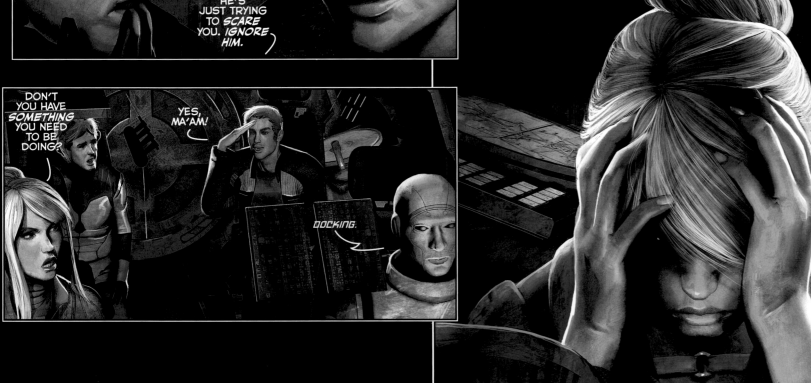

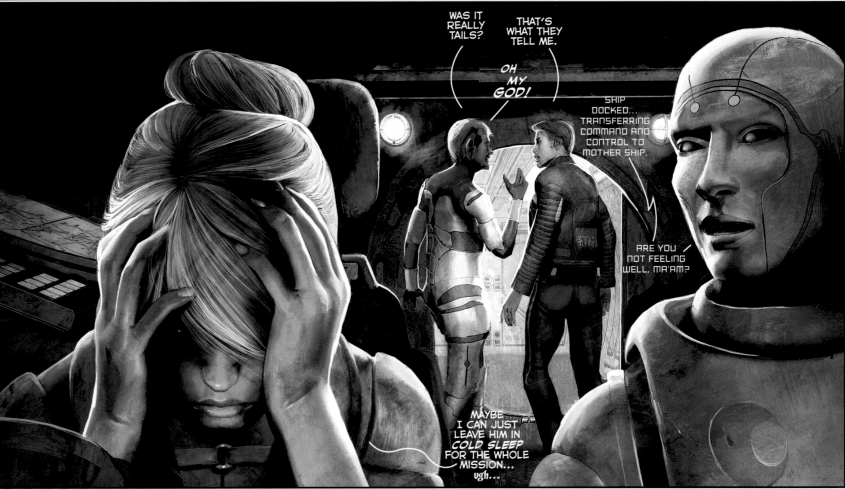

HERE'S TO THE START OF A *HISTORIC* MISSION. WE'LL BE SETTING THE *NEW STANDARD* IN OFF WORLD CONTACT.

WE'LL SHOW THE CONGLOMERATE THAT WITH *RESPECT* AND *UNDERSTANDING* YOU CAN ACCOMPLISH *GREAT THINGS.*

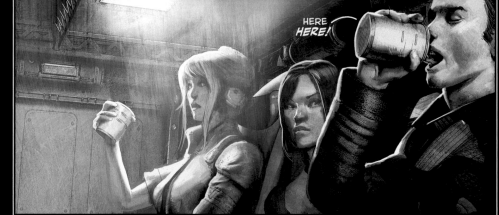

HERE *HERE!*

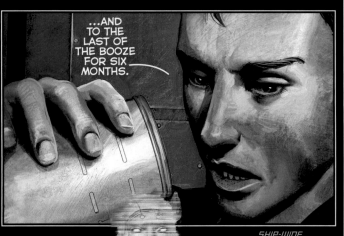

...AND TO THE LAST OF THE BOOZE FOR SIX MONTHS.

SHIP-WIDE MESSAGE. PREPARE FOR GATE TRAVEL IN 15 MINUTES....THEN ALL HUMAN CREW NEED TO REPORT TO COLD SLEEP CHAMBERS BY 0530.

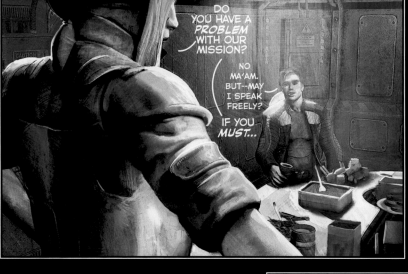

DO YOU HAVE A *PROBLEM* WITH OUR MISSION?

NO MA'AM. BUT--MAY I SPEAK FREELY?

IF YOU *MUST...*

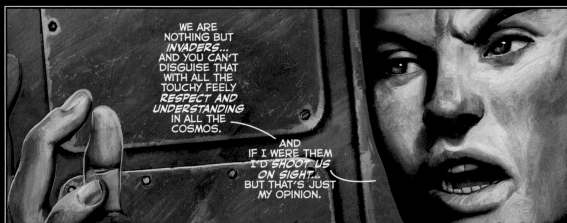

WE ARE NOTHING BUT *INVADERS...* AND YOU CAN'T DISGUISE THAT WITH ALL THE TOUCHY FEELY *RESPECT* AND *UNDERSTANDING* IN ALL THE COSMOS.

AND IF I WERE THEM I'D *SHOOT US ON SIGHT...* BUT THAT'S JUST MY OPINION.

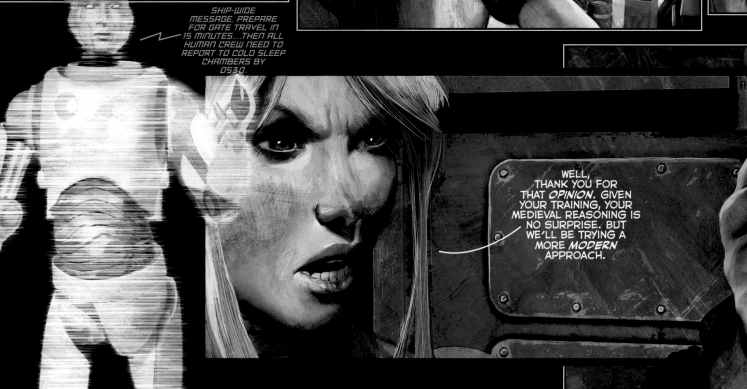

WELL, THANK YOU FOR THAT *OPINION.* GIVEN YOUR TRAINING, YOUR MEDIEVAL REASONING IS NO SURPRISE. BUT WE'LL BE TRYING A MORE *MODERN* APPROACH.

FAIR ENOUGH, MA'AM.... FAIR ENOUGH.

ALRIGHT, PEOPLE. MAKE SURE YOU FINISH ALL YOUR PORTIONS. THEY ARE BALANCED FOR WHAT YOUR BODY WILL NEED FOR THE NEXT SIX MONTHS IN HIBERNATION...

AND IF YOU DON'T, WHEN YOU WAKE UP YOU'LL FEEL LIKE--

WELL, YOU'LL FEEL LIKE SOMETHING THAT NEEDS HOSPITAL CARE.

MUNCH

CRUNCH

⇒ gulp ⇐

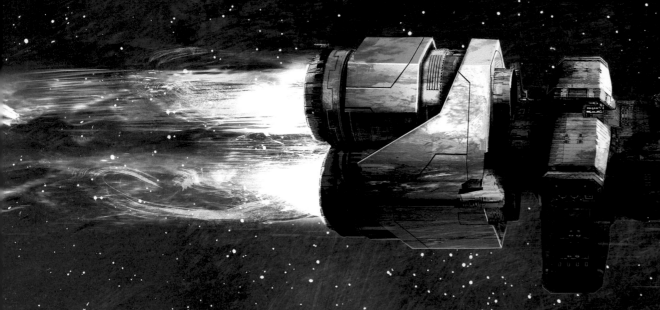

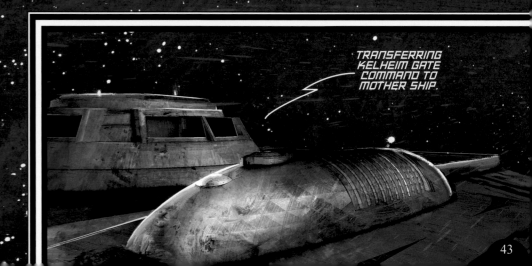

TRANSFERRING KELHEIM GATE COMMAND TO MOTHER SHIP.

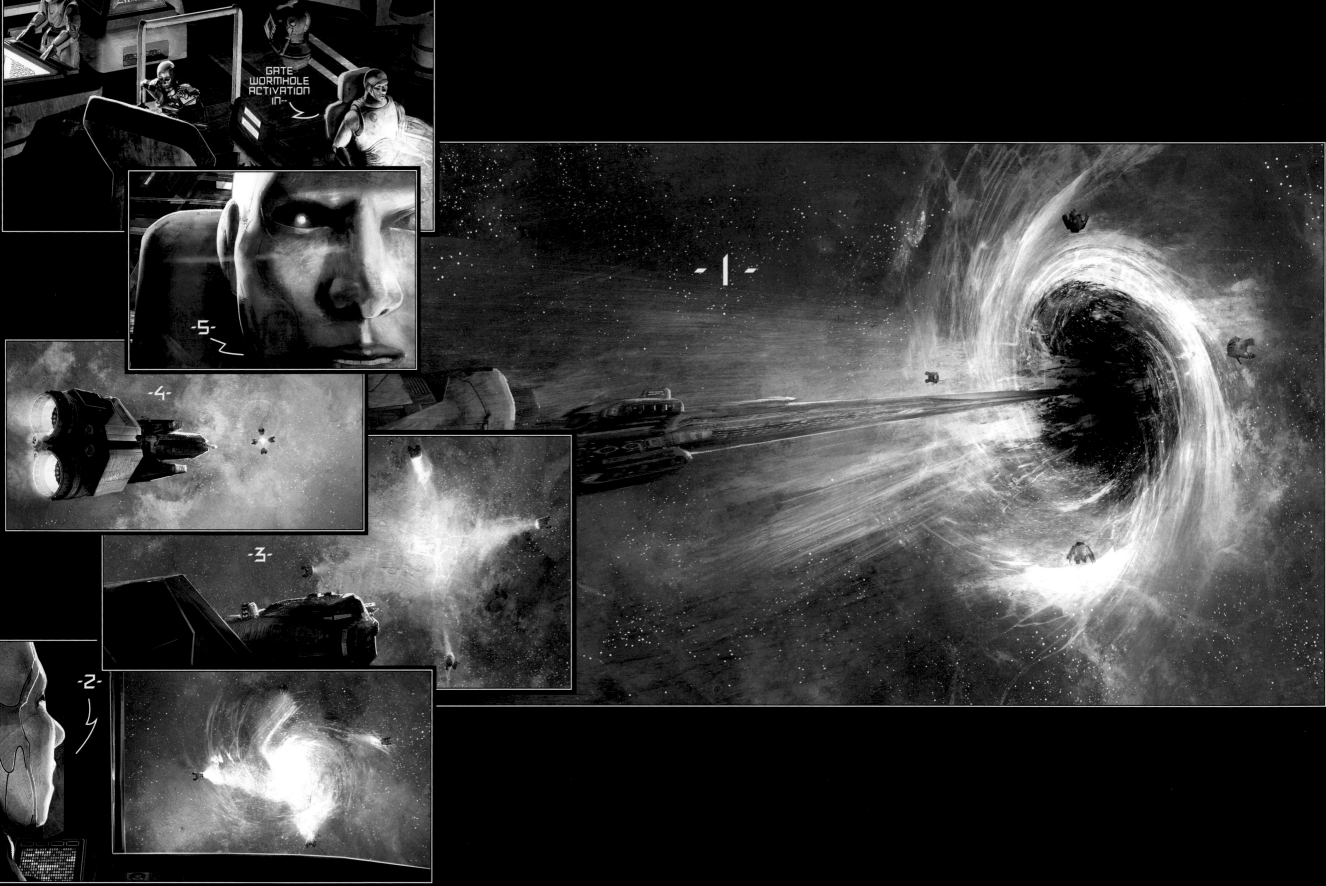

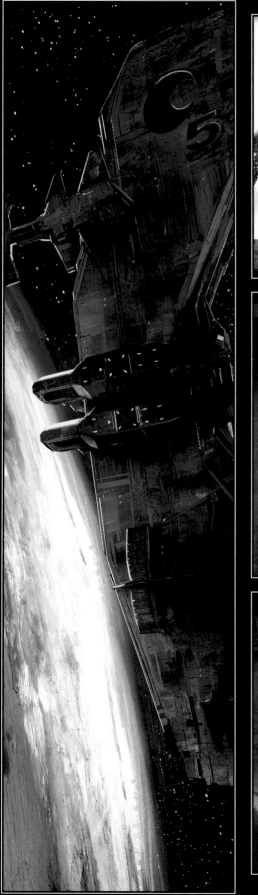
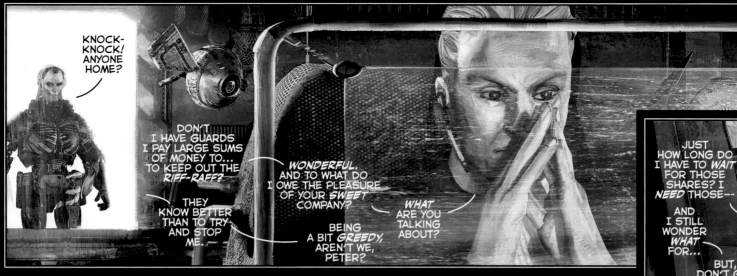
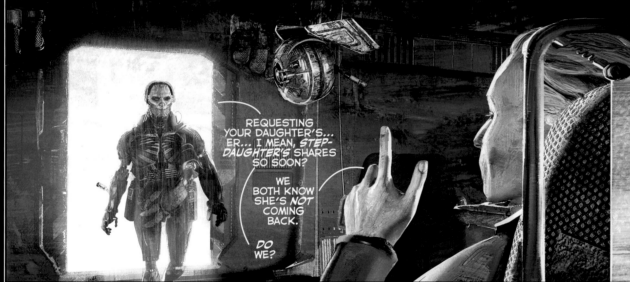
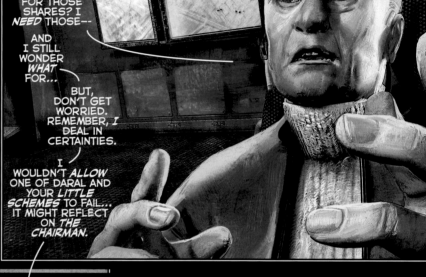
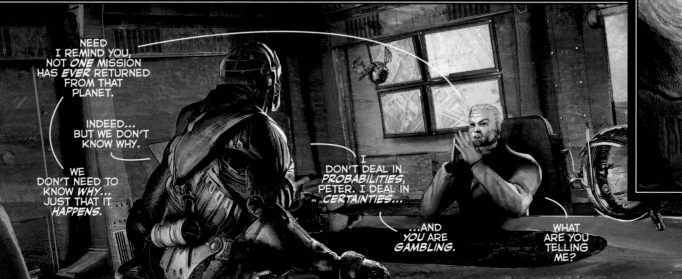

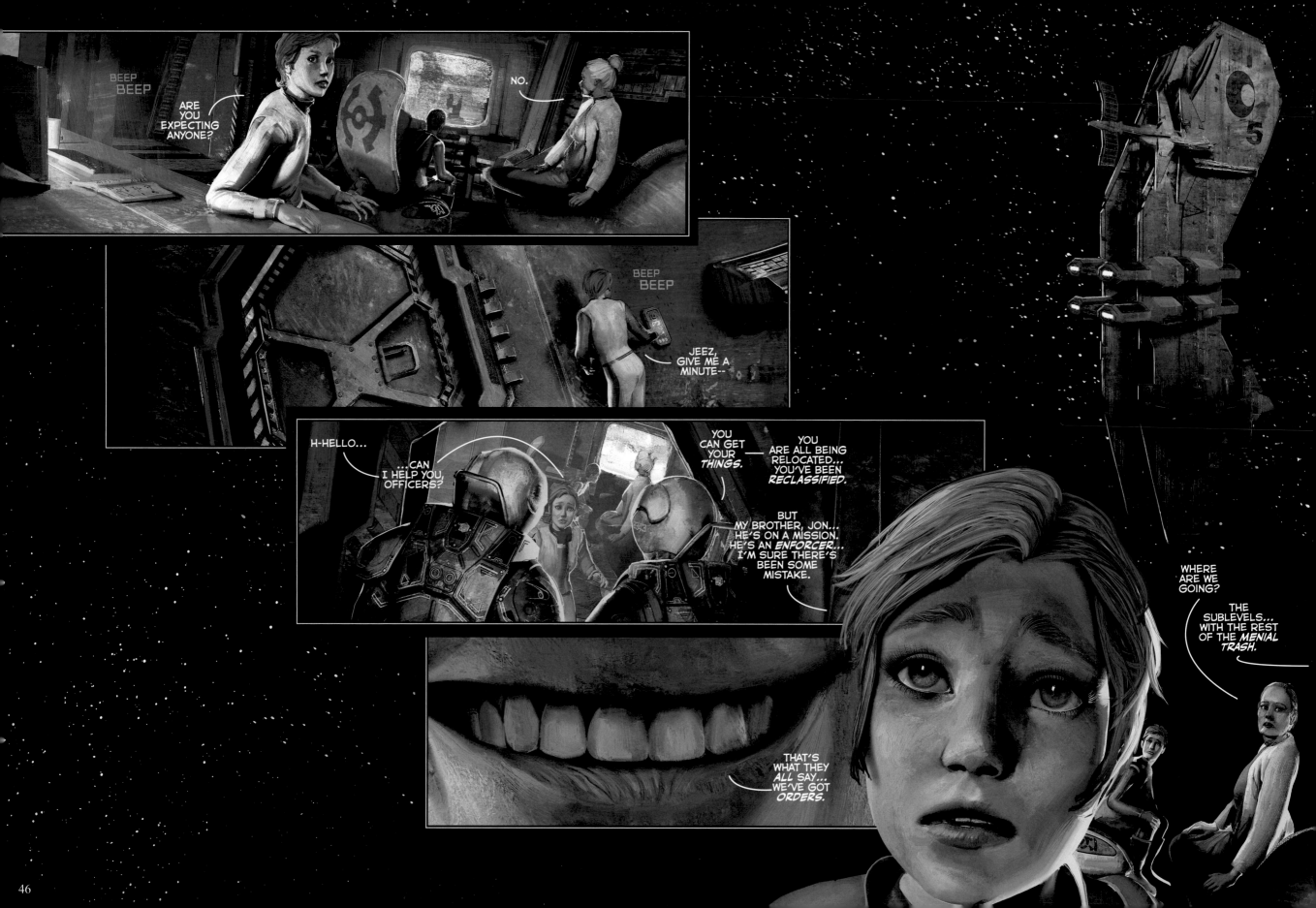

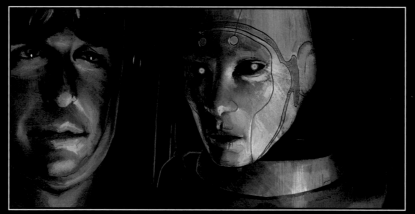

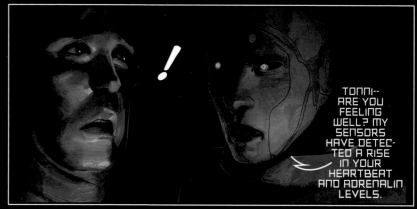

TONNI-- ARE YOU FEELING WELL? MY SENSORS HAVE DETECTED A RISE IN YOUR HEARTBEAT AND ADRENALIN LEVELS.

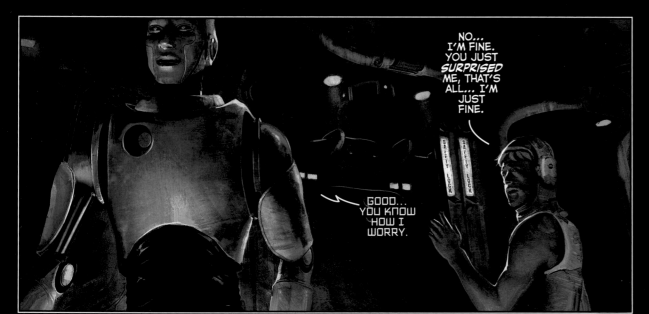

NO... I'M FINE. YOU JUST *SURPRISED* ME, THAT'S ALL... I'M JUST FINE.

GOOD... YOU KNOW HOW I WORRY.

EH-HEM.

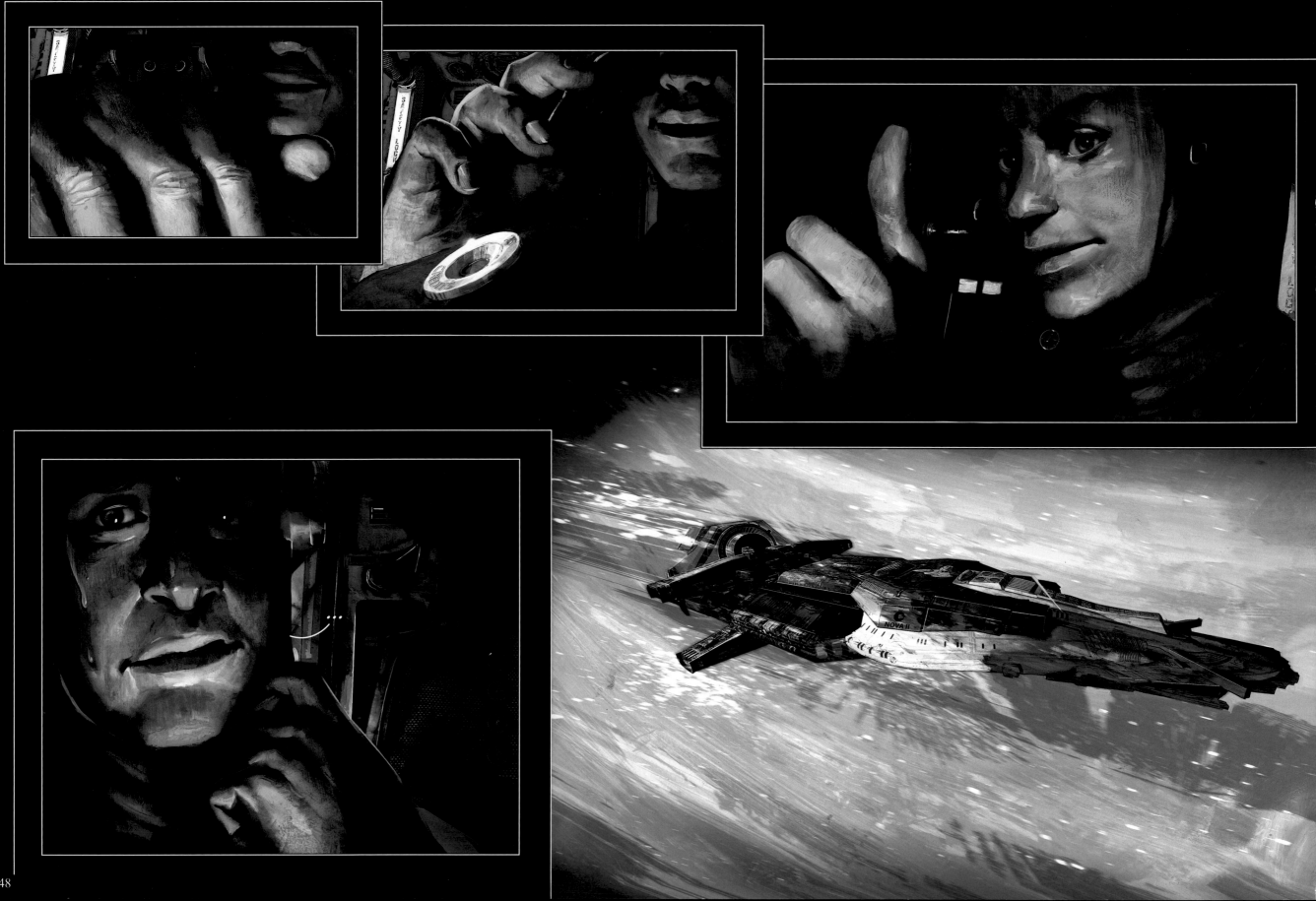

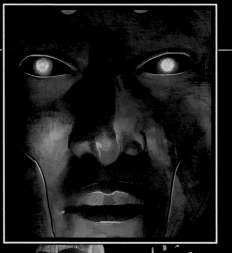

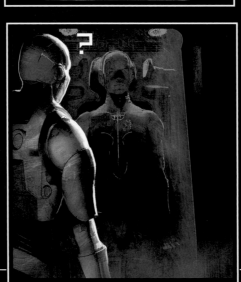

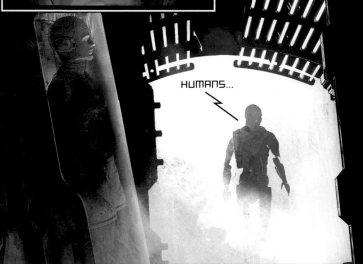

HUMANS...

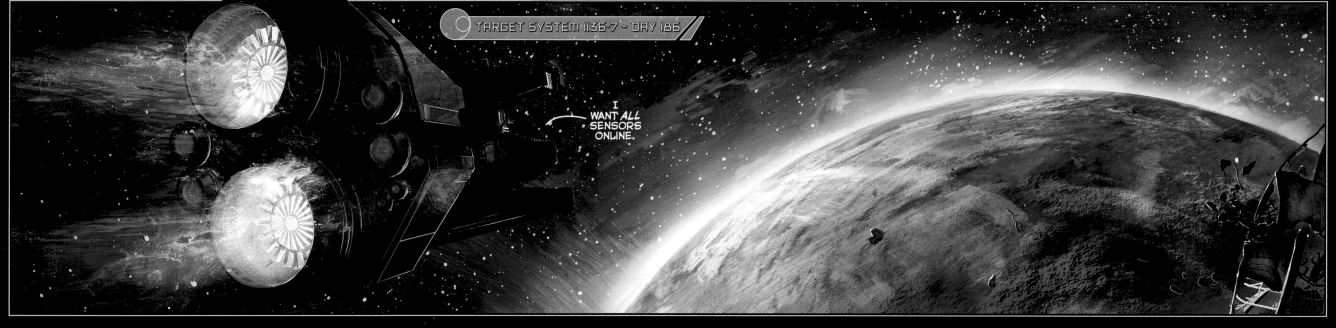

I WANT *ALL* SENSORS ONLINE.

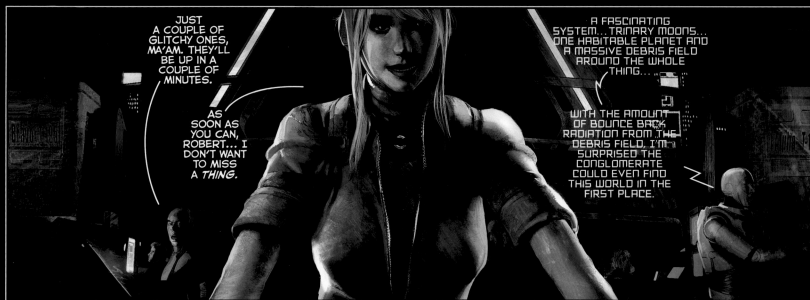

JUST A COUPLE OF GLITCHY ONES, MA'AM. THEY'LL BE UP IN A COUPLE OF MINUTES.

AS SOON AS YOU CAN, ROBERT... I DON'T WANT TO MISS A *THING*.

A FASCINATING SYSTEM... TRINARY MOONS... ONE HABITABLE PLANET AND A MASSIVE DEBRIS FIELD AROUND THE WHOLE THING...

WITH THE AMOUNT OF BOUNCE BACK RADIATION FROM THE DEBRIS FIELD, I'M SURPRISED THE CONGLOMERATE COULD EVEN FIND THIS WORLD IN THE FIRST PLACE.

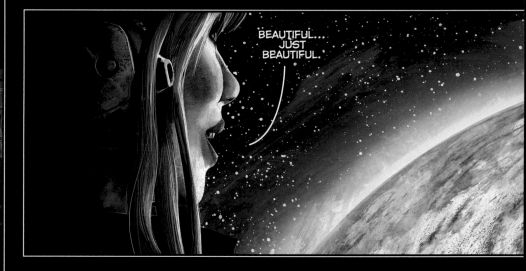

BEAUTIFUL... JUST BEAUTIFUL.

ENVIRONMENT IS STABLE— GRAVITY IS 0.9 EARTH... SHOULD GIVE US A LITTLE SPRING IN OUR STEP UNTIL WE ADJUST.

BEEP BEEP

I'M READING SEVERAL METALLIC OBJECTS IN ORBIT.

BUT THIS WAS SUPPOSED TO BE A LOW TECH PLANET— BRONZE AGE EQUIVALENT. ROBERT, IS THAT ONE OF YOUR GLITCHY SENSORS ACTING UP?

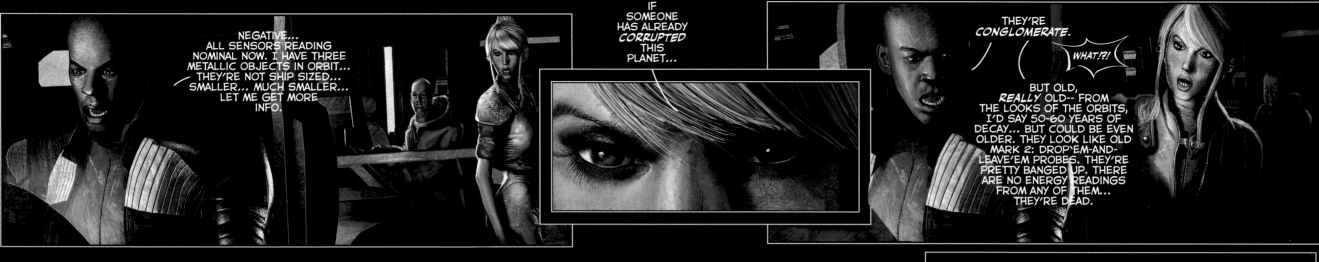

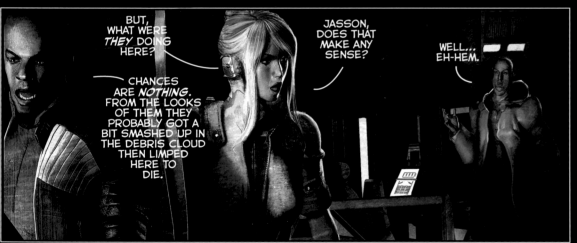

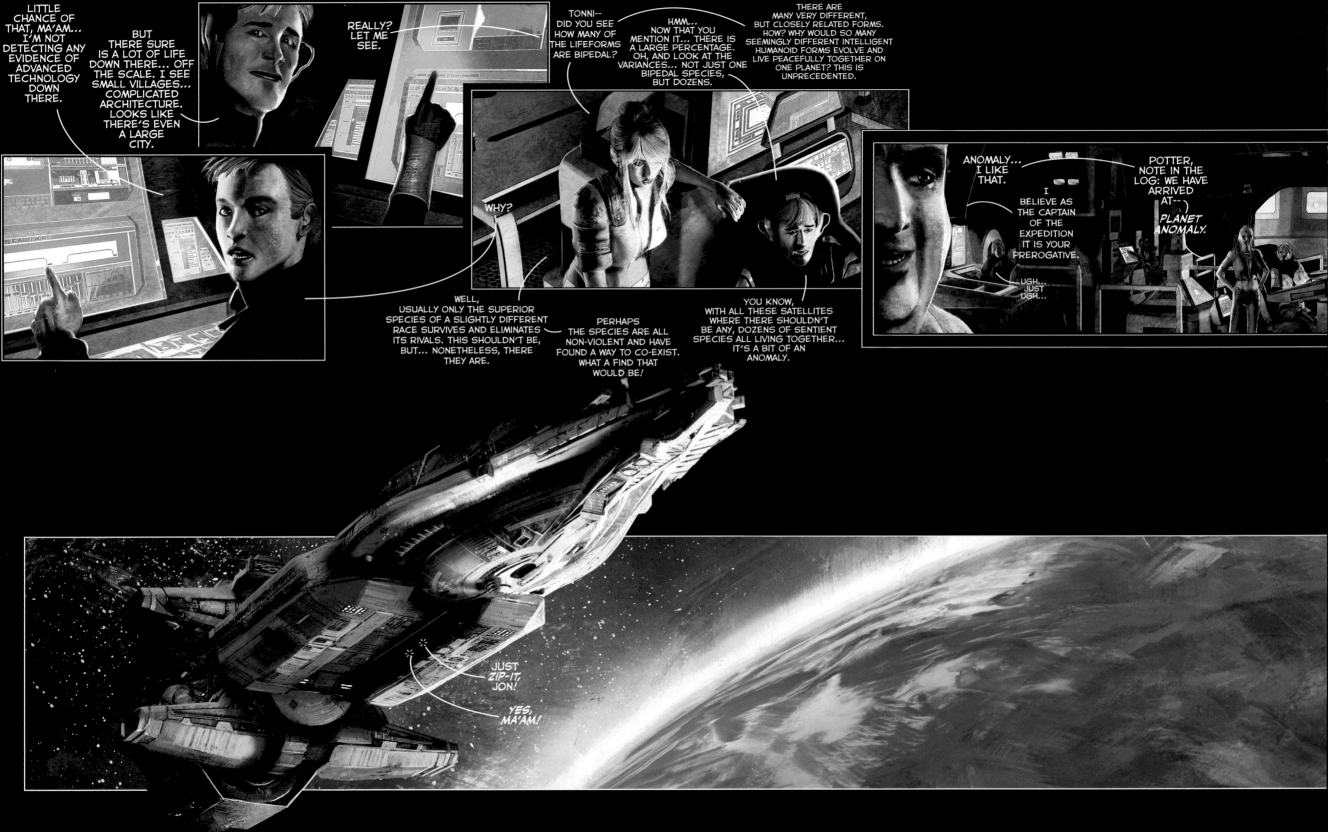

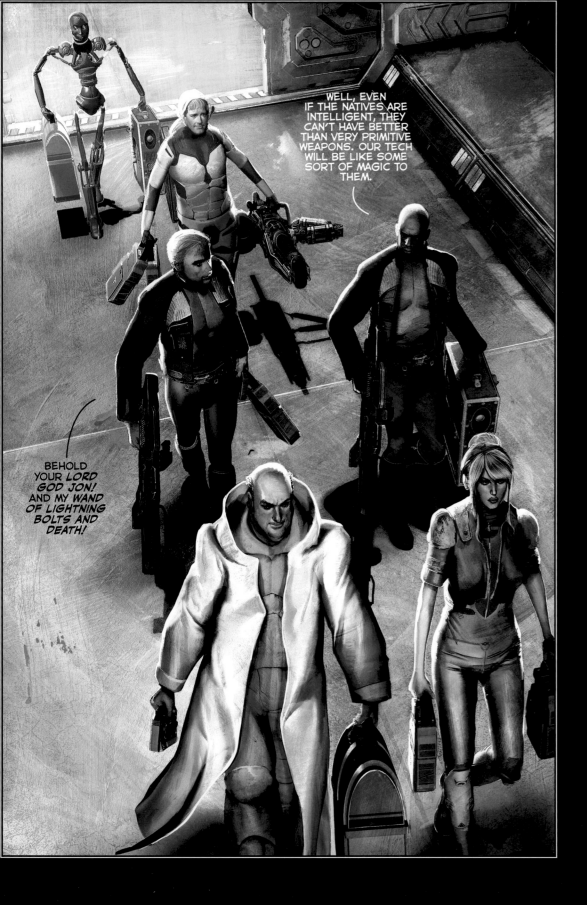

WELL, EVEN IF THE NATIVES ARE INTELLIGENT, THEY CAN'T HAVE BETTER THAN VERY PRIMITIVE WEAPONS. OUR TECH WILL BE LIKE SOME SORT OF MAGIC TO THEM.

BEHOLD YOUR *LORD GOD JON!* AND MY *WAND* OF *LIGHTNING BOLTS* AND *DEATH!*

WAND OF *LIGHTNING* BOLTS?

MY *BLASTER.*

UH... SORRY...

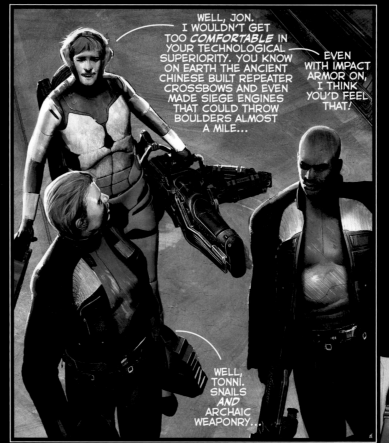

WELL, JON. I WOULDN'T GET TOO *COMFORTABLE* IN YOUR TECHNOLOGICAL SUPERIORITY. YOU KNOW ON EARTH THE ANCIENT CHINESE BUILT REPEATER CROSSBOWS AND EVEN MADE SIEGE ENGINES THAT COULD THROW BOULDERS ALMOST A MILE...

EVEN WITH IMPACT ARMOR ON, I THINK YOU'D *FEEL* THAT!

WELL, TONNI. SNAILS *AND* ARCHAIC WEAPONRY...

...WILL YOUR USEFULNESS EVER END?

....

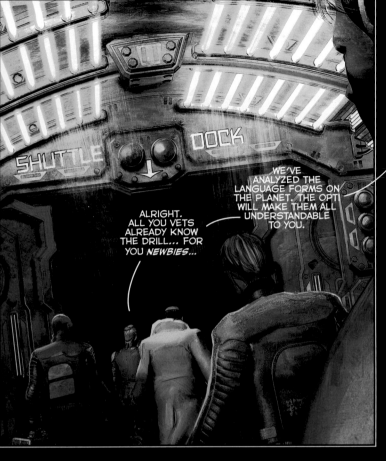

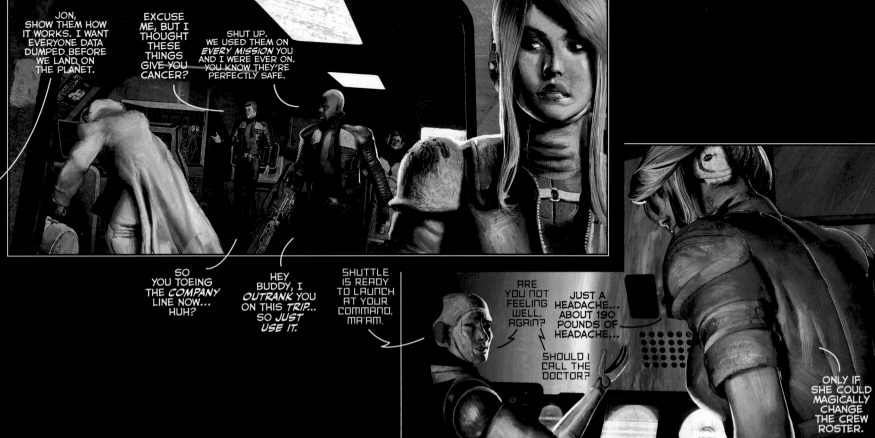

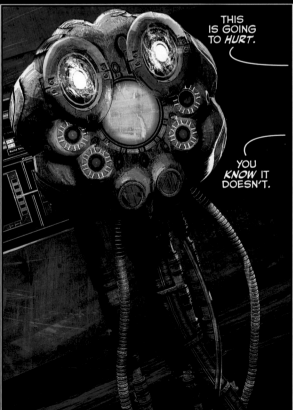

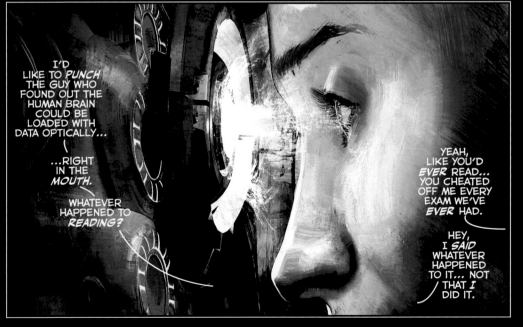

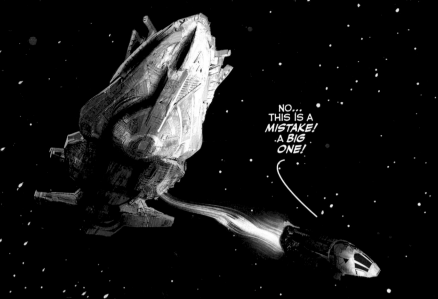

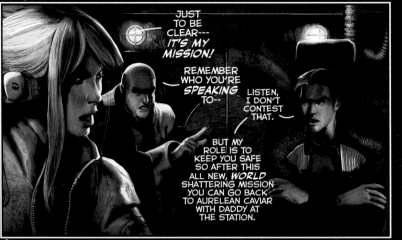

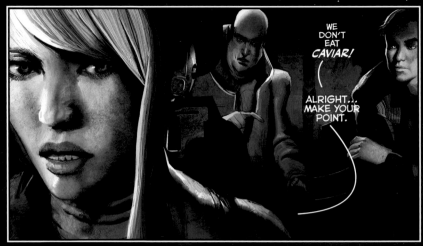

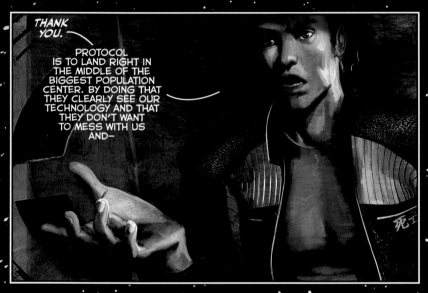

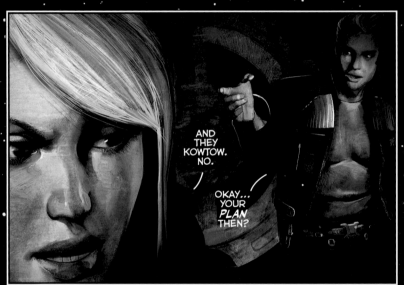

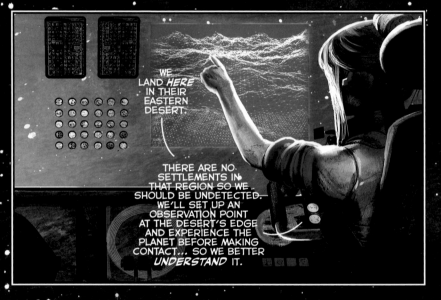

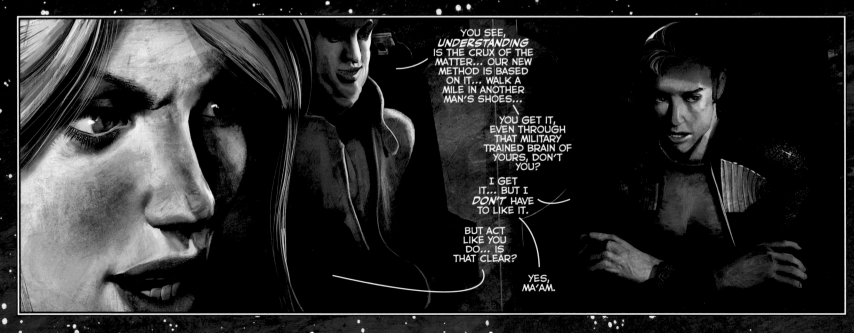

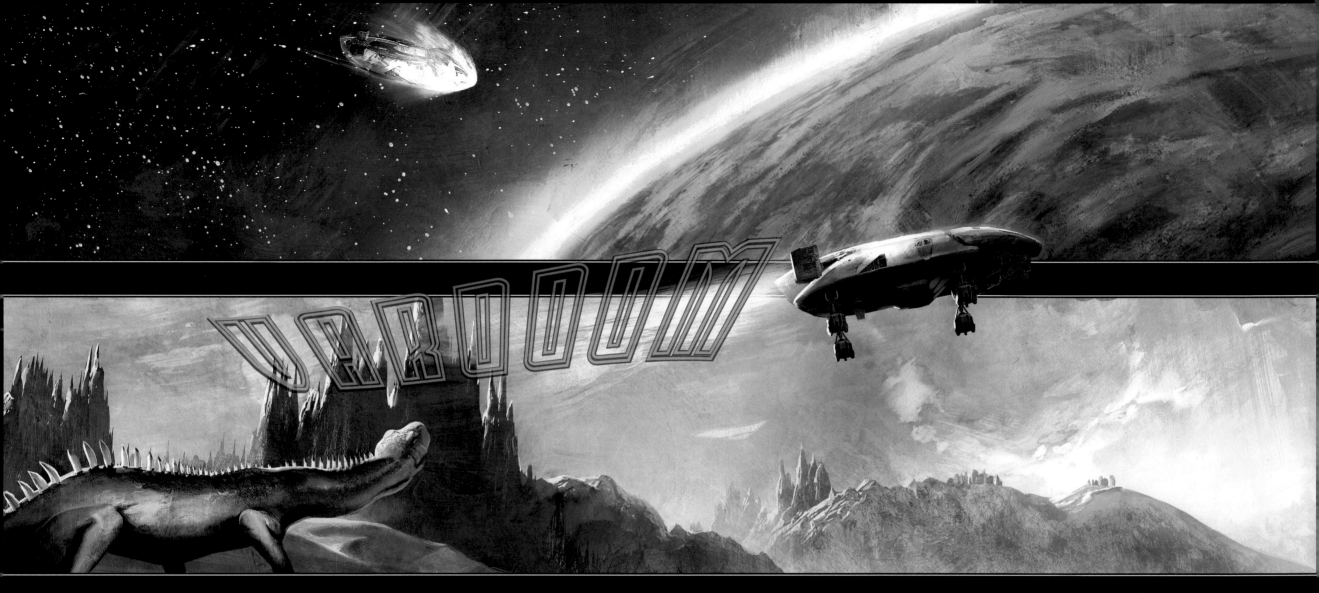

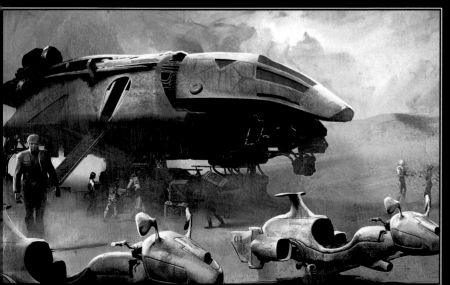

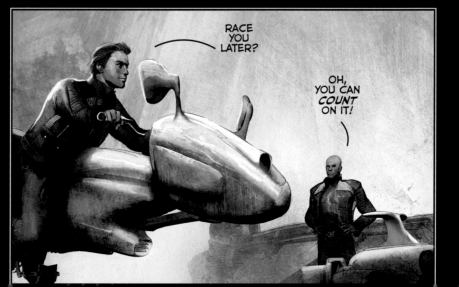

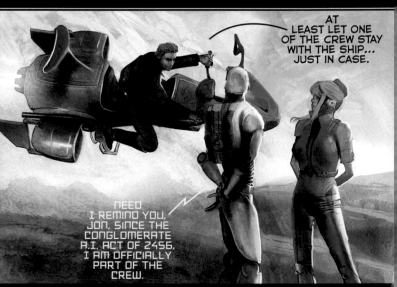

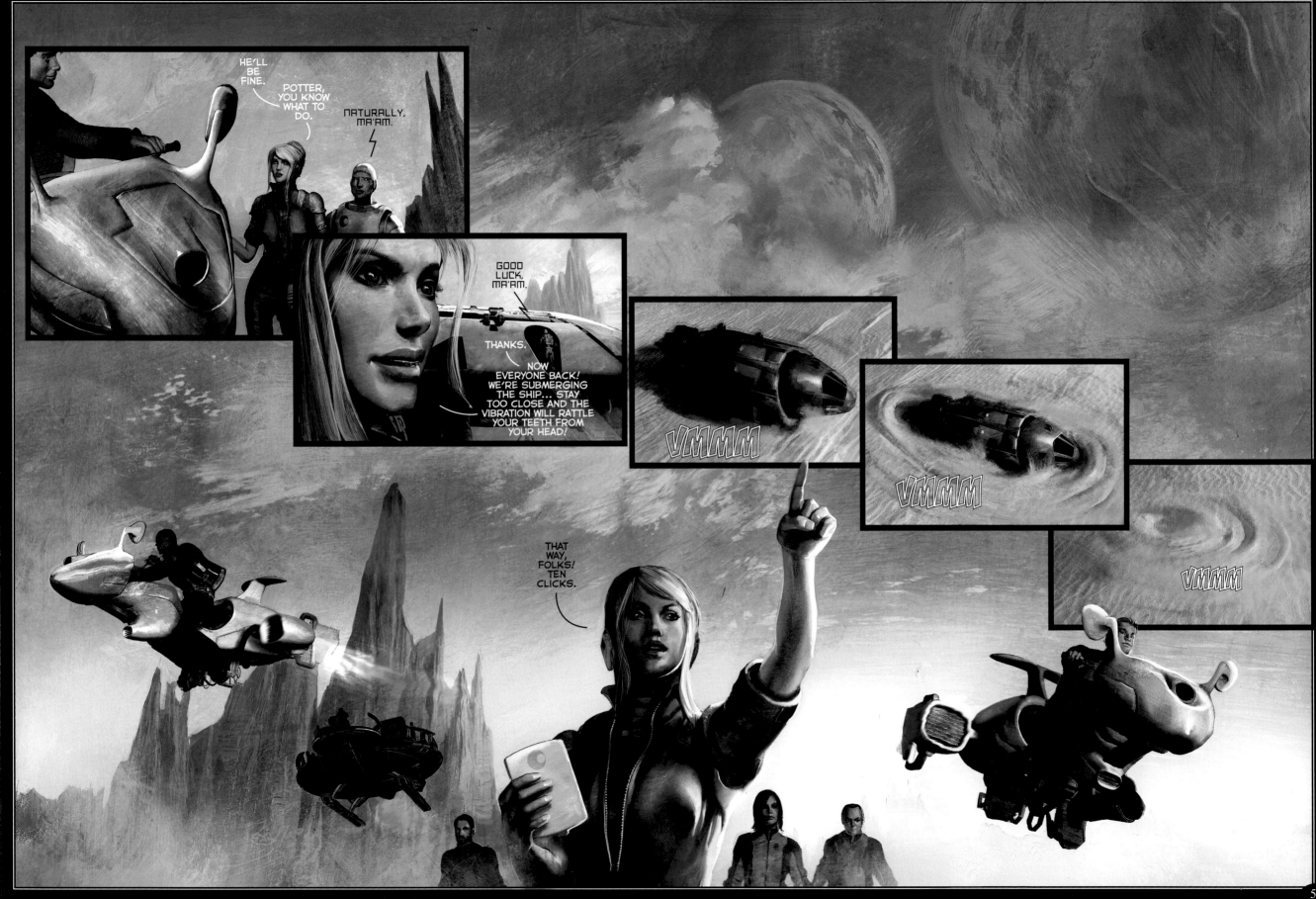

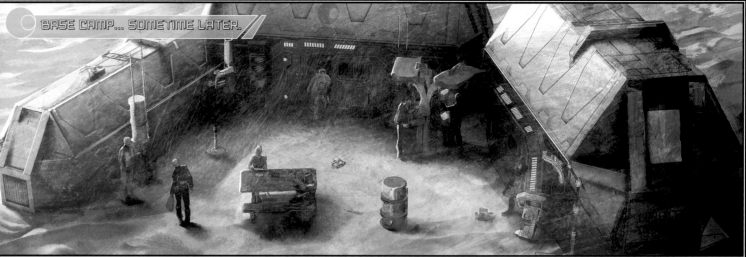

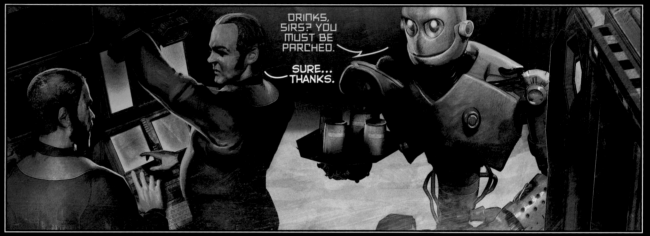

DRINKS, SIRS? YOU MUST BE PARCHED.

SURE... THANKS.

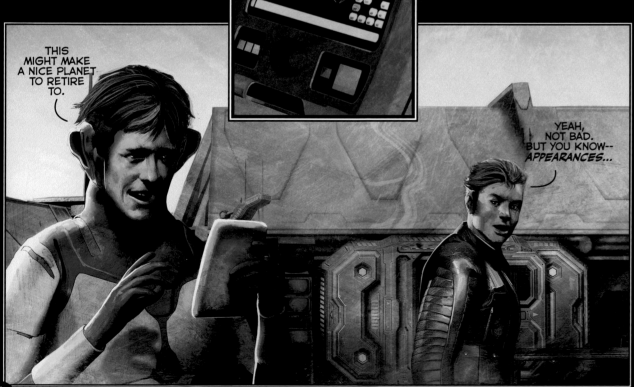

THIS MIGHT MAKE A NICE PLANET TO RETIRE TO.

YEAH, NOT BAD. BUT YOU KNOW-- APPEARANCES...

I KNOW.

CAN BE DECEIVING.

NO-- CAN BITE YOU IN THE ASS WHEN YOU'RE NOT LOOKING.

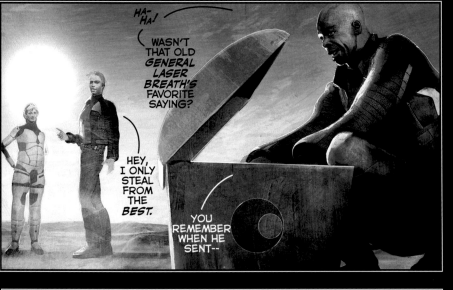

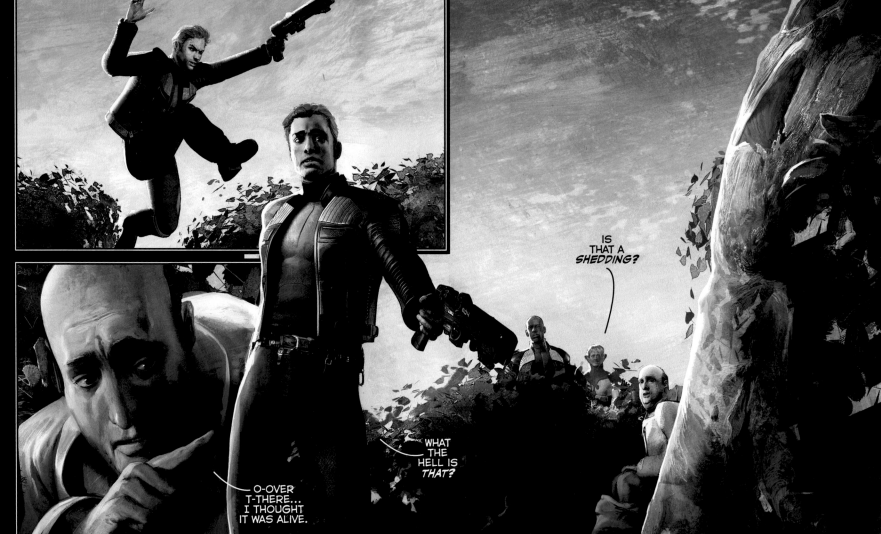
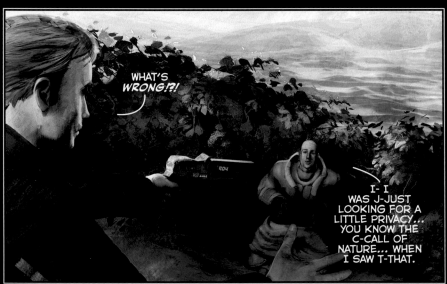

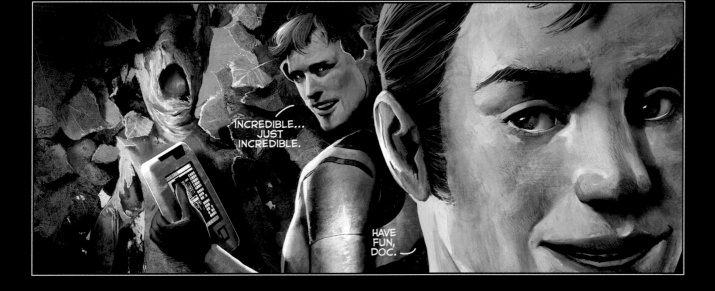

INCREDIBLE... JUST INCREDIBLE.

HAVE FUN, DOC.

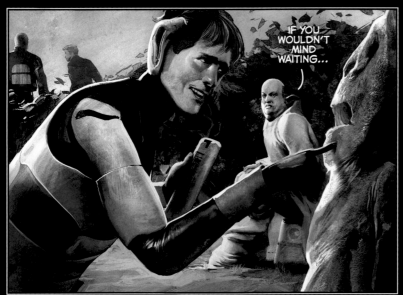

IF YOU WOULDN'T MIND WAITING...

SORRY, JASSON.

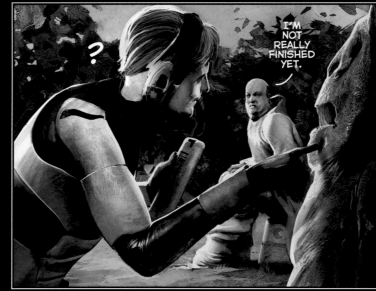

I'M NOT REALLY FINISHED YET.

?

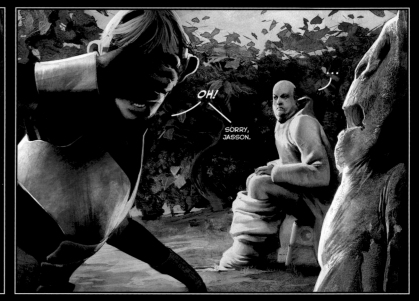

OH!

SORRY, JASSON.

LATER...

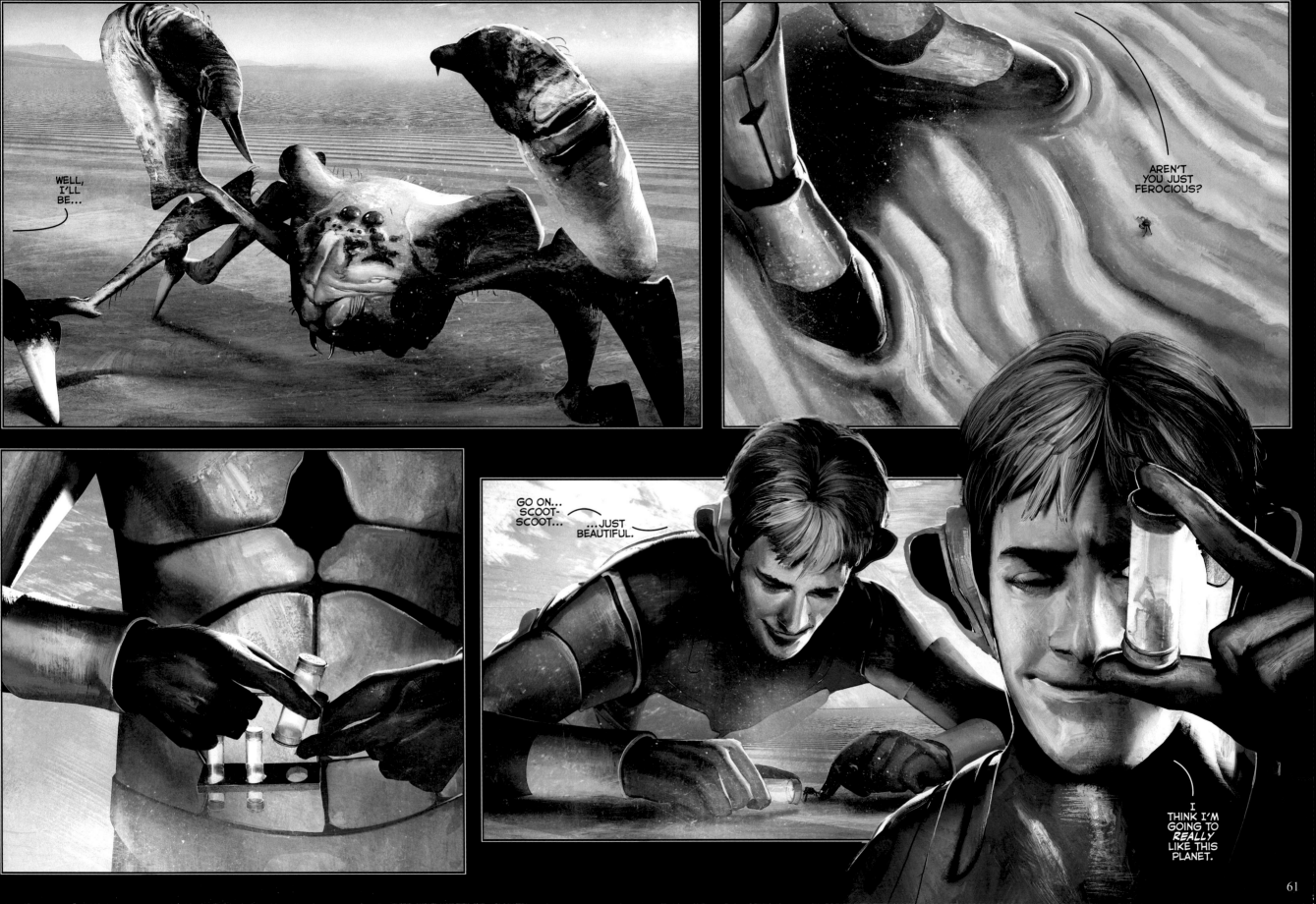

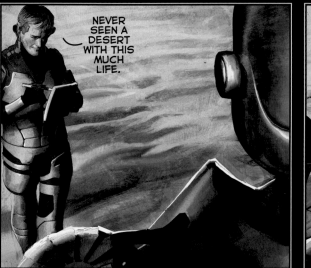

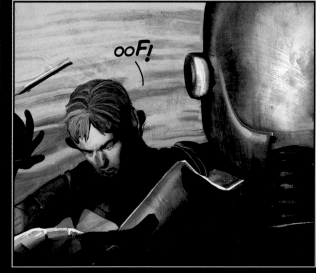

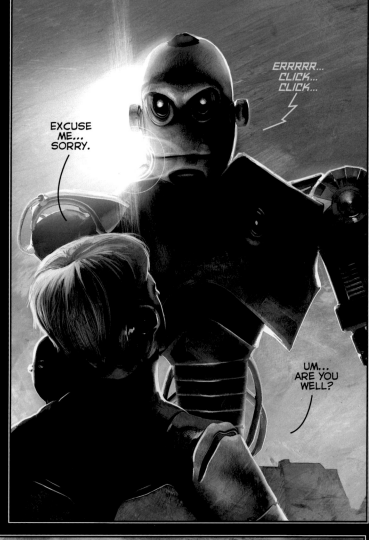

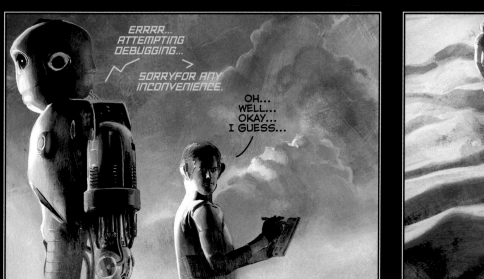

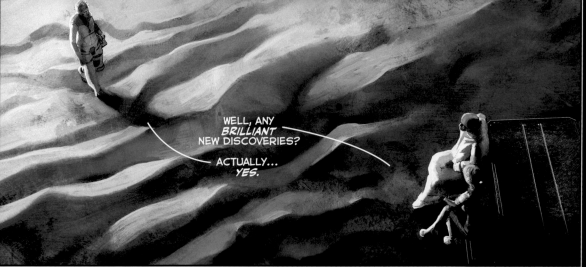

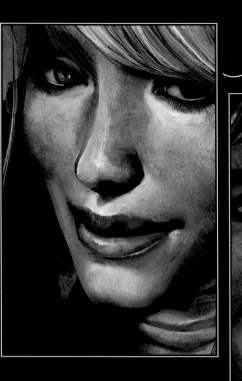

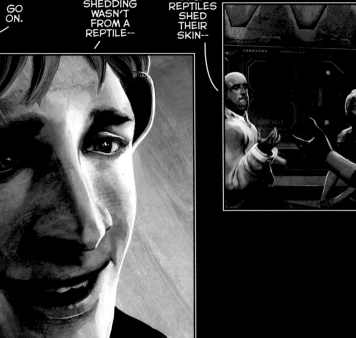

GO ON.

THAT SHEDDING WASN'T FROM A REPTILE--

I THOUGHT *ONLY* REPTILES SHED THEIR SKIN--

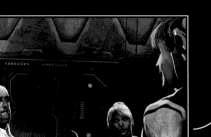

NO, THAT'S NOT CORRECT... WE ACTUALLY SHED OUR SKIN ALL THE TIME... IN FACT MOST OF THE DUST IN OUR HOMES IS COMPOSED OF DEAD SKIN.

CHARMING.

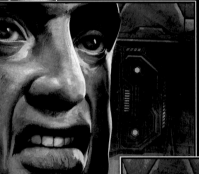

THE CREATURE THAT SHED THAT SKIN WASN'T A REPTILE... IT WAS A BIPEDAL HUMANOID... CLEARLY A MAMMAL... AND FROM THE MARKS ON THE SHEDDING IT HAD BEEN WEARING CLOTHES!

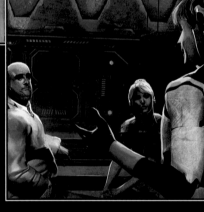

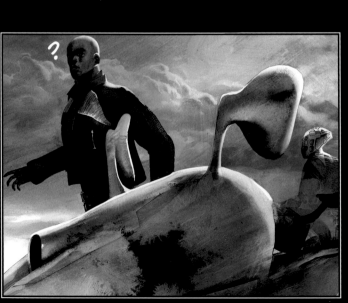

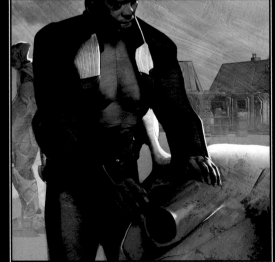

WHAT THE--?

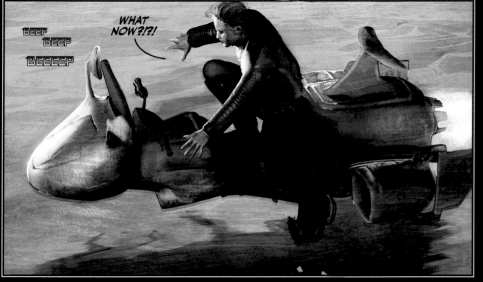

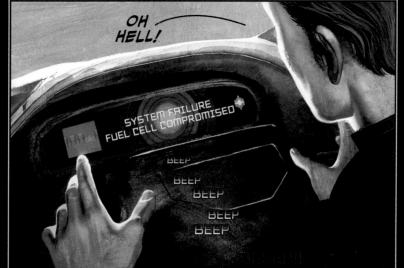

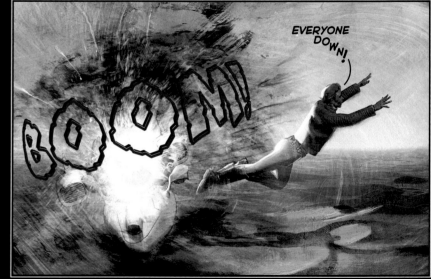

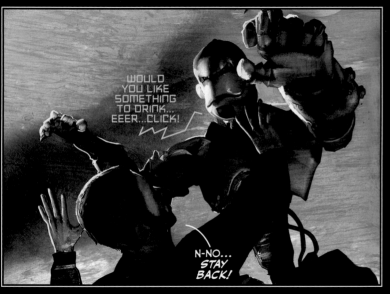

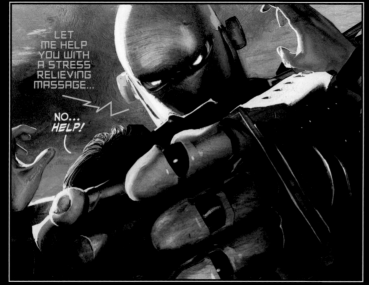

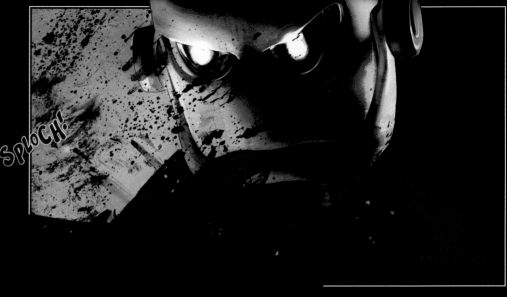

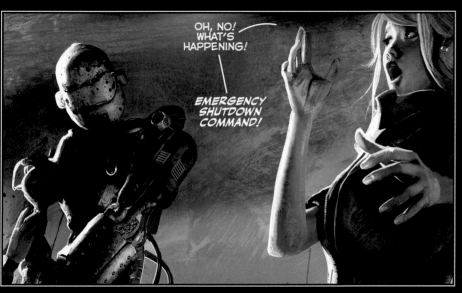

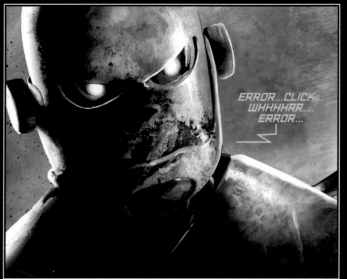

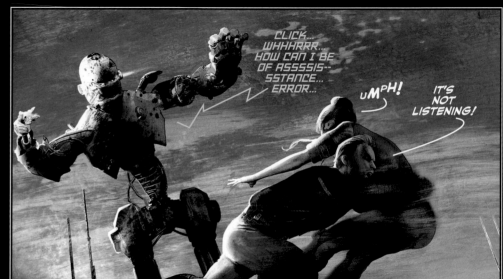

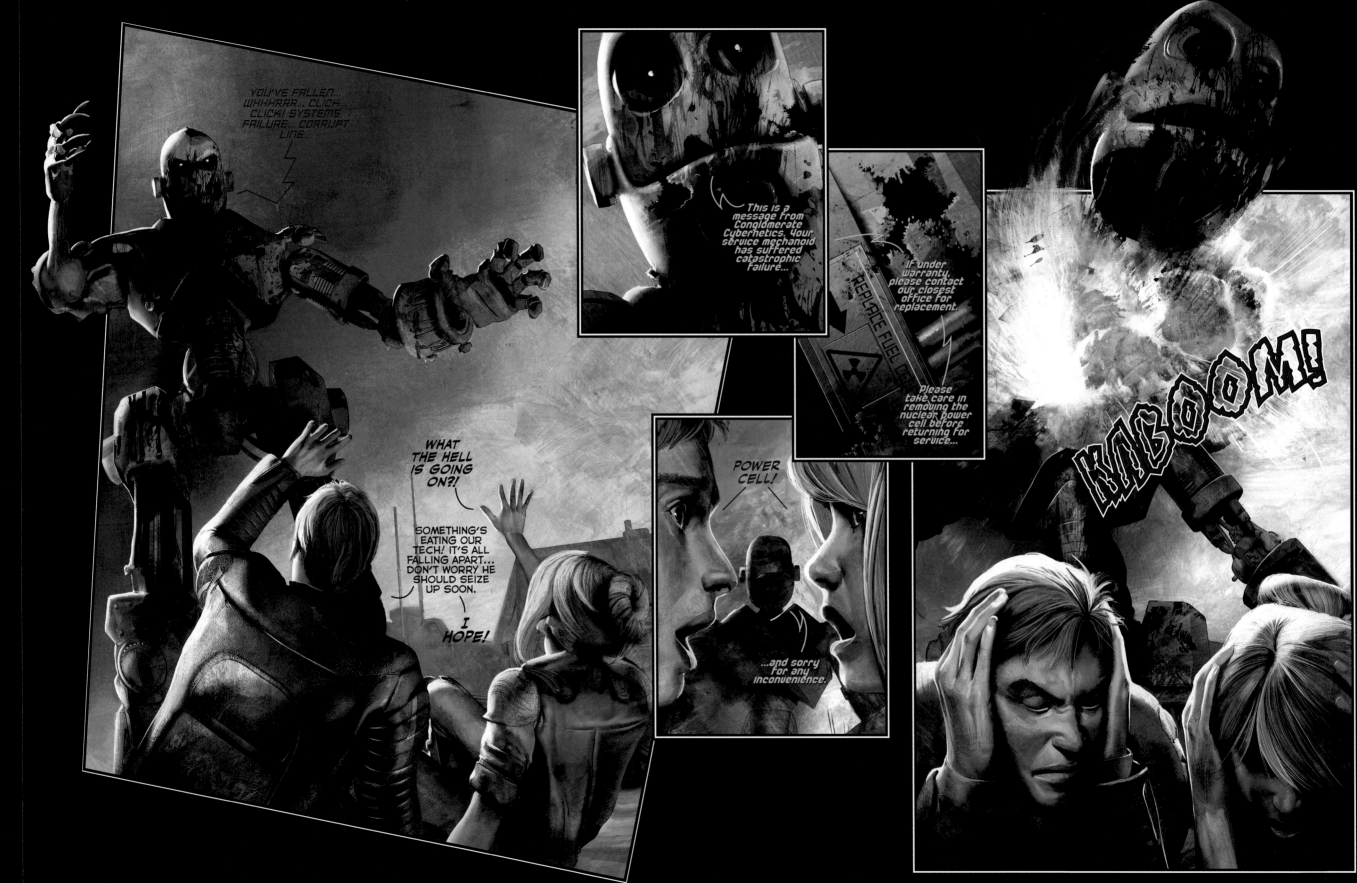

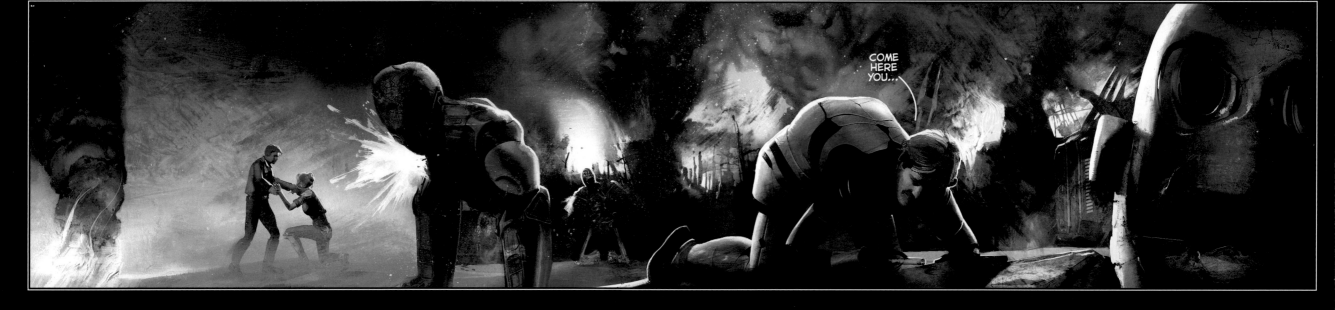

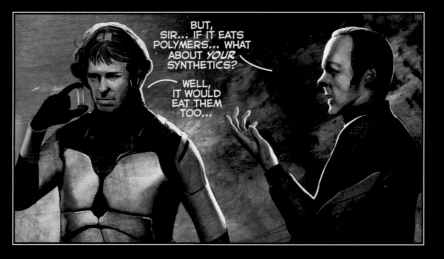

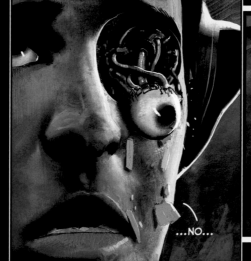

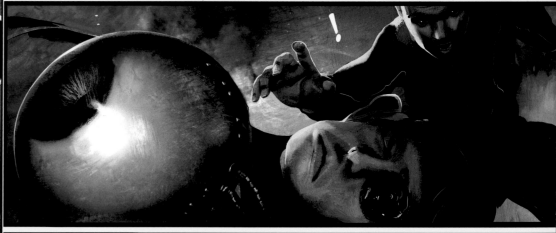

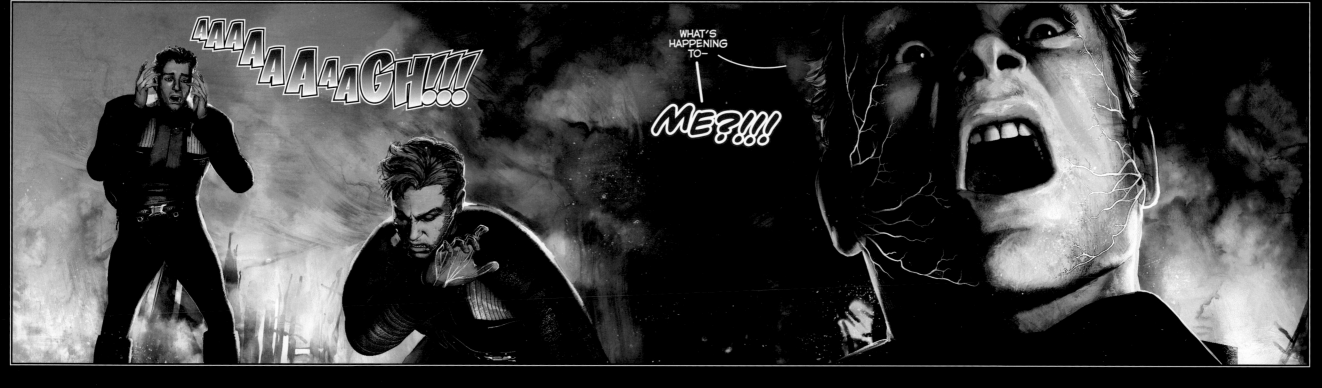

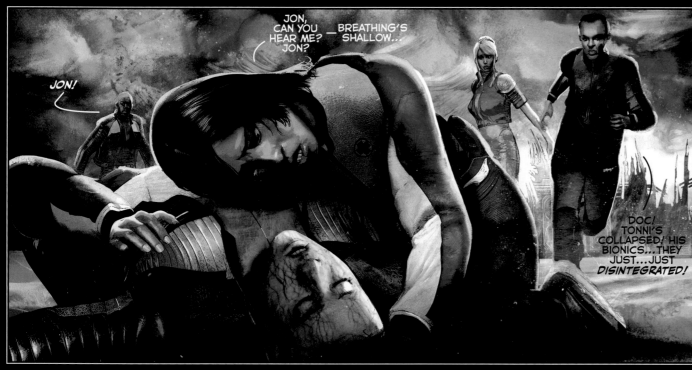

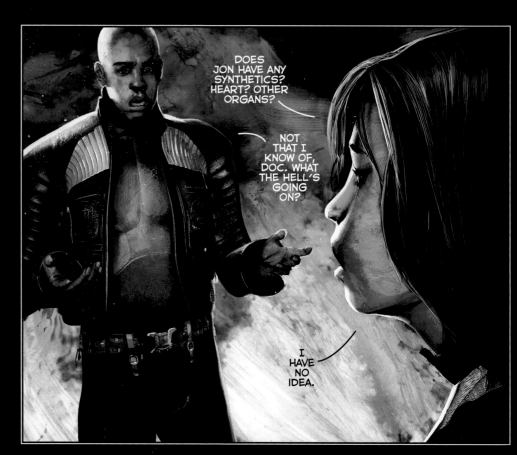

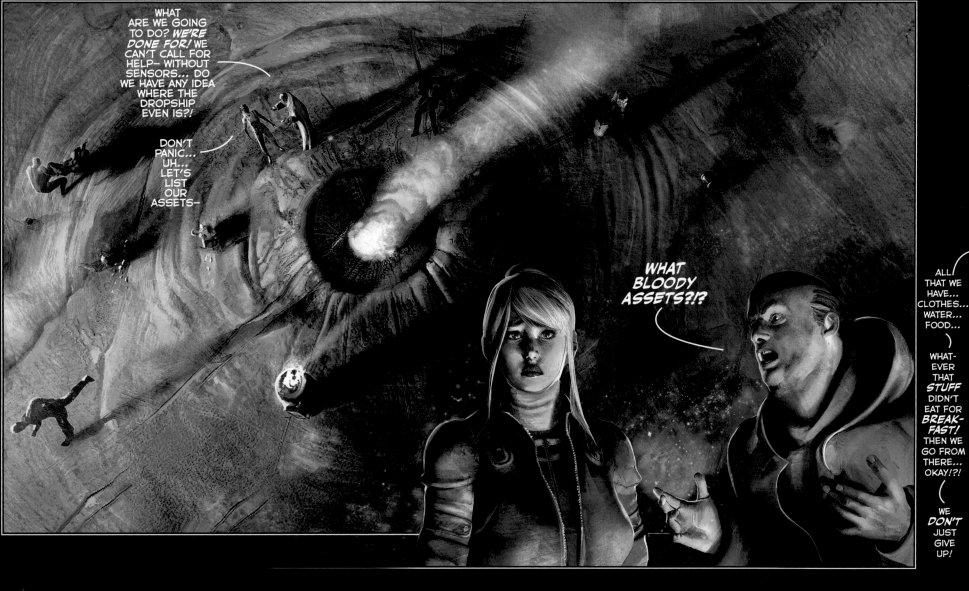

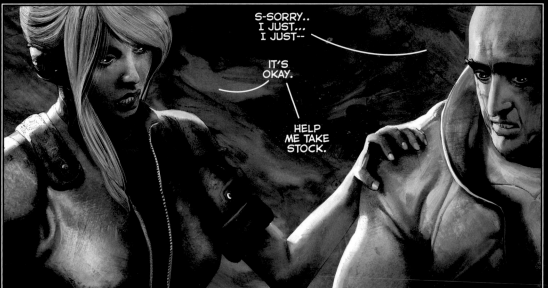

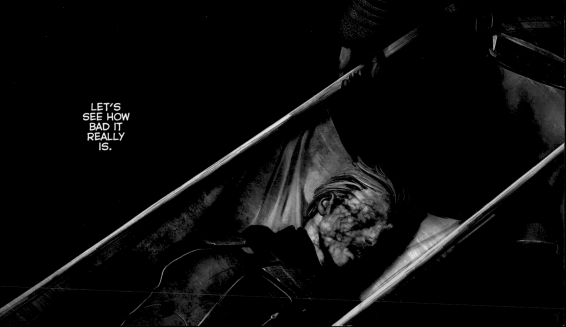

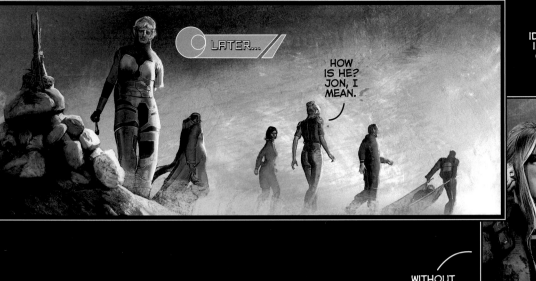

HOW IS HE? JON, I MEAN.

I HAVE NO IDEA. WITHOUT MY INSTRUMENTS... ONLY TIME WILL TELL.

BETWEEN YOU AND ME... DO YOU KNOW WHERE YOU'RE GOING?

WITHOUT SHIP'S GUIDANCE... ONLY TIME WILL TELL. NO...

...JUST KIDDING...

I SEEM TO REMEMBER ON THE SURVEY SCANS THERE WAS A RIVER...

...OR AT LEAST A STREAM IN THIS DIRECTION... NOT REALLY SURE OF THE DISTANCE THOUGH.

WHO'D HAVE THOUGHT WE'D BE SO HELPLESS WITHOUT OUR VAUNTED TECHNOLOGY... THE MIGHTY CITIZENS OF THE CONGLOMERATE... NO BETTER THAN NATIVES—

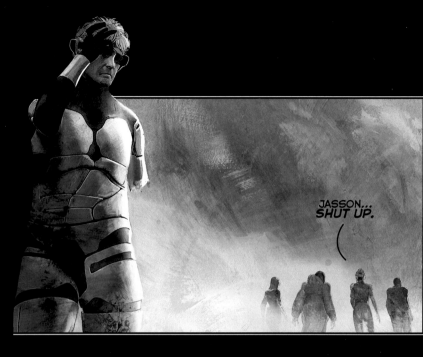

JASSON... *SHUT UP.*

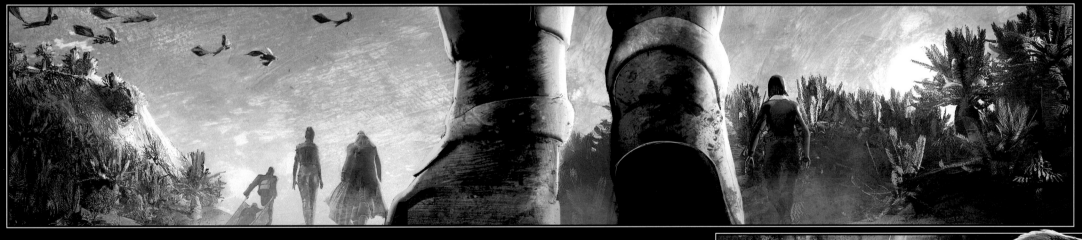

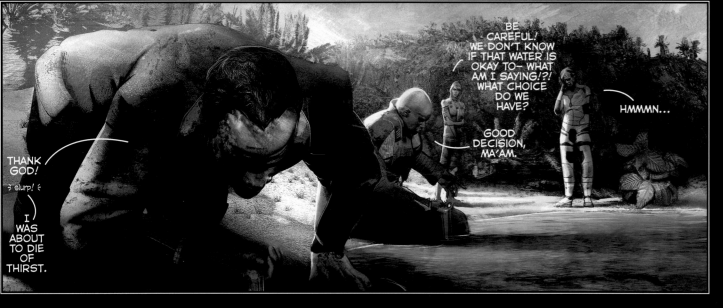

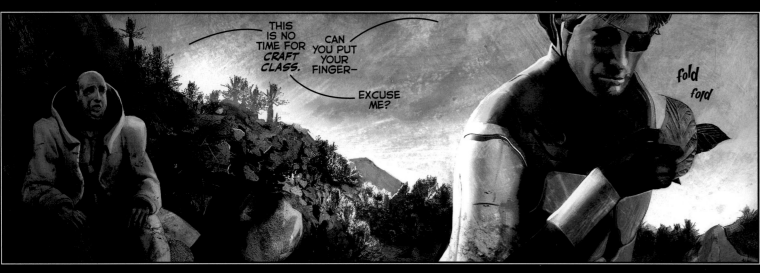

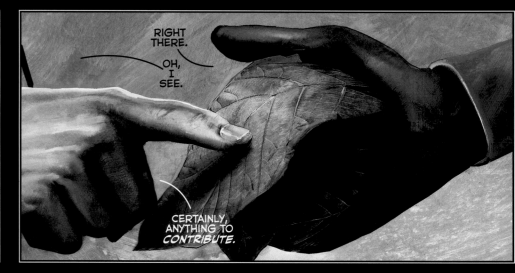

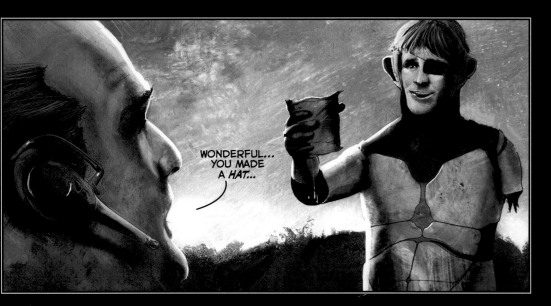

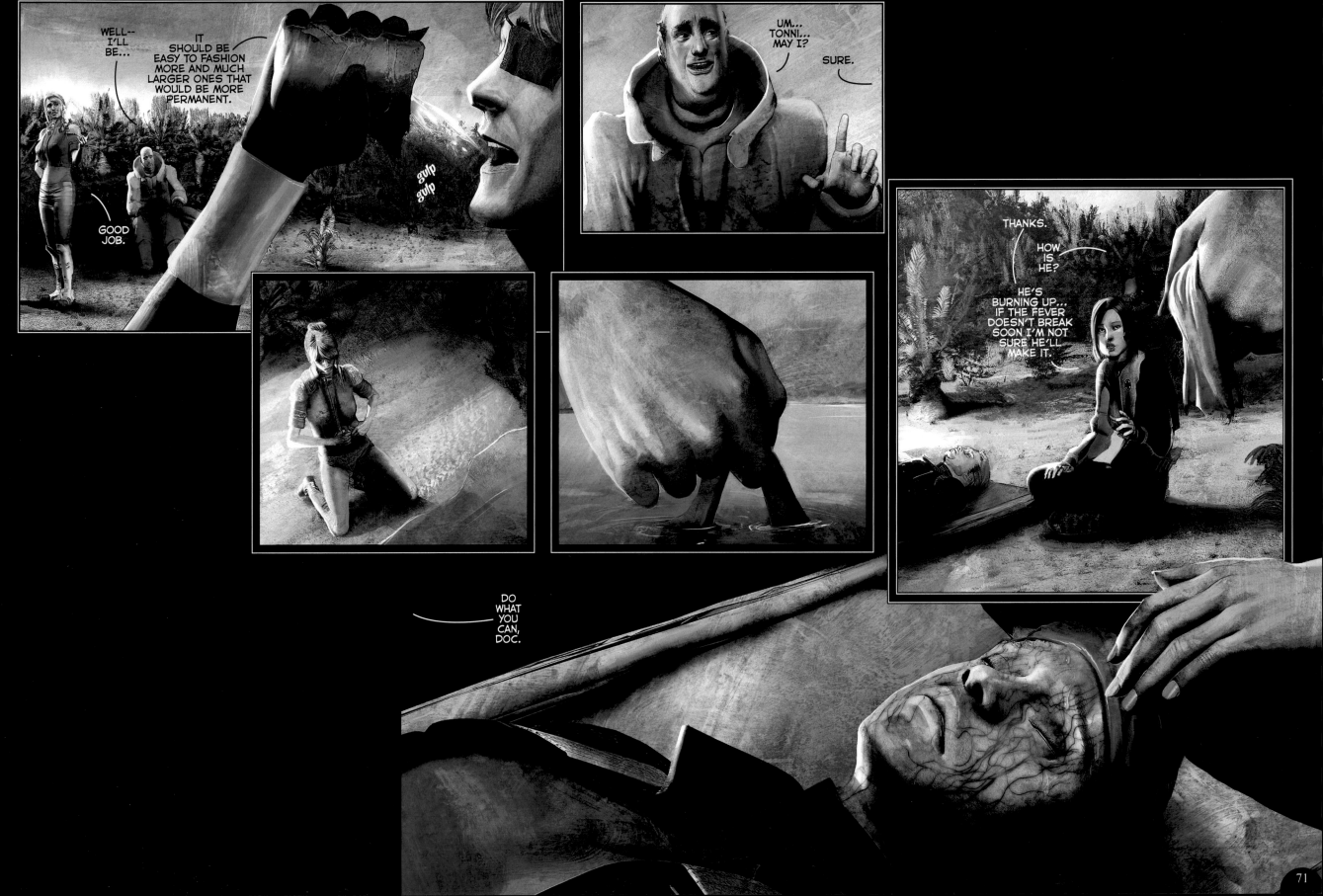

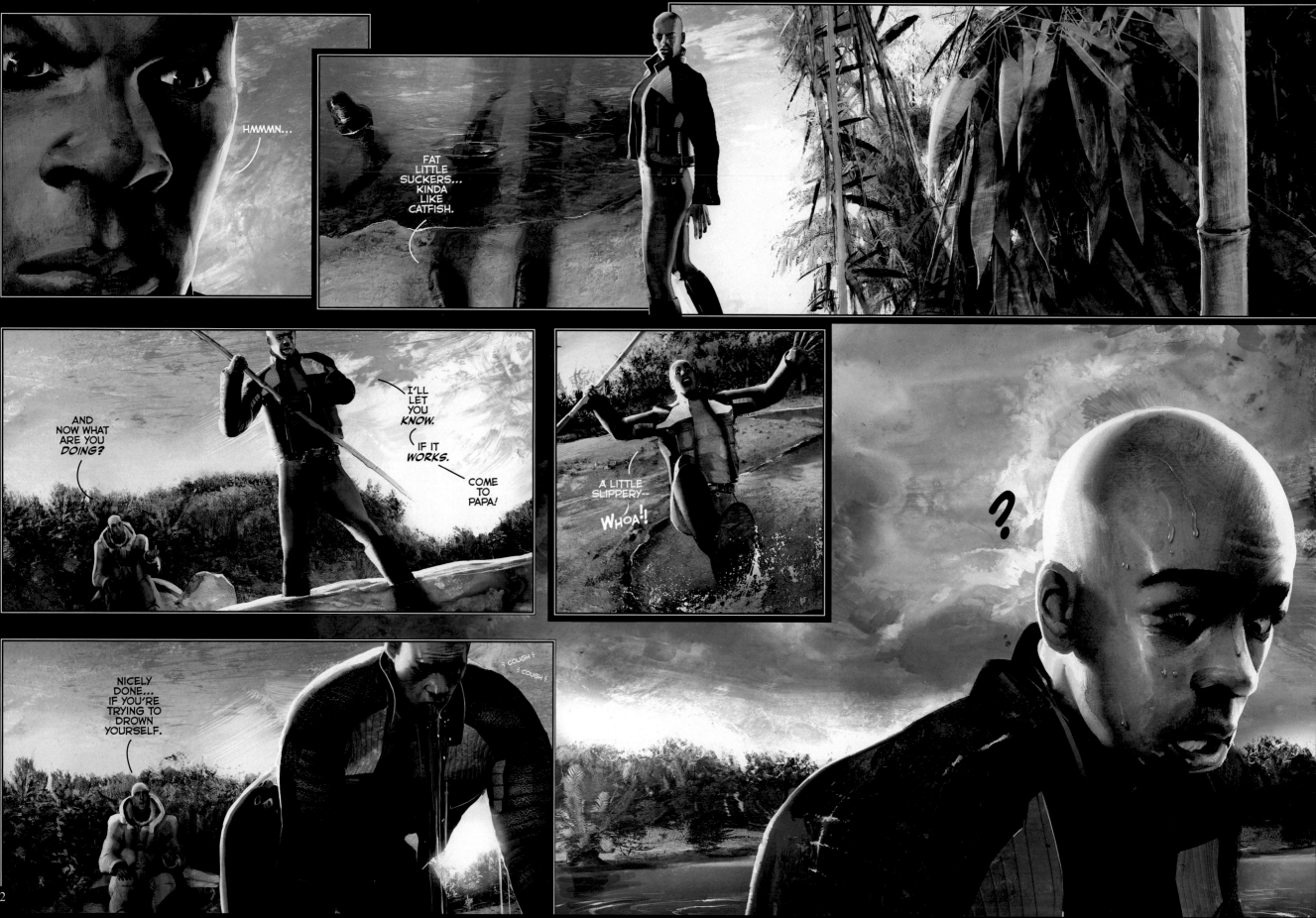

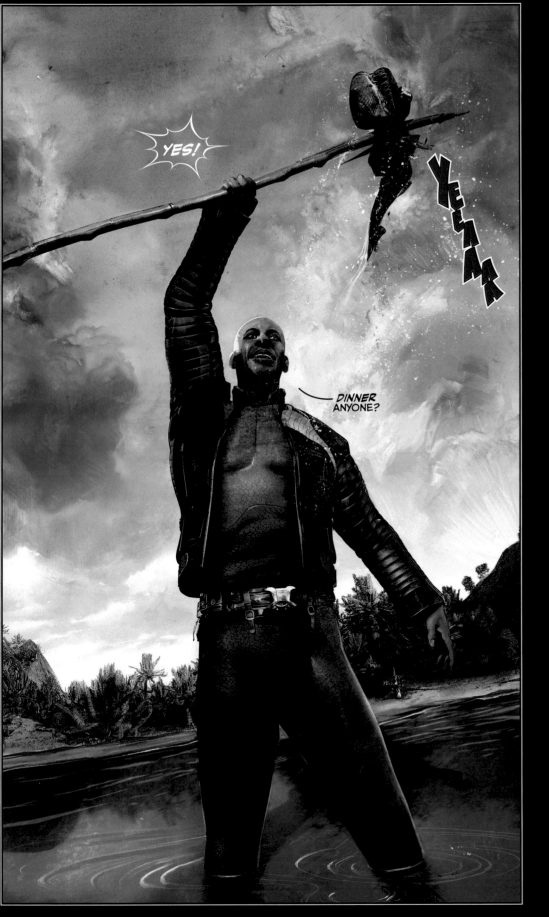

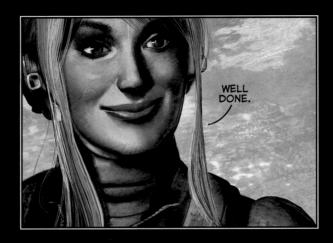

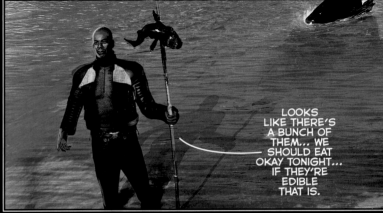

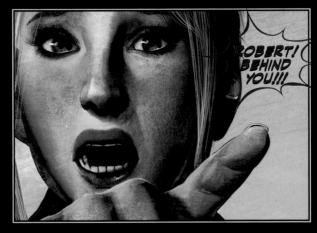

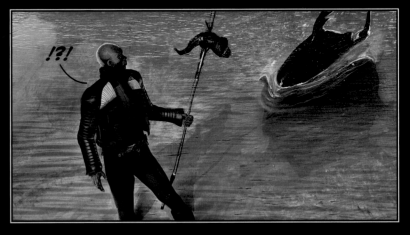

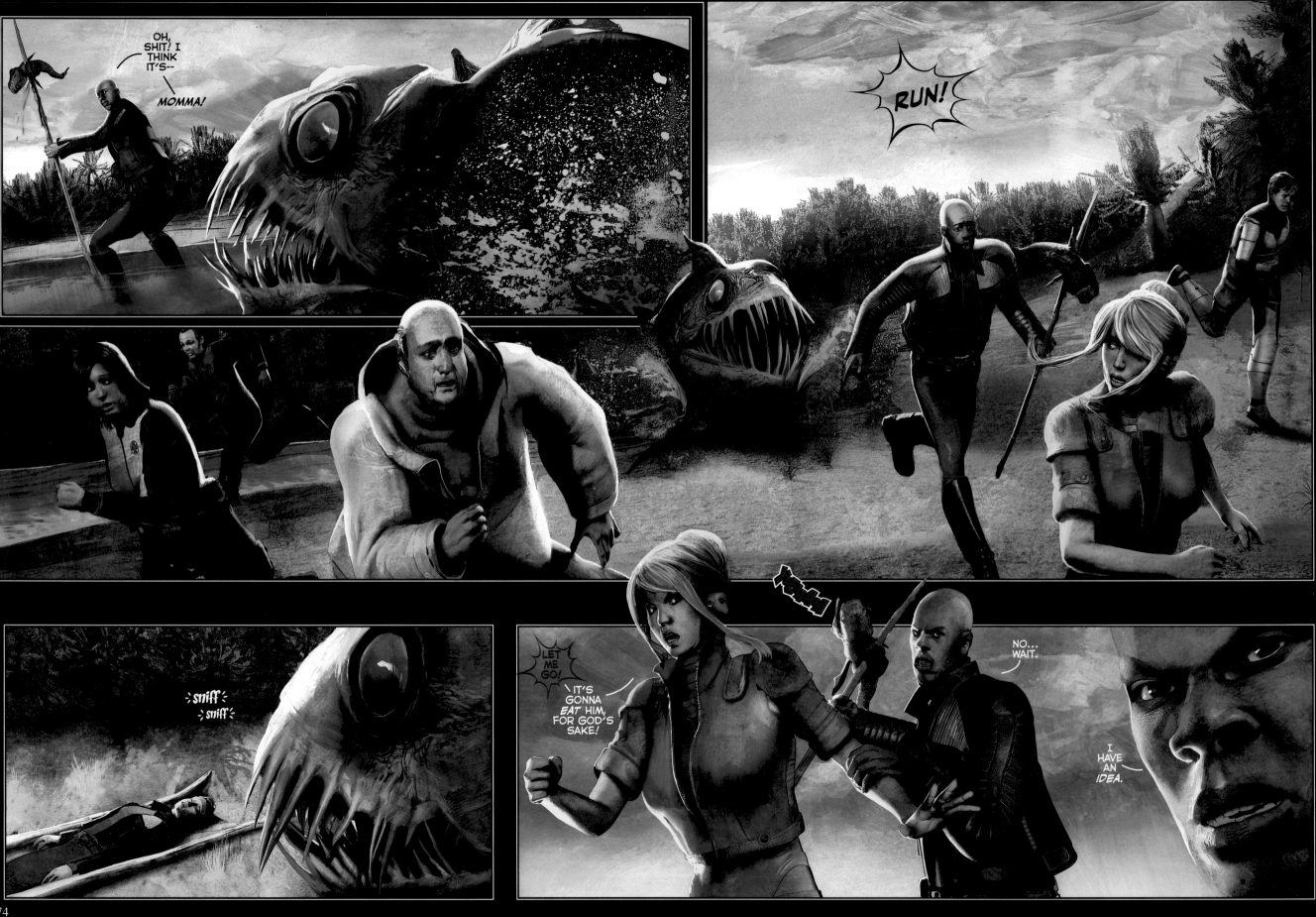

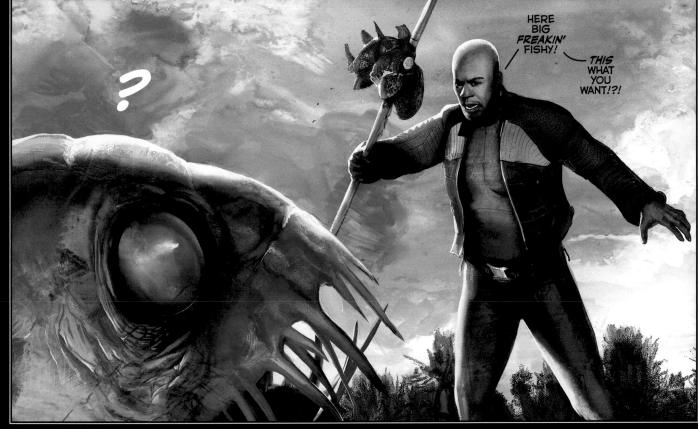

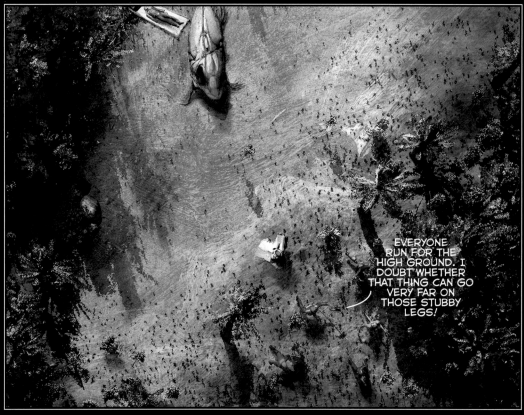

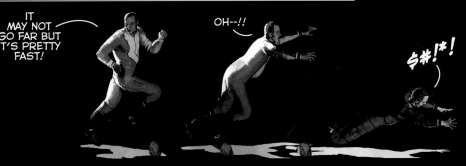

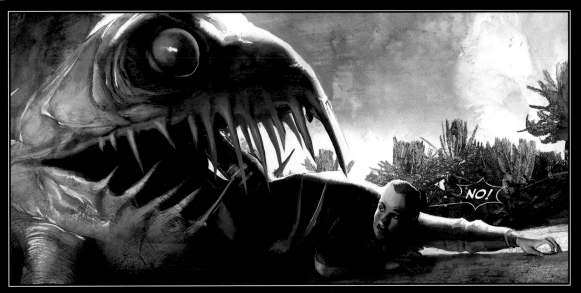

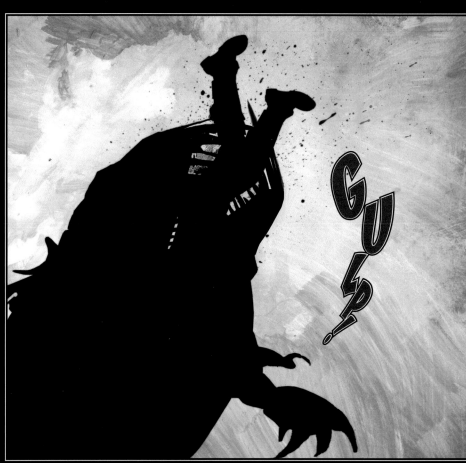

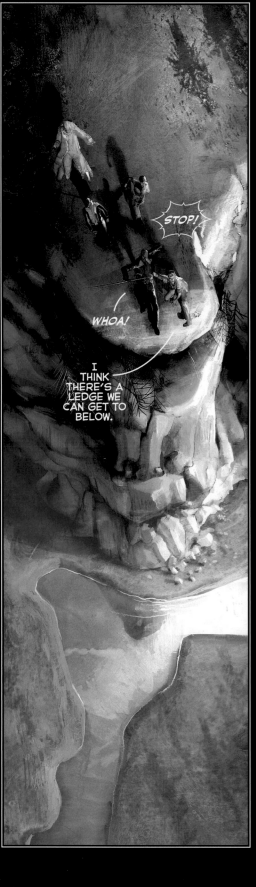
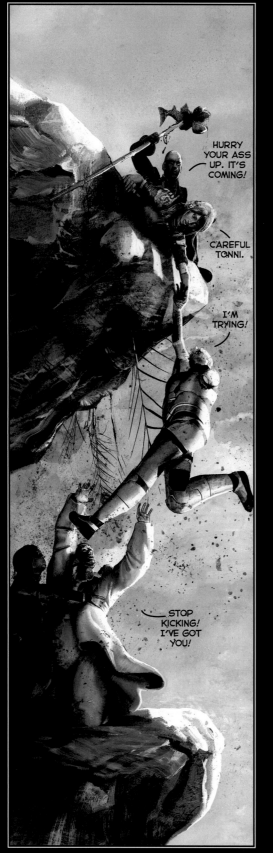
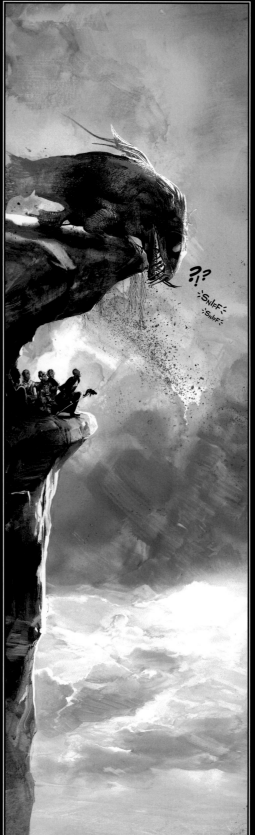
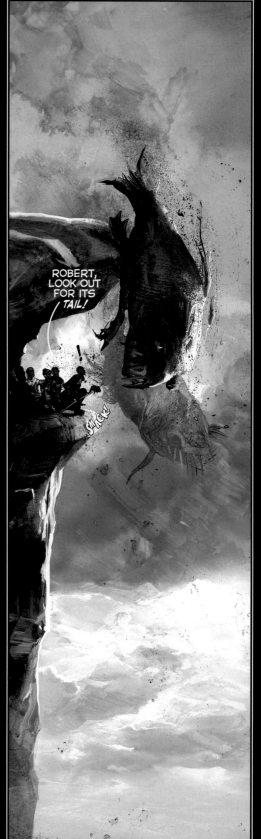
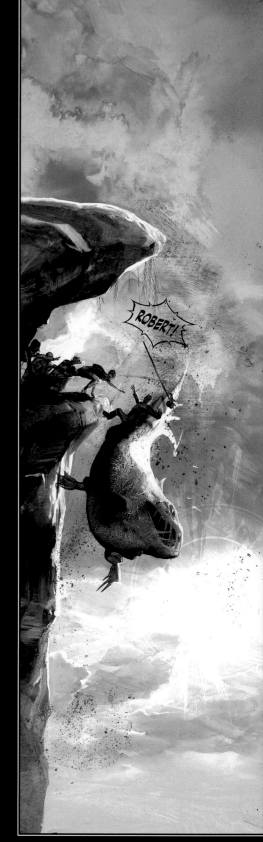

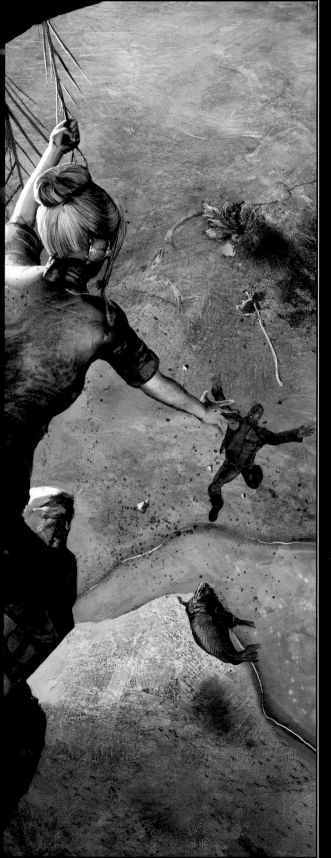
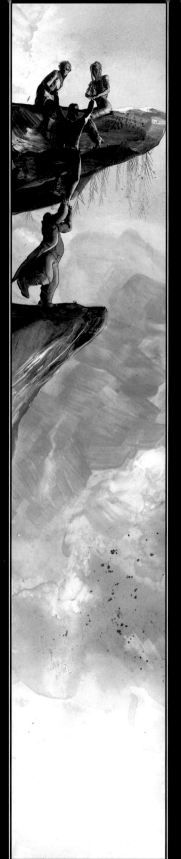

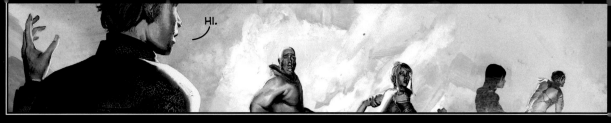
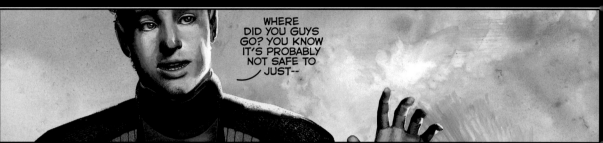
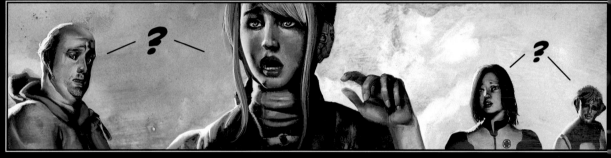
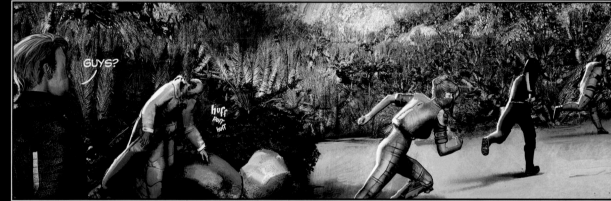
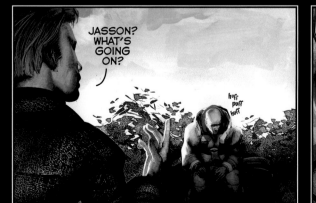
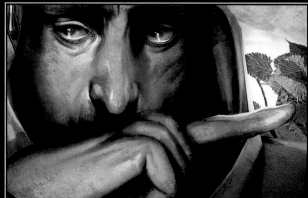

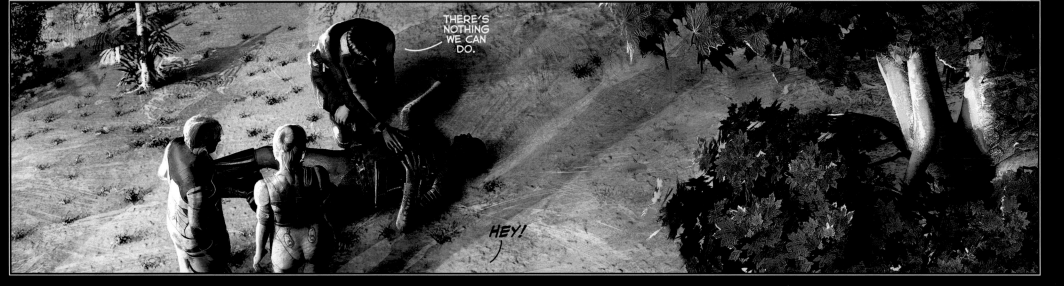

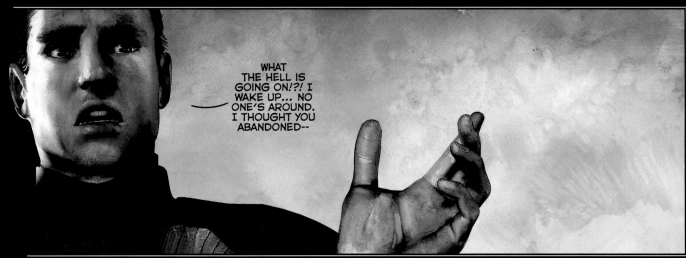

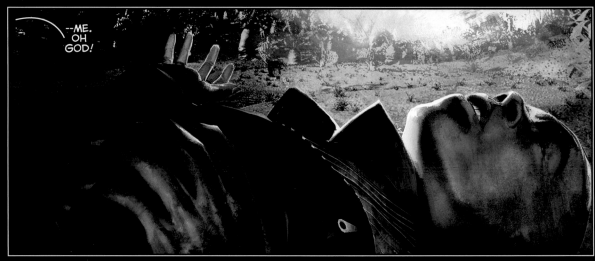

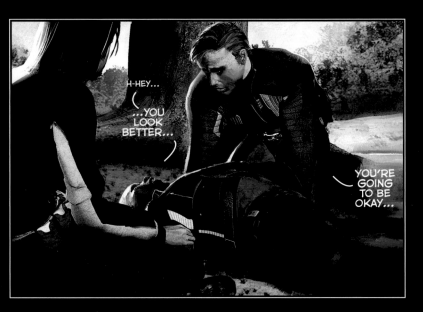

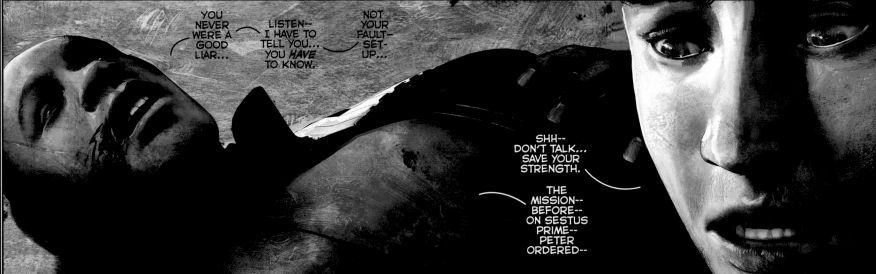

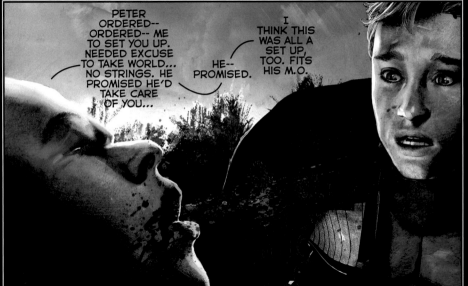

PETER ORDERED-- ORDERED-- ME TO SET YOU UP. NEEDED EXCUSE TO TAKE WORLD... NO STRINGS. HE PROMISED HE'D TAKE CARE OF YOU...

HE-- PROMISED.

I THINK THIS WAS ALL A SET UP, TOO. FITS HIS M.O.

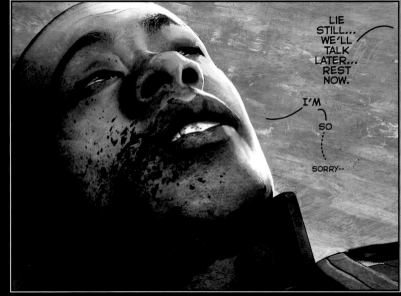

LIE STILL... WE'LL TALK LATER... REST NOW.

I'M SO SORRY--

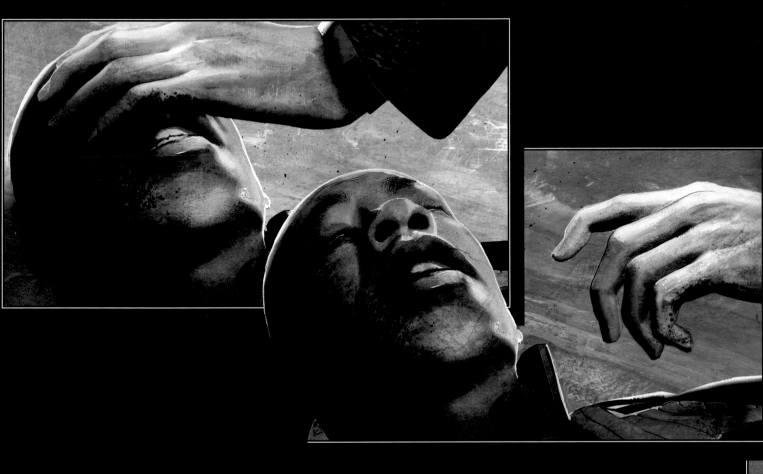

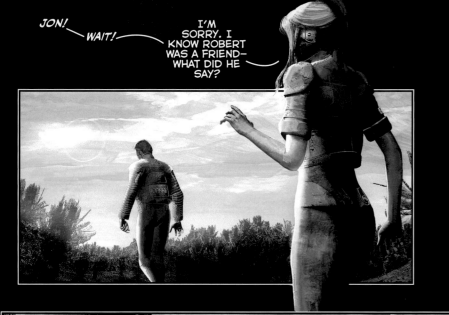

JON! — WAIT! — I'M SORRY. I KNOW ROBERT WAS A FRIEND— WHAT DID HE SAY?

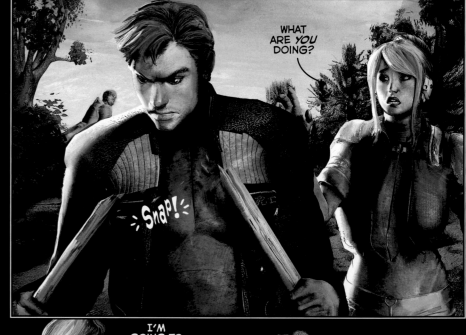

WHAT ARE *YOU* DOING?

Snap!

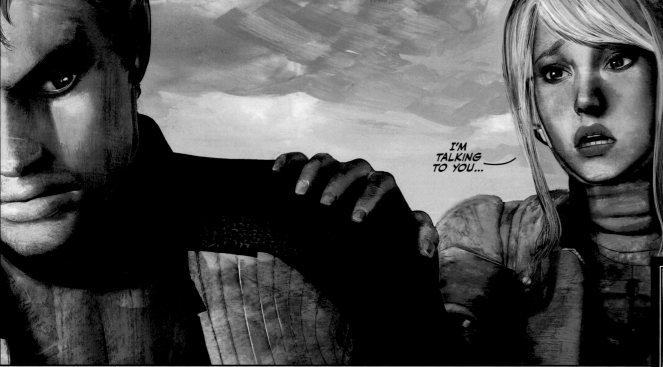

I'M TALKING TO YOU...

YOU'RE SO NAIVE! YOUR SWEET *FATHER* IS TYING UP LOOSE ENDS AND BEEFING UP HIS SHARES AT THE SAME TIME... THE *MACHIAVELLIAN SHIT!*

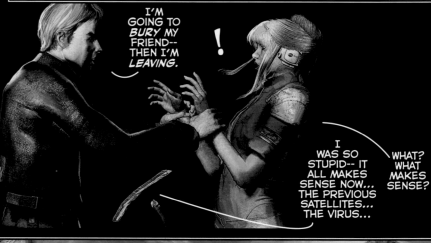

I'M GOING TO *BURY* MY FRIEND-- THEN I'M *LEAVING.*

!

I WAS SO STUPID-- IT ALL MAKES SENSE NOW... THE PREVIOUS SATELLITES... THE VIRUS...

WHAT? WHAT *MAKES* SENSE?

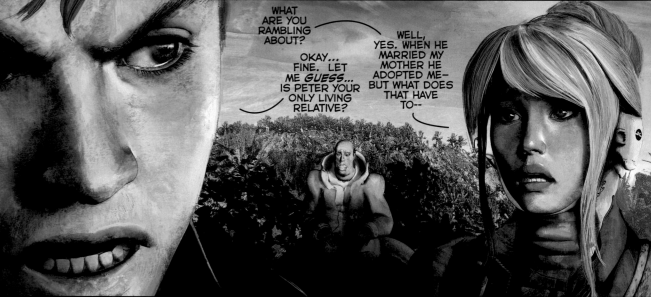

WHAT ARE YOU RAMBLING ABOUT?

OKAY... FINE. LET ME *GUESS...* IS PETER YOUR ONLY LIVING RELATIVE?

WELL, YES. WHEN HE MARRIED MY MOTHER HE ADOPTED ME-- BUT WHAT DOES THAT HAVE TO--

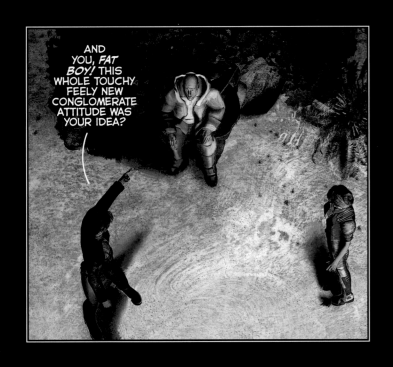

AND YOU, *FAT BOY!* THIS WHOLE TOUCHY FEELY NEW CONGLOMERATE ATTITUDE WAS YOUR IDEA?

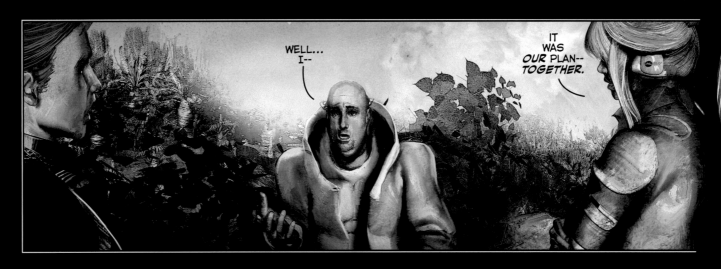

WELL... I--

IT WAS *OUR* PLAN-- *TOGETHER.*

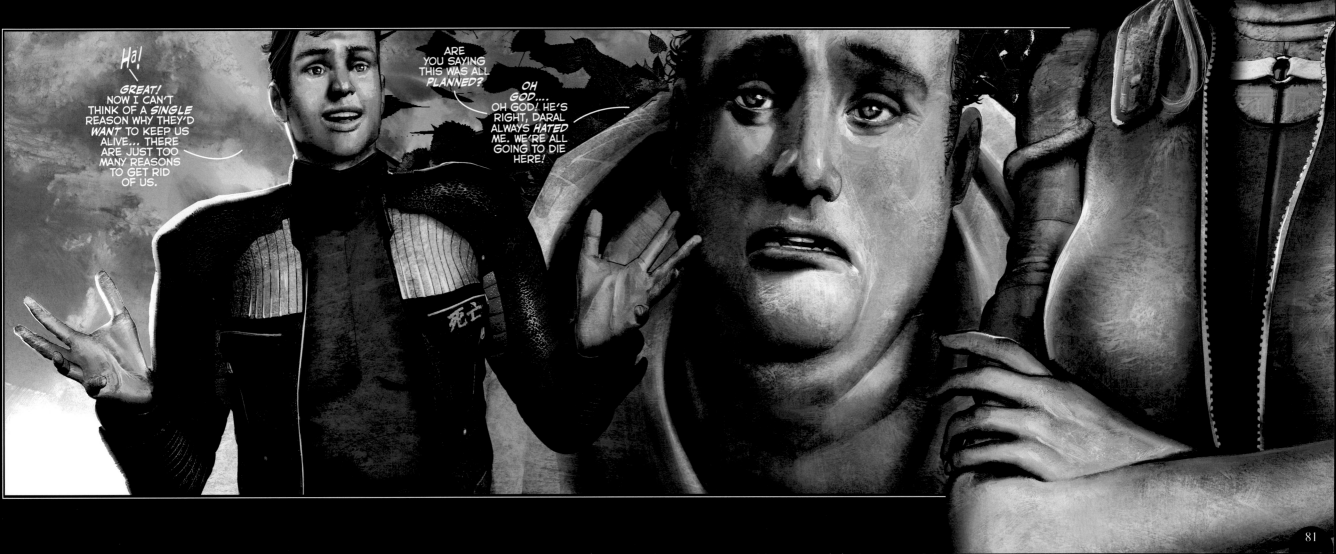

HA!

GREAT! NOW I CAN'T THINK OF A *SINGLE* REASON WHY THEY'D *WANT* TO KEEP US ALIVE... THERE ARE JUST TOO MANY REASONS TO GET RID OF US.

ARE YOU SAYING THIS WAS ALL *PLANNED?*

OH GOD.... OH GOD! HE'S RIGHT, DARAL ALWAYS *HATED* ME. WE'RE ALL GOING TO DIE HERE!

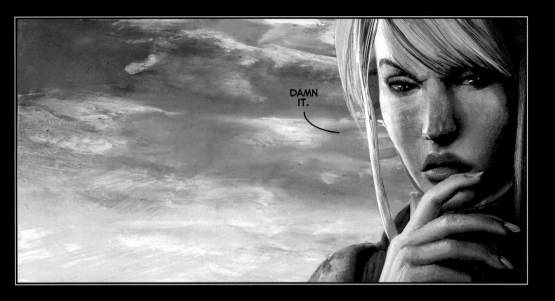

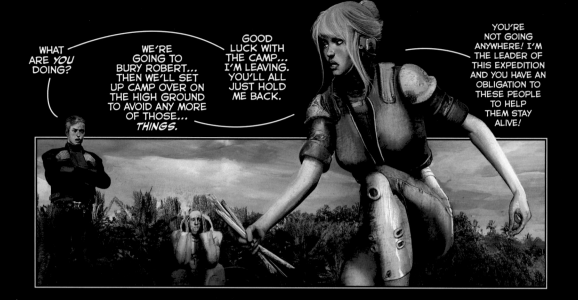

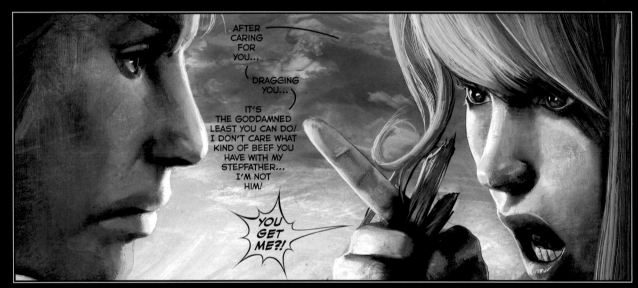

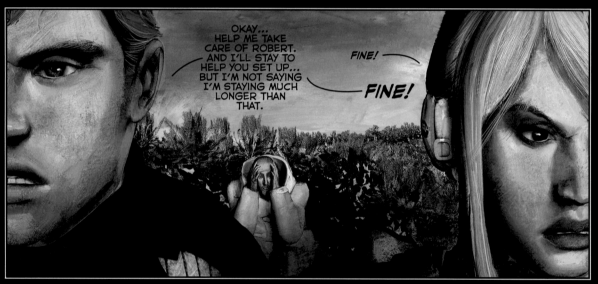

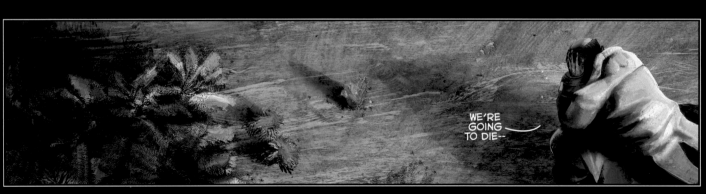

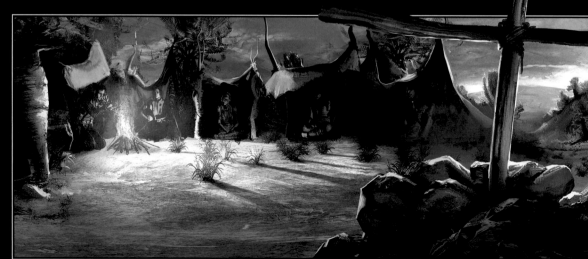

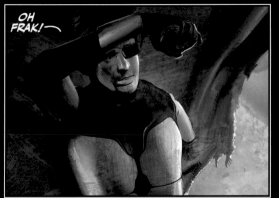
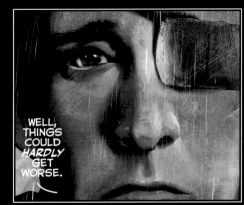
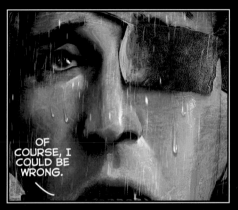
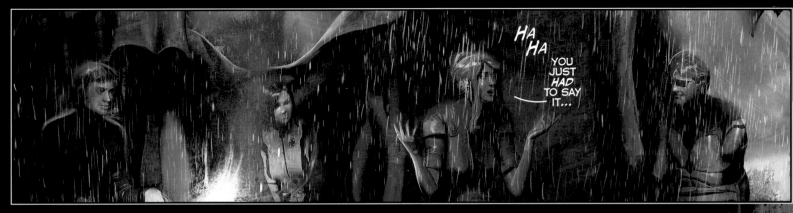

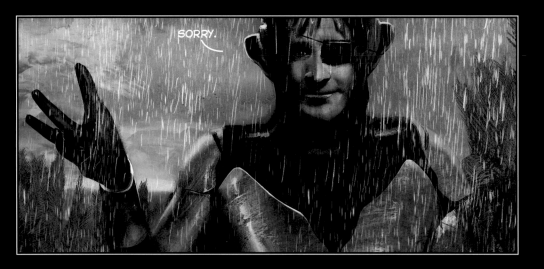

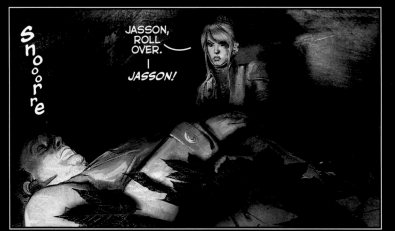

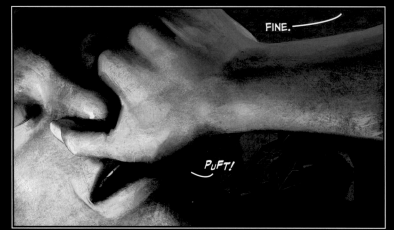

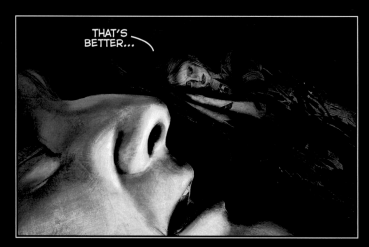

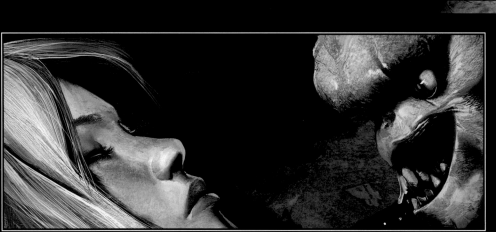

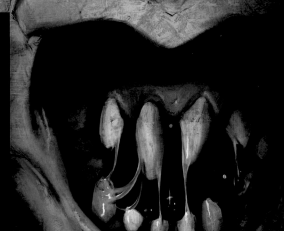

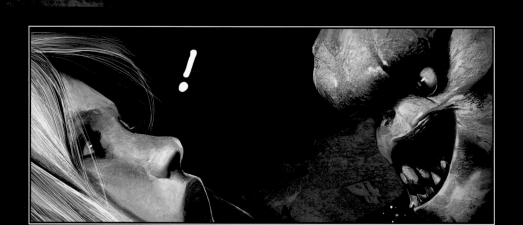

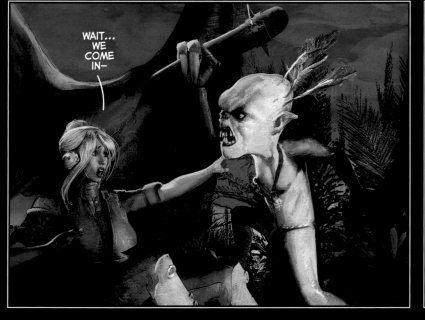

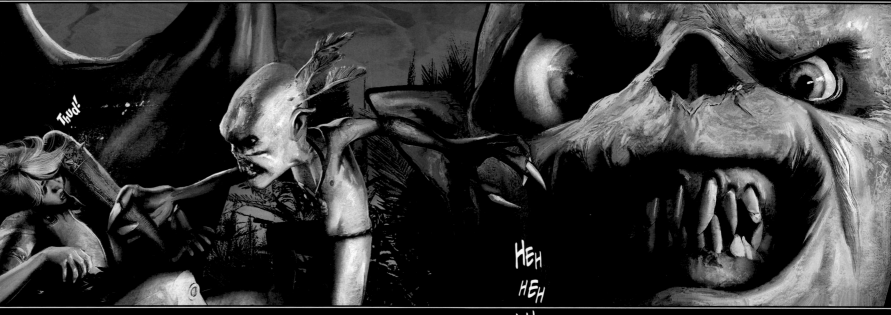

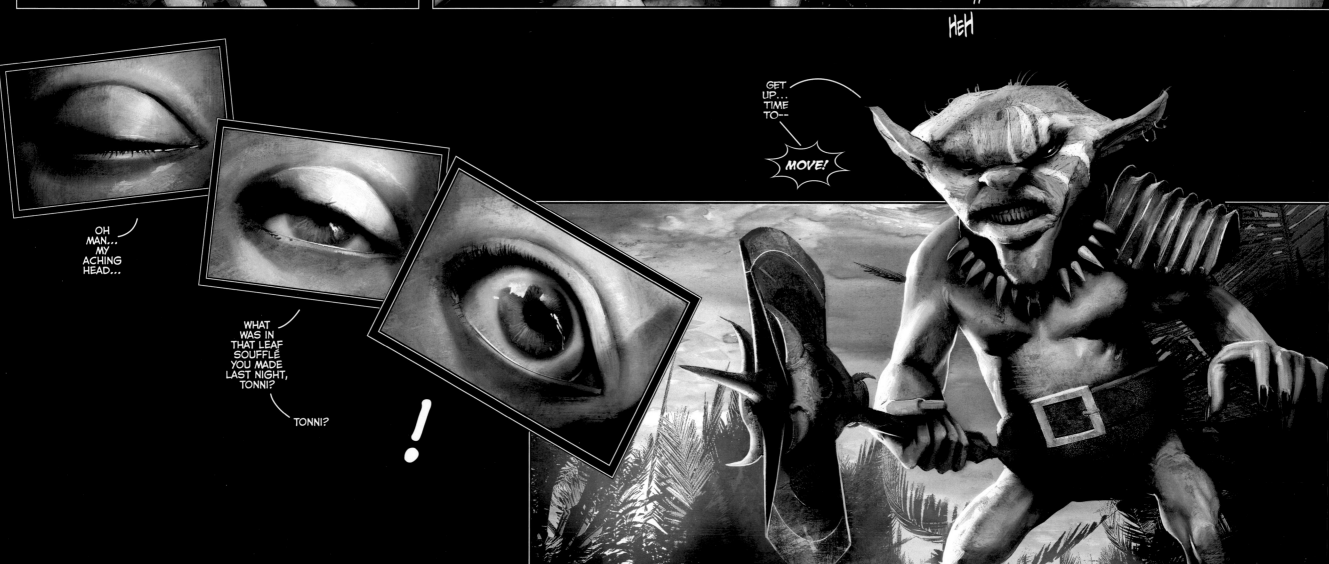

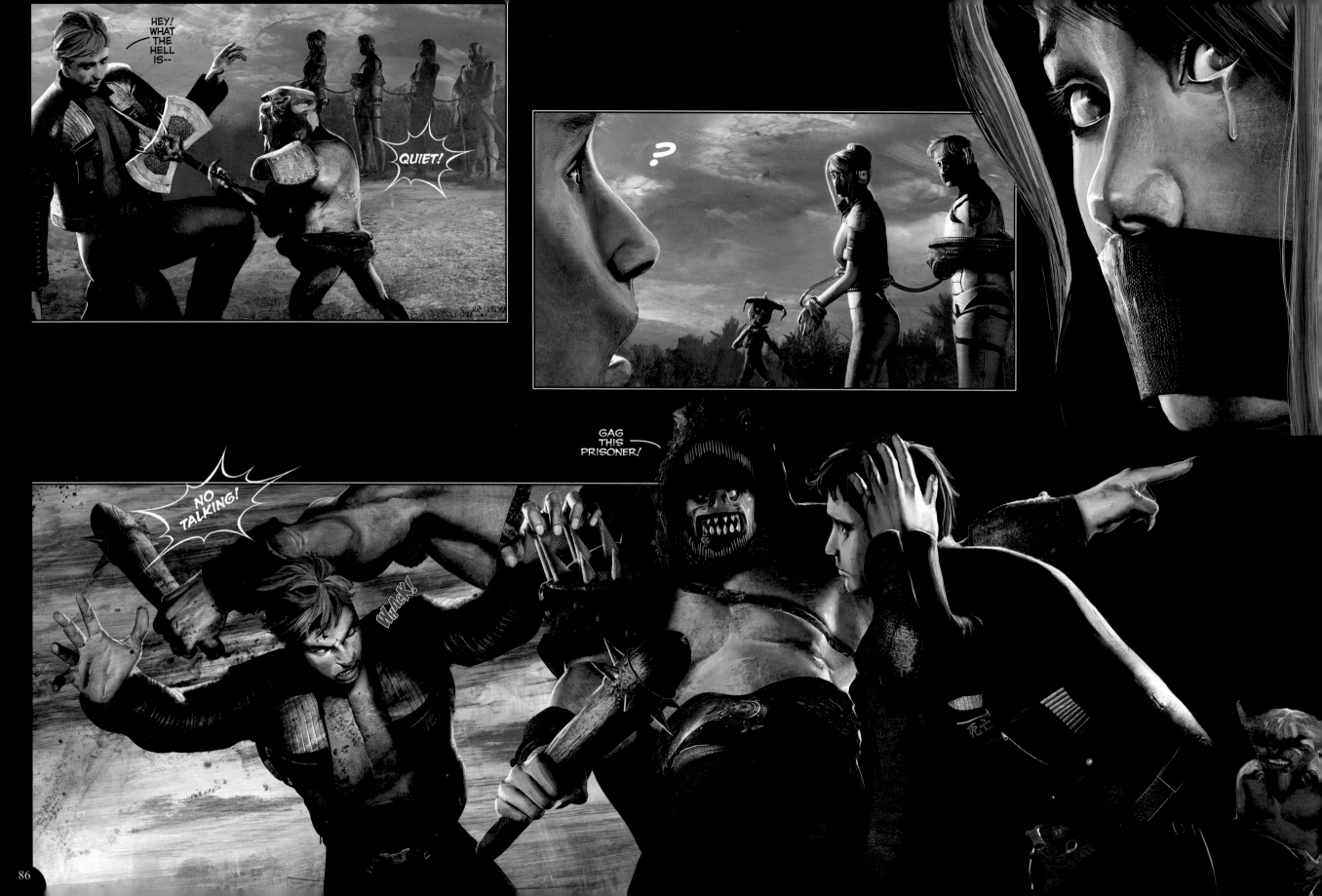

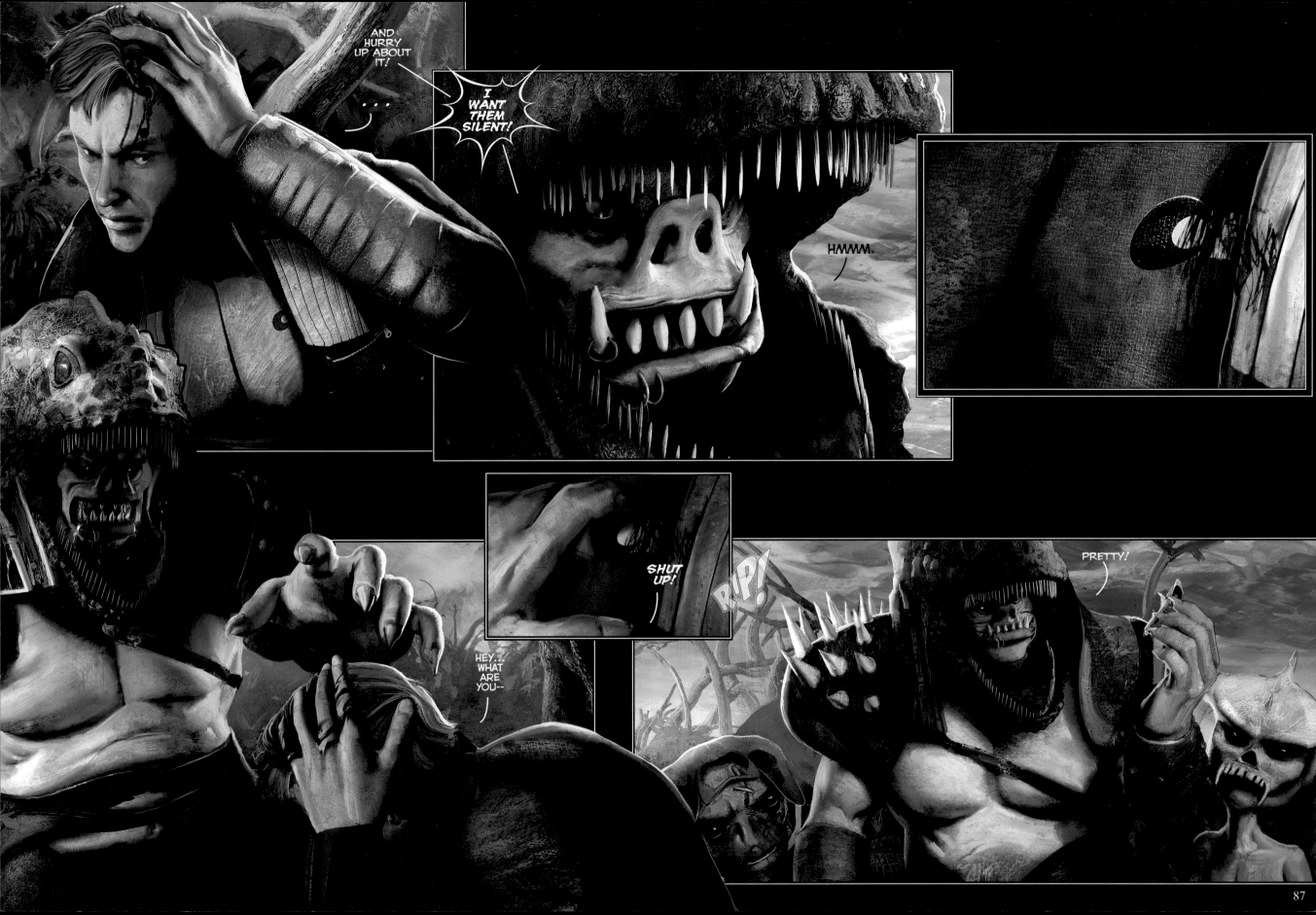

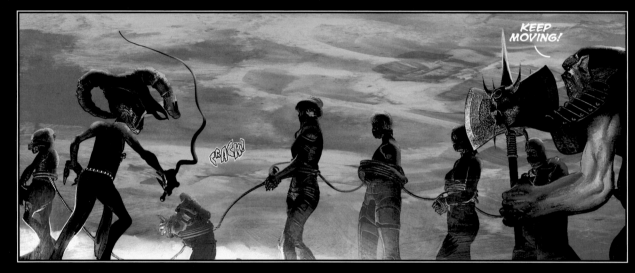

KEEP MOVING!

FRAK!

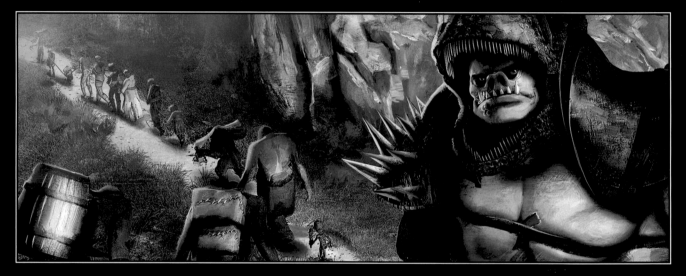

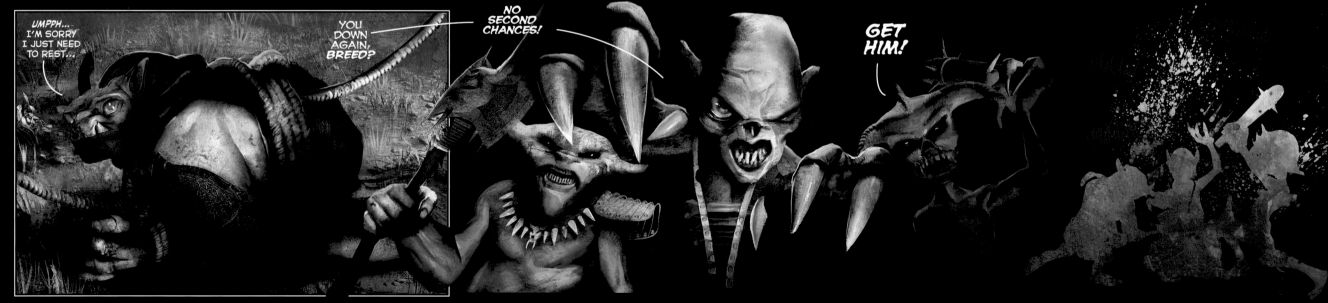

UMPPH... I'M SORRY I JUST NEED TO REST...

YOU DOWN AGAIN, BREED?

NO SECOND CHANCES!

GET HIM!

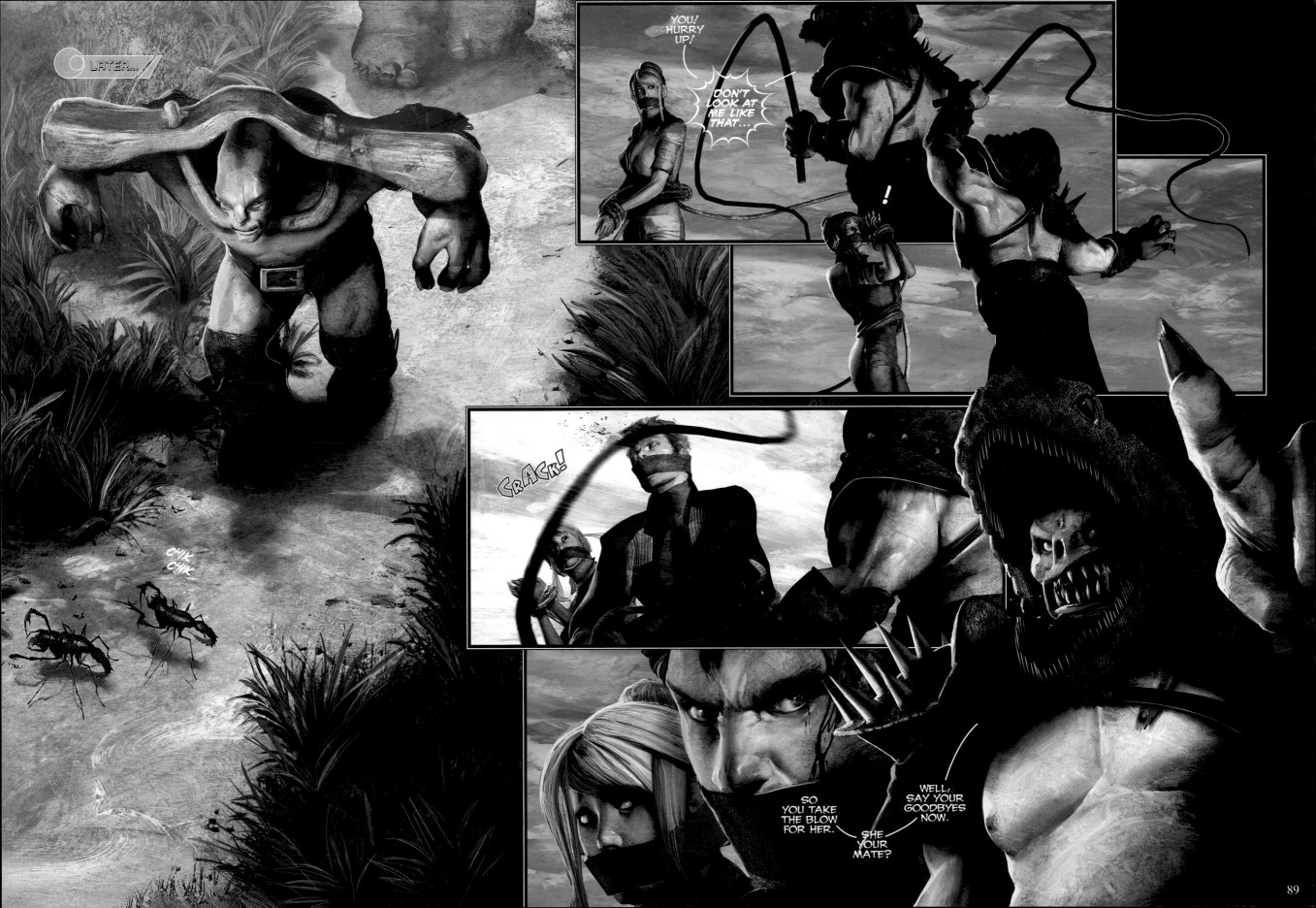

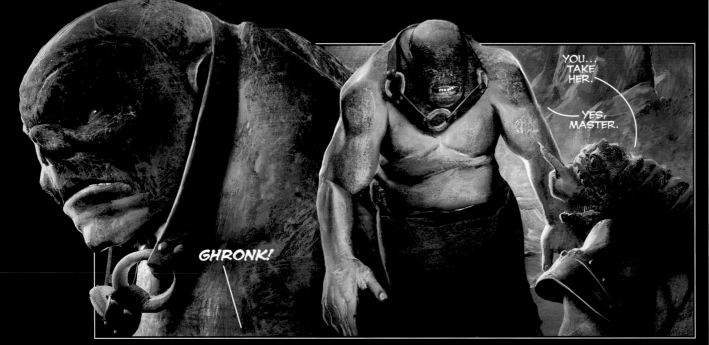

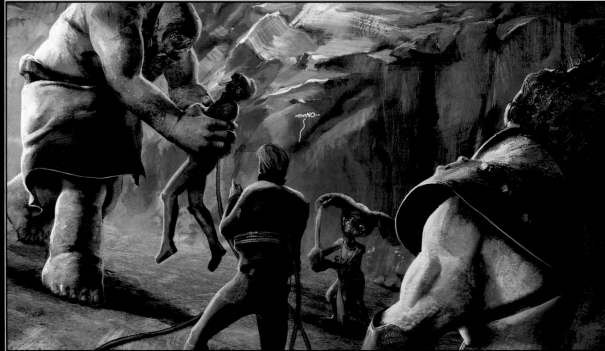

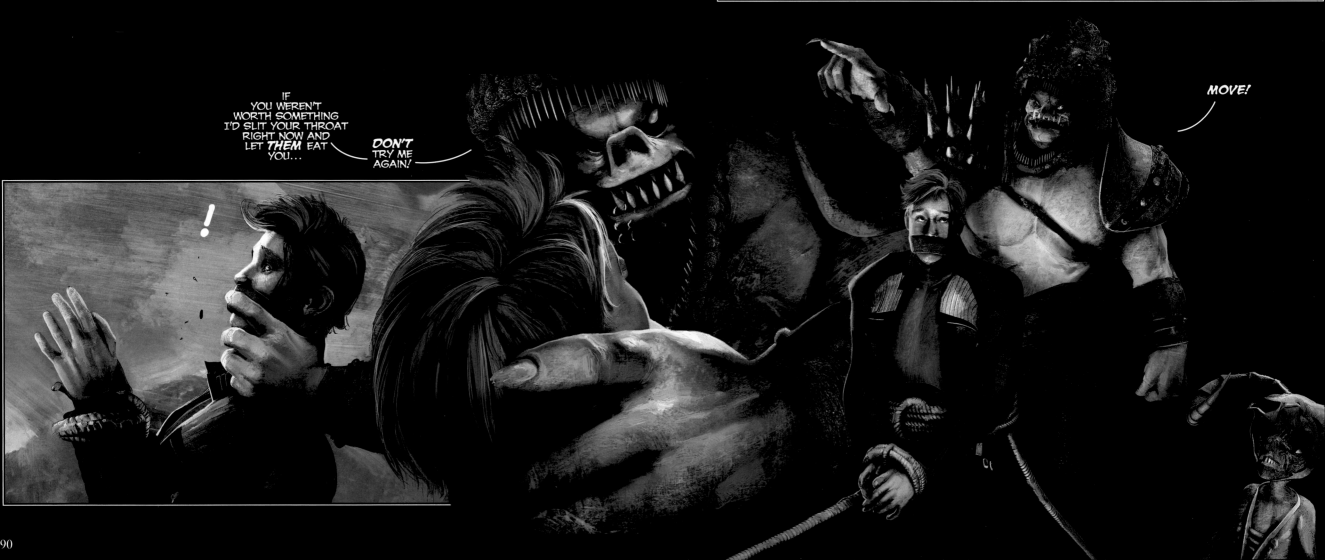

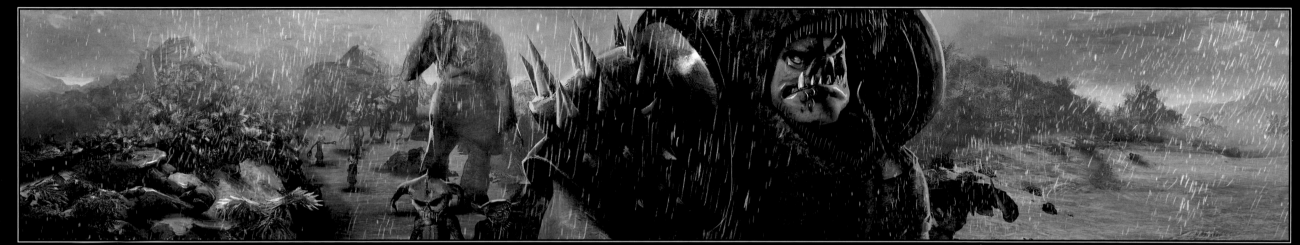

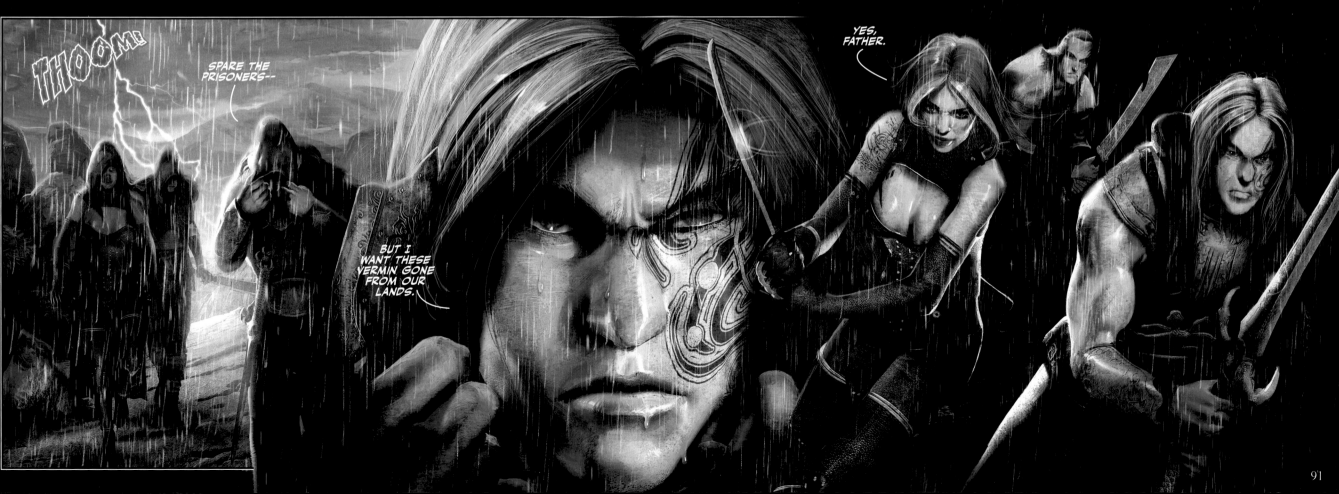

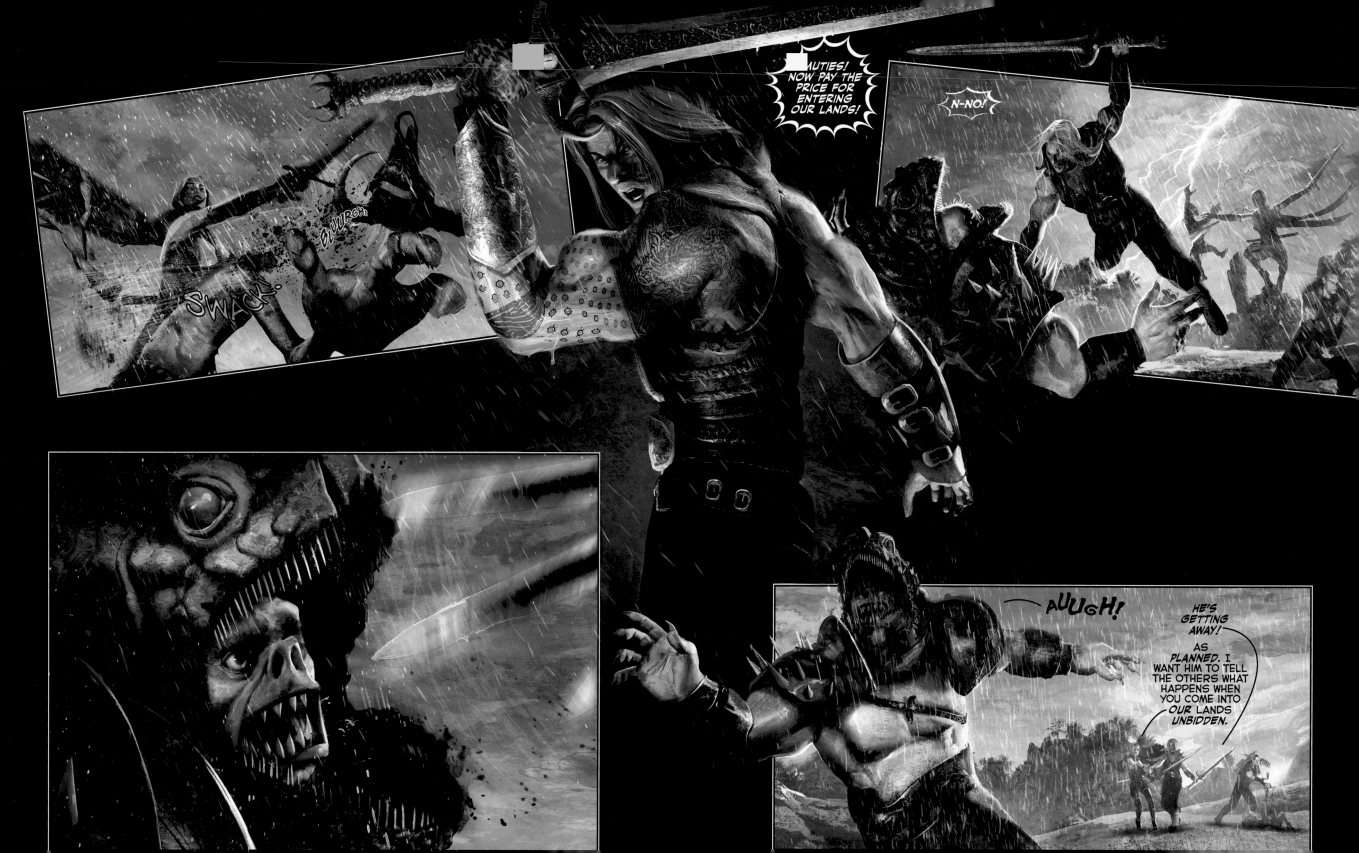

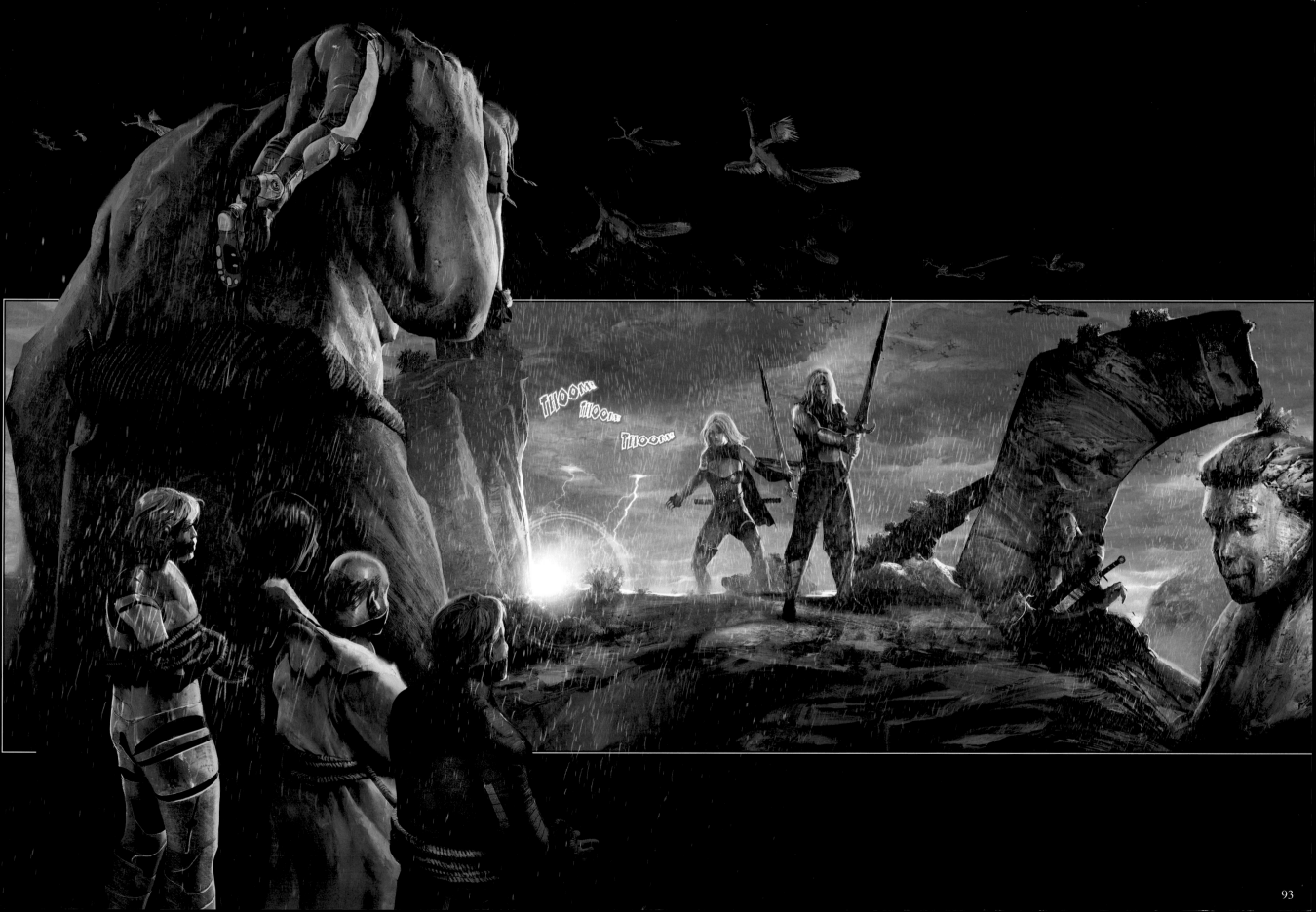

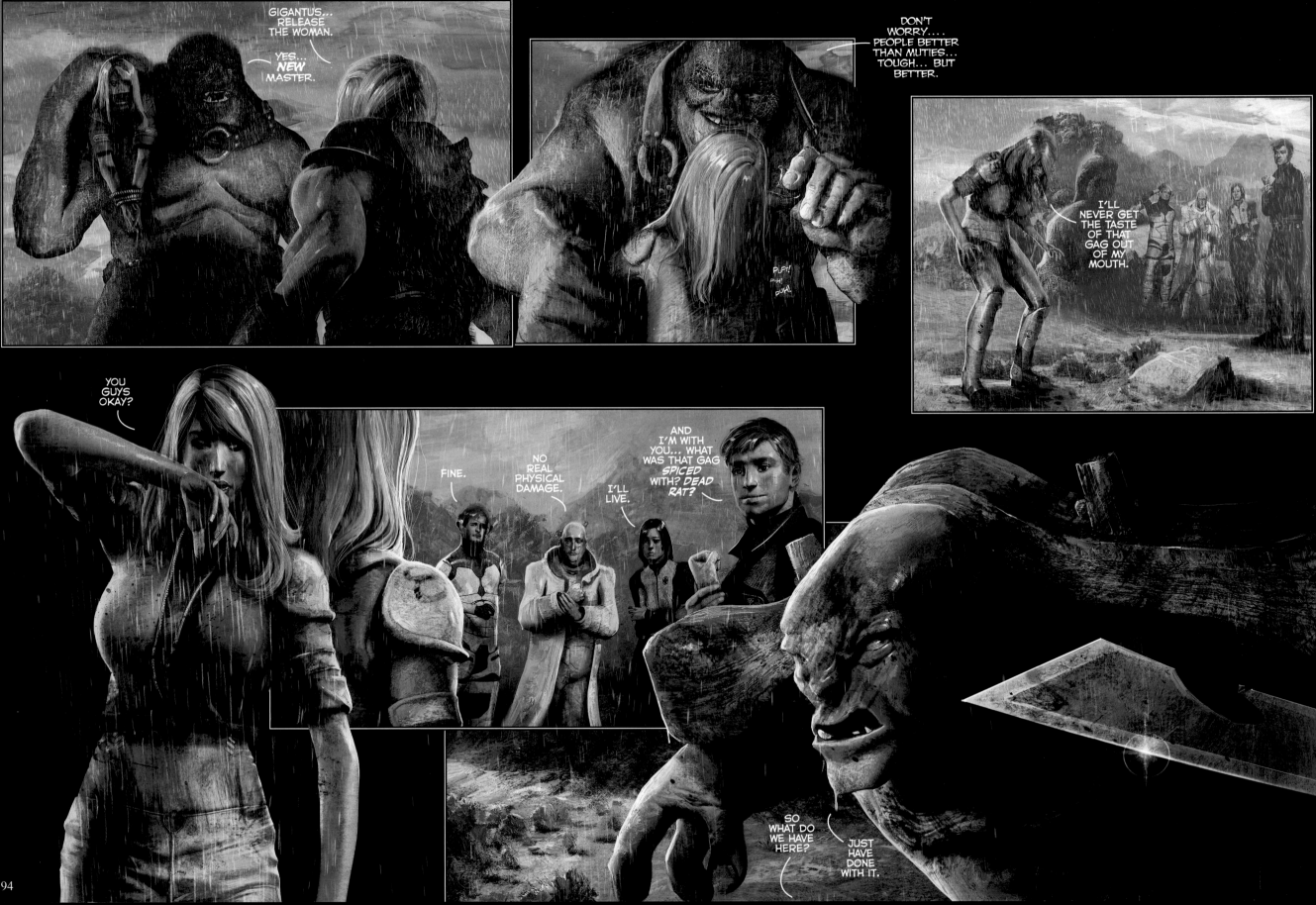

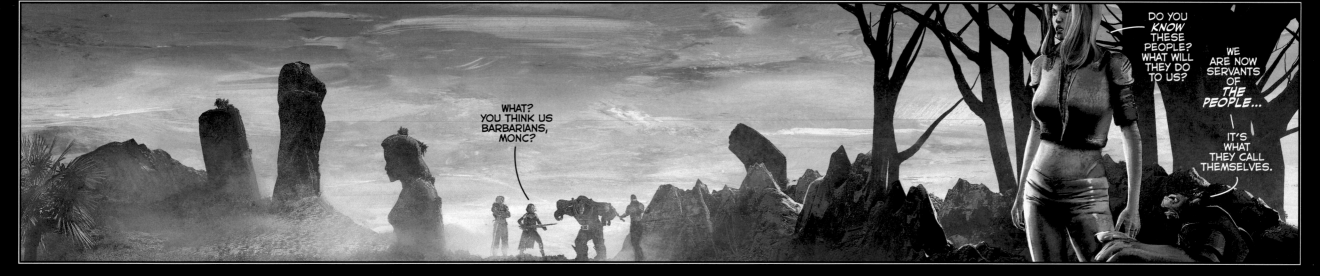

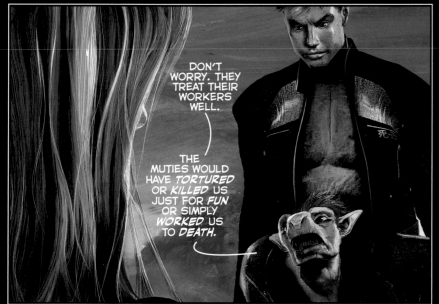

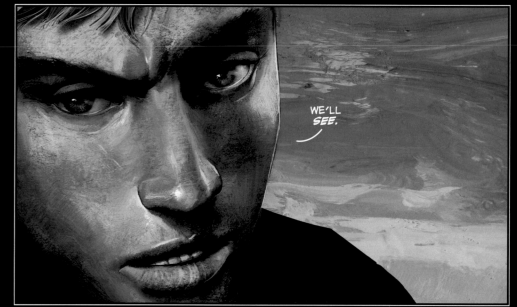

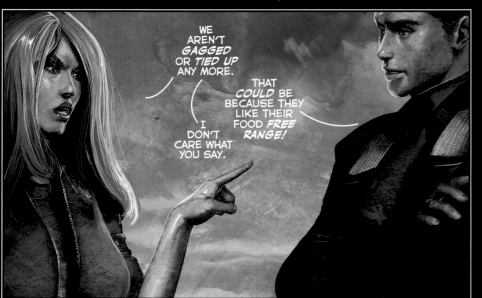

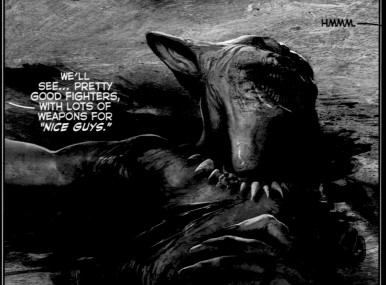

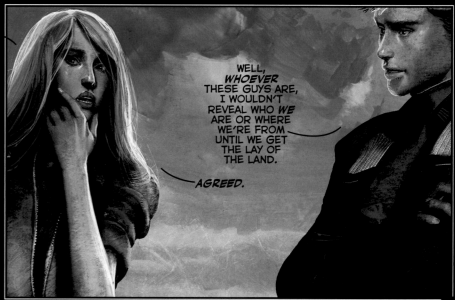

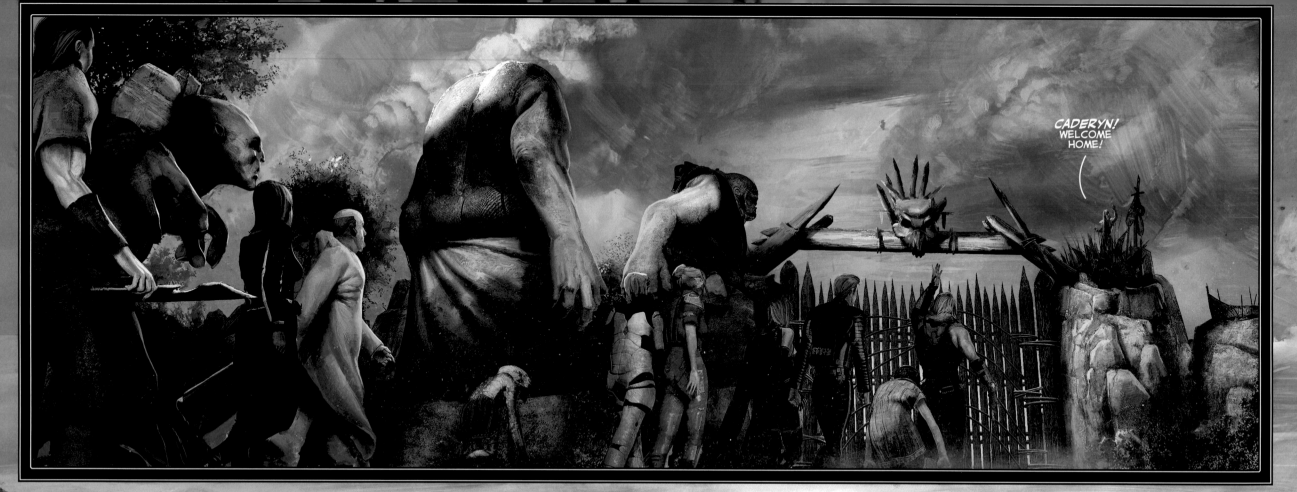

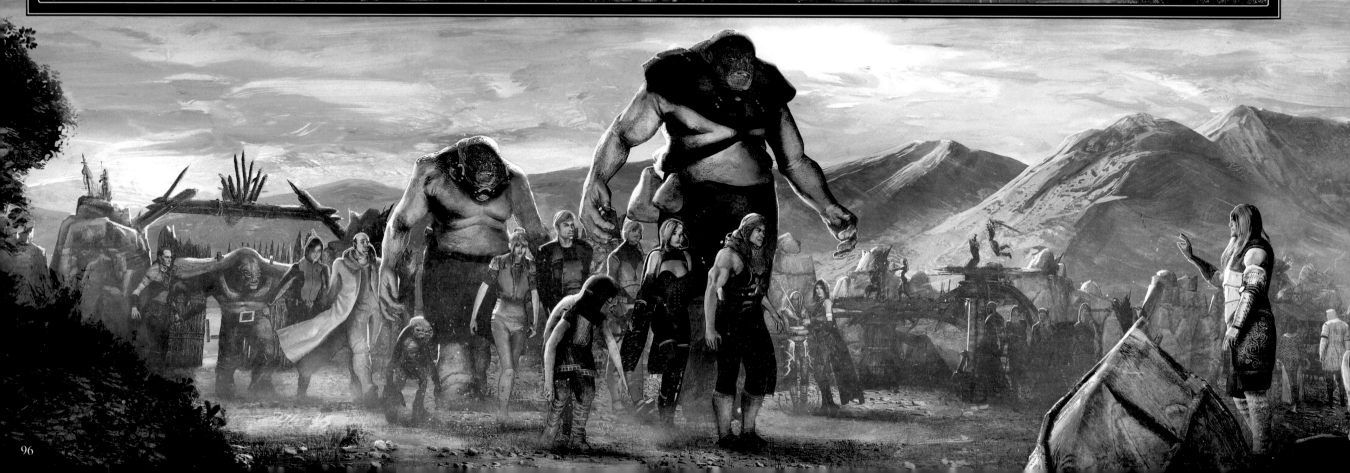

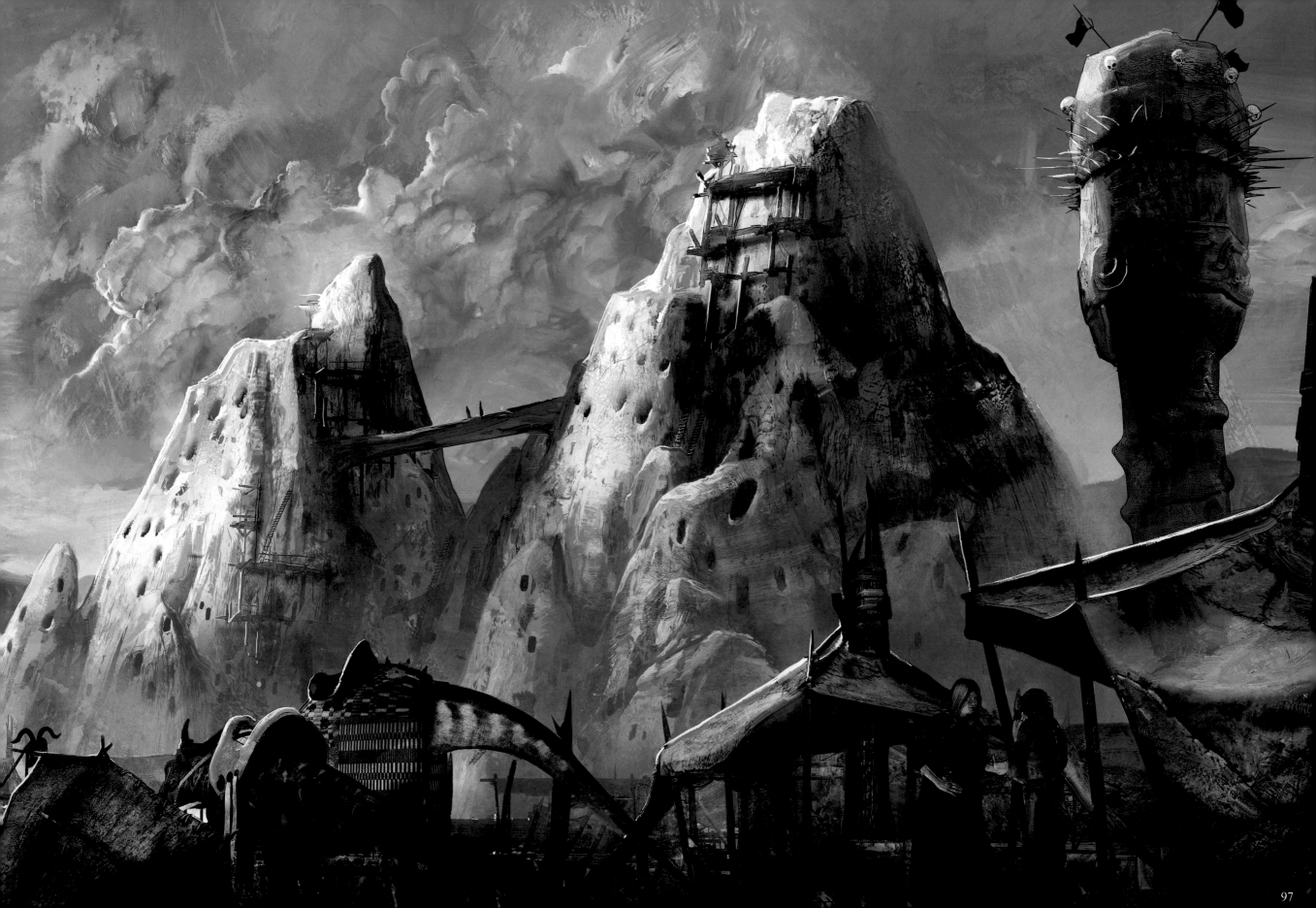

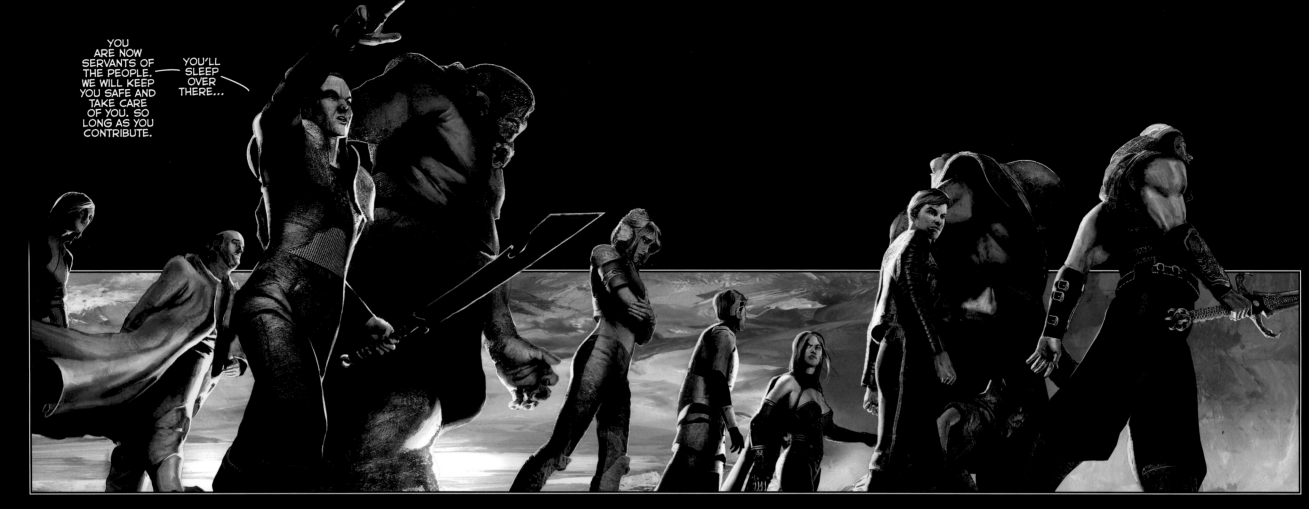

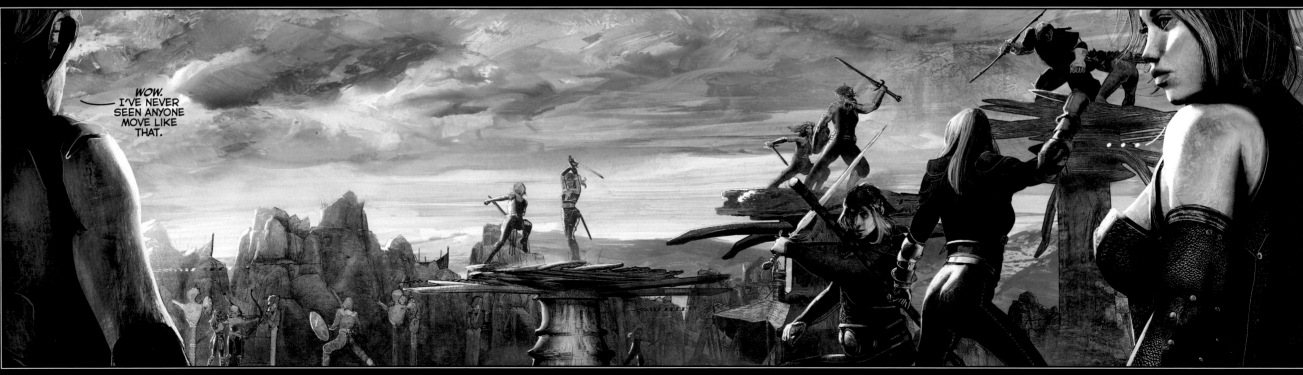

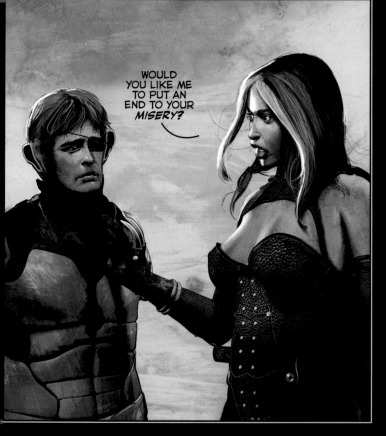

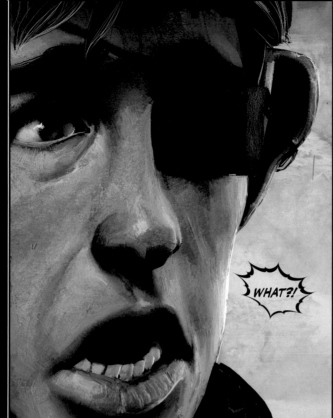

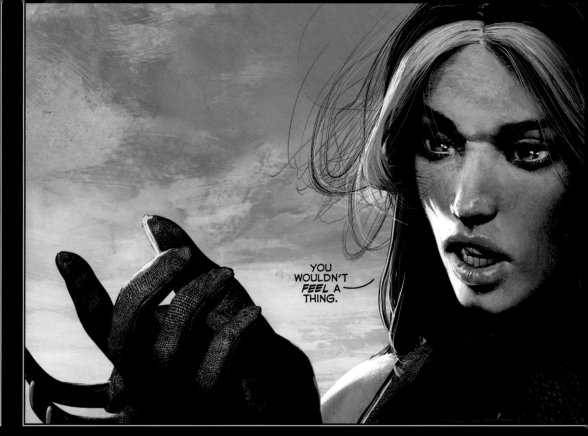

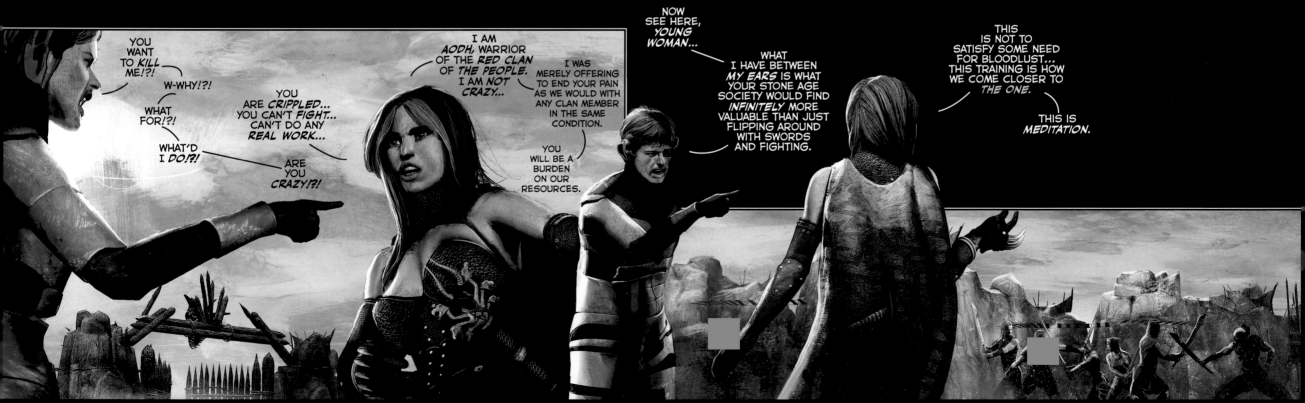

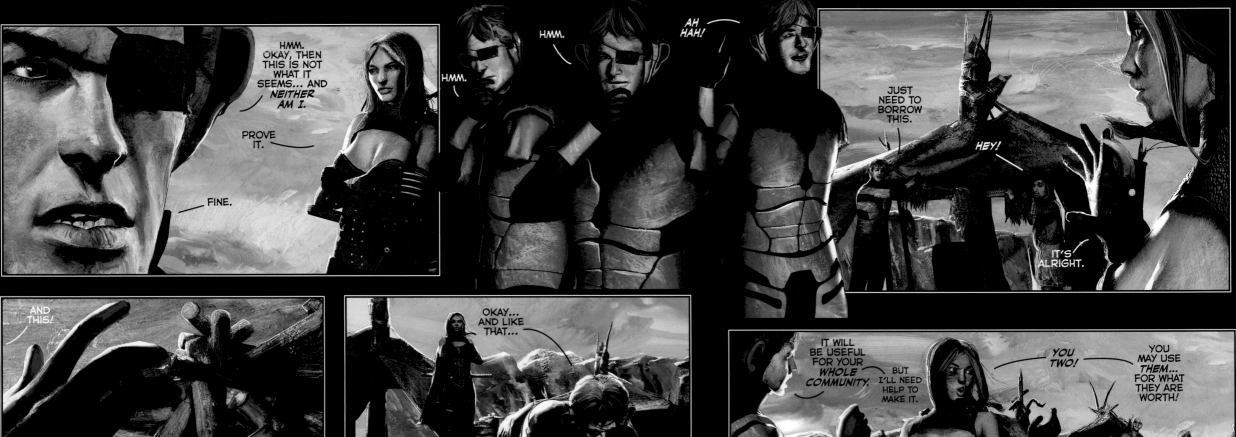

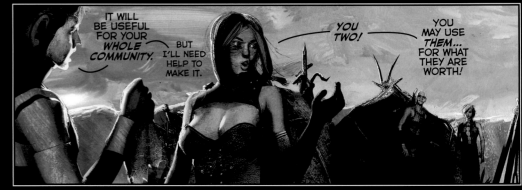

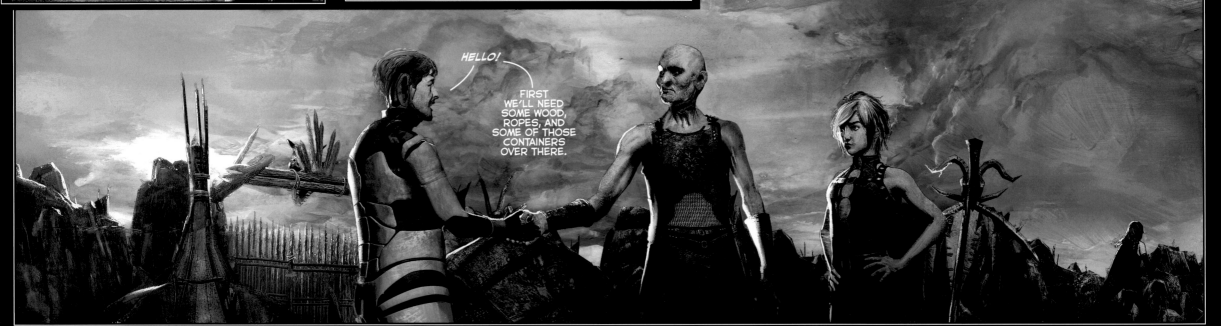

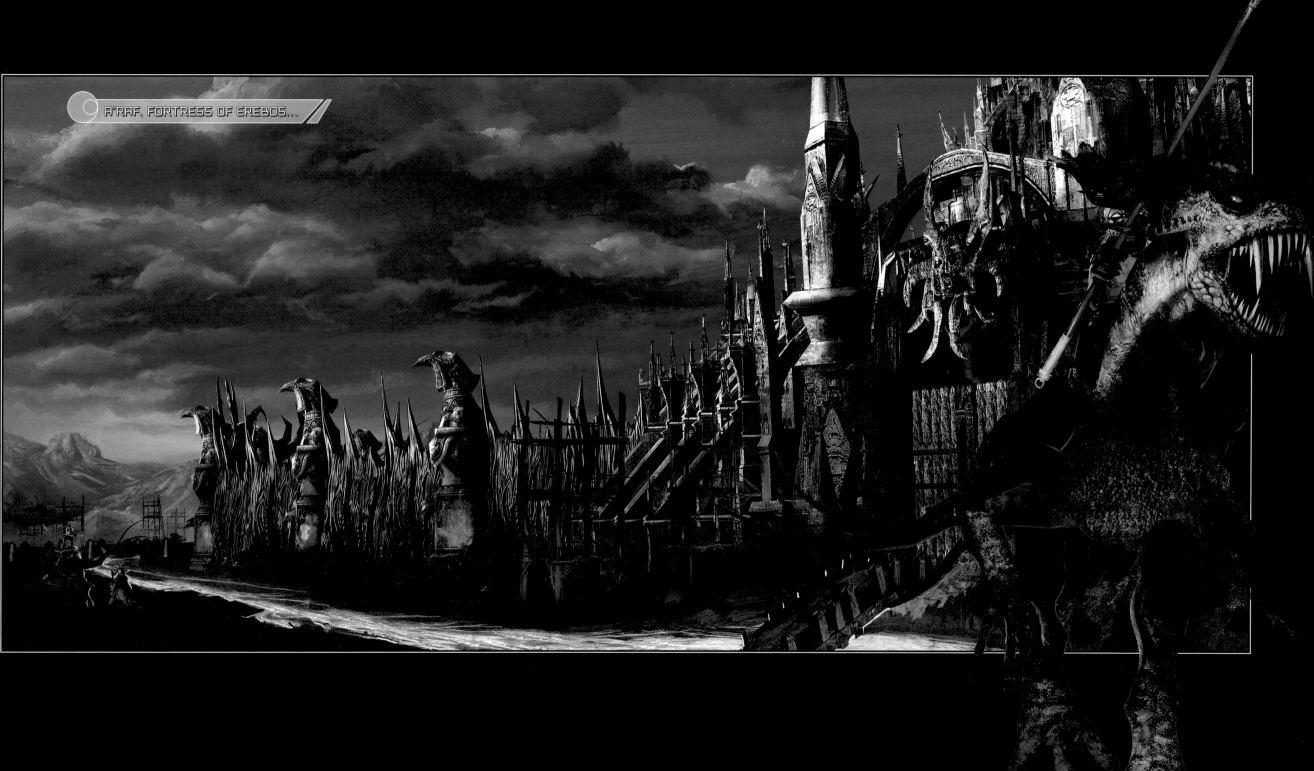

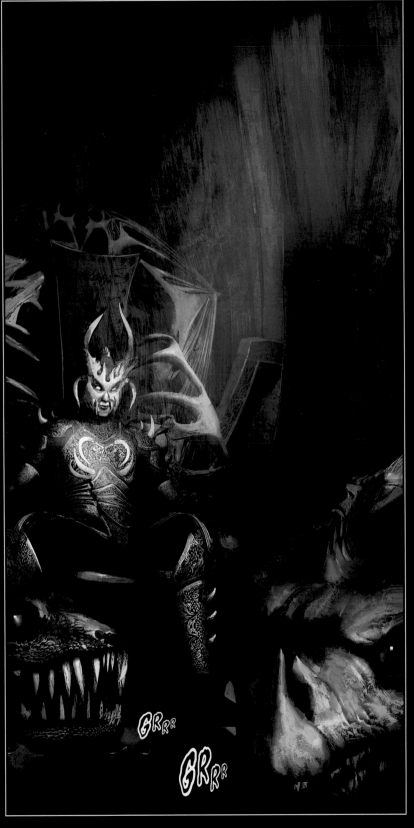

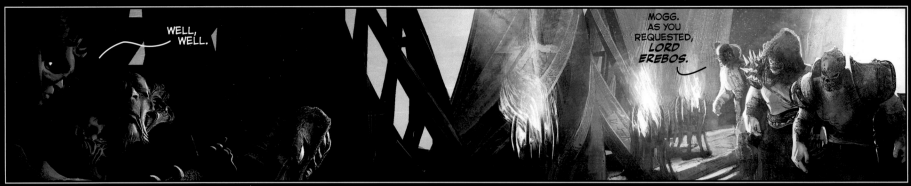

WELL, WELL.

MOGG. AS YOU REQUESTED, LORD EREBOS.

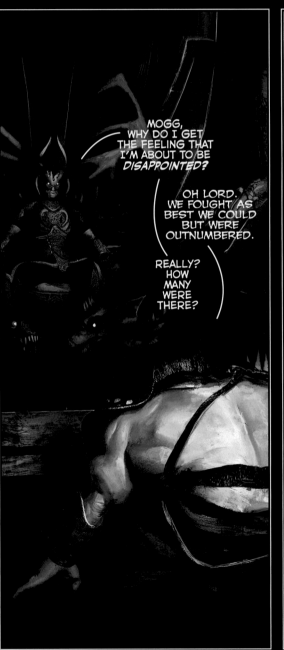

MOGG, WHY DO I GET THE FEELING THAT I'M ABOUT TO BE DISAPPOINTED?

OH LORD. WE FOUGHT AS BEST WE COULD BUT WERE OUTNUMBERED.

REALLY? HOW MANY WERE THERE?

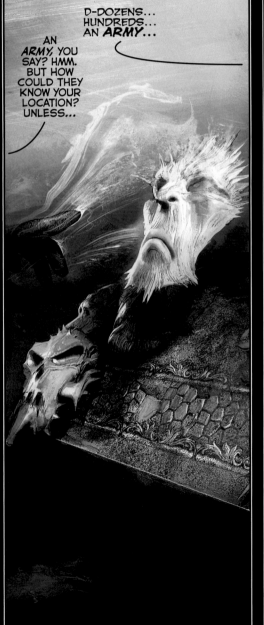

D-DOZENS... HUNDREDS... AN ARMY...

AN ARMY, YOU SAY? HMM. BUT HOW COULD THEY KNOW YOUR LOCATION? UNLESS...

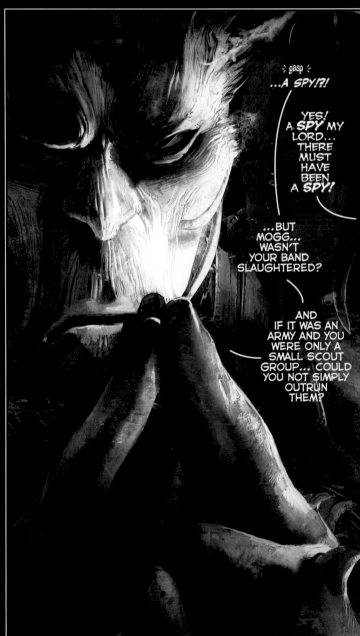

≻ gasp ≺
...A SPY!?!

YES! A SPY MY LORD... THERE MUST HAVE BEEN A SPY!

...BUT MOGG... WASN'T YOUR BAND SLAUGHTERED?

AND IF IT WAS AN ARMY AND YOU WERE ONLY A SMALL SCOUT GROUP... COULD YOU NOT SIMPLY OUTRUN THEM?

GRRR

GRRR

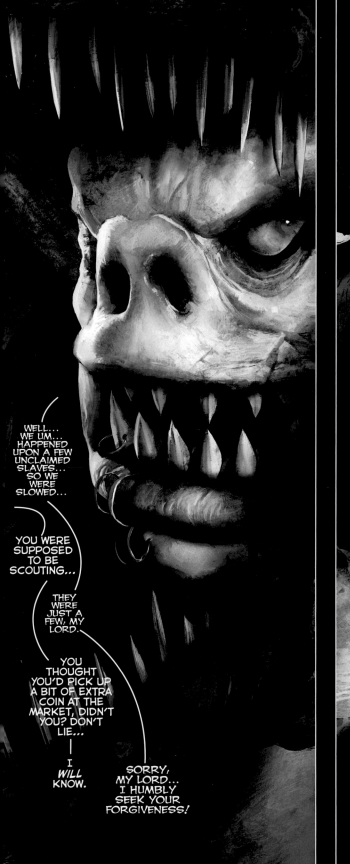
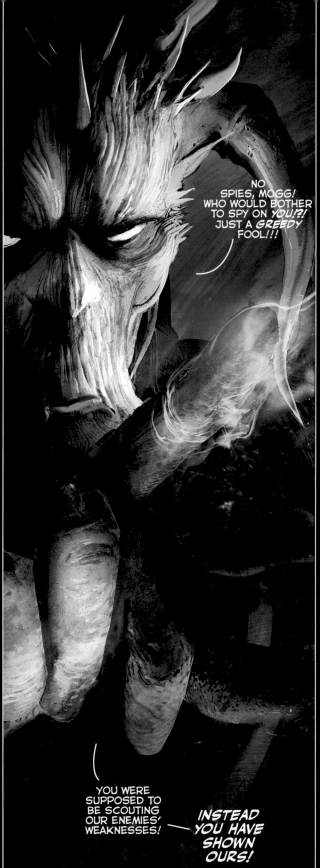
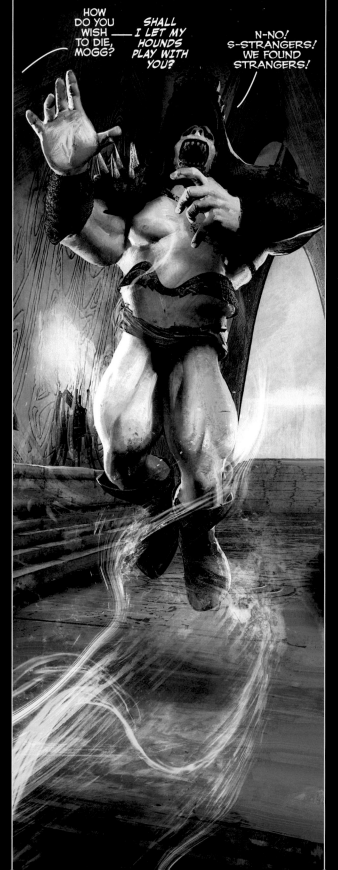
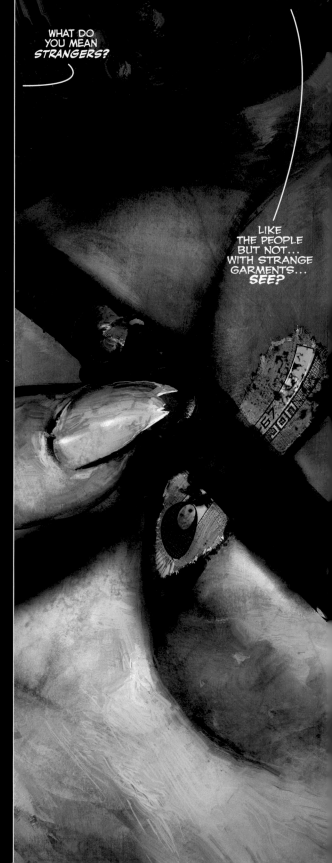

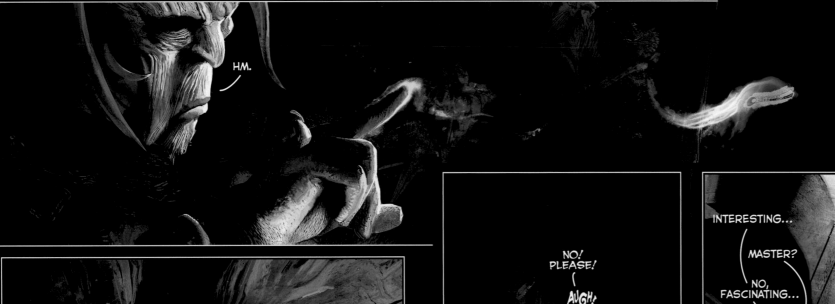
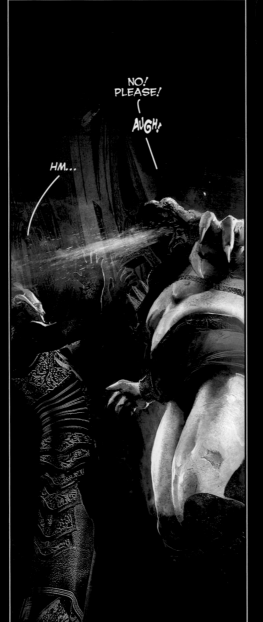
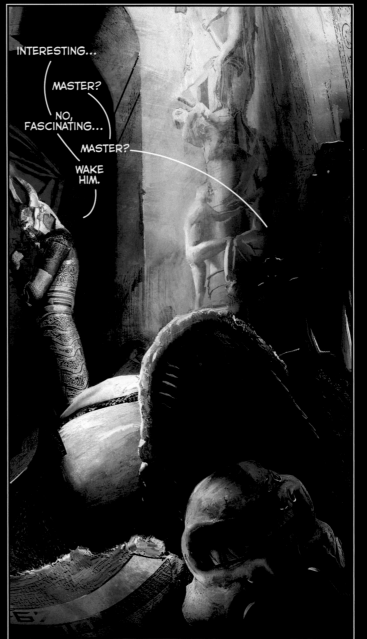

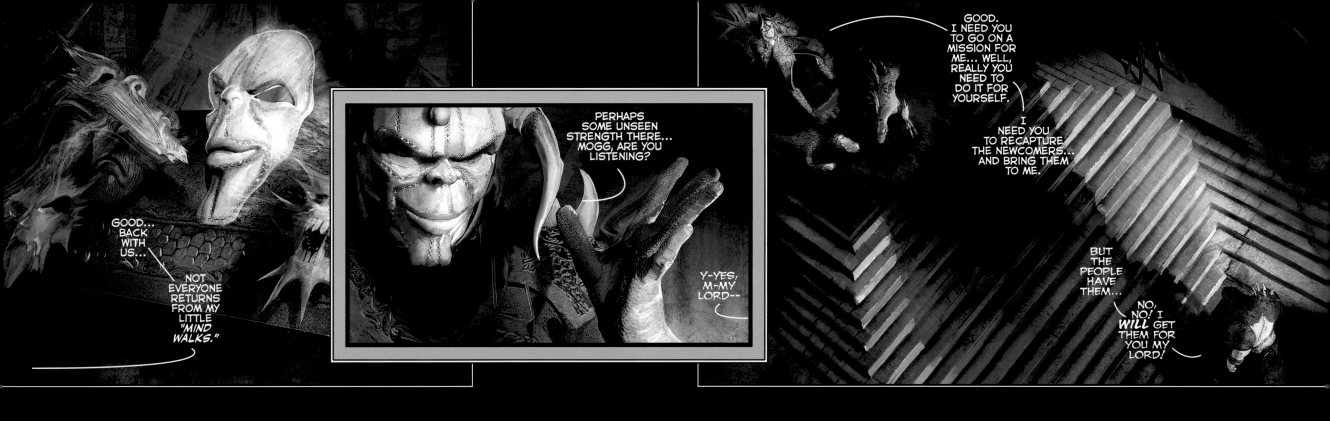

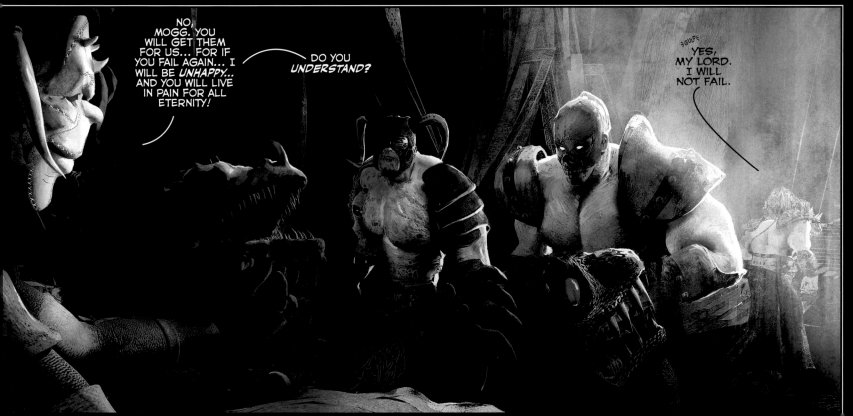

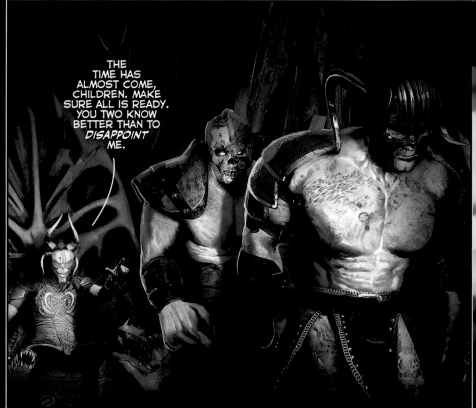

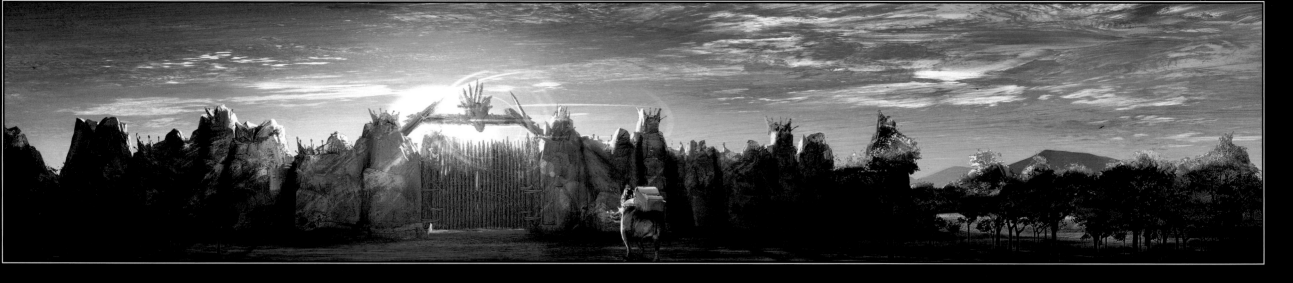

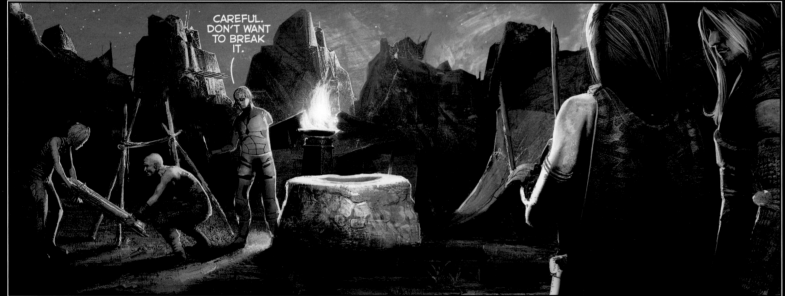

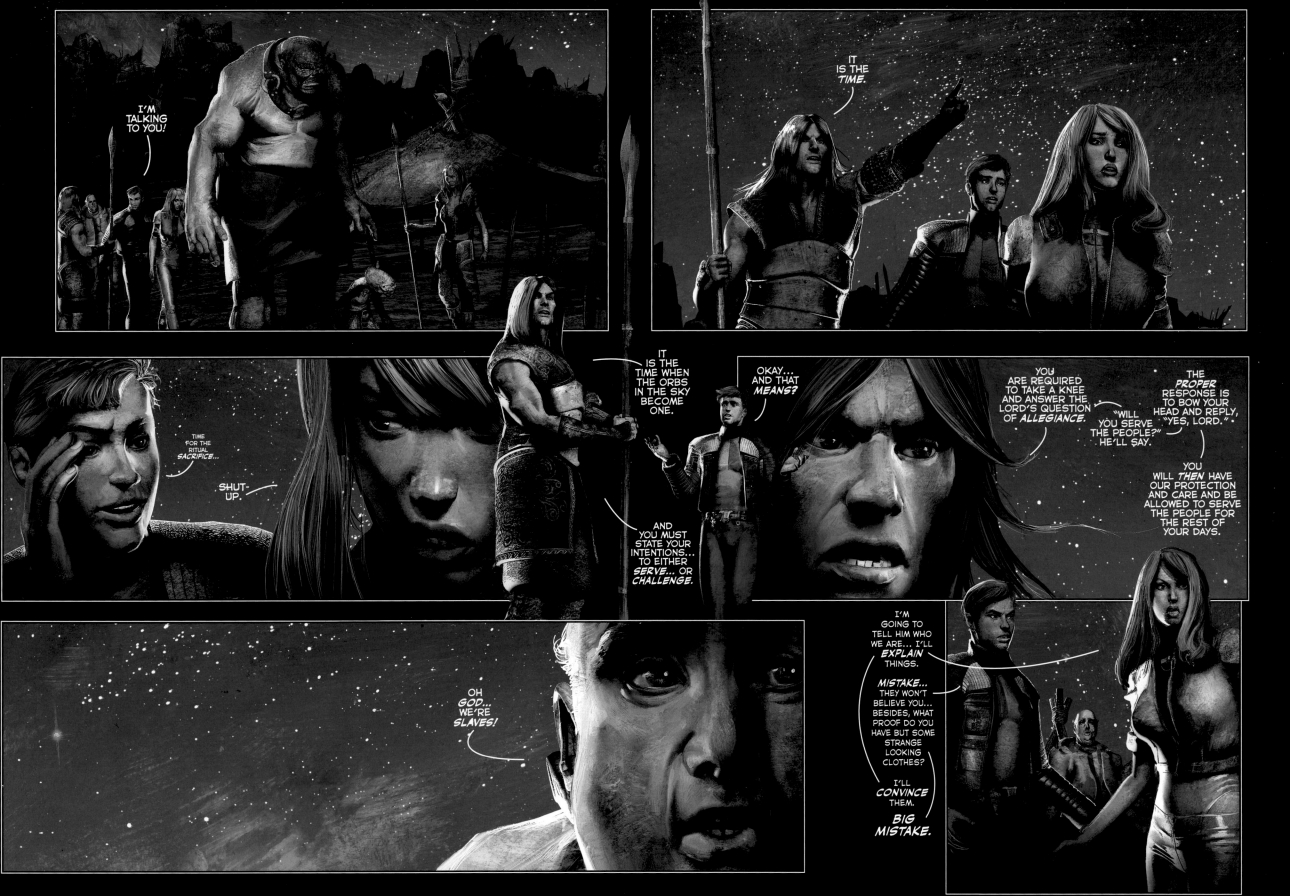

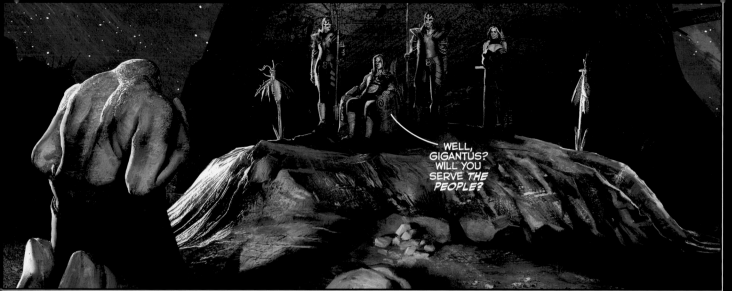
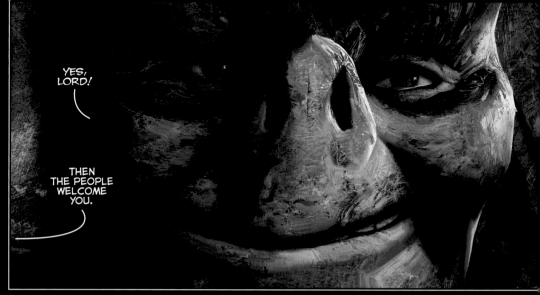
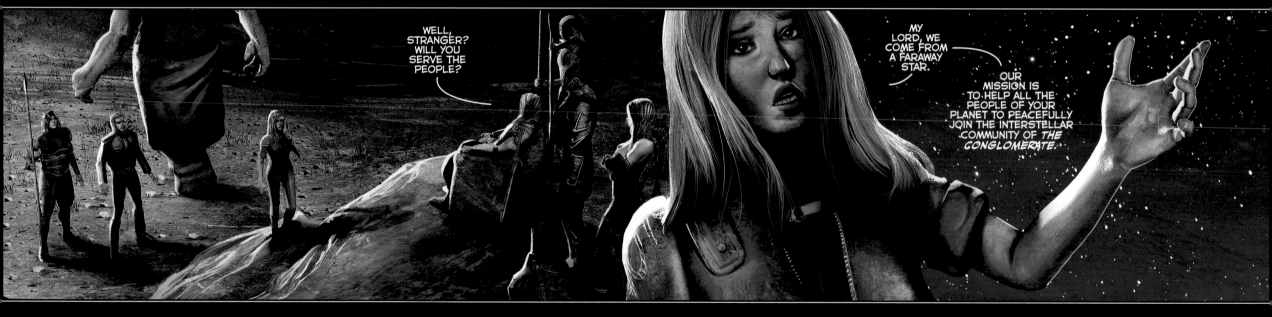
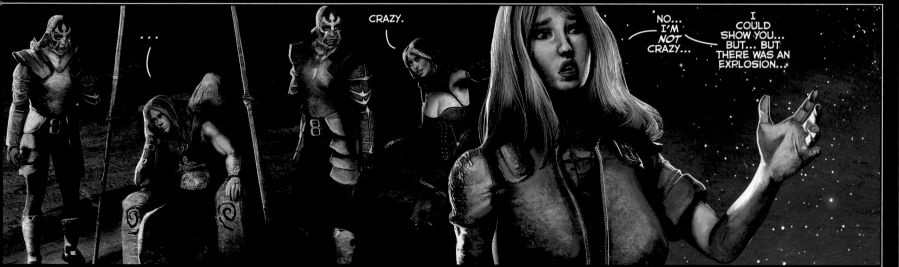
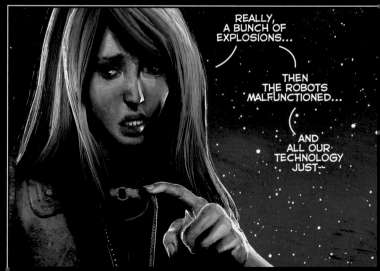

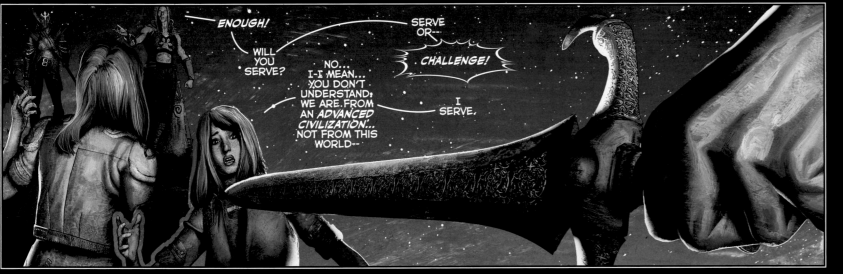
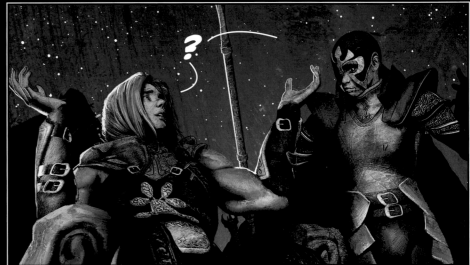
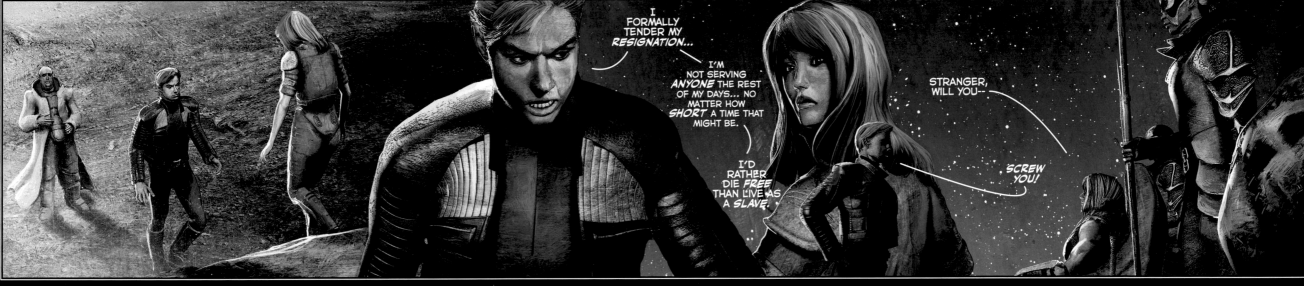
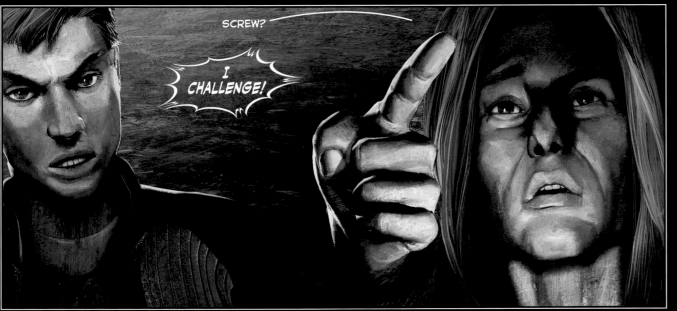
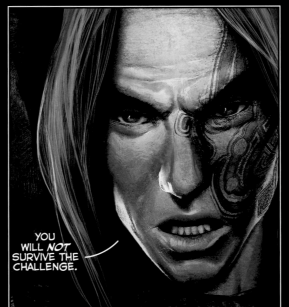

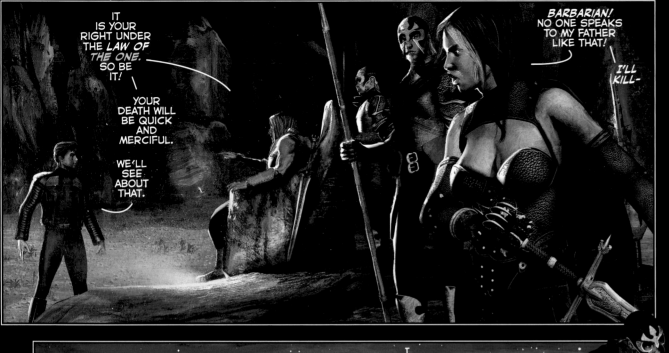
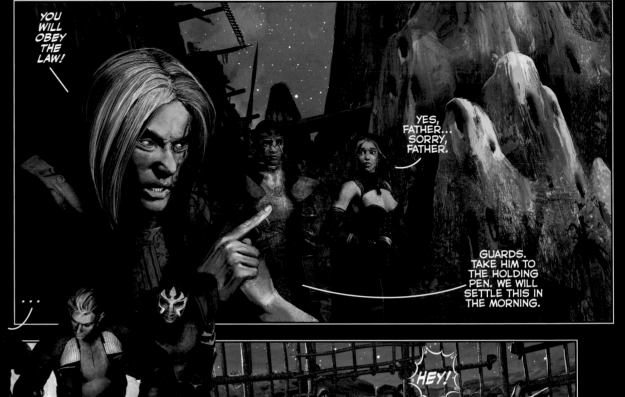

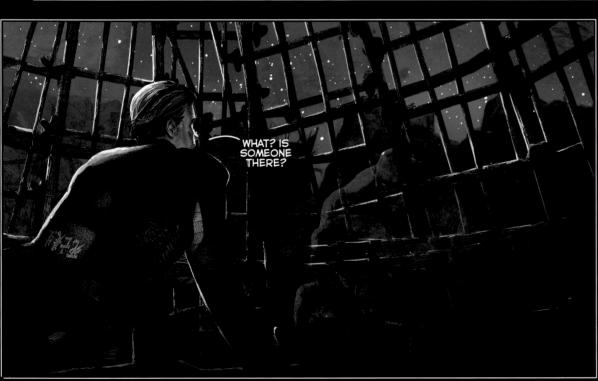
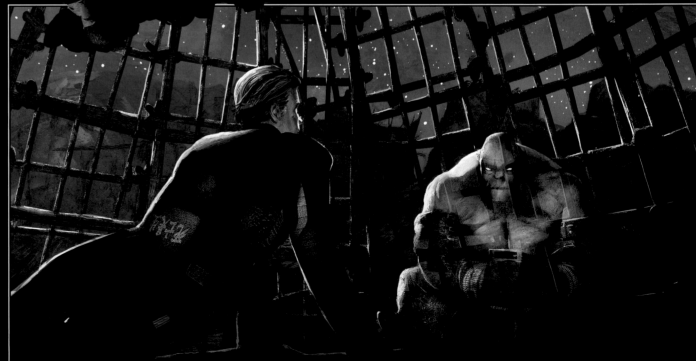

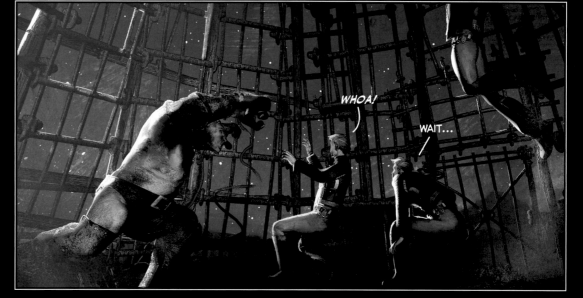

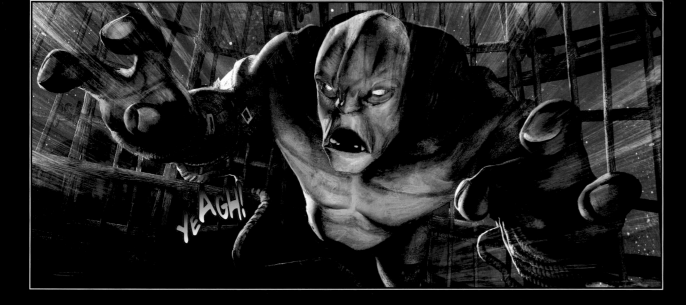

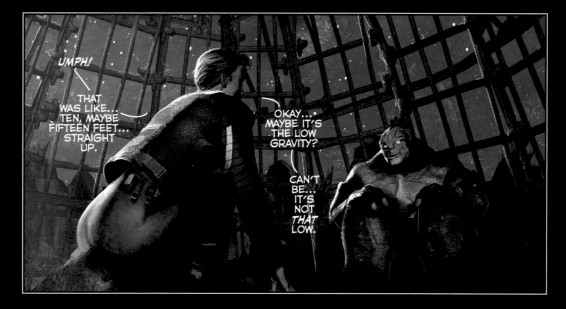

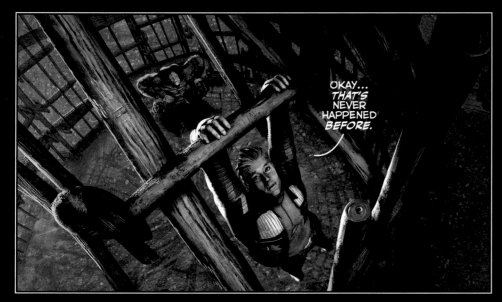

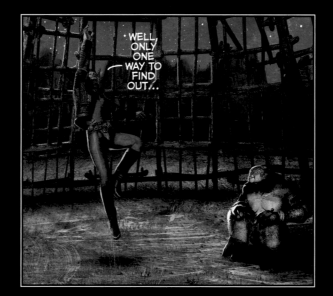

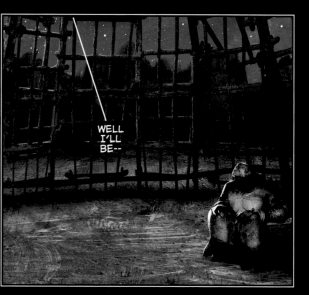

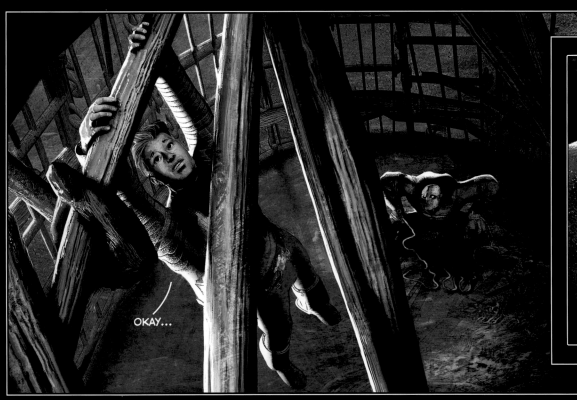

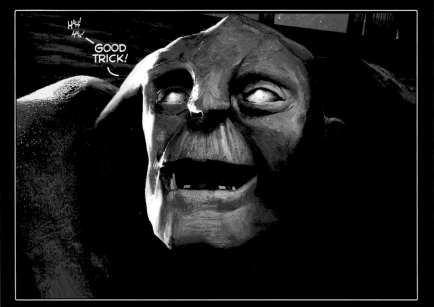

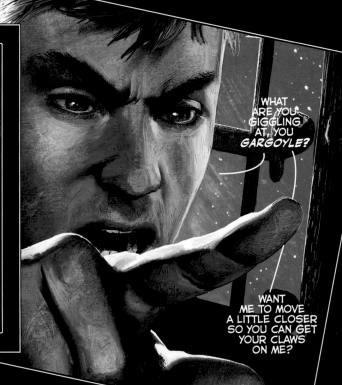

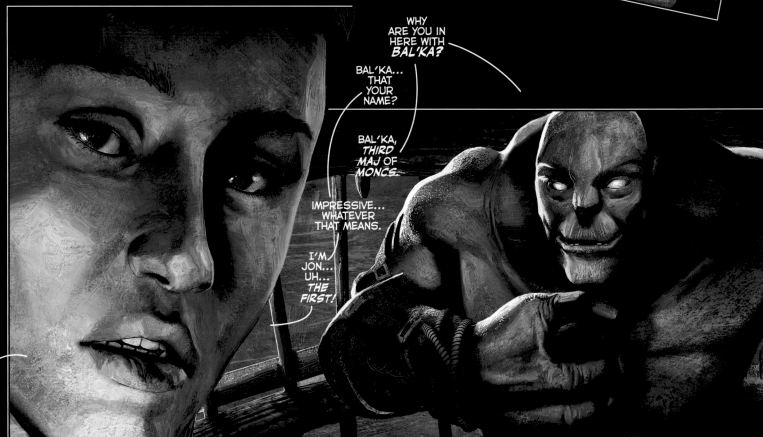

AND I'M IN HERE 'CUZ I TOLD THE OL' LORD OUT THERE WHERE TO STICK IT.

YOU CHALLENGED?

HAH! HAH!

YEAH... BUT THAT DOESN'T SEEM TOO SMART AN IDEA FROM IN HERE...

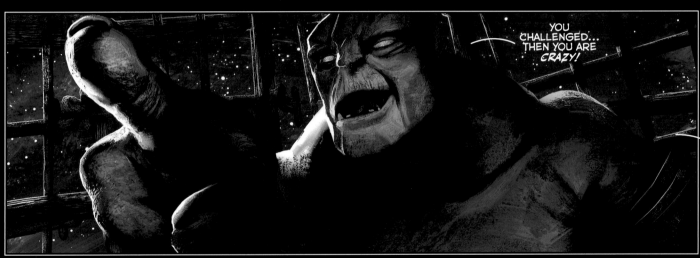

YOU CHALLENGED... THEN YOU ARE CRAZY!

JON THE FIRST... JON THE LAST! HA!

OKAY... THANKS FOR THAT... YOU KNOW, WE DON'T REALLY HAVE TO TALK ANYMORE.

YOU CAN JUST SIT THERE DOING YOUR "BLENDY" IN THING.

I LIKE YOU. TOO BAD CAN'T BE FRIENDS FOR LONG.

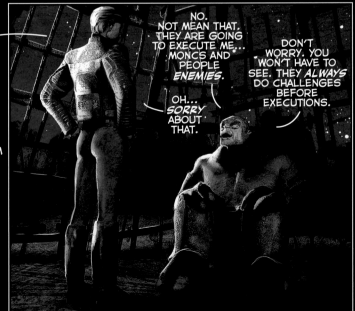

HEY, LISTEN... I MIGHT JUST SURPRISE EVERYONE DURING THIS CHALLENGE THING.

I'M NOT SUCH A BAD FIGHTER... OF COURSE, I'M BETTER WITH A BLASTER THAN A SWORD...

NO. NOT MEAN THAT. THEY ARE GOING TO EXECUTE ME... MONCS AND PEOPLE ENEMIES.

OH... SORRY ABOUT THAT.

DON'T WORRY. YOU WON'T HAVE TO SEE. THEY ALWAYS DO CHALLENGES BEFORE EXECUTIONS.

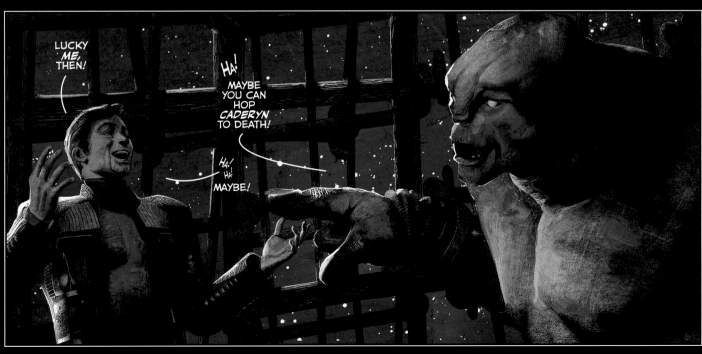

LUCKY ME, THEN!

MAYBE YOU CAN HOP CADERYN TO DEATH!

HA! HA!

MAYBE!

PUT THESE ON.

CHOOSE YOUR WEAPONS FROM THE RACK.

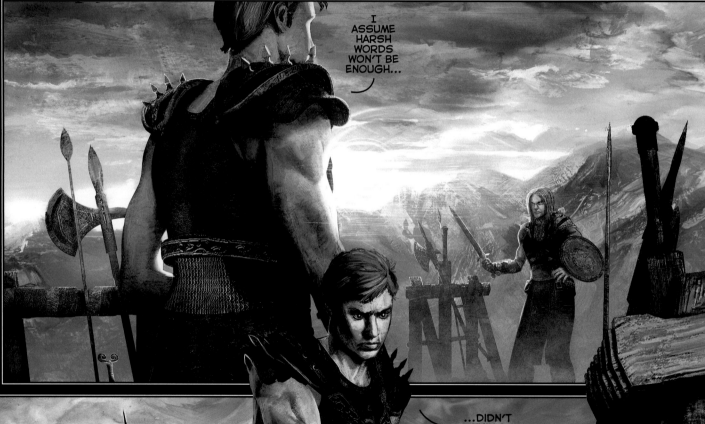

I ASSUME HARSH WORDS WON'T BE ENOUGH...

...DIDN'T THINK SO...

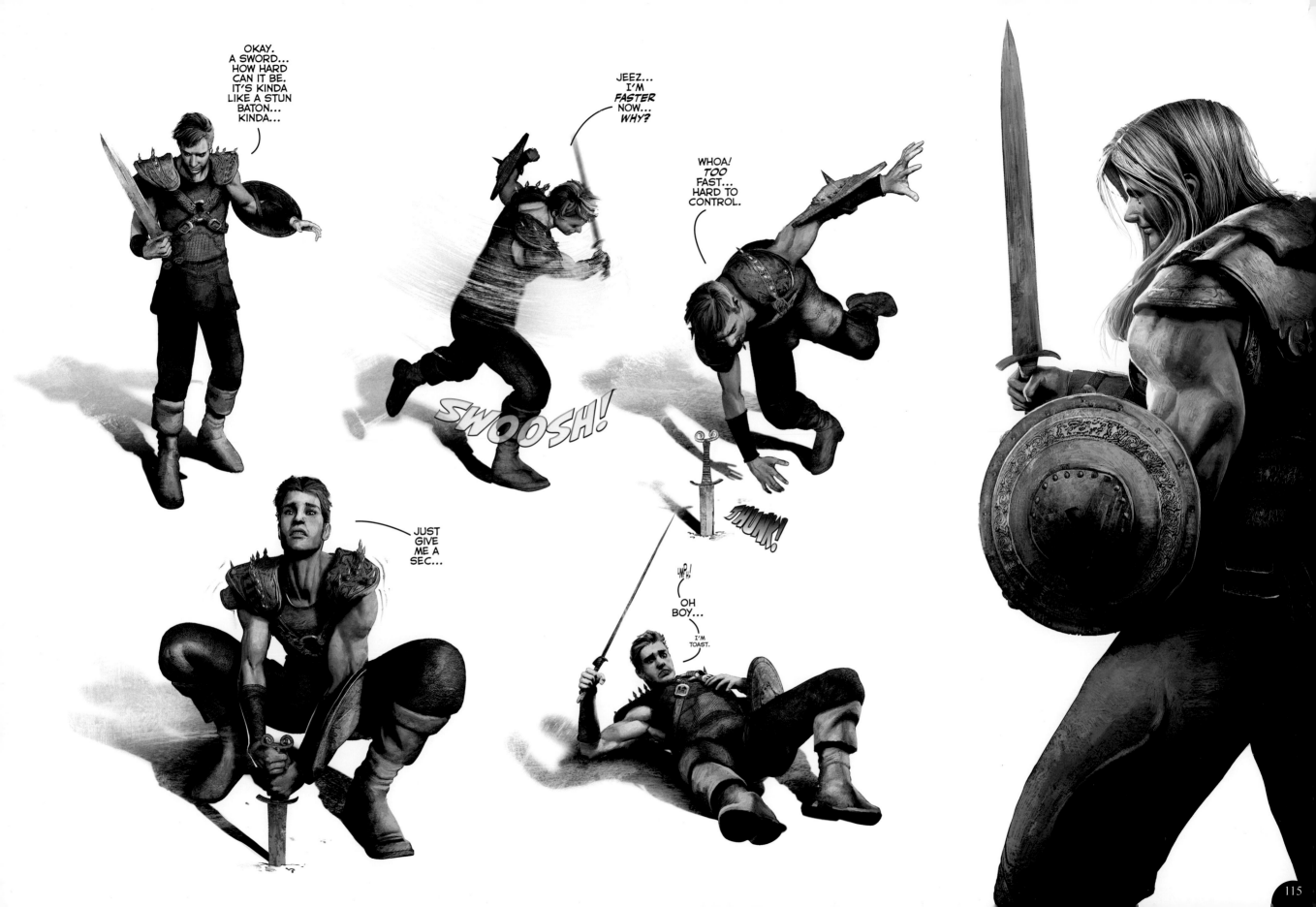

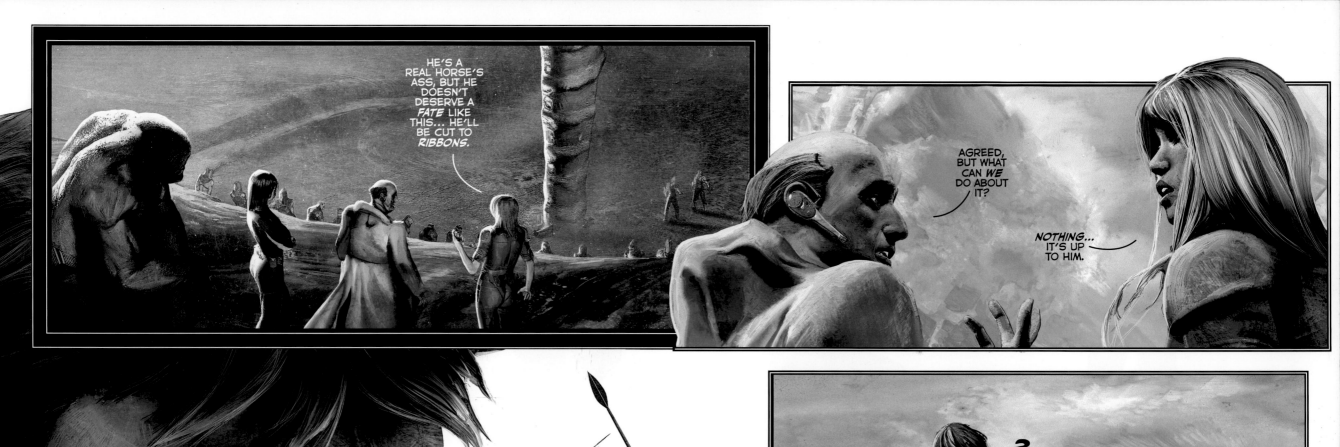

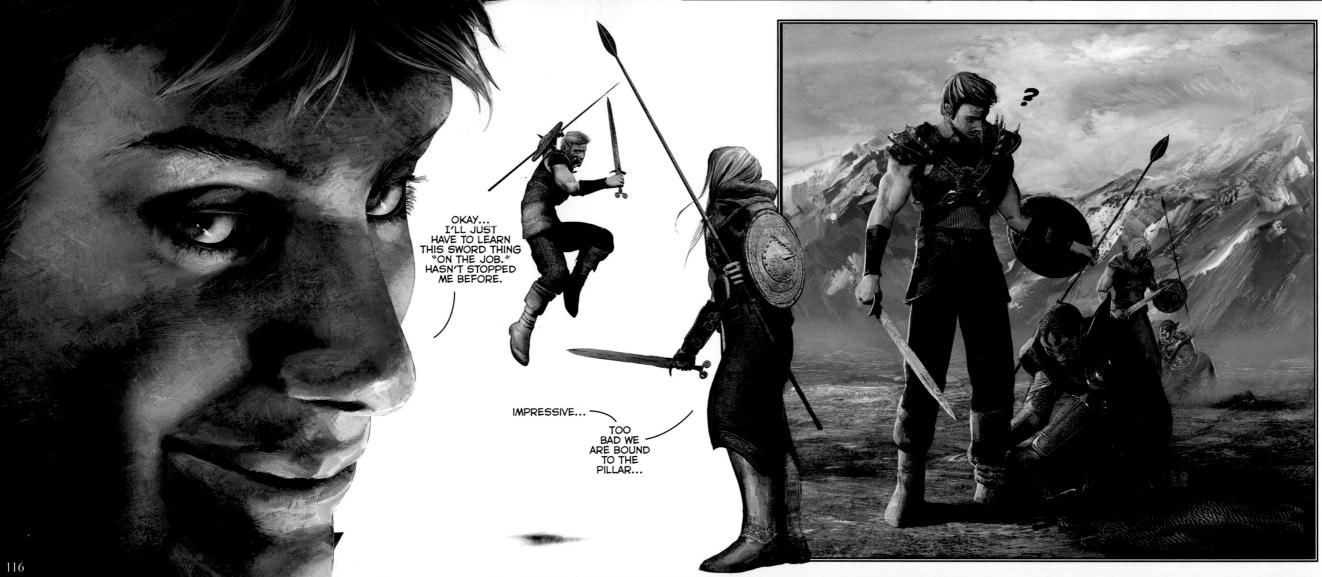

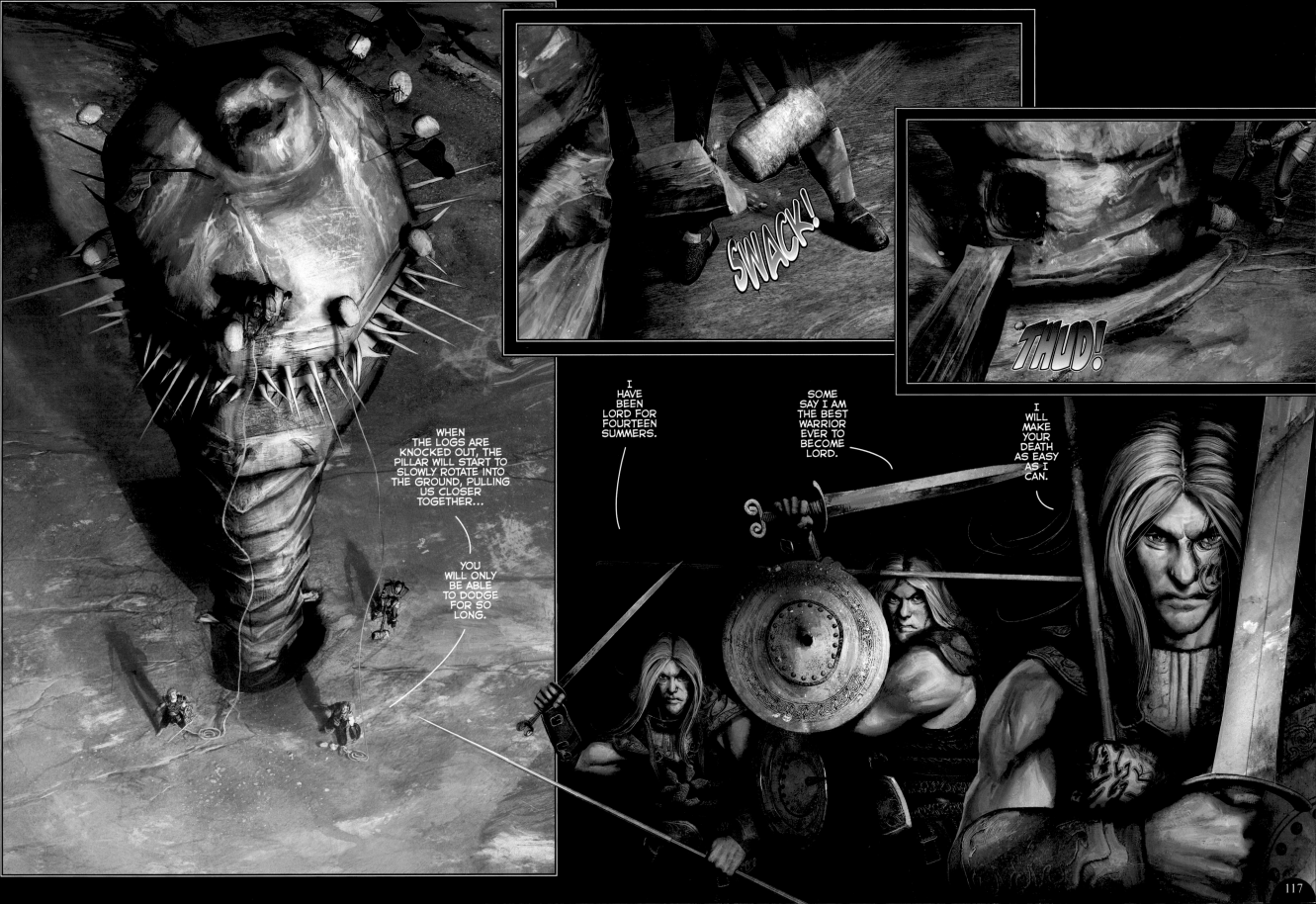

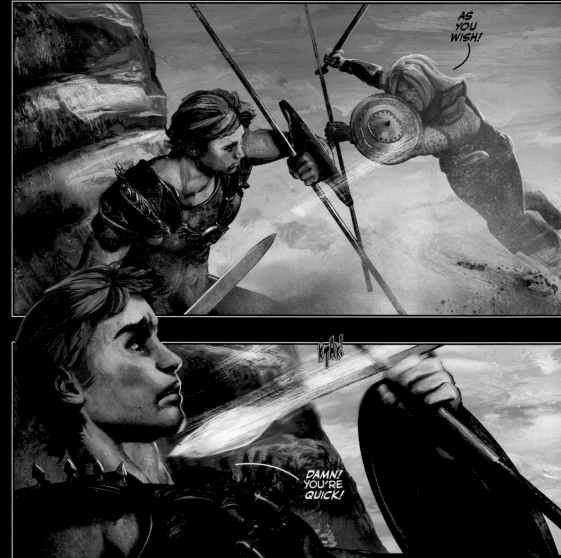

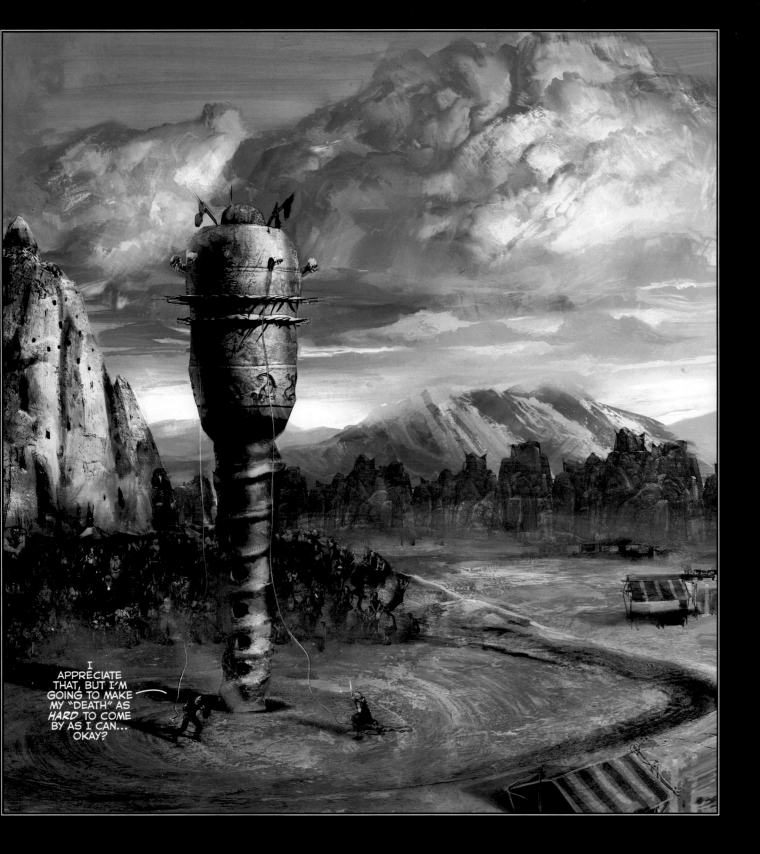

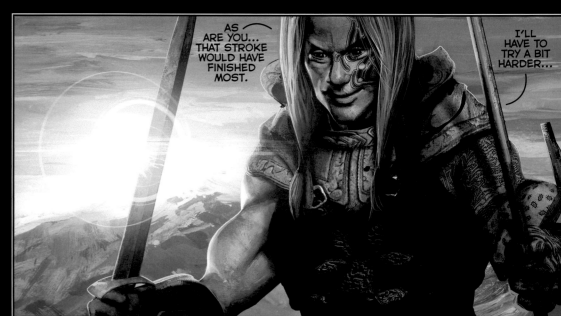

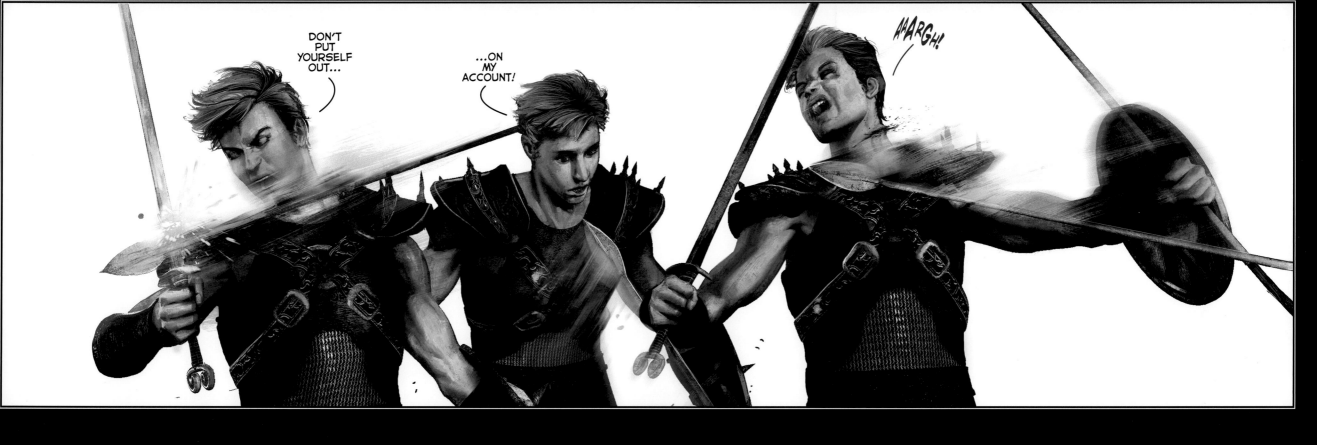
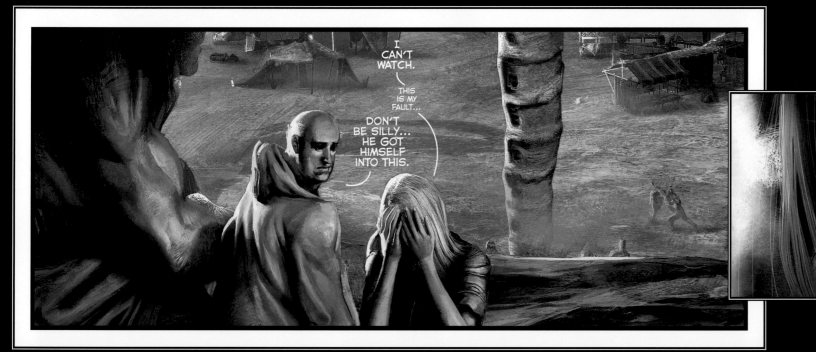

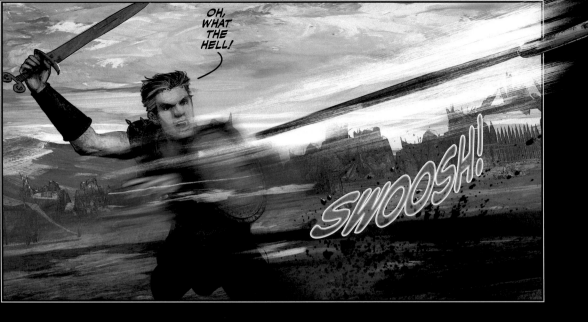

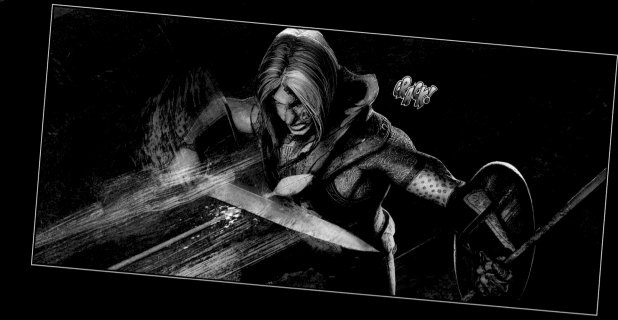

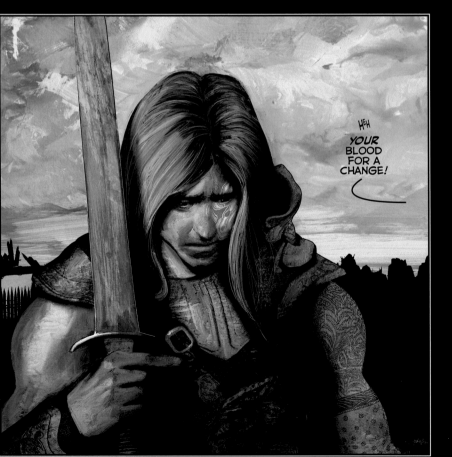

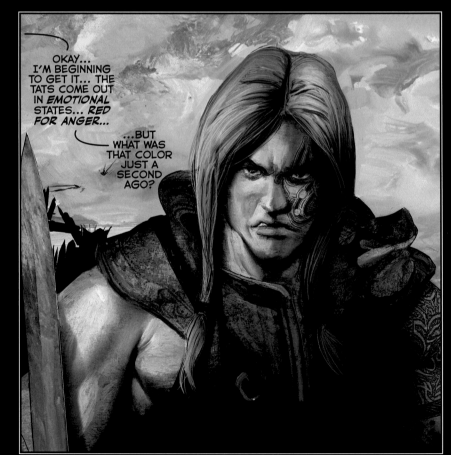

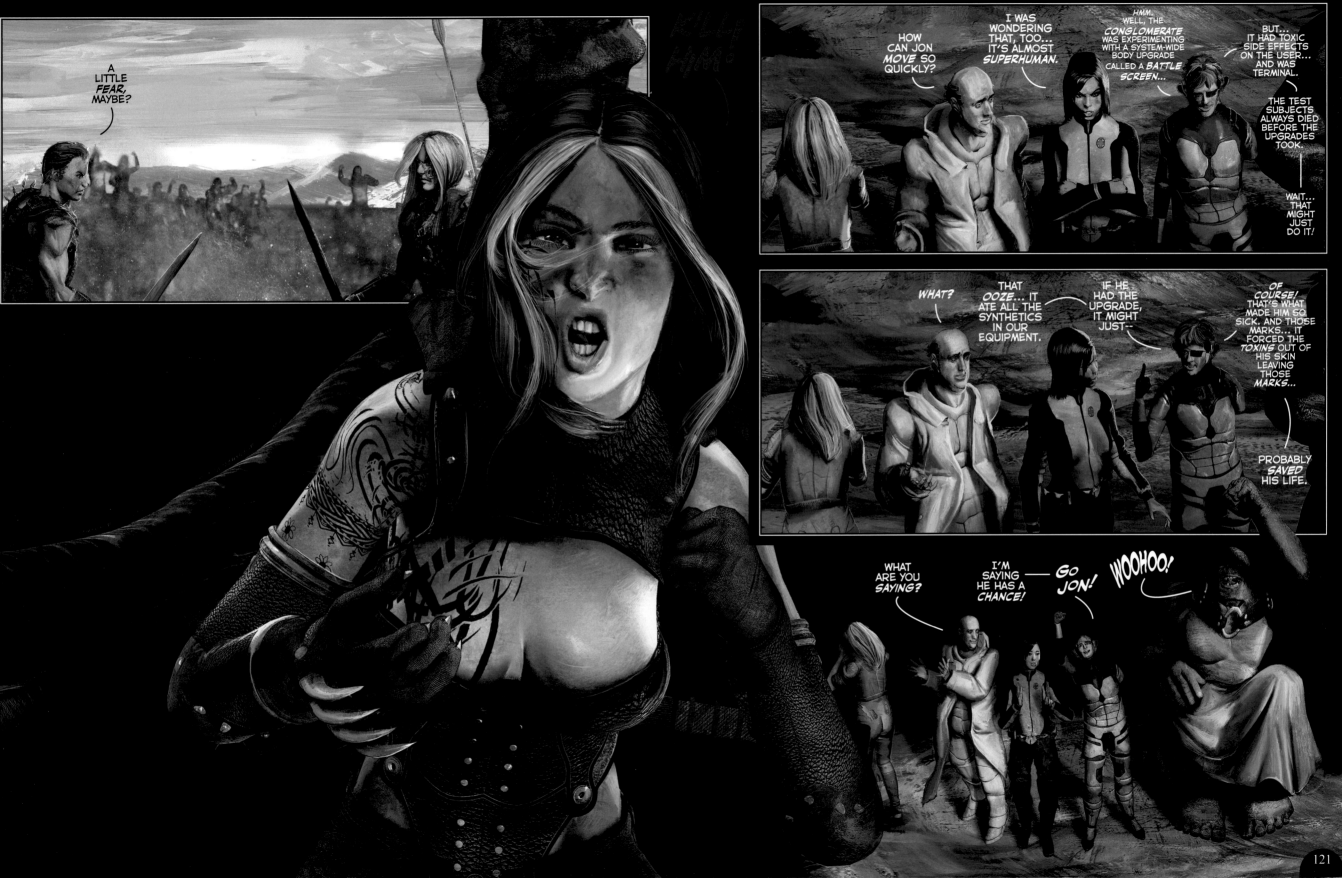

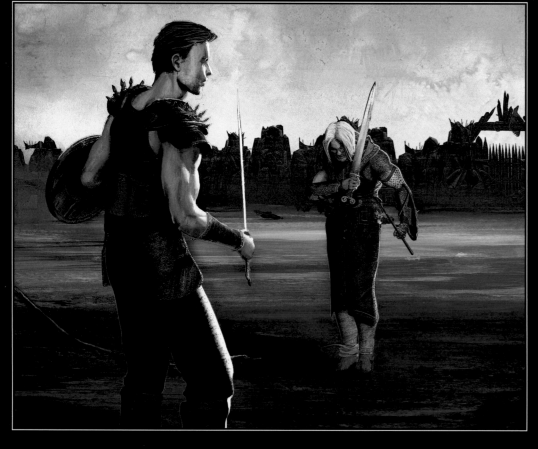
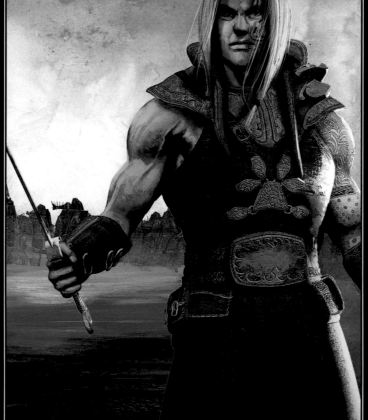

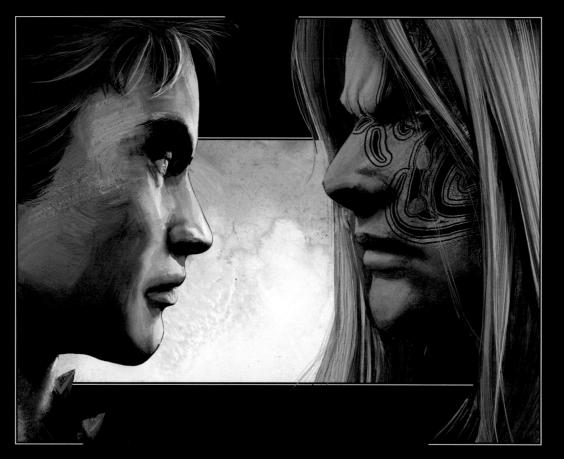
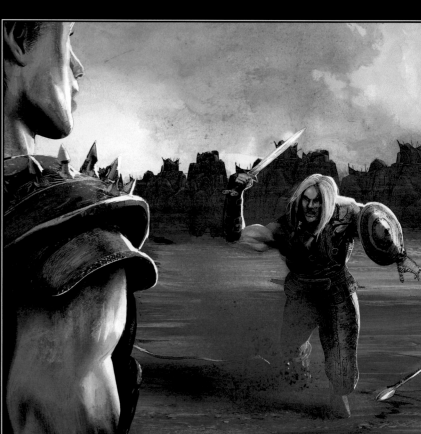

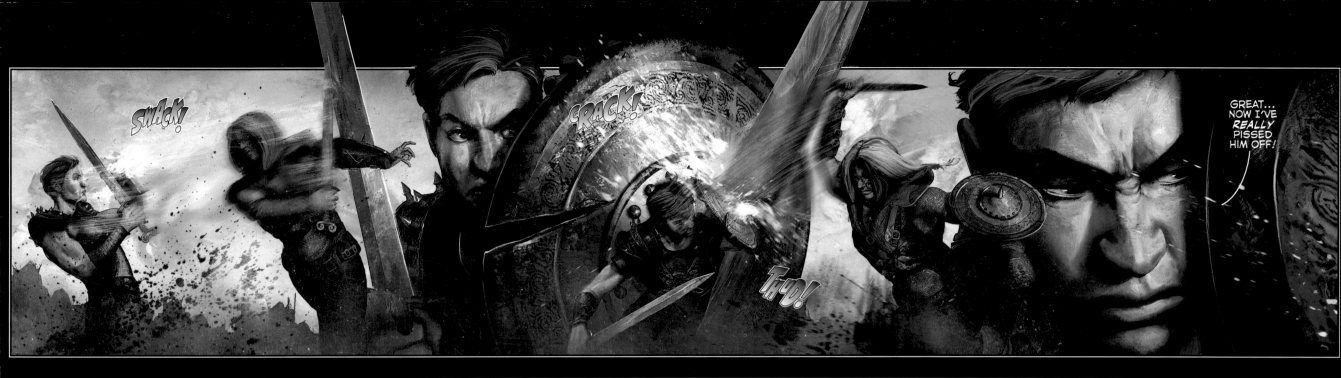

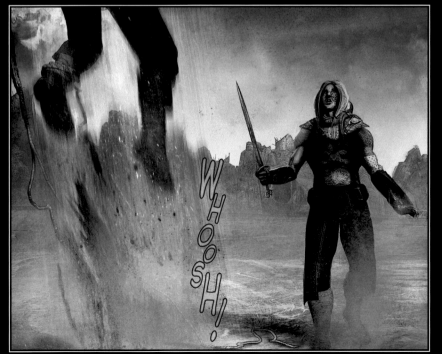

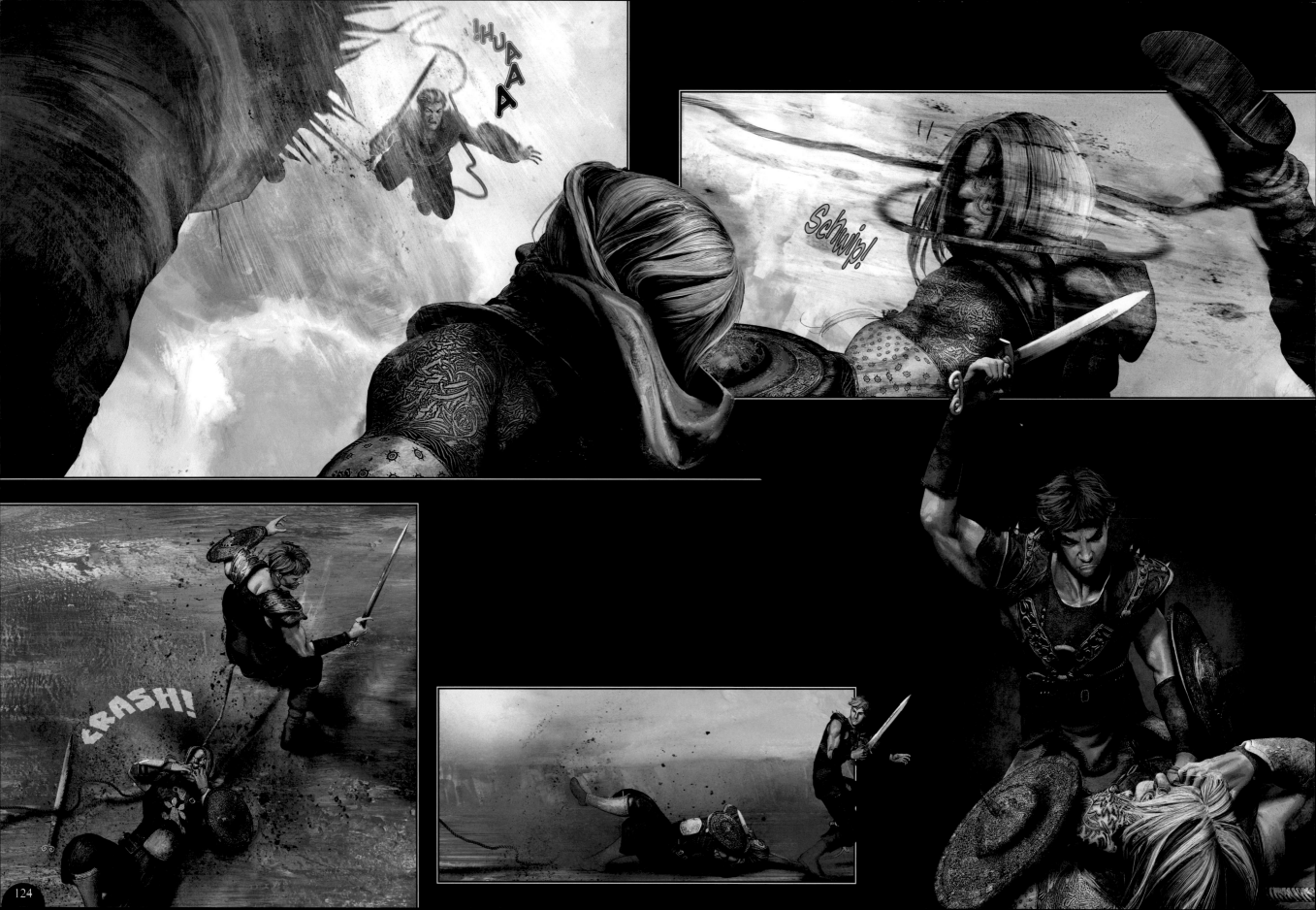

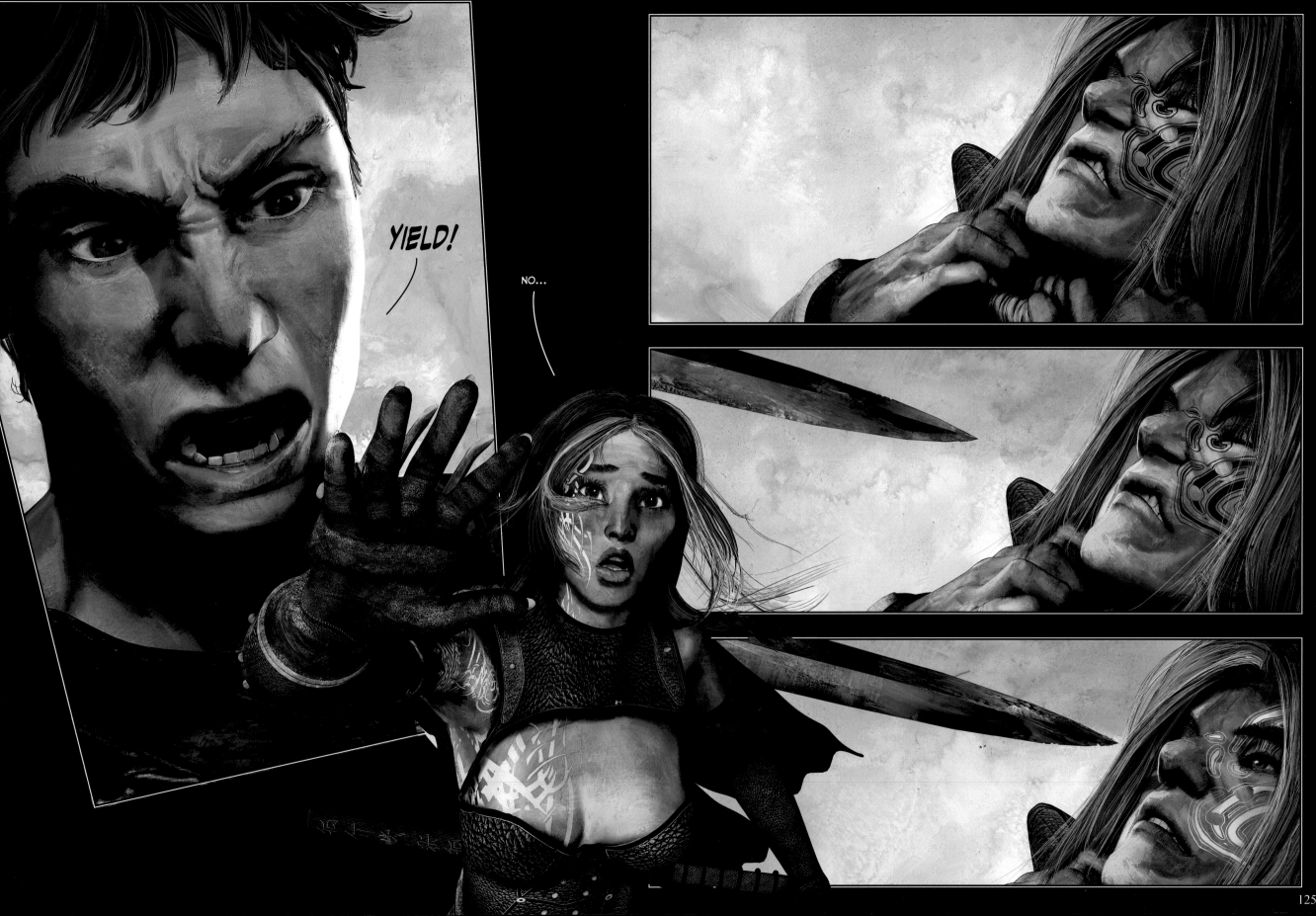

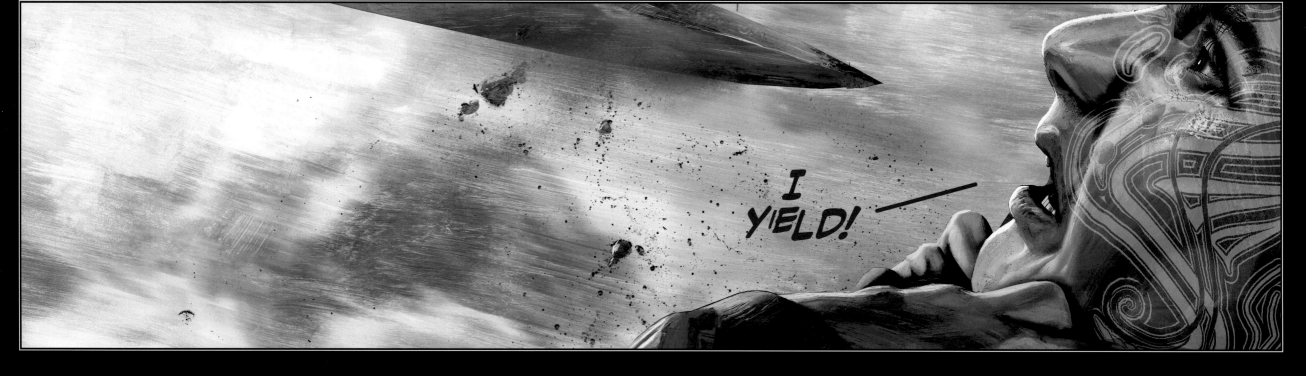

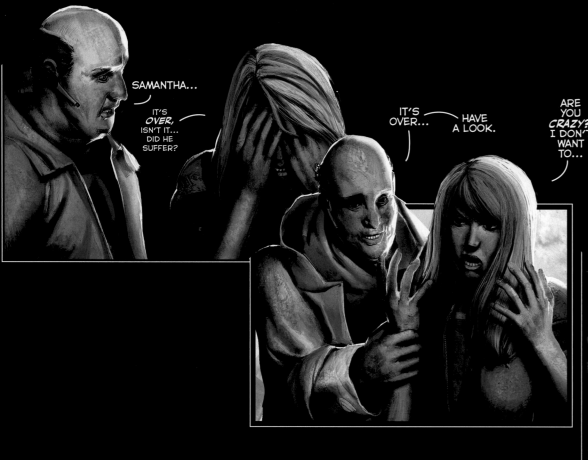

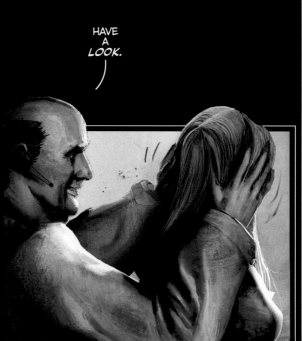

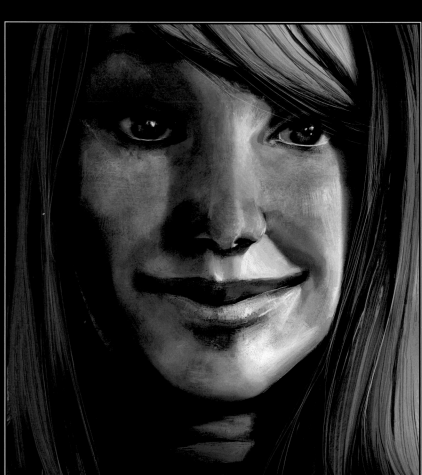

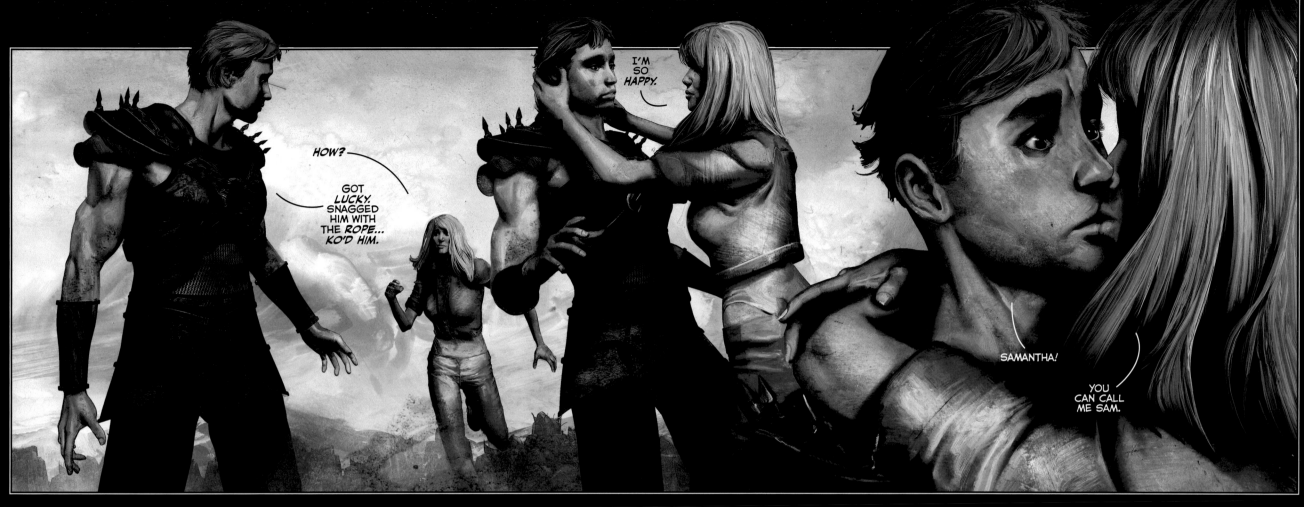

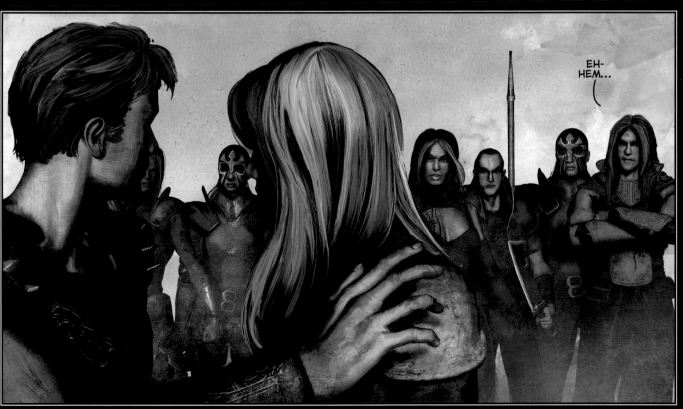

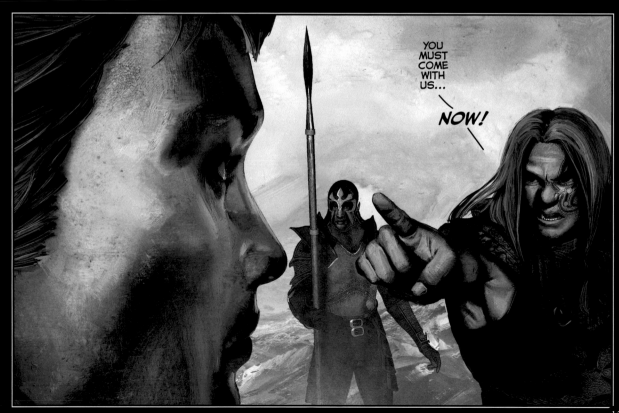

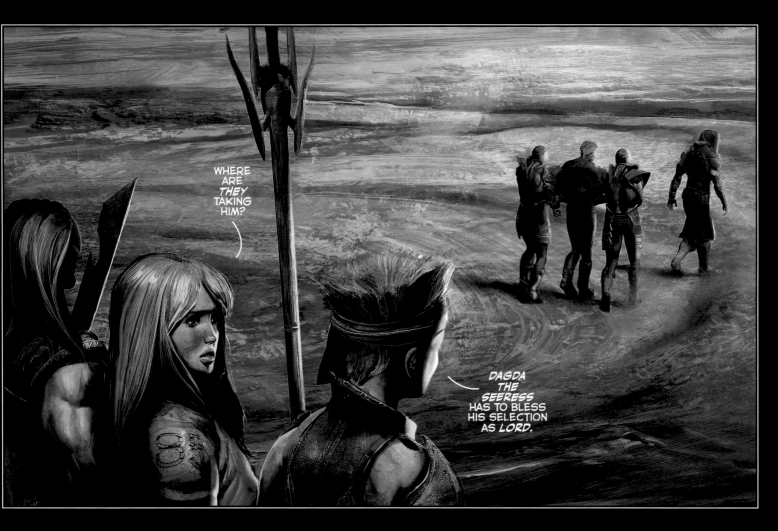

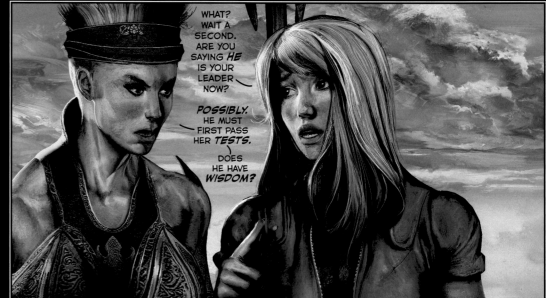

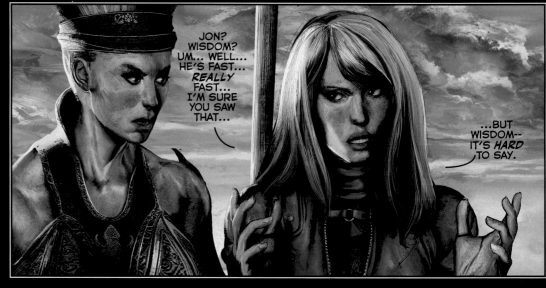

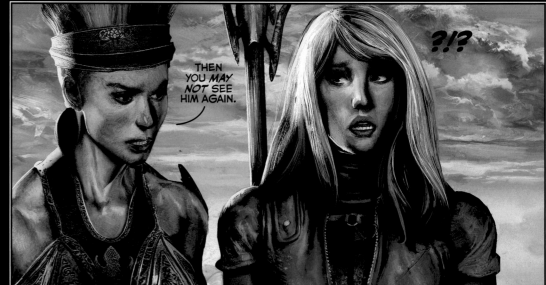

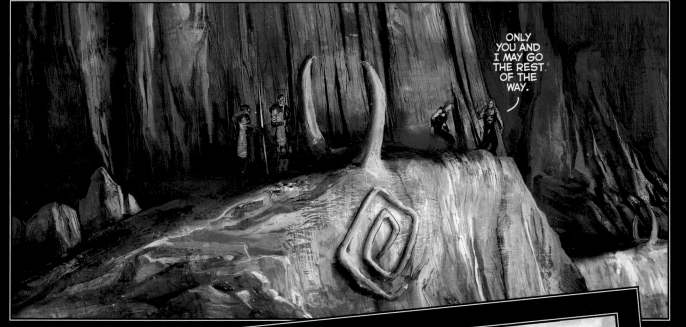

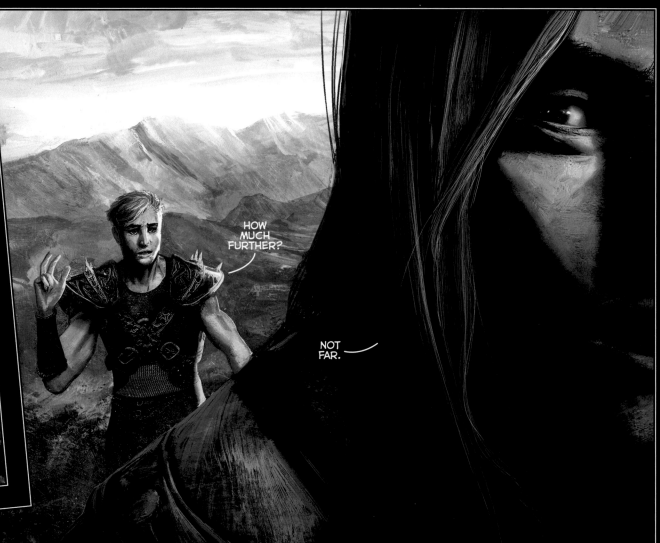

129

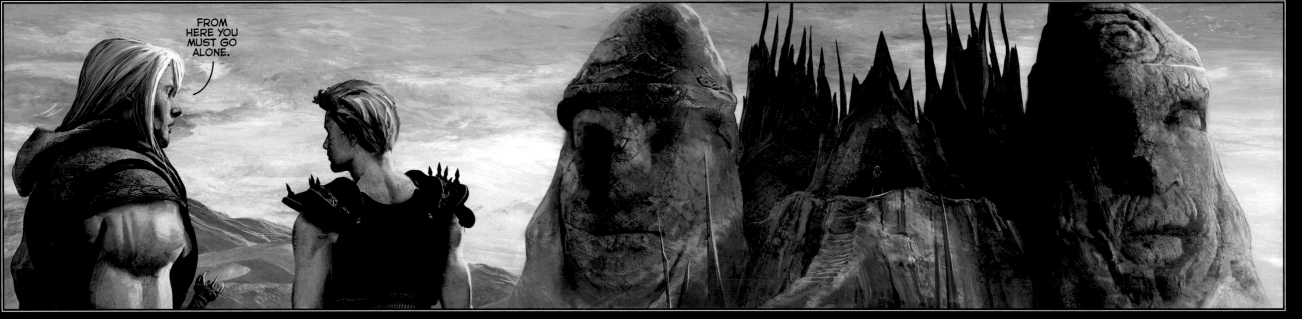

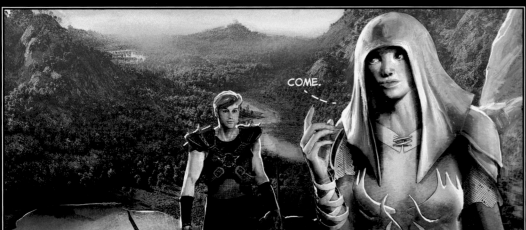

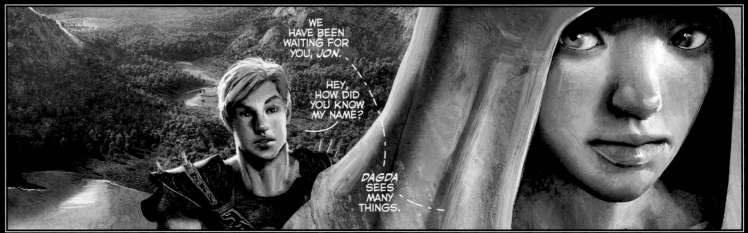

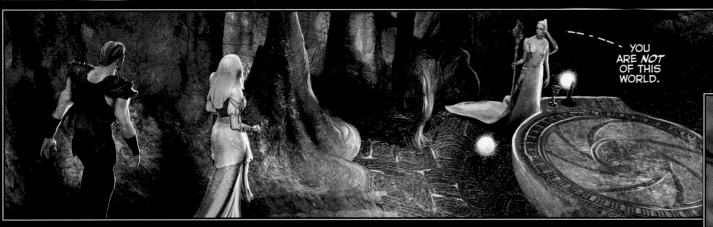

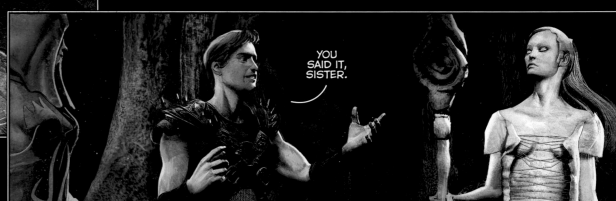

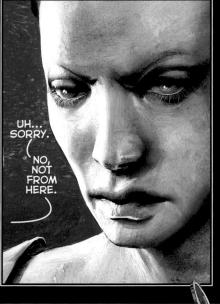

UH... SORRY.

NO, NOT FROM HERE.

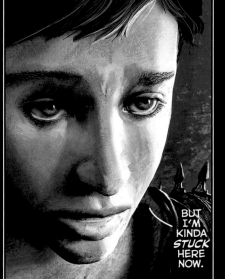

BUT I'M KINDA *STUCK* HERE NOW.

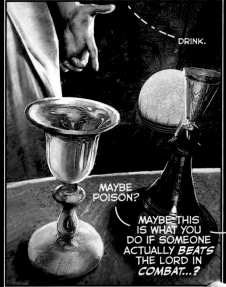

DRINK.

MAYBE POISON?

MAYBE THIS IS WHAT YOU DO IF SOMEONE ACTUALLY *BEATS* THE LORD IN *COMBAT*...?

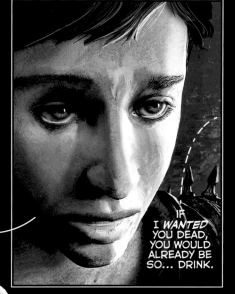

IF I *WANTED* YOU DEAD, YOU WOULD ALREADY BE SO... DRINK.

OH, WHAT THE *HELL* THEN...

BY THE WAY...

...WITH A SALES PITCH LIKE THAT, YOU SURE WOULD MAKE ONE LOUSY *BARTENDER*...

UHHH

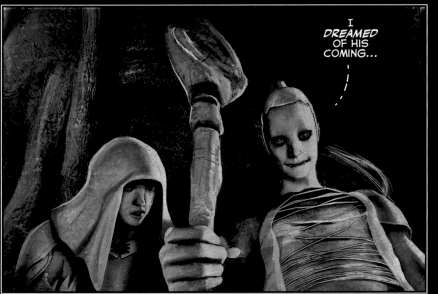

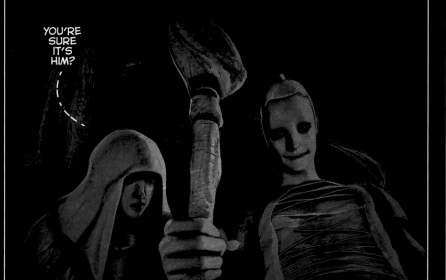

I *DREAMED* OF HIS COMING...

YOU'RE SURE IT'S HIM?

WE SHALL SEE...

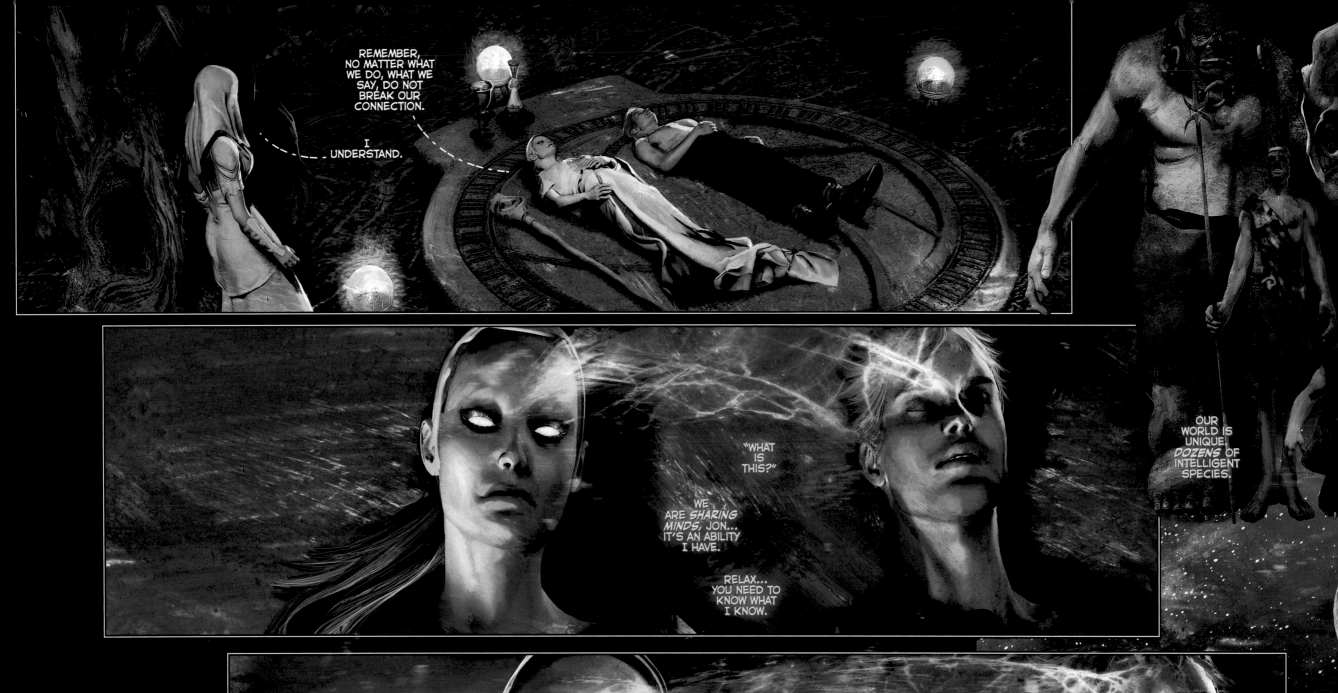

REMEMBER, NO MATTER WHAT WE DO, WHAT WE SAY, DO NOT BREAK OUR CONNECTION.

I UNDERSTAND.

"WHAT IS THIS?"

WE ARE *SHARING MINDS*, JON... IT'S AN ABILITY I HAVE.

RELAX... YOU NEED TO KNOW WHAT I KNOW.

OUR WORLD IS UNIQUE. *DOZENS* OF INTELLIGENT SPECIES.

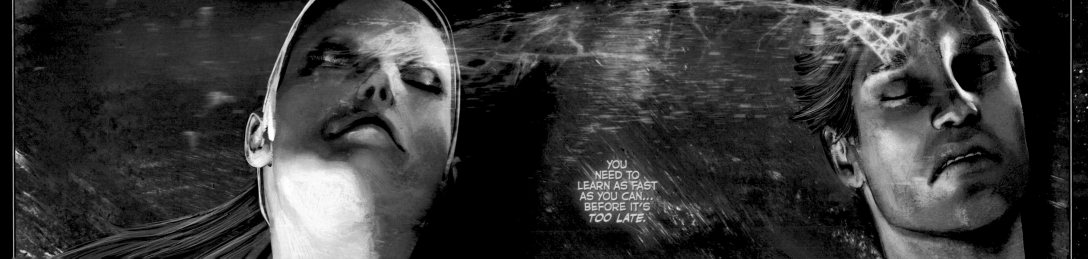

YOU NEED TO LEARN AS FAST AS YOU CAN... BEFORE IT'S *TOO LATE.*

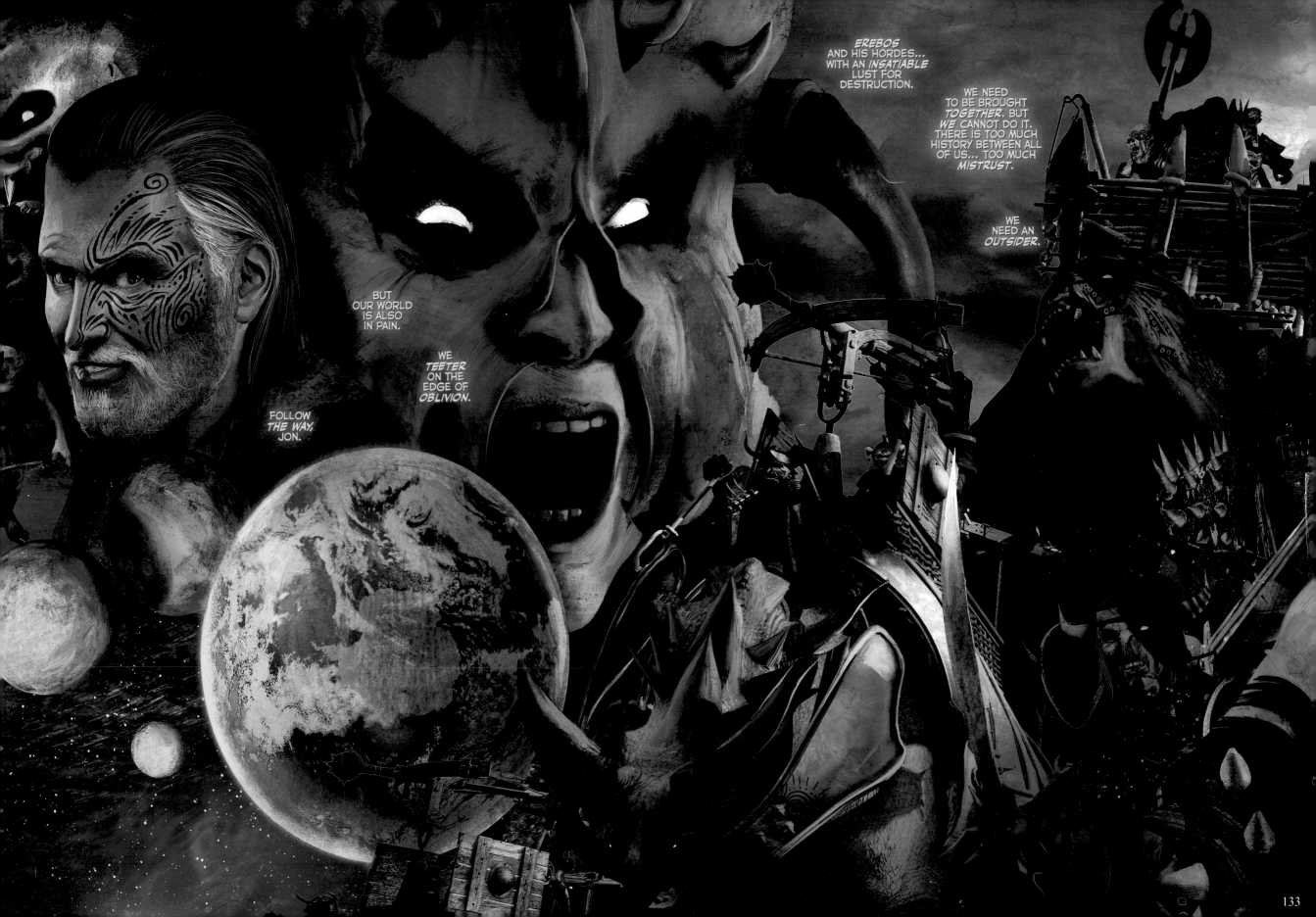

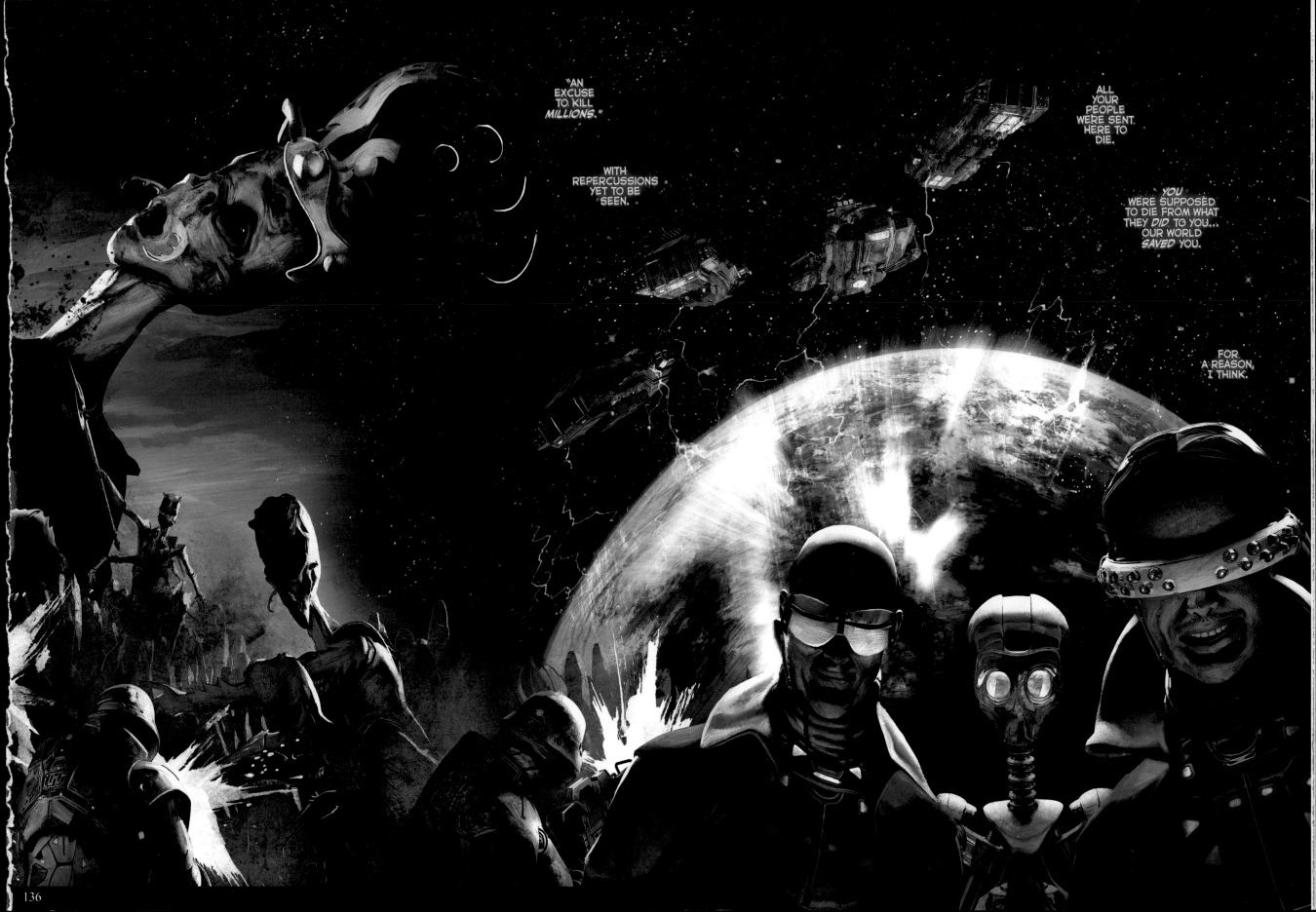

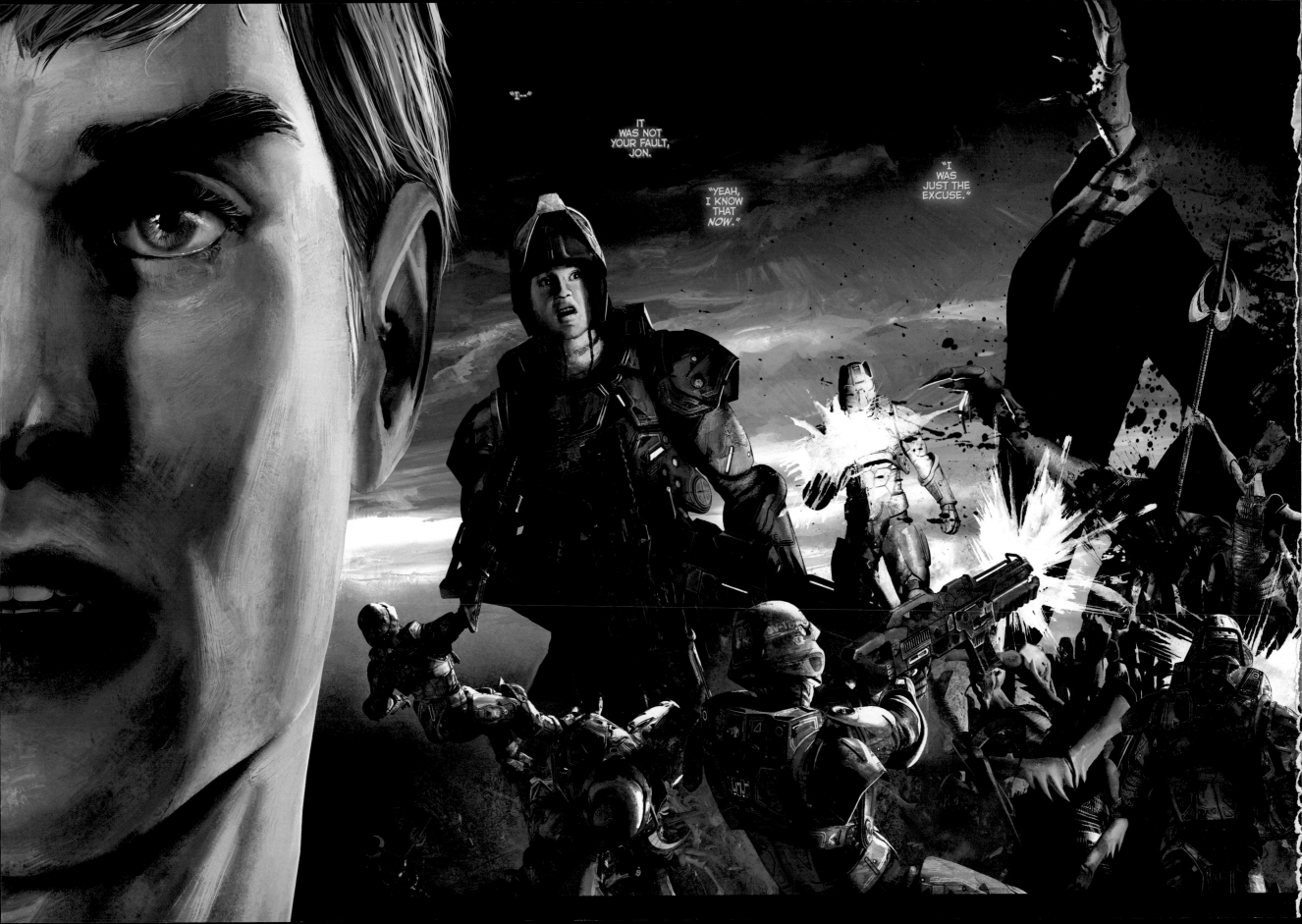

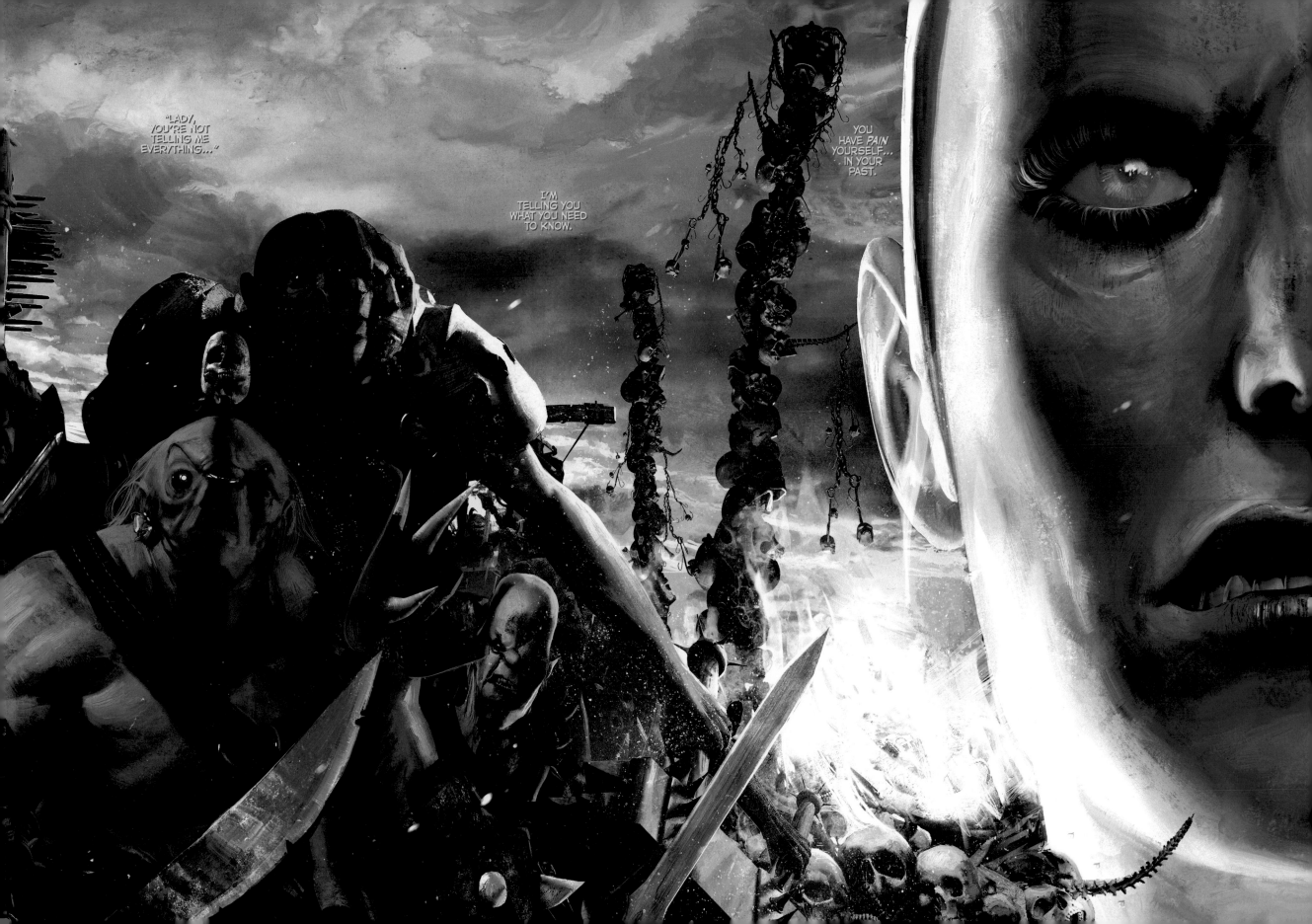

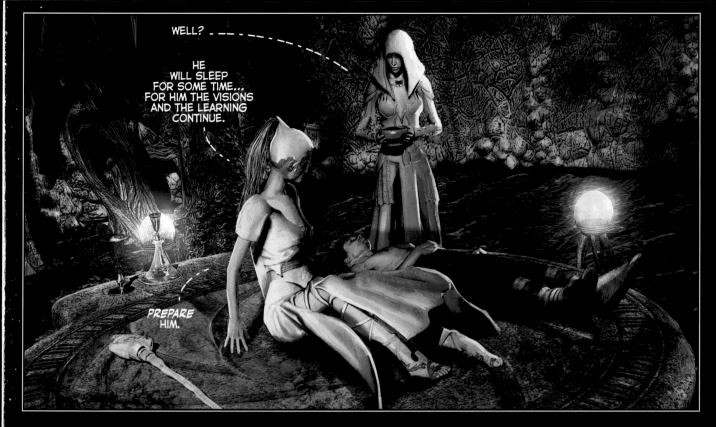

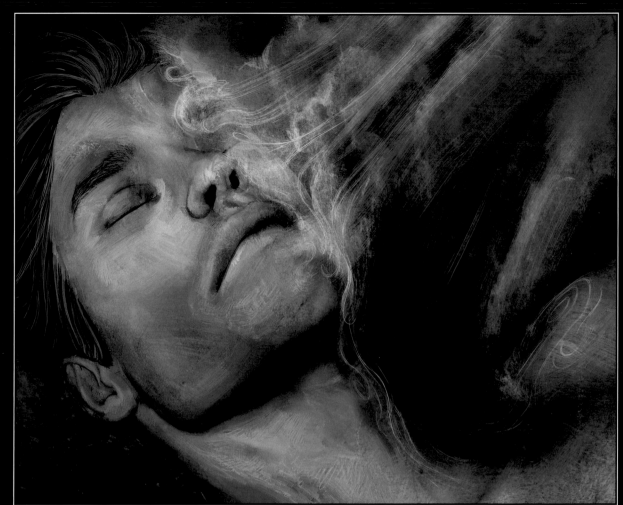

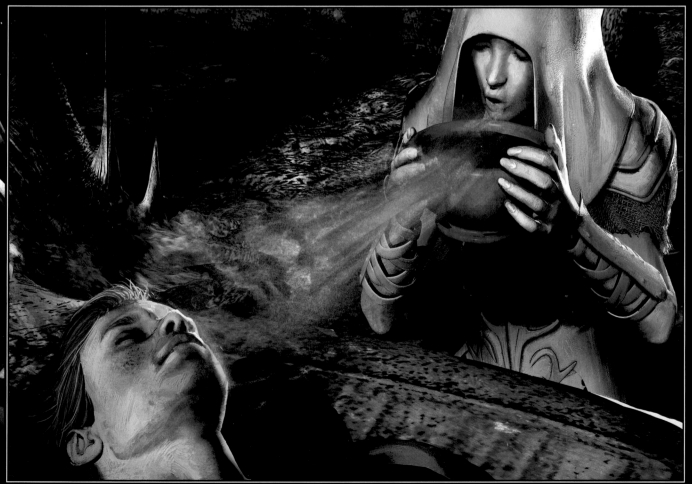

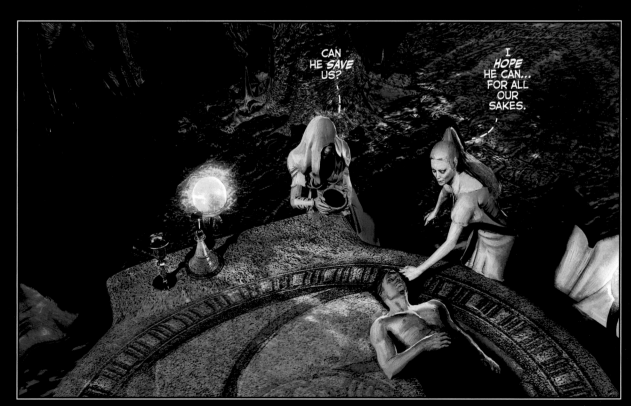

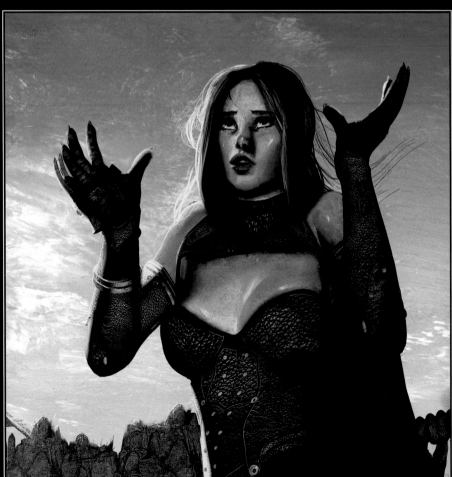

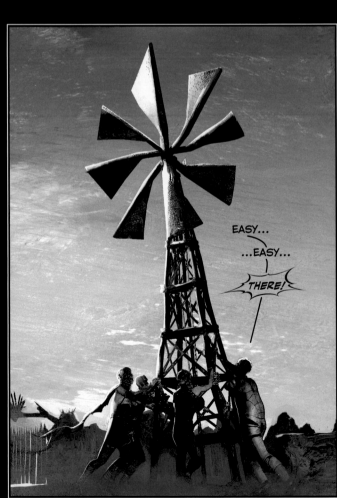

138

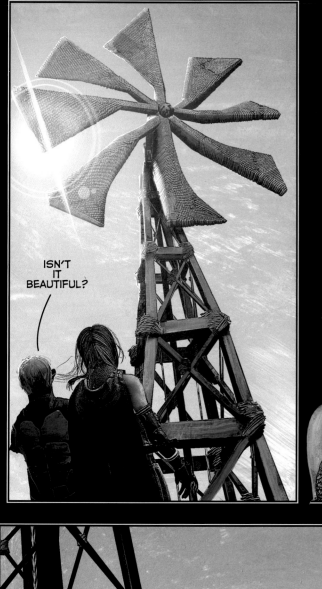

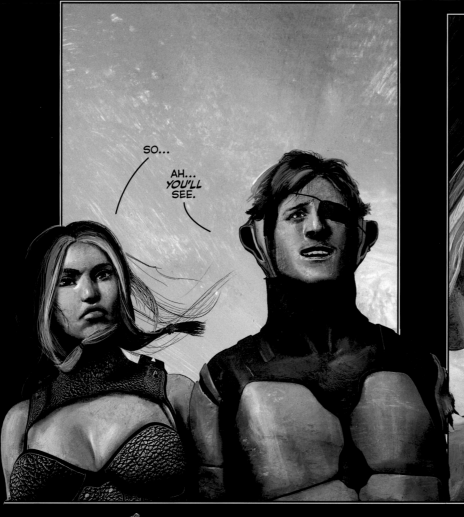

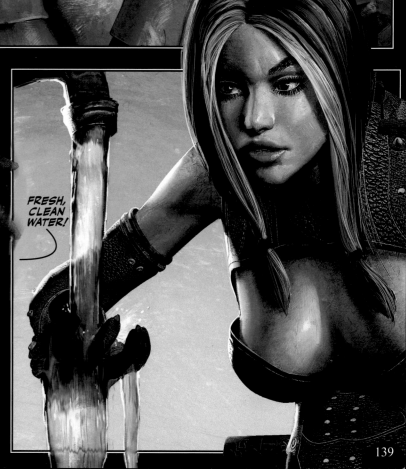

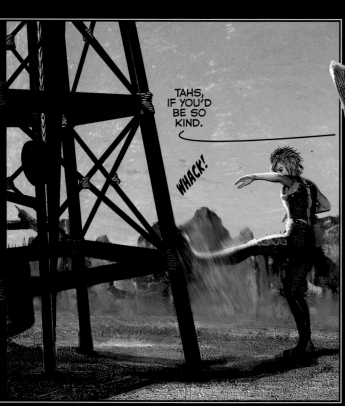

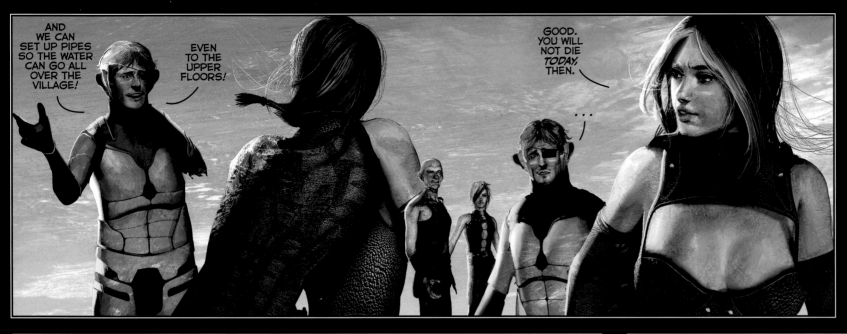

AND WE CAN SET UP PIPES SO THE WATER CAN GO ALL OVER THE VILLAGE!

EVEN TO THE UPPER FLOORS!

GOOD. YOU WILL NOT DIE *TODAY*, THEN.

...

OH... I ALMOST FORGOT.

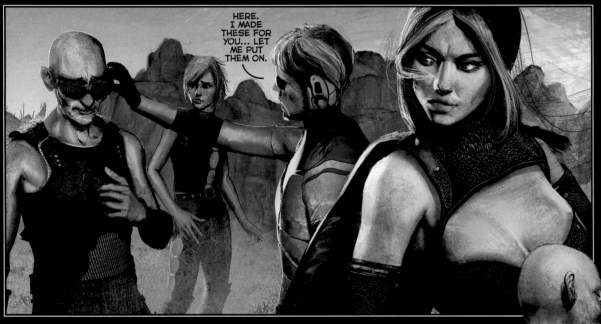

HERE. I MADE THESE FOR YOU... LET ME PUT THEM ON.

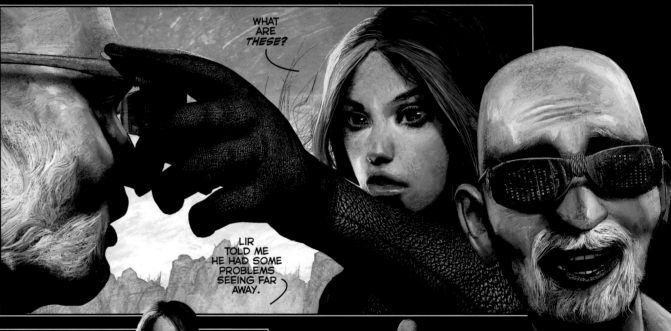

WHAT ARE *THESE*?

LIR TOLD ME HE HAD SOME PROBLEMS SEEING FAR AWAY.

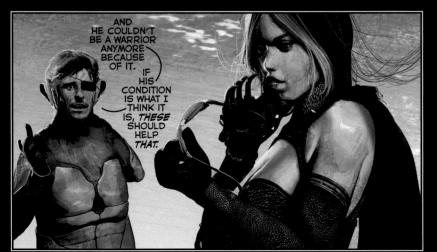

AND HE COULDN'T BE A WARRIOR ANYMORE BECAUSE OF IT. IF HIS CONDITION IS WHAT I THINK IT IS, *THESE* SHOULD HELP *THAT*.

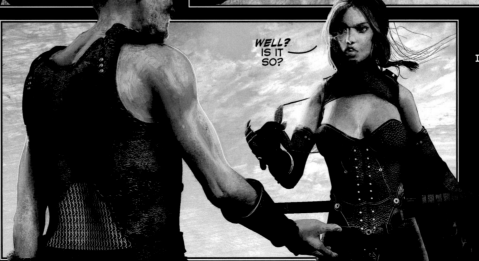

WELL? IS IT SO?

SHALL I *SHOW* YOU?

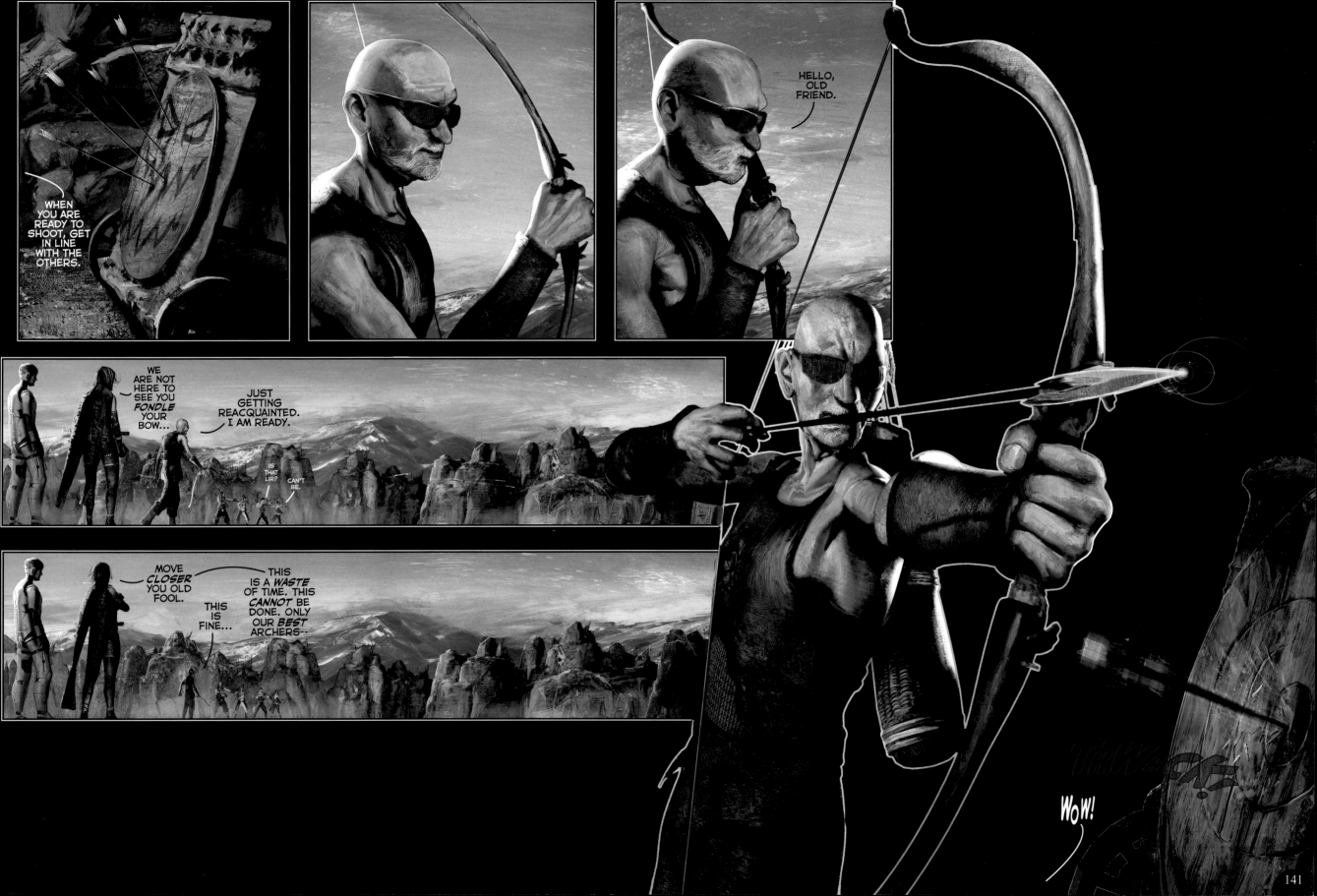

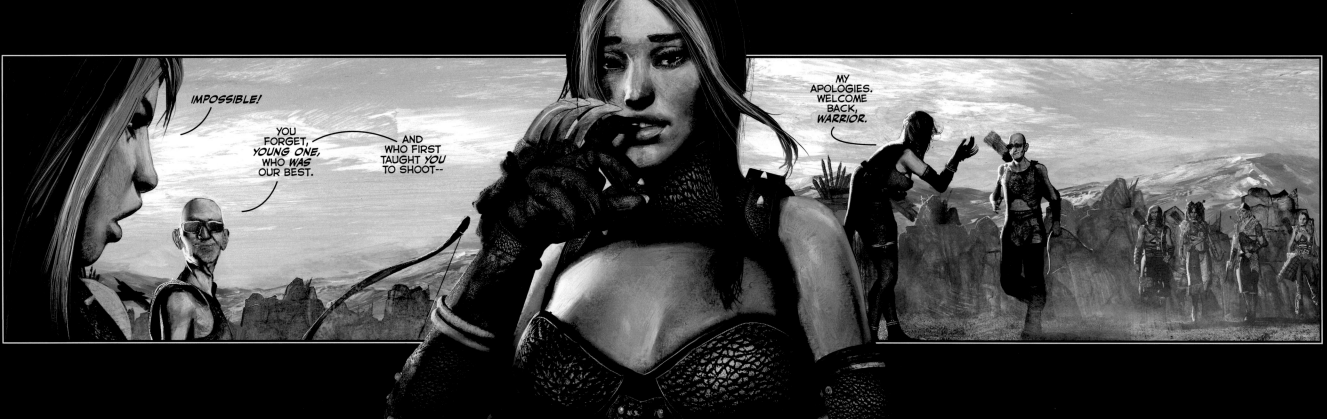

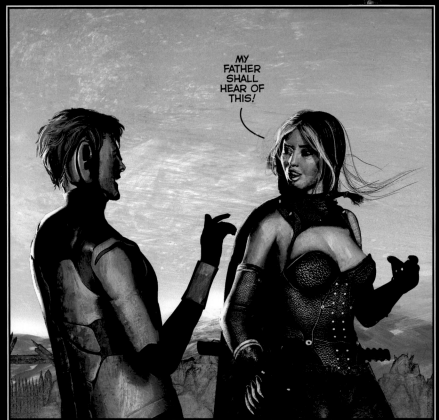

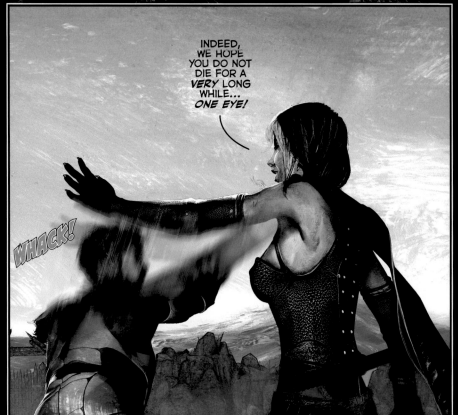

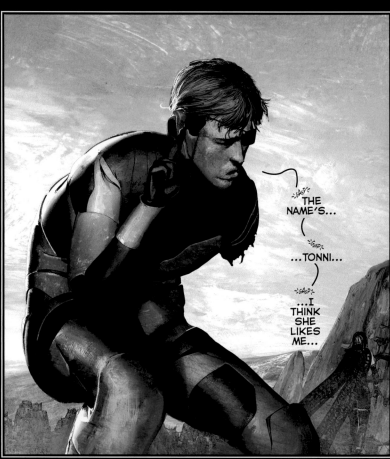

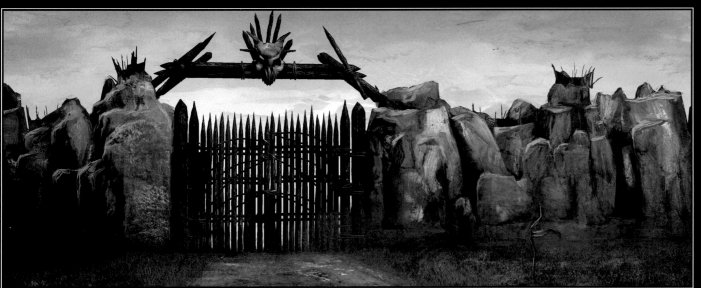

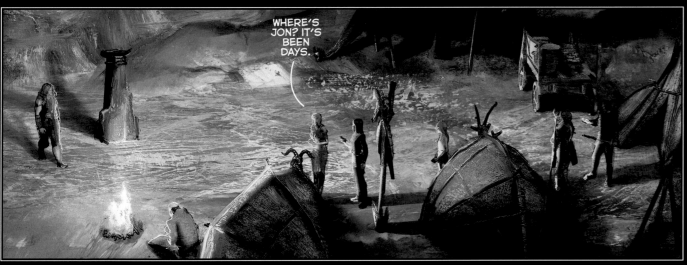

WHERE'S JON? IT'S BEEN DAYS.

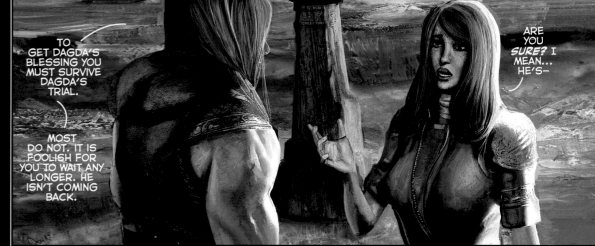

TO GET DAGDA'S BLESSING YOU MUST SURVIVE DAGDA'S TRIAL.

MOST DO NOT. IT IS FOOLISH FOR YOU TO WAIT ANY LONGER. HE ISN'T COMING BACK.

ARE YOU *SURE?* I MEAN... HE'S—

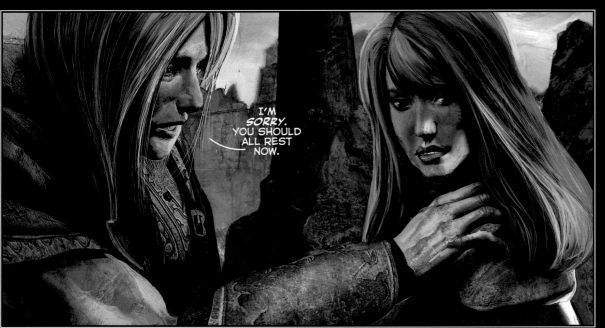

I'M *SORRY.* YOU SHOULD ALL REST NOW.

TOMORROW YOU WILL JOIN THE OTHER SERVANTS IN THE FIELDS.

...

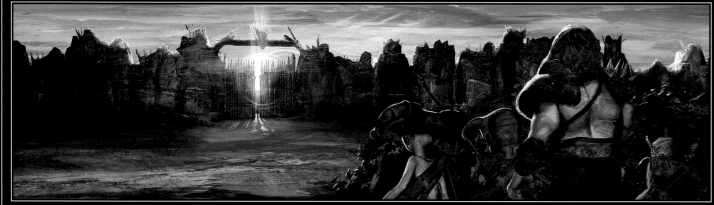

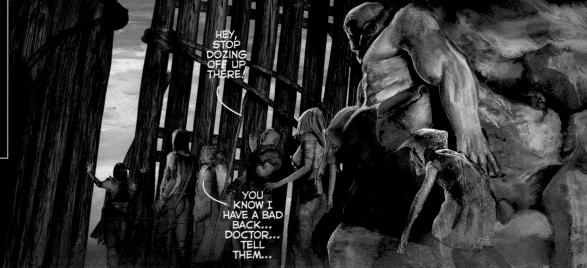

HEY, STOP DOZING OFF UP THERE!

YOU KNOW I HAVE A BAD BACK... DOCTOR... TELL THEM...

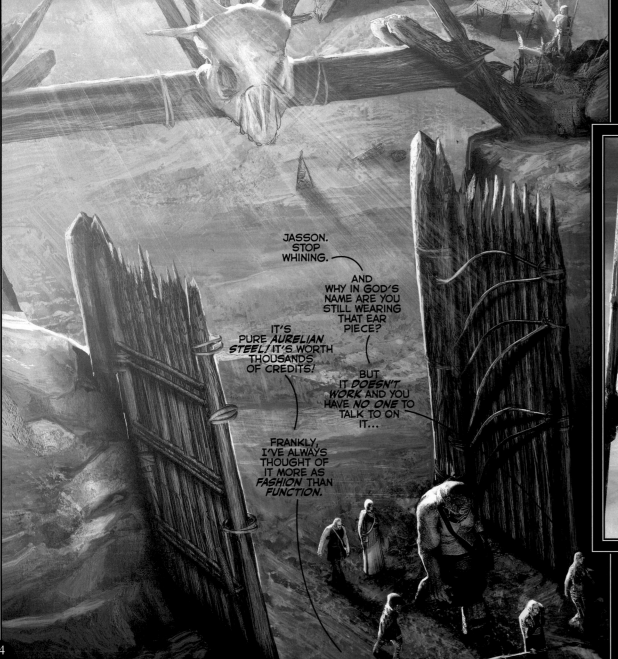

JASSON. STOP WHINING.

AND WHY IN GOD'S NAME ARE YOU STILL WEARING THAT EAR PIECE?

IT'S PURE *AURELIAN STEEL!* IT'S WORTH THOUSANDS OF CREDITS!

BUT IT *DOESN'T WORK* AND YOU HAVE *NO ONE* TO TALK TO ON IT...

FRANKLY, I'VE ALWAYS THOUGHT OF IT MORE AS *FASHION* THAN *FUNCTION.*

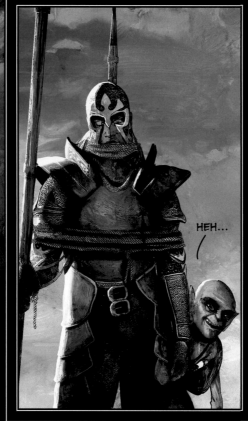

HEH...

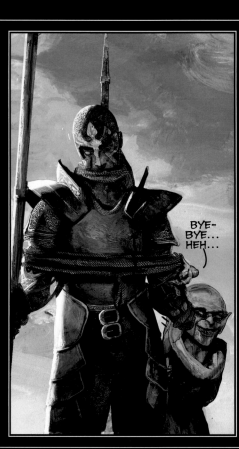

BYE-BYE... HEH...

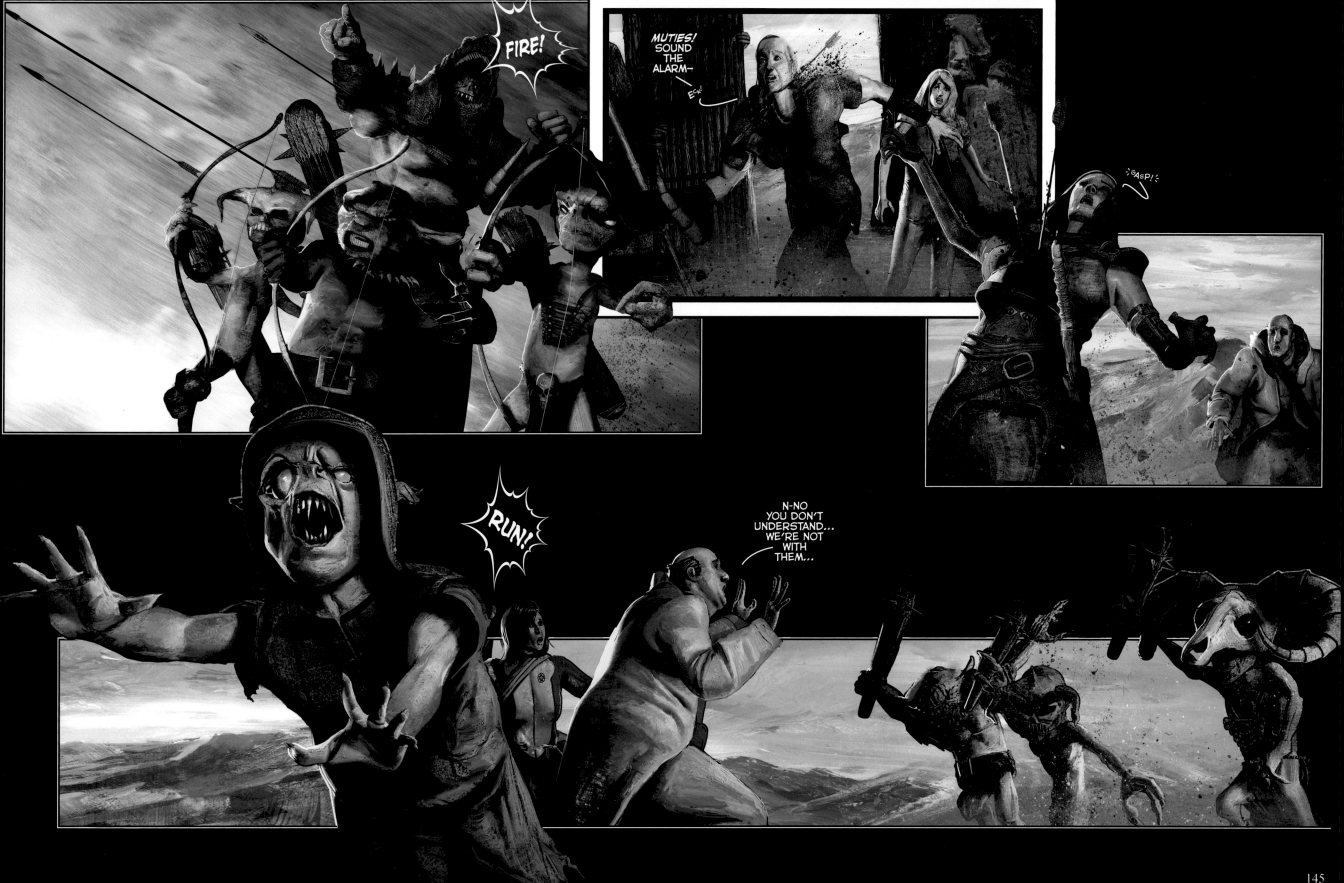

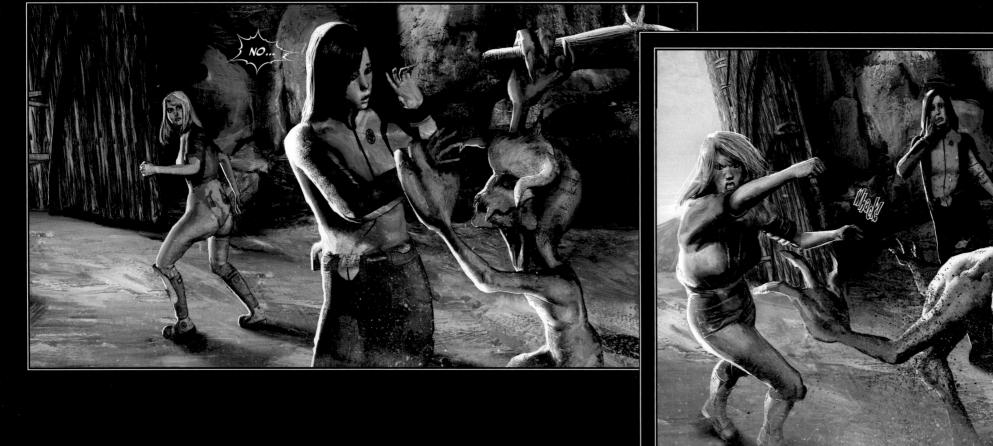
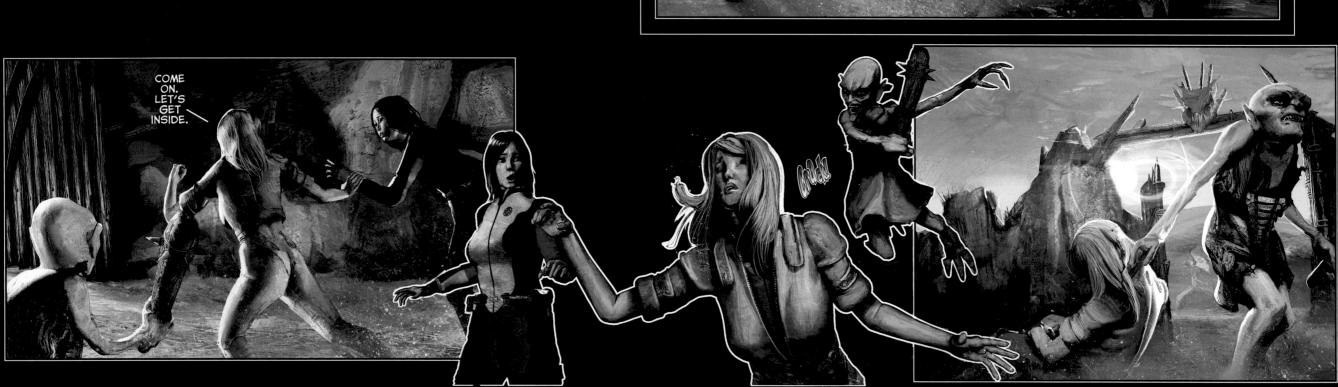

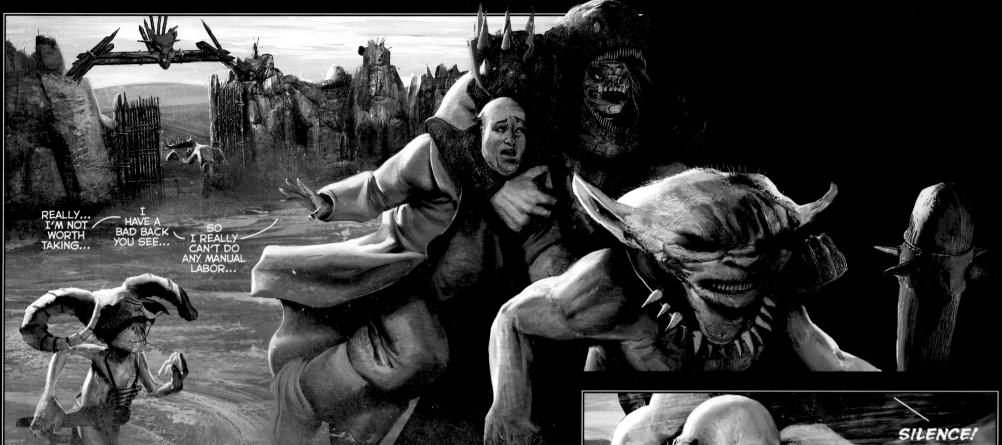

REALLY... I'M NOT WORTH TAKING...

I HAVE A BAD BACK YOU SEE...

SO I REALLY CAN'T DO ANY MANUAL LABOR...

SILENCE!

WHAM!

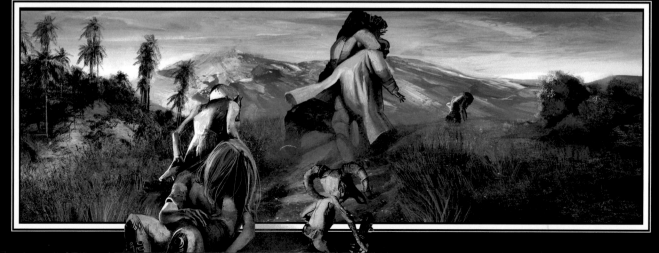

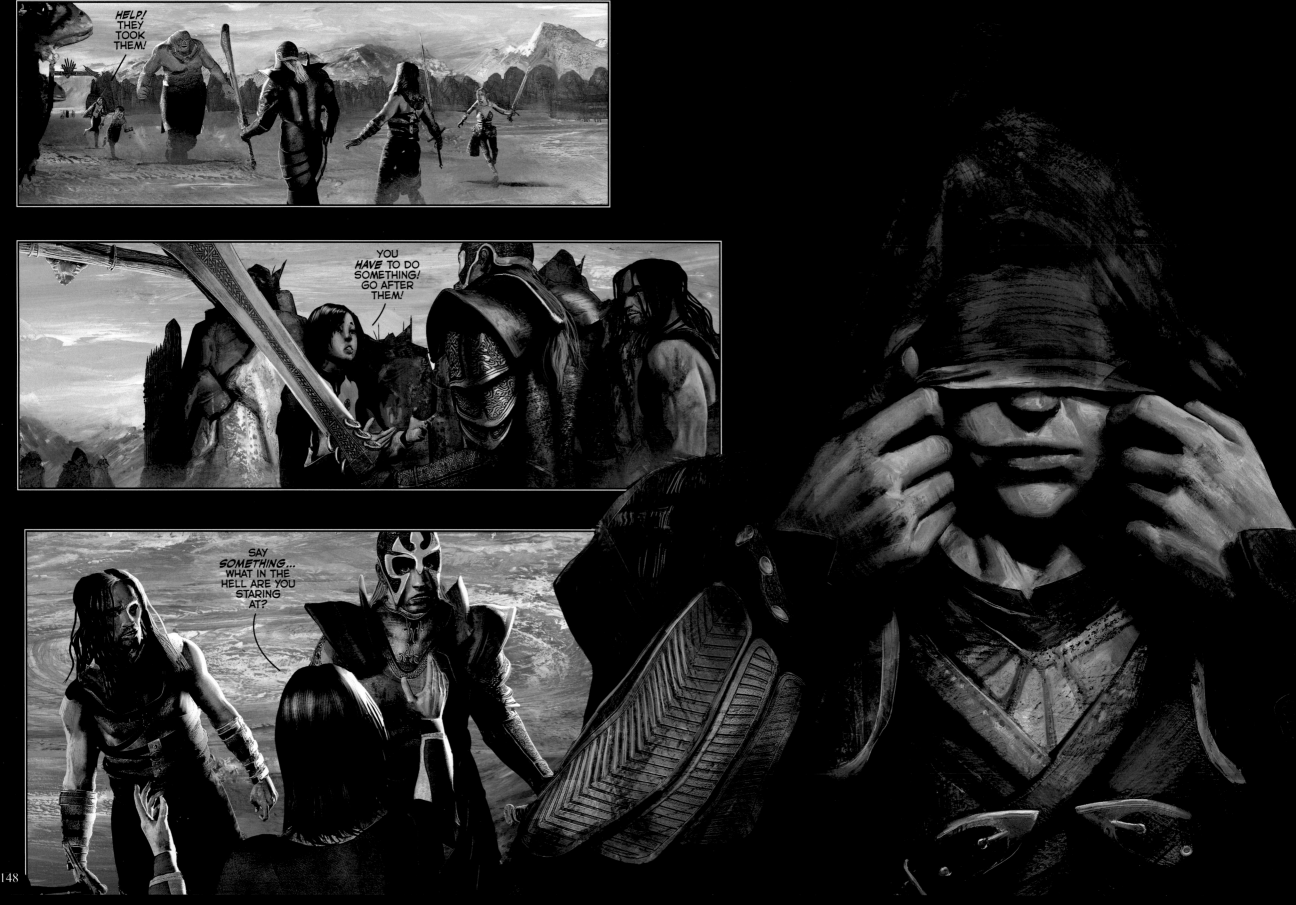

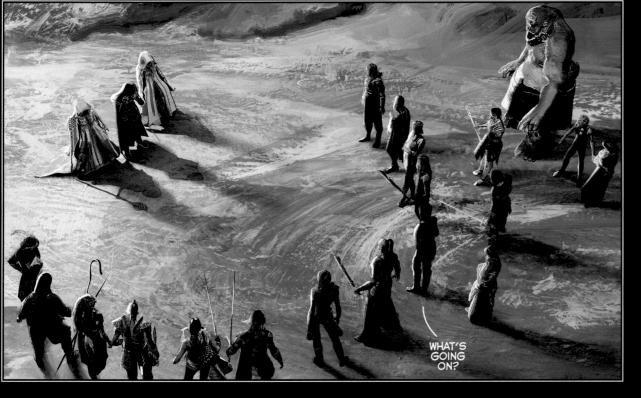

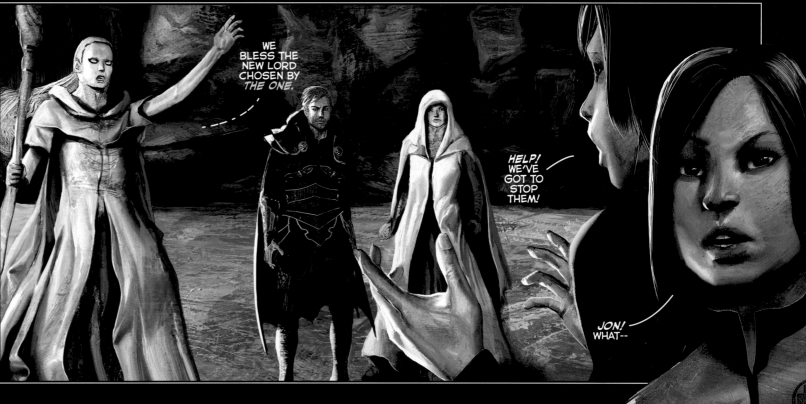

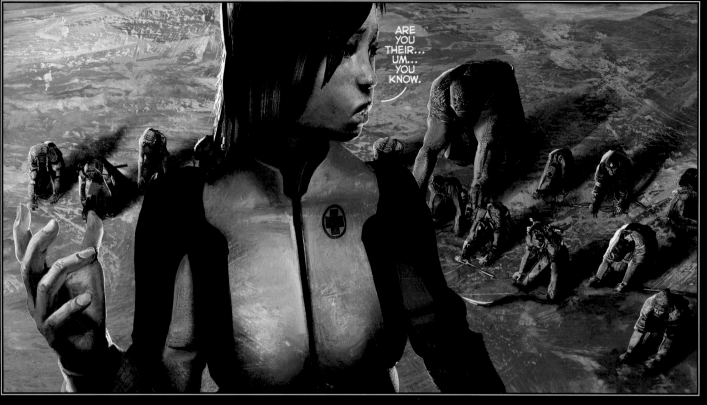

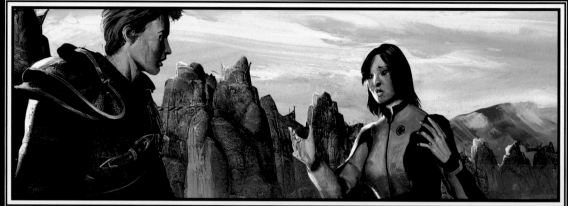

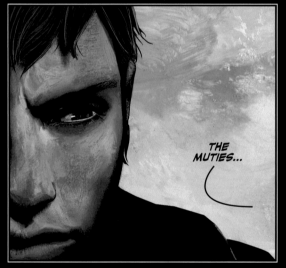

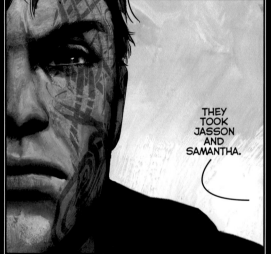

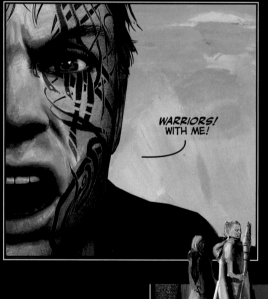

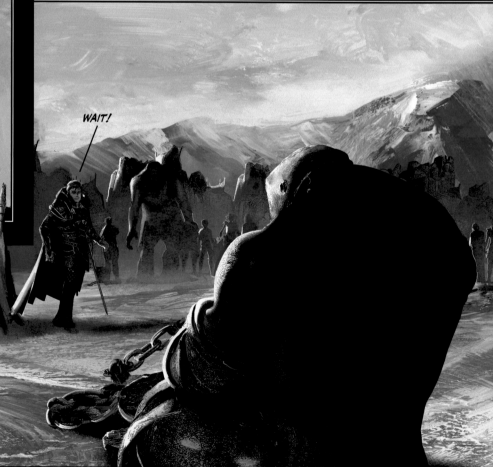

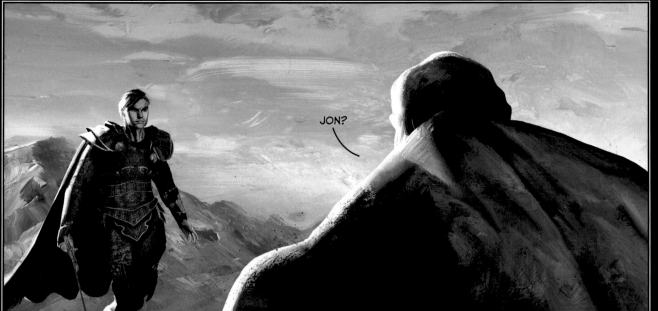

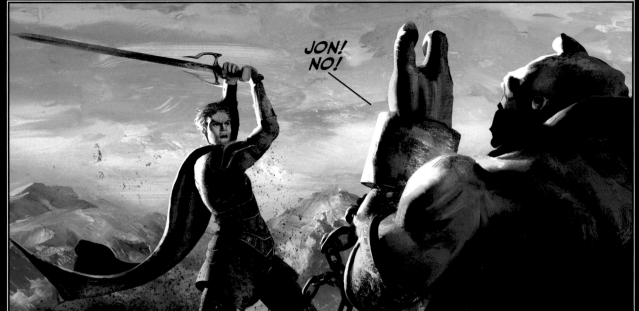

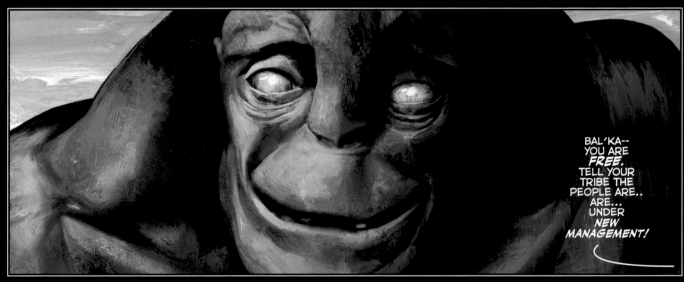

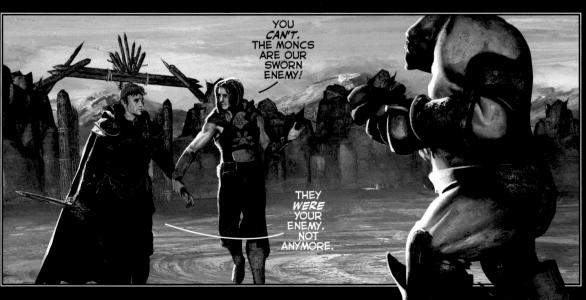

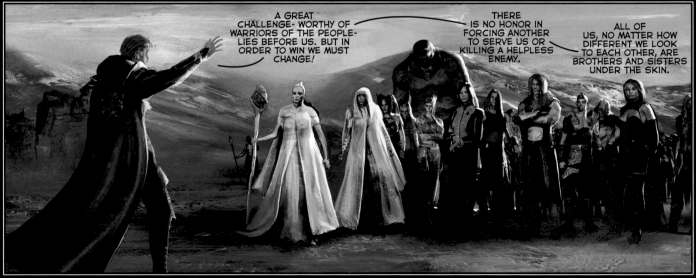

15

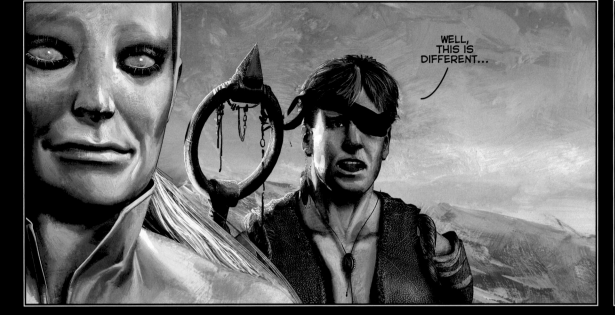

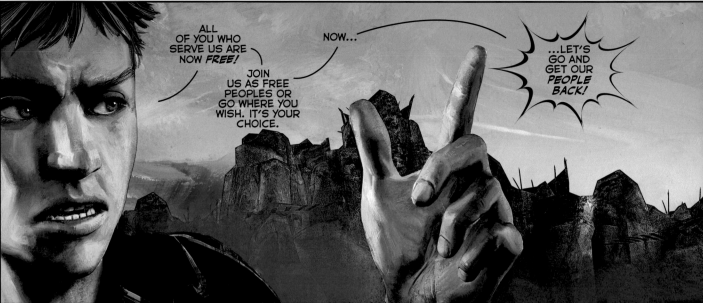

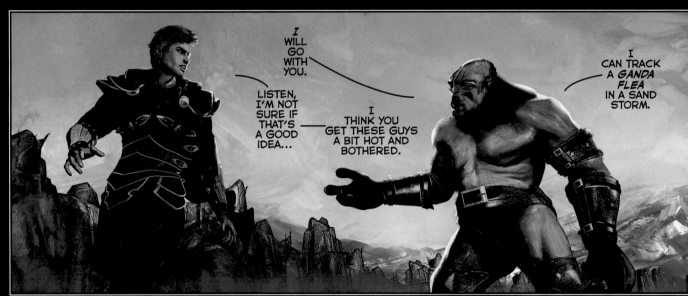

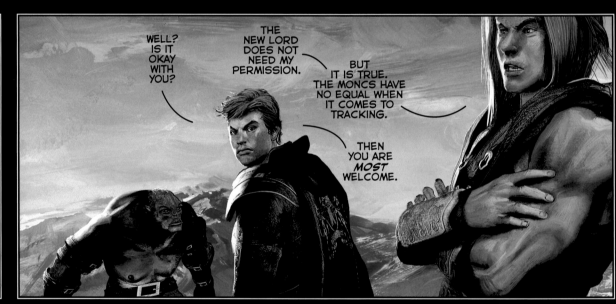

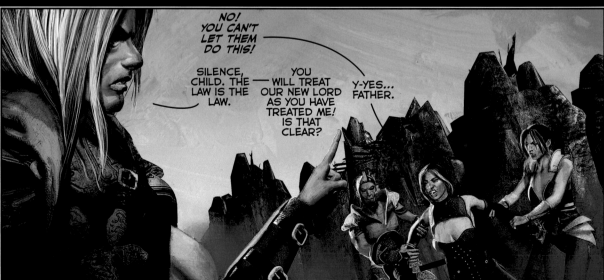

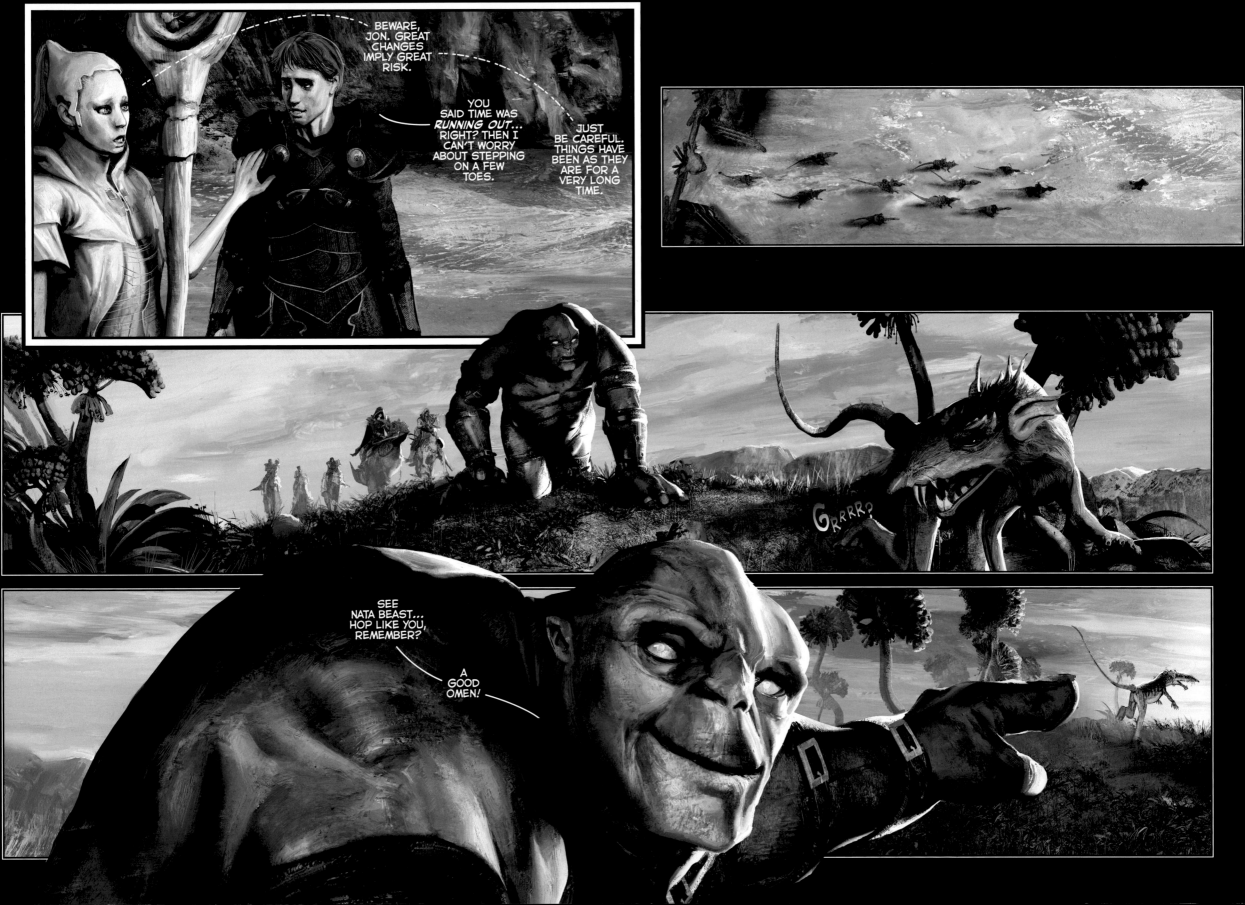

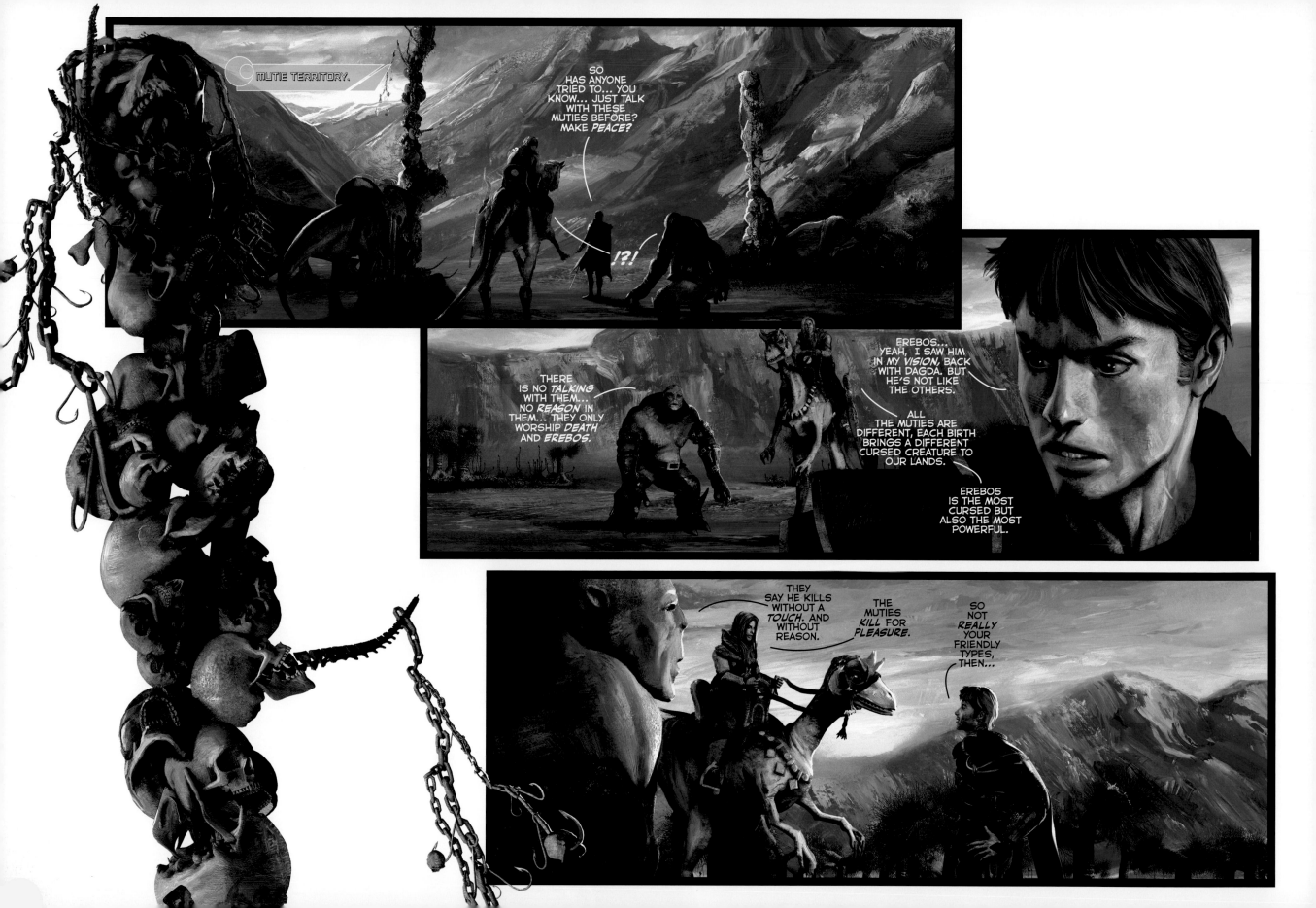

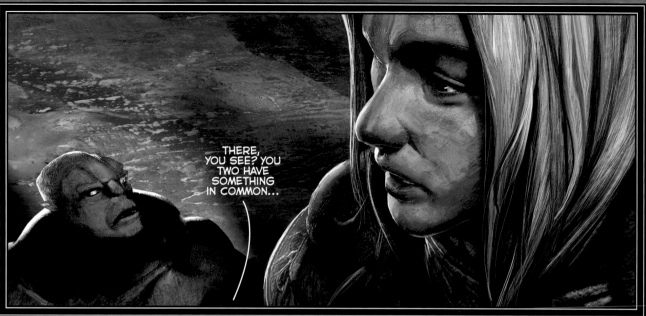

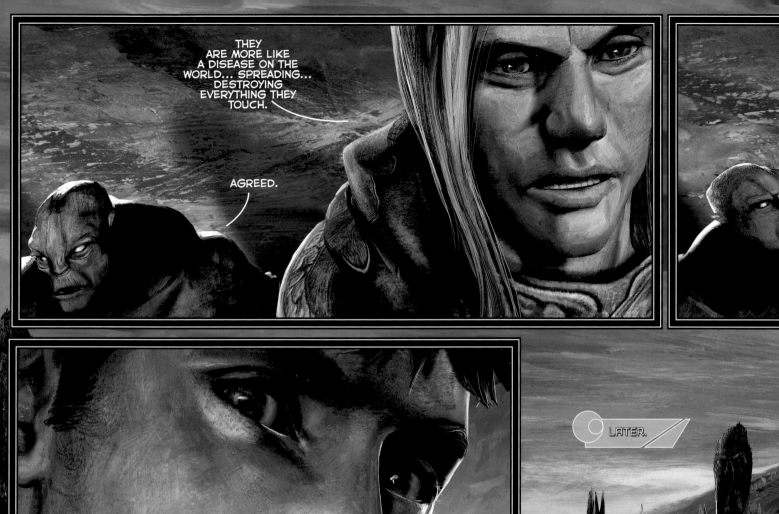

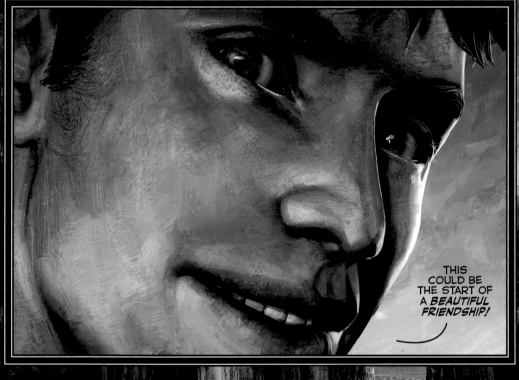

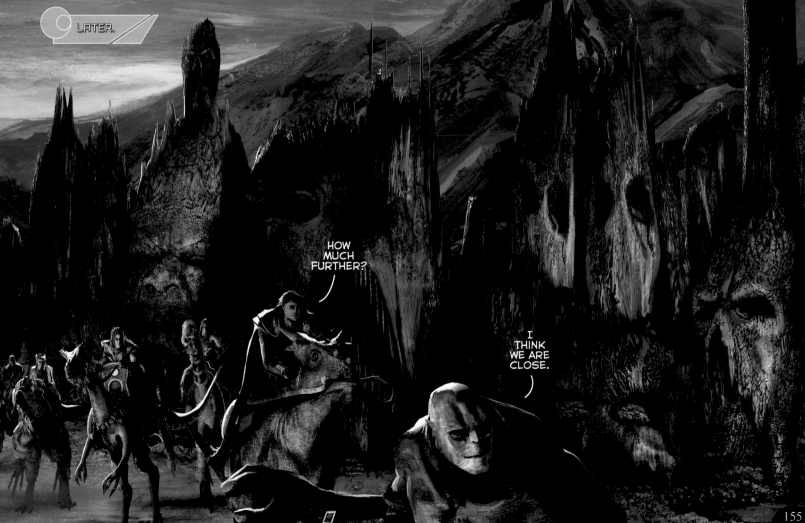

155

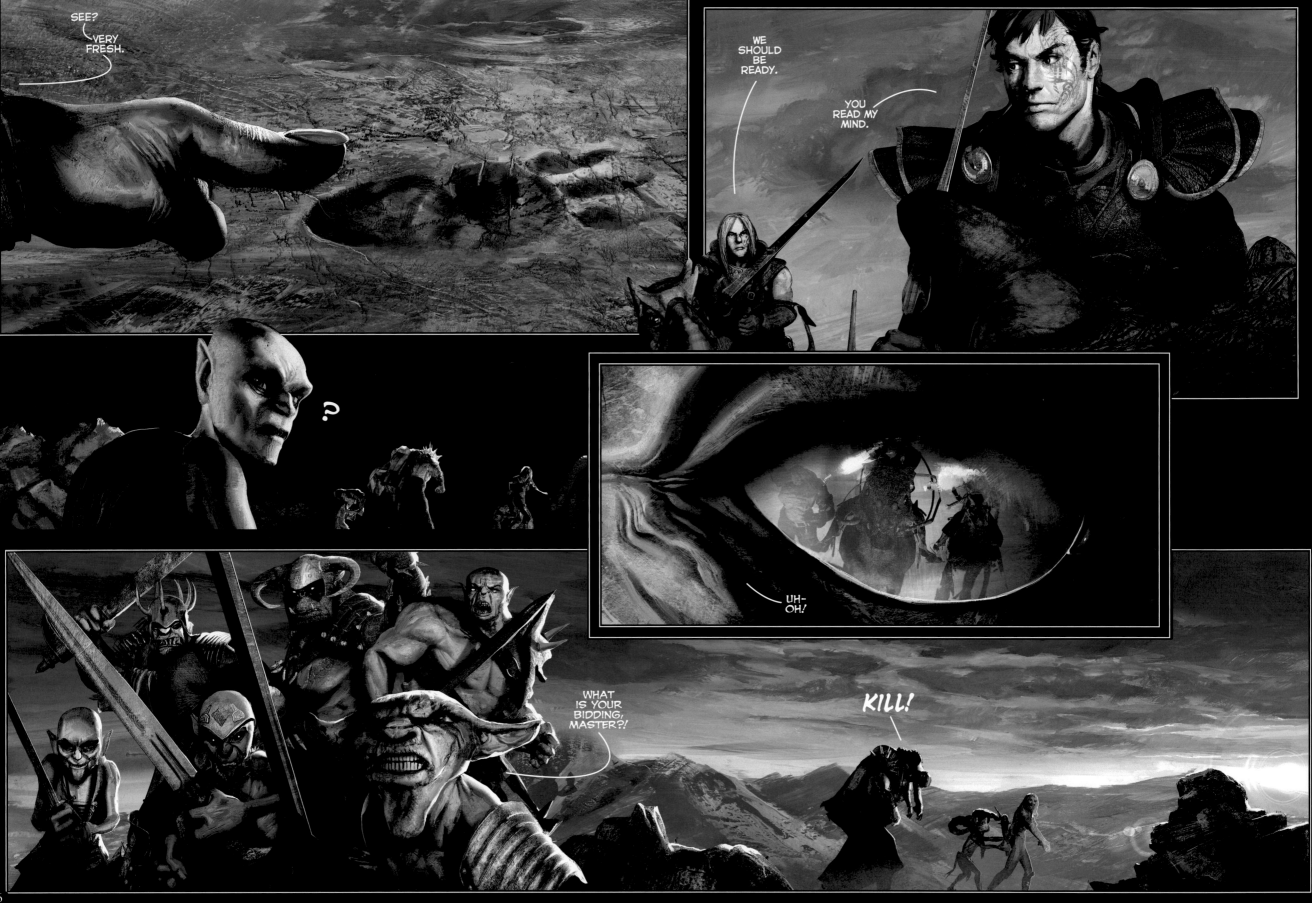

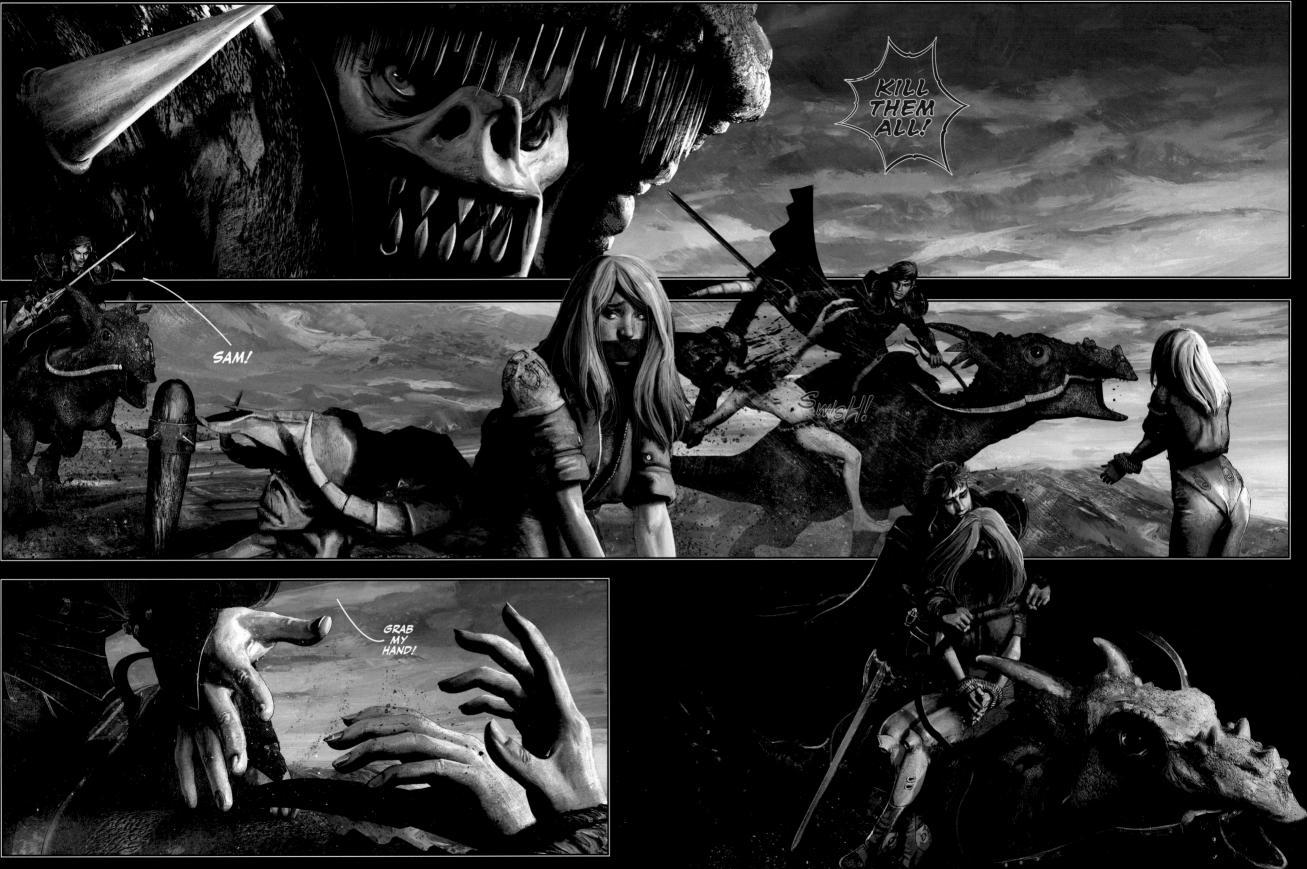

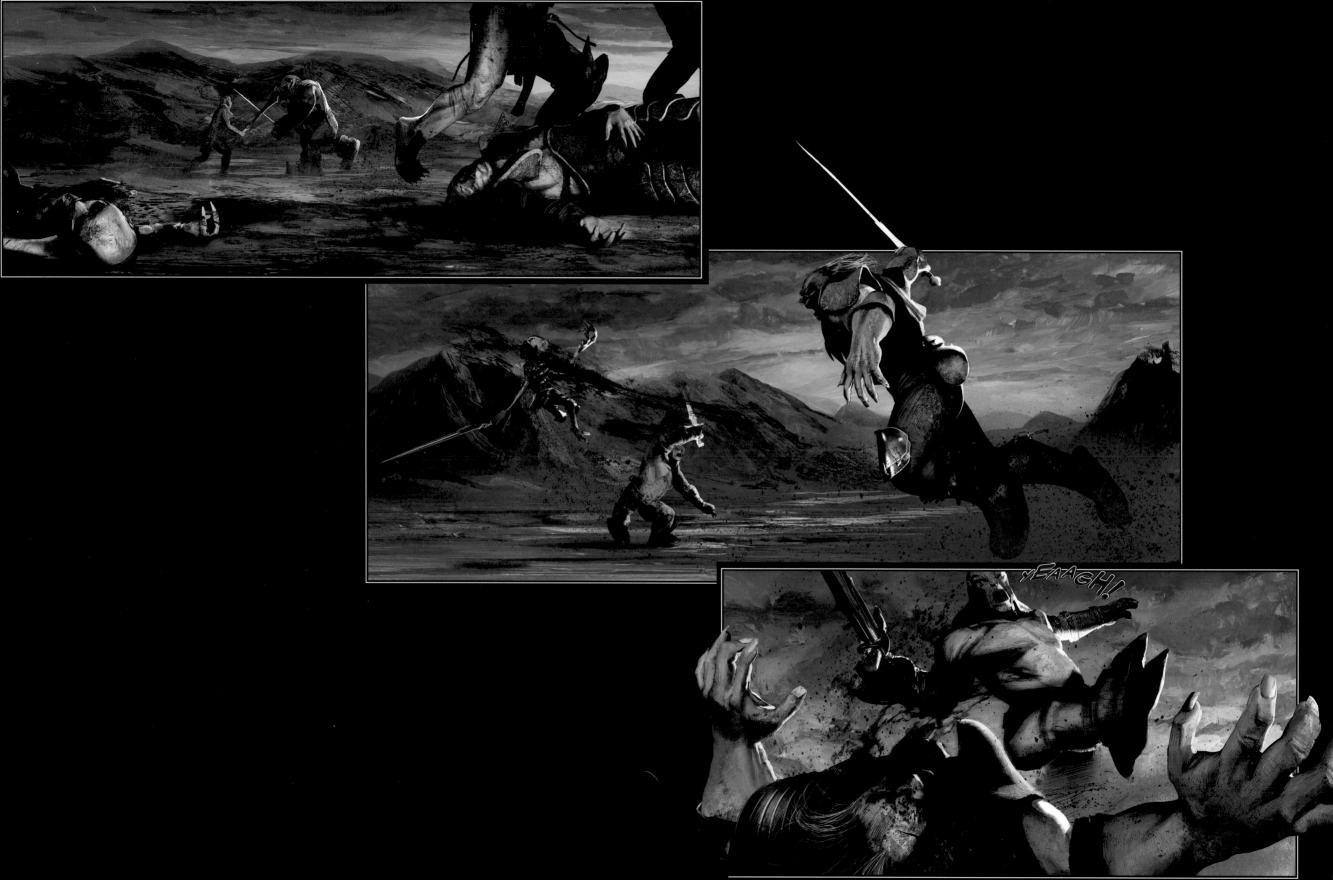

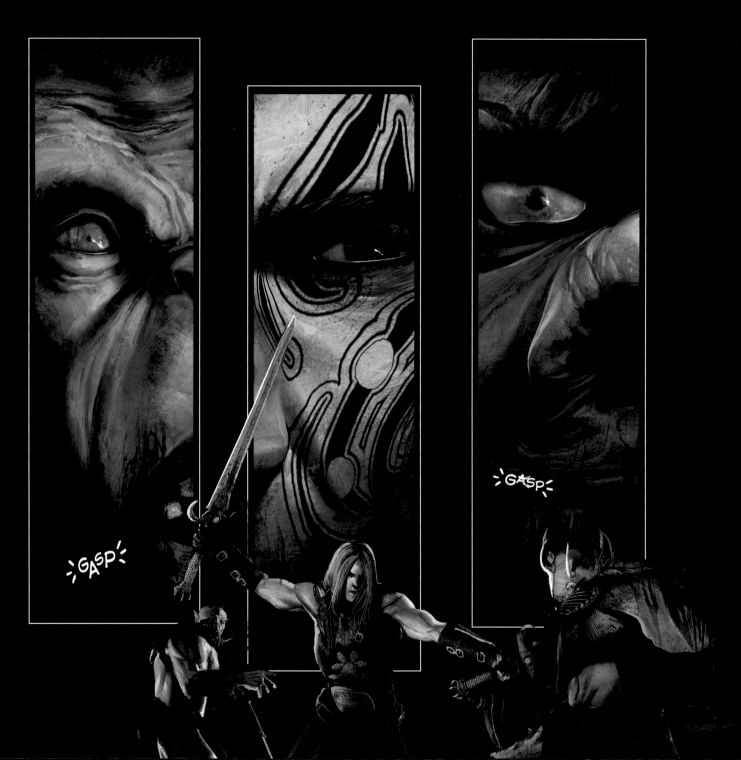

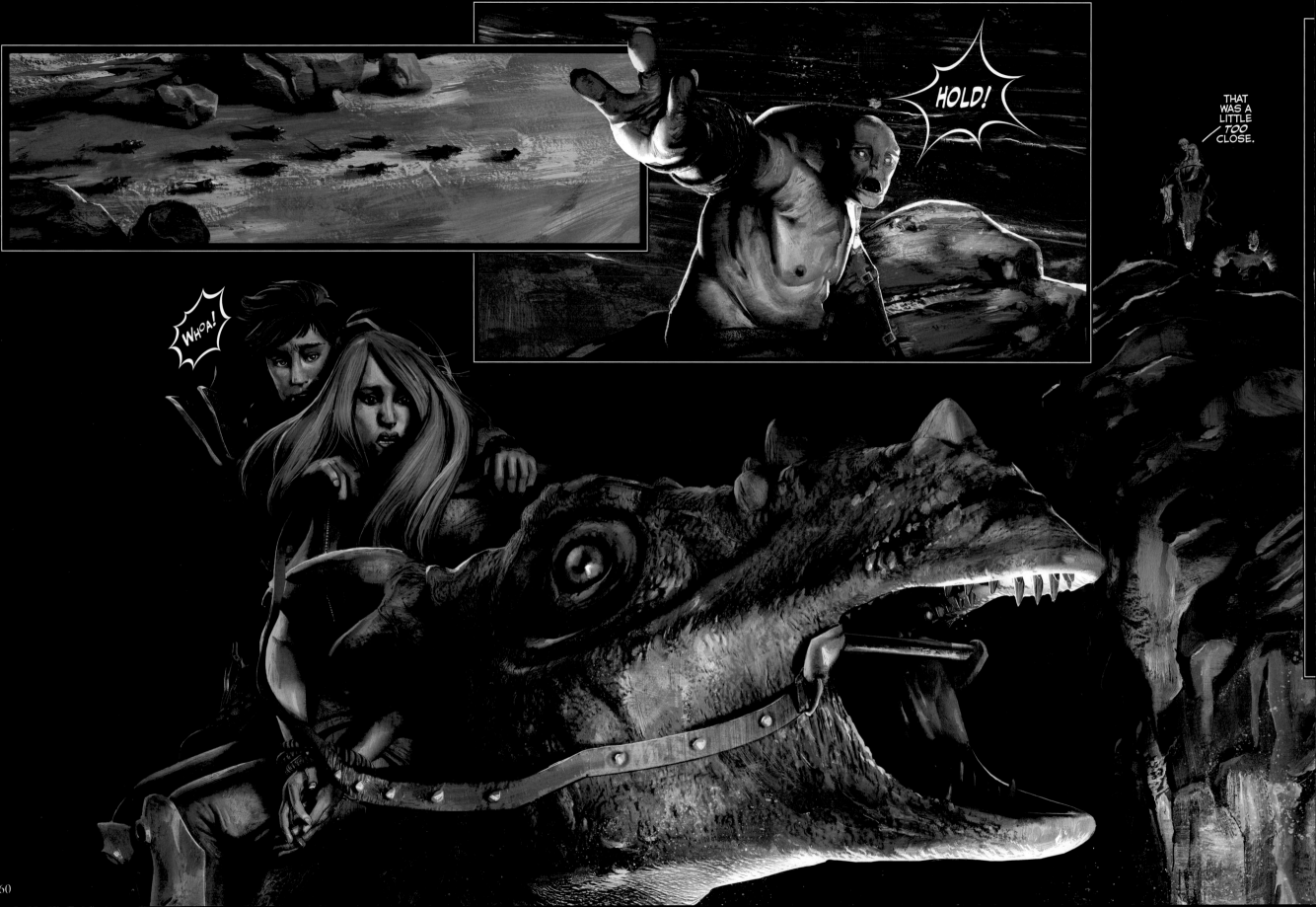

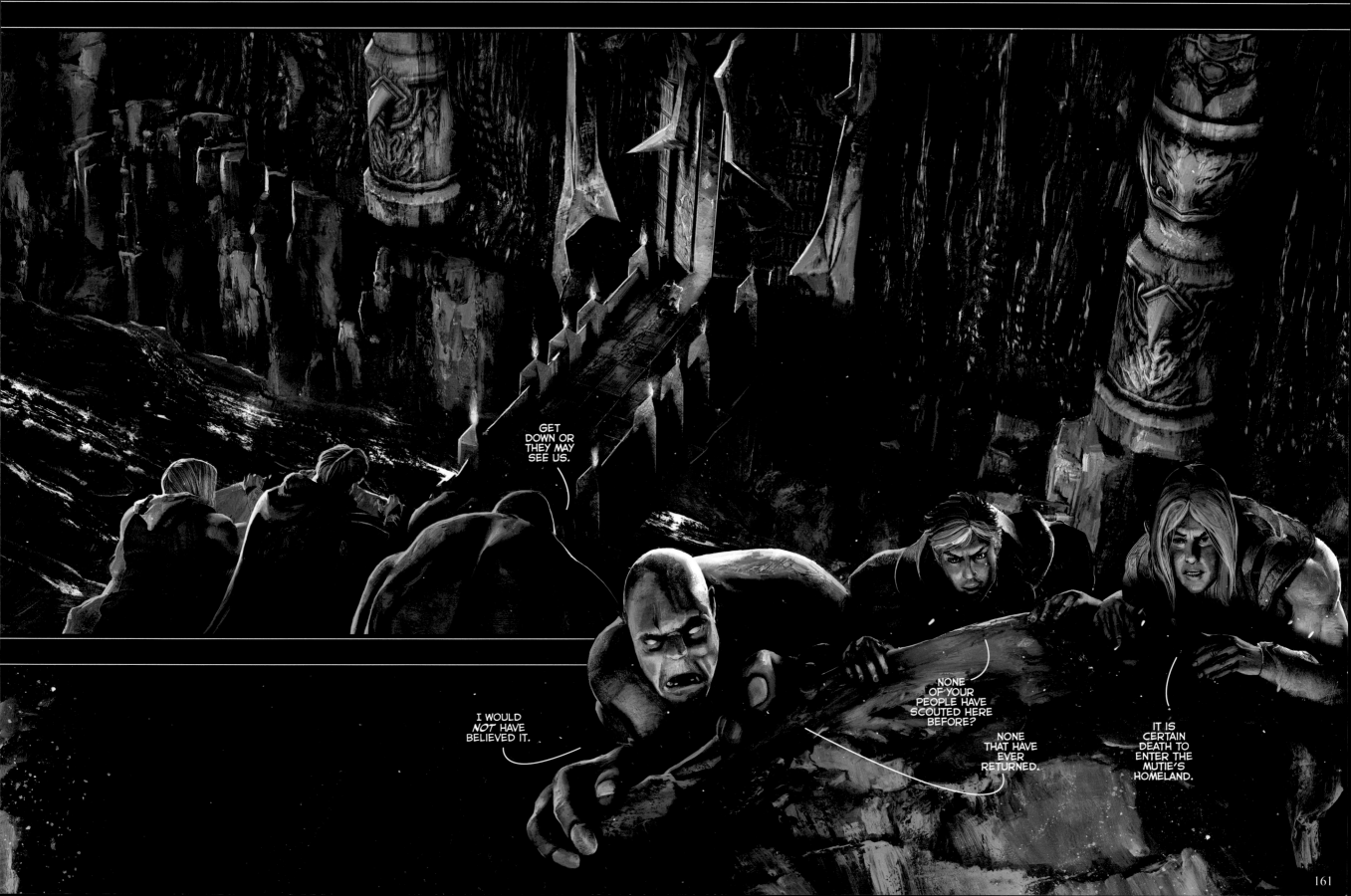

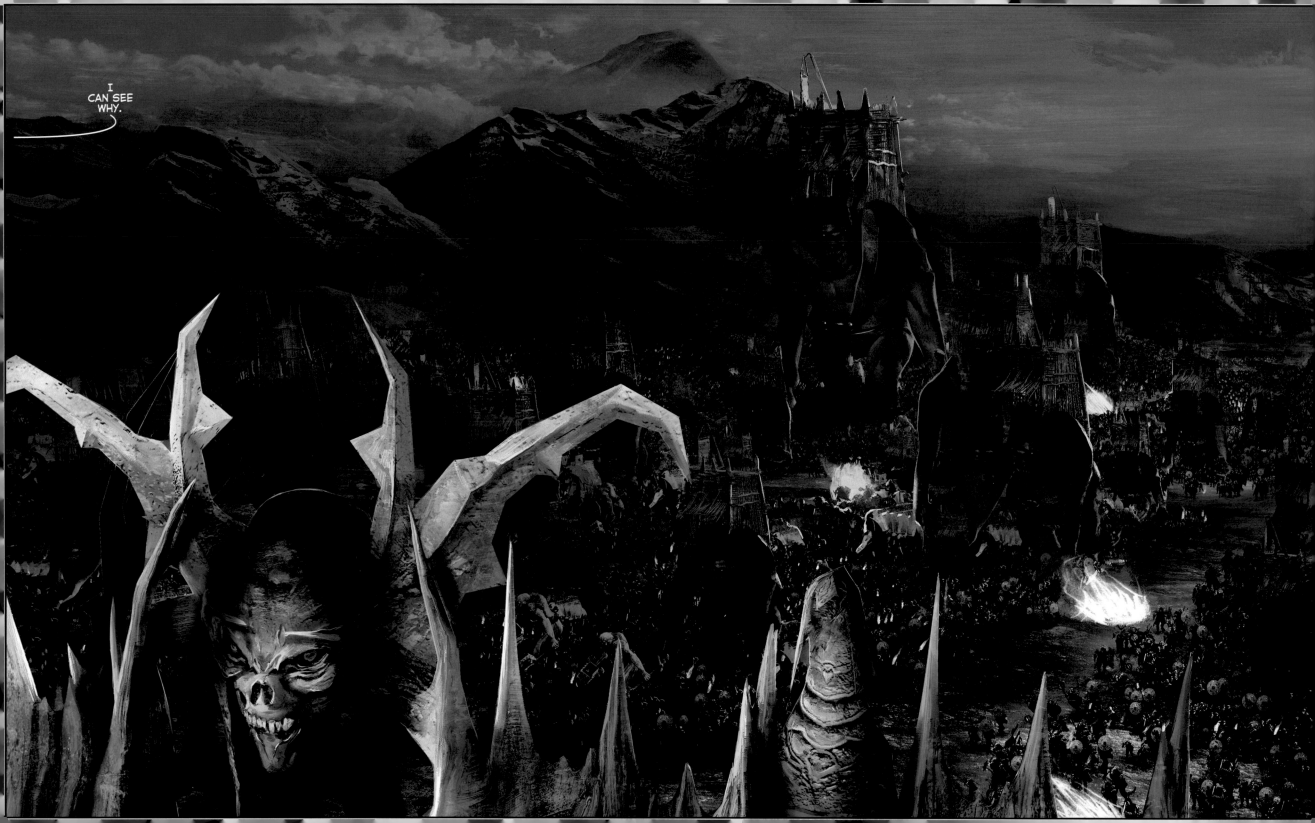

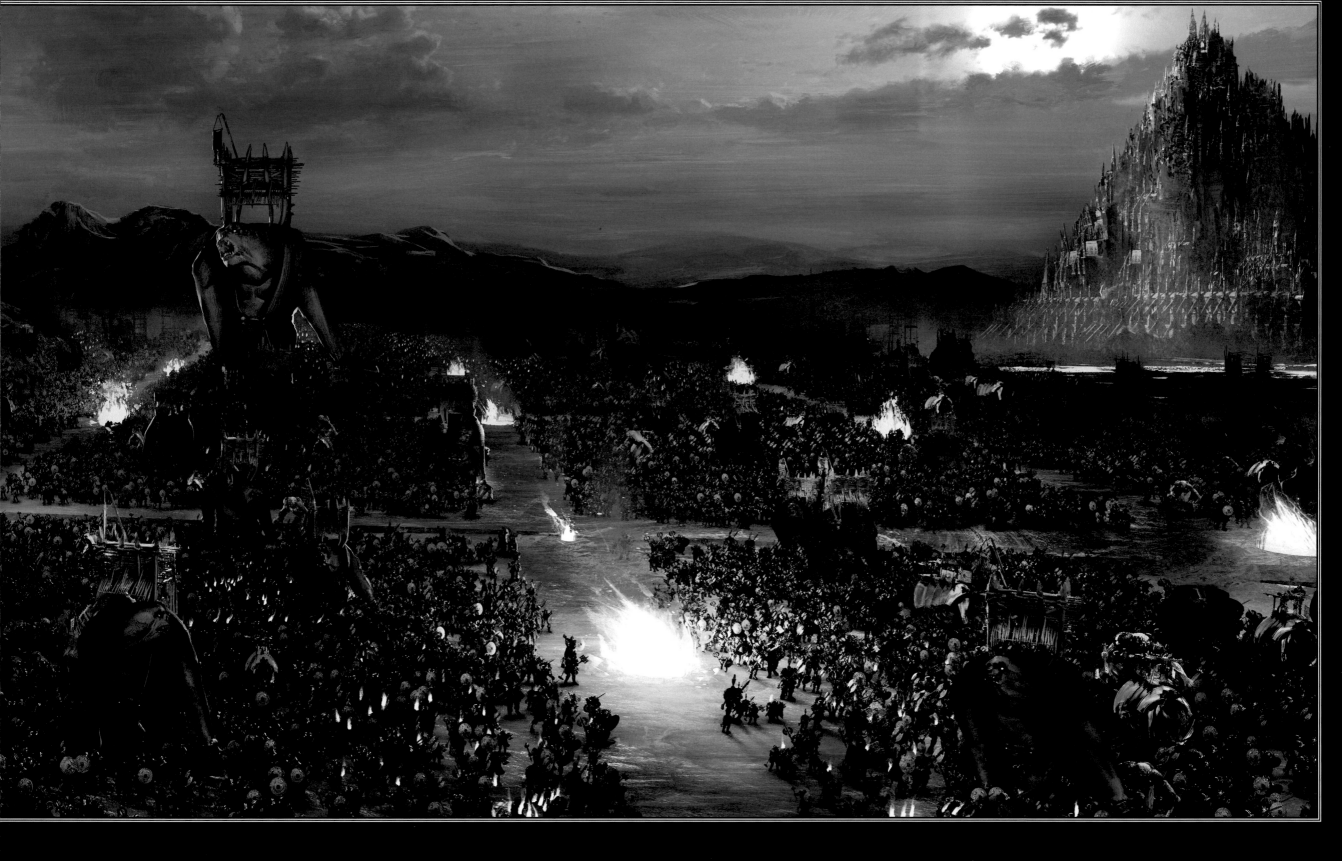

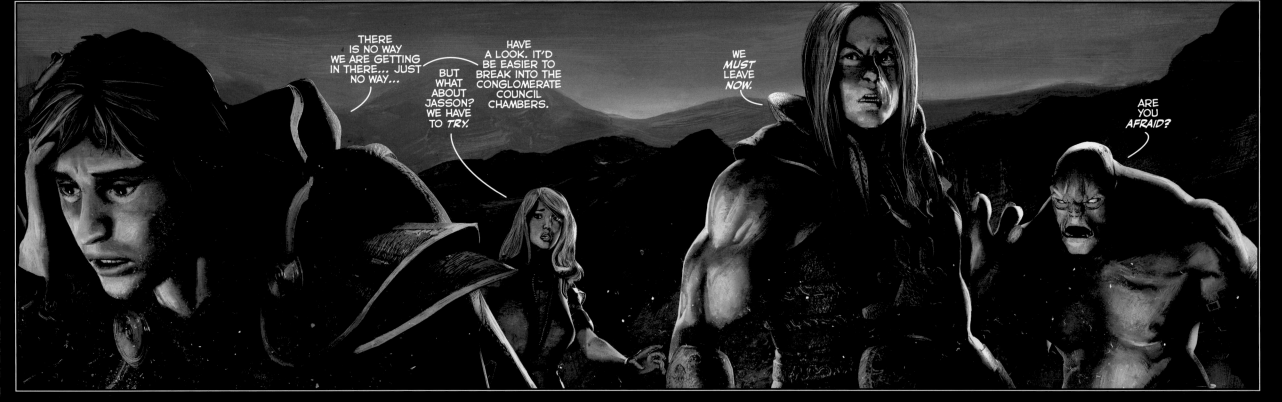

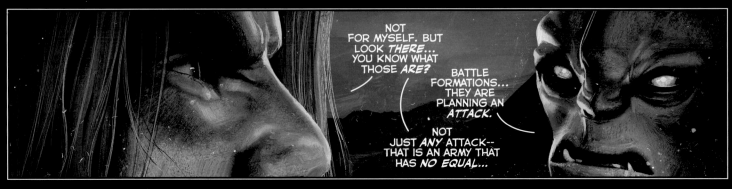

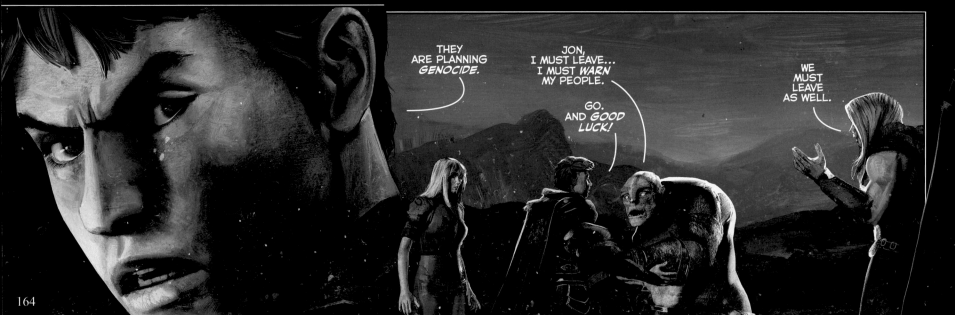

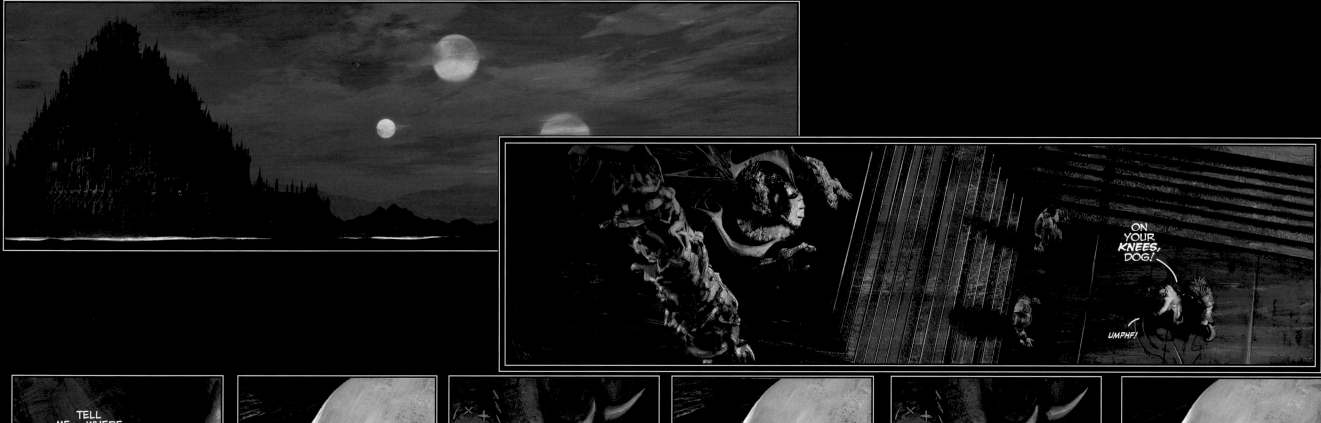

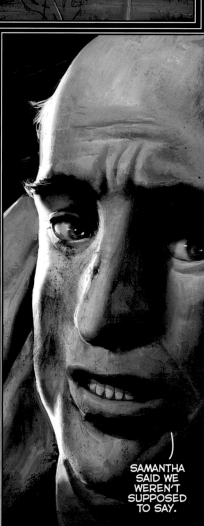

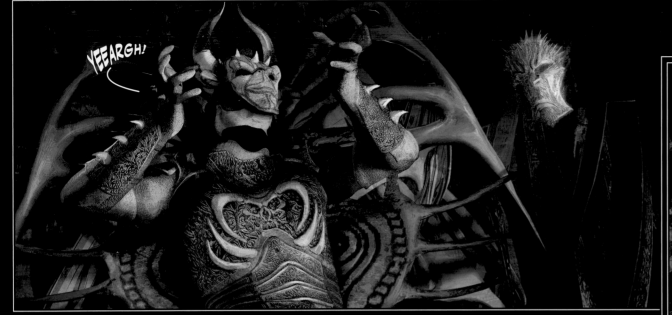

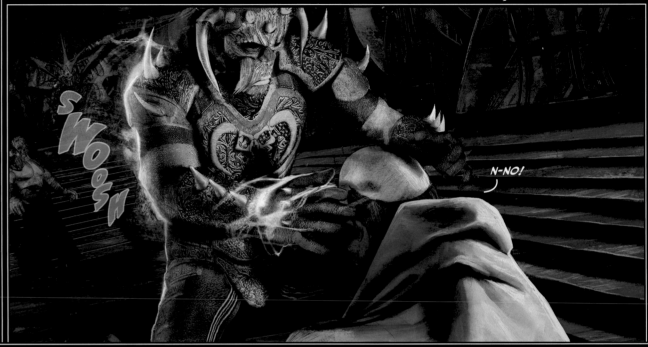

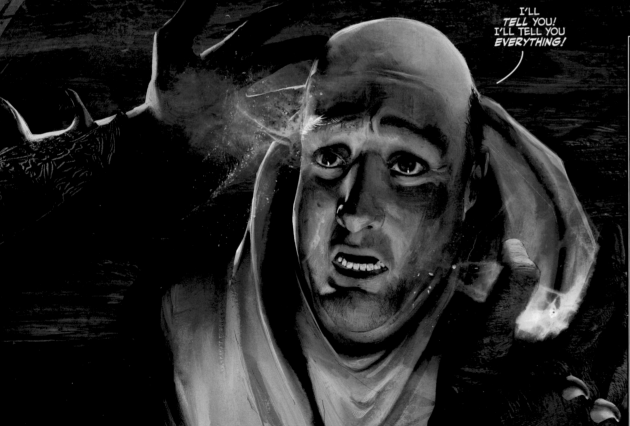

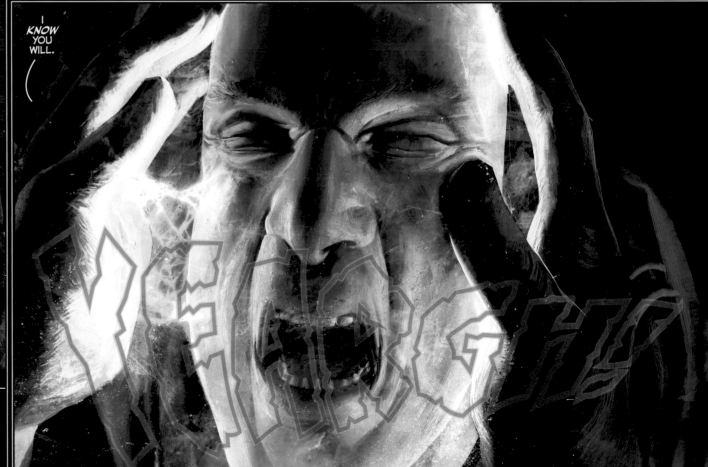

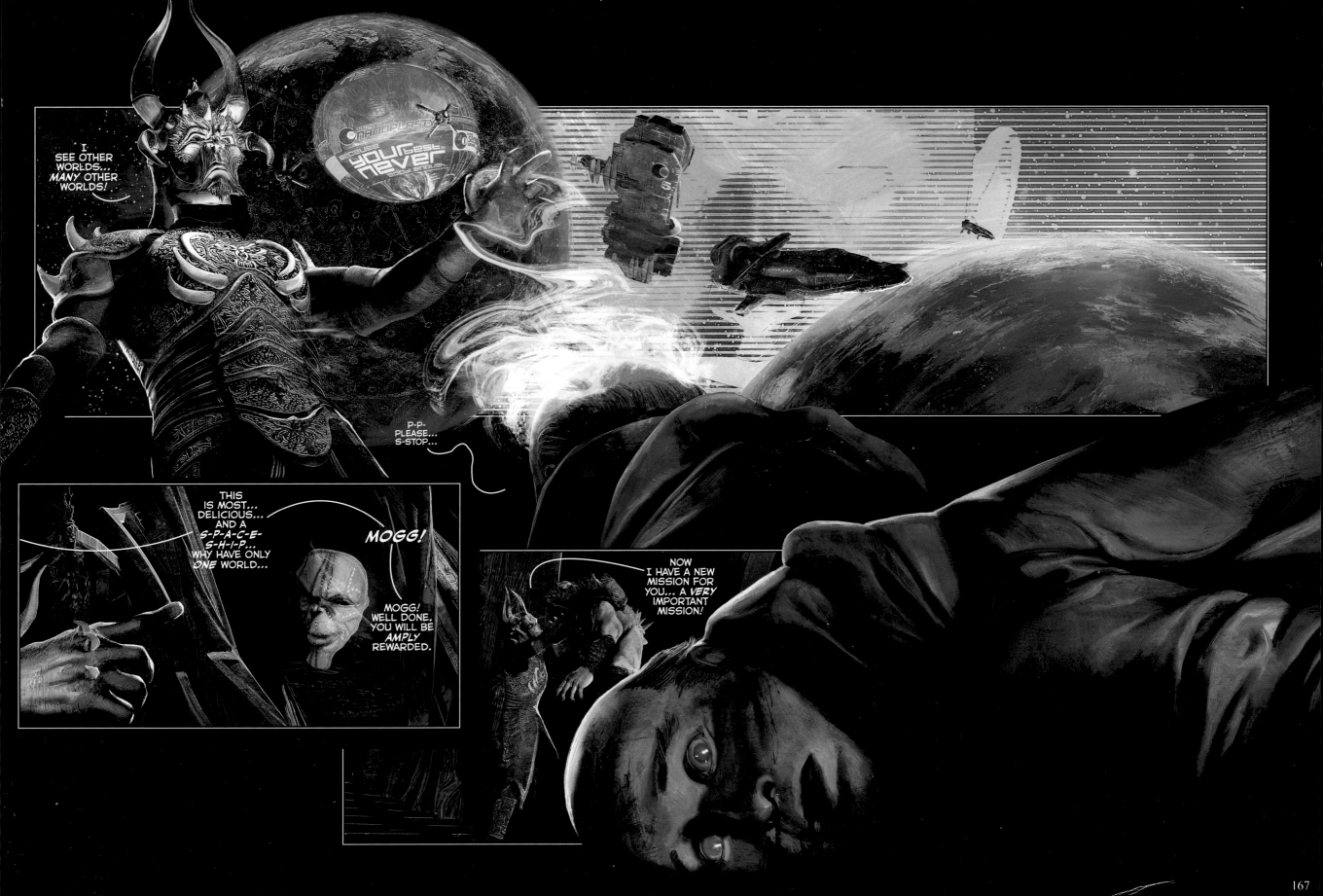

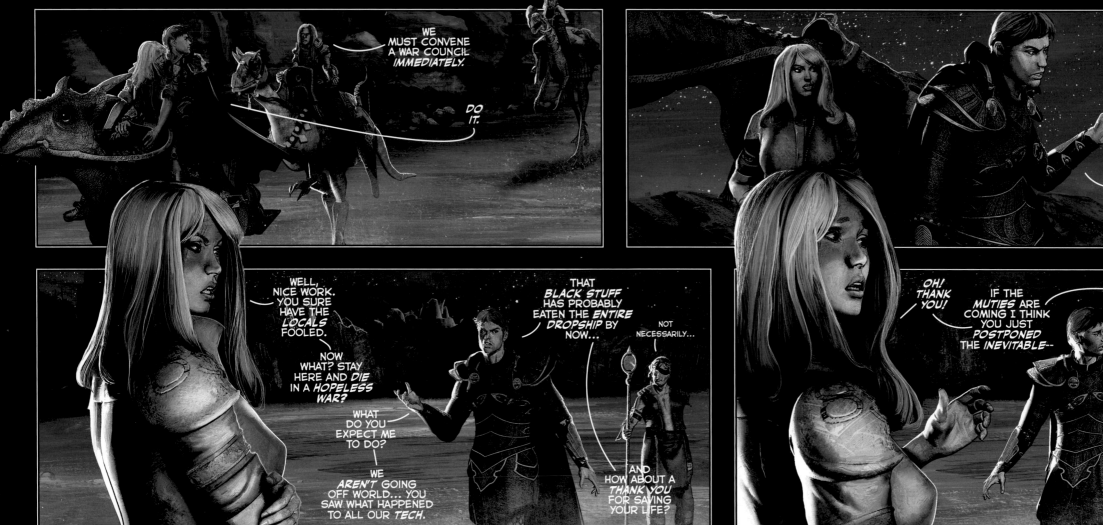

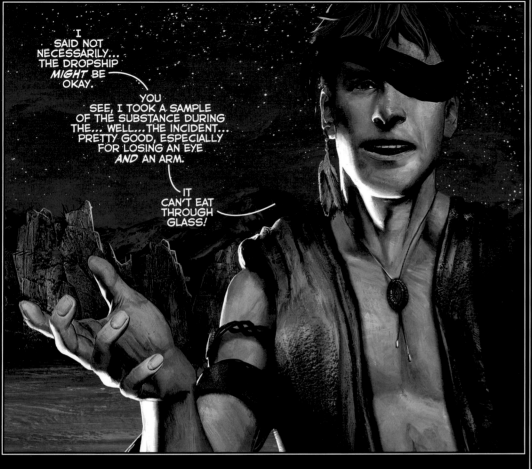

I SAID NOT NECESSARILY... THE DROPSHIP *MIGHT* BE OKAY.

YOU SEE, I TOOK A SAMPLE OF THE SUBSTANCE DURING THE... WELL... THE INCIDENT... PRETTY GOOD, ESPECIALLY FOR LOSING AN EYE *AND* AN ARM.

IT CAN'T EAT THROUGH GLASS!

THE SHIP'S *NOT* MADE OF GLASS, ▮▮TONNI.

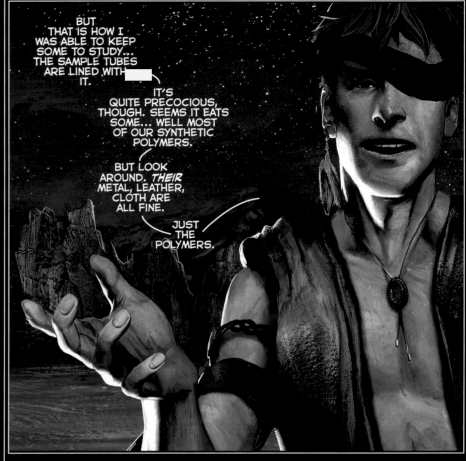

BUT THAT IS HOW I WAS ABLE TO KEEP SOME TO STUDY... THE SAMPLE TUBES ARE LINED WITH ▮▮ IT.

IT'S QUITE PRECOCIOUS, THOUGH. SEEMS IT EATS SOME... WELL MOST OF OUR SYNTHETIC POLYMERS.

BUT LOOK AROUND. *THEIR* METAL, LEATHER, CLOTH ARE ALL FINE.

JUST THE POLYMERS.

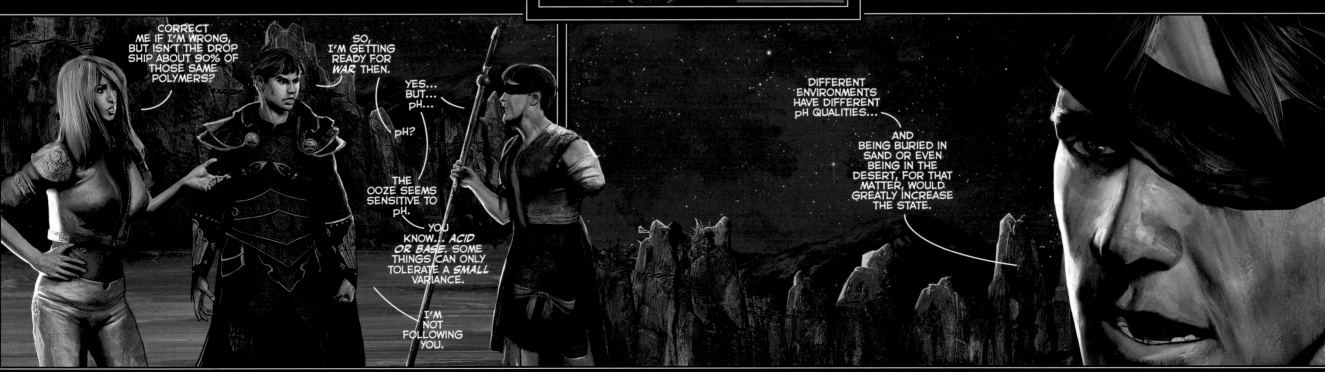

CORRECT ME IF I'M WRONG, BUT ISN'T THE DROP SHIP ABOUT 90% OF THOSE SAME POLYMERS?

SO, I'M GETTING READY FOR *WAR* THEN.

YES... BUT... pH...

pH?

THE OOZE SEEMS SENSITIVE TO pH.

YOU KNOW... *ACID OR BASE.* SOME THINGS CAN ONLY TOLERATE A *SMALL* VARIANCE.

I'M NOT FOLLOWING YOU.

DIFFERENT ENVIRONMENTS HAVE DIFFERENT pH QUALITIES...

AND BEING BURIED IN SAND OR EVEN BEING IN THE DESERT, FOR THAT MATTER, WOULD GREATLY INCREASE THE STATE.

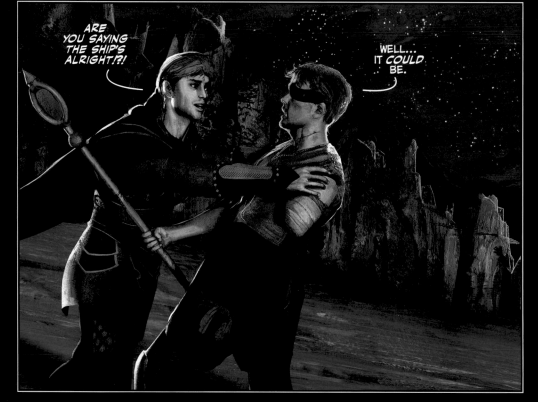

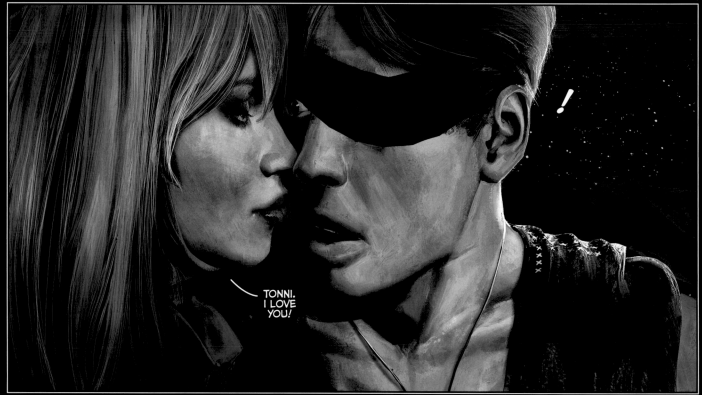

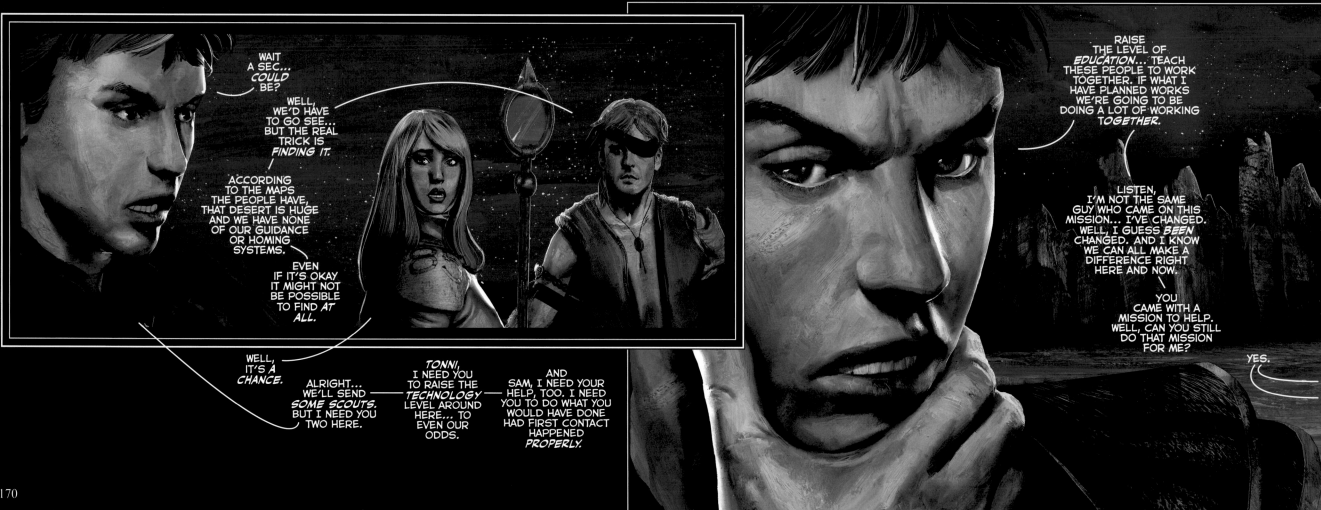

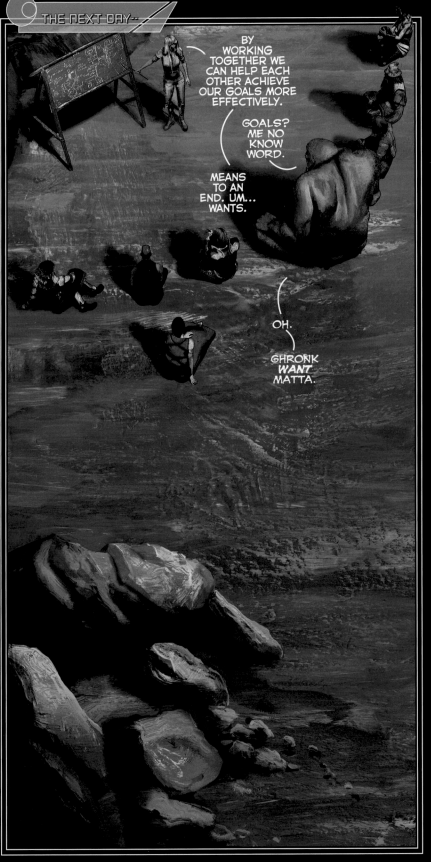

BY WORKING TOGETHER WE CAN HELP EACH OTHER ACHIEVE OUR GOALS MORE EFFECTIVELY.

GOALS? ME NO KNOW WORD.

MEANS TO AN END. UM... WANTS.

OH.

GHRONK *WANT* MATTA.

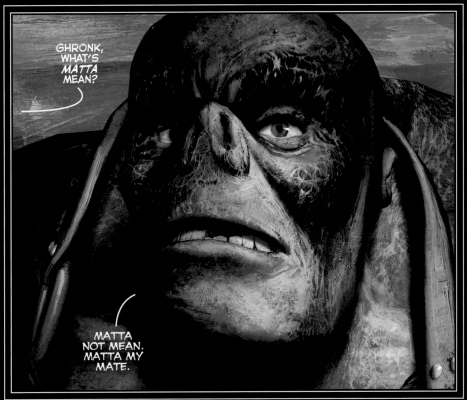

GHRONK, WHAT'S *MATTA* MEAN?

MATTA NOT MEAN. MATTA MY MATE.

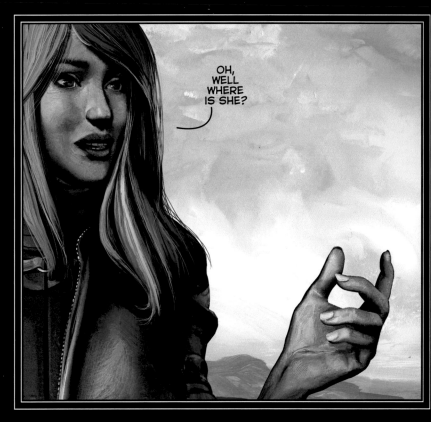

OH, WELL WHERE IS SHE?

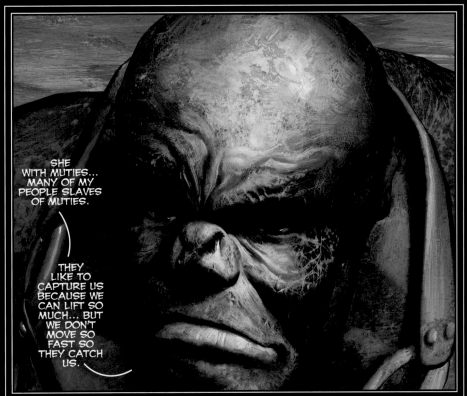

SHE WITH MUTIES... MANY OF MY PEOPLE SLAVES OF MUTIES.

THEY LIKE TO CAPTURE US BECAUSE WE CAN LIFT SO MUCH... BUT WE DON'T MOVE SO FAST SO THEY CATCH US.

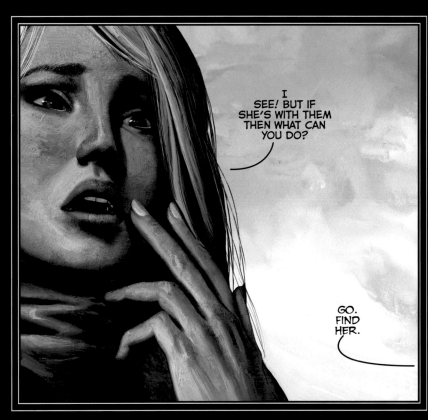

I SEE! BUT IF SHE'S WITH THEM THEN WHAT CAN YOU DO?

GO. FIND HER.

17

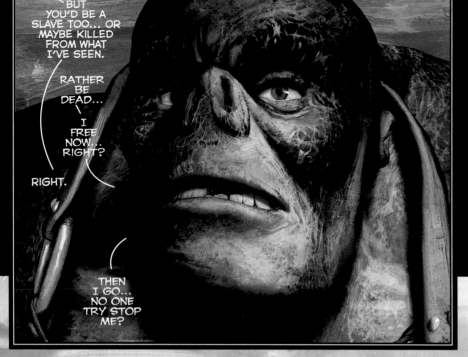

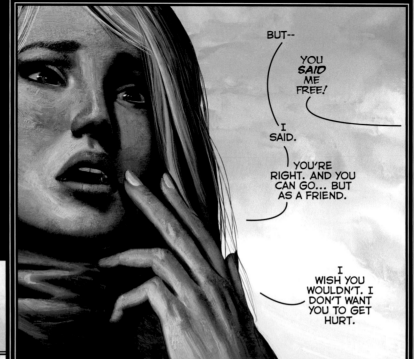

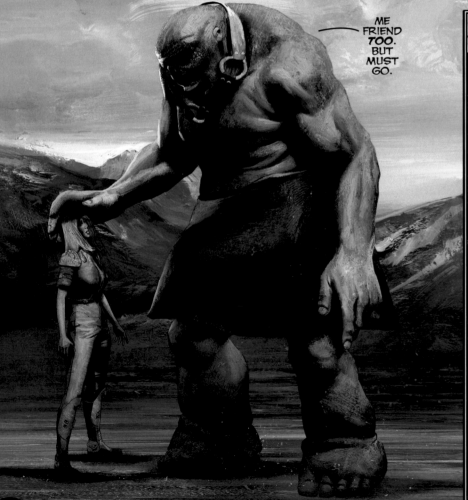

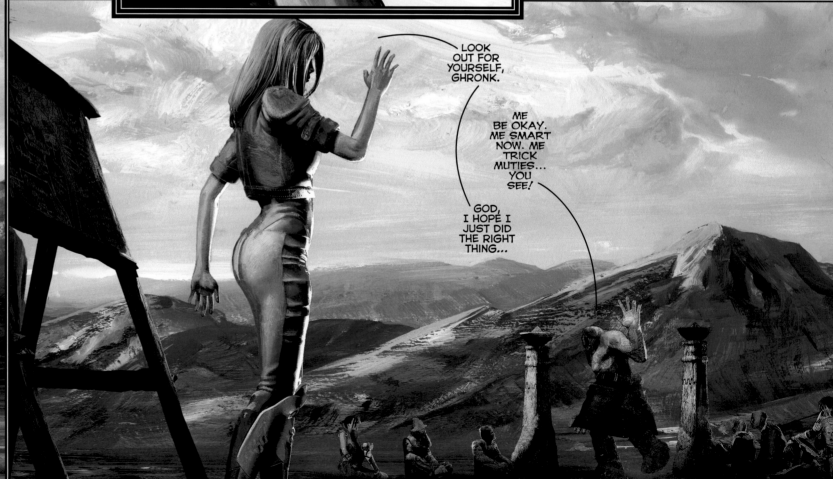

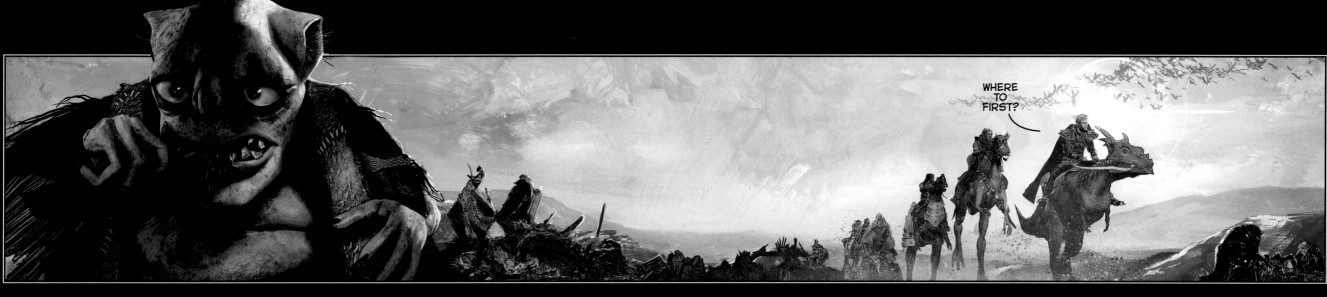

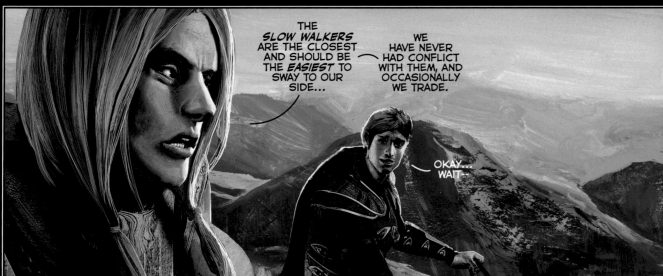

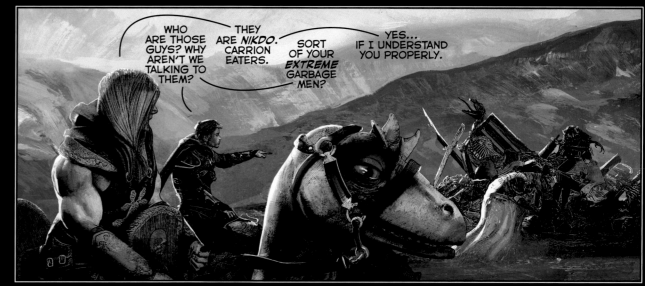

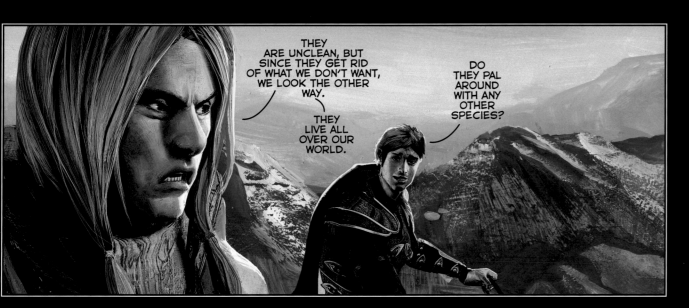

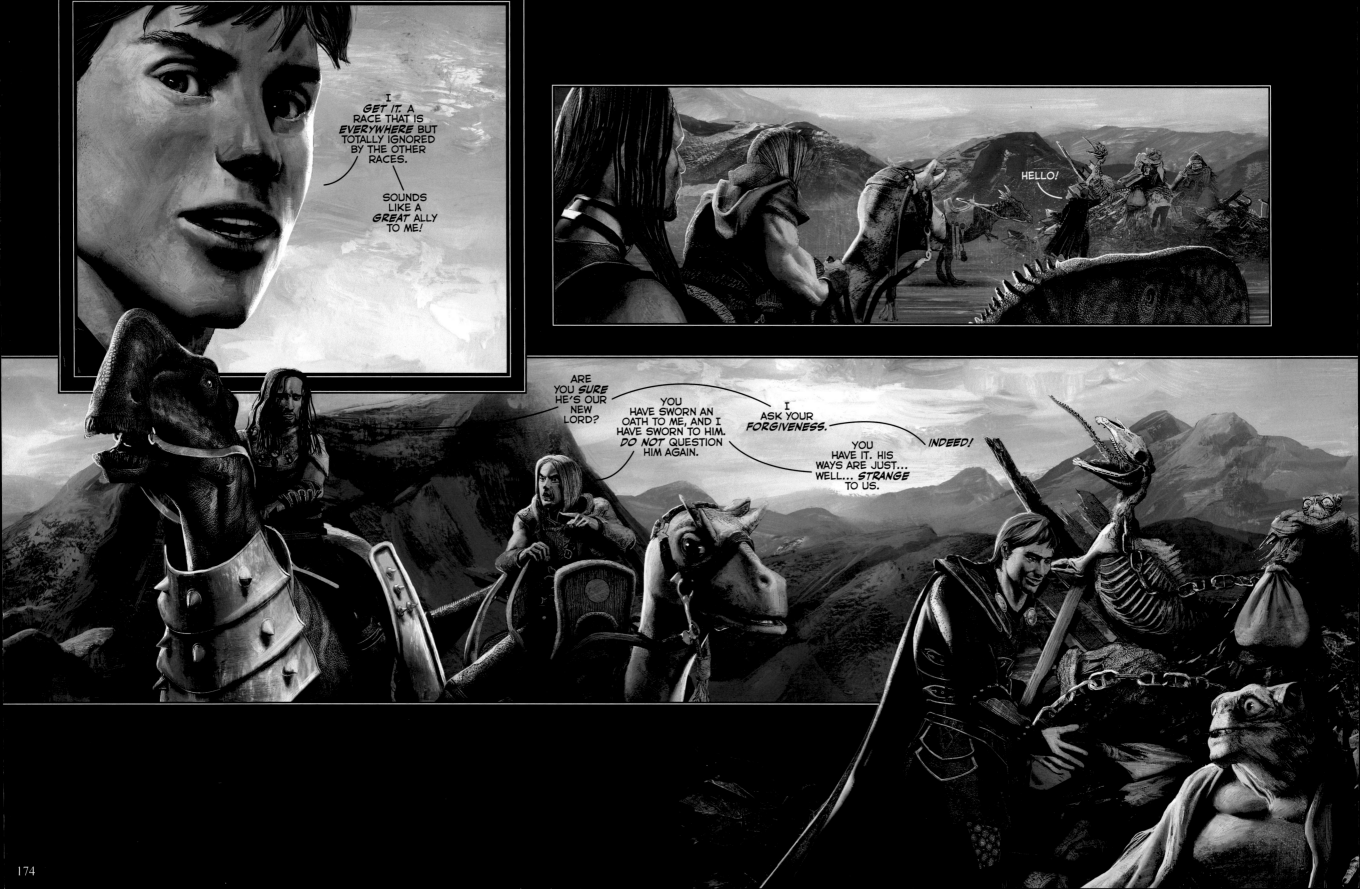

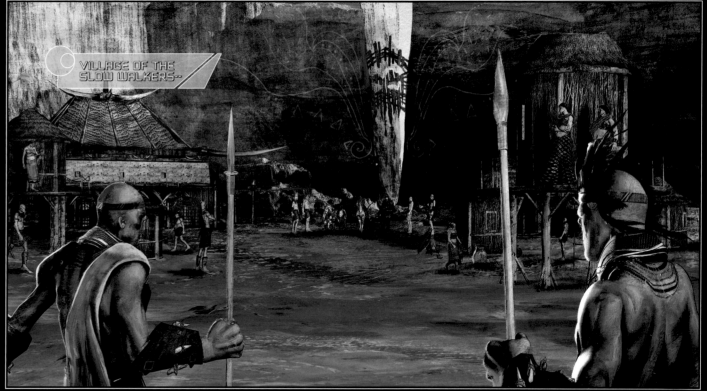

IMAGINE THE *MASAI* FROM *OLD EARTH...* NOW, IMAGINE THEM *THREE METERS TALL* AND ABLE TO THROW SPEARS *HALF A KILOMETER,* WITH ACCURACY. WE GOTTA GET THESE GUYS ON OUR SIDE.

OH, IF I WERE ONLY A *PRO RINGBALL* RECRUITER... NO ONE COULD BLOCK THEM.

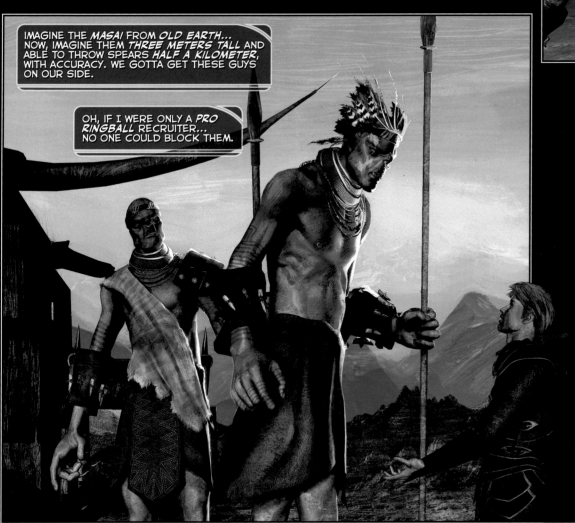

THEY POLITELY LISTEN TO MY SPIEL.

THEY JOIN UP WITHOUT A MOMENT'S HESITATION.

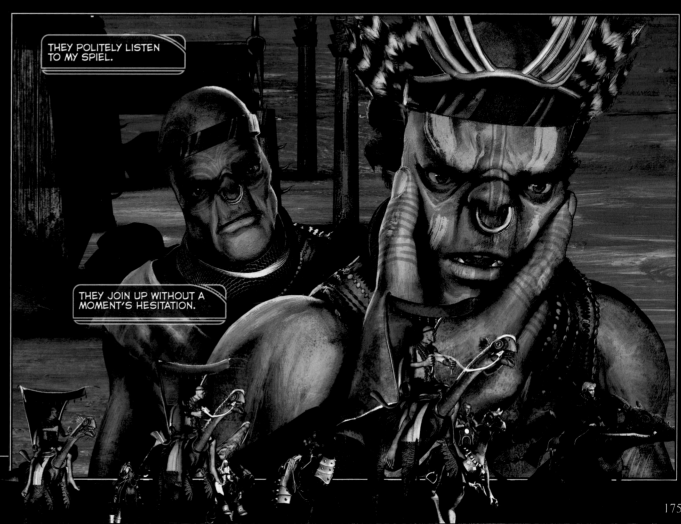

175

THEY'RE ABOUT THE SAME HEIGHT AS A MAN BUT MUST WEIGH IN AT ABOUT *150 KILOS*... AND THEY CAN LIFT UP TO *TWICE* THAT, AS CADERYN TELLS IT.

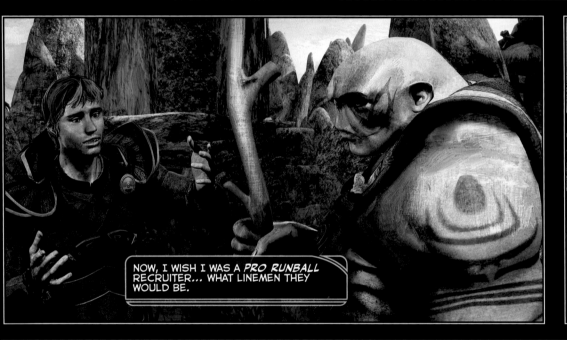

NOW, I WISH I WAS A *PRO RUNBALL* RECRUITER... WHAT LINEMEN THEY WOULD BE.

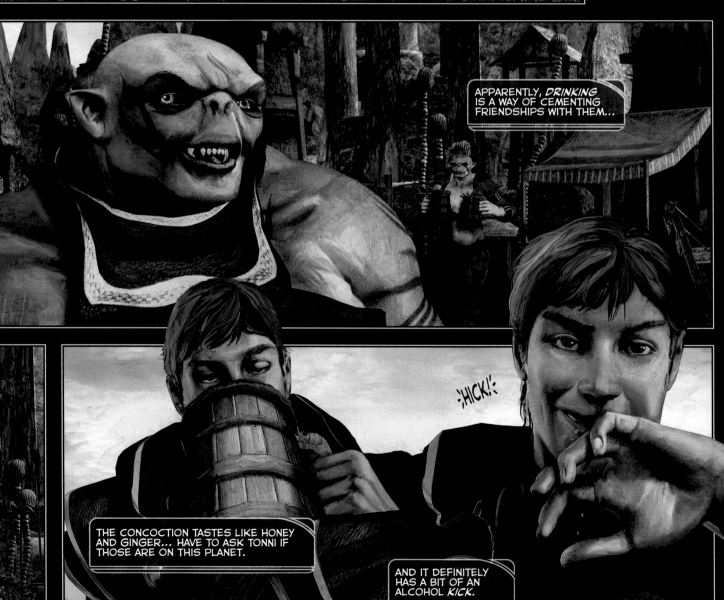

APPARENTLY, *DRINKING* IS A WAY OF CEMENTING FRIENDSHIPS WITH THEM...

:HICK!:

THE CONCOCTION TASTES LIKE HONEY AND GINGER... HAVE TO ASK TONNI IF THOSE ARE ON THIS PLANET.

AND IT DEFINITELY HAS A BIT OF AN ALCOHOL *KICK*.

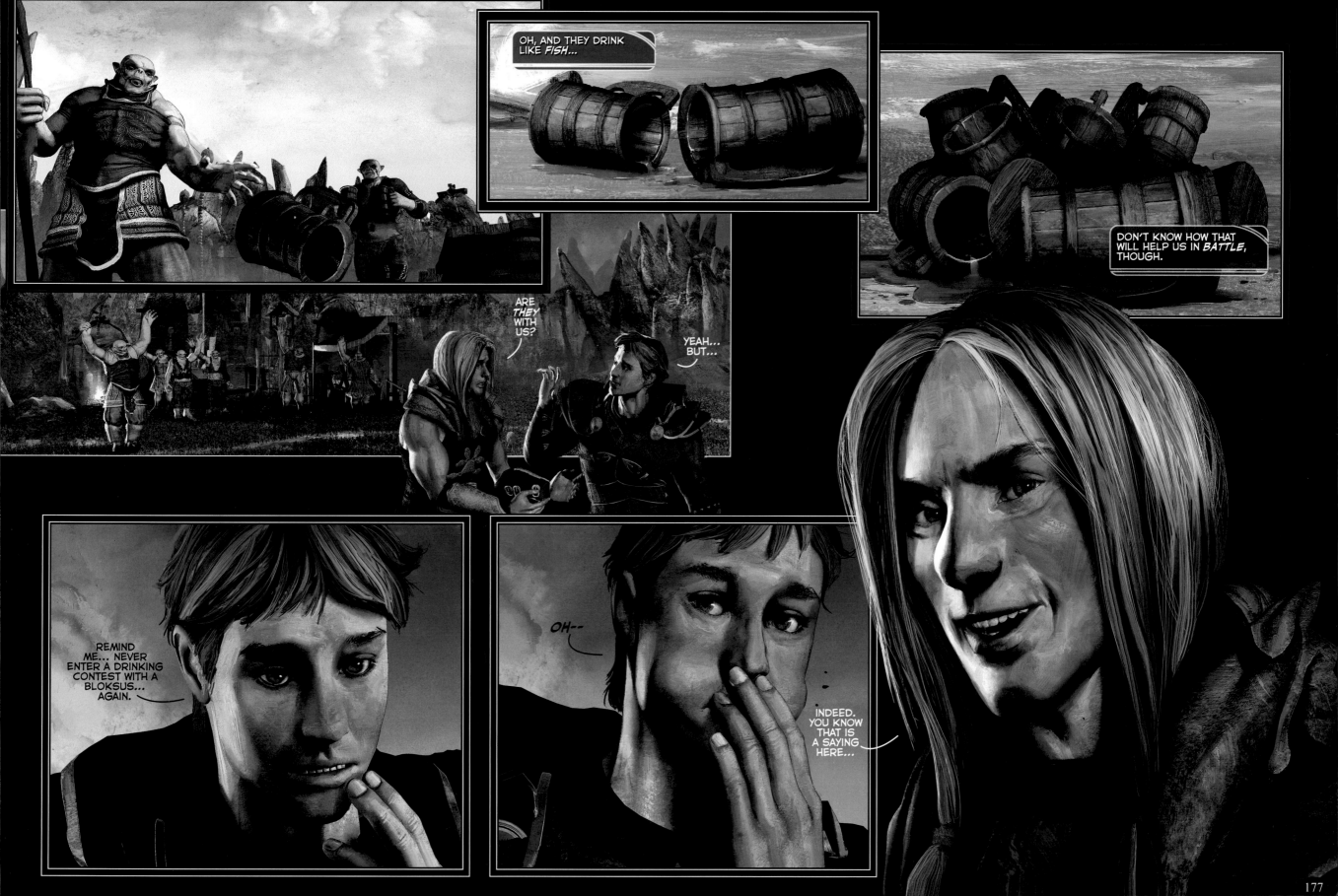

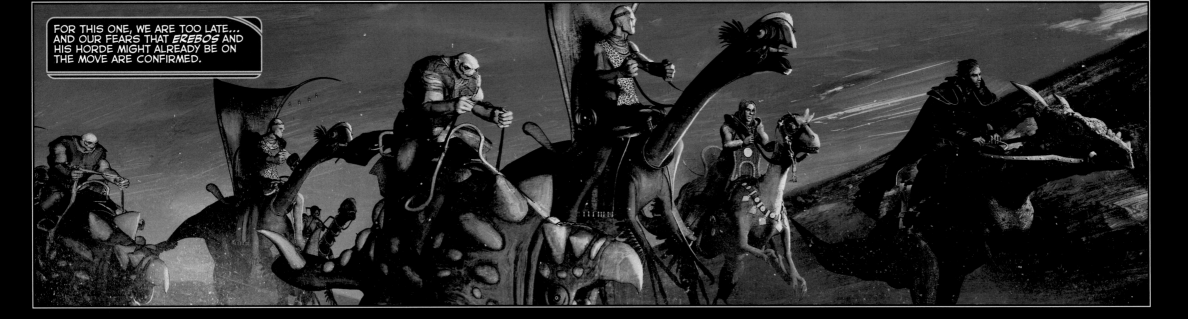

FOR THIS ONE, WE ARE TOO LATE... AND OUR FEARS THAT *EREBOS* AND HIS HORDE MIGHT ALREADY BE ON THE MOVE ARE CONFIRMED.

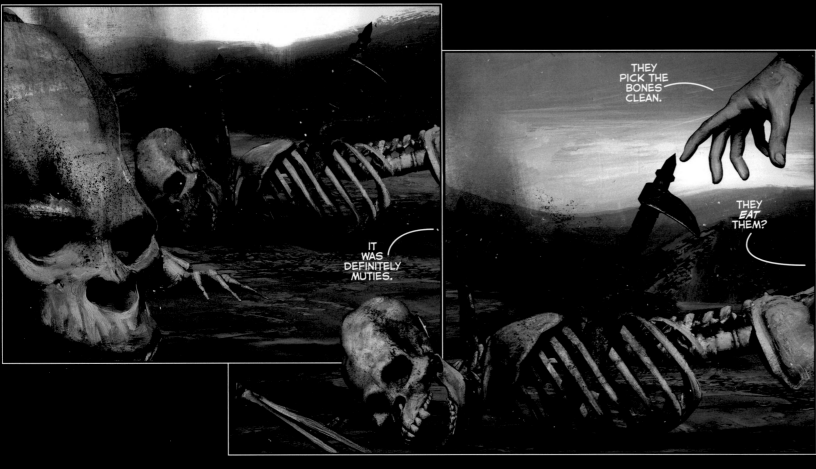

IT WAS DEFINITELY MUTIES.

THEY PICK THE BONES CLEAN.

THEY *EAT* THEM?

INDEED THEY DO.

THE BREEDS DIDN'T GIVE UP WITHOUT A FIGHT... AND THEY ARE POWERFUL WARRIORS.

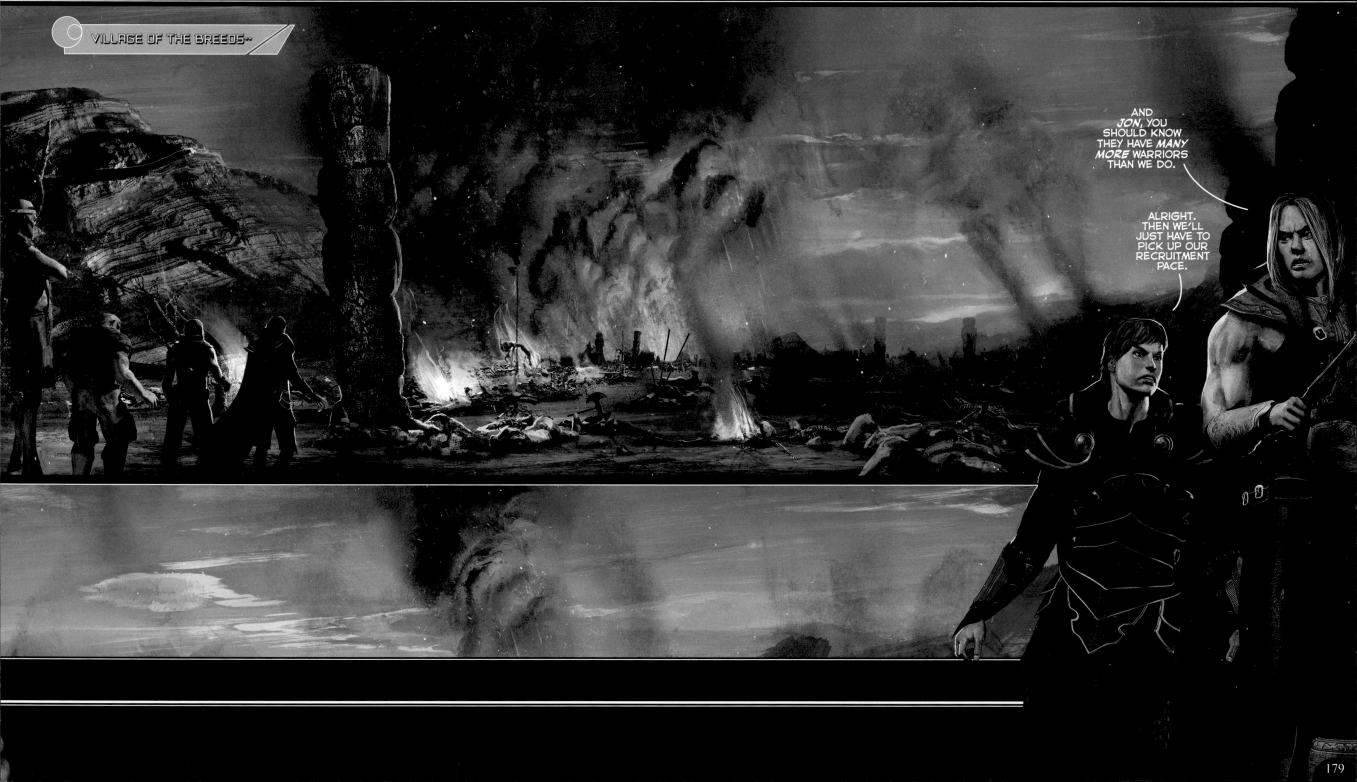

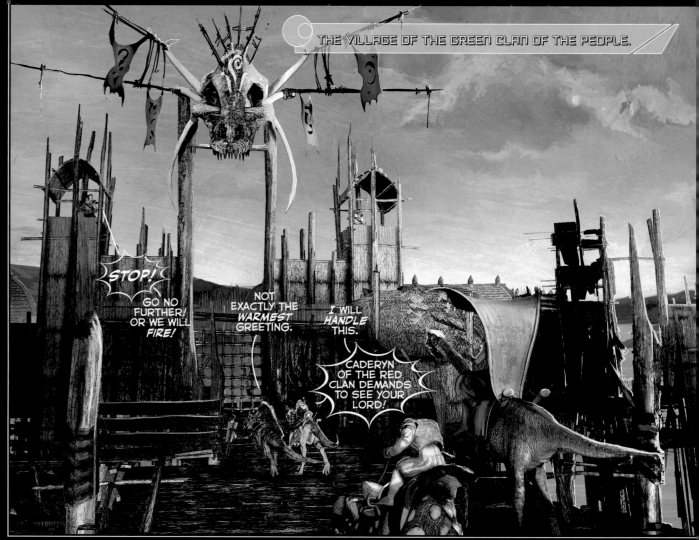

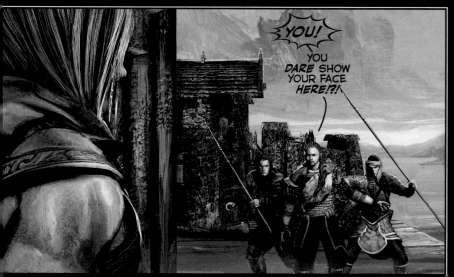

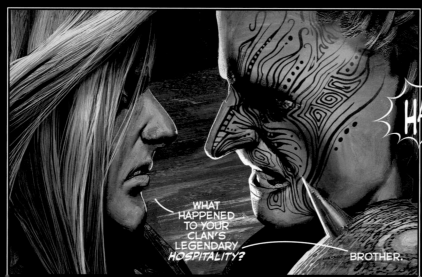

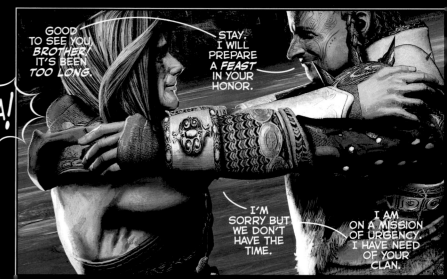

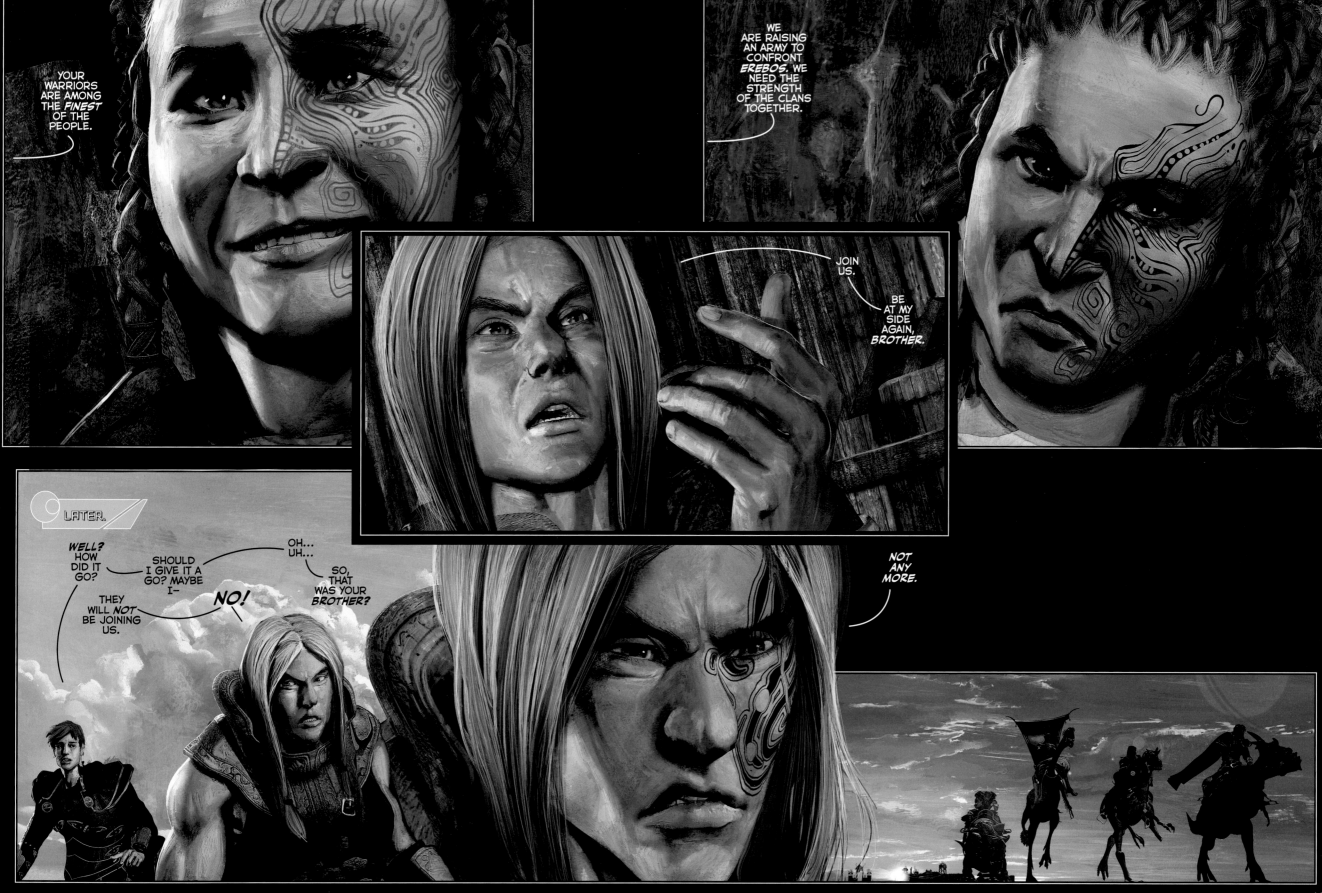

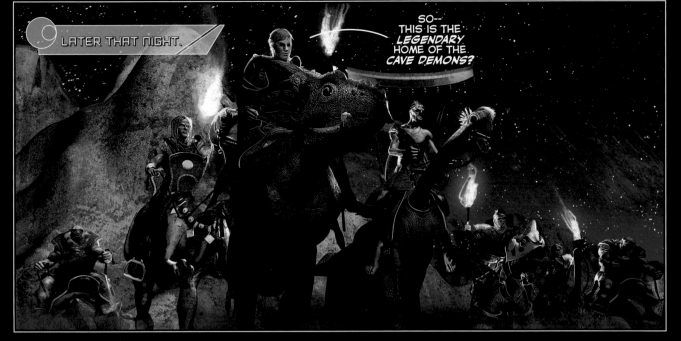

SO-- THIS IS THE *LEGENDARY* HOME OF THE *CAVE DEMONS?*

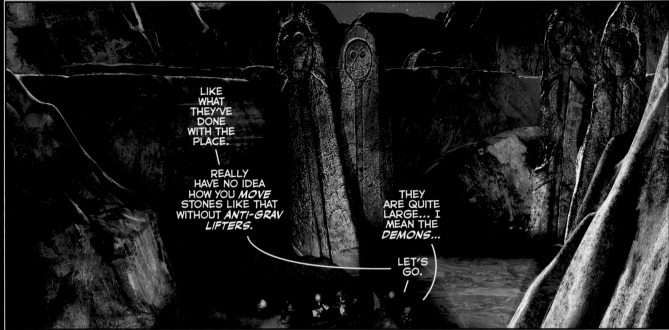

LIKE WHAT THEY'VE DONE WITH THE PLACE.

REALLY HAVE NO IDEA HOW YOU *MOVE* STONES LIKE THAT WITHOUT *ANTI-GRAV LIFTERS.*

THEY ARE QUITE *LARGE...* I MEAN THE *DEMONS...*

LET'S *GO.*

WHAT ARE YOU WAITING FOR?

REALLY?

OKAY...

I WILL BE STAYING HERE... TO *GUARD* THE ANIMALS.

AS WILL I... UH... TO KEEP THE *ANIMALS* SAFE.

...OKAY...

IF THESE *DEMON* GUYS SCARE *THOSE TWO,* THEN WE *REALLY NEED* TO HAVE THEM ON OUR SIDE.

THEY SCARE *ME* AS WELL, BUT *I* GO WHERE *YOU* GO.

THANKS... AND BETWEEN YOU AND ME, I'M A LITTLE *SCARED* MYSELF.

WHY'D WE HAVE TO DO THIS AT *NIGHT,* ANYWAY?

THAT DOESN'T HELP.

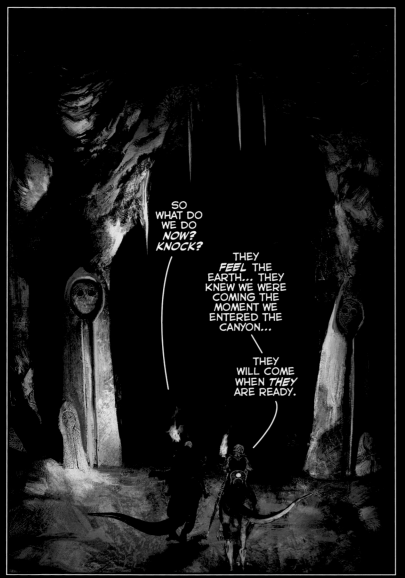

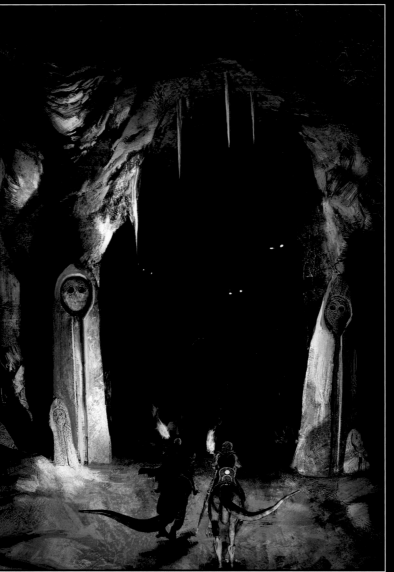

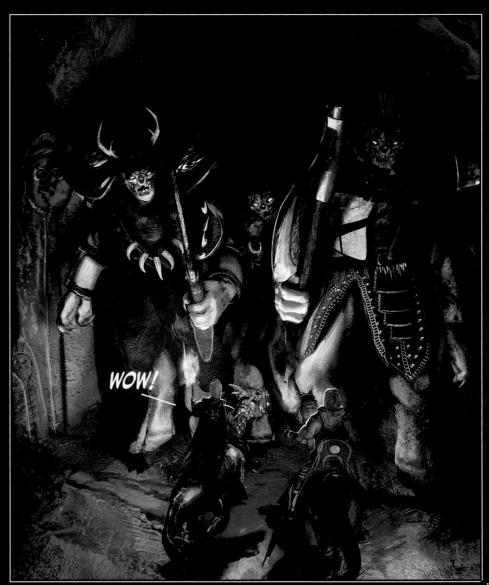

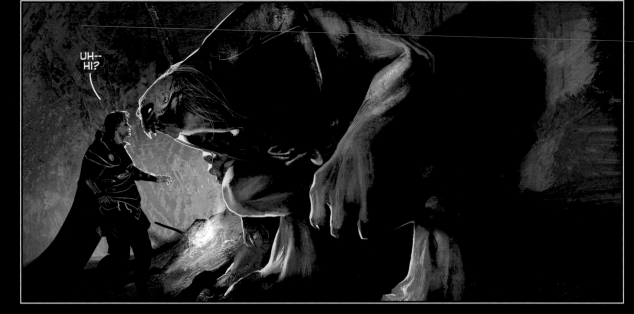

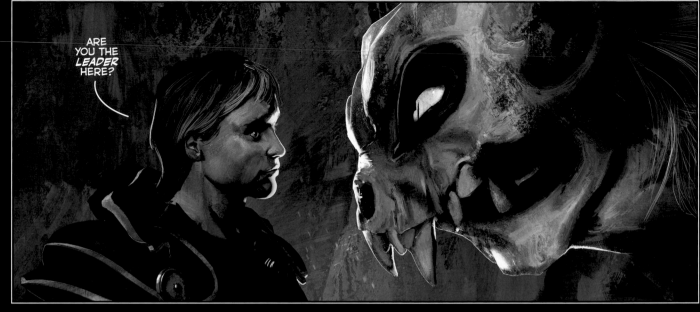

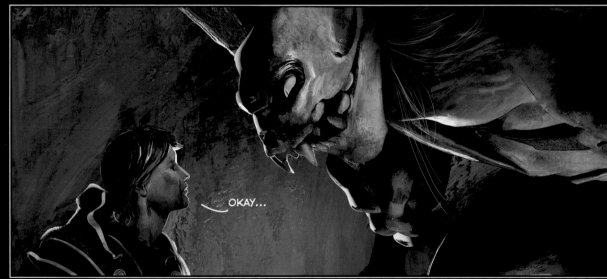

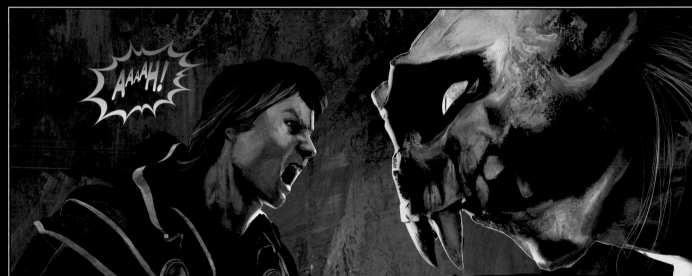

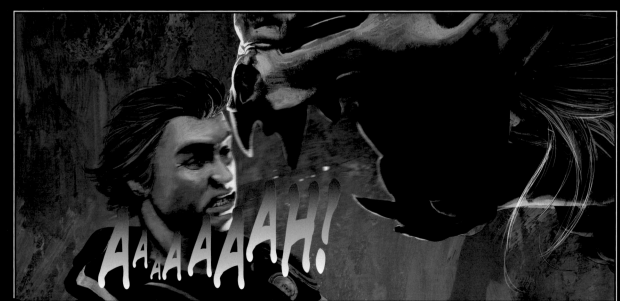

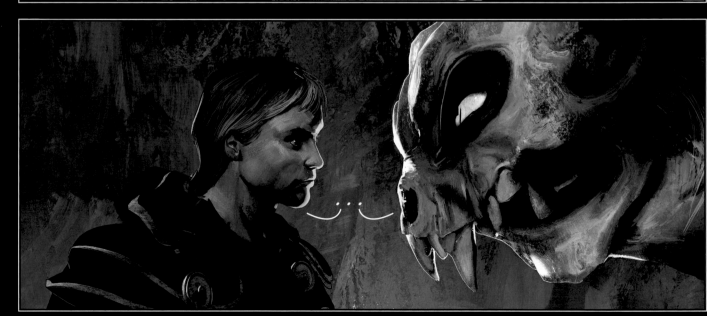

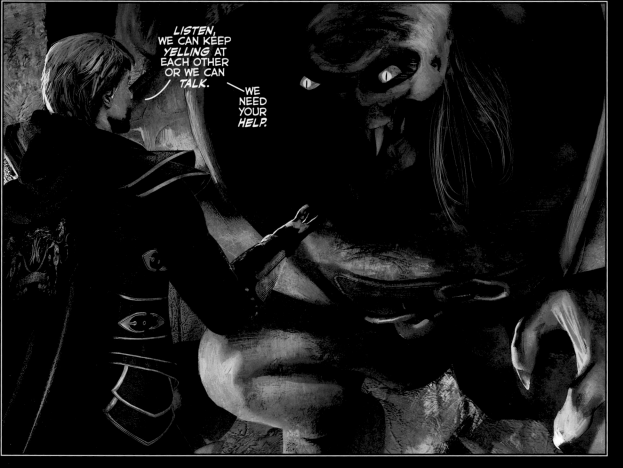

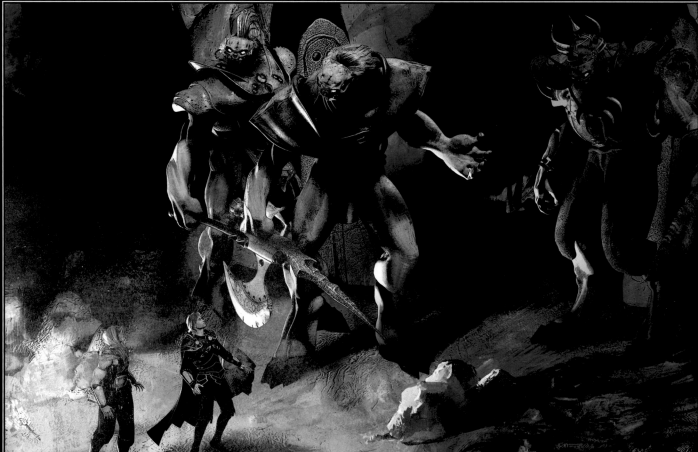

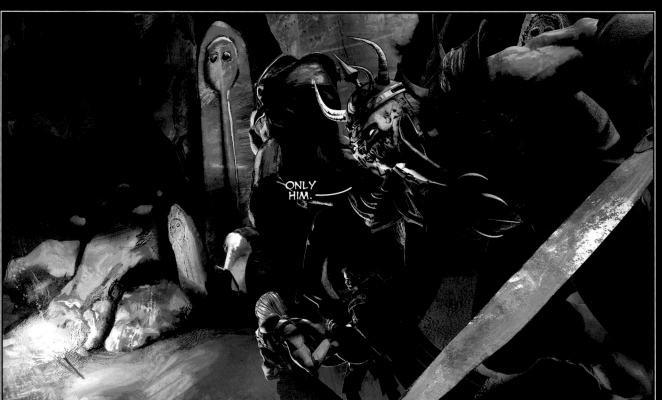

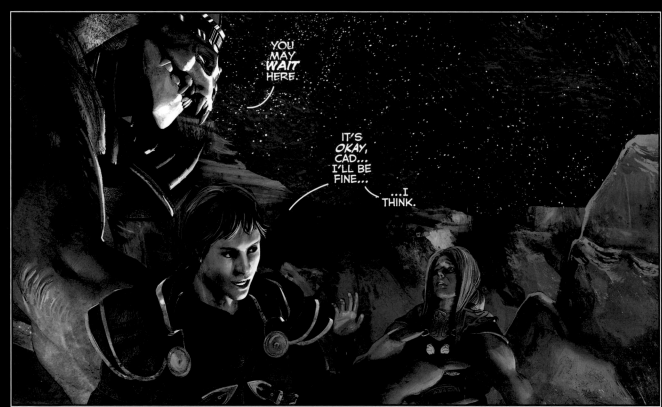

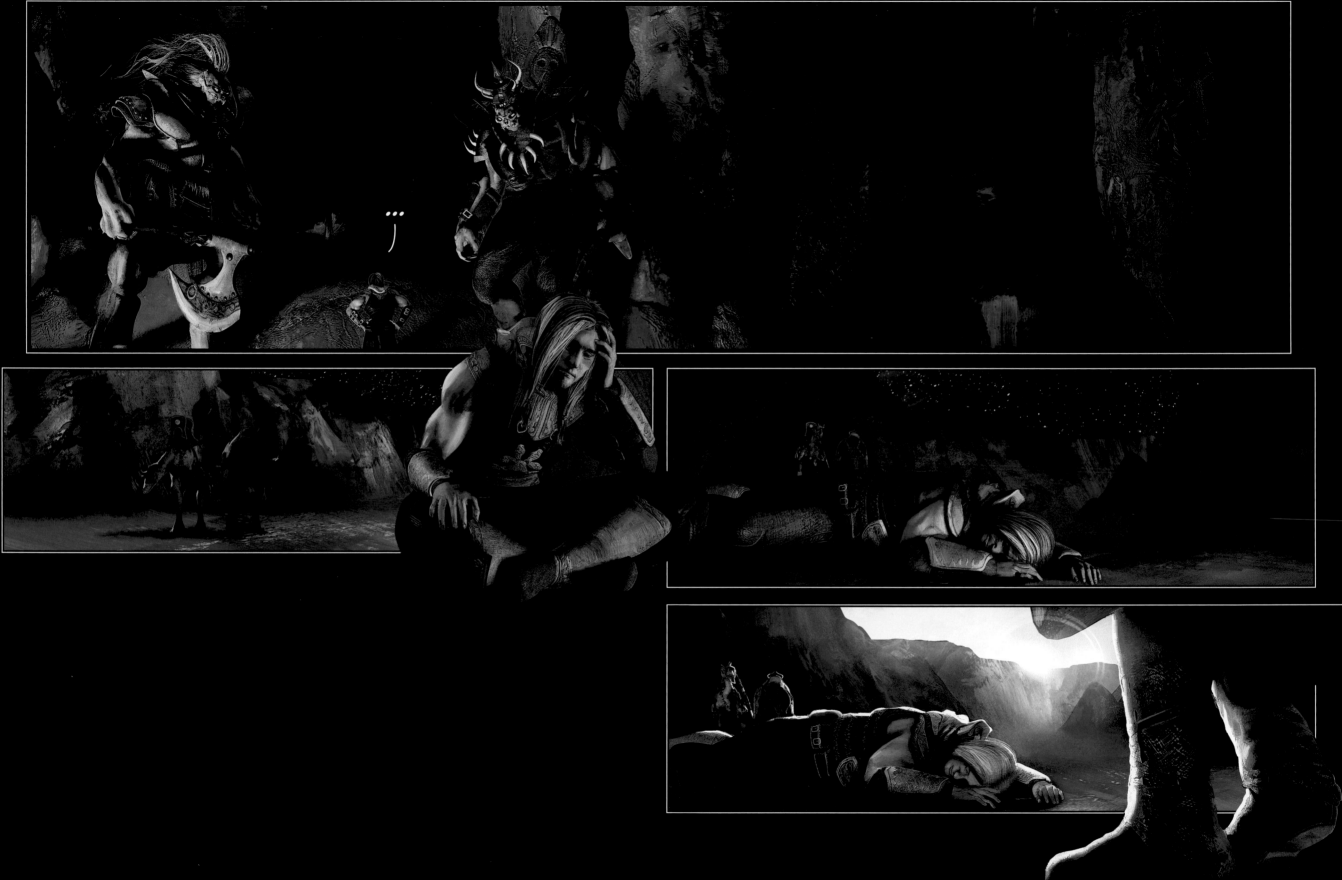

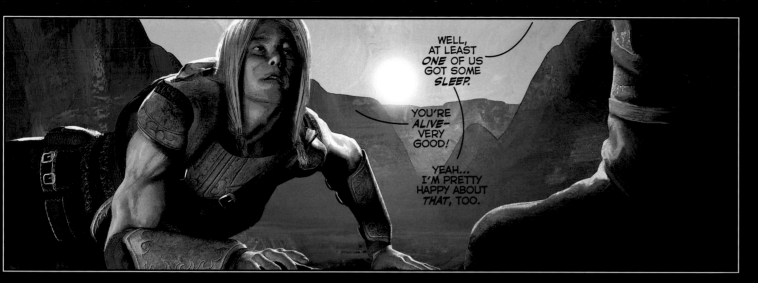

WELL, AT LEAST *ONE* OF US GOT SOME *SLEEP.*

YOU'RE *ALIVE—VERY GOOD!*

YEAH... I'M PRETTY HAPPY ABOUT *THAT,* TOO.

HMMM... WELL... THAT *MIGHT* JUST WORK... WITH A TWIST THAT IS...

HOPEFULLY, TONNI WILL HAVE SOME SURPRISES FOR US WHEN WE GET BACK TO THE VILLAGE...

AND I THINK YOU'D LIKE TO HEAR ABOUT SOME BATTLES FROM OUR WORLD...

OLD TACTICS THERE, BUT BRAND NEW HERE.

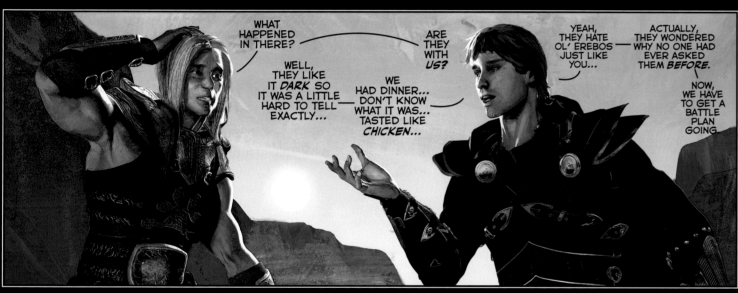

WHAT HAPPENED IN THERE?

WELL, THEY LIKE IT *DARK* SO IT WAS A LITTLE HARD TO TELL EXACTLY...

WE HAD DINNER... DON'T KNOW WHAT IT WAS... TASTED LIKE *CHICKEN*...

ARE THEY WITH *US?*

YEAH, THEY HATE OL' EREBOS JUST LIKE YOU...

ACTUALLY, THEY WONDERED WHY NO ONE HAD EVER ASKED THEM *BEFORE.*

NOW, WE HAVE TO GET A BATTLE PLAN GOING

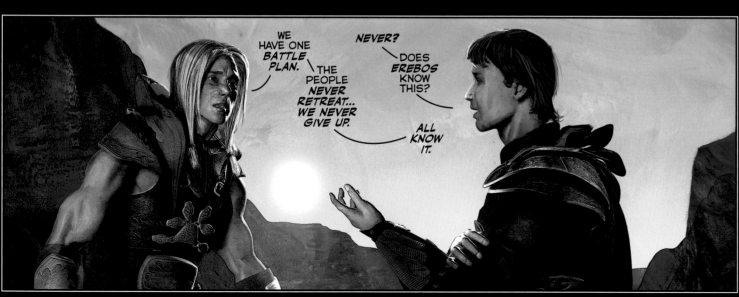

WE HAVE ONE *BATTLE PLAN.*

THE PEOPLE *NEVER* RETREAT... WE NEVER GIVE UP.

NEVER?

DOES *EREBOS* KNOW THIS?

ALL KNOW IT.

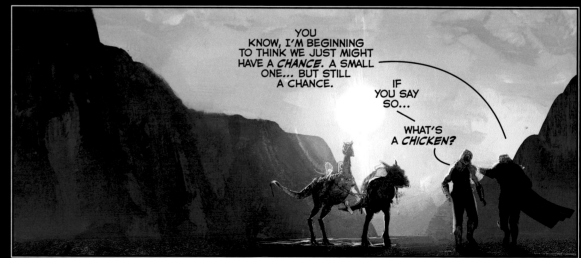

YOU KNOW, I'M BEGINNING TO THINK WE JUST MIGHT HAVE A *CHANCE.* A SMALL ONE... BUT STILL A CHANCE.

IF YOU SAY SO...

WHAT'S A *CHICKEN?*

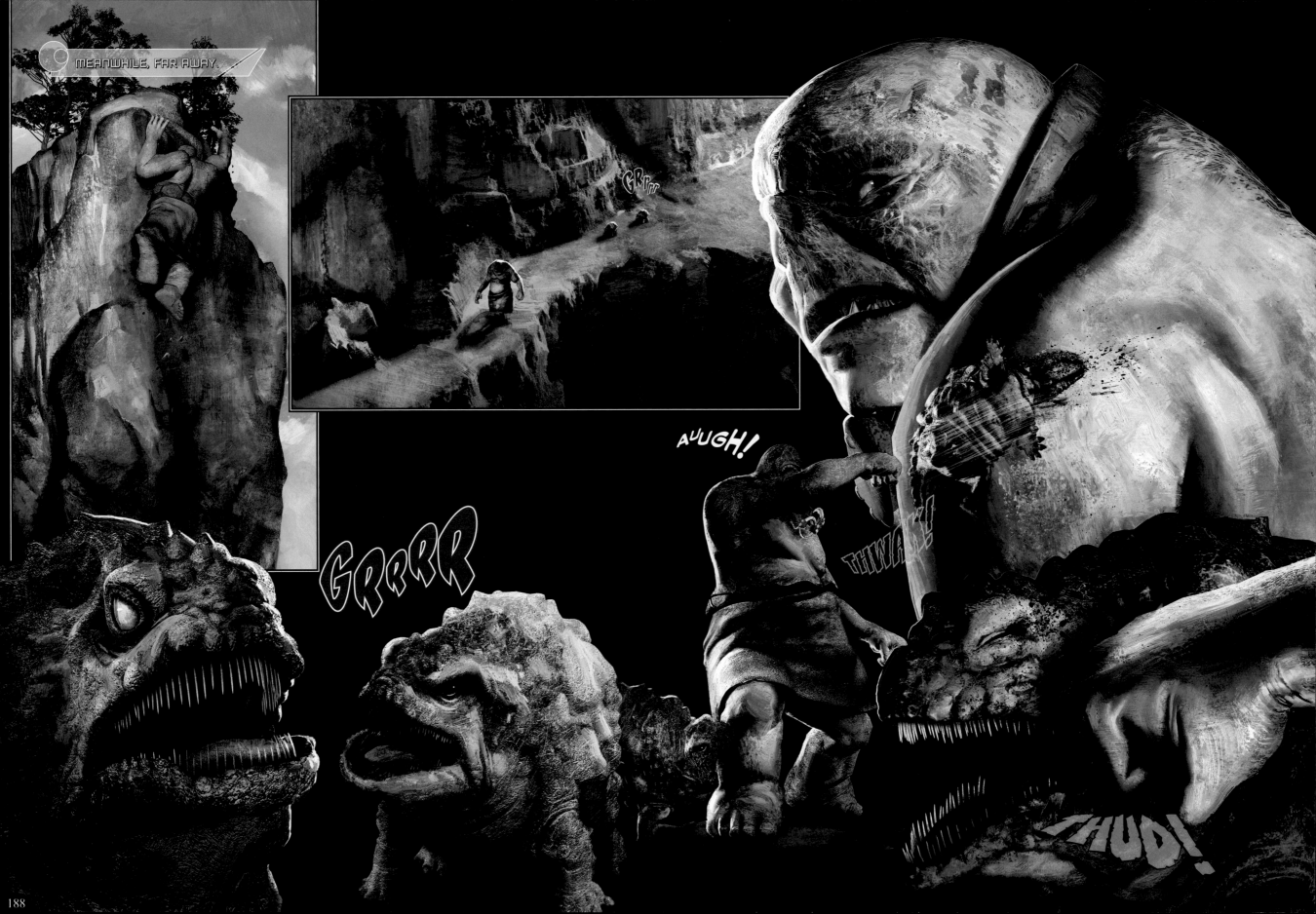

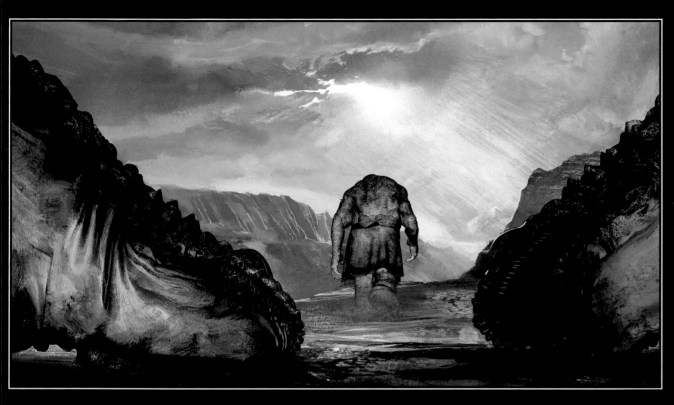
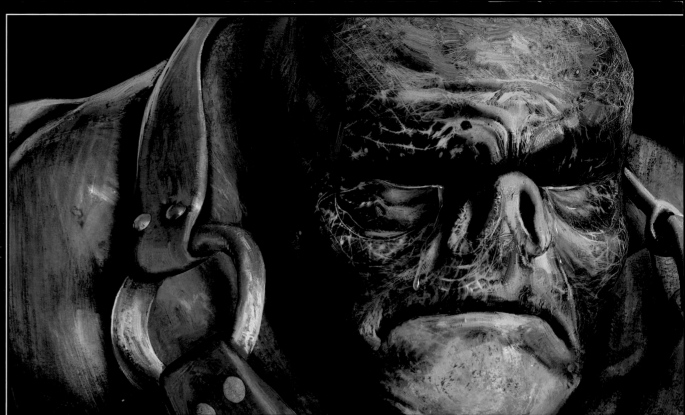

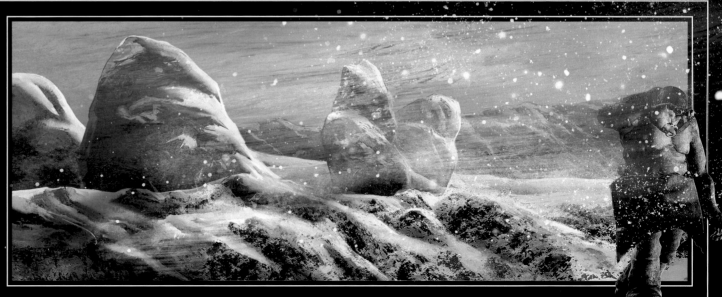

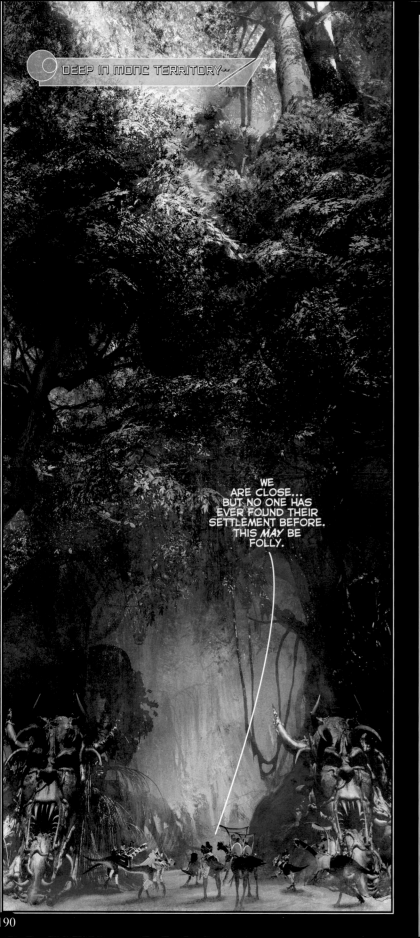

WE ARE CLOSE... BUT NO ONE HAS EVER FOUND THEIR SETTLEMENT BEFORE. THIS *MAY* BE FOLLY.

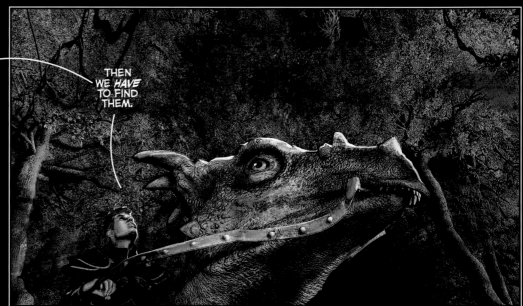

THEY'RE THE SECOND LARGEST ARMY HERE, RIGHT?

THEN WE *HAVE* TO FIND THEM.

JUST BEAUTIFUL.

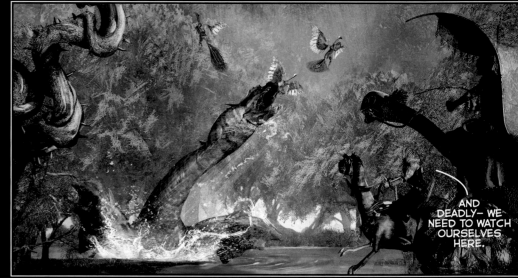

AND DEADLY— WE NEED TO WATCH OURSELVES HERE.

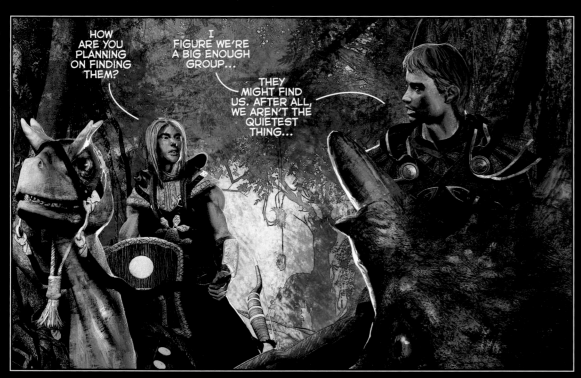

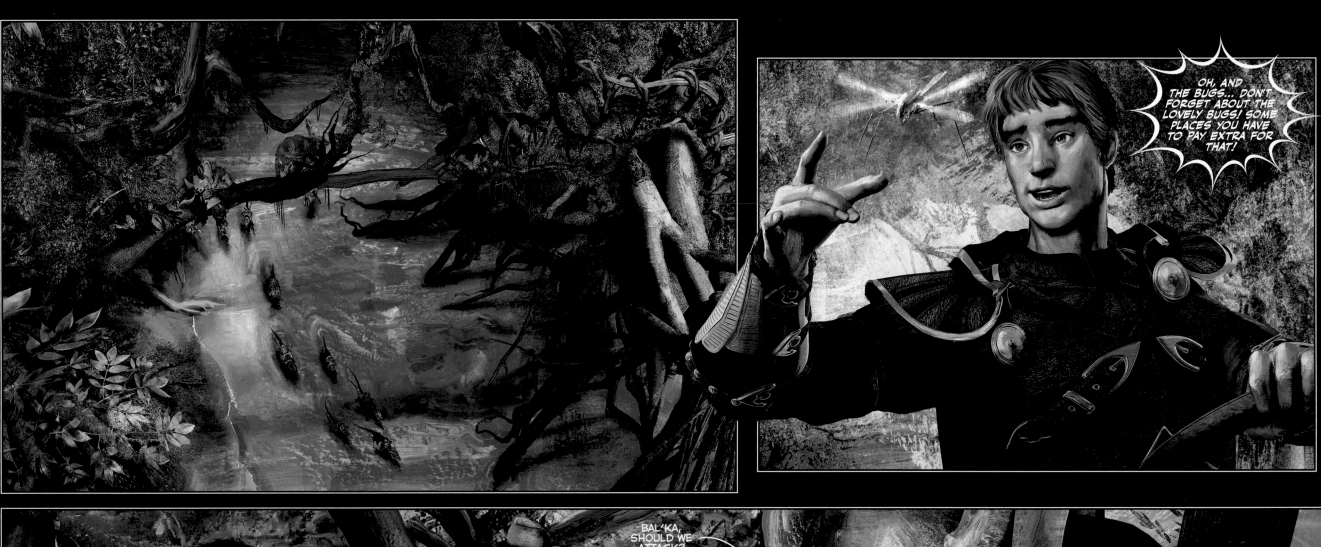

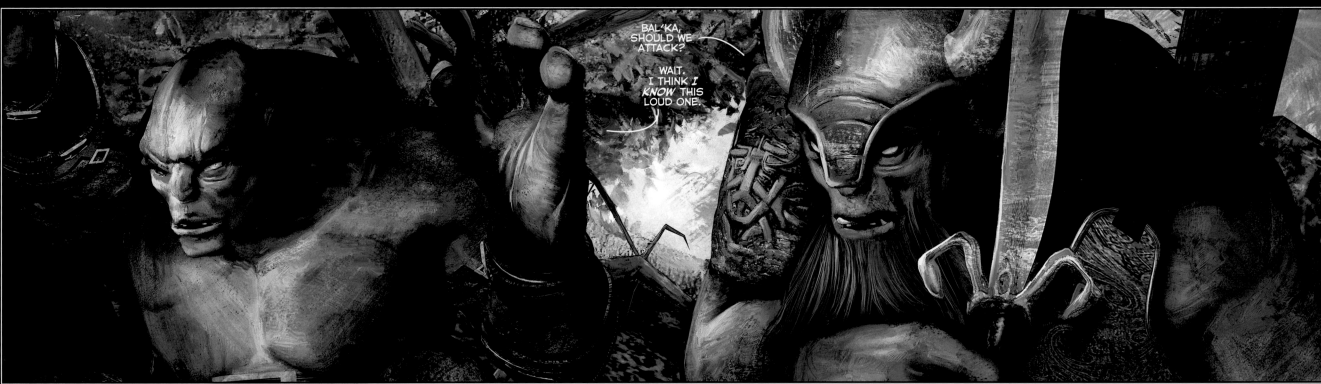

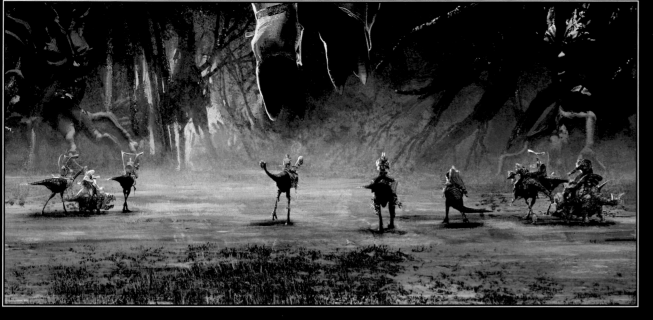

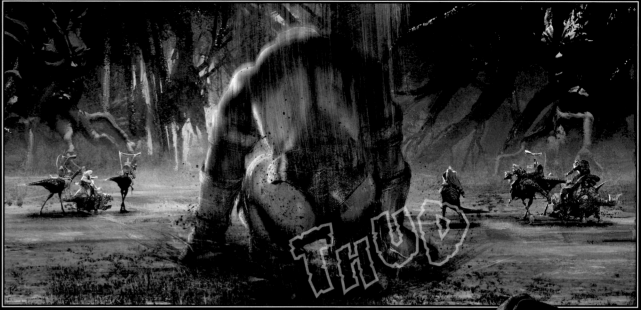

THUD

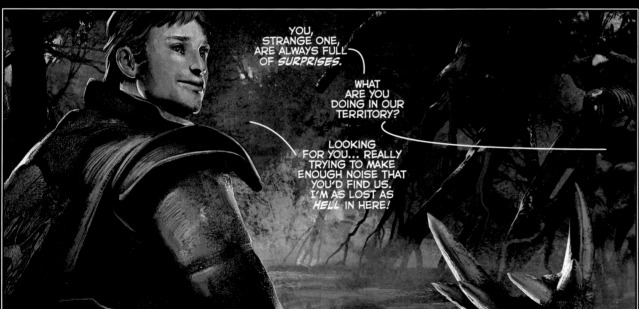

YOU, STRANGE ONE, ARE ALWAYS FULL OF *SURPRISES.*

WHAT ARE YOU DOING IN OUR TERRITORY?

LOOKING FOR YOU... REALLY TRYING TO MAKE ENOUGH NOISE THAT YOU'D FIND US. I'M AS LOST AS *HELL* IN HERE!

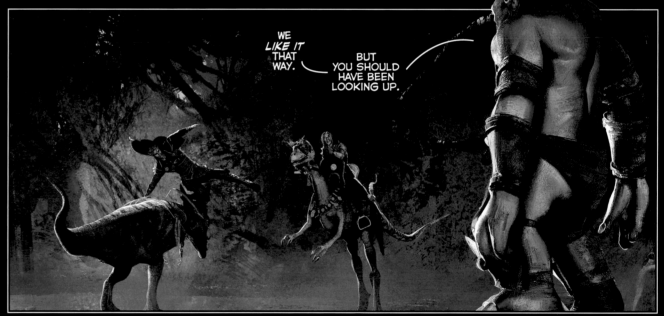

WE *LIKE IT* THAT WAY.

BUT YOU SHOULD HAVE BEEN LOOKING UP.

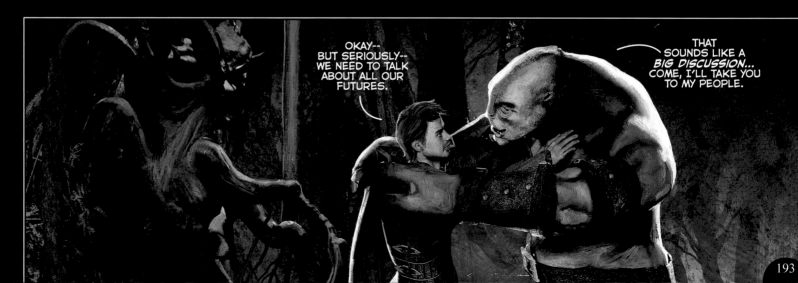

OKAY-- BUT SERIOUSLY-- WE NEED TO TALK ABOUT ALL OUR FUTURES.

THAT SOUNDS LIKE A *BIG DISCUSSION...* COME, I'LL TAKE YOU TO MY PEOPLE.

193

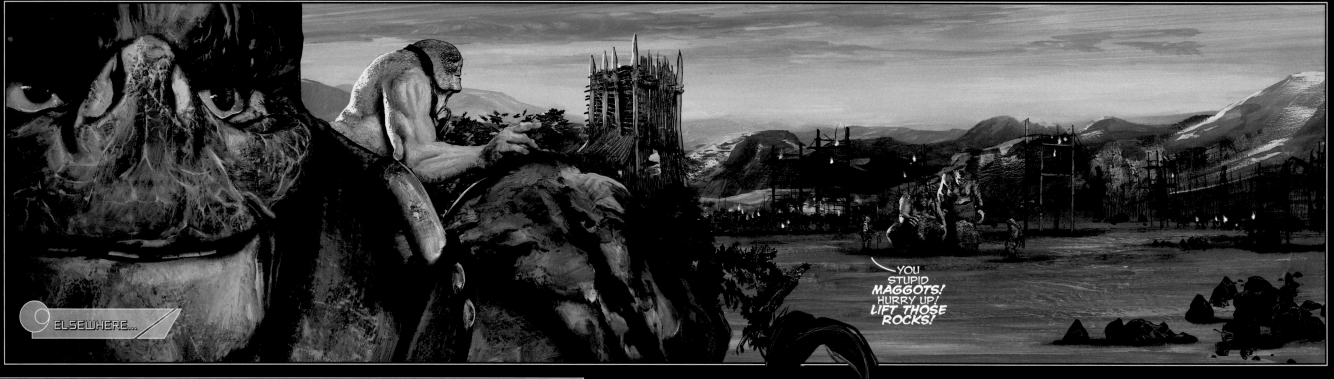

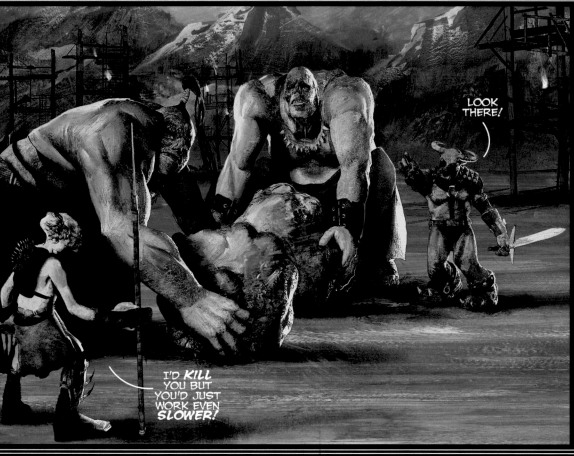

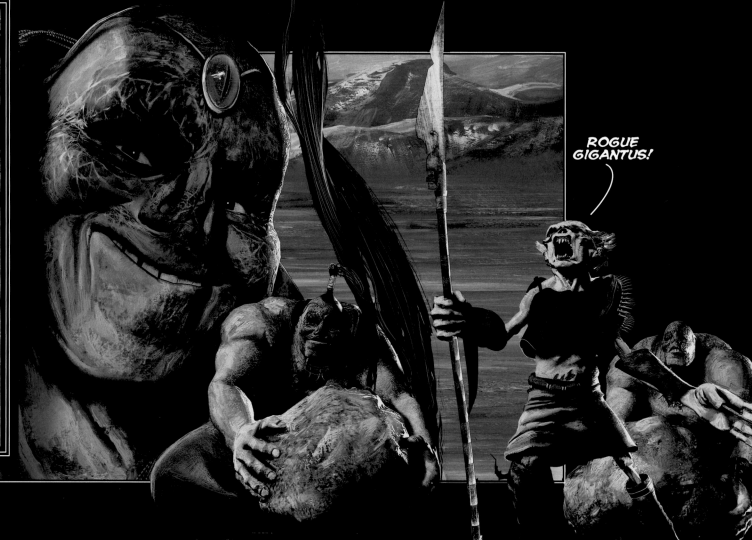

94

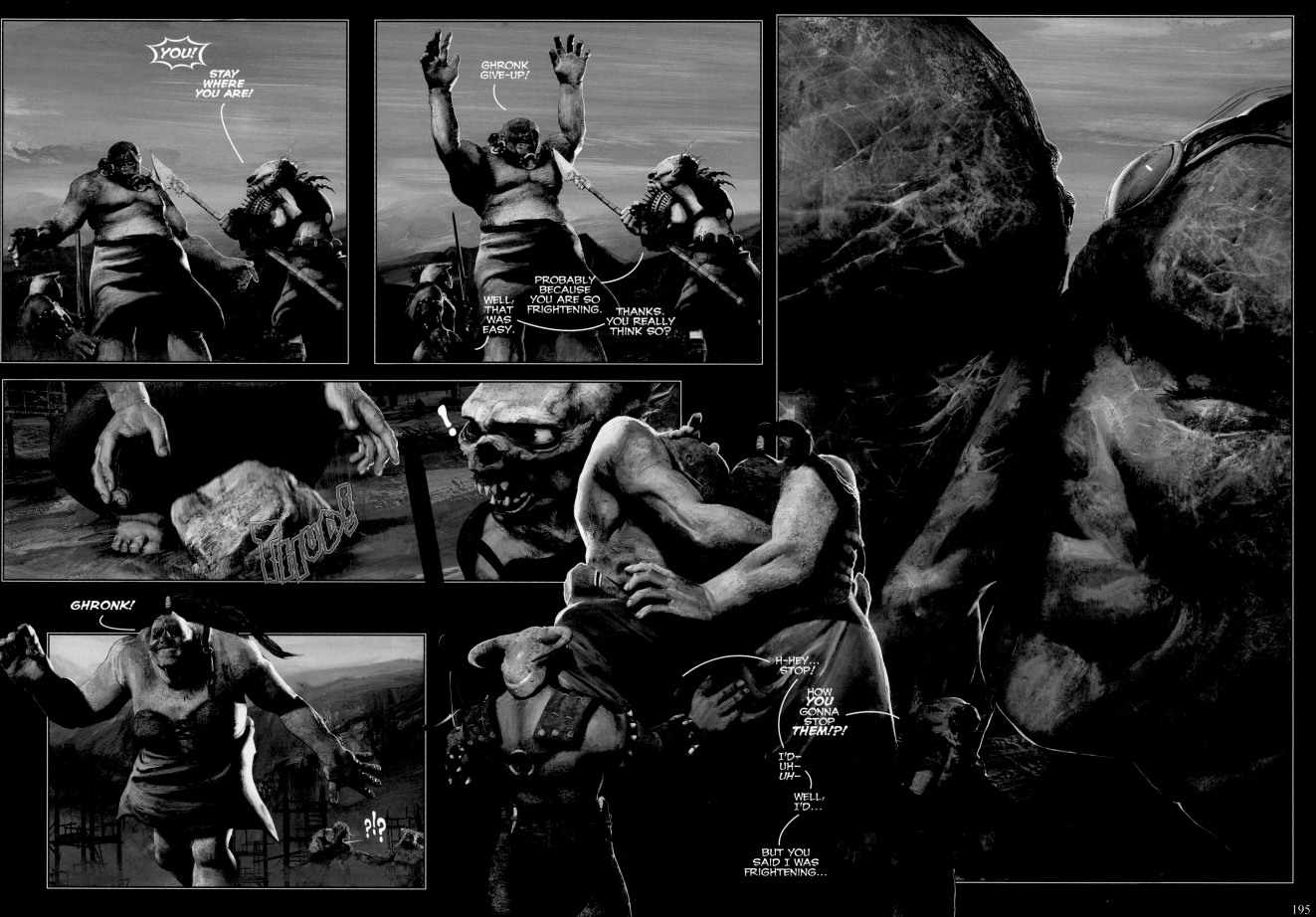

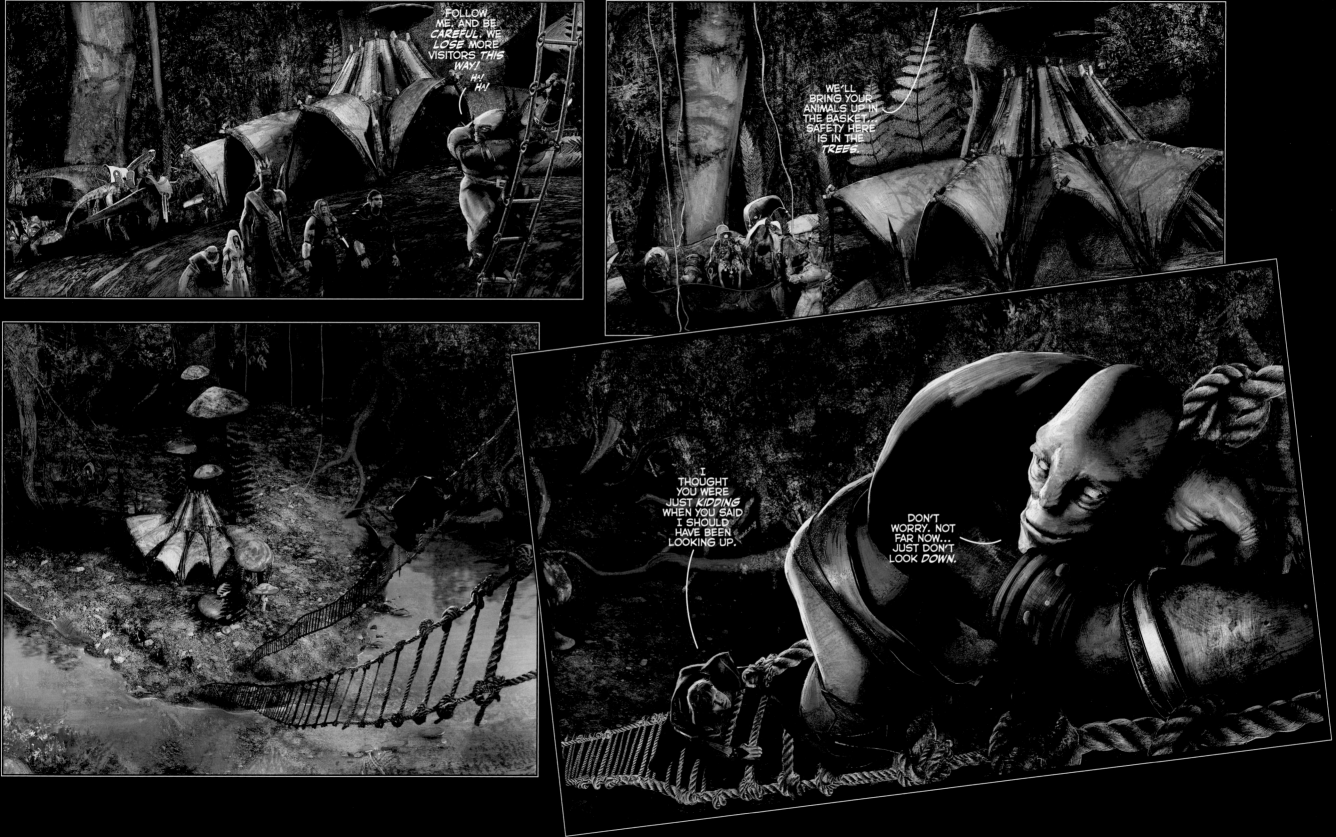

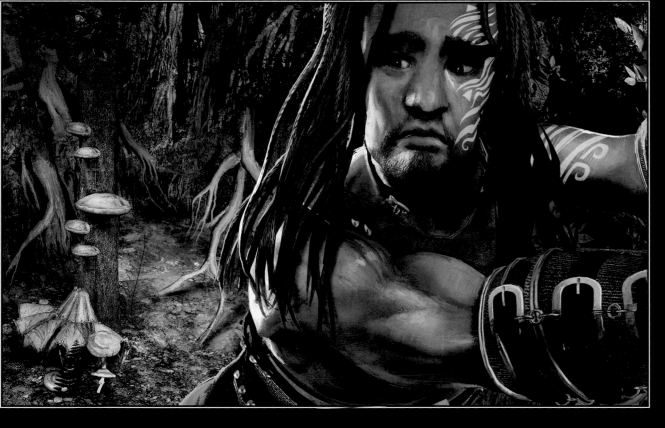
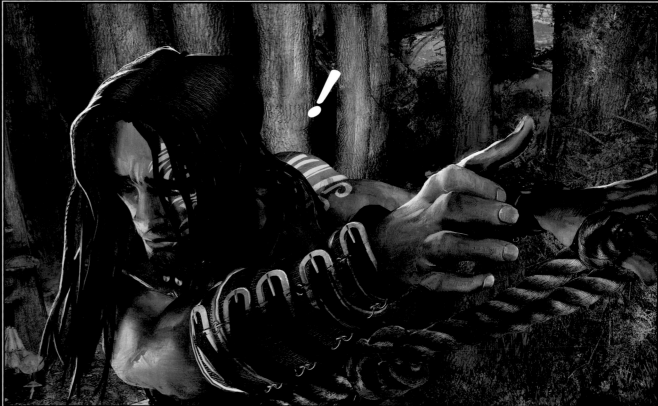
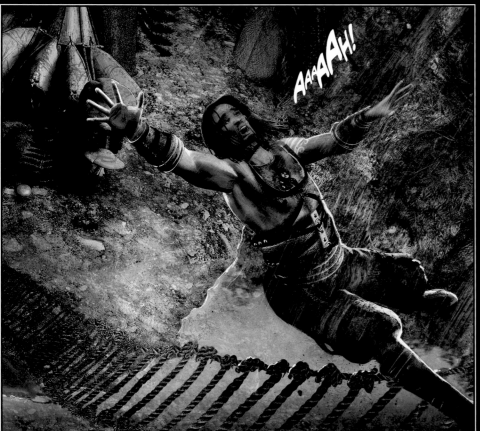

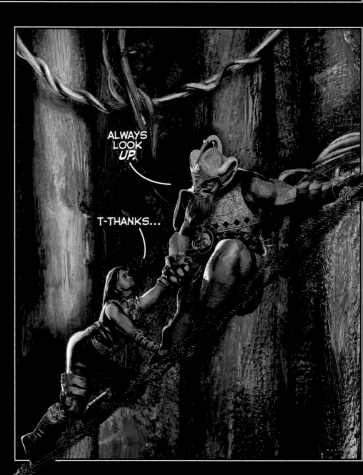

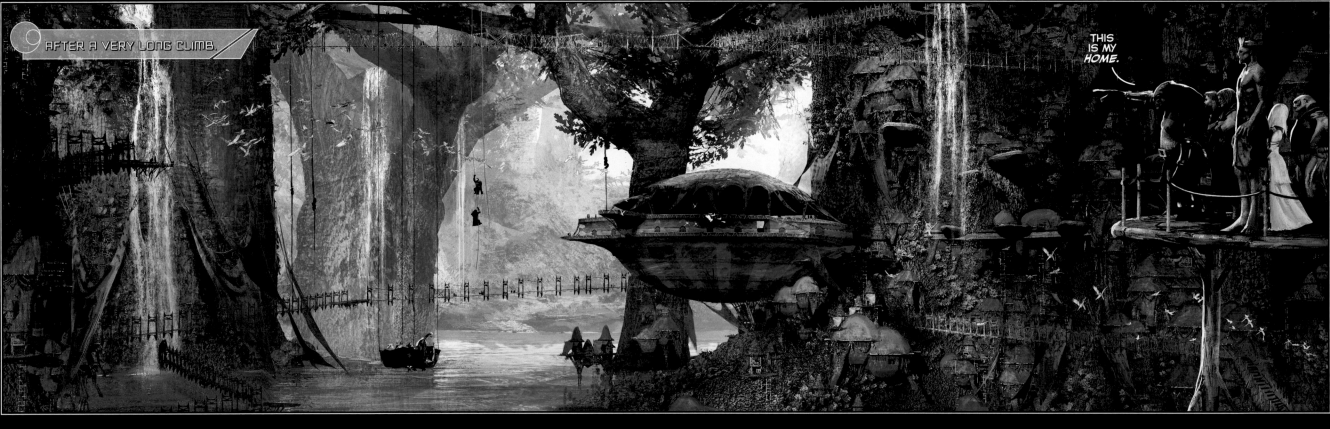

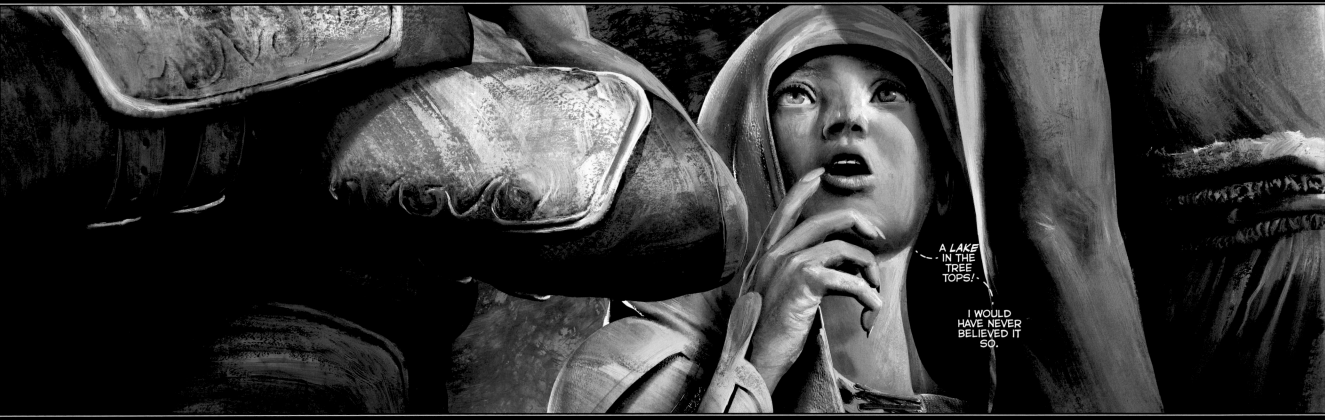

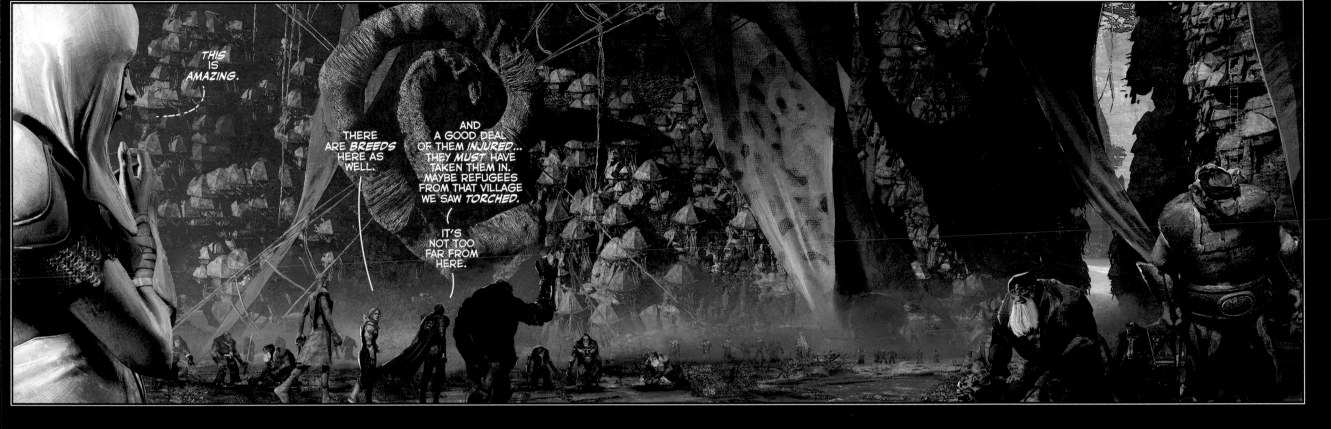

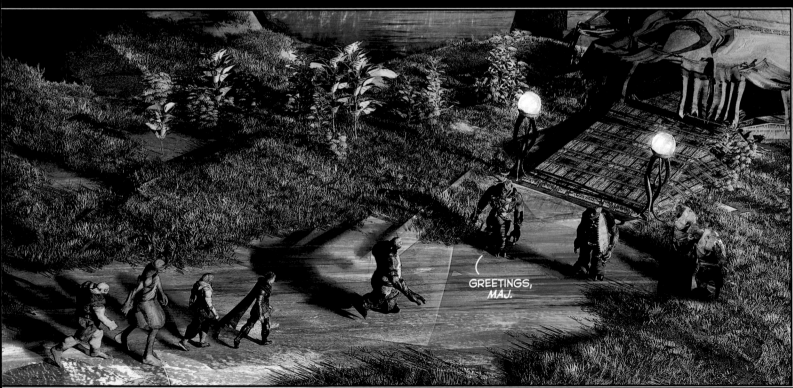

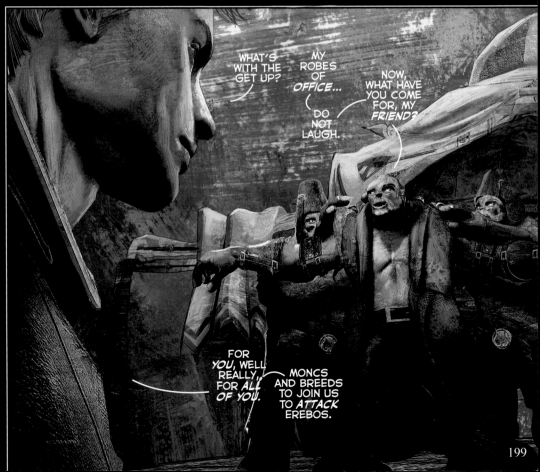

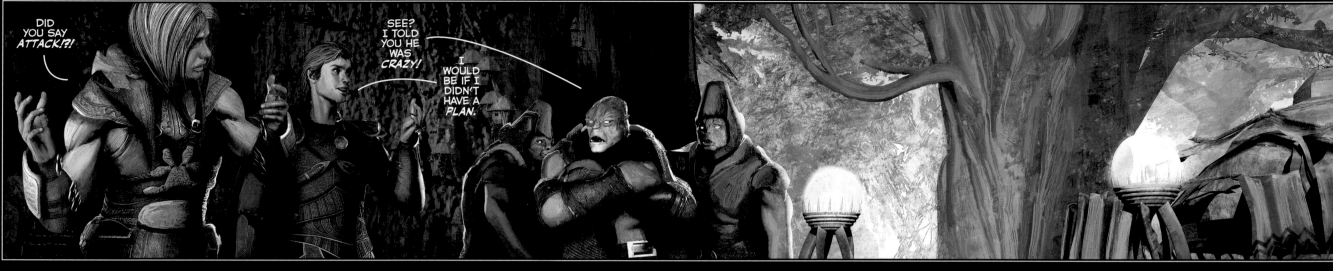

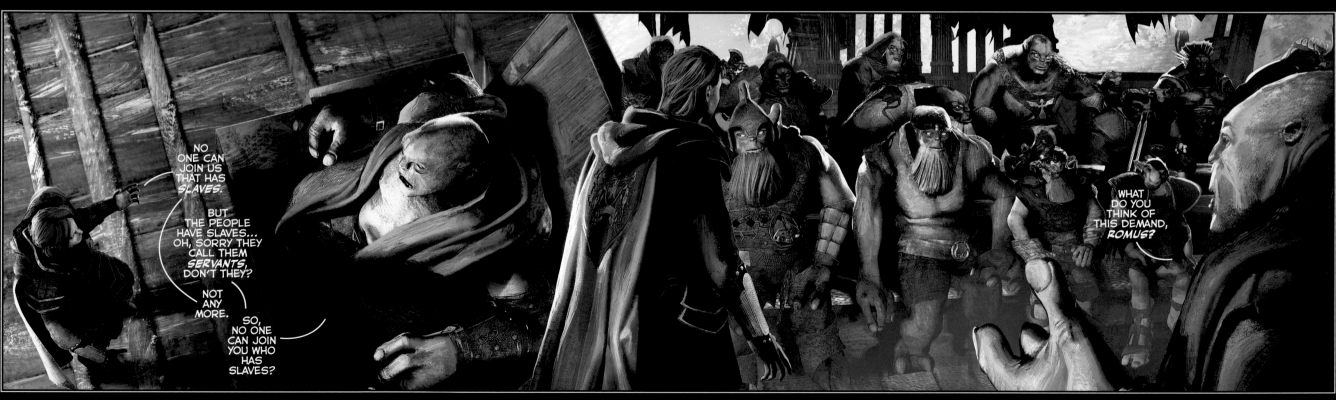

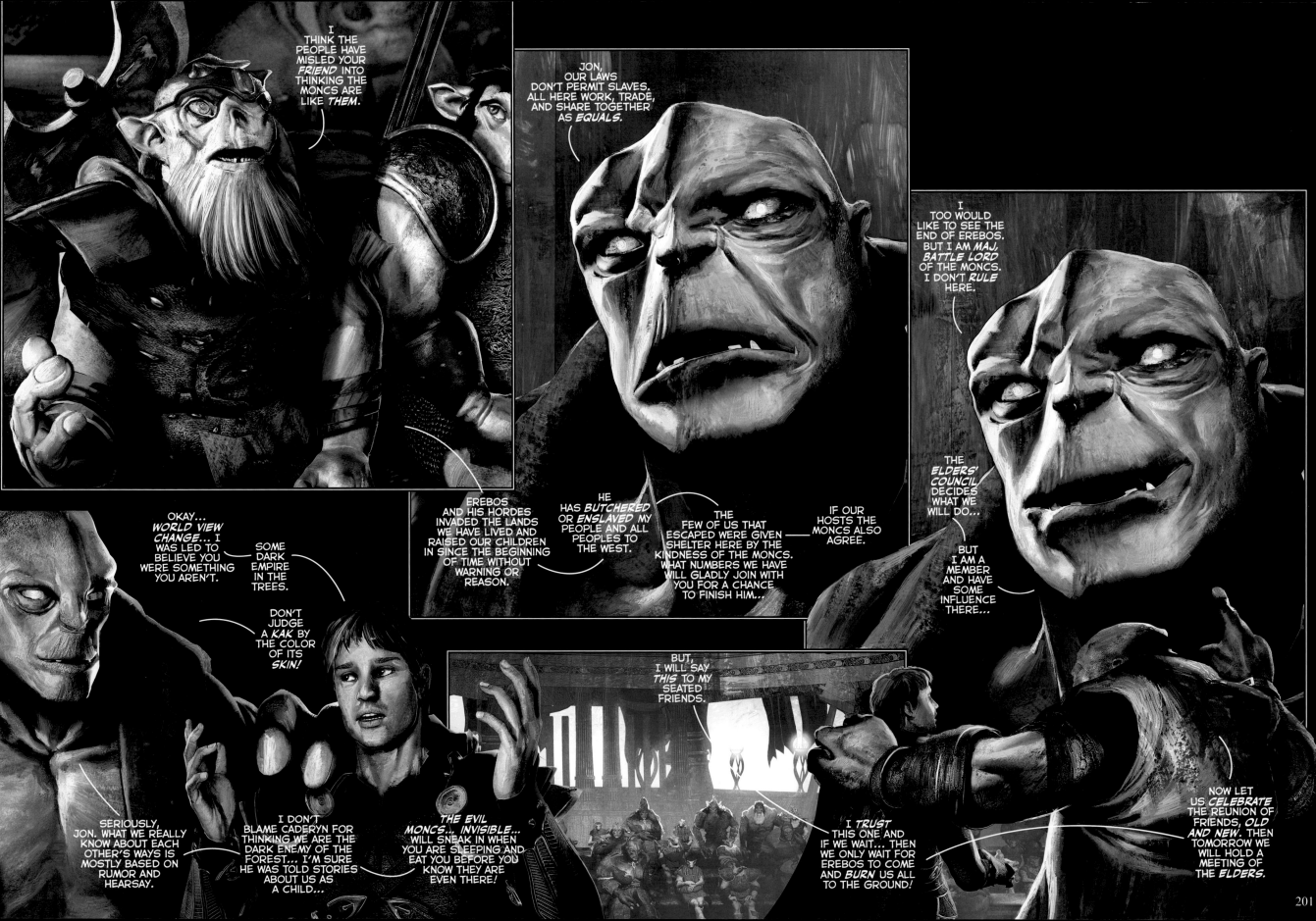

I THINK THE PEOPLE HAVE MISLED YOUR *FRIEND* INTO THINKING THE MONCS ARE LIKE *THEM*.

JON, OUR LAWS DON'T PERMIT SLAVES. ALL HERE WORK, TRADE, AND SHARE TOGETHER AS *EQUALS*.

I TOO WOULD LIKE TO SEE THE END OF EREBOS. BUT I AM *MAJ*, *BATTLE LORD* OF THE MONCS. I DON'T *RULE* HERE.

THE ELDERS' COUNCIL DECIDES WHAT WE WILL DO...

BUT I AM A MEMBER AND HAVE SOME INFLUENCE THERE...

OKAY... *WORLD VIEW CHANGE...* I WAS LED TO BELIEVE YOU WERE SOMETHING YOU AREN'T.

SOME DARK EMPIRE IN THE TREES.

DON'T JUDGE A *KAK* BY THE COLOR OF ITS *SKIN!*

EREBOS AND HIS HORDES INVADED THE LANDS WE HAVE LIVED AND RAISED OUR CHILDREN IN SINCE THE BEGINNING OF TIME WITHOUT WARNING OR REASON.

HE HAS *BUTCHERED* OR *ENSLAVED* MY PEOPLE AND ALL PEOPLES TO THE WEST.

THE FEW OF US THAT ESCAPED WERE GIVEN SHELTER HERE BY THE KINDNESS OF THE MONCS. WHAT NUMBERS WE HAVE WILL GLADLY JOIN WITH YOU FOR A CHANCE TO FINISH HIM...

IF OUR HOSTS THE MONCS ALSO AGREE.

BUT, I WILL SAY *THIS* TO MY SEATED FRIENDS.

SERIOUSLY, JON. WHAT WE REALLY KNOW ABOUT EACH OTHER'S WAYS IS MOSTLY BASED ON RUMOR AND HEARSAY.

I DON'T BLAME CADERYN FOR THINKING WE ARE THE DARK ENEMY OF THE FOREST... I'M SURE HE WAS TOLD STORIES ABOUT US AS A CHILD...

THE EVIL *MONCS...* INVISIBLE... WILL SNEAK IN WHEN YOU ARE SLEEPING AND EAT YOU BEFORE YOU KNOW THEY ARE EVEN THERE!

I *TRUST* THIS ONE AND IF WE WAIT... THEN WE ONLY WAIT FOR EREBOS TO COME AND *BURN* US ALL TO THE GROUND!

NOW LET US *CELEBRATE* THE REUNION OF FRIENDS, *OLD AND NEW*. THEN TOMORROW WE WILL HOLD A MEETING OF THE *ELDERS*.

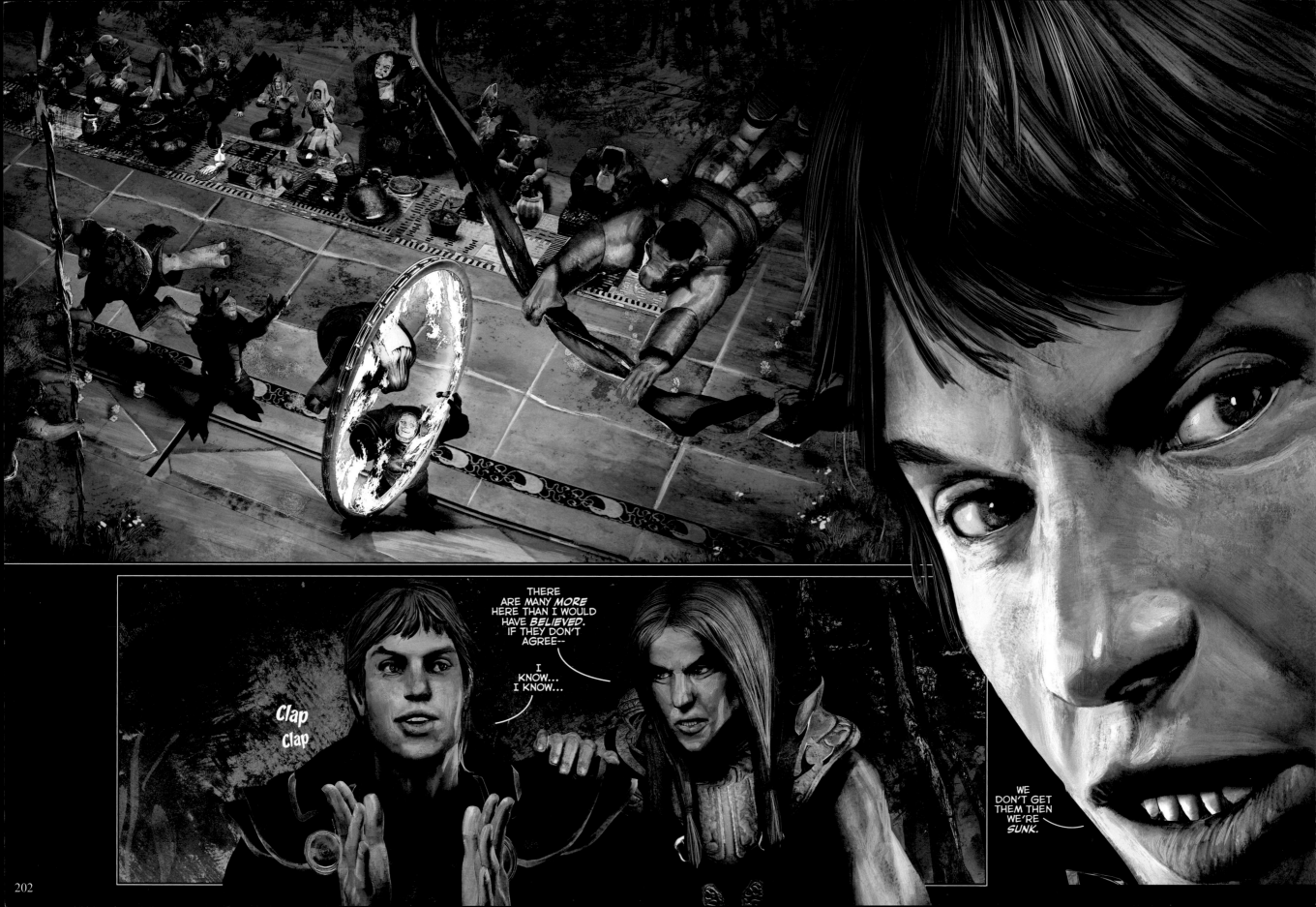

THE ELDERS ARE READY FOR YOU NOW.

... SO THE ELDERS... EARLY RISERS, HUH?

YOU HAVE *NO* IDEA.

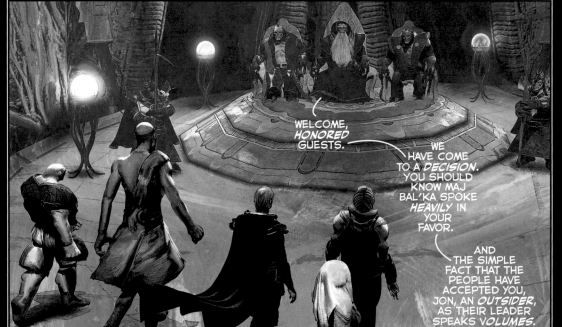

WELCOME, *HONORED* GUESTS.

WE HAVE COME TO A *DECISION.* YOU SHOULD KNOW MAJ BAL'KA SPOKE *HEAVILY* IN YOUR FAVOR.

AND THE SIMPLE FACT THAT THE PEOPLE HAVE ACCEPTED YOU, JON, AN *OUTSIDER*, AS THEIR LEADER SPEAKS *VOLUMES.*

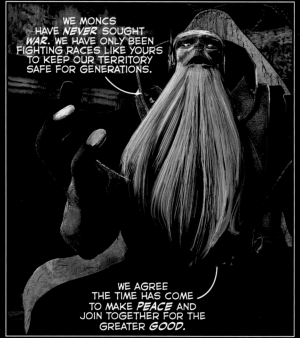

WE MONCS HAVE *NEVER* SOUGHT *WAR.* WE HAVE ONLY BEEN FIGHTING RACES LIKE YOURS TO KEEP OUR TERRITORY SAFE FOR GENERATIONS.

WE AGREE THE TIME HAS COME TO MAKE *PEACE* AND JOIN TOGETHER FOR THE GREATER *GOOD.*

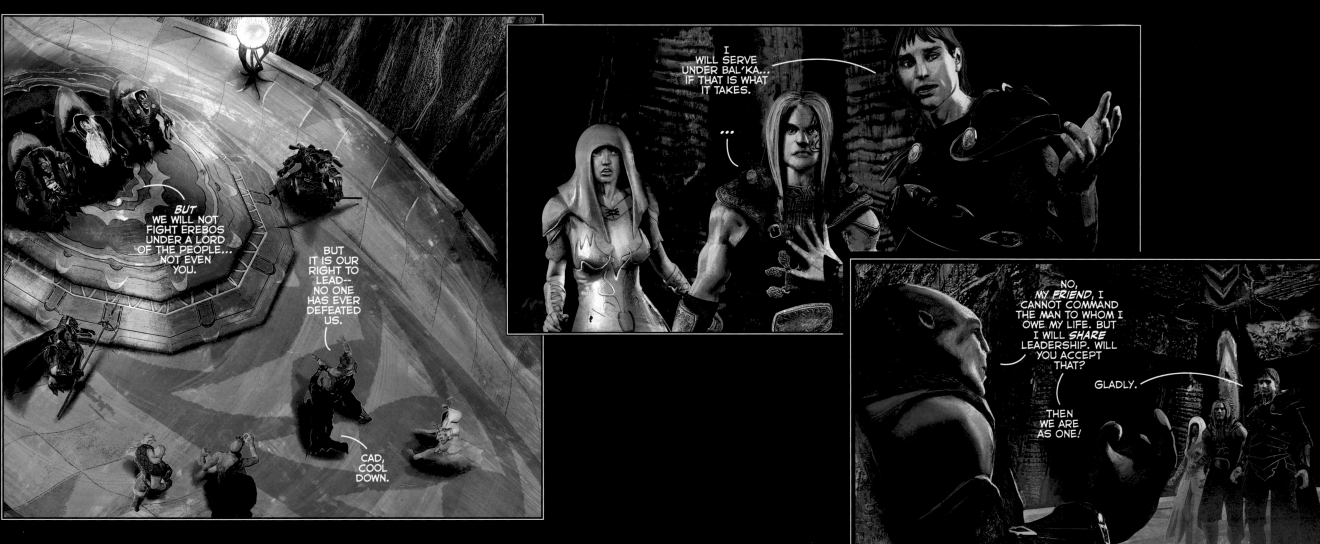

BUT WE WILL NOT FIGHT EREBOS UNDER A LORD OF THE PEOPLE... NOT EVEN YOU.

BUT IT IS OUR RIGHT TO LEAD-- NO ONE HAS EVER DEFEATED US.

CAD, COOL DOWN.

I WILL SERVE UNDER BAL'KA... IF THAT IS WHAT IT TAKES.

...

NO, MY *FRIEND*, I CANNOT COMMAND THE MAN TO WHOM I OWE MY LIFE. BUT I WILL *SHARE* LEADERSHIP. WILL YOU ACCEPT THAT?

GLADLY.

THEN WE ARE AS ONE!

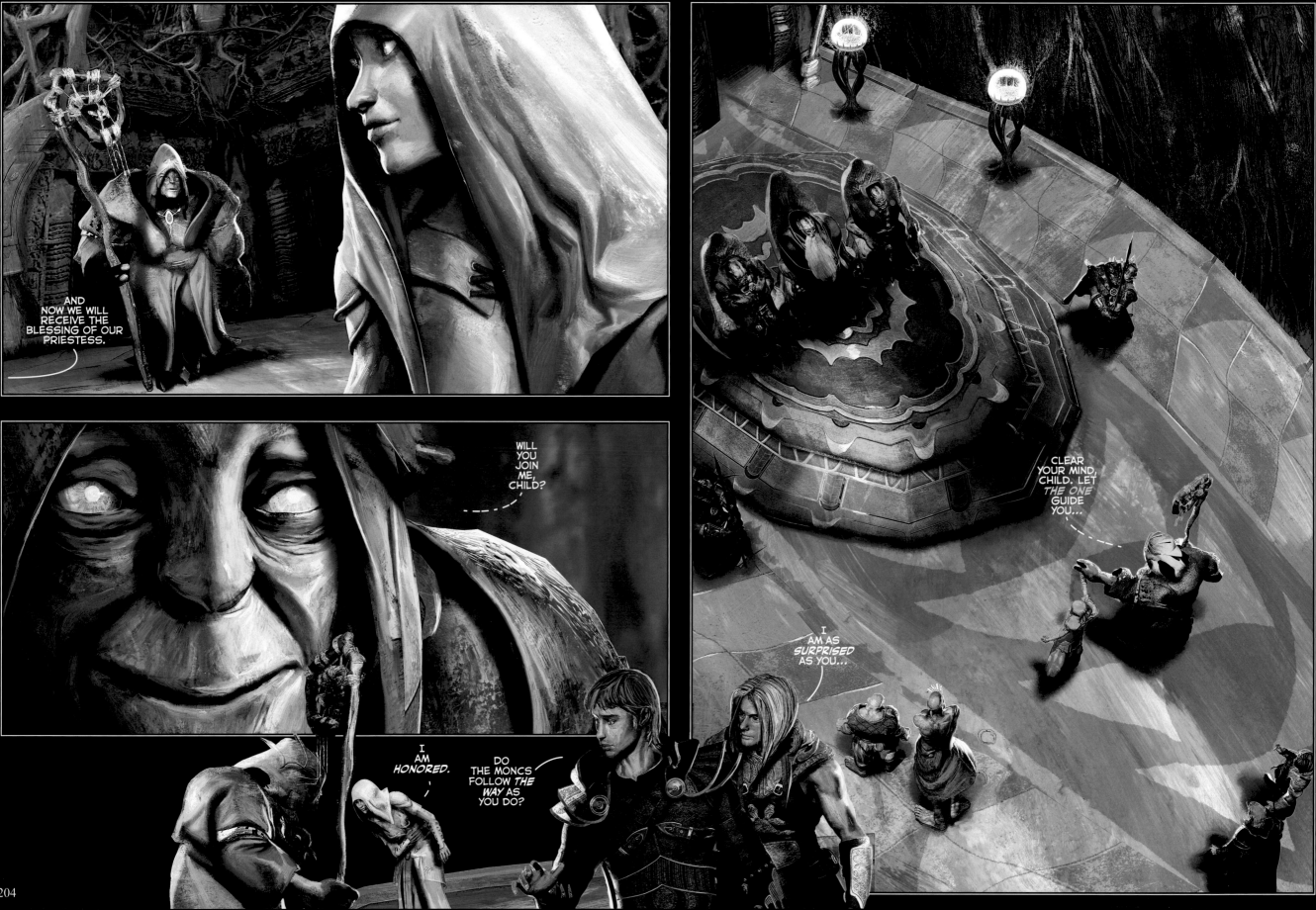

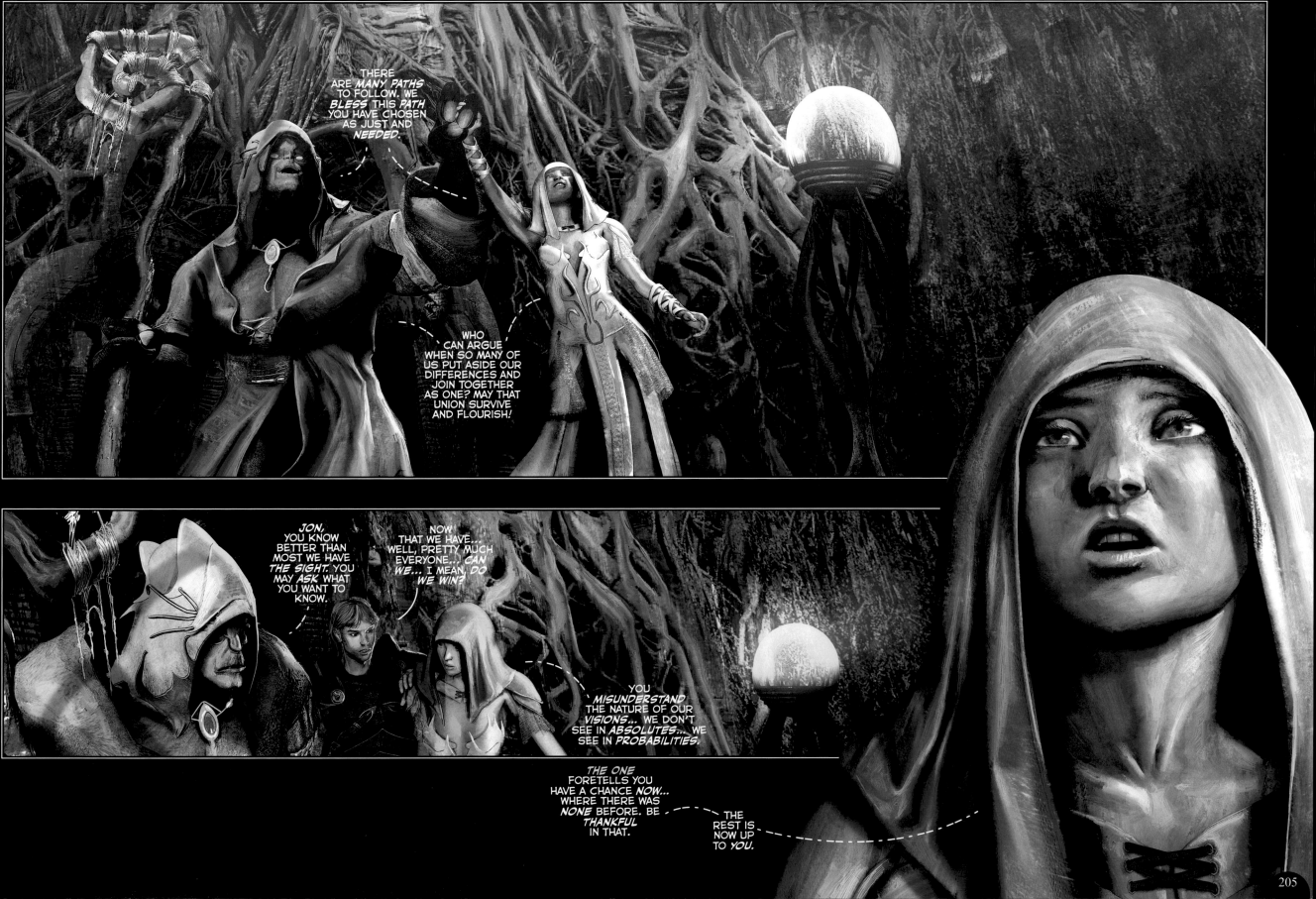

205

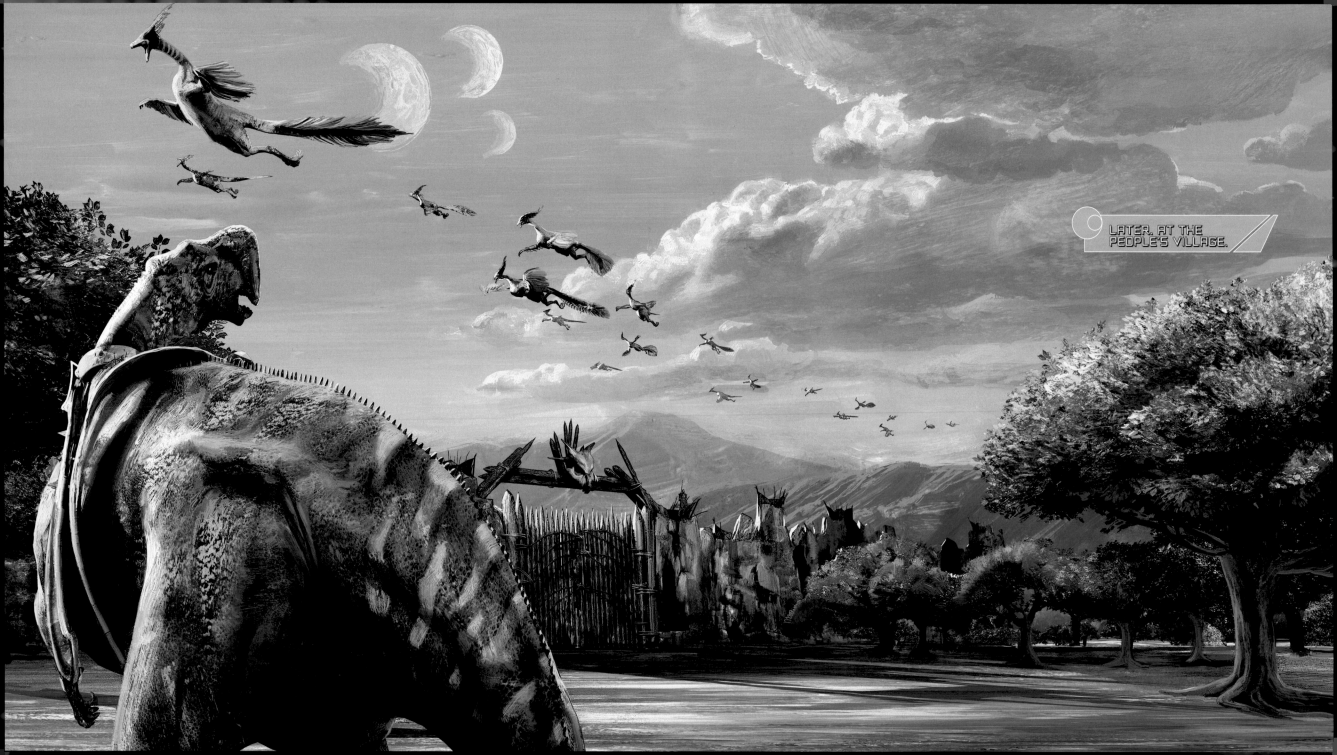
LATER, AT THE PEOPLE'S VILLAGE.

COME ON... SHOW SOME BACKBONE.

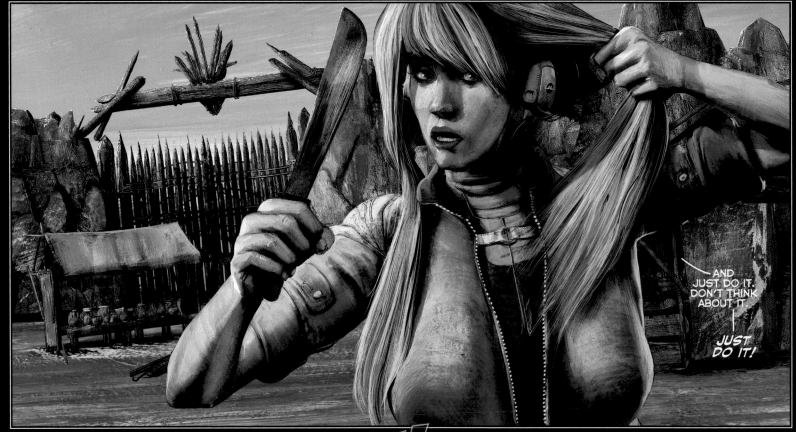

AND JUST DO IT. DON'T THINK ABOUT IT.

JUST DO IT!

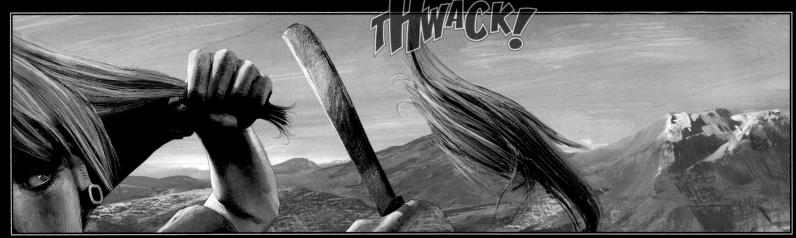

THWACK!

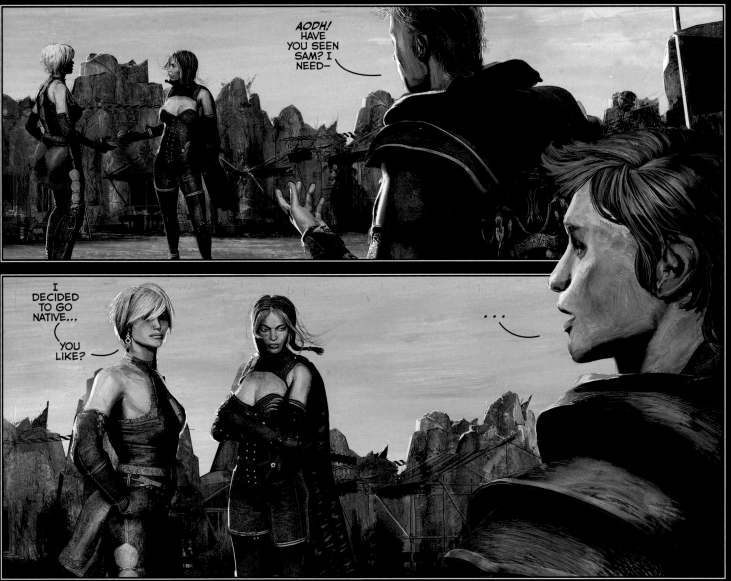

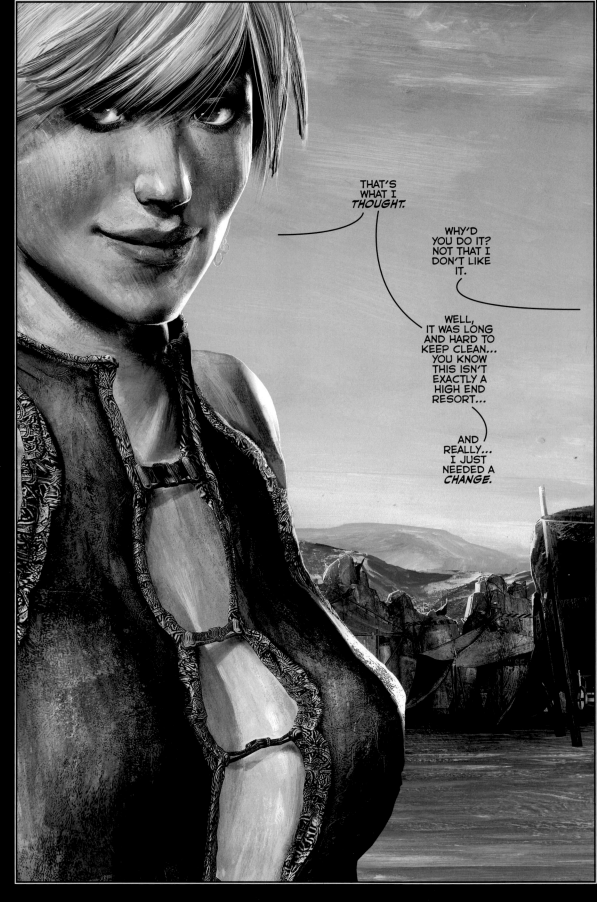

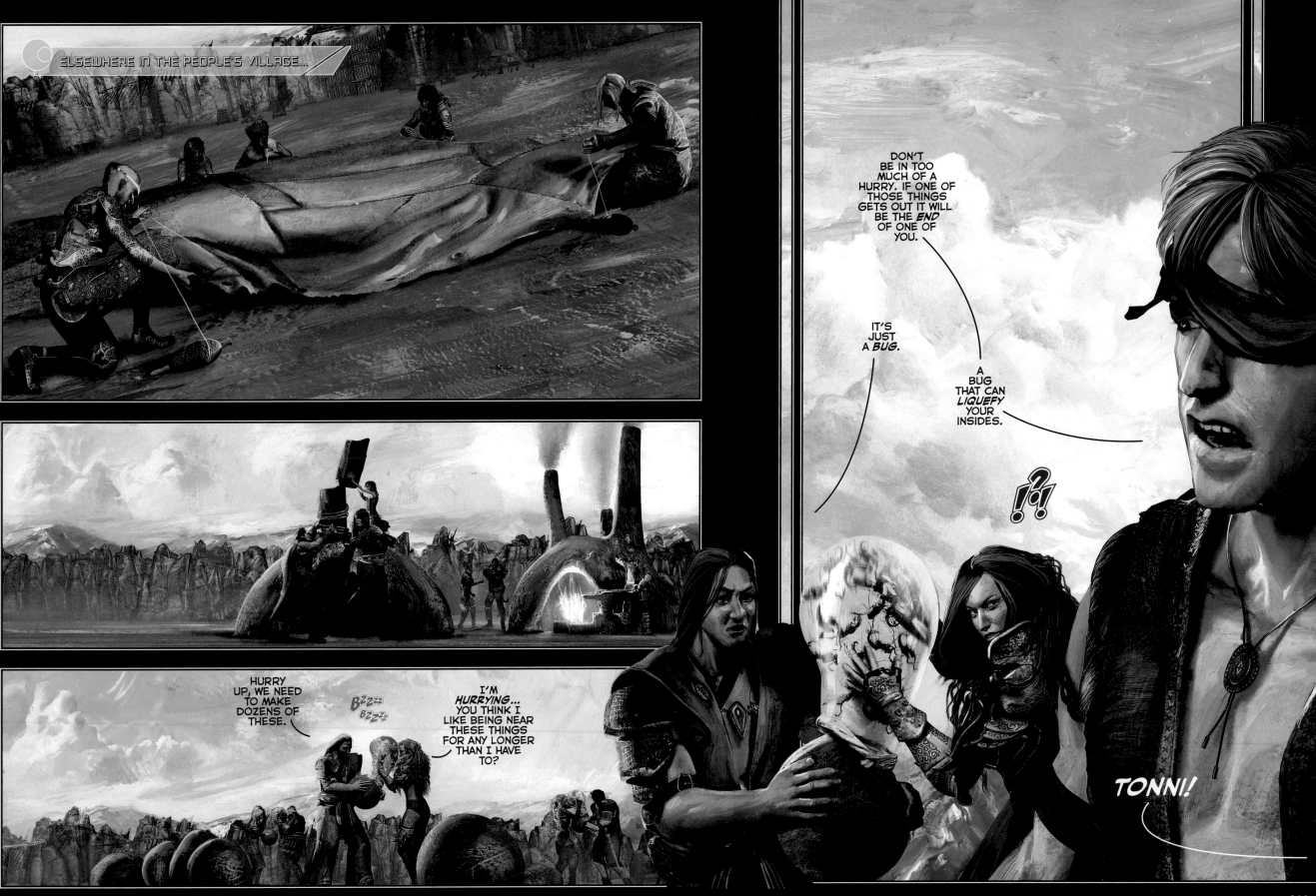

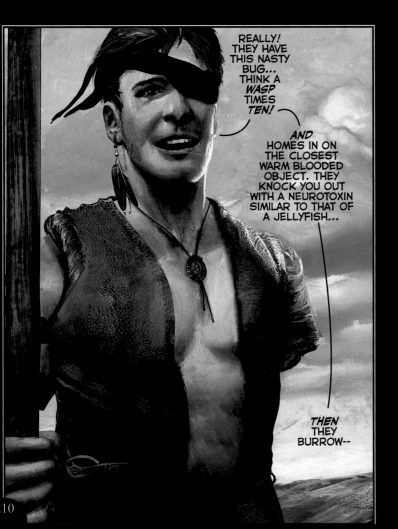

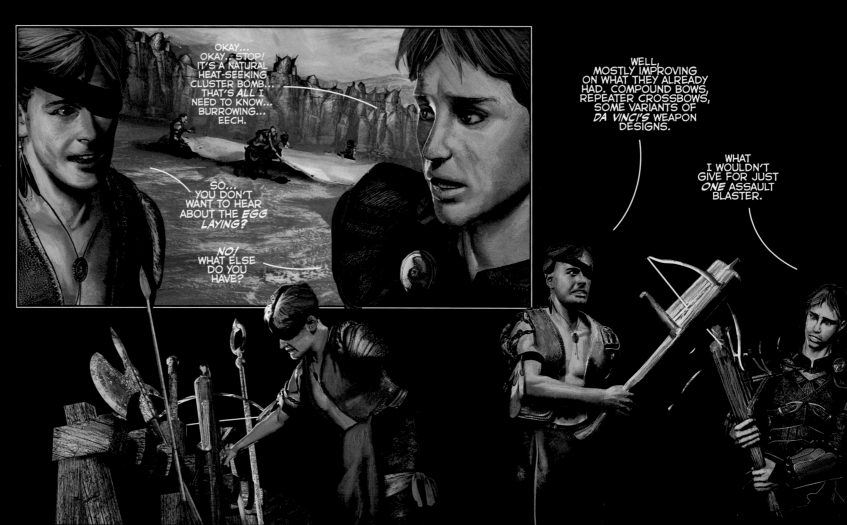

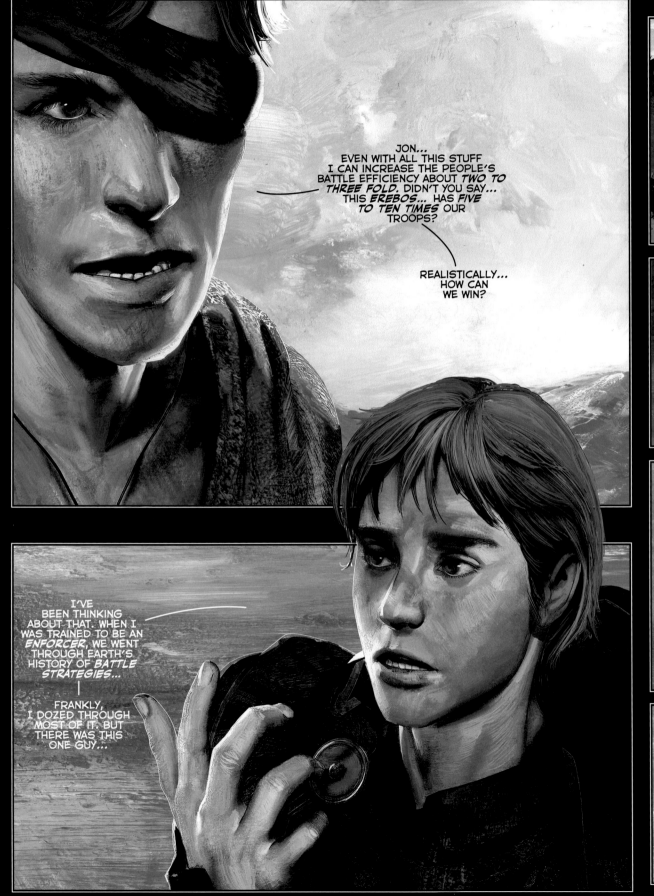

JON...
EVEN WITH ALL THIS STUFF
I CAN INCREASE THE PEOPLE'S
BATTLE EFFICIENCY ABOUT *TWO TO
THREE FOLD*. DIDN'T YOU SAY...
THIS *EREBOS*... HAS *FIVE
TO TEN TIMES* OUR
TROOPS?

REALISTICALLY...
HOW CAN
WE WIN?

I'VE
BEEN THINKING
ABOUT THAT. WHEN I
WAS TRAINED TO BE AN
ENFORCER, WE WENT
THROUGH EARTH'S
HISTORY OF *BATTLE
STRATEGIES*...

FRANKLY,
I DOZED THROUGH
MOST OF IT. BUT
THERE WAS THIS
ONE GUY...

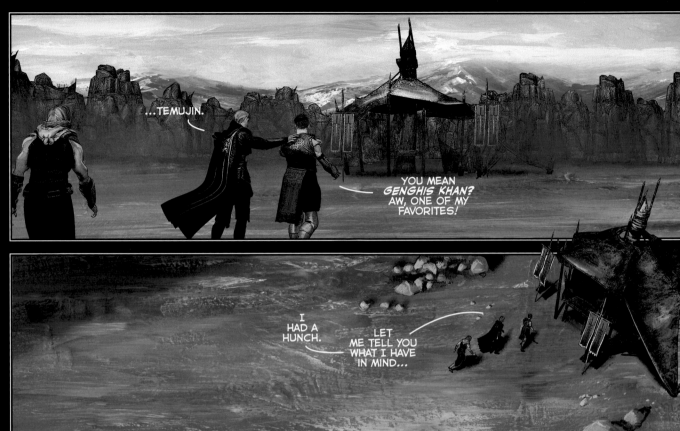

...TEMUJIN.

YOU MEAN
GENGHIS KHAN?
AW, ONE OF MY
FAVORITES!

I
HAD A
HUNCH.

LET
ME TELL YOU
WHAT I HAVE
IN MIND...

OH, AND
BY THE WAY,
WHAT'S WITH ALL
THE SEWING
CIRCLES? WHAT
ARE THEY MAKING
WITH ALL THOSE
SKINS?

I'LL
LET YOU
KNOW IF IT
WORKS.

FAIR
ENOUGH.

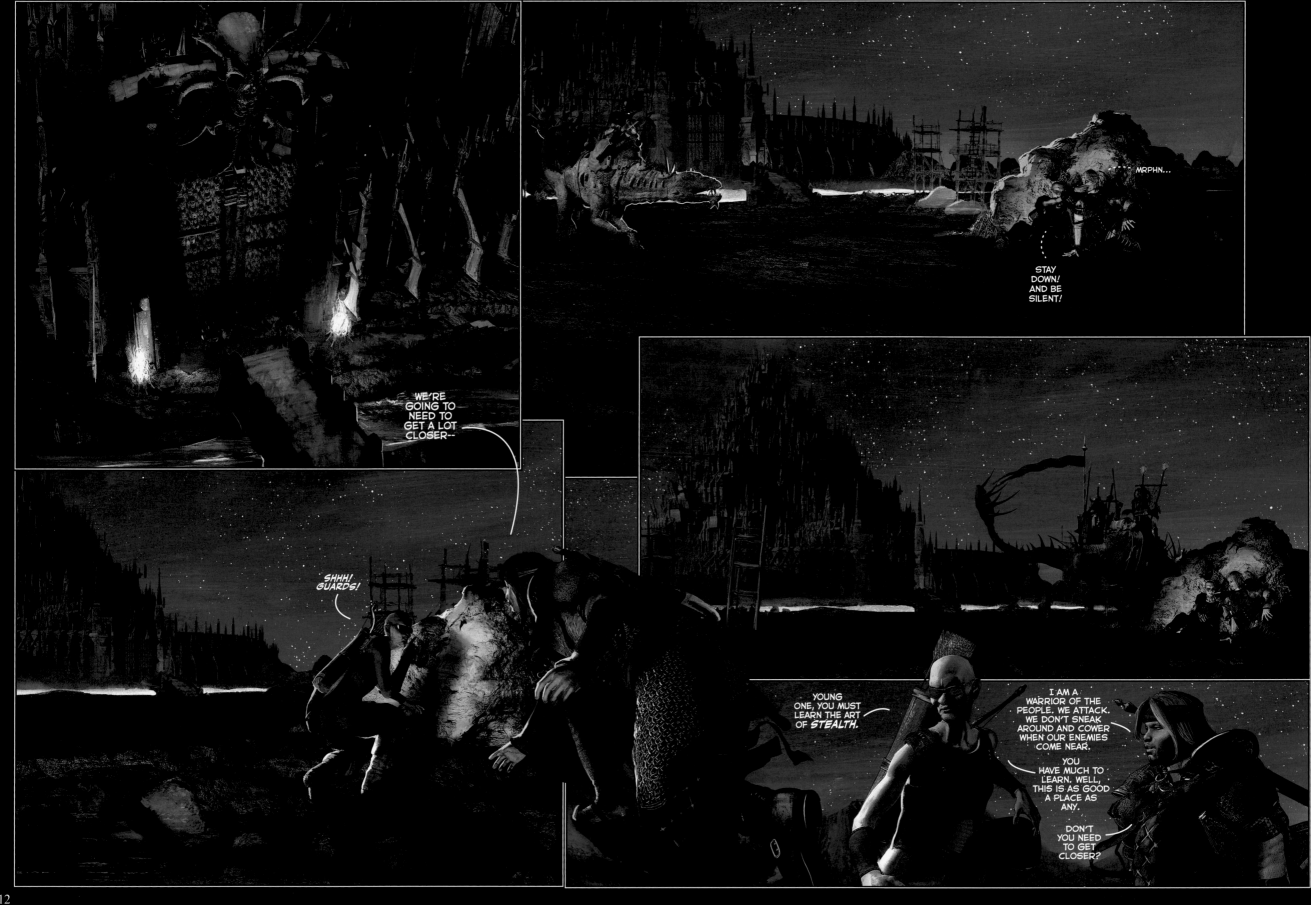

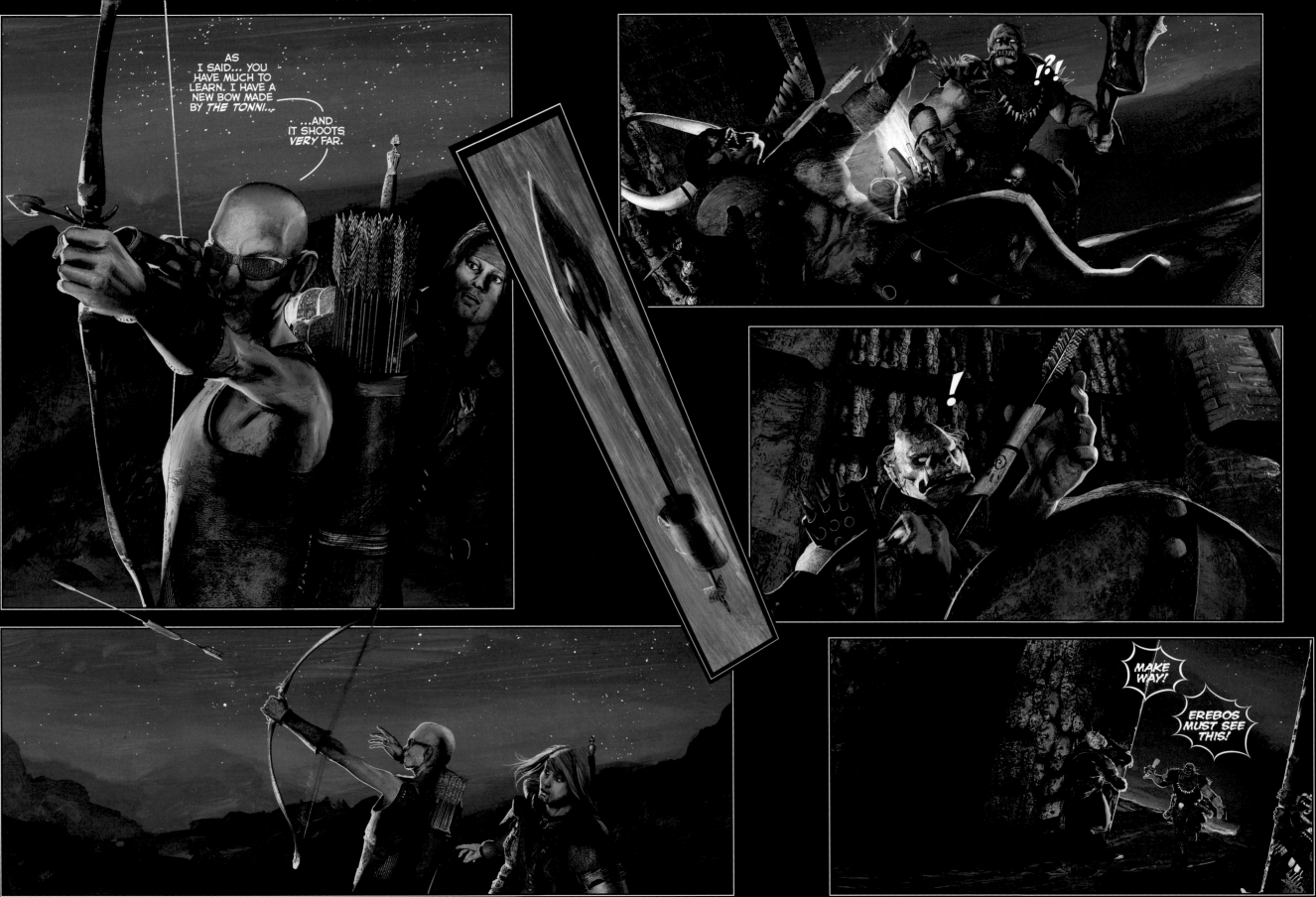

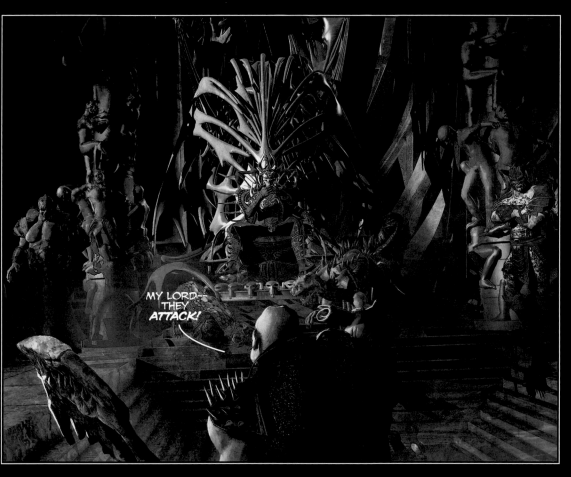

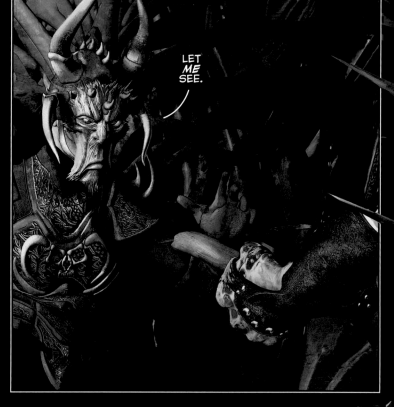

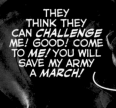

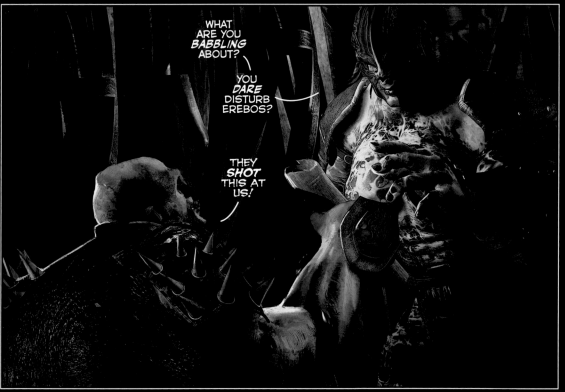

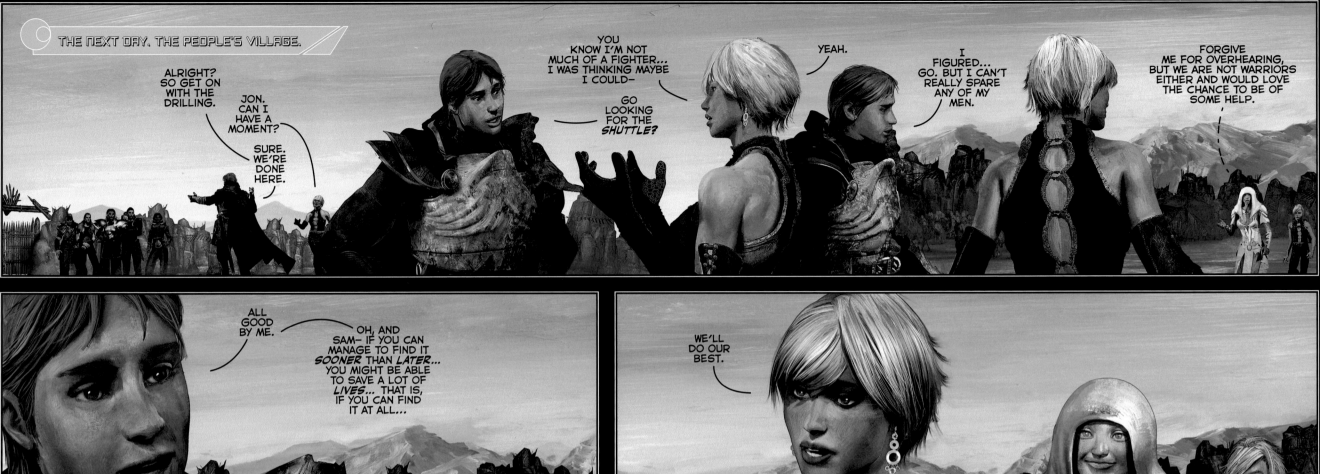

ALRIGHT? SO GET ON WITH THE DRILLING.

JON. CAN I HAVE A MOMENT?

SURE. WE'RE DONE HERE.

YOU KNOW I'M NOT MUCH OF A FIGHTER... I WAS THINKING MAYBE I COULD—

GO LOOKING FOR THE SHUTTLE?

YEAH.

I FIGURED... GO. BUT I CAN'T REALLY SPARE ANY OF MY MEN.

FORGIVE ME FOR OVERHEARING, BUT WE ARE NOT WARRIORS EITHER AND WOULD LOVE THE CHANCE TO BE OF SOME HELP.

ALL GOOD BY ME.

OH, AND SAM— IF YOU CAN MANAGE TO FIND IT SOONER THAN LATER... YOU MIGHT BE ABLE TO SAVE A LOT OF LIVES... THAT IS, IF YOU CAN FIND IT AT ALL...

WE'LL DO OUR BEST.

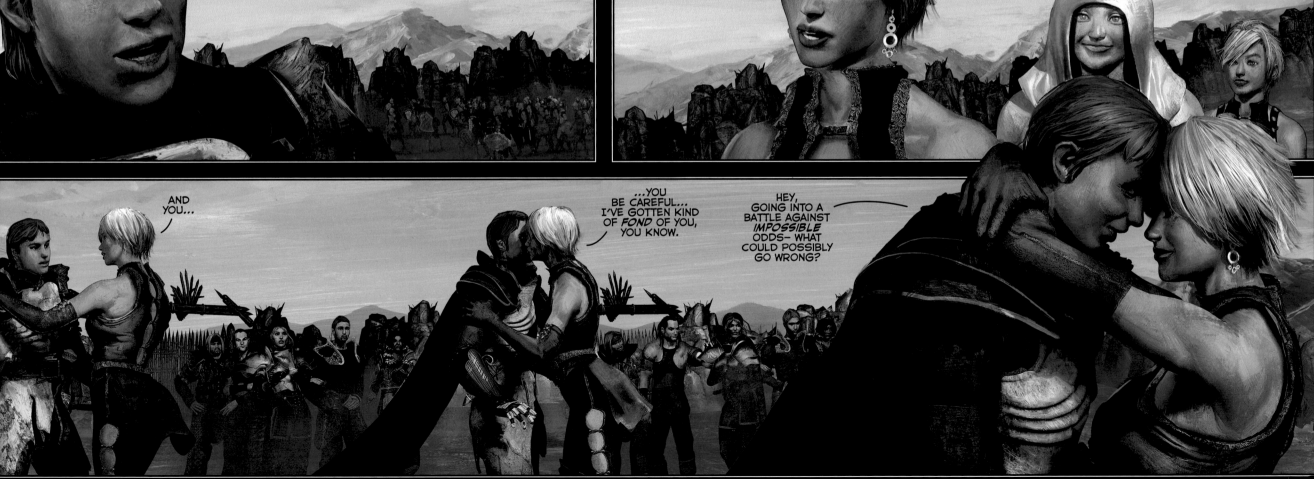

AND YOU...

...YOU BE CAREFUL... I'VE GOTTEN KIND OF FOND OF YOU, YOU KNOW.

HEY, GOING INTO A BATTLE AGAINST IMPOSSIBLE ODDS— WHAT COULD POSSIBLY GO WRONG?

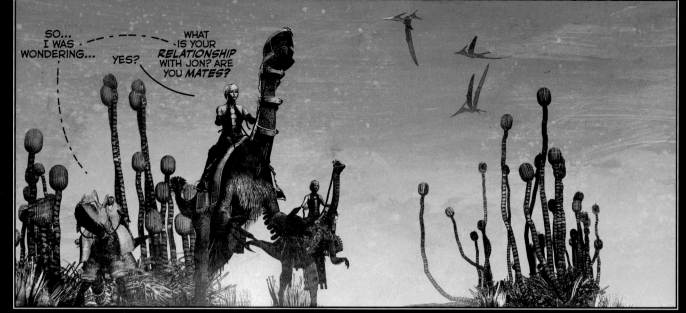

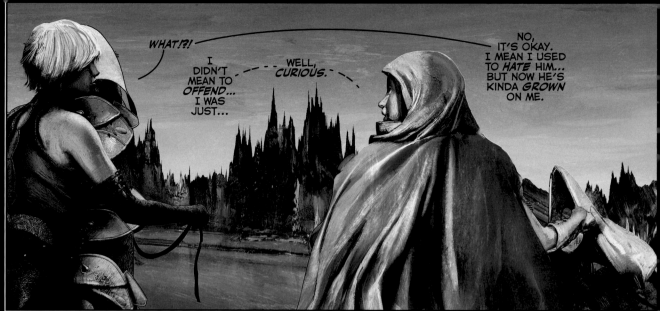

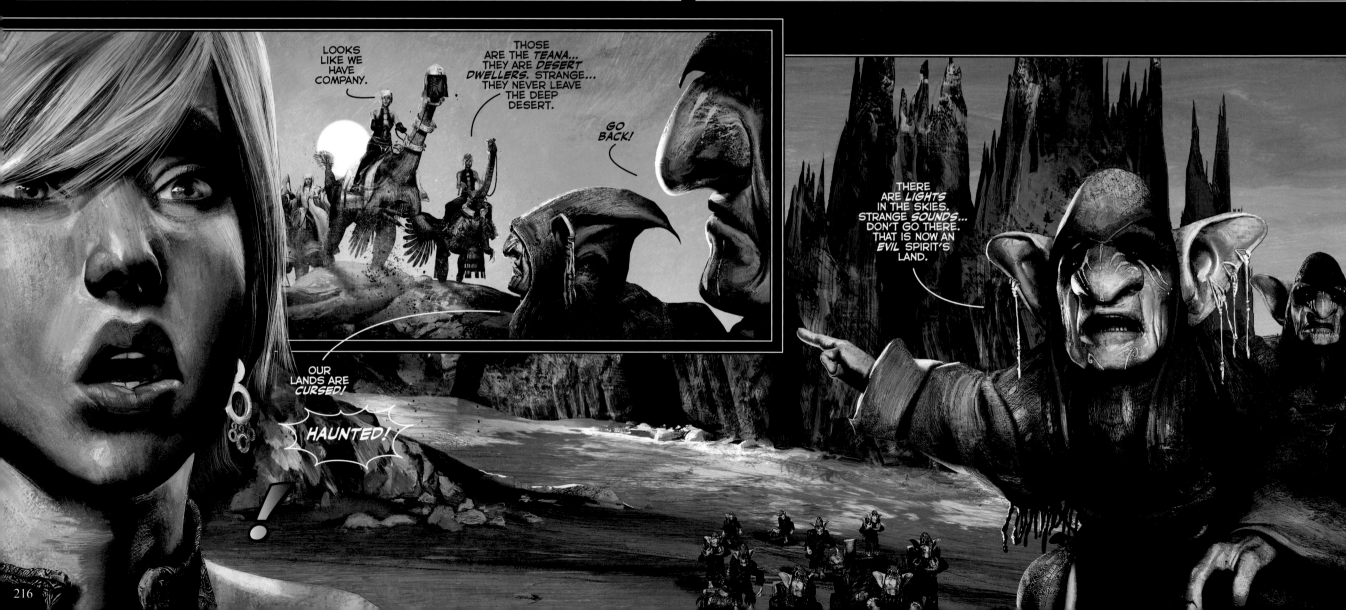

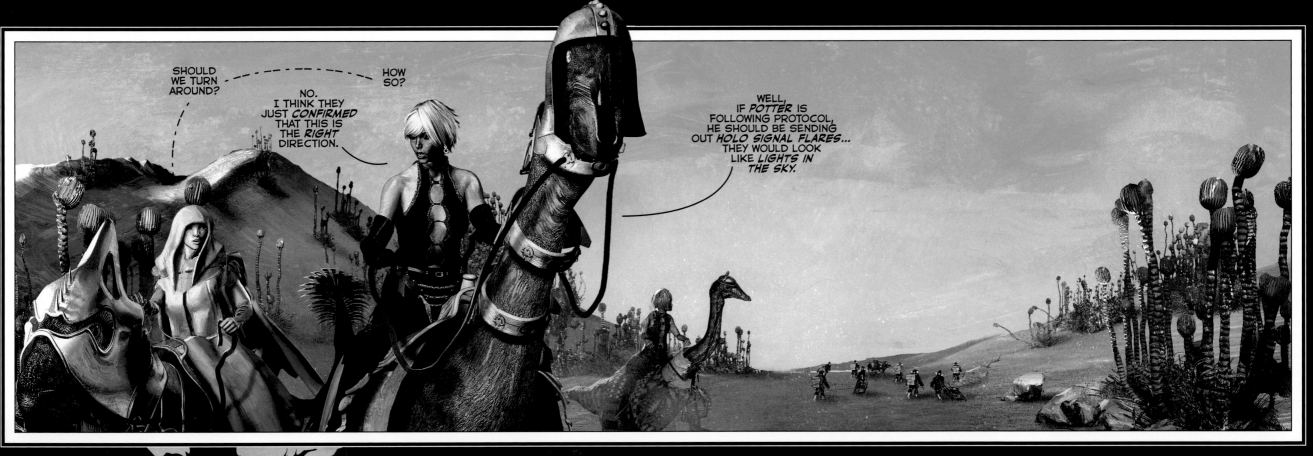

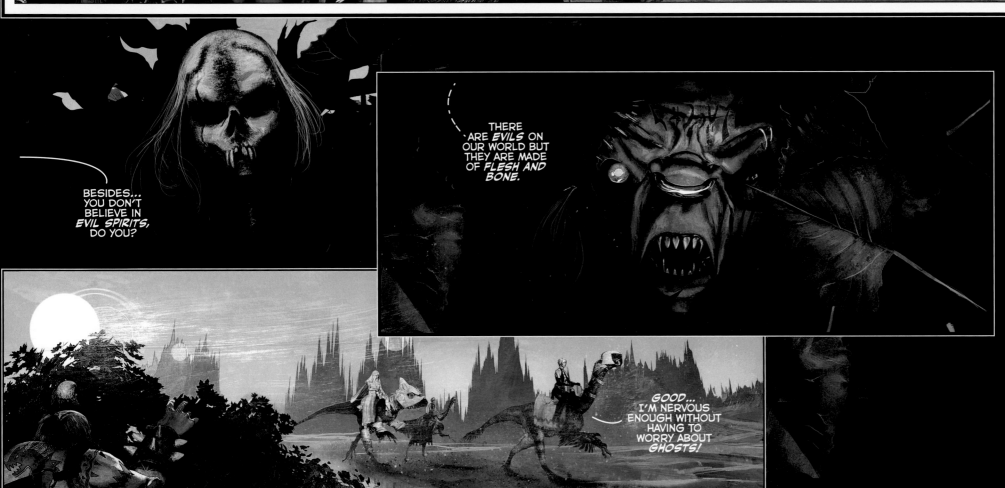

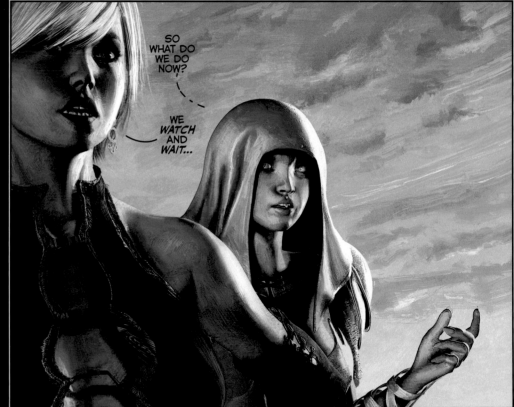

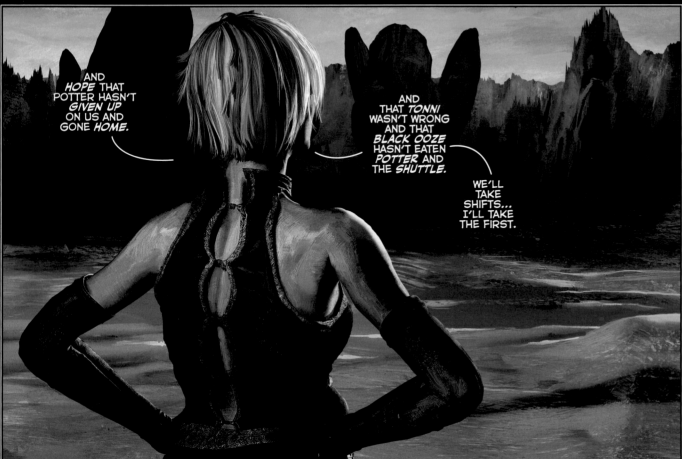

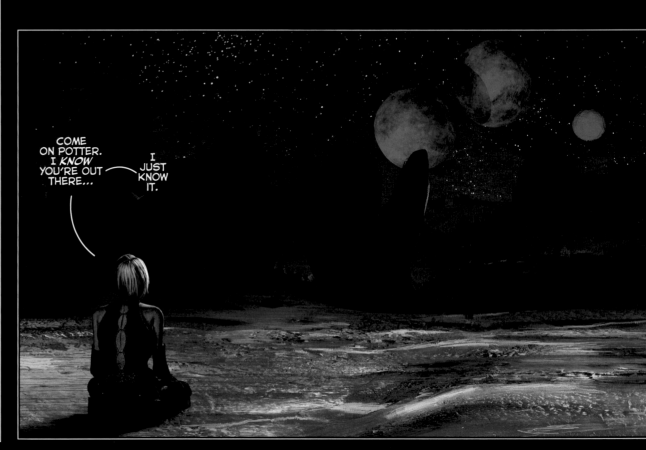

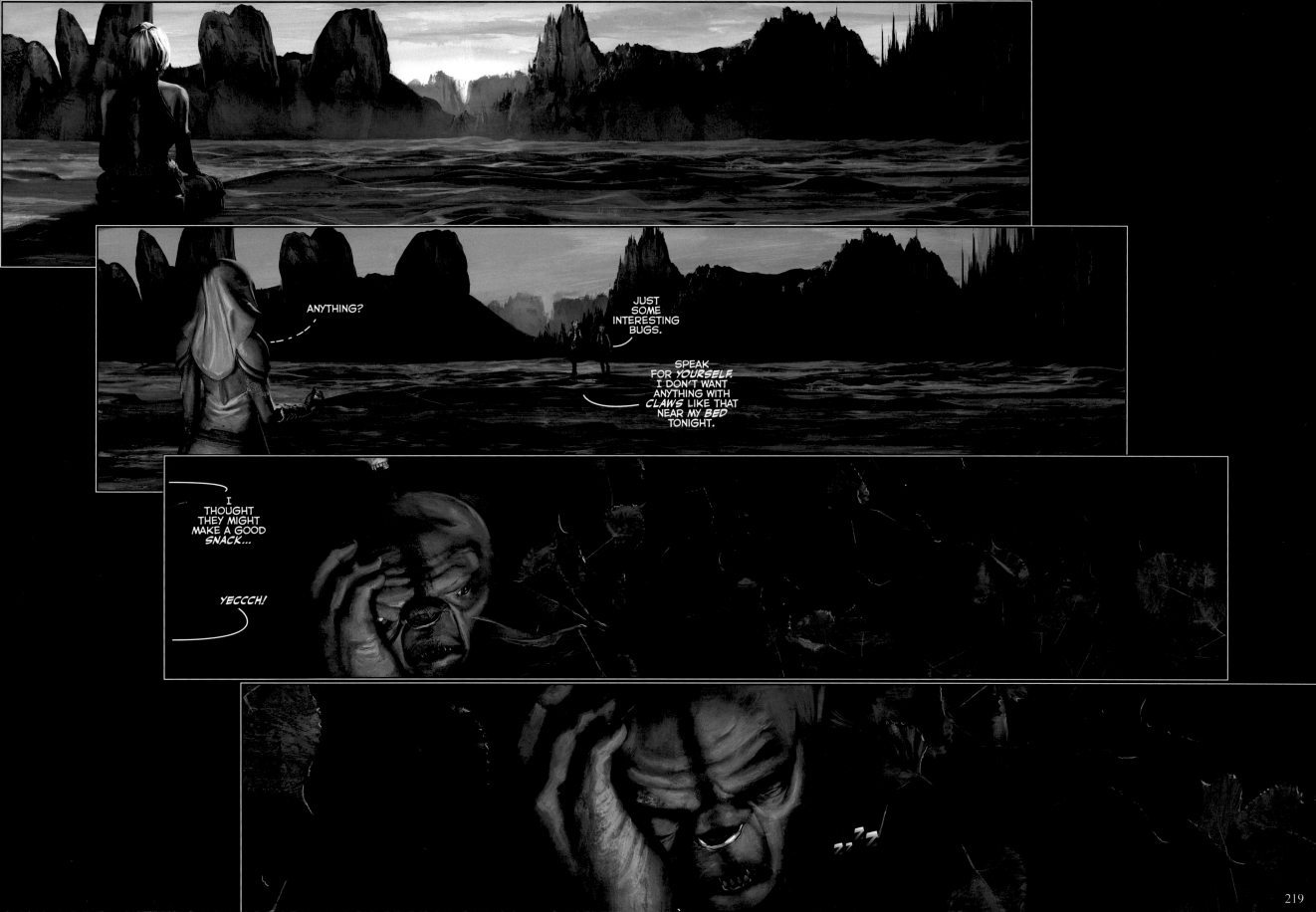

219

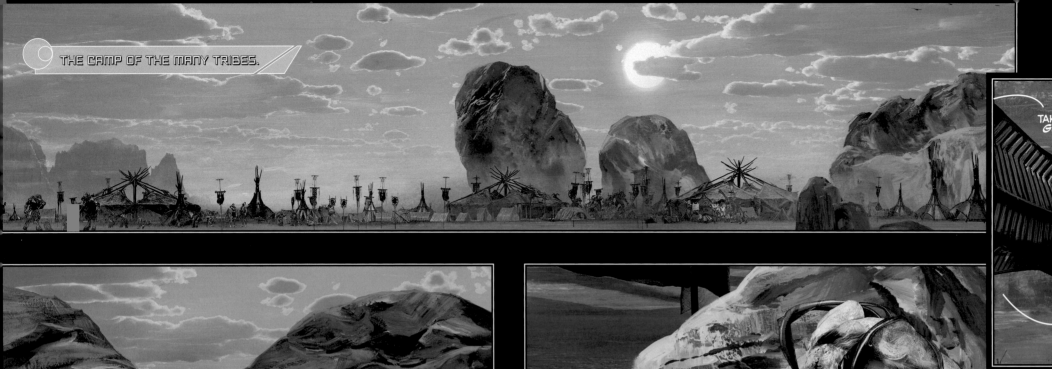

NO TAKERS? *GOOD.*

NOW THAT THAT'S OVER... HERE'S TO KICKING SOME *MUTIE ASS!*

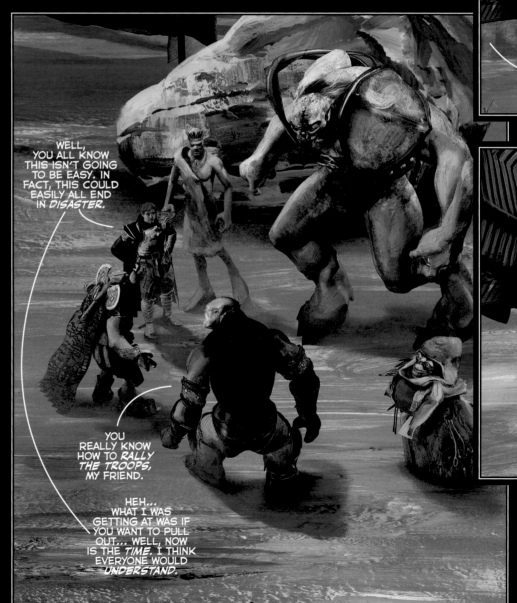

HOW'D YOU GET SO *BIG?*

HOW'D YOU GET SO *SMALL?*

WELL, YOU ALL KNOW THIS ISN'T GOING TO BE EASY. IN FACT, THIS COULD EASILY ALL END IN *DISASTER.*

YOU REALLY KNOW HOW TO *RALLY THE TROOPS,* MY FRIEND.

HEH... WHAT I WAS GETTING AT WAS IF YOU WANT TO PULL OUT... WELL, NOW IS THE *TIME.* I THINK EVERYONE WOULD *UNDERSTAND.*

INDEED!

AGREED!

LET'S GET TO KICKIN'!

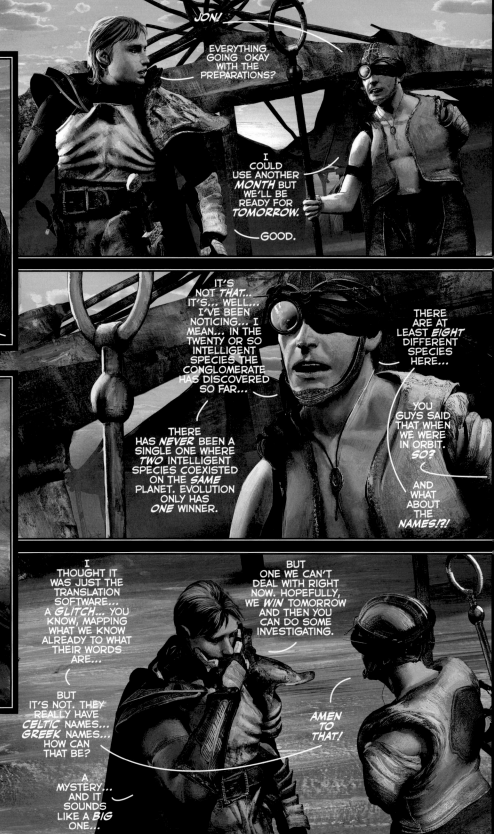

JON!

EVERYTHING GOING OKAY WITH THE PREPARATIONS?

I COULD USE ANOTHER *MONTH* BUT WE'LL BE READY FOR *TOMORROW*.

— GOOD.

IT'S NOT *THAT*... IT'S... WELL... I'VE BEEN NOTICING... I MEAN... IN THE TWENTY OR SO INTELLIGENT SPECIES THE CONGLOMERATE HAS DISCOVERED SO FAR...

THERE ARE AT LEAST *EIGHT* DIFFERENT SPECIES HERE...

THERE HAS *NEVER* BEEN A SINGLE ONE WHERE *TWO* INTELLIGENT SPECIES COEXISTED ON THE *SAME* PLANET. EVOLUTION ONLY HAS *ONE* WINNER.

YOU GUYS SAID THAT WHEN WE WERE IN ORBIT. *SO?*

AND WHAT ABOUT THE *NAMES!?!*

I THOUGHT IT WAS JUST THE TRANSLATION SOFTWARE... A *GLITCH*... YOU KNOW, MAPPING WHAT WE KNOW ALREADY TO WHAT THEIR WORDS ARE...

BUT IT'S NOT. THEY REALLY HAVE *CELTIC* NAMES... *GREEK* NAMES... HOW CAN THAT BE?

A MYSTERY... AND IT SOUNDS LIKE A *BIG* ONE...

BUT ONE WE CAN'T DEAL WITH RIGHT NOW. HOPEFULLY, WE *WIN* TOMORROW AND THEN YOU CAN DO SOME INVESTIGATING.

AMEN TO THAT!

IT WILL BE AN *HONOR!*

GrrRrr

COULDN'T HAVE SAID IT *BETTER* MYSELF!

YOU KNOW, YOU SHOULD THINK ABOUT A *MATE.*

A *WHAT?*

IT'S CUSTOMARY. I ASSUME YOU AND SAMANTHA--

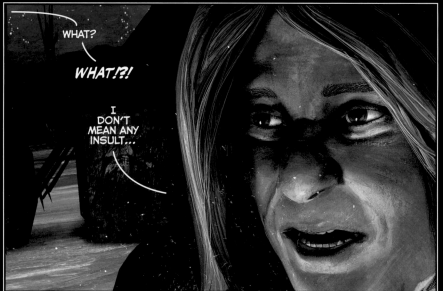

WHAT?

WHAT!?!

I DON'T MEAN ANY INSULT...

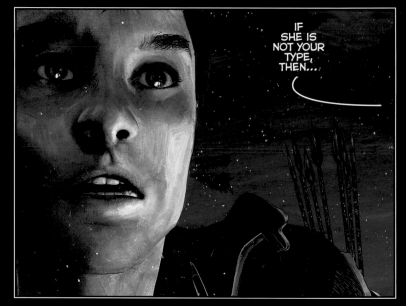

IF SHE IS NOT YOUR TYPE, THEN...

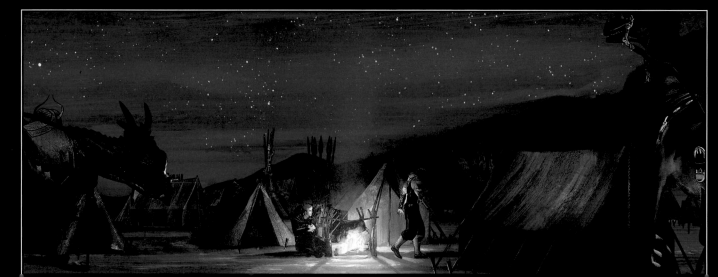

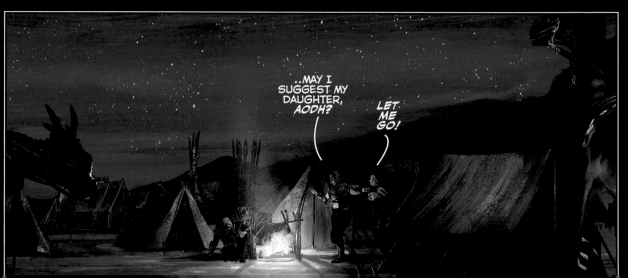

..MAY I SUGGEST MY DAUGHTER, AODH?

LET ME GO!

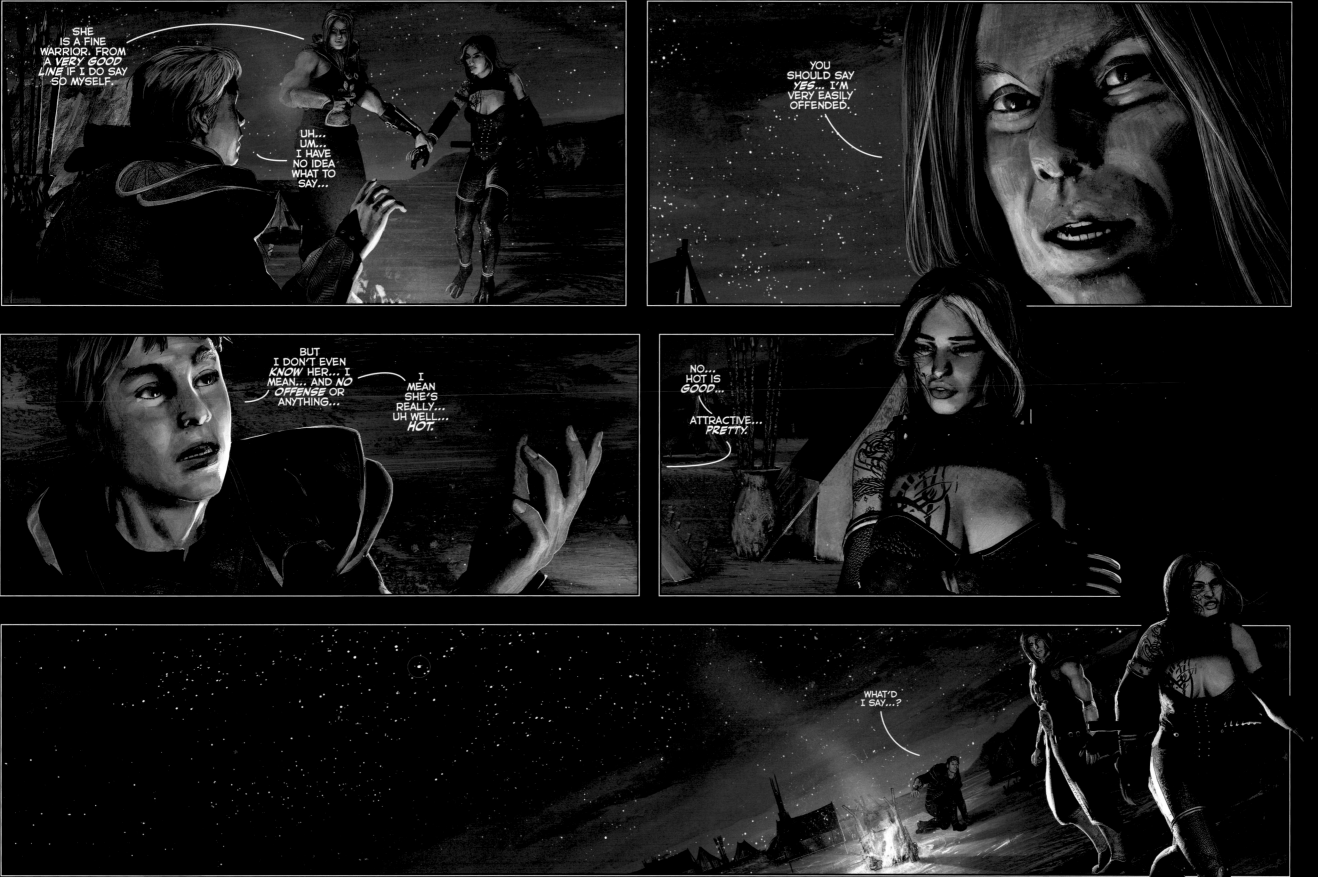

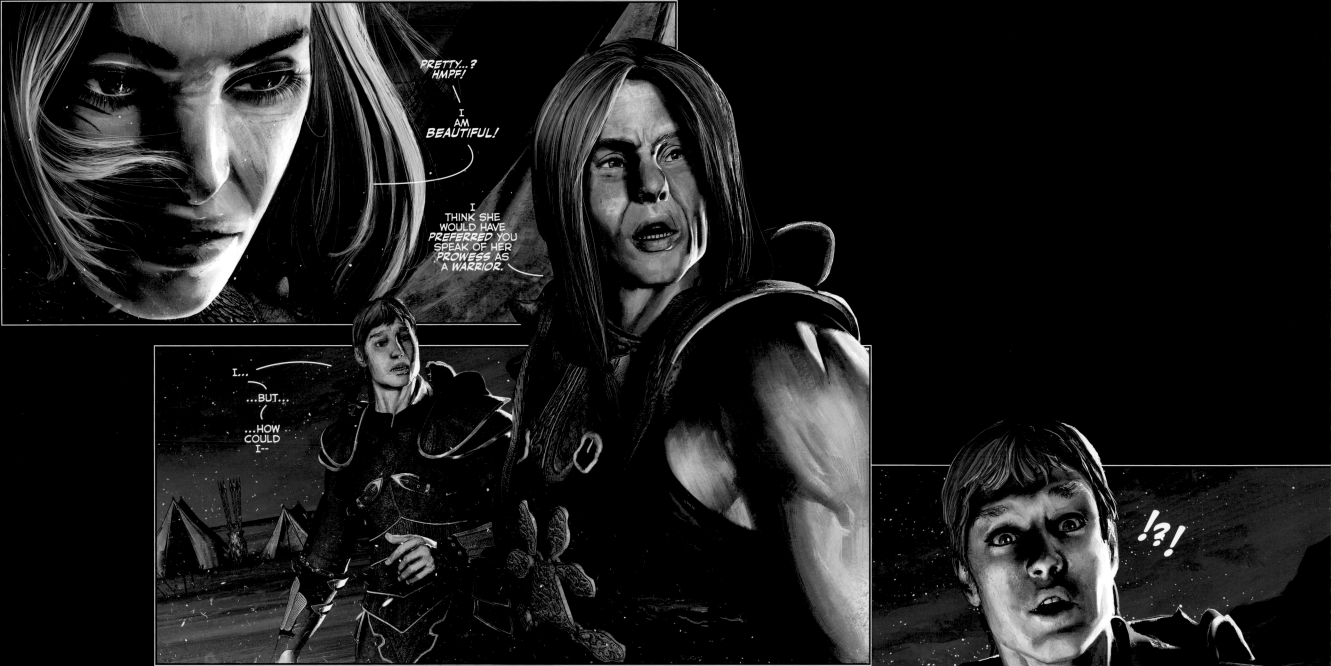

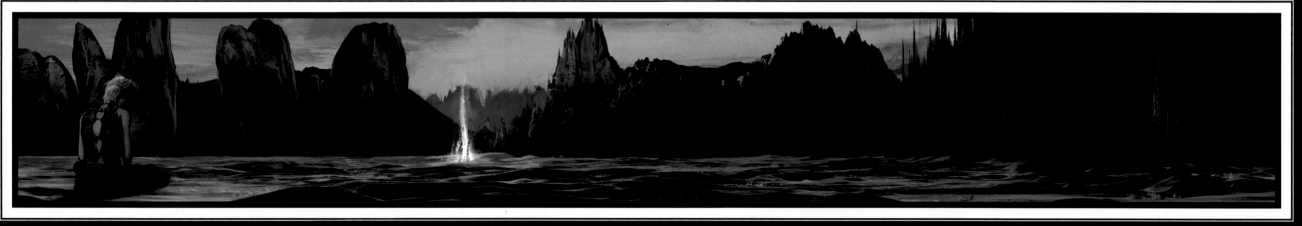

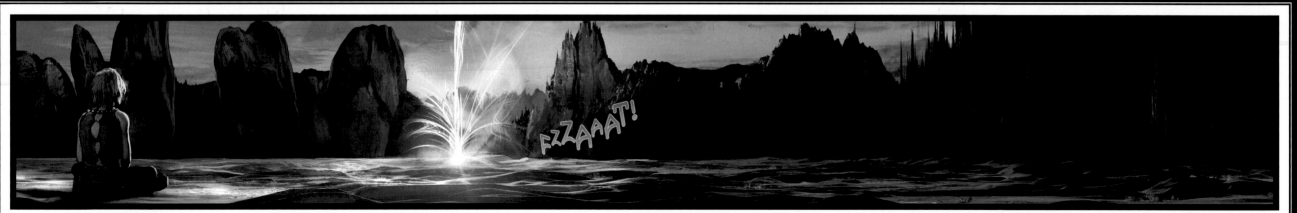

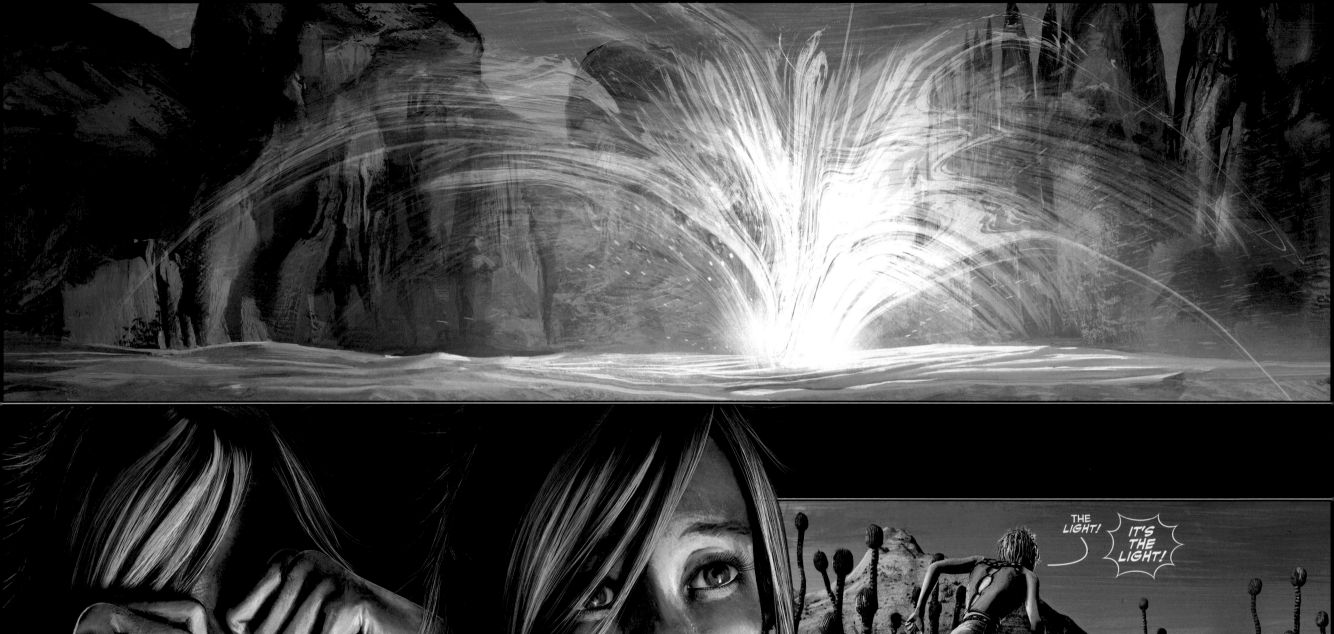
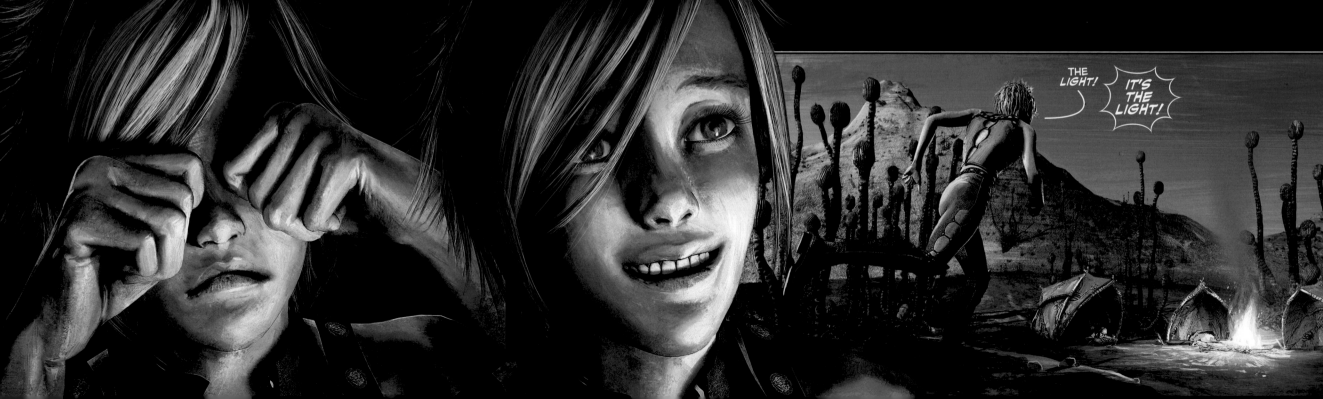

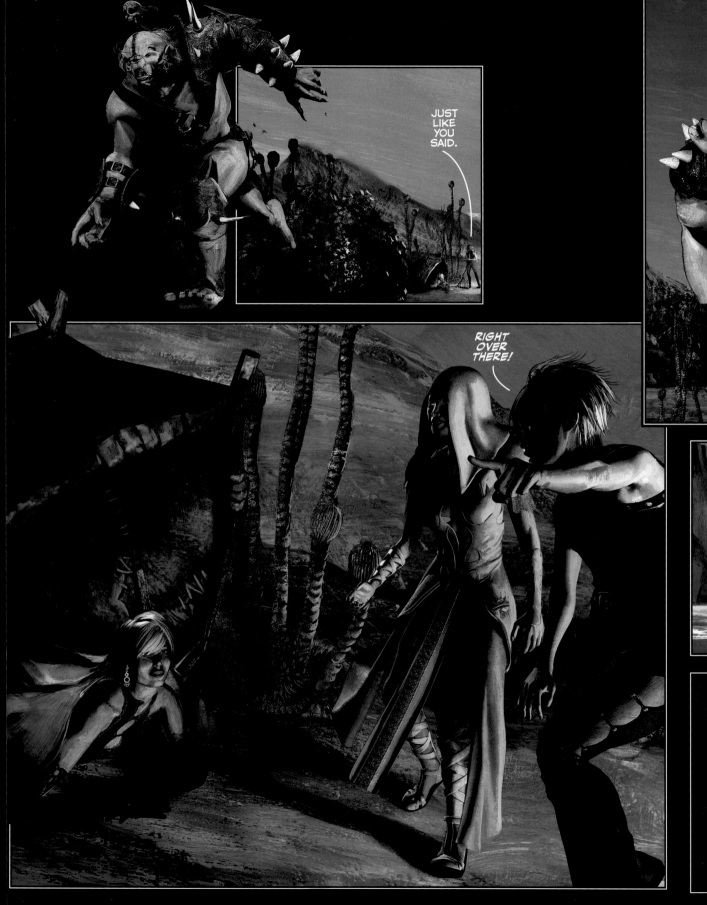
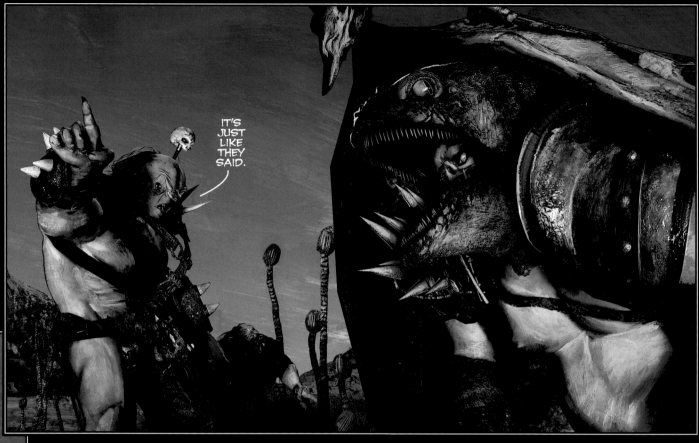
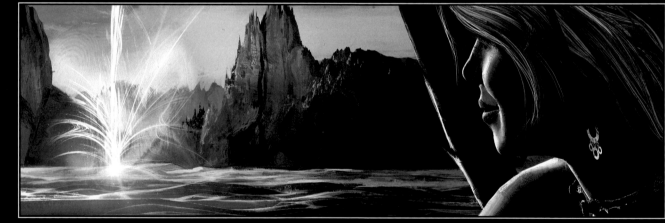
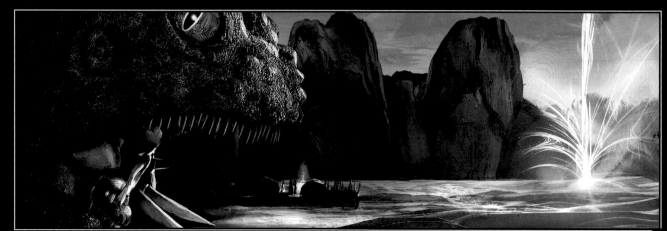

229

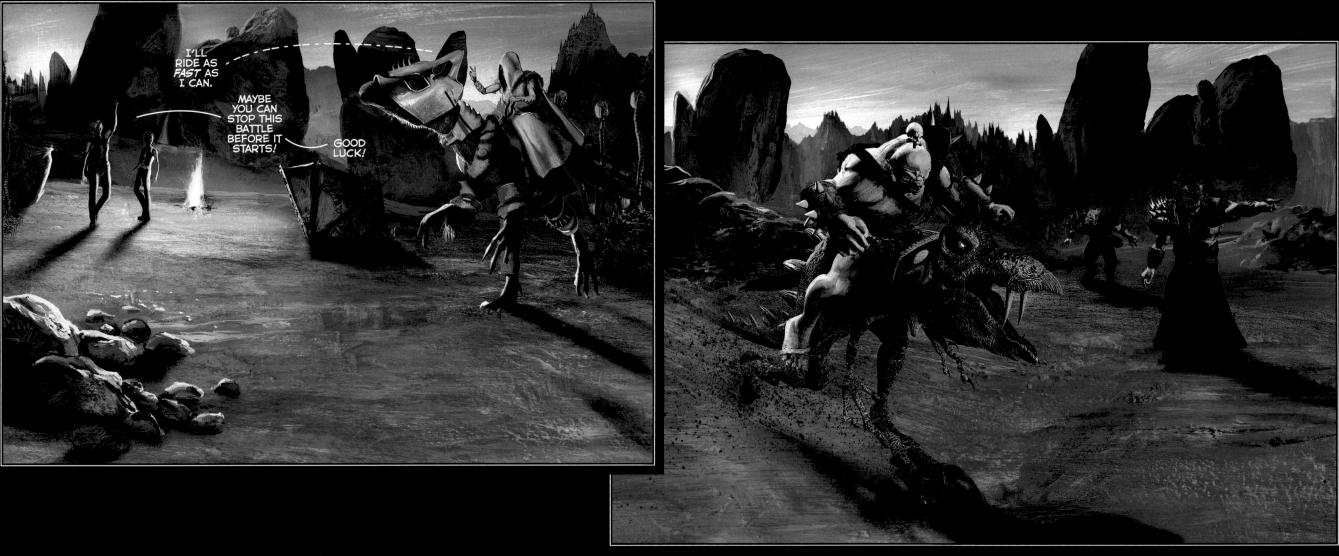

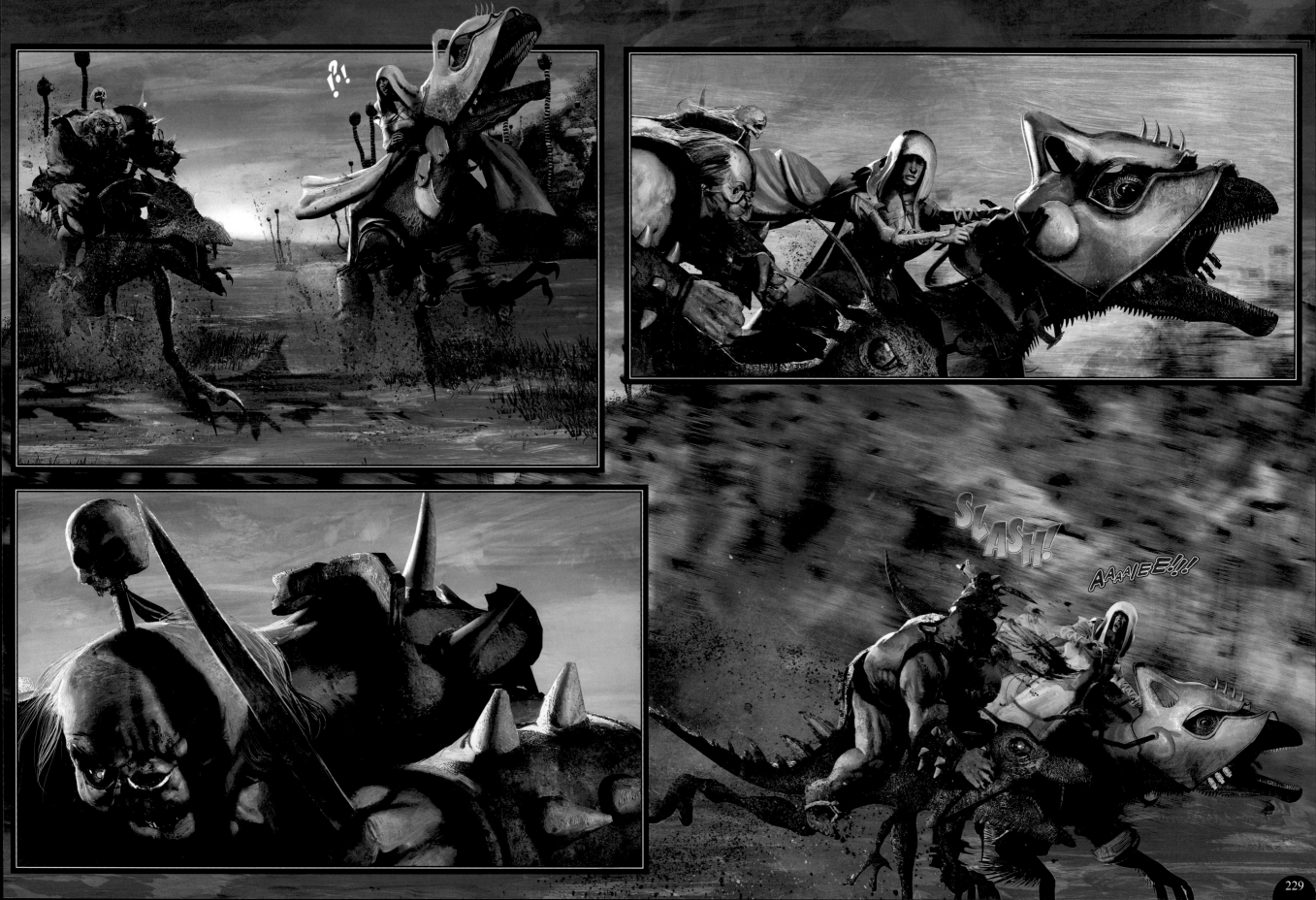

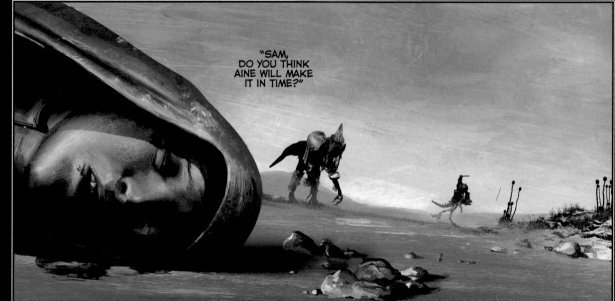

"SAM, DO YOU THINK AINE WILL MAKE IT IN TIME?"

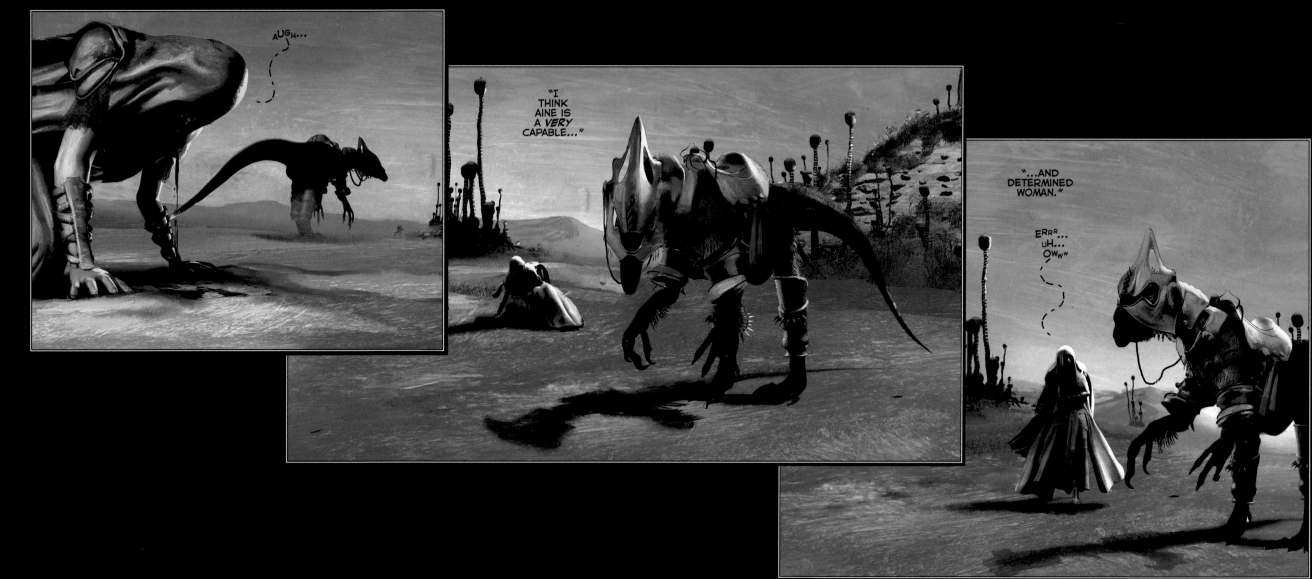

AUGH...

"I THINK AINE IS A *VERY* CAPABLE..."

"...AND DETERMINED WOMAN."

ERRR... UH... OWWW

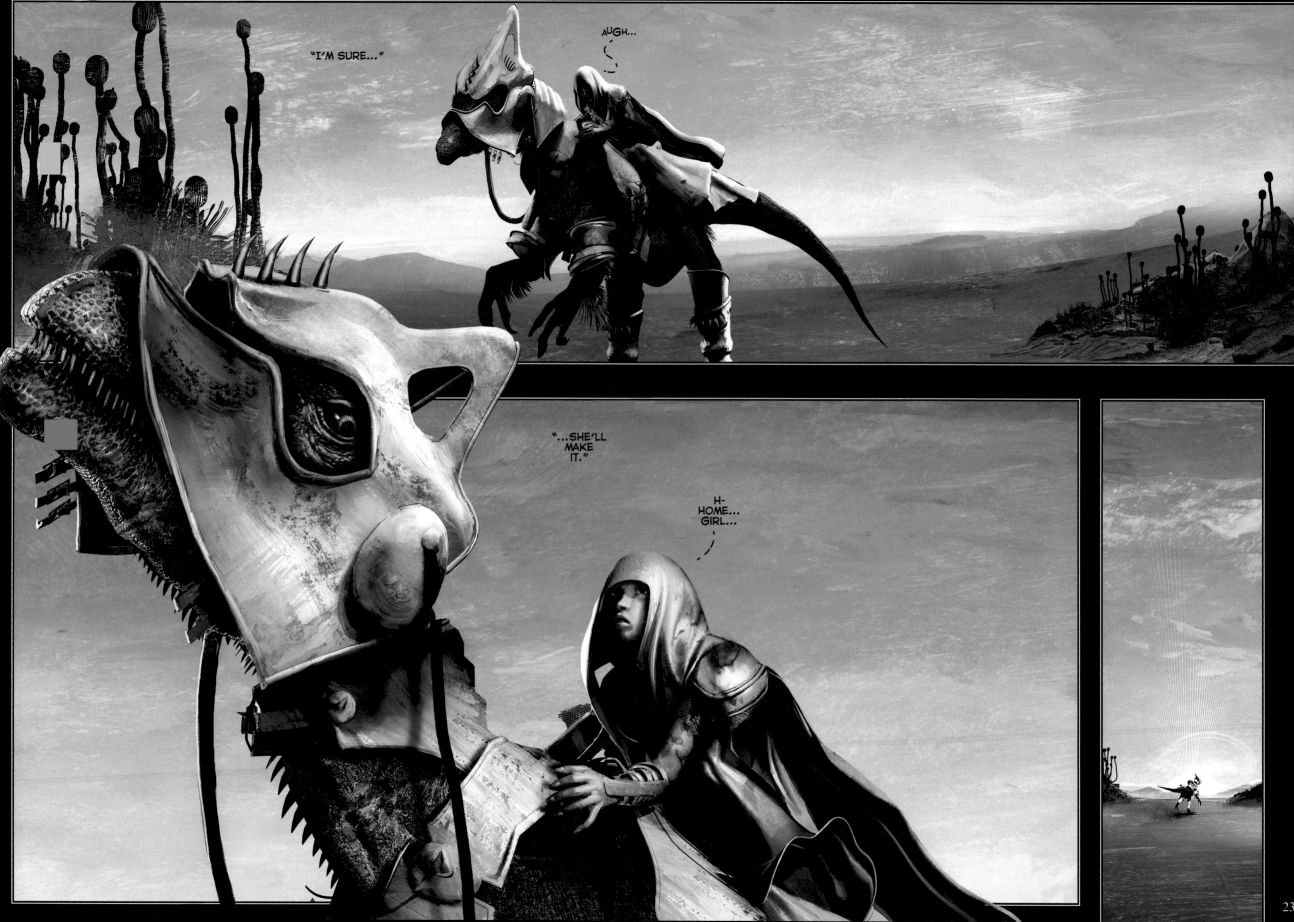

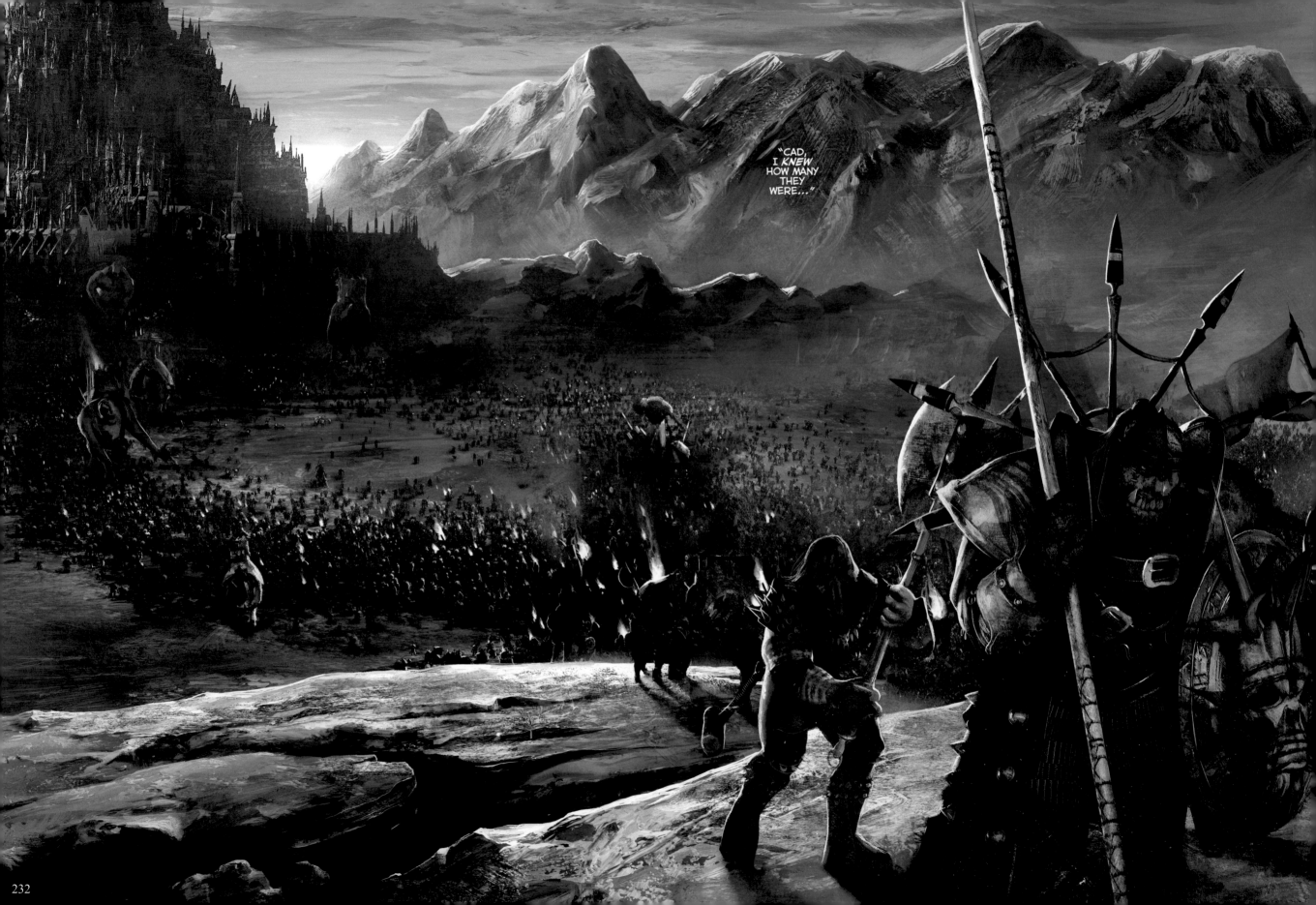

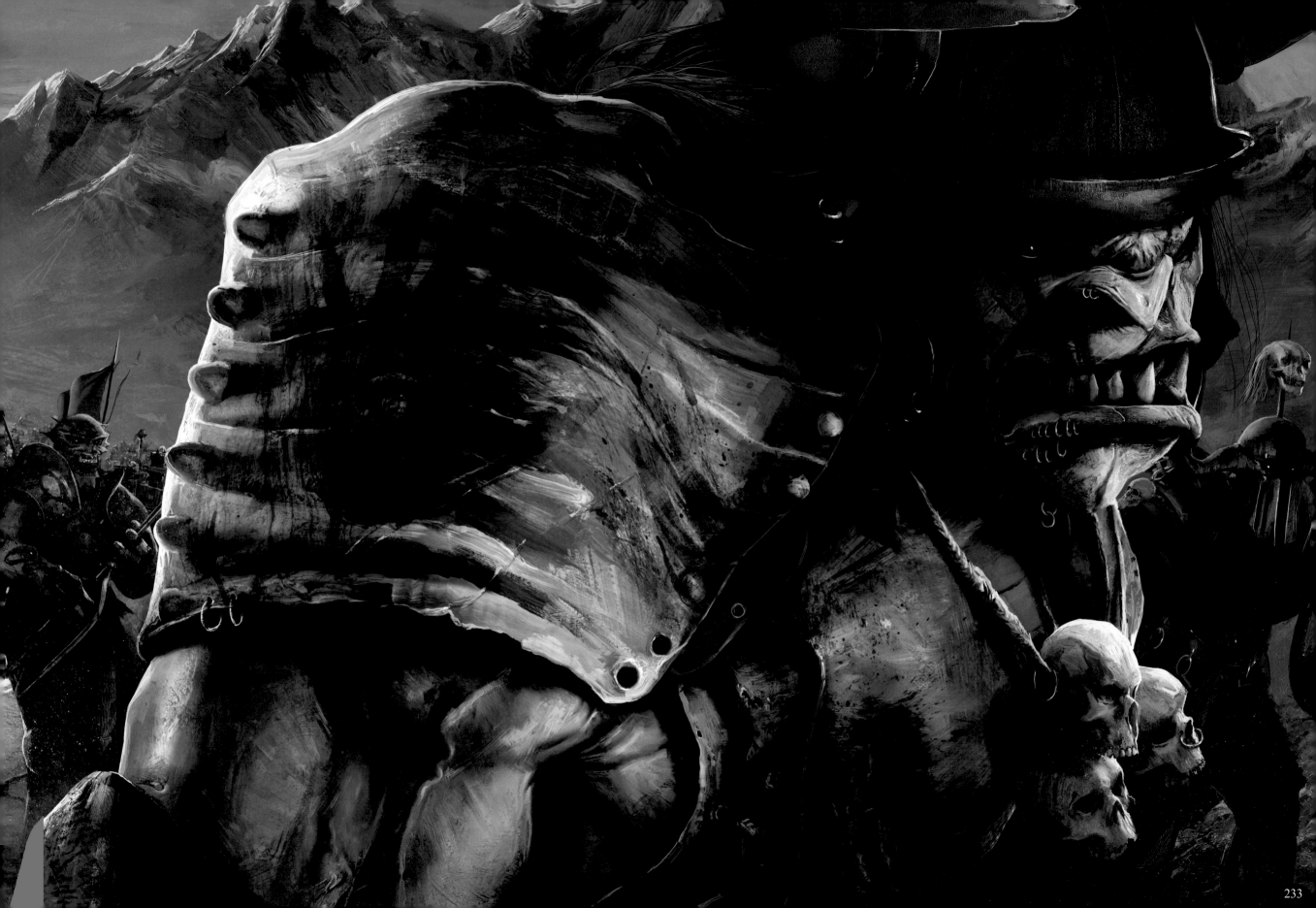

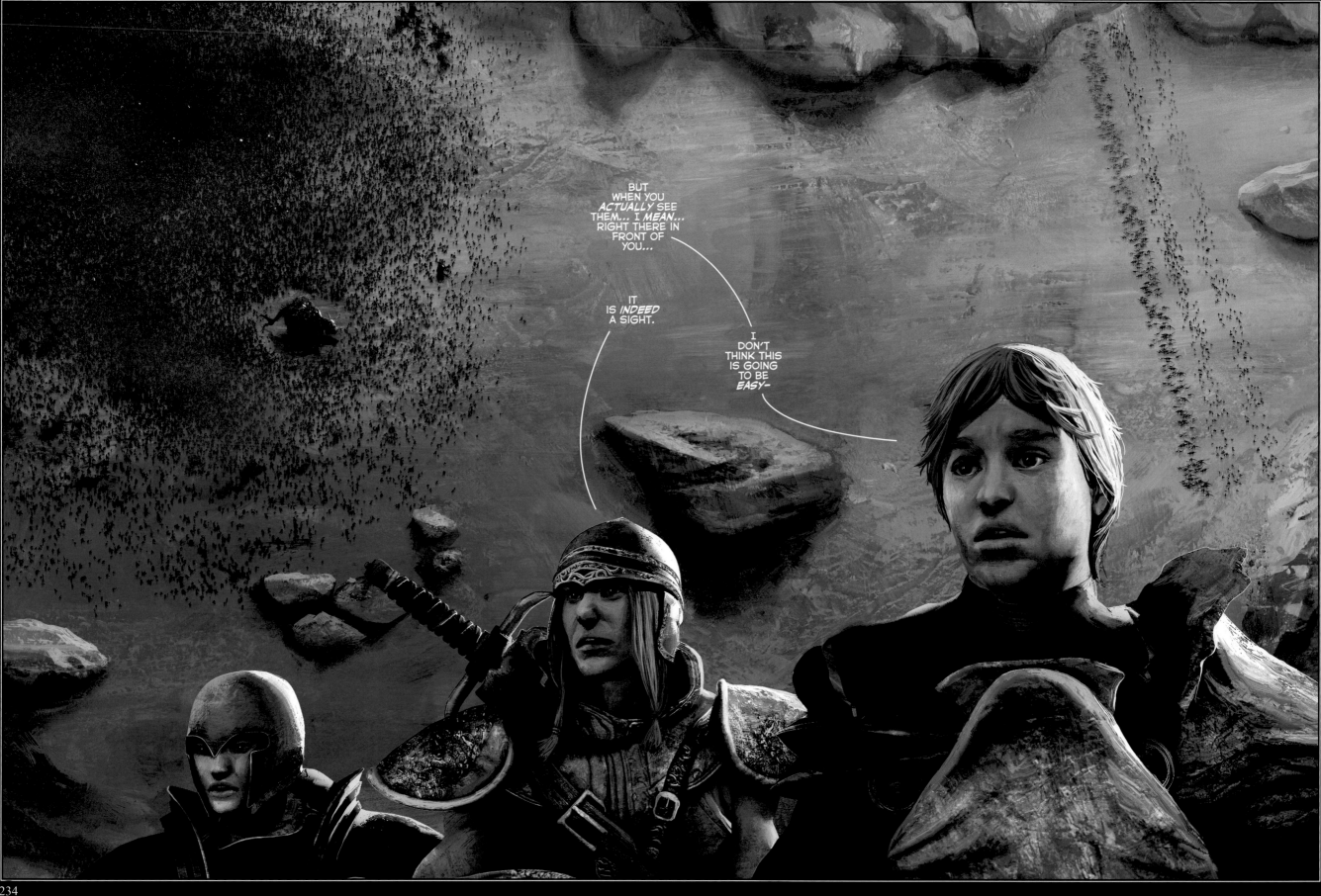

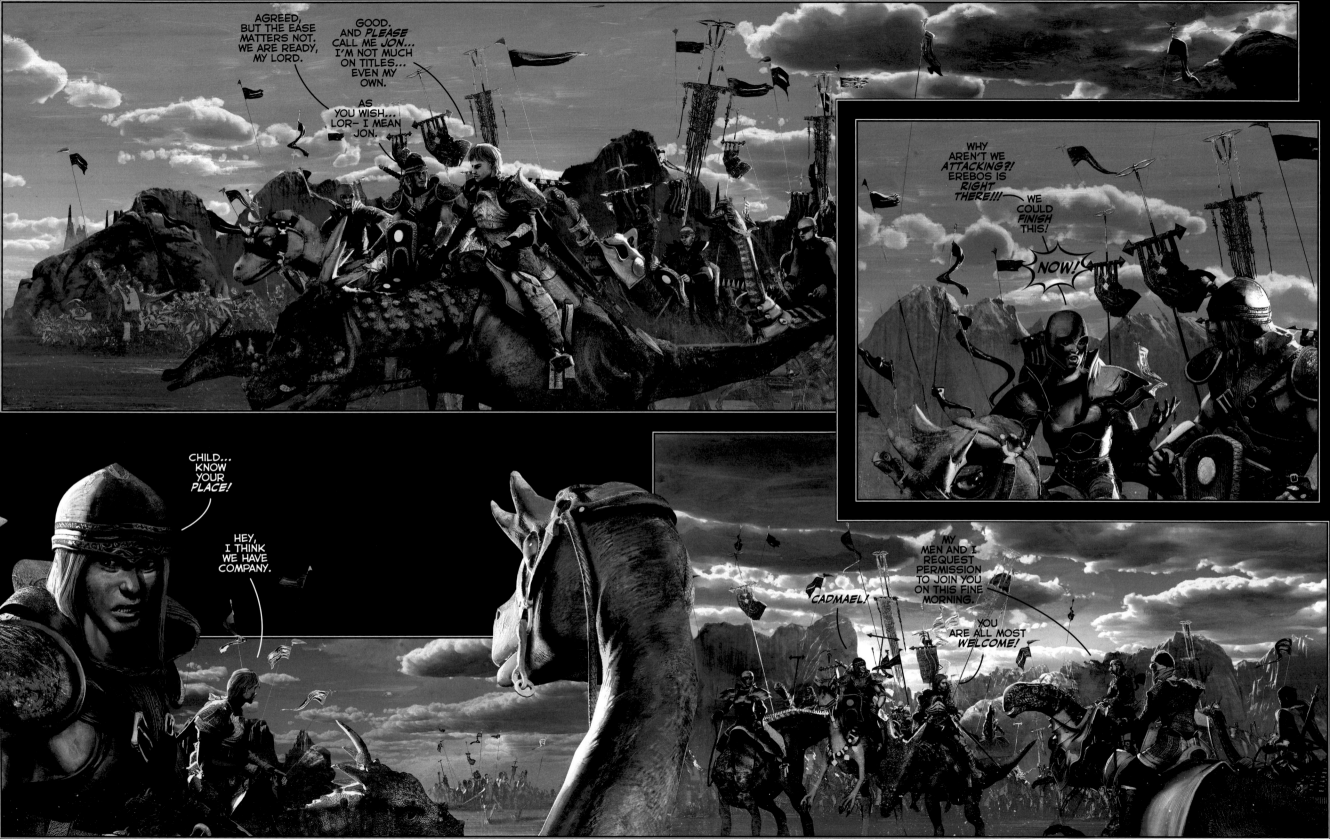

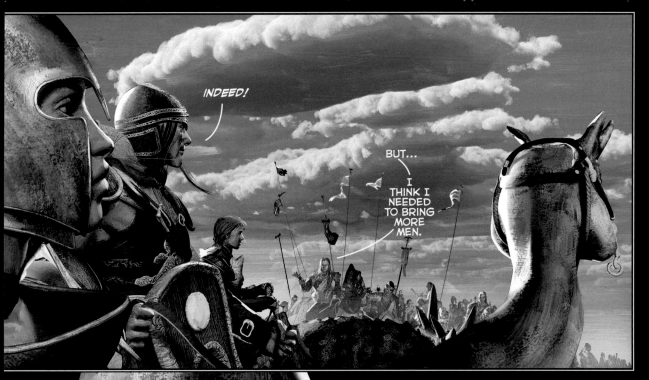

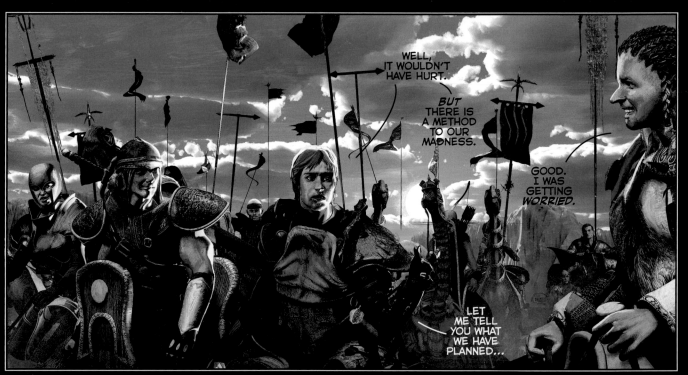

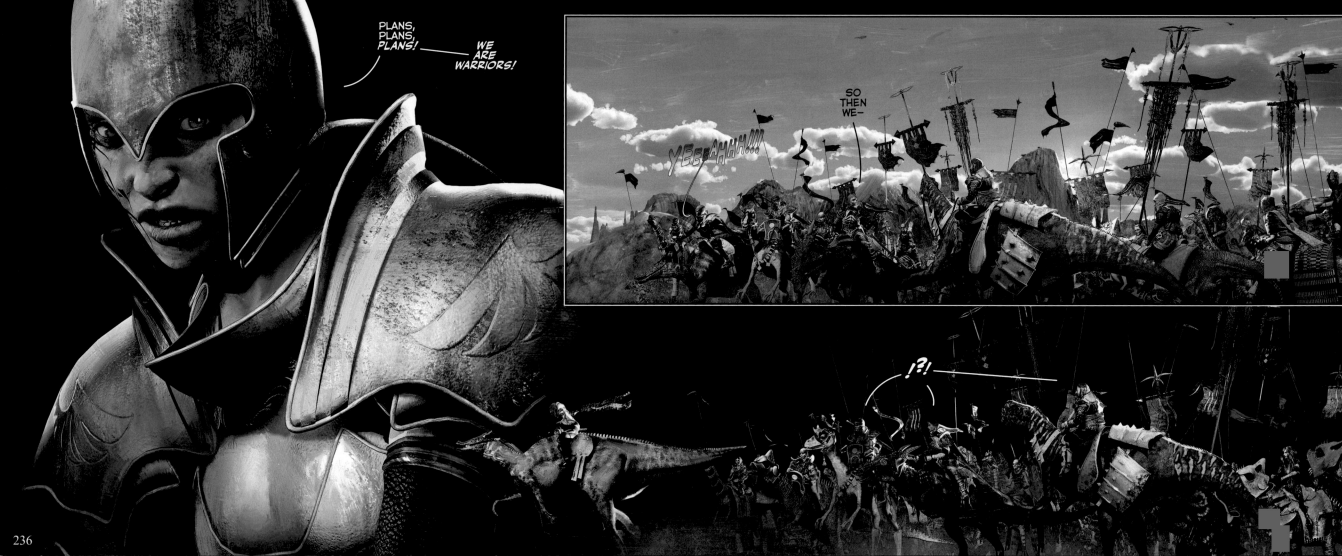

236

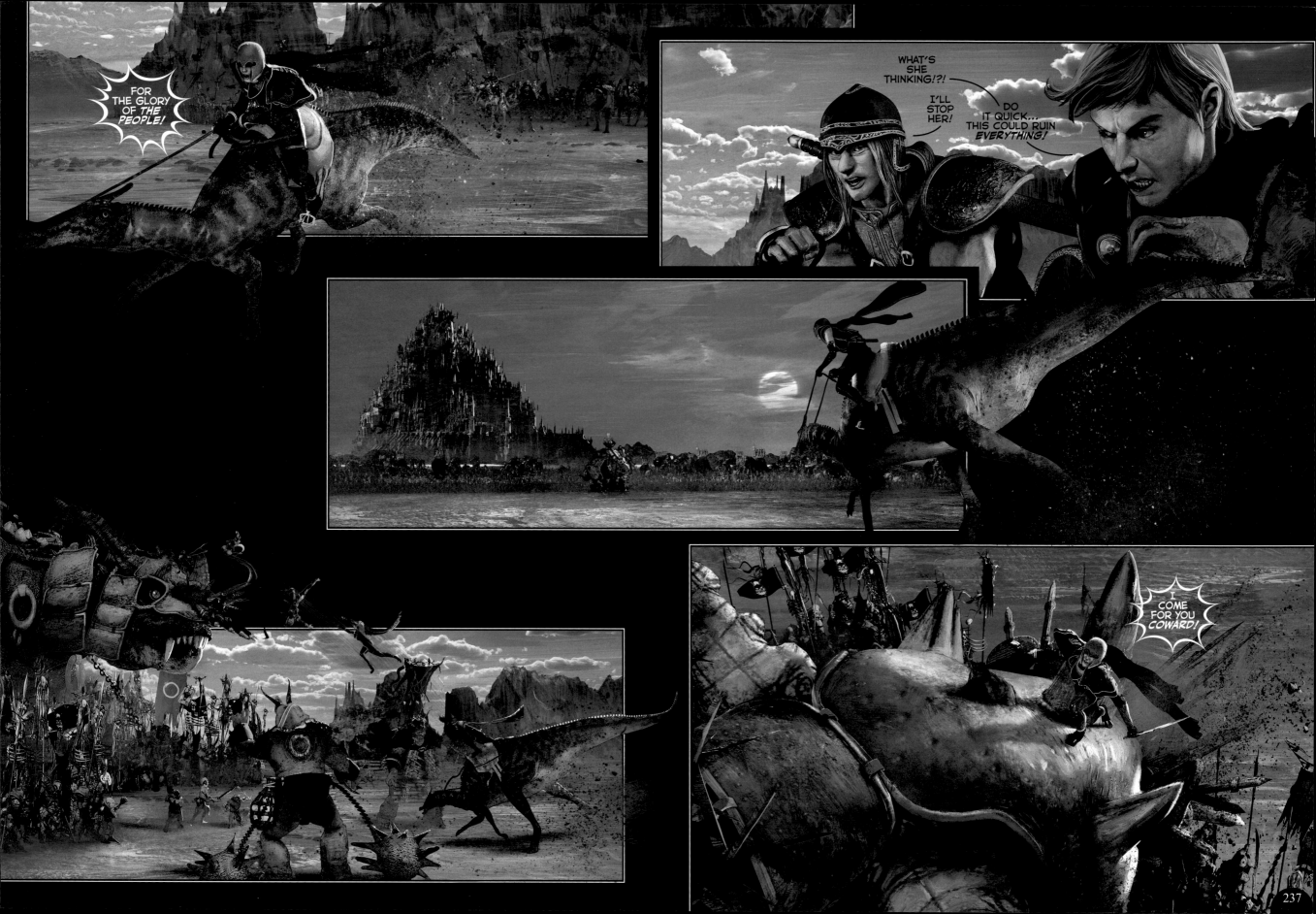

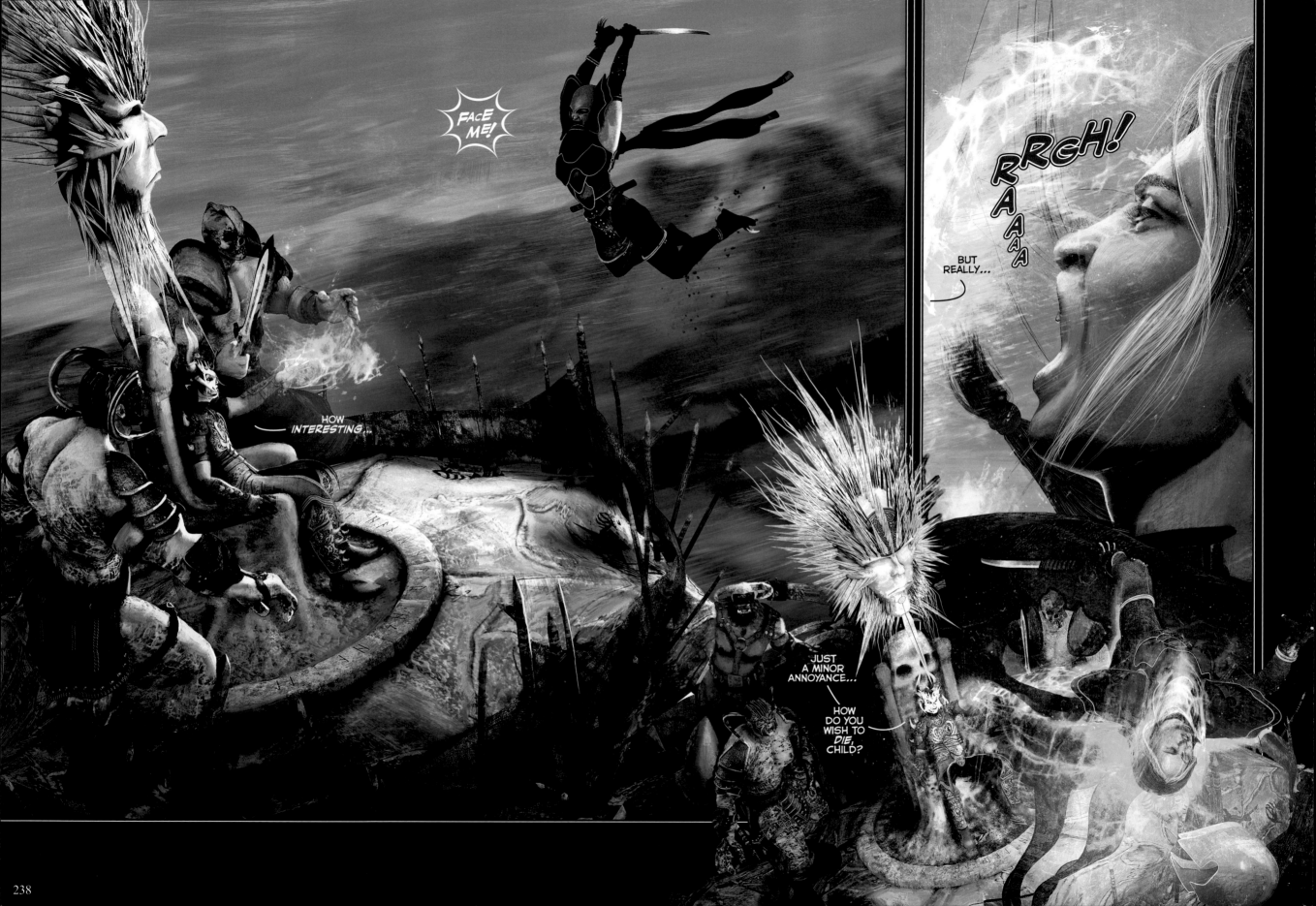

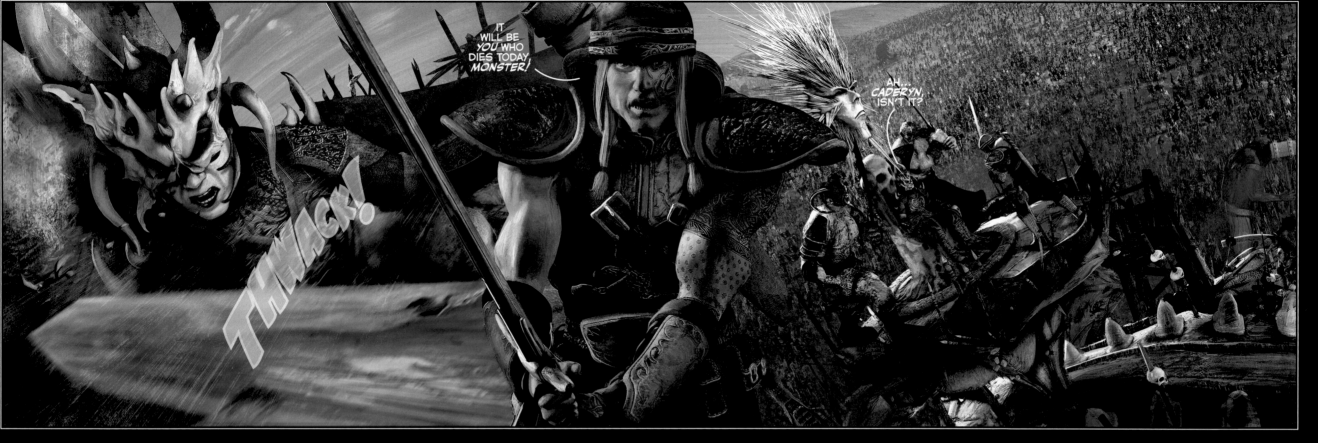

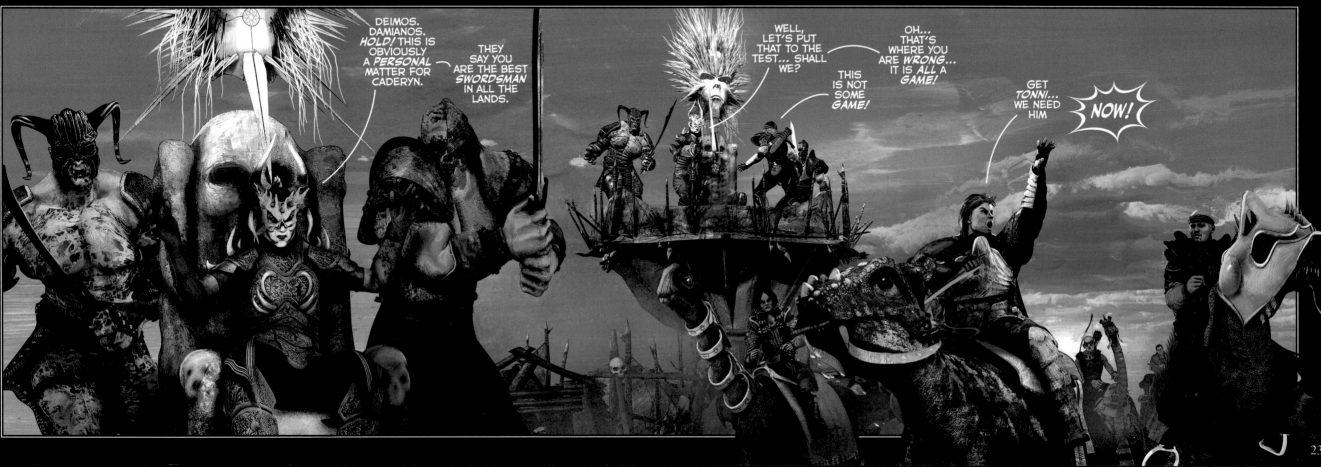

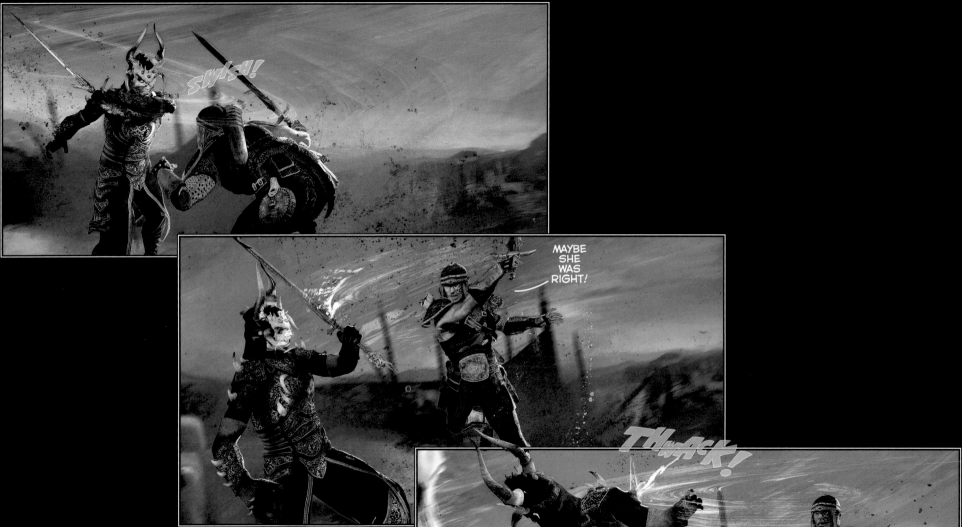

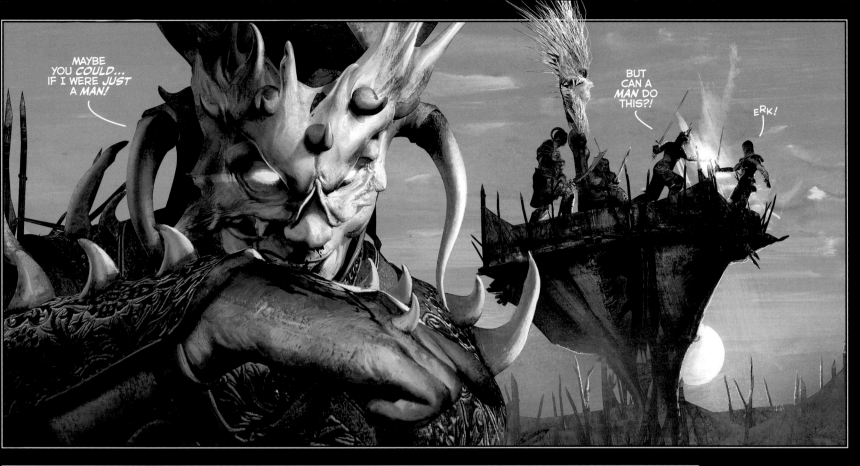

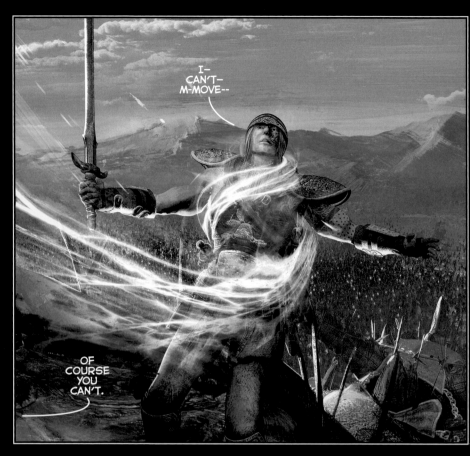

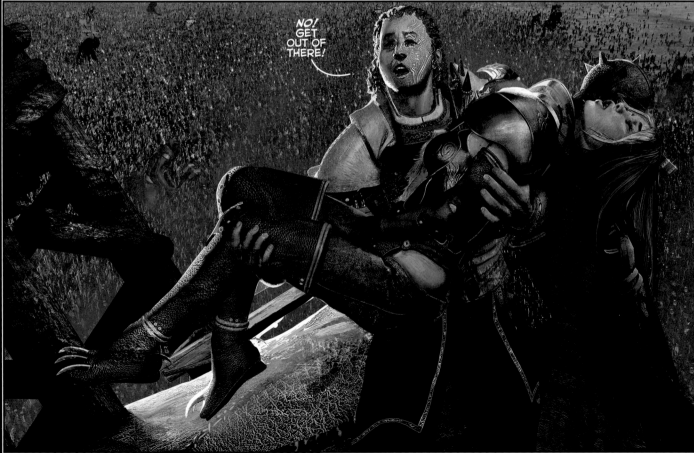

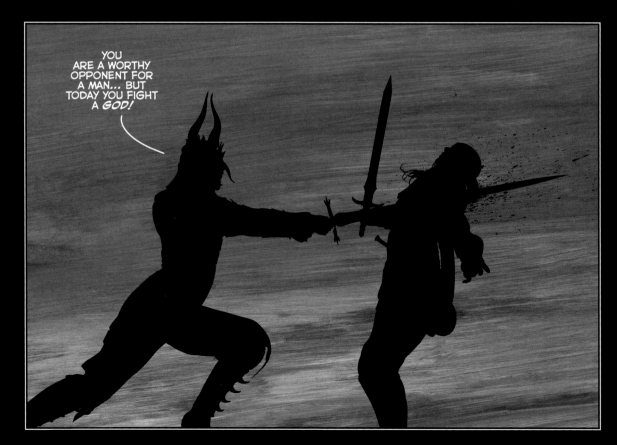

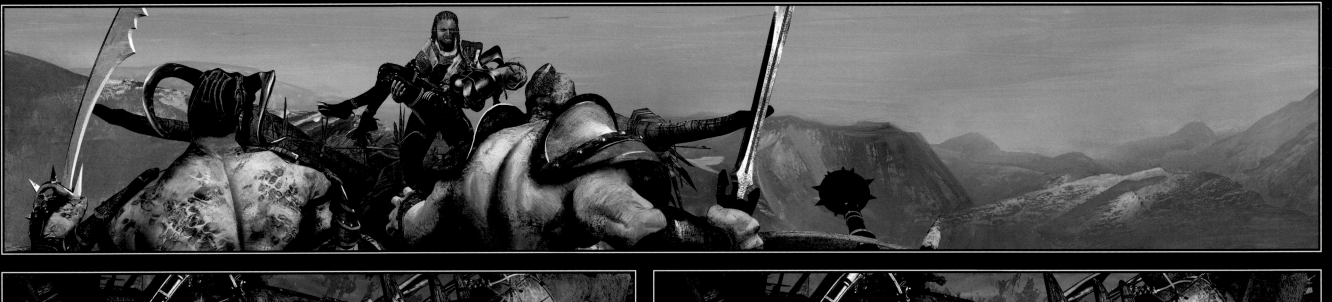
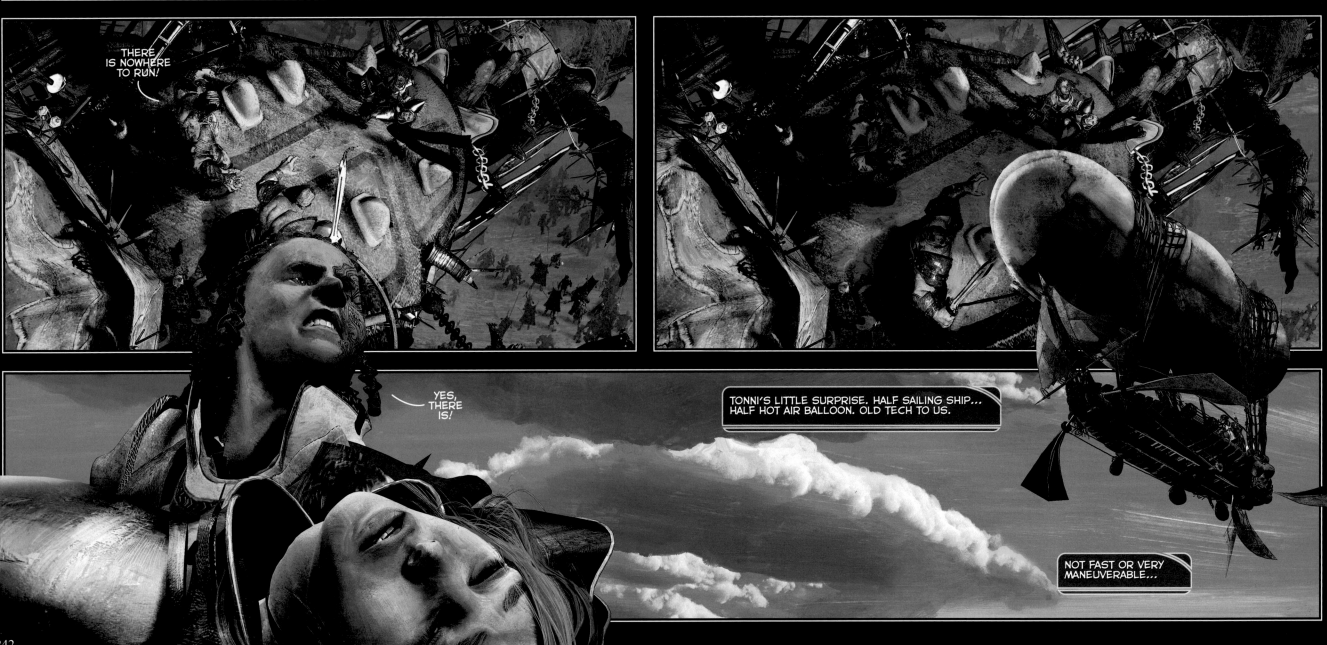

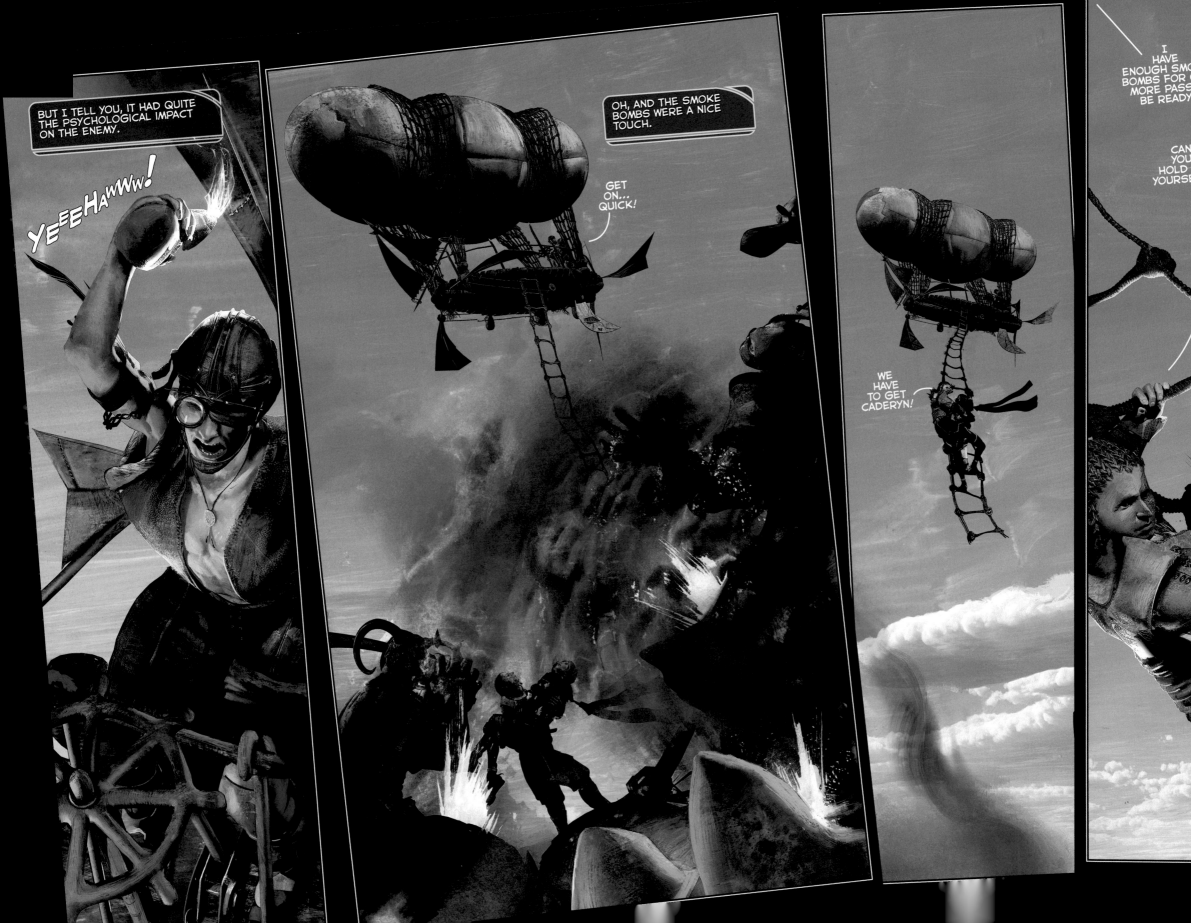
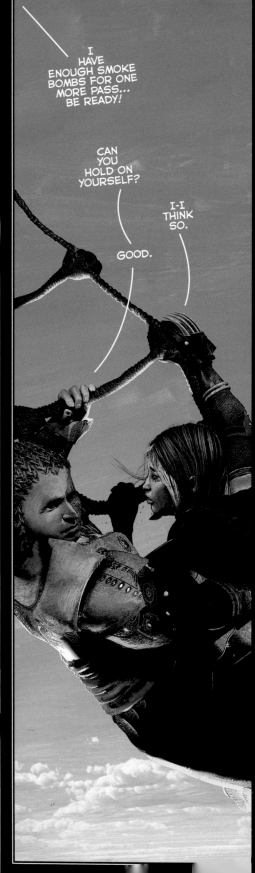

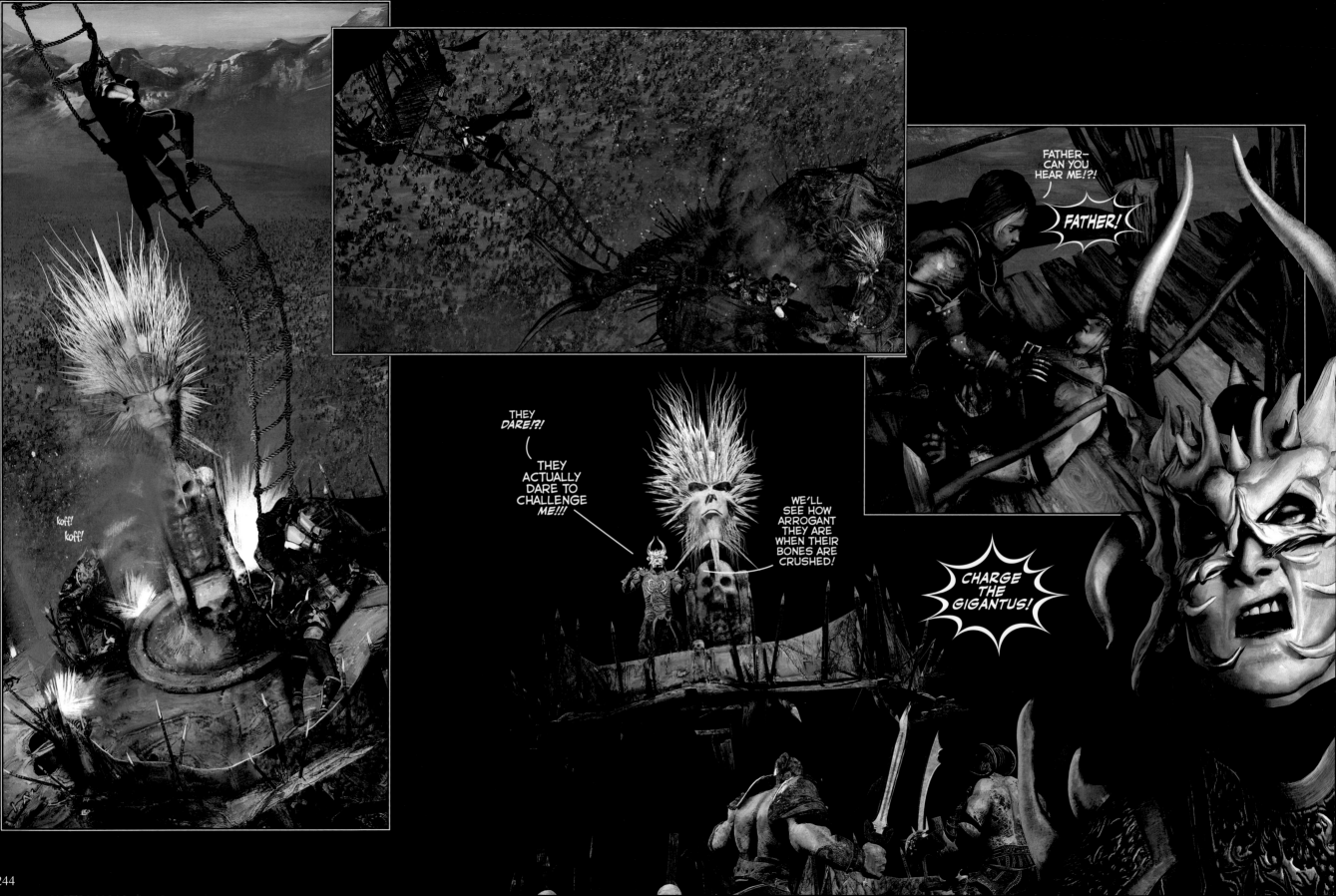

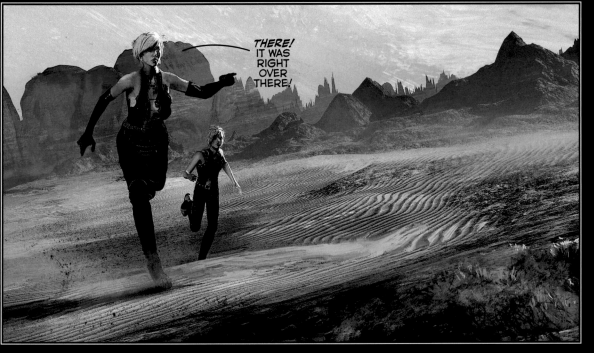

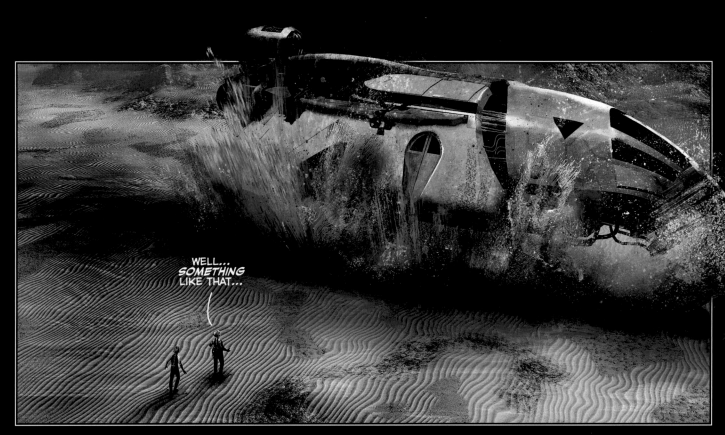

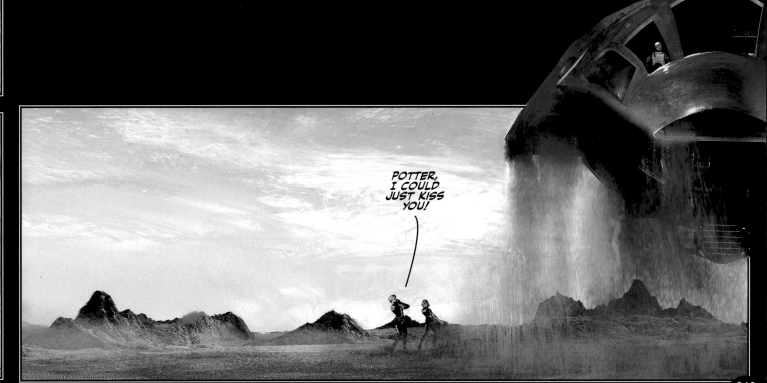

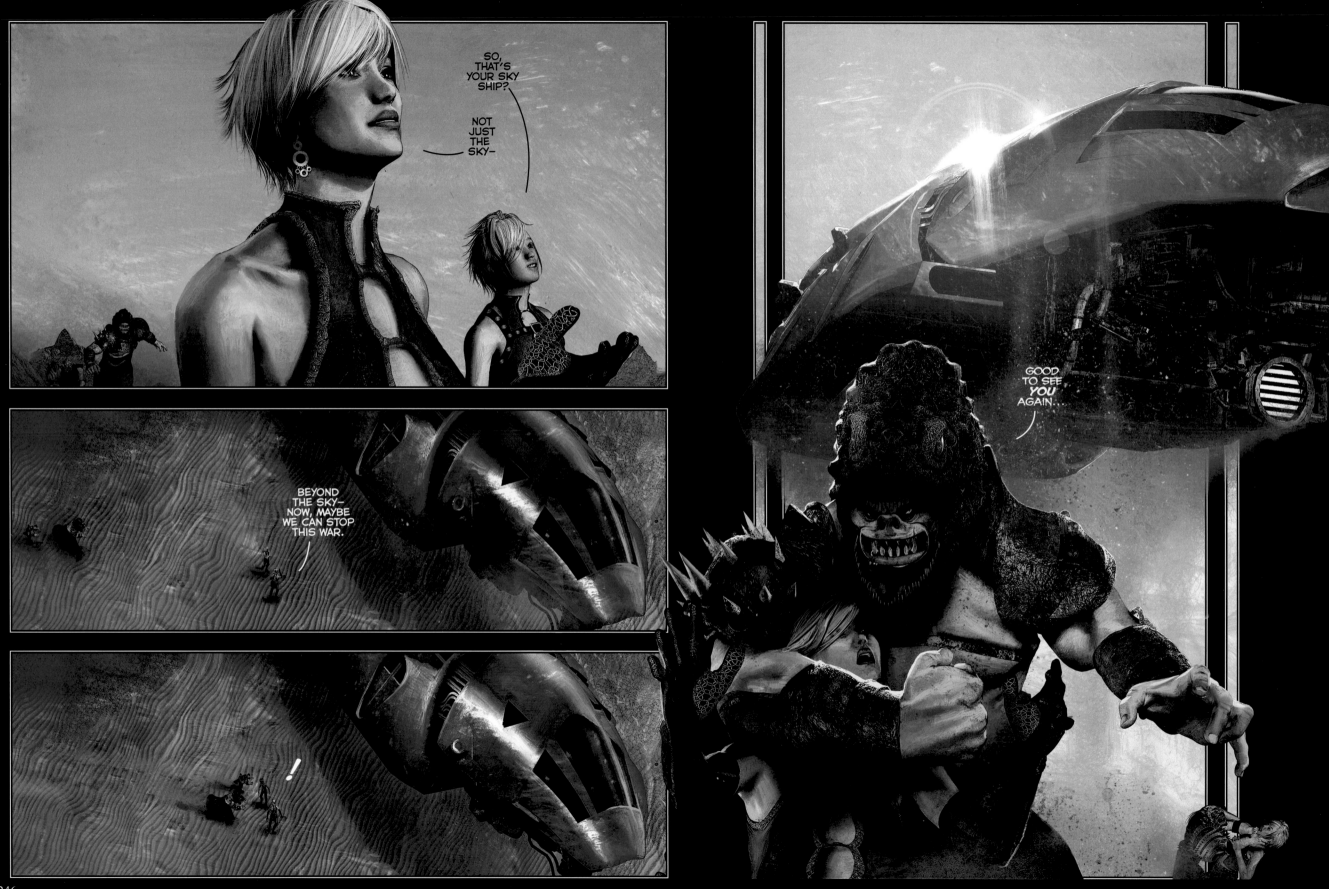

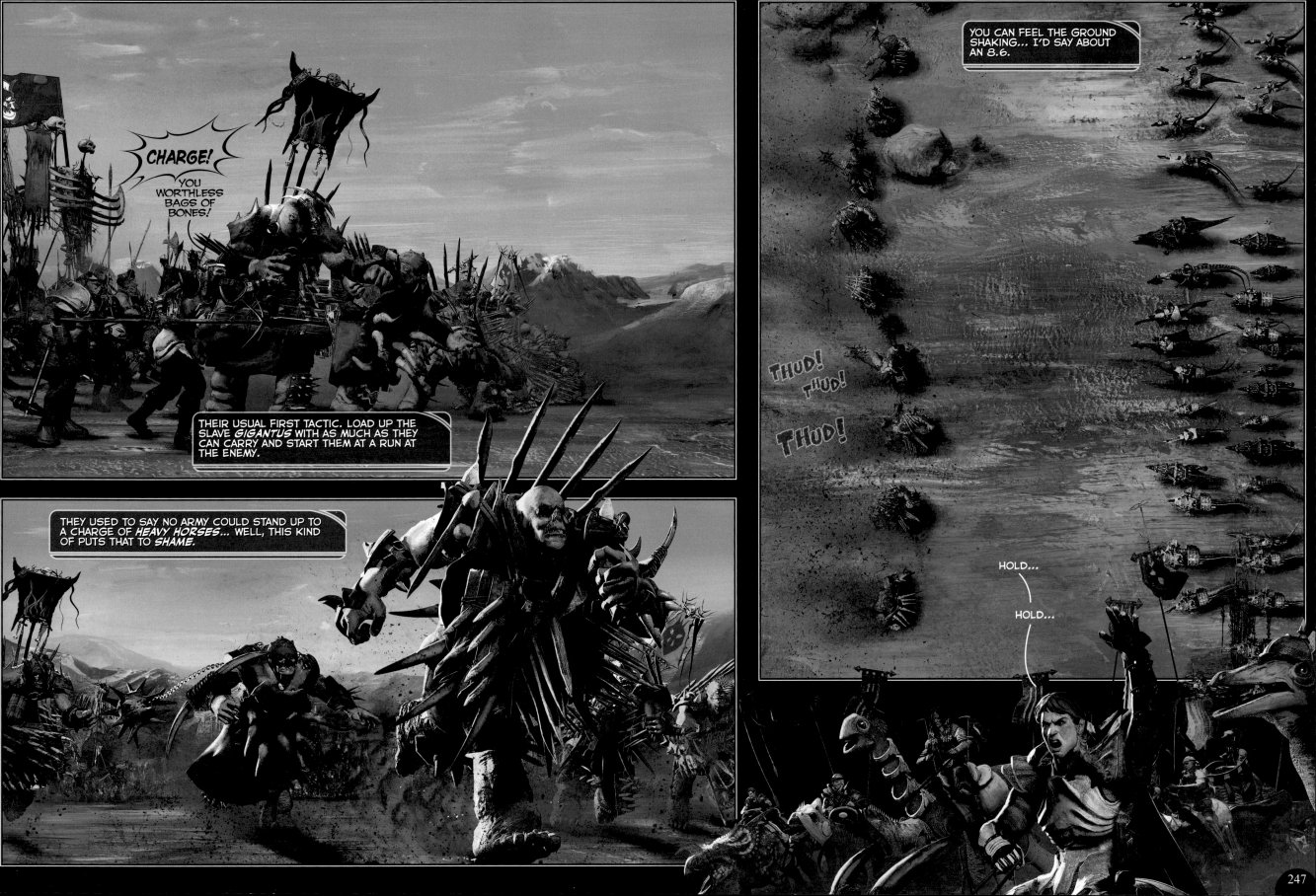

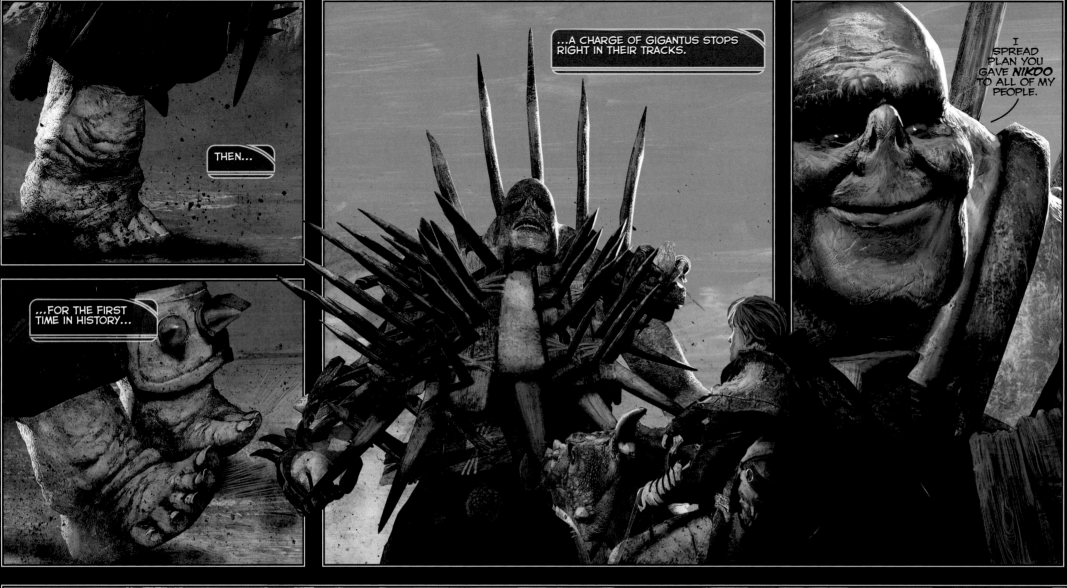

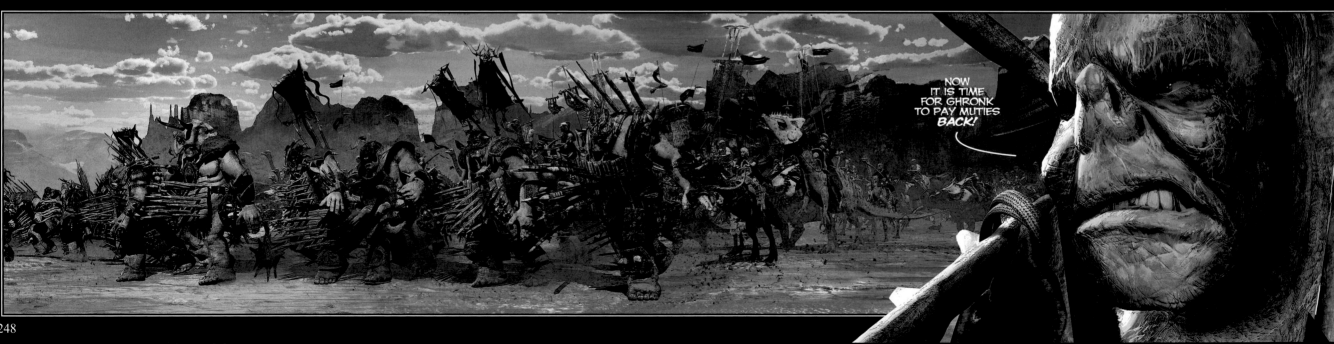

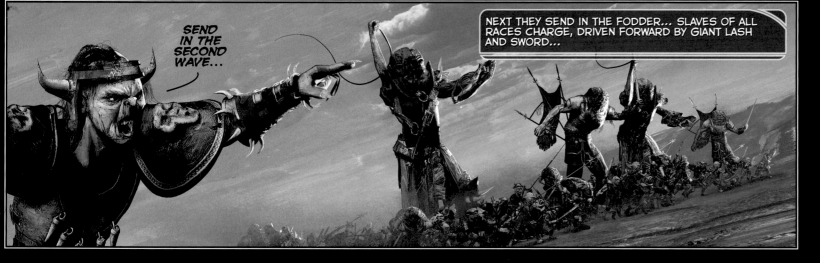

SEND IN THE SECOND WAVE...

NEXT THEY SEND IN THE FODDER... SLAVES OF ALL RACES CHARGE, DRIVEN FORWARD BY GIANT LASH AND SWORD...

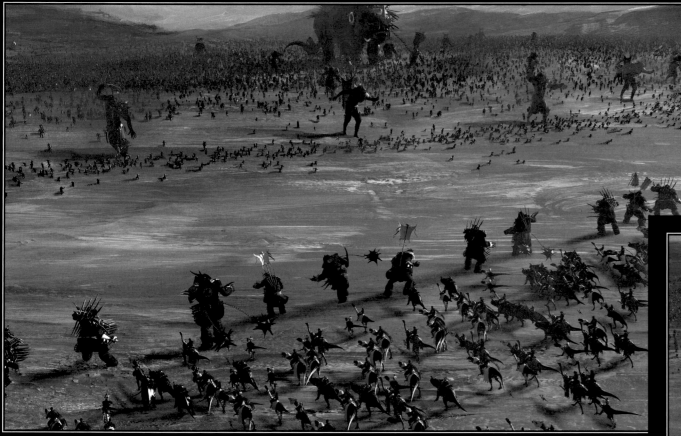

THE SLAVES AREN'T MEANT TO REALLY DO DAMAGE... JUST TO DRAIN STRENGTH AND RESOURCES FROM THE OPPOSING ARMY.

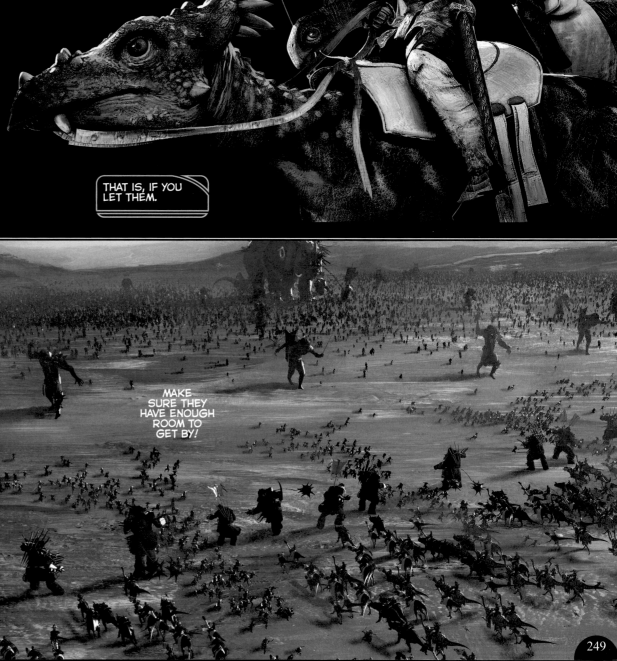

STEADY....

NOW!

THAT IS, IF YOU LET THEM.

MAKE SURE THEY HAVE ENOUGH ROOM TO GET BY!

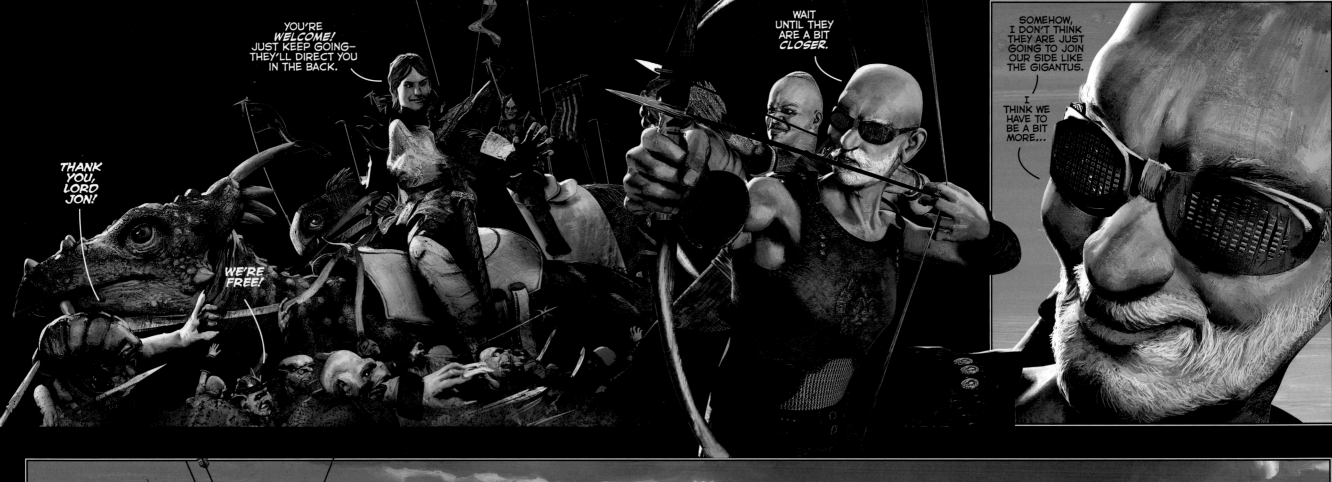

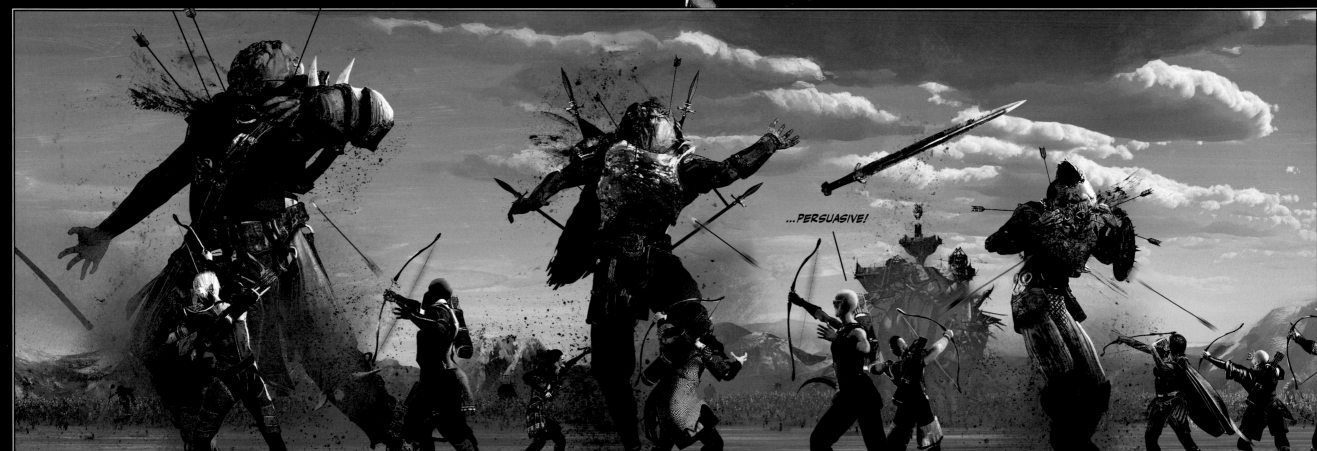

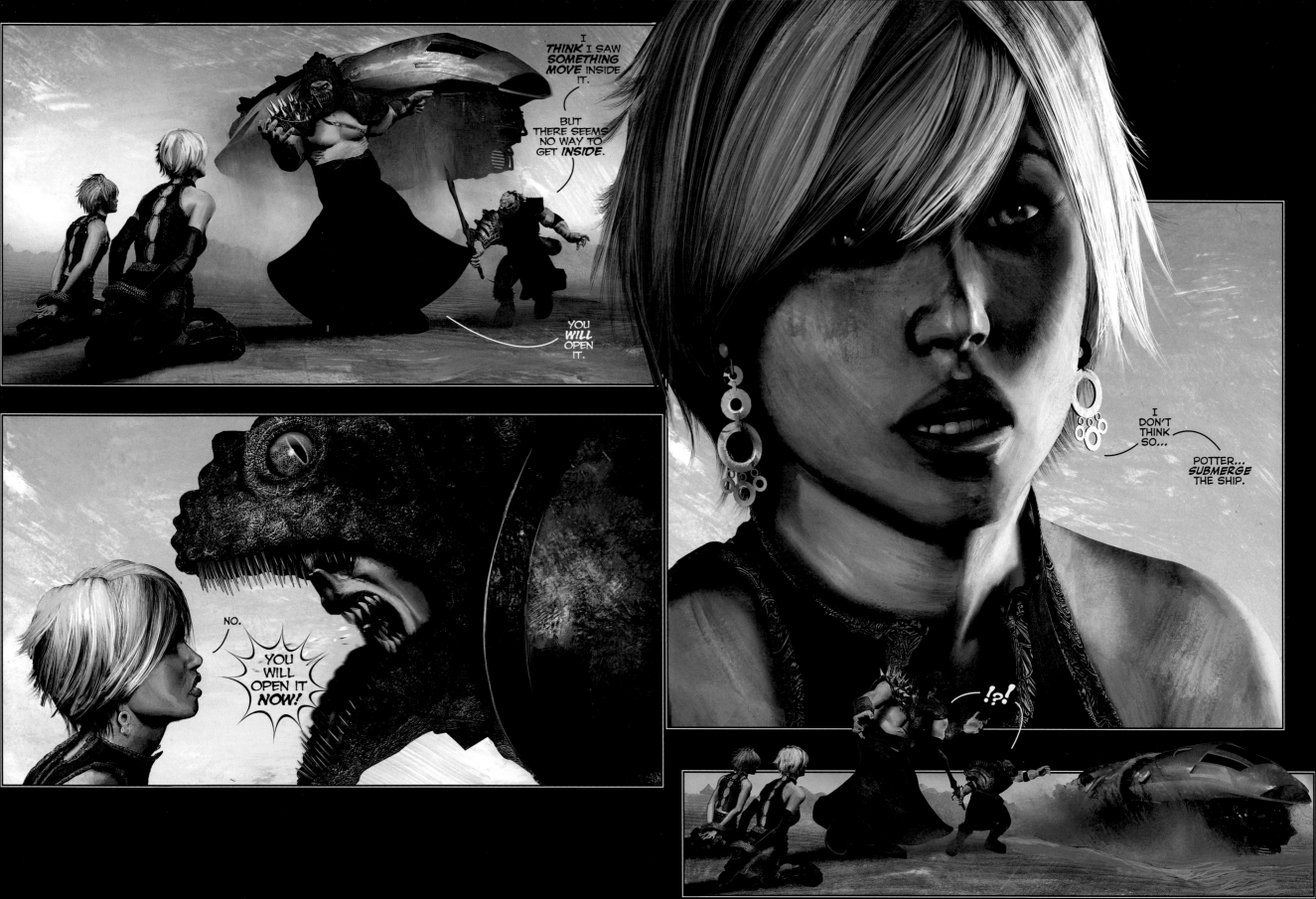

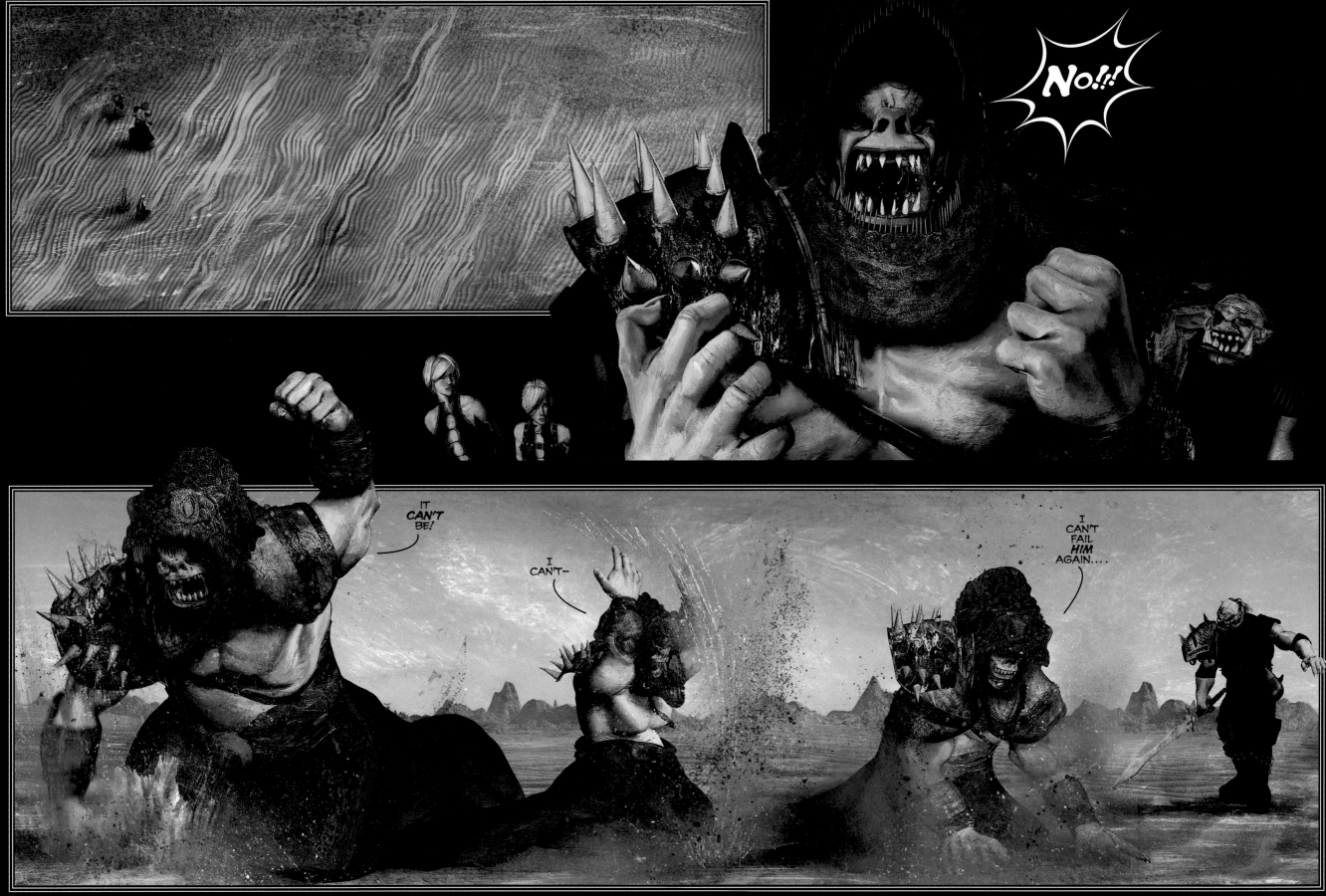

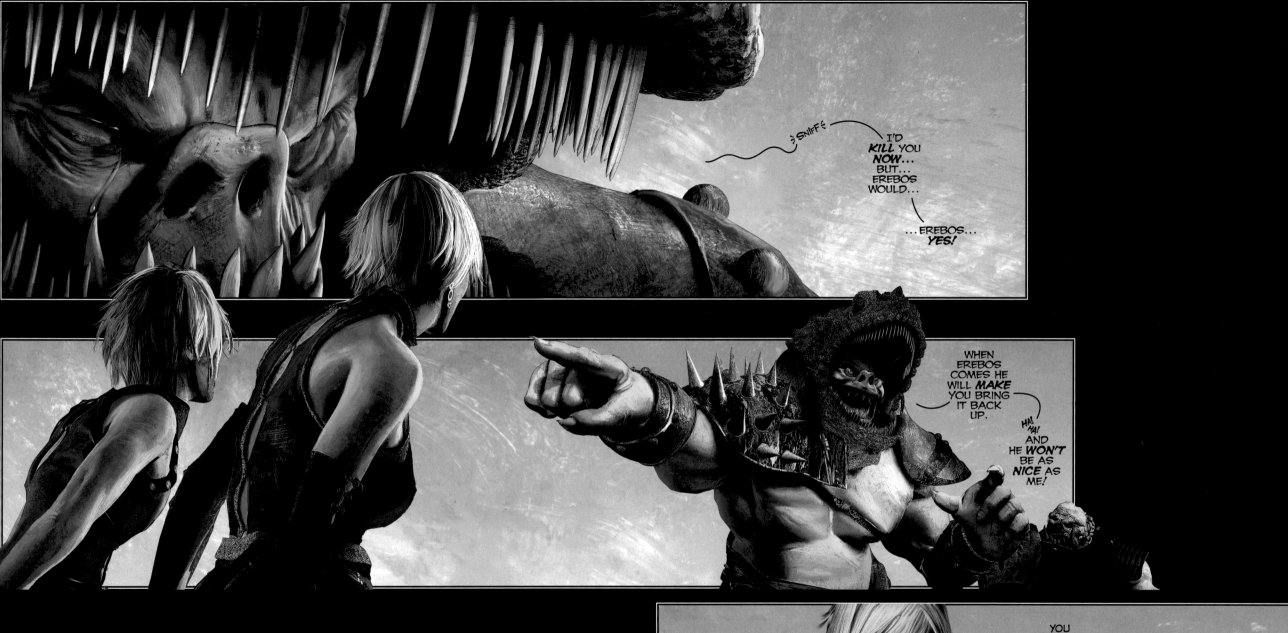

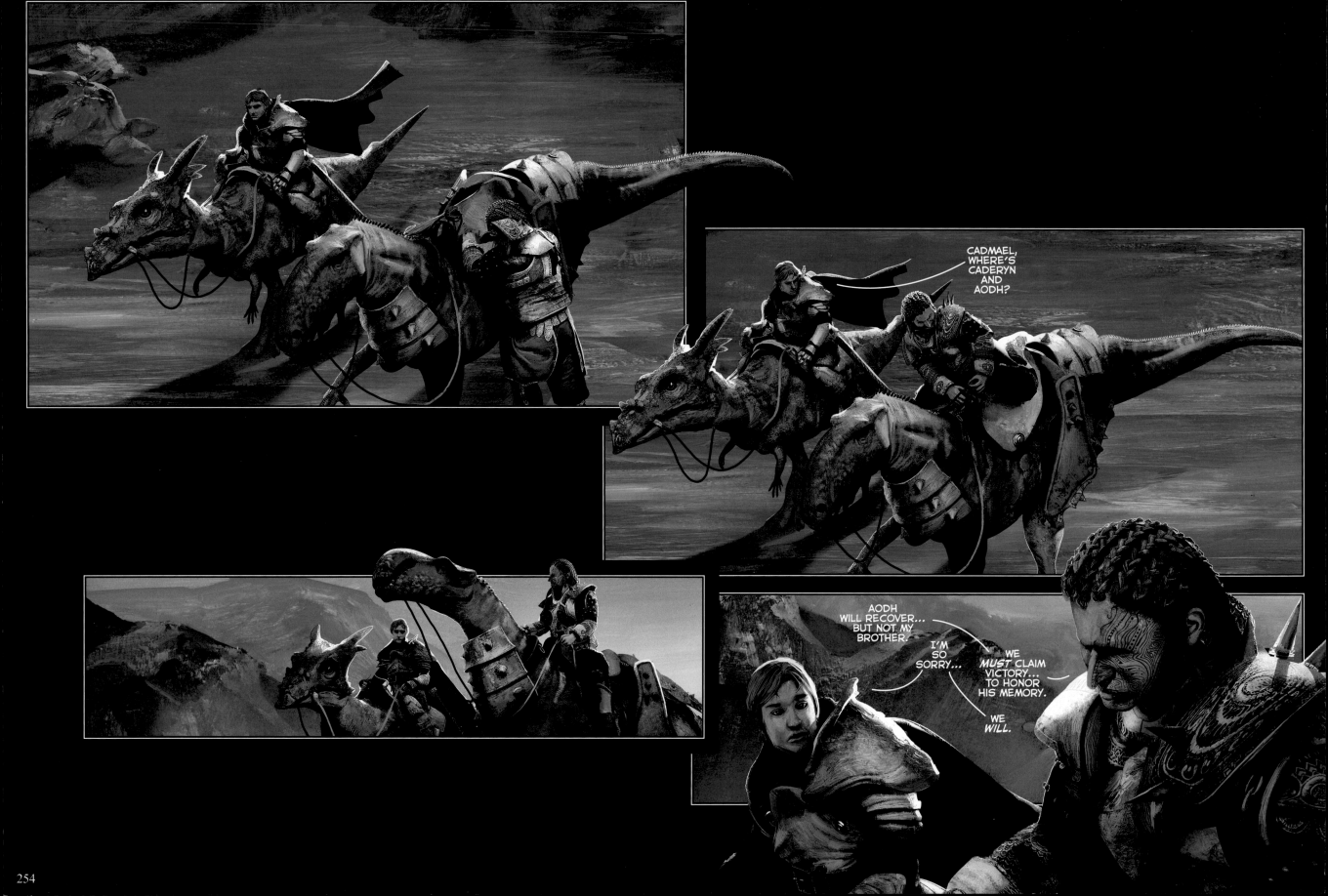

254

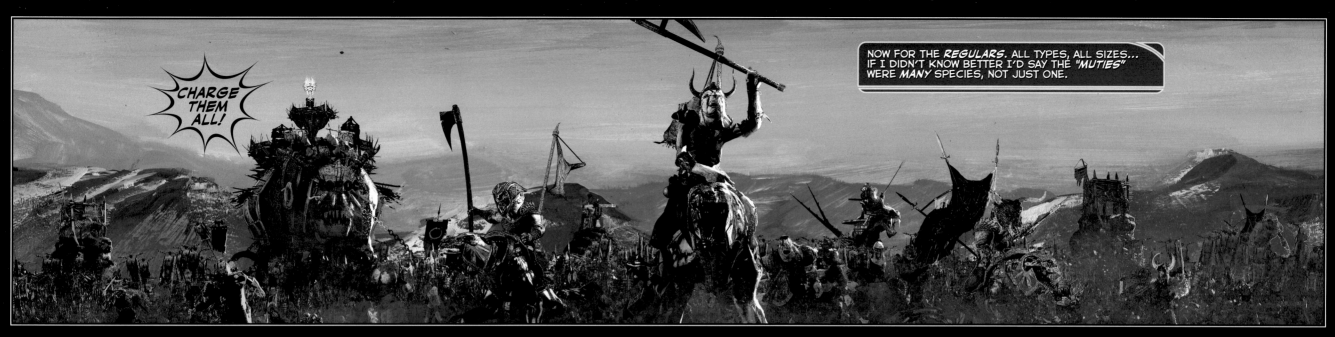

CHARGE THEM ALL!

NOW FOR THE *REGULARS*. ALL TYPES, ALL SIZES... IF I DIDN'T KNOW BETTER I'D SAY THE *"MUTIES"* WERE *MANY* SPECIES, NOT JUST ONE.

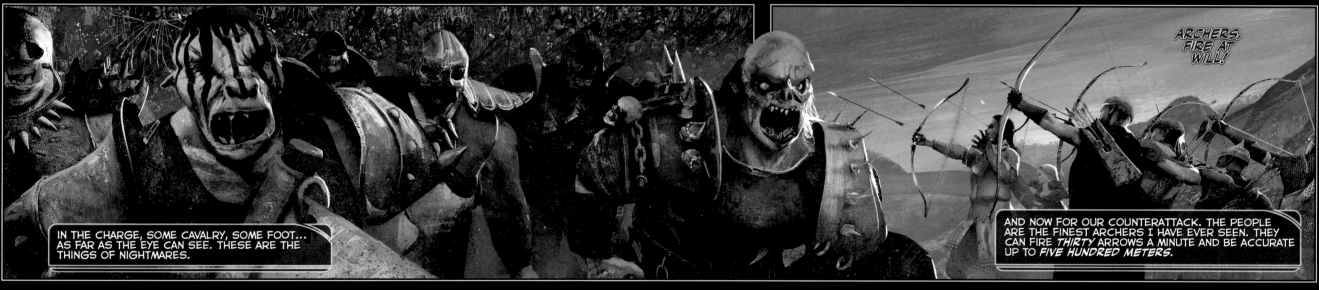

IN THE CHARGE, SOME CAVALRY, SOME FOOT... AS FAR AS THE EYE CAN SEE. THESE ARE THE THINGS OF NIGHTMARES.

ARCHERS, FIRE AT WILL!

AND NOW FOR OUR COUNTERATTACK. THE PEOPLE ARE THE FINEST ARCHERS I HAVE EVER SEEN. THEY CAN FIRE *THIRTY* ARROWS A MINUTE AND BE ACCURATE UP TO *FIVE HUNDRED METERS*.

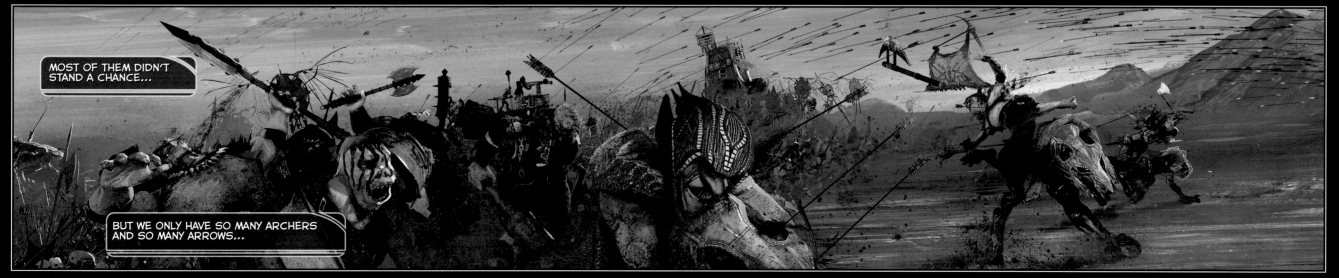

MOST OF THEM DIDN'T STAND A CHANCE...

BUT WE ONLY HAVE SO MANY ARCHERS AND SO MANY ARROWS...

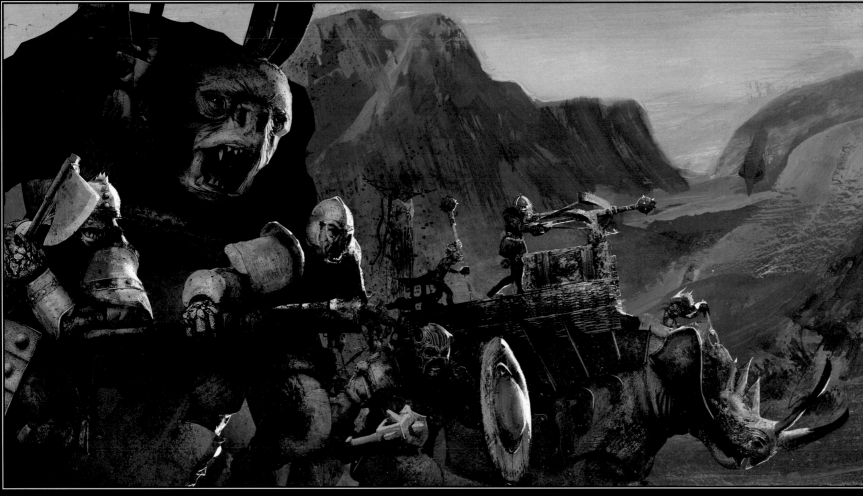

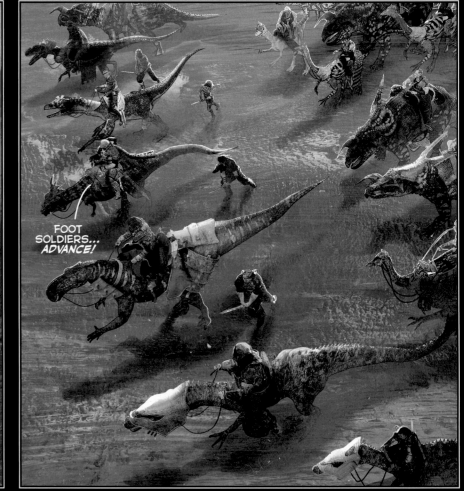

FOOT SOLDIERS... *ADVANCE!*

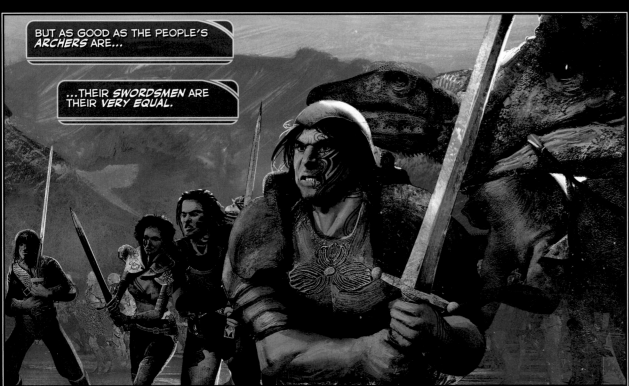

BUT AS GOOD AS THE PEOPLE'S *ARCHERS* ARE...

...THEIR *SWORDSMEN* ARE THEIR *VERY EQUAL.*

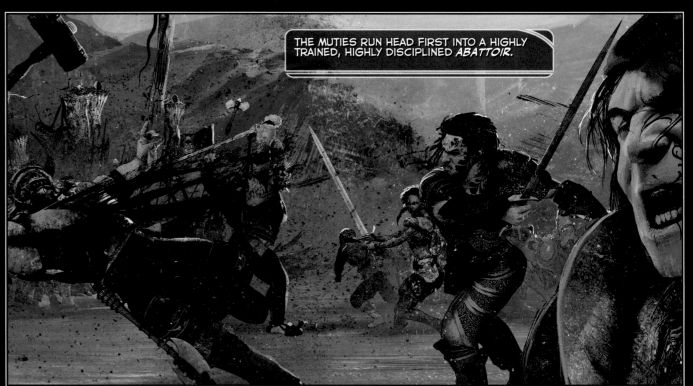

THE MUTIES RUN HEAD FIRST INTO A HIGHLY TRAINED, HIGHLY DISCIPLINED *ABATTOIR.*

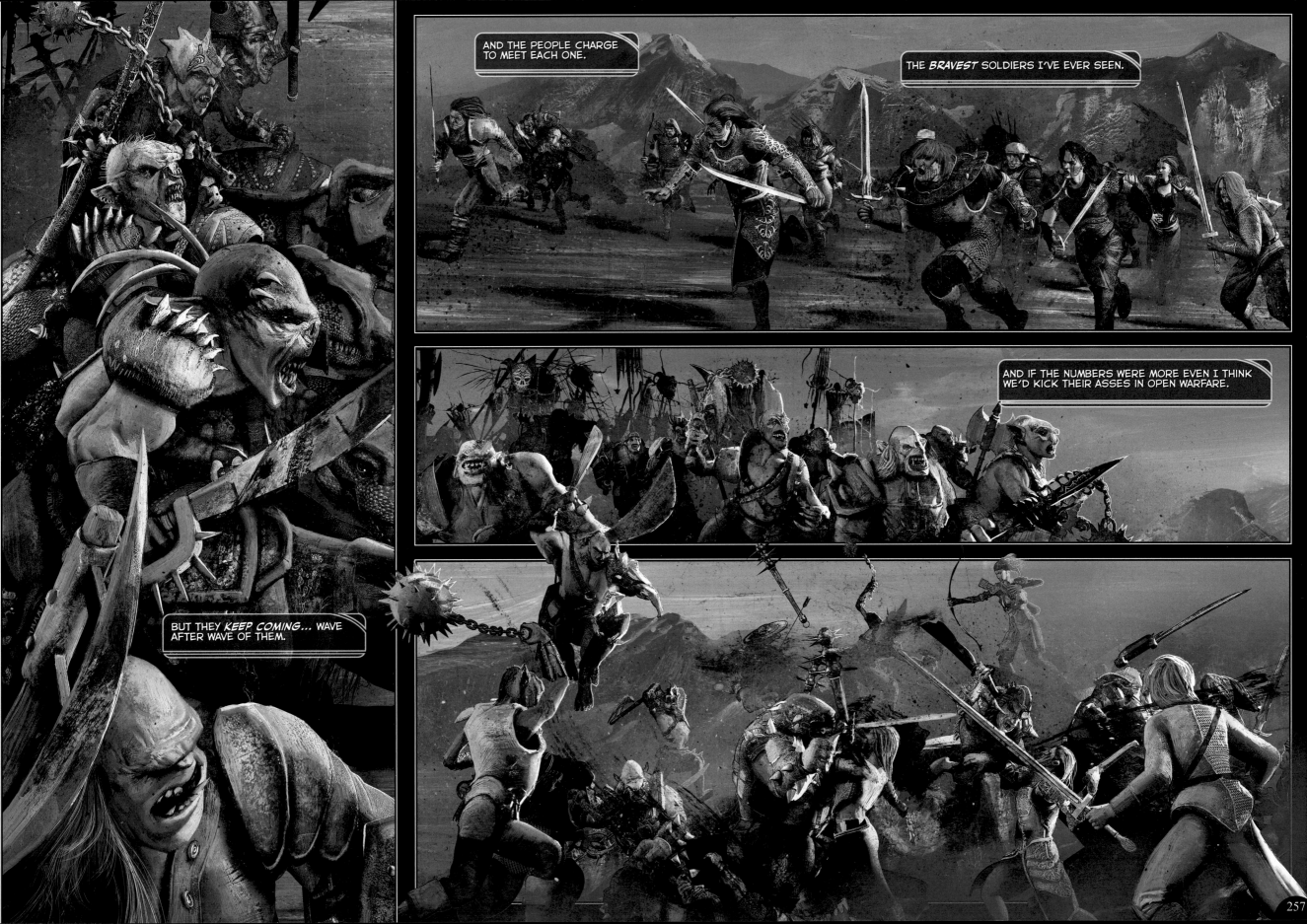

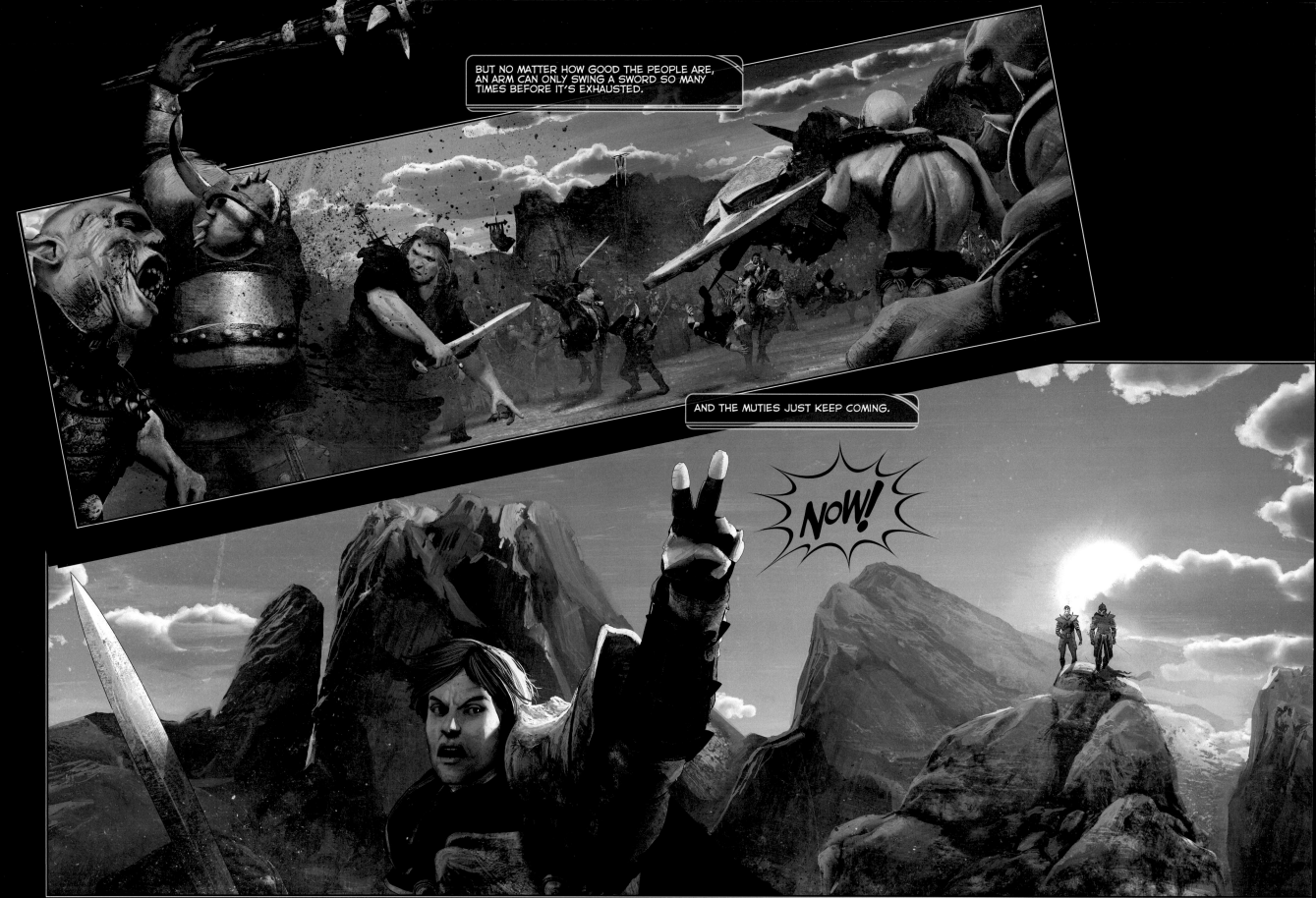

THEY BOTH WANTED TO BE IN THE BATTLE SO BADLY.

BUT THEY PLAY A MORE CRUCIAL ROLL.

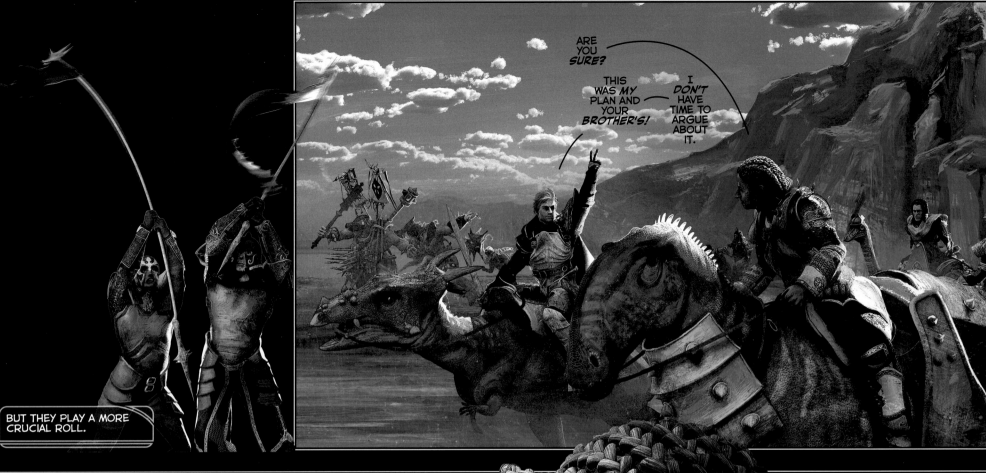

ARE YOU SURE?

THIS WAS MY PLAN AND YOUR BROTHER'S!

I DON'T HAVE TIME TO ARGUE ABOUT IT.

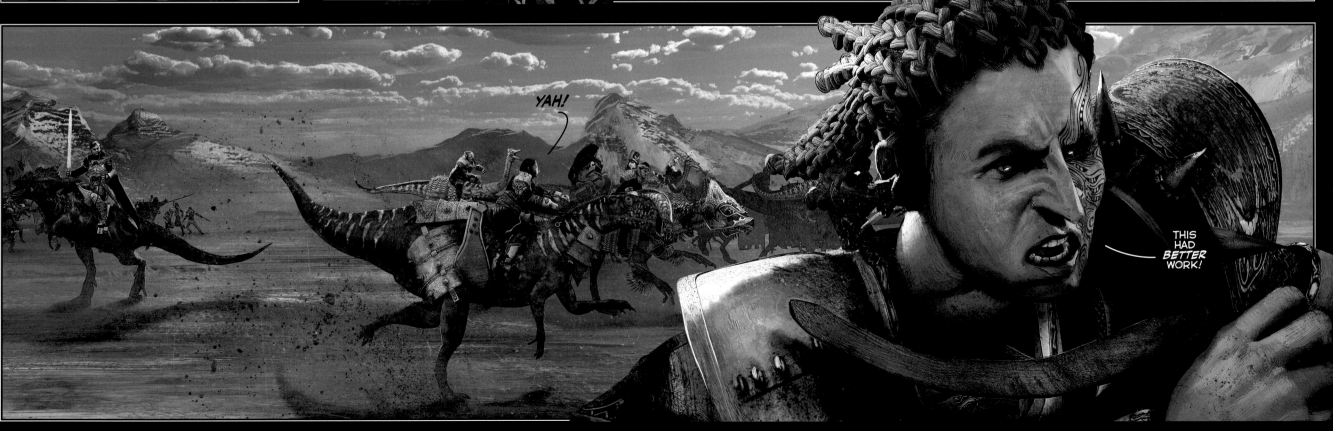

YAH!

THIS HAD BETTER WORK!

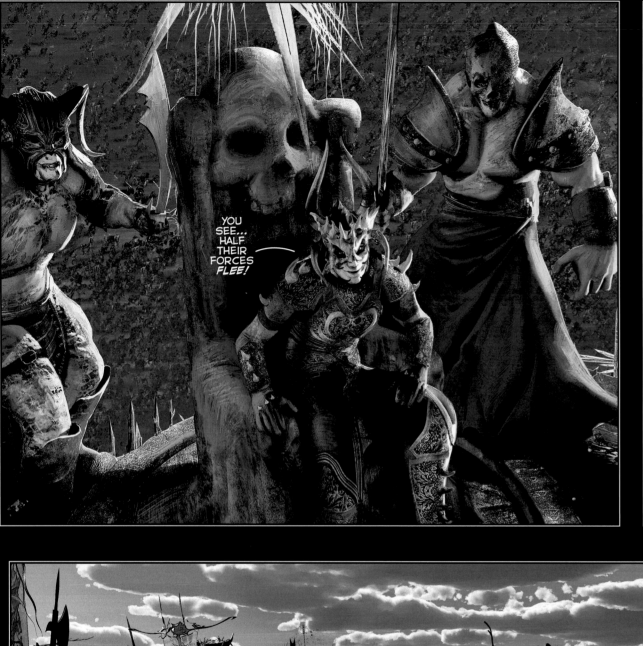

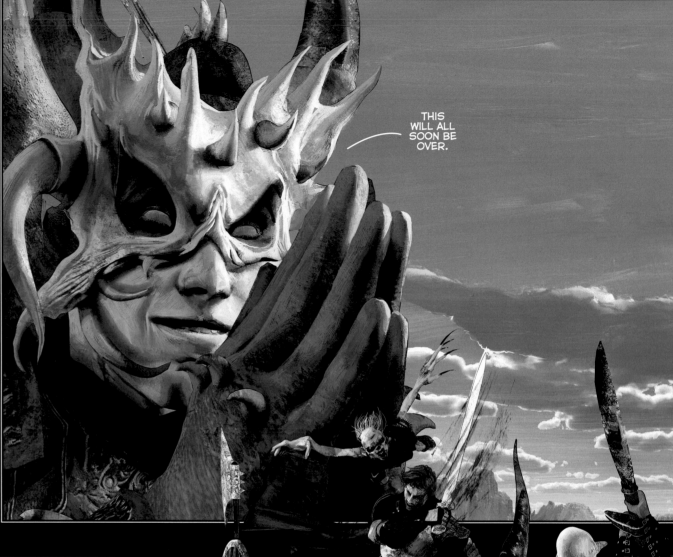

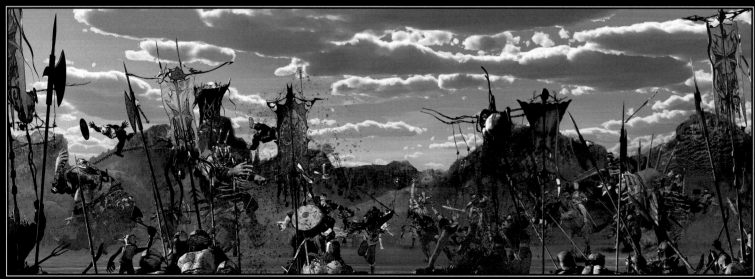

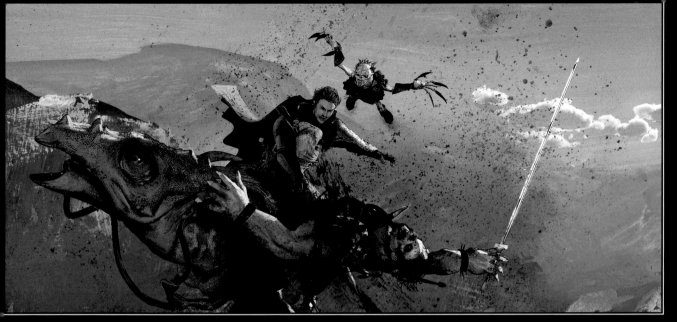

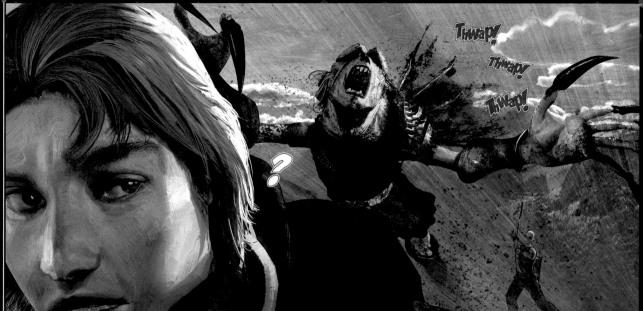

THWAP!
THWAP!
THWAP!

?

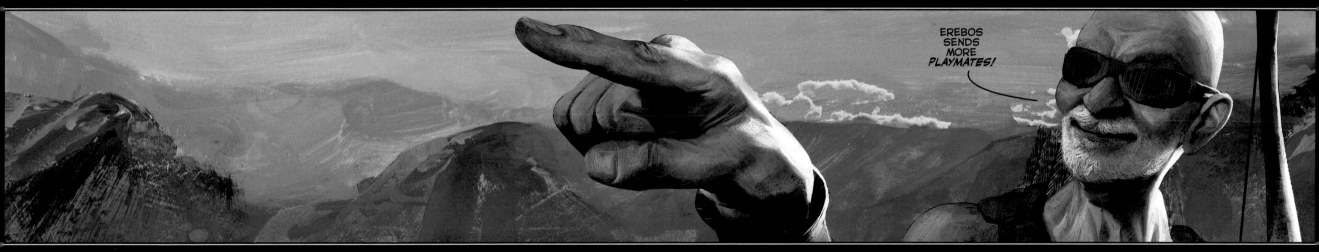

EREBOS SENDS MORE *PLAYMATES!*

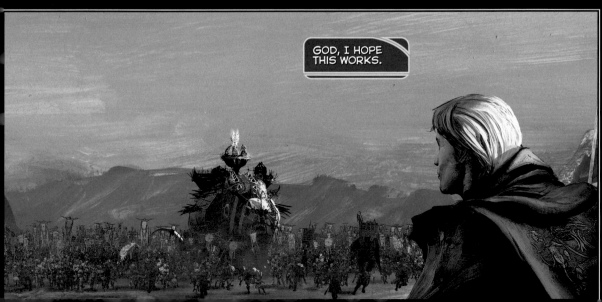

GOD, I HOPE THIS WORKS.

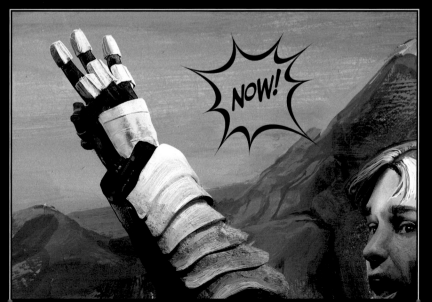

NOW!

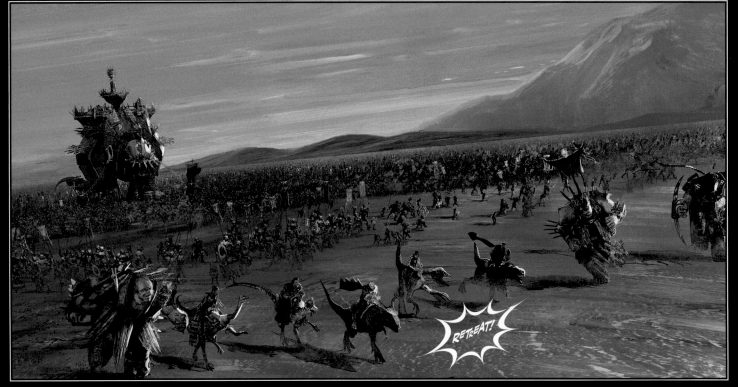

RETREAT!

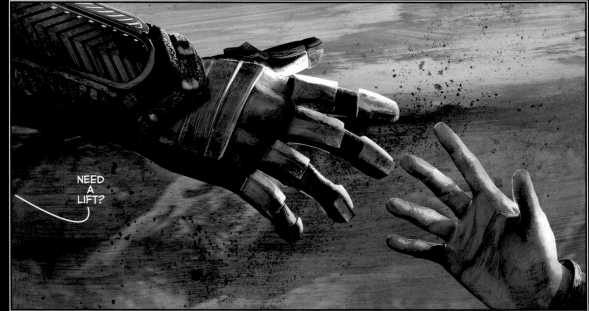

NEED A LIFT?

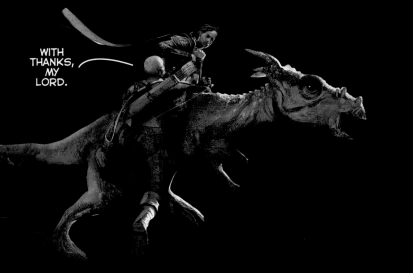

WITH THANKS, MY LORD.

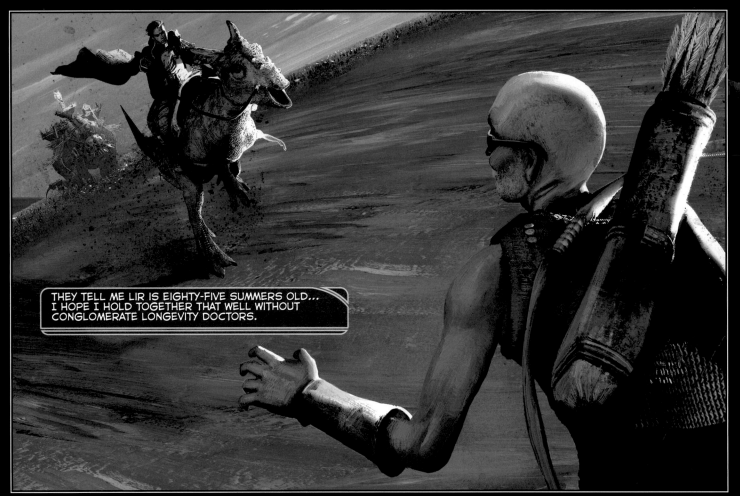

THEY TELL ME LIR IS EIGHTY-FIVE SUMMERS OLD... I HOPE I HOLD TOGETHER THAT WELL WITHOUT CONGLOMERATE LONGEVITY DOCTORS.

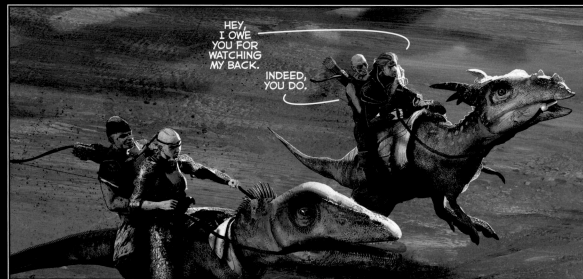

HEY, I OWE YOU FOR WATCHING MY BACK.

INDEED, YOU DO.

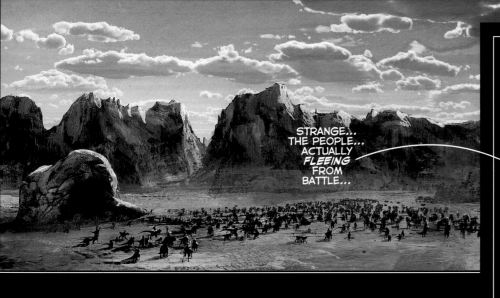

STRANGE... THE PEOPLE... ACTUALLY *FLEEING* FROM BATTLE...

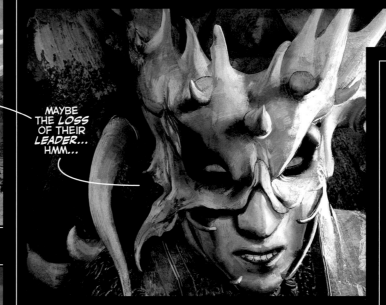

MAYBE THE *LOSS* OF THEIR *LEADER*... HMM...

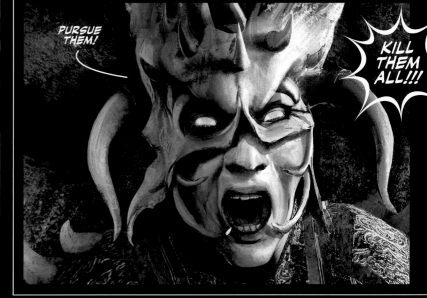

PURSUE THEM!

KILL THEM ALL!!!

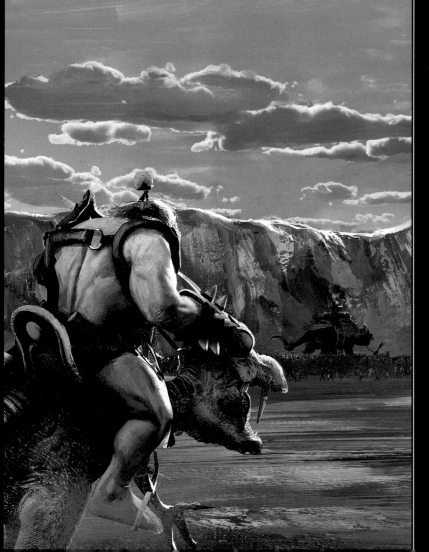

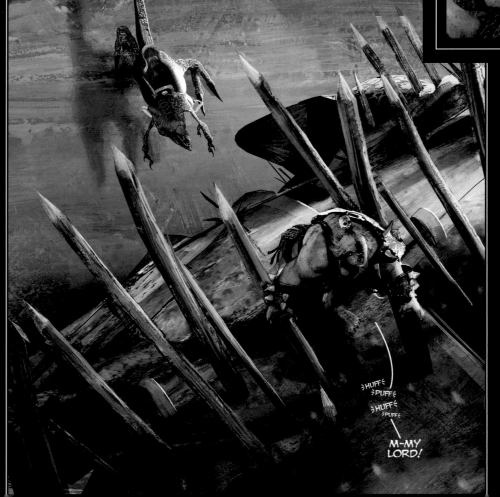

§HUFF§
§PUFF§
§HUFF§
§PUFF§

M-MY LORD!

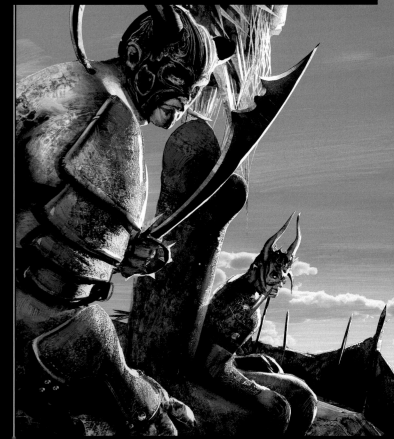

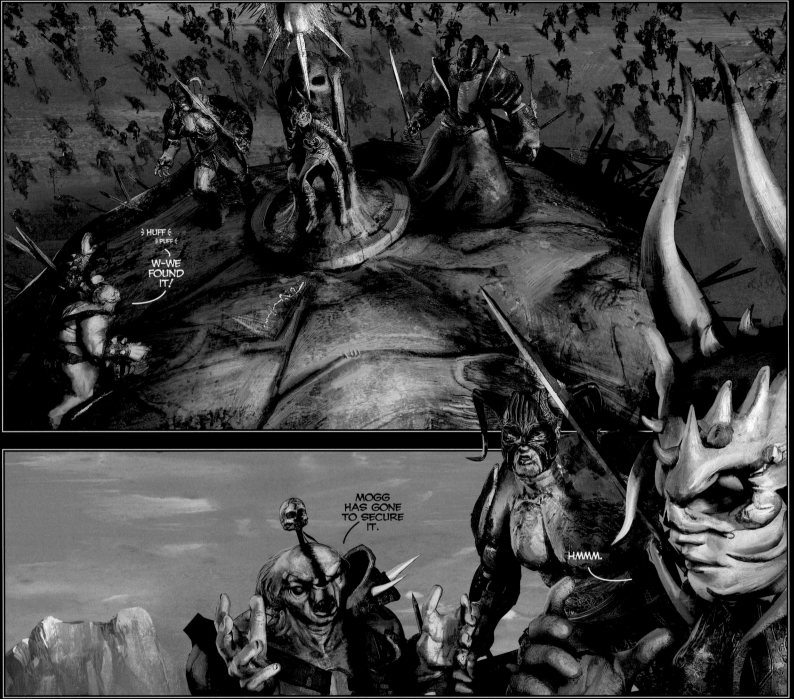

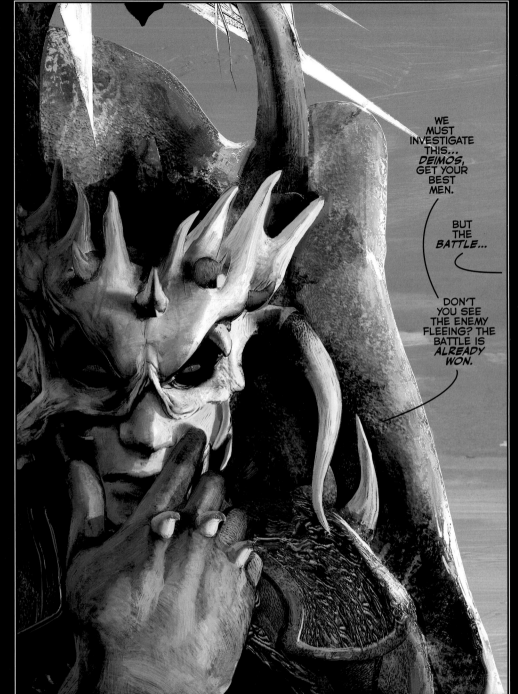

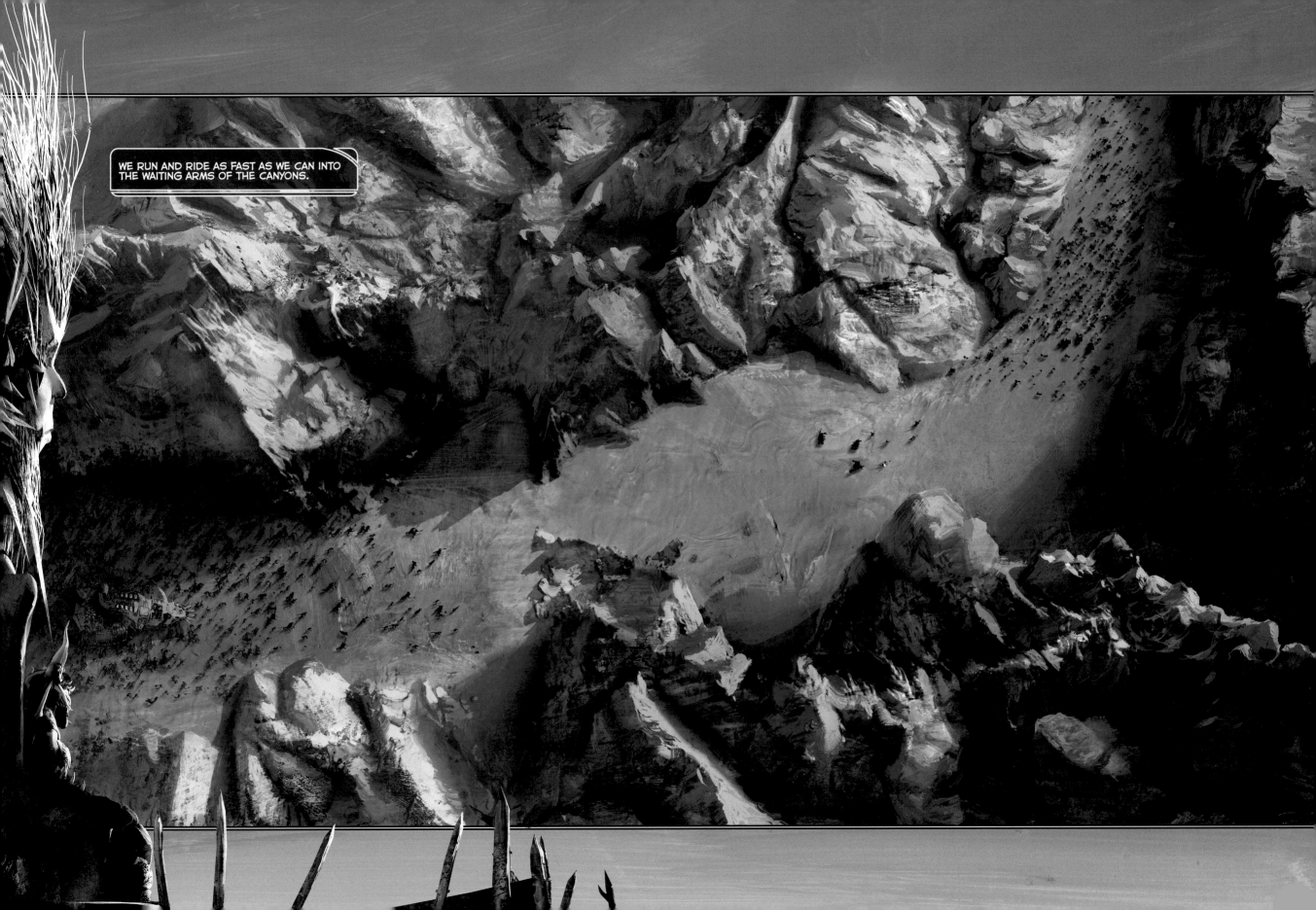

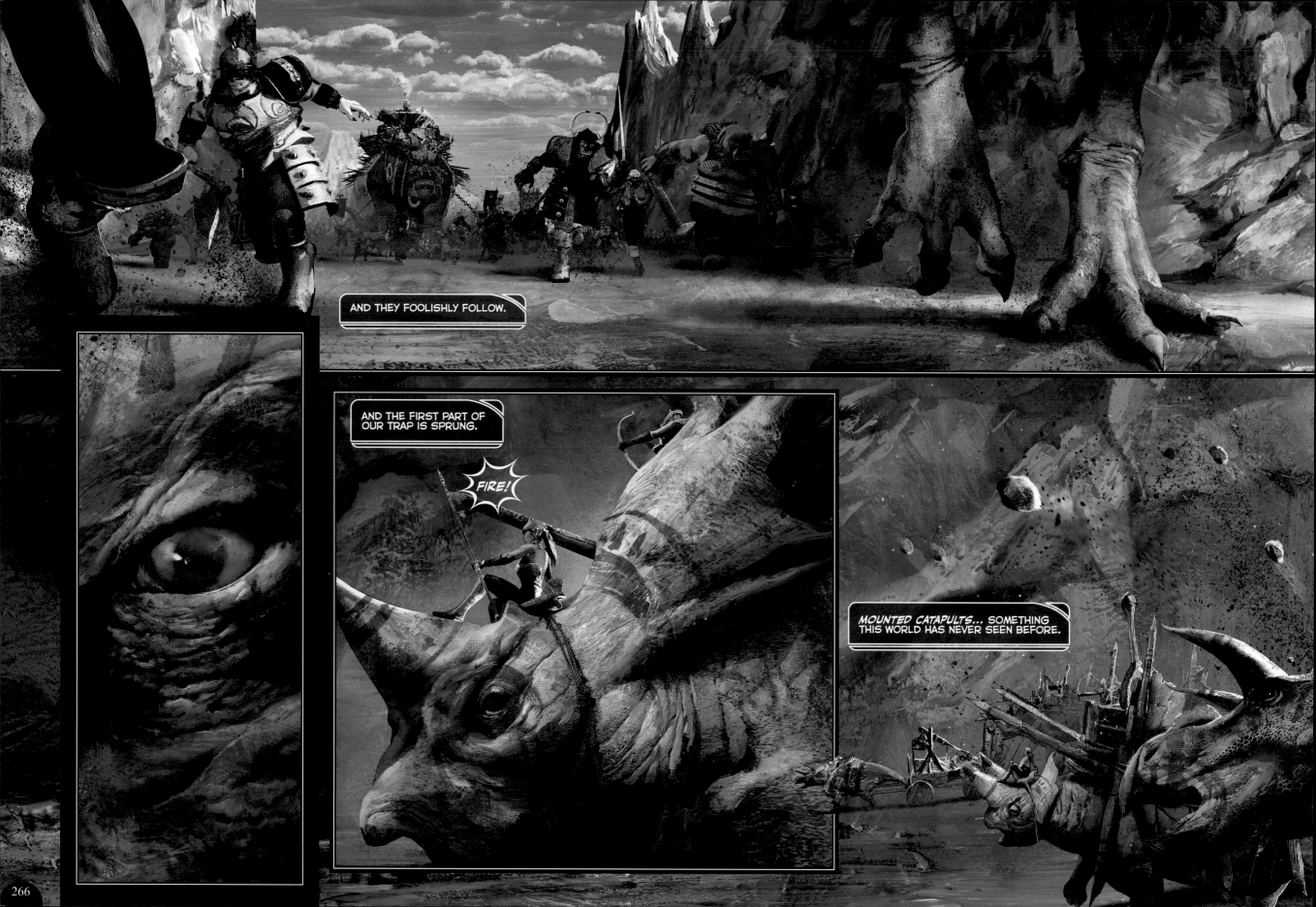

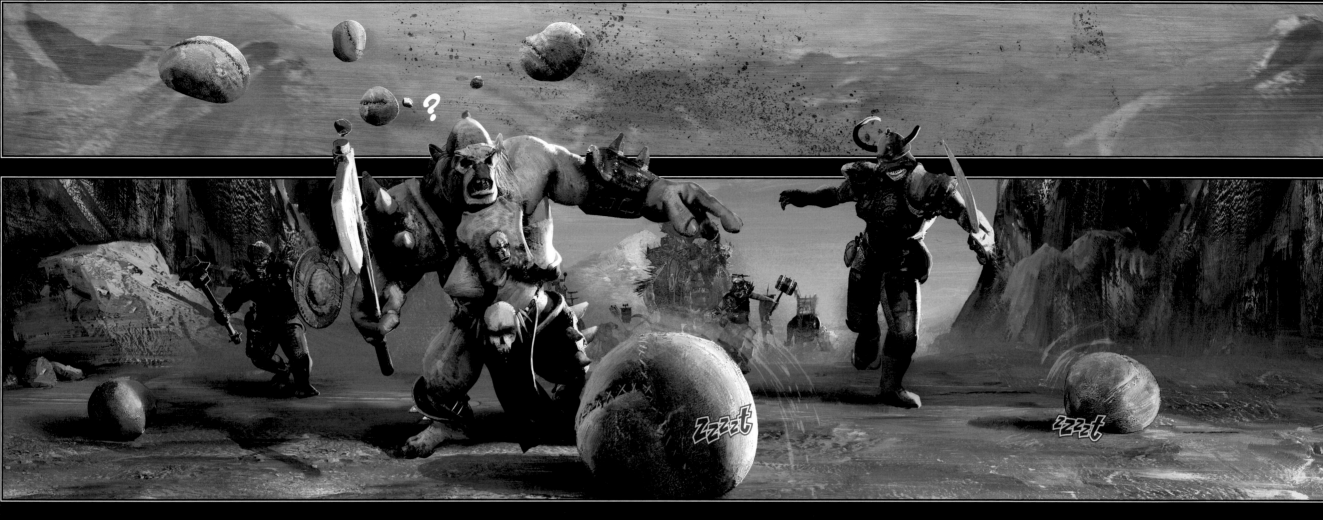

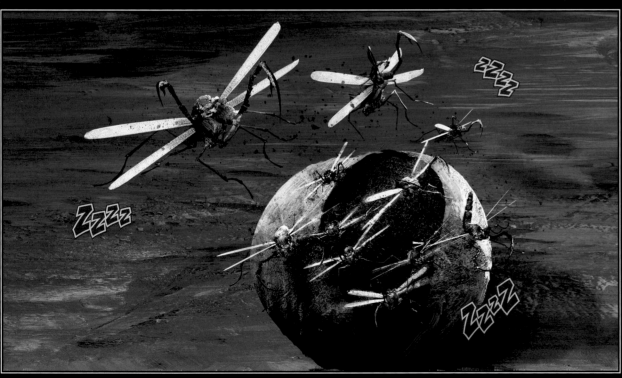

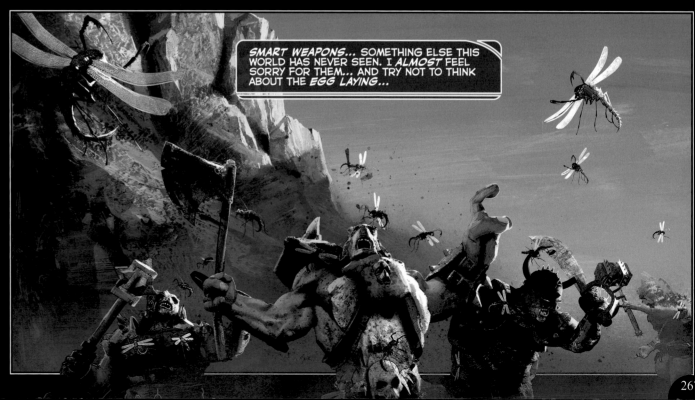

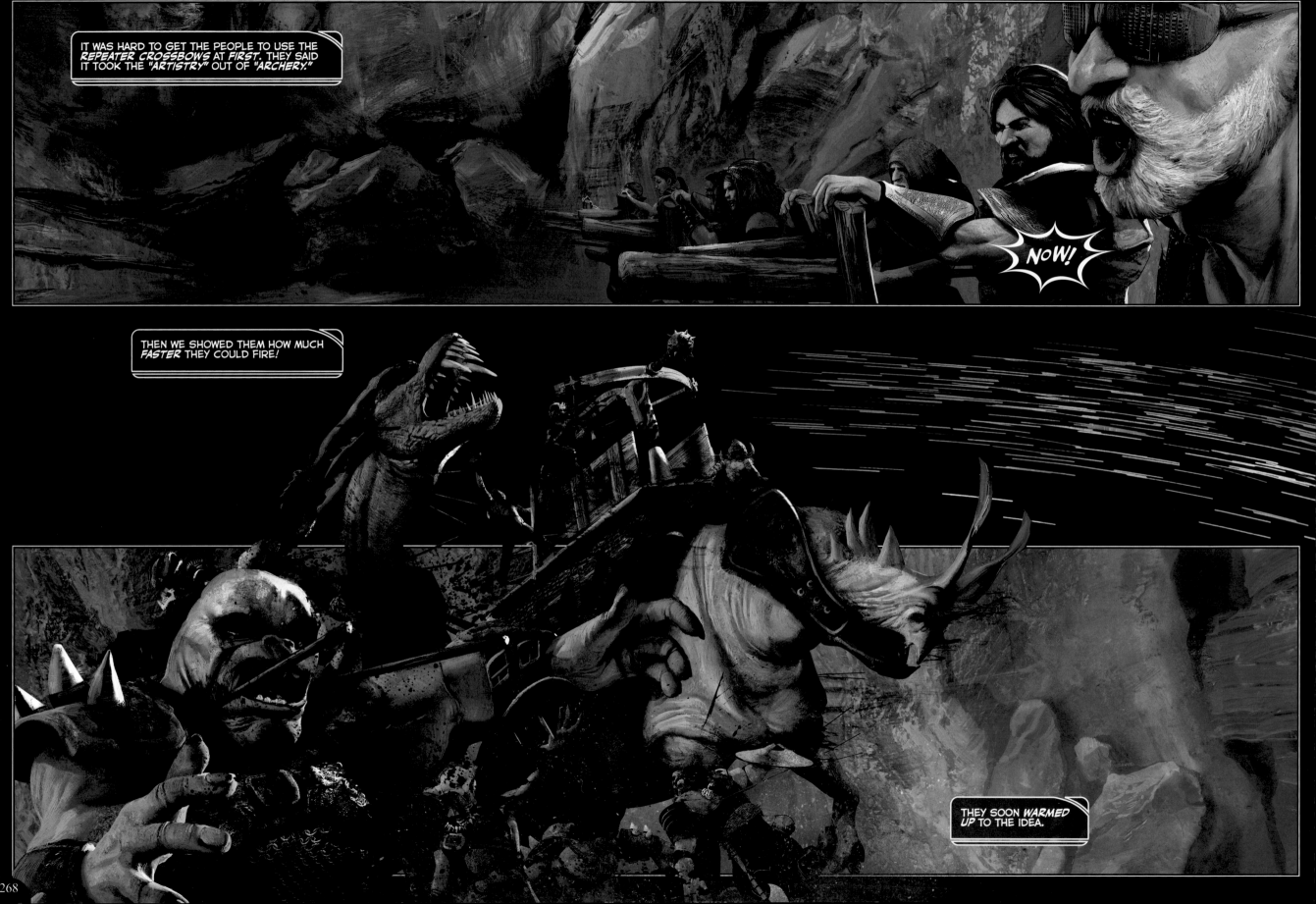

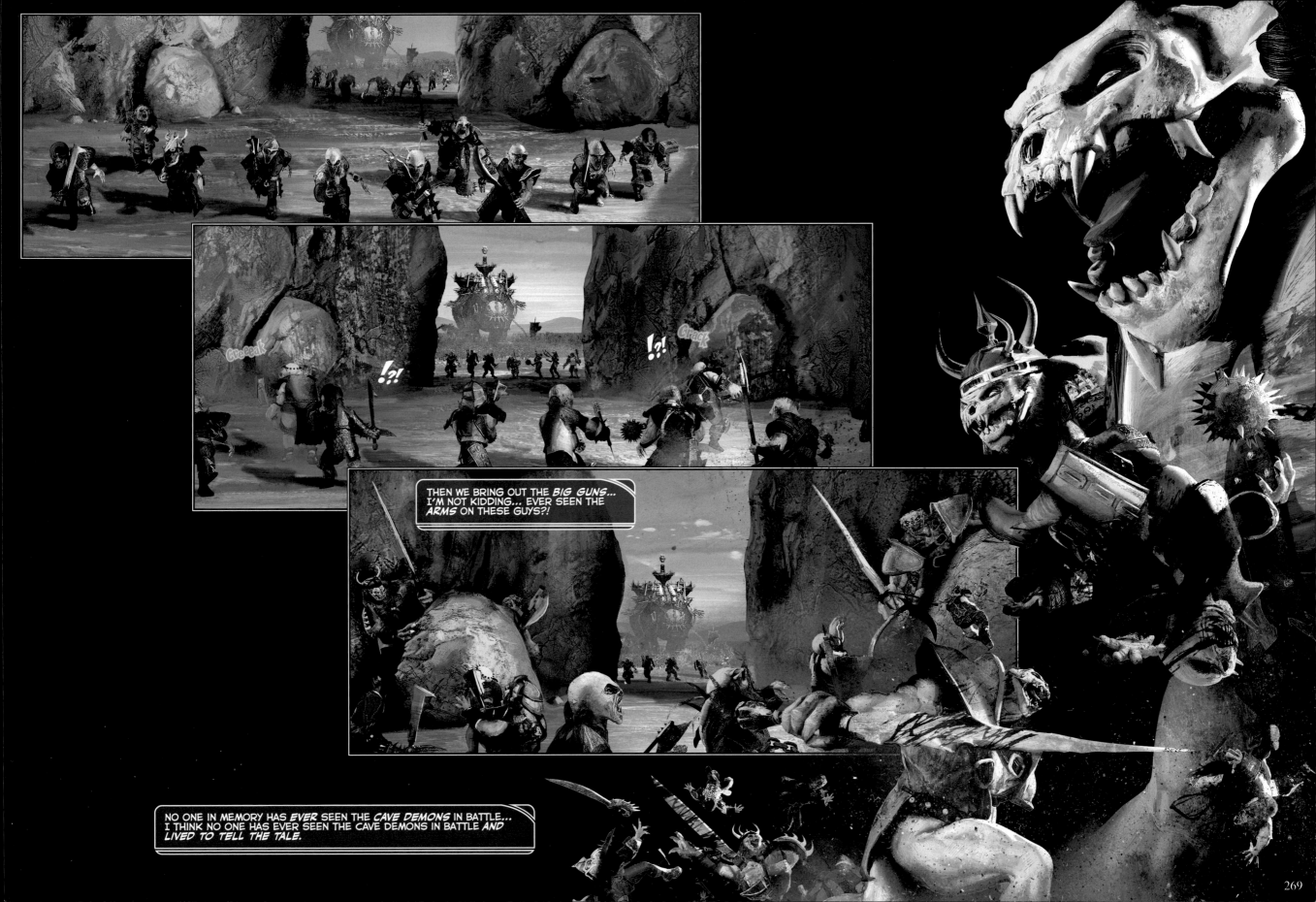

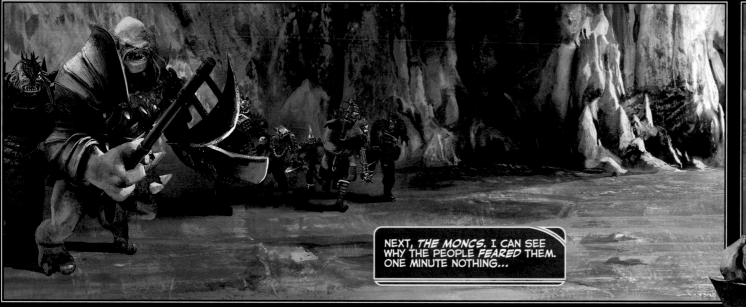

NEXT, *THE MONCS.* I CAN SEE WHY THE PEOPLE *FEARED* THEM. ONE MINUTE NOTHING...

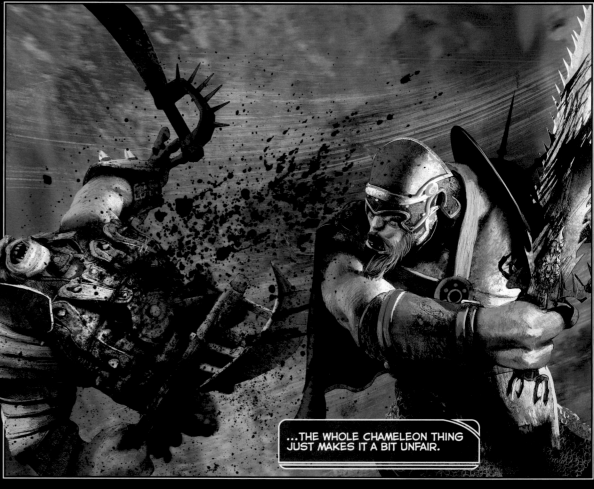

...THE WHOLE CHAMELEON THING JUST MAKES IT A BIT UNFAIR.

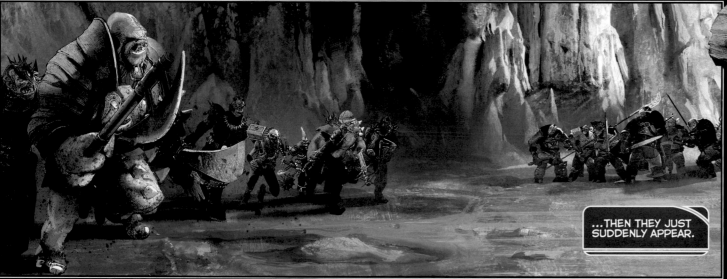

...THEN THEY JUST SUDDENLY APPEAR.

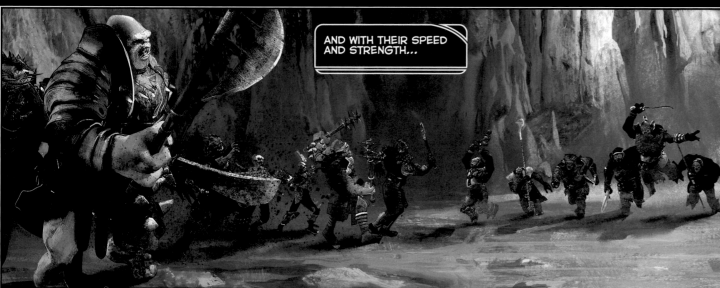

AND WITH THEIR SPEED AND STRENGTH...

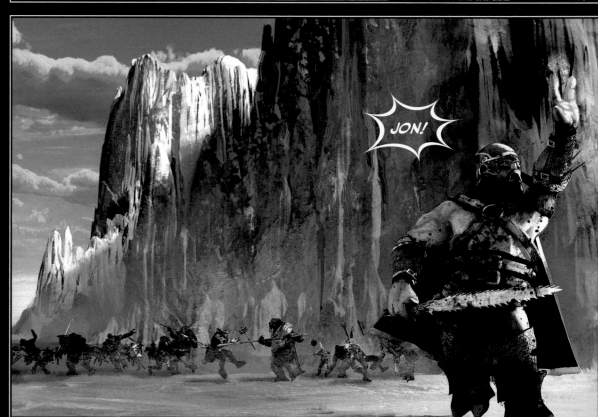

JON!

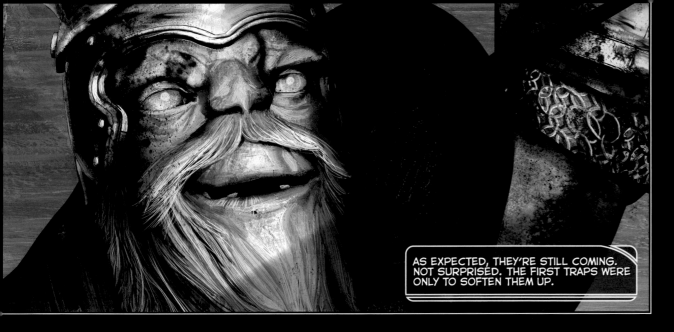

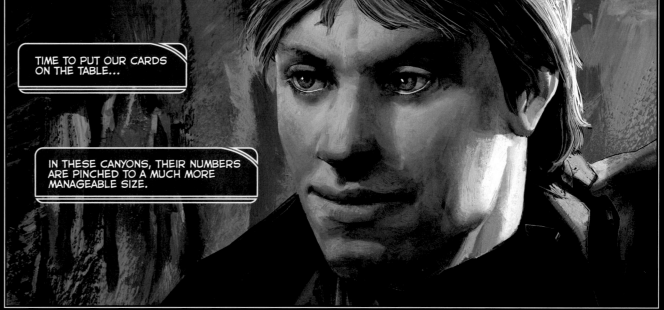

AS EXPECTED, THEY'RE STILL COMING. NOT SURPRISED. THE FIRST TRAPS WERE ONLY TO SOFTEN THEM UP.

TIME TO PUT OUR CARDS ON THE TABLE...

IN THESE CANYONS, THEIR NUMBERS ARE PINCHED TO A MUCH MORE MANAGEABLE SIZE.

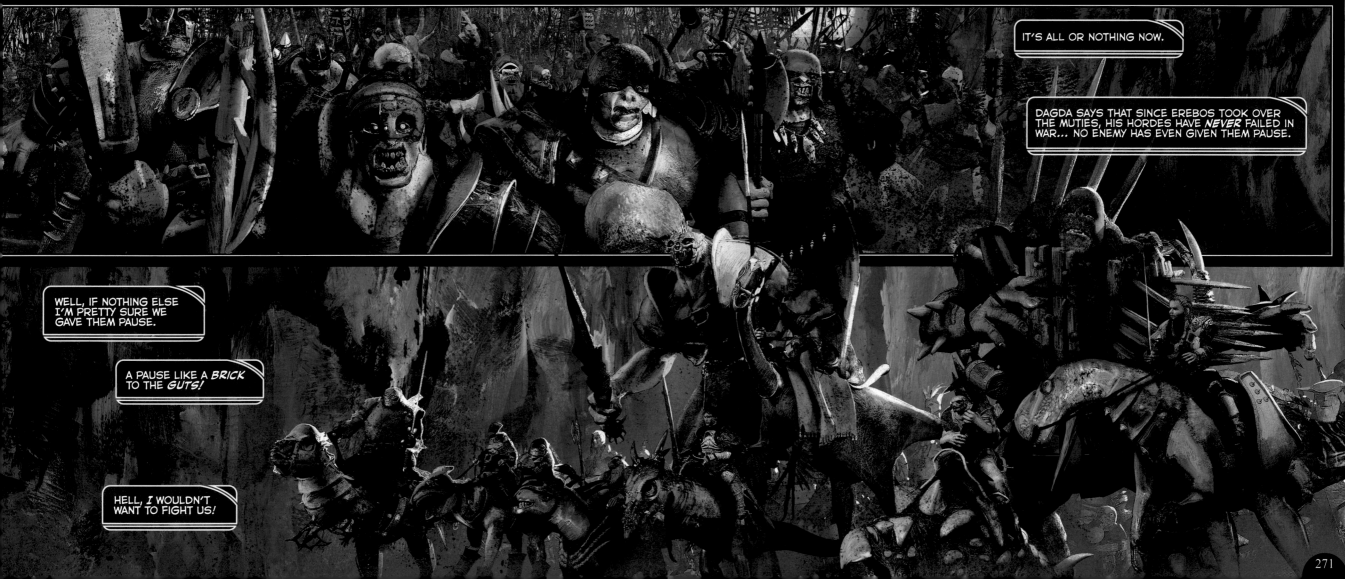

IT'S ALL OR NOTHING NOW.

DAGDA SAYS THAT SINCE EREBOS TOOK OVER THE MUTIES, HIS HORDES HAVE *NEVER* FAILED IN WAR... NO ENEMY HAS EVEN GIVEN THEM PAUSE.

WELL, IF NOTHING ELSE I'M PRETTY SURE WE GAVE THEM PAUSE.

A PAUSE LIKE A *BRICK* TO THE *GUTS!*

HELL, *I* WOULDN'T WANT TO FIGHT US!

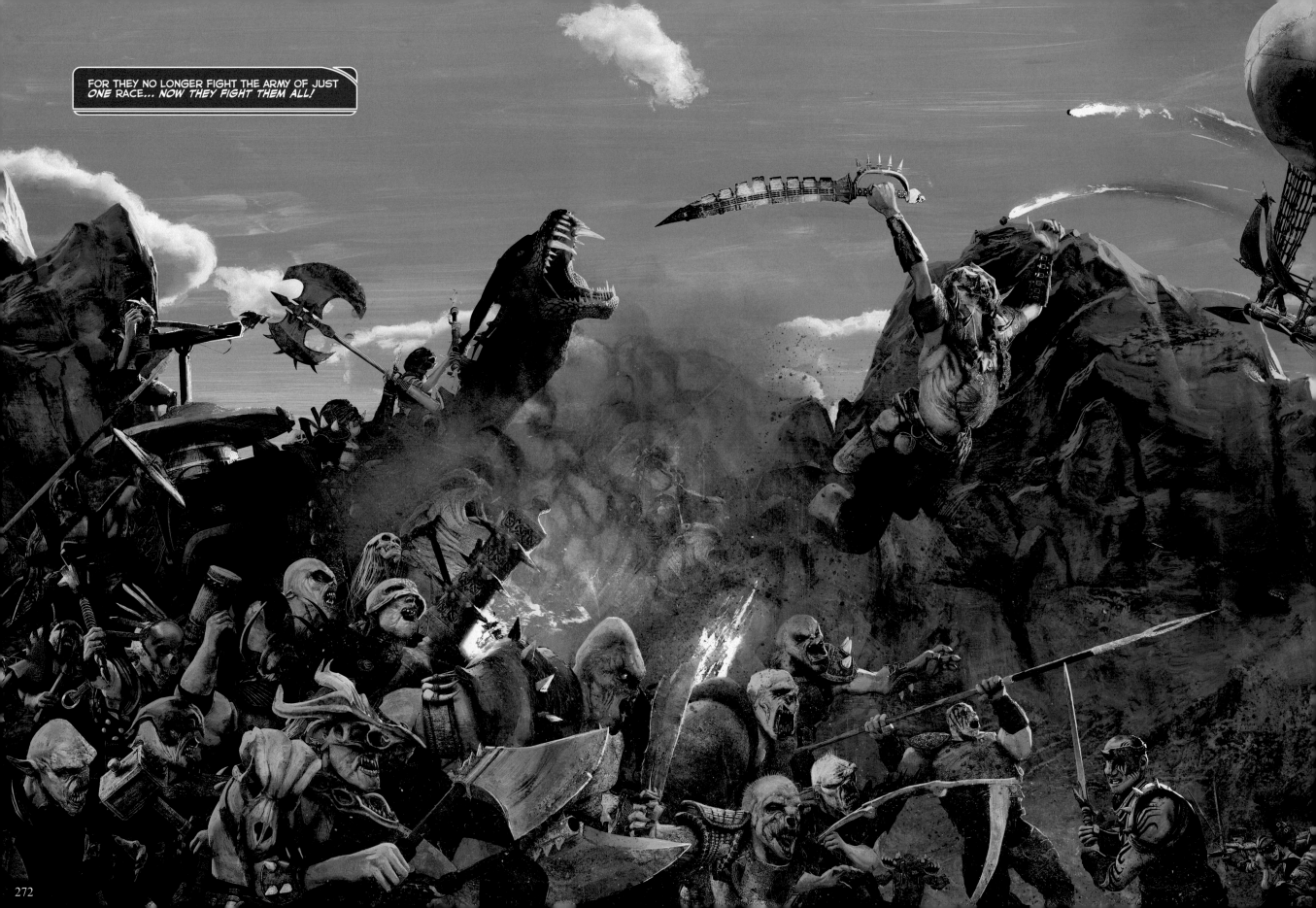

FOR THEY NO LONGER FIGHT THE ARMY OF JUST *ONE* RACE... *NOW THEY FIGHT THEM ALL!*

272

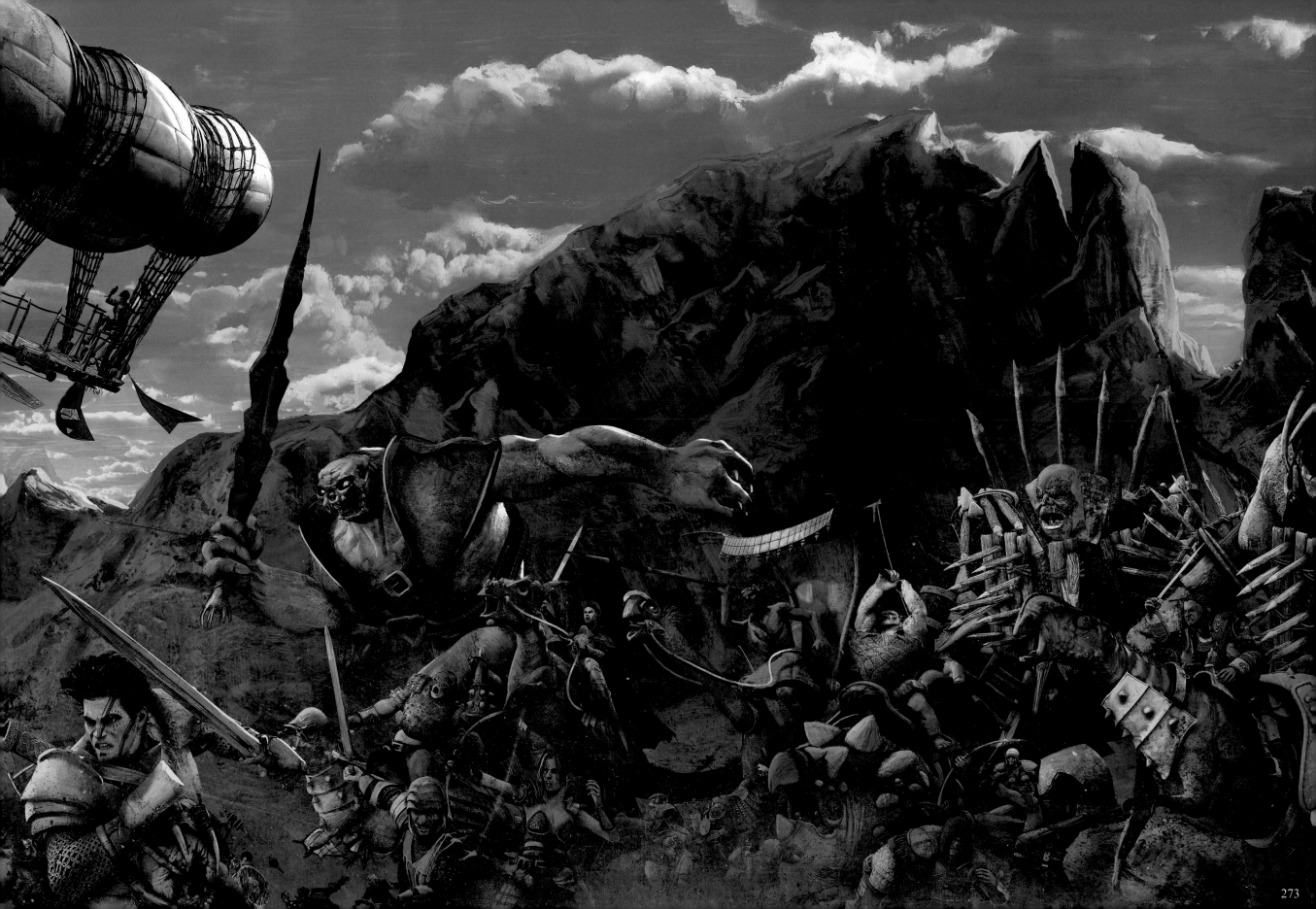

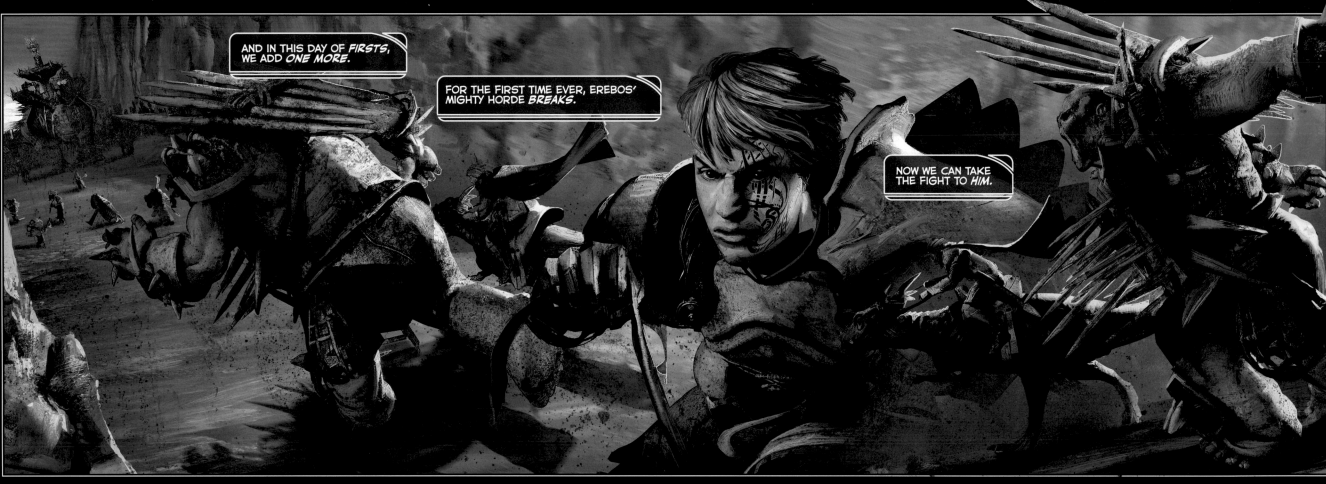

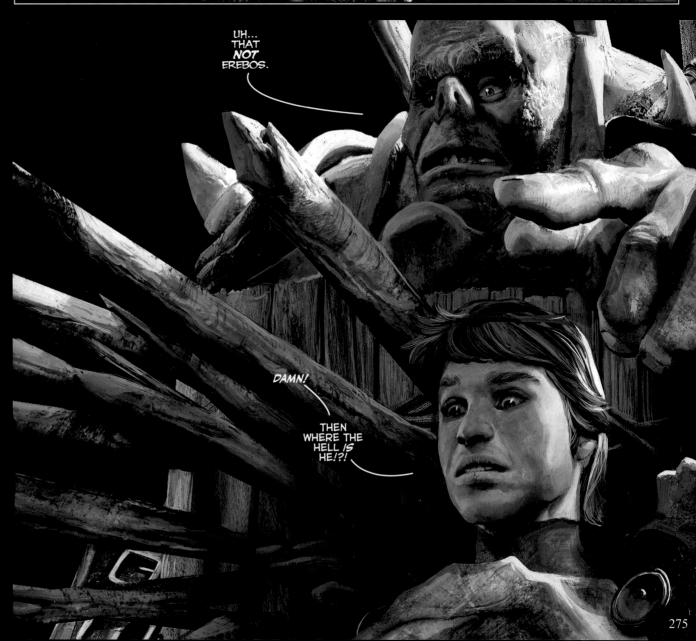

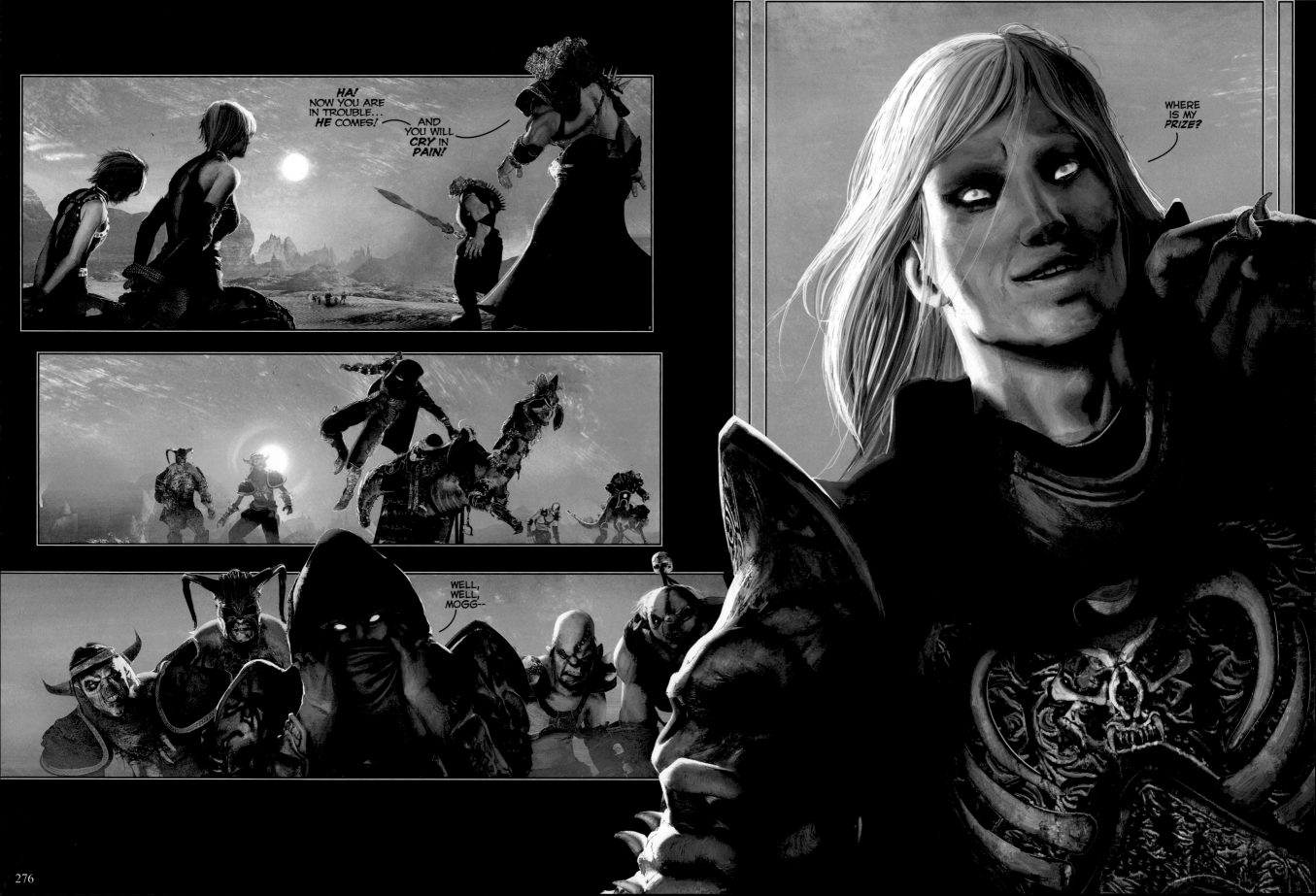

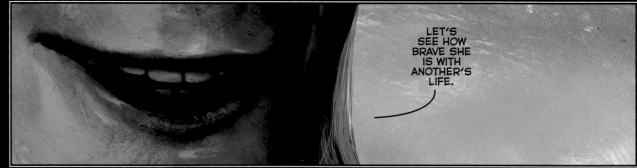

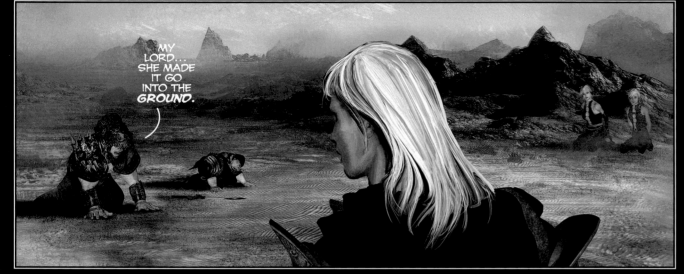

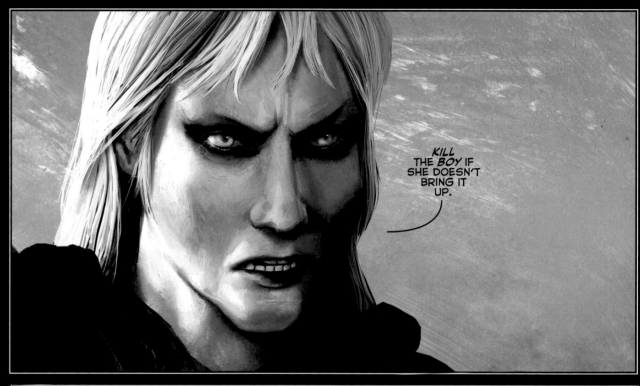

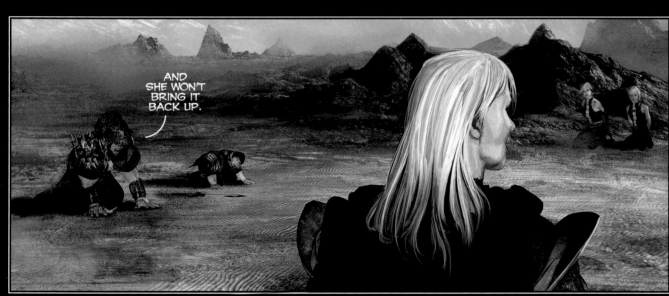

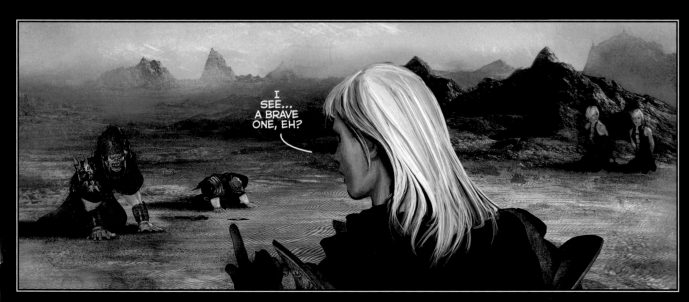

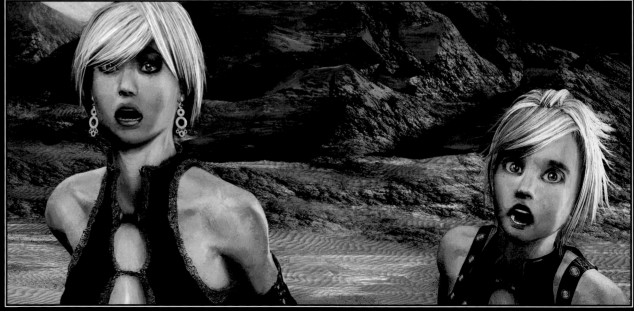

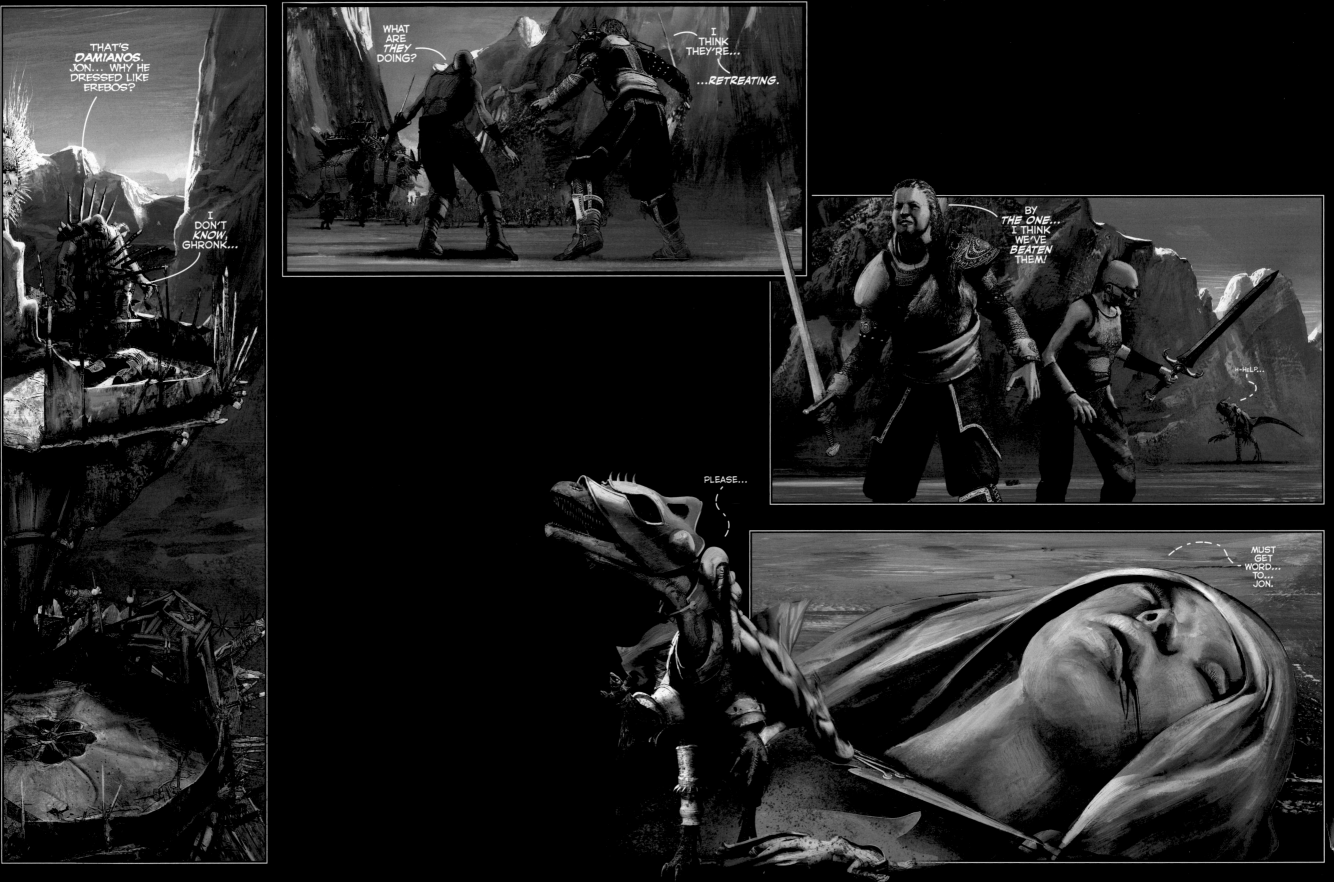

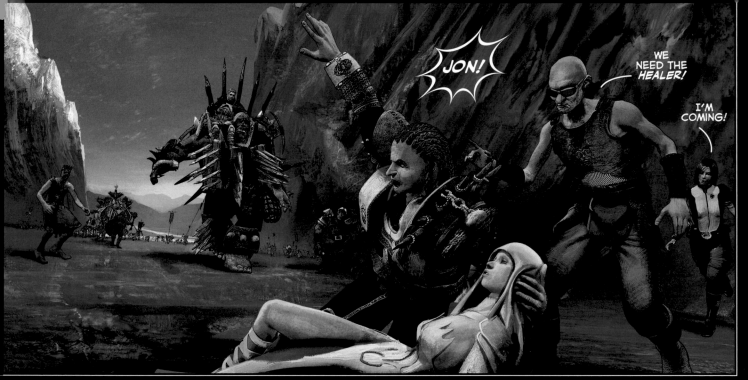

JON!

WE NEED THE HEALER!

I'M COMING!

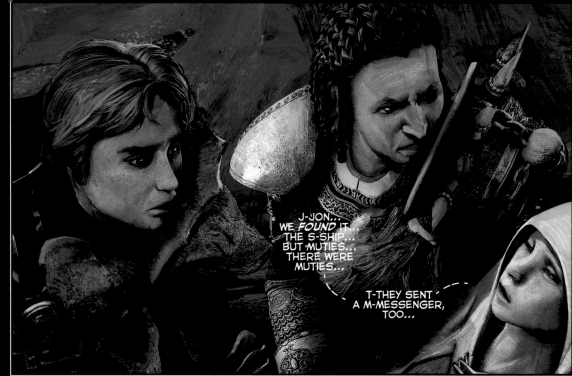

J-JON... WE FOUND IT... THE S-SHIP... BUT MUTIES... THERE WERE MUTIES...

T-THEY SENT A M-MESSENGER, TOO...

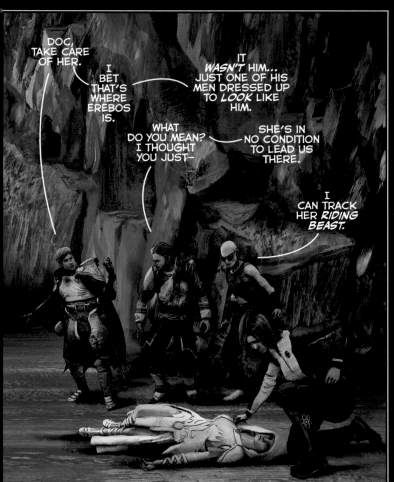

DOC, TAKE CARE OF HER.

I BET THAT'S WHERE EREBOS IS.

IT WASN'T HIM... JUST ONE OF HIS MEN DRESSED UP TO LOOK LIKE HIM.

WHAT DO YOU MEAN? I THOUGHT YOU JUST—

SHE'S IN NO CONDITION TO LEAD US THERE.

I CAN TRACK HER RIDING BEAST.

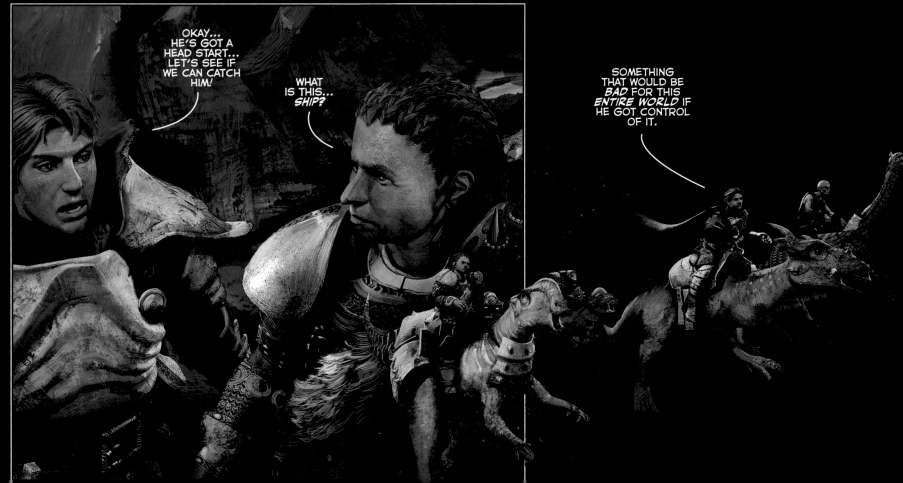

OKAY... HE'S GOT A HEAD START... LET'S SEE IF WE CAN CATCH HIM!

WHAT IS THIS... SHIP?

SOMETHING THAT WOULD BE BAD FOR THIS ENTIRE WORLD IF HE GOT CONTROL OF IT.

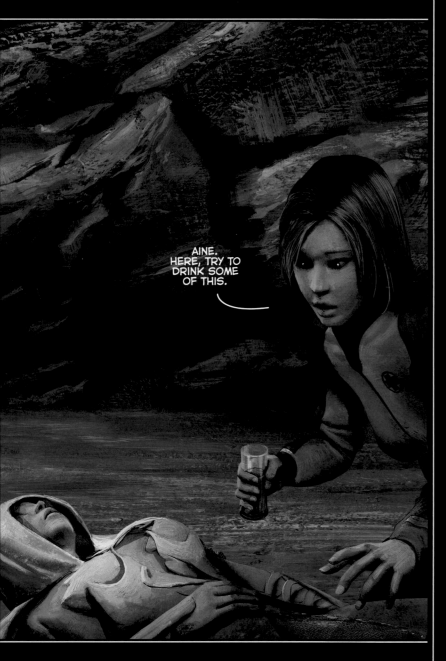

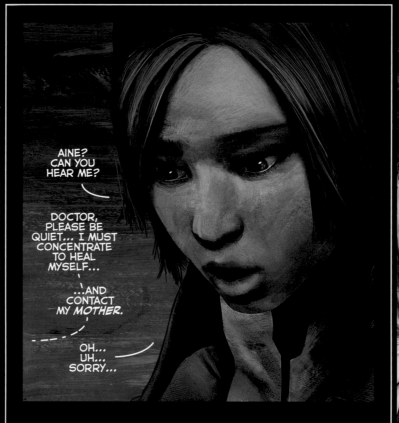

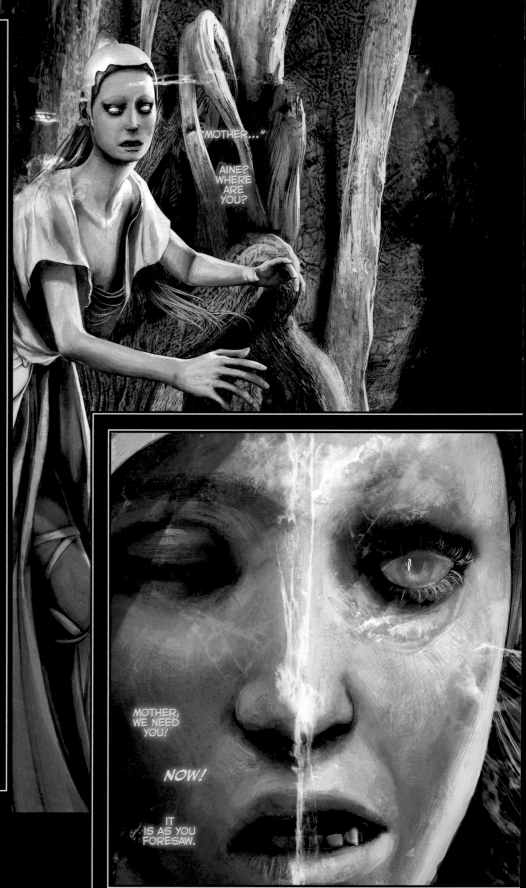

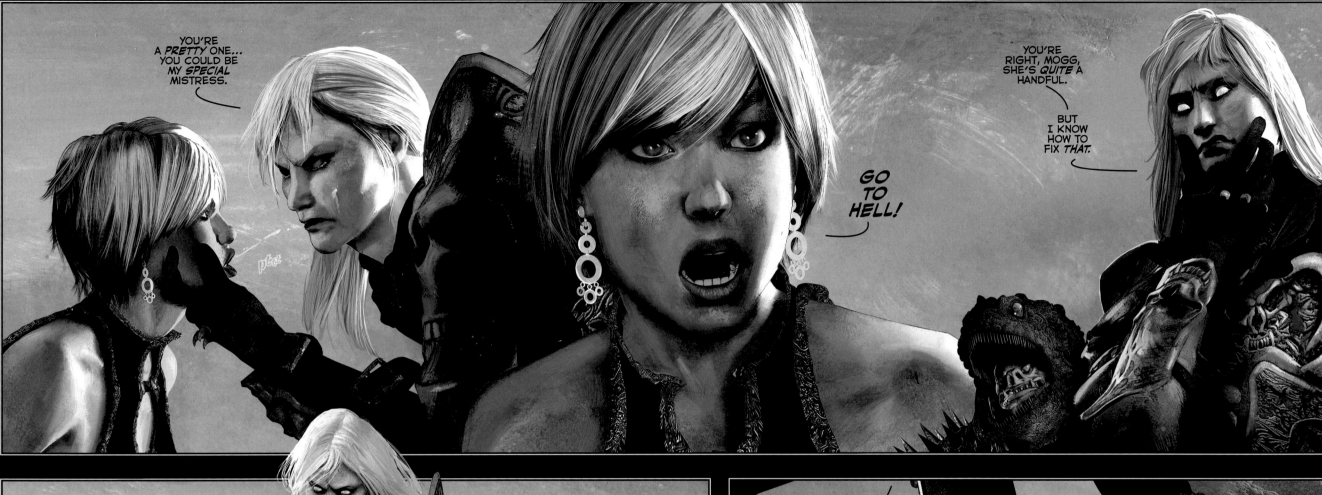

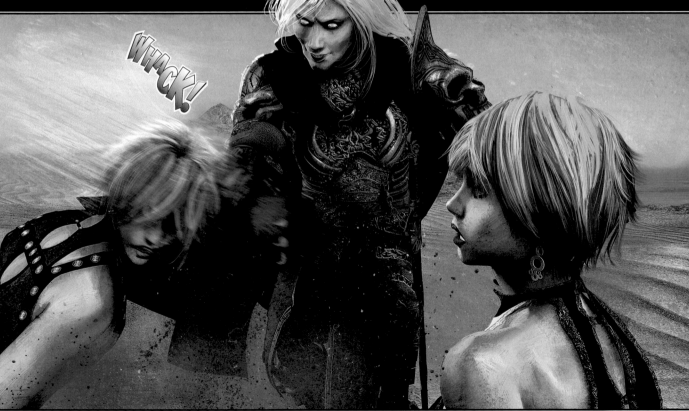

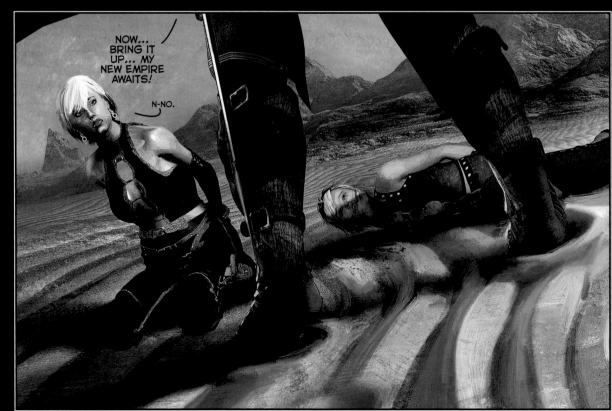

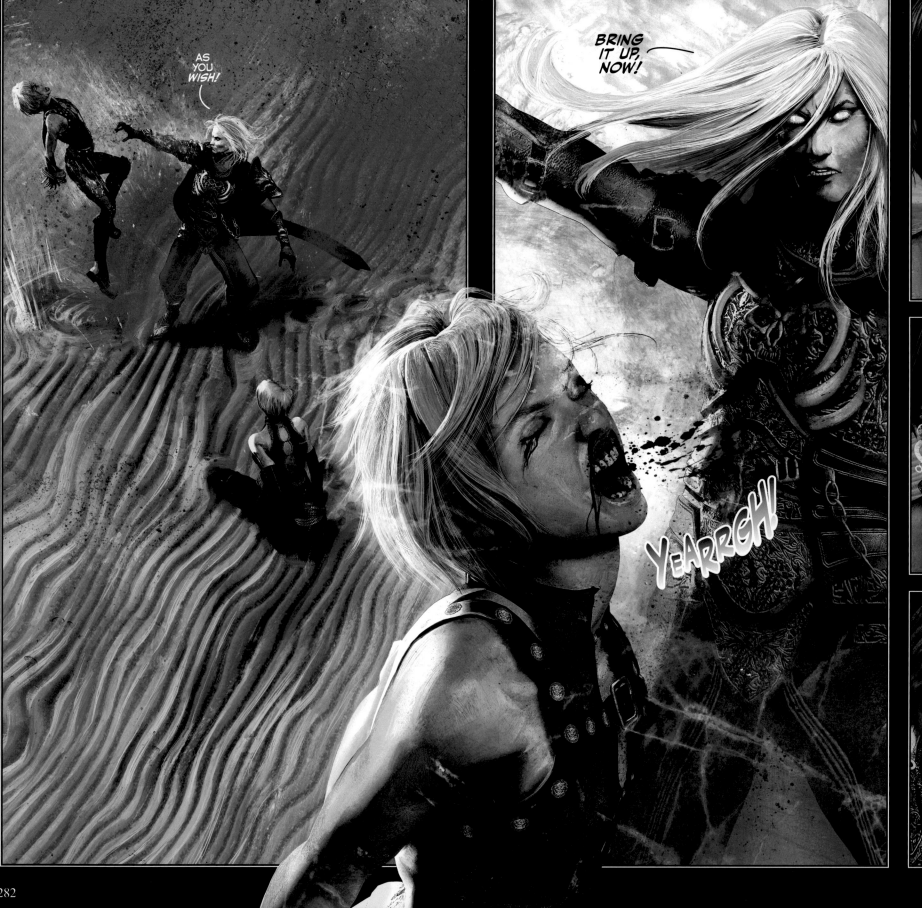
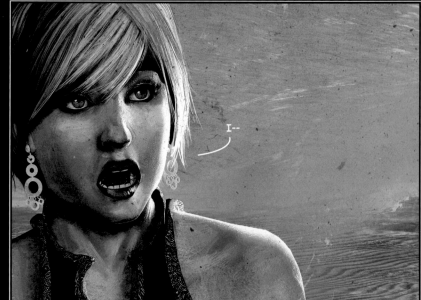
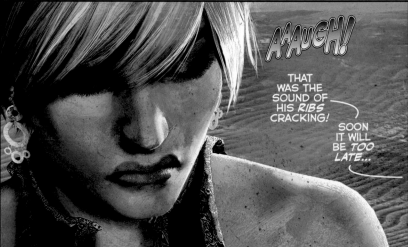
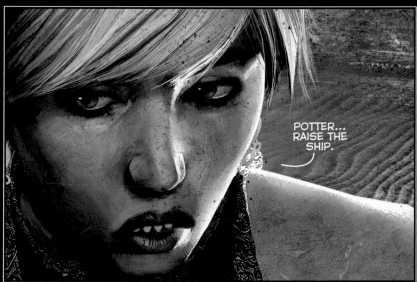

282

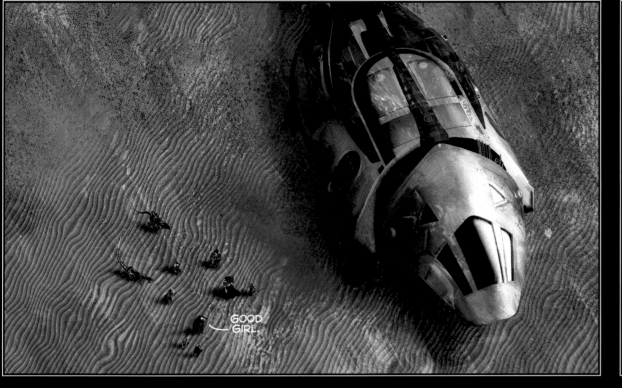

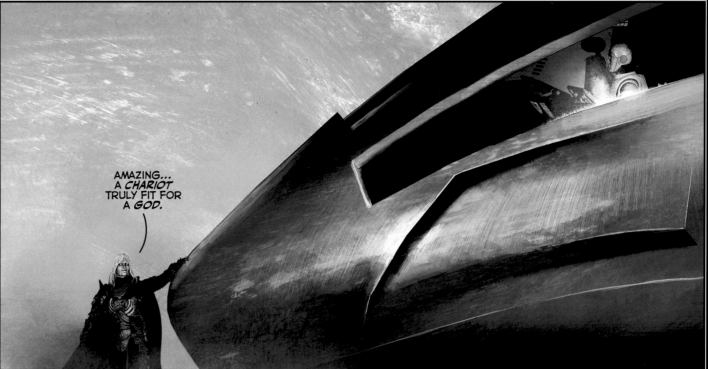

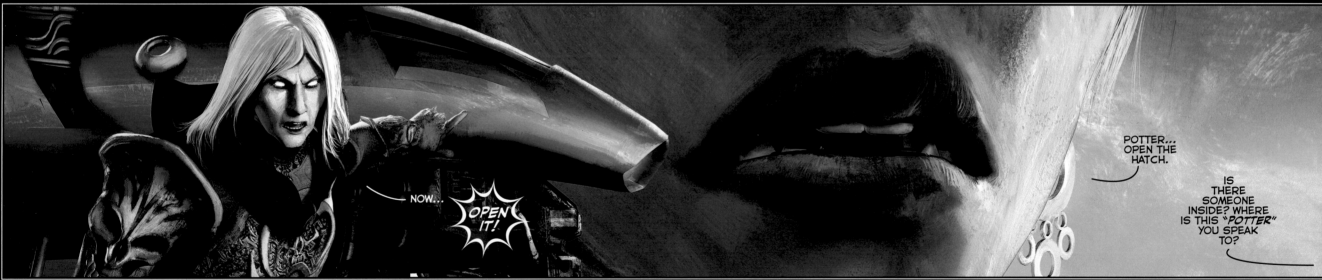

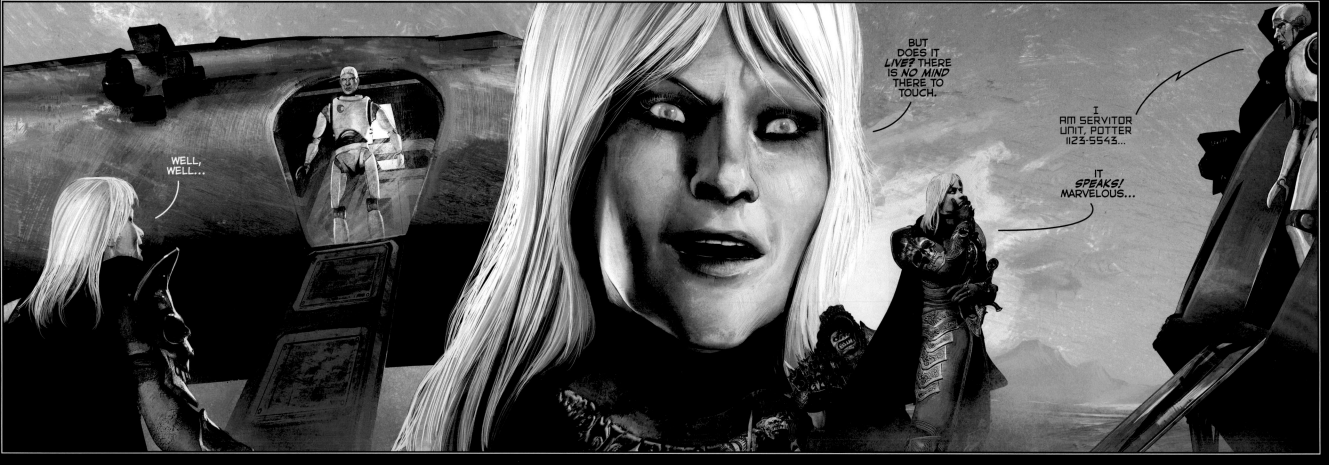

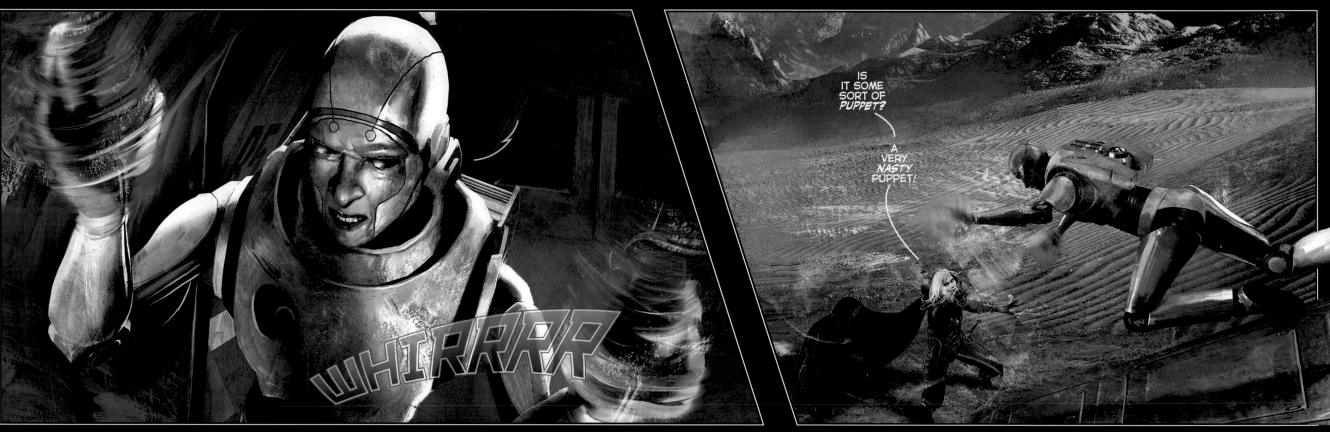

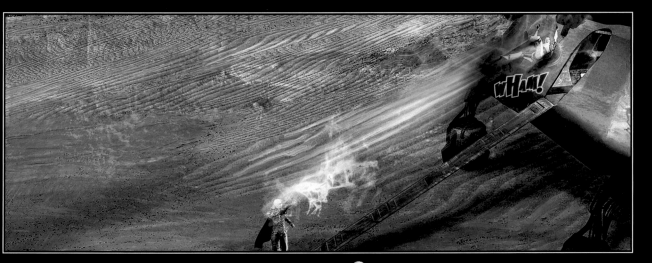

WHAM!

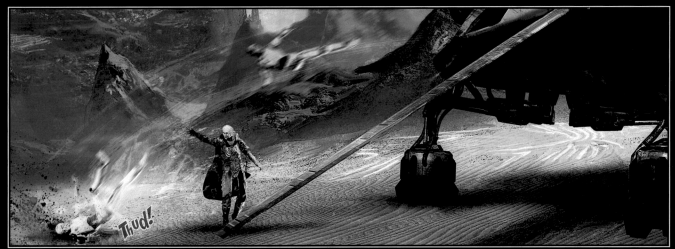

Thud!

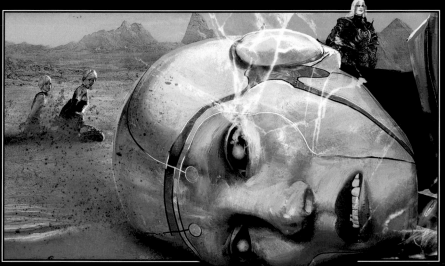

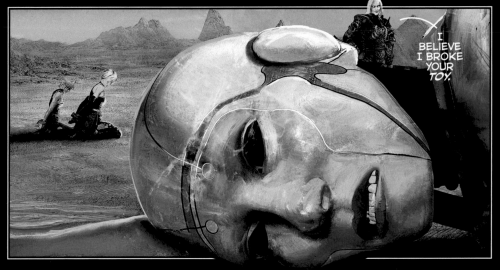

I BELIEVE I BROKE YOUR *TOY.*

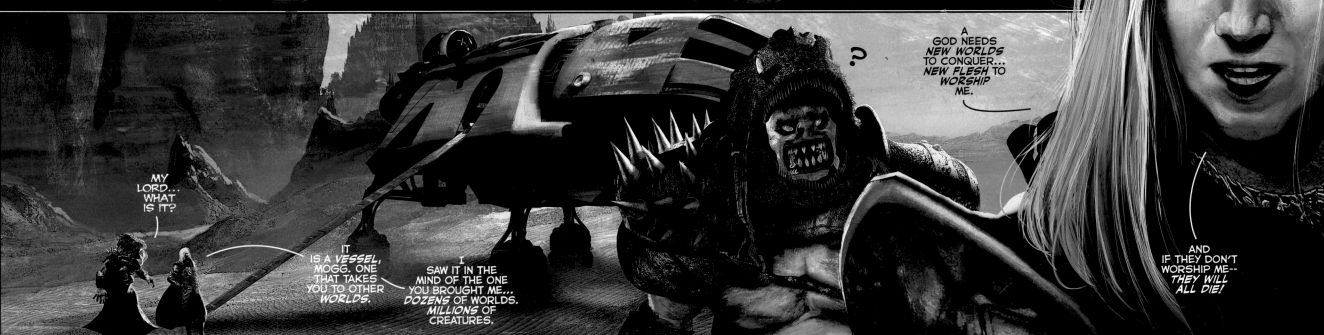

MY LORD... WHAT IS IT?

IT IS A *VESSEL,* MOGG. ONE THAT TAKES YOU TO OTHER *WORLDS.*

I SAW IT IN THE MIND OF THE ONE YOU BROUGHT ME... *DOZENS* OF WORLDS. *MILLIONS* OF CREATURES.

?

A GOD NEEDS *NEW WORLDS* TO CONQUER... *NEW FLESH* TO WORSHIP ME.

AND IF THEY DON'T WORSHIP ME-- *THEY WILL ALL DIE!*

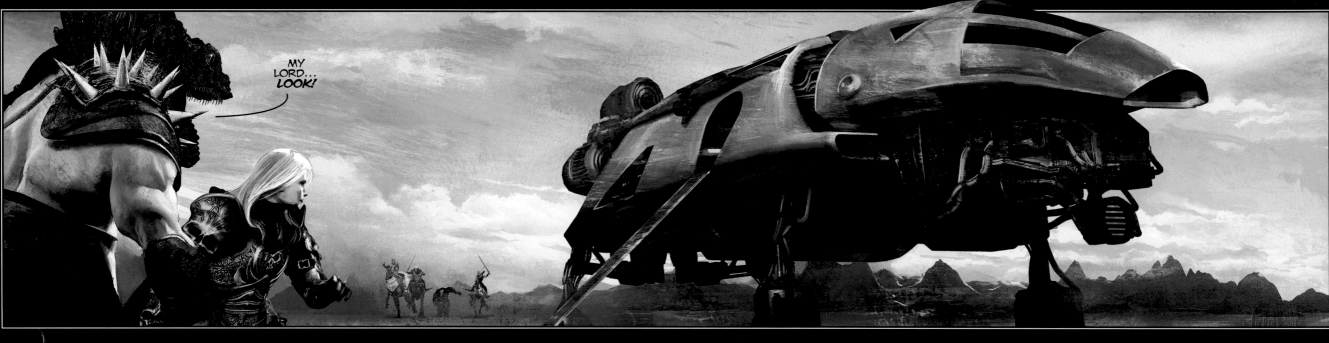

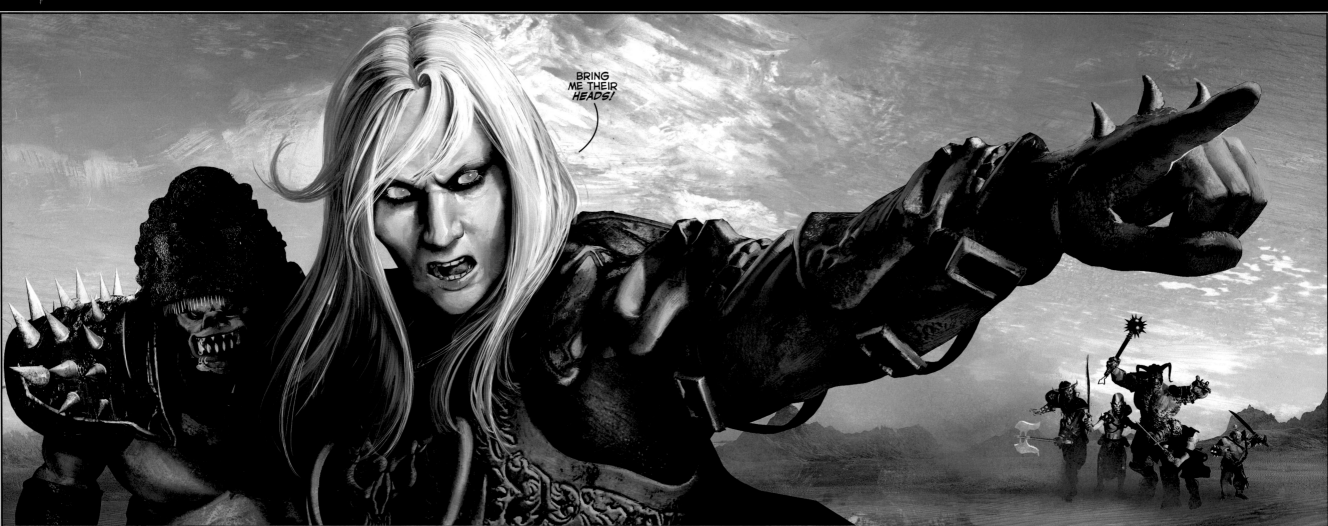

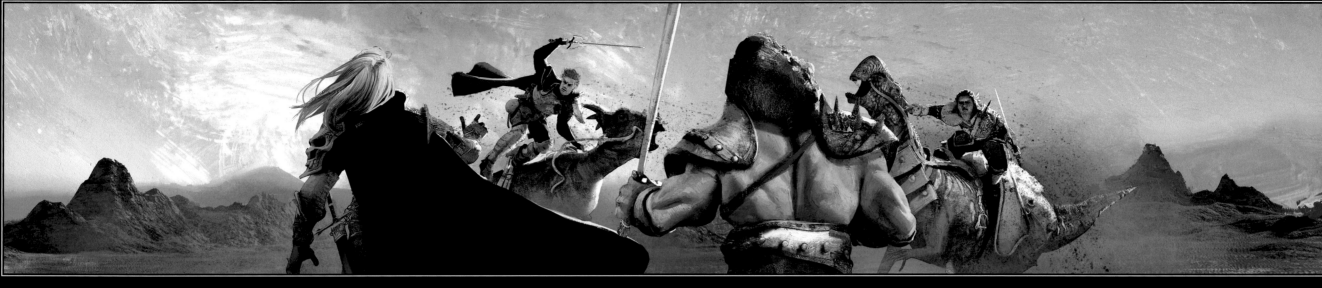

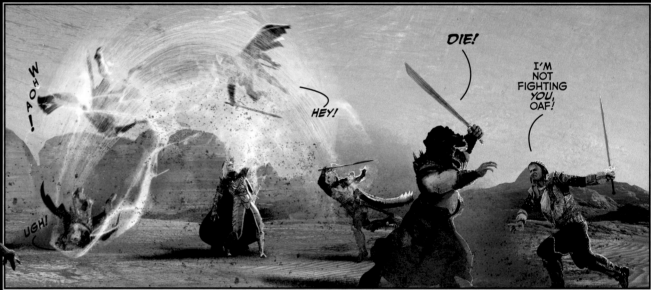

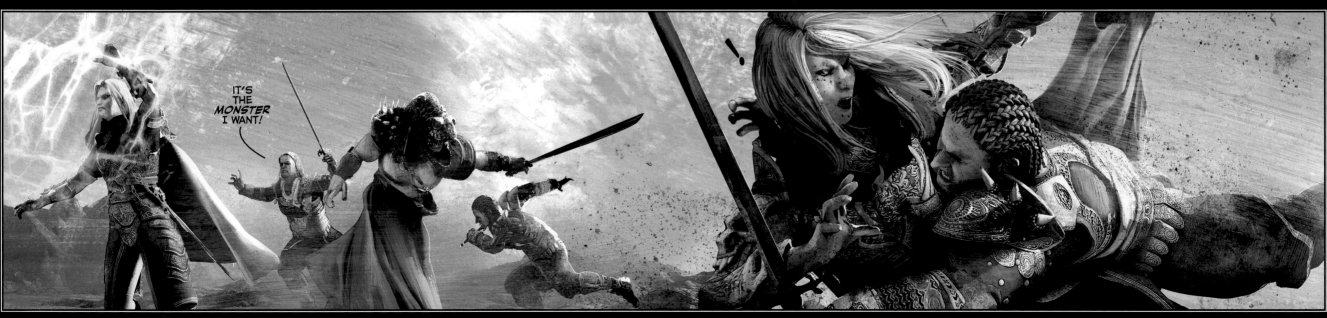

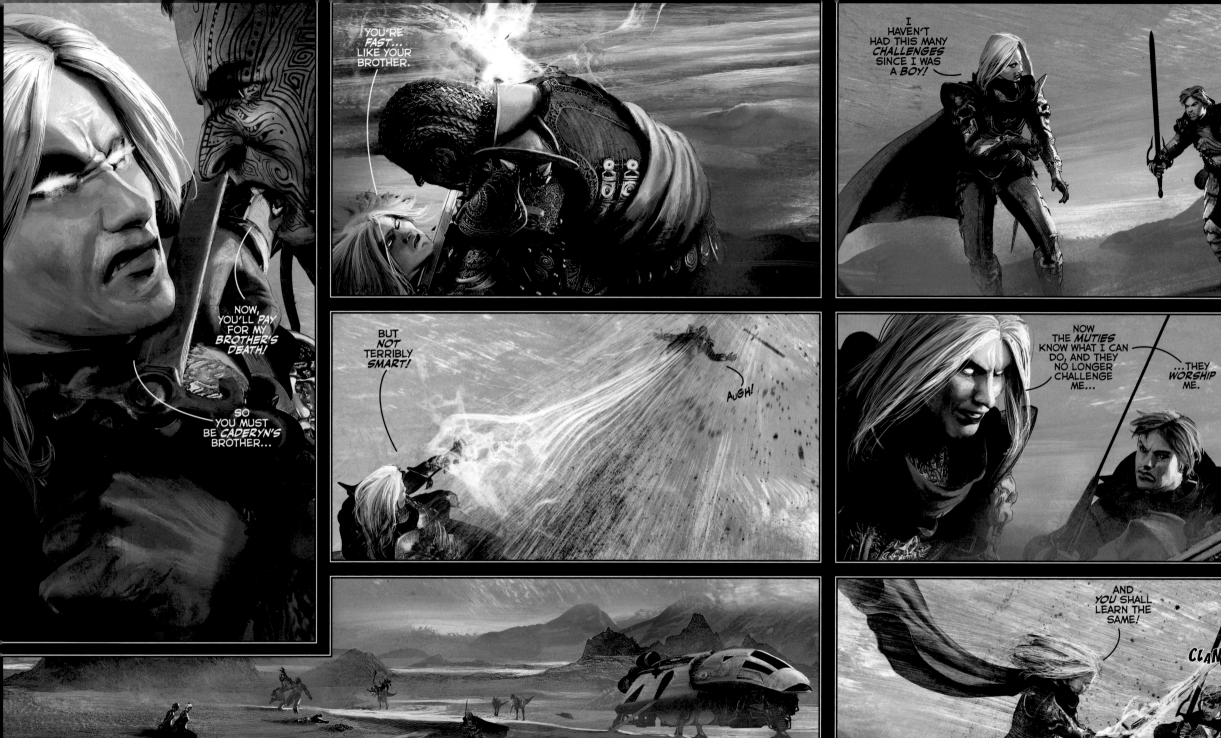

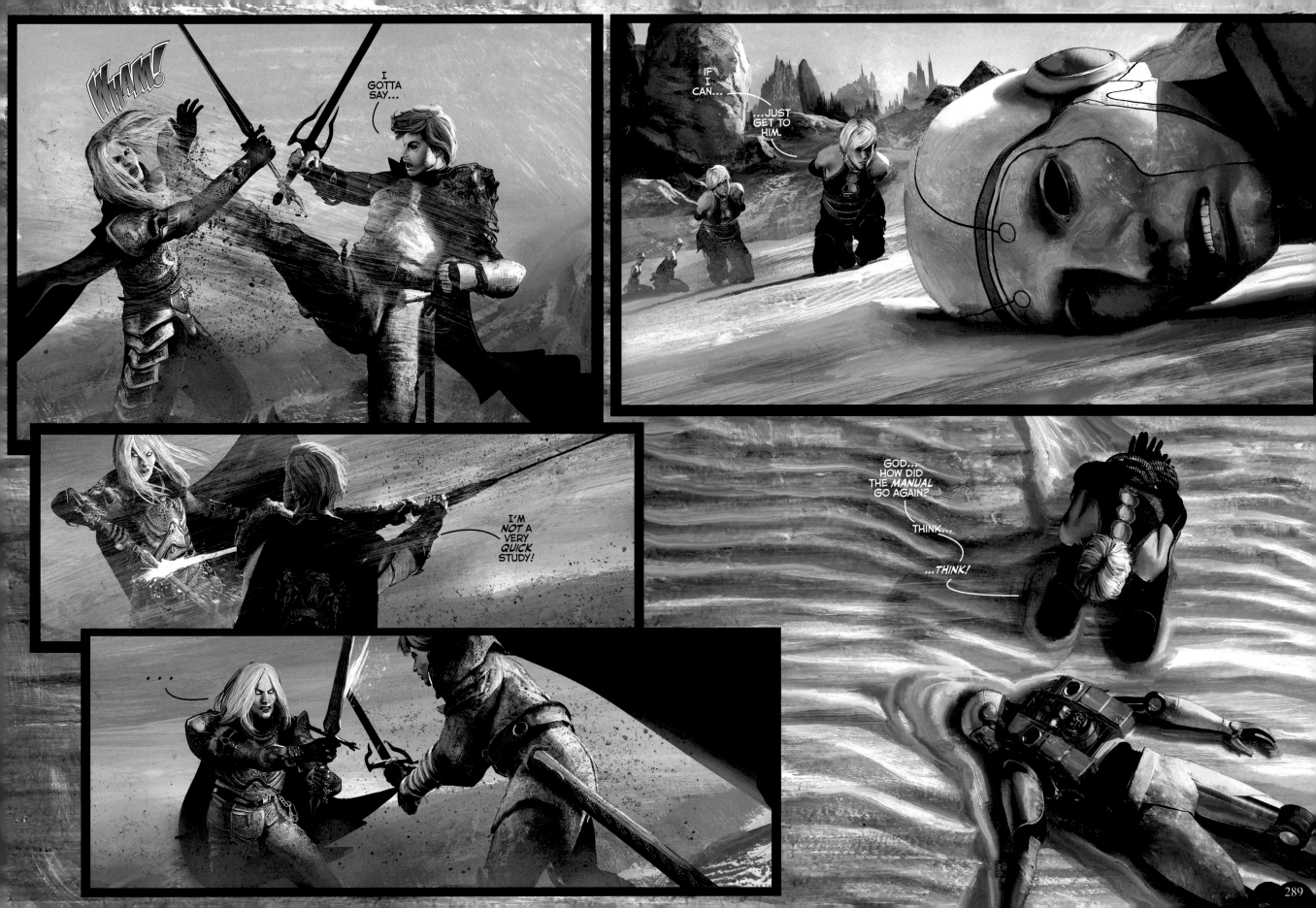

289

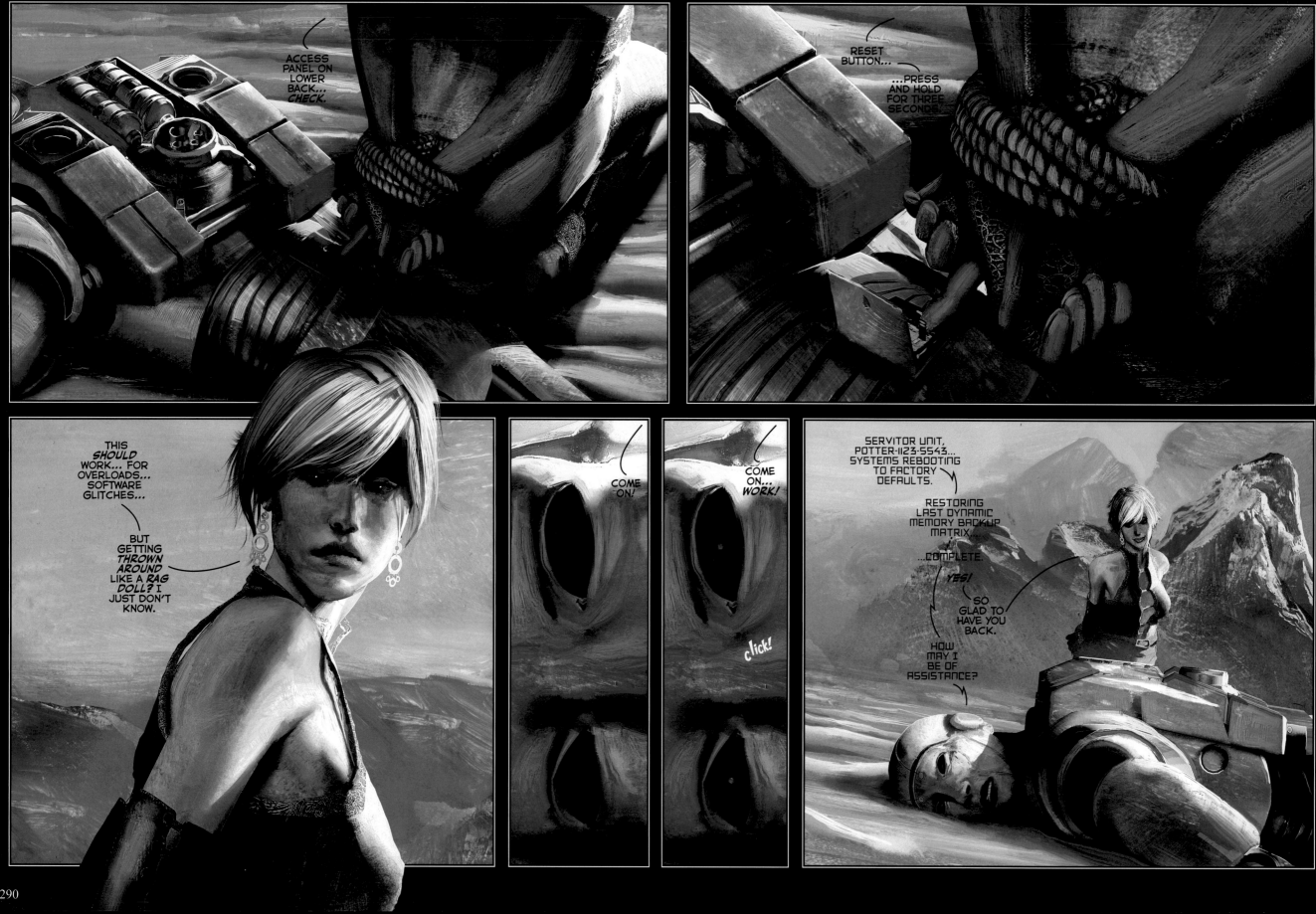

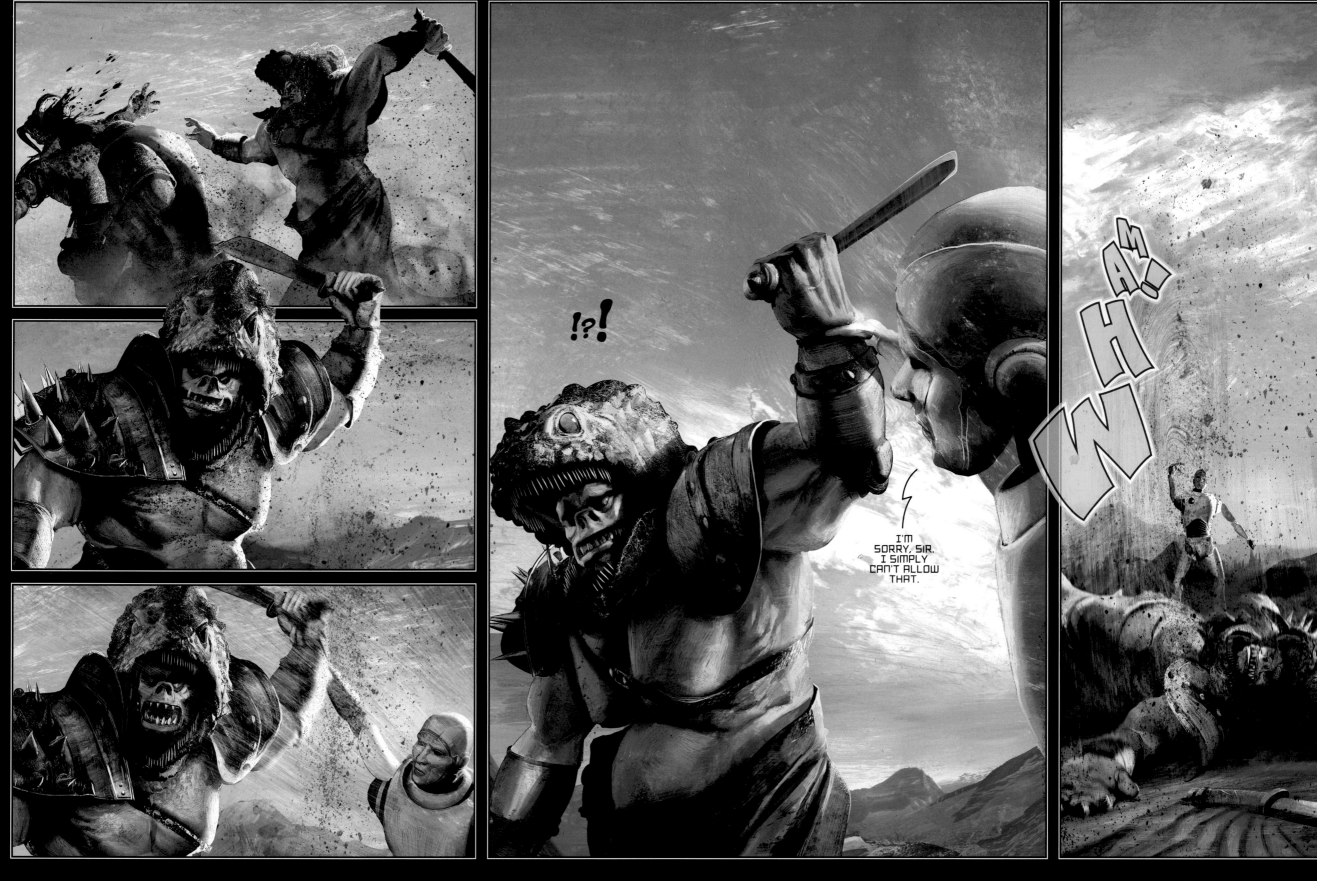

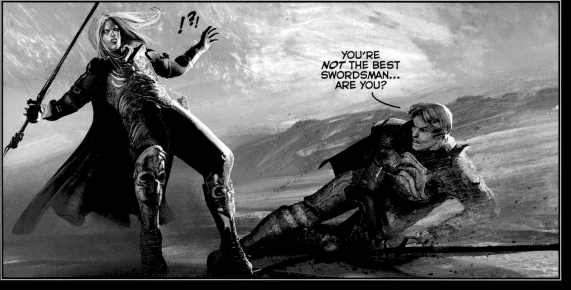

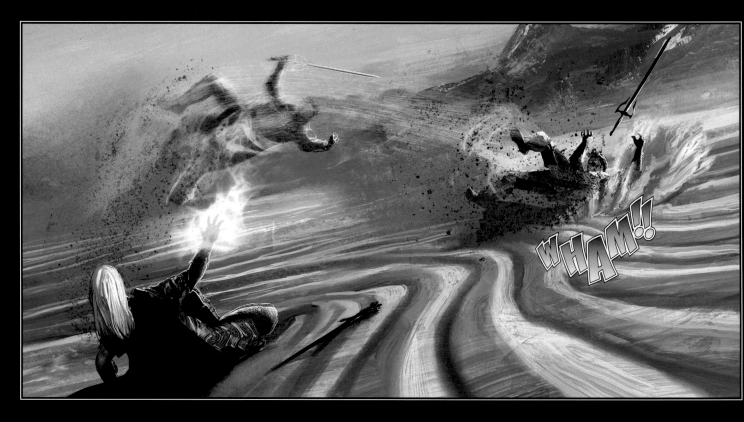

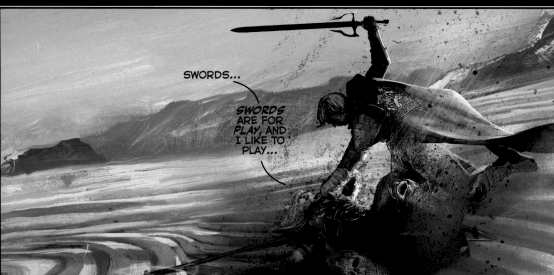

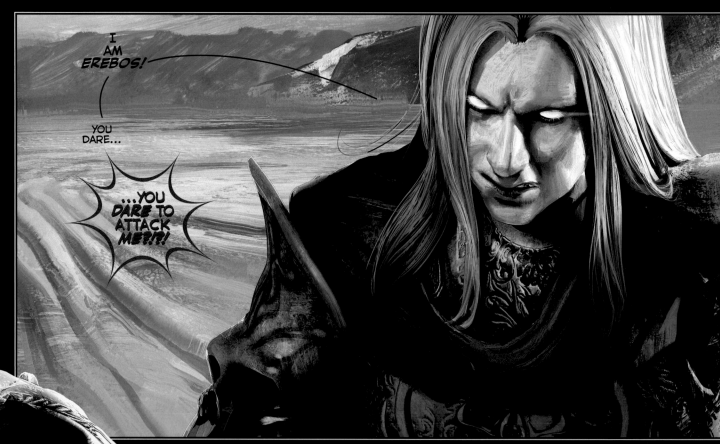

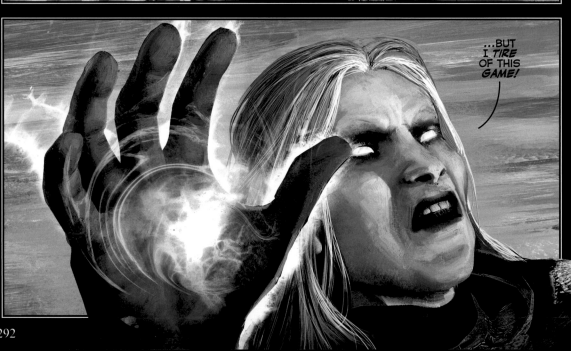

292

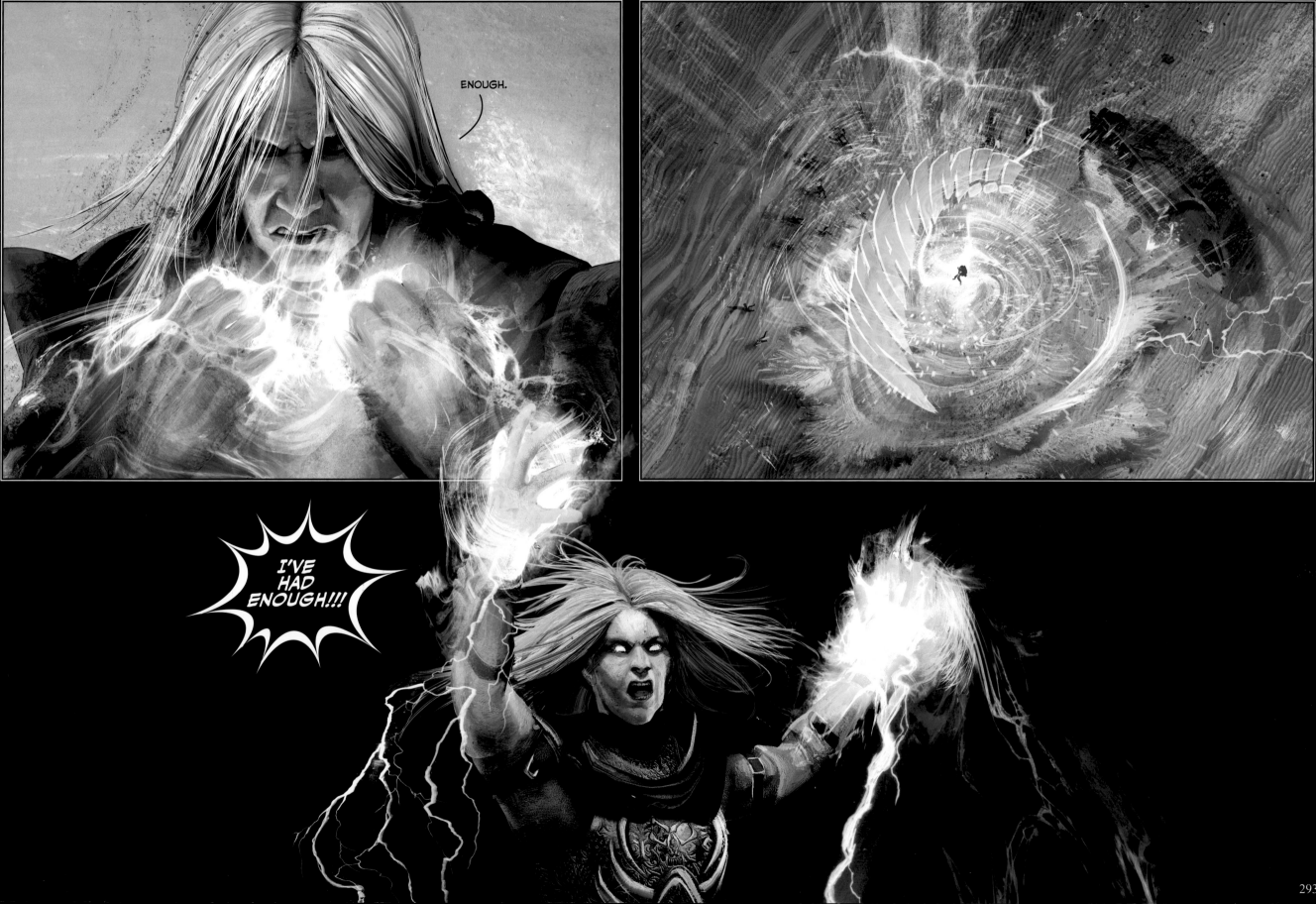

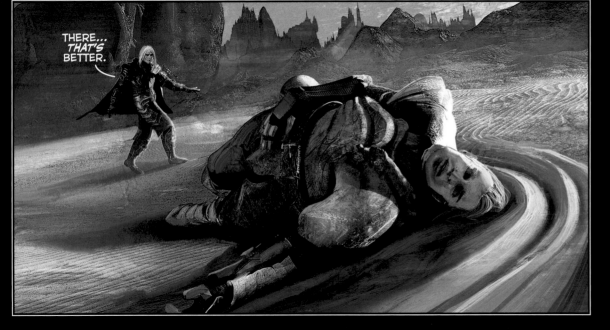

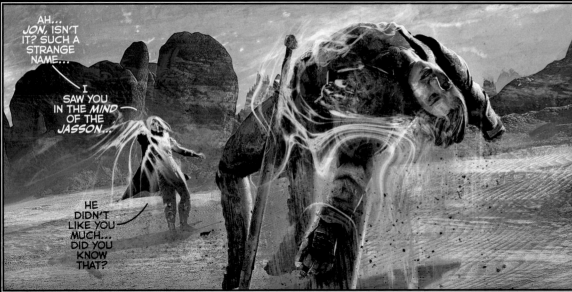

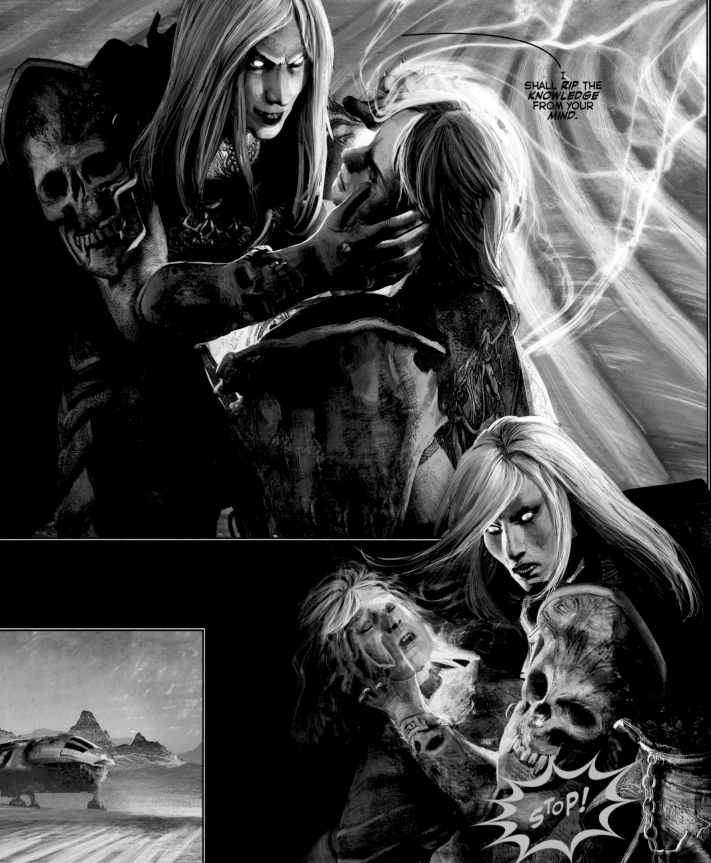

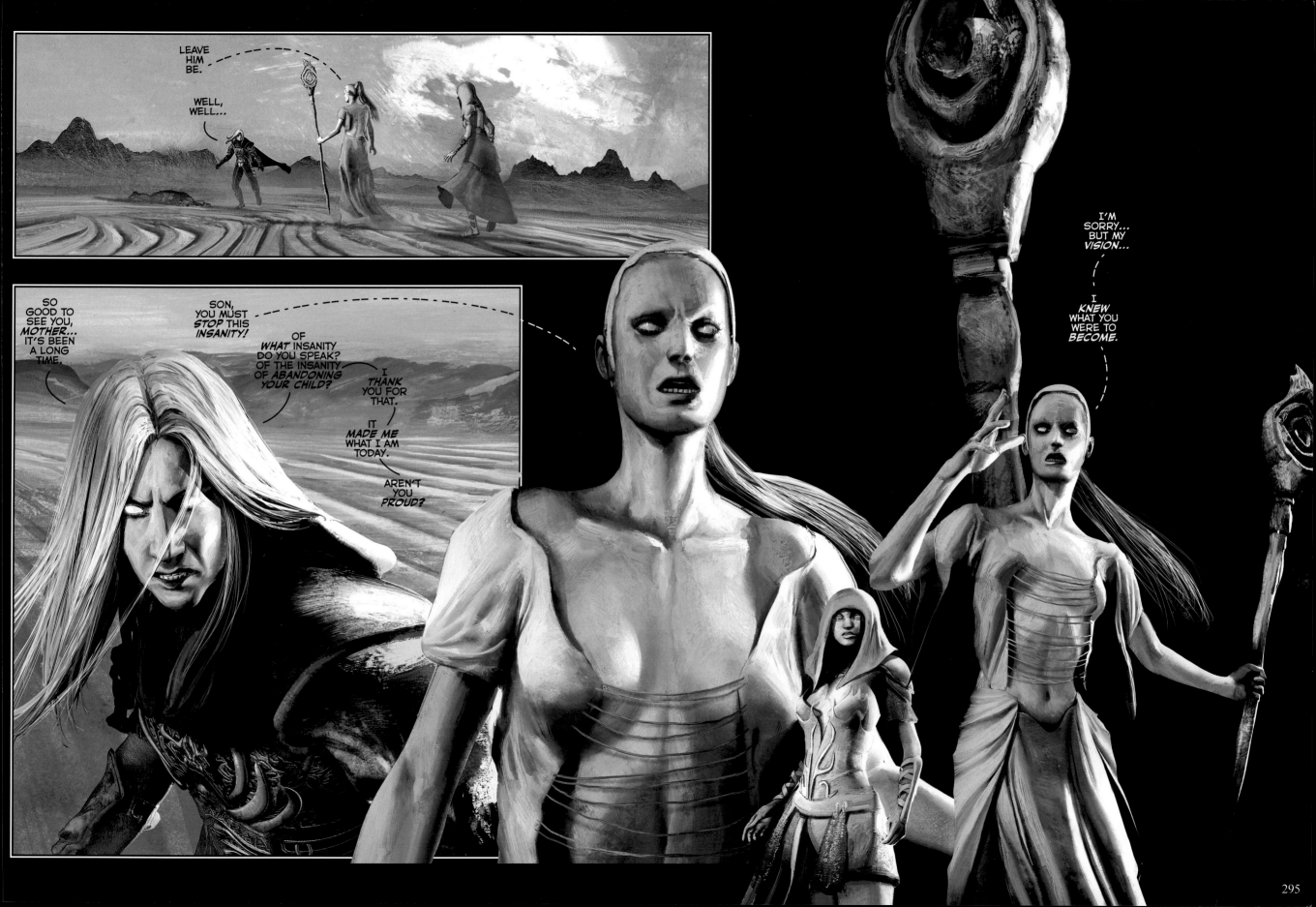

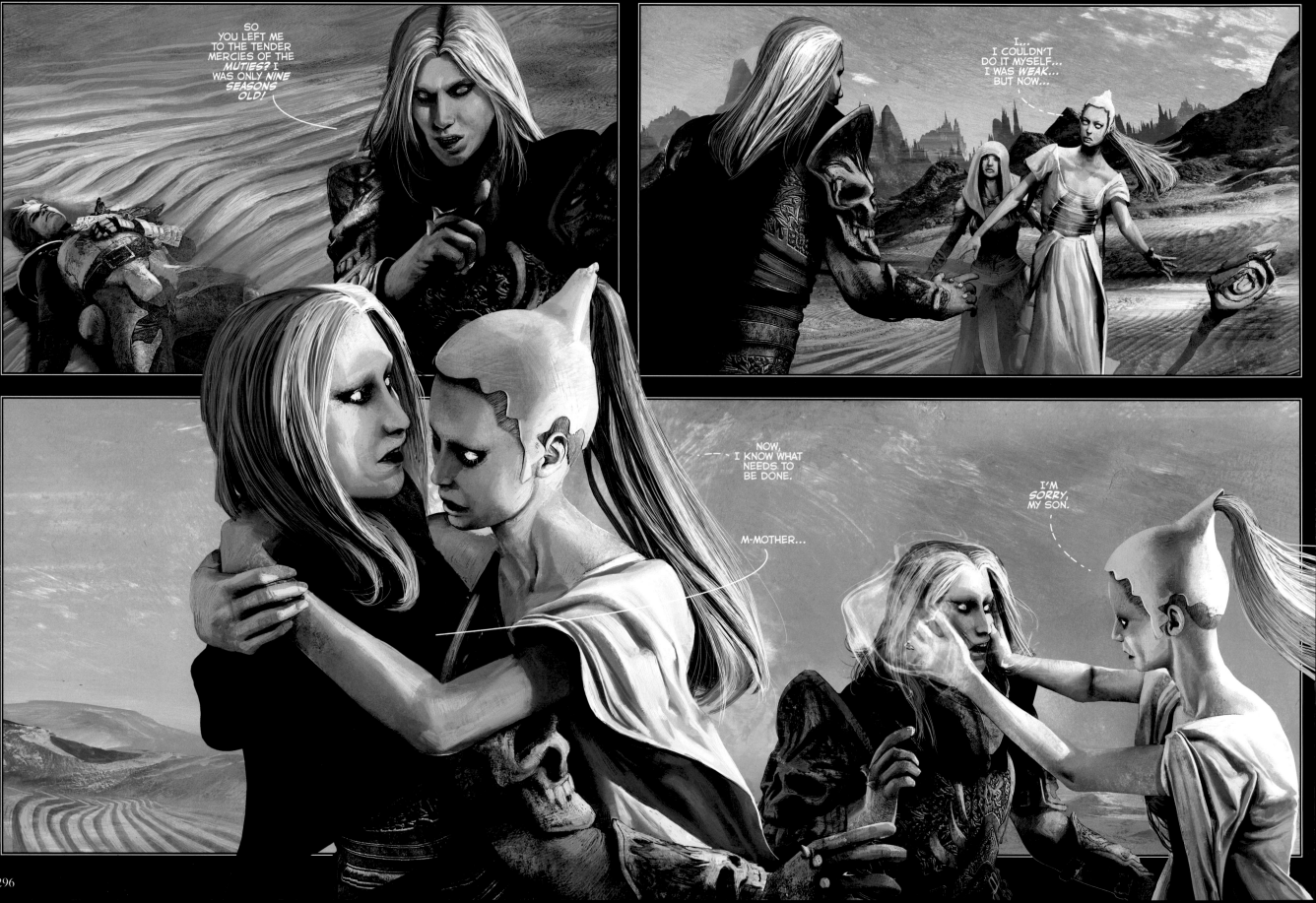

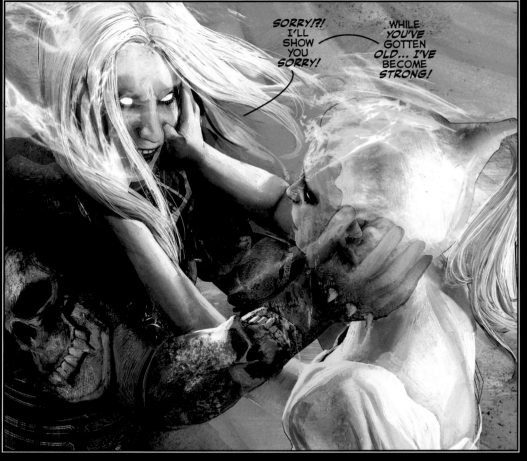

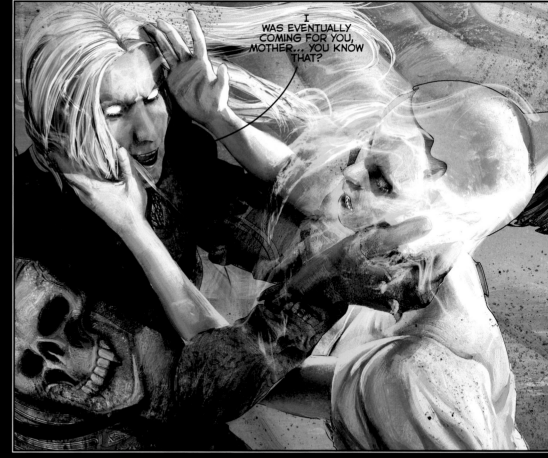

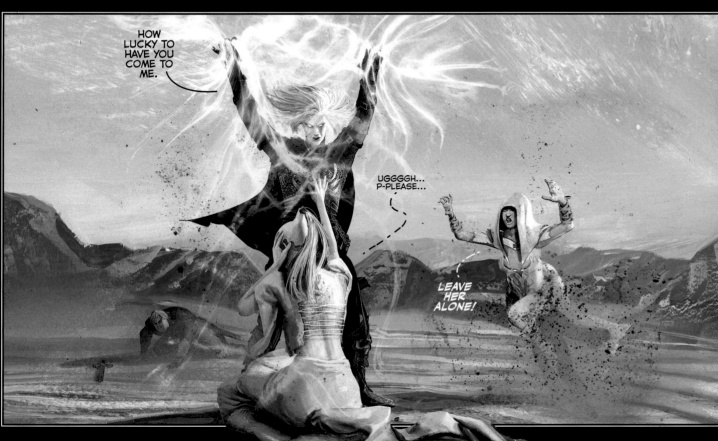

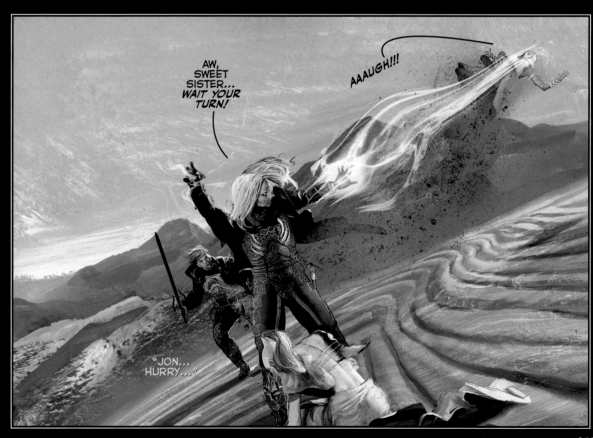

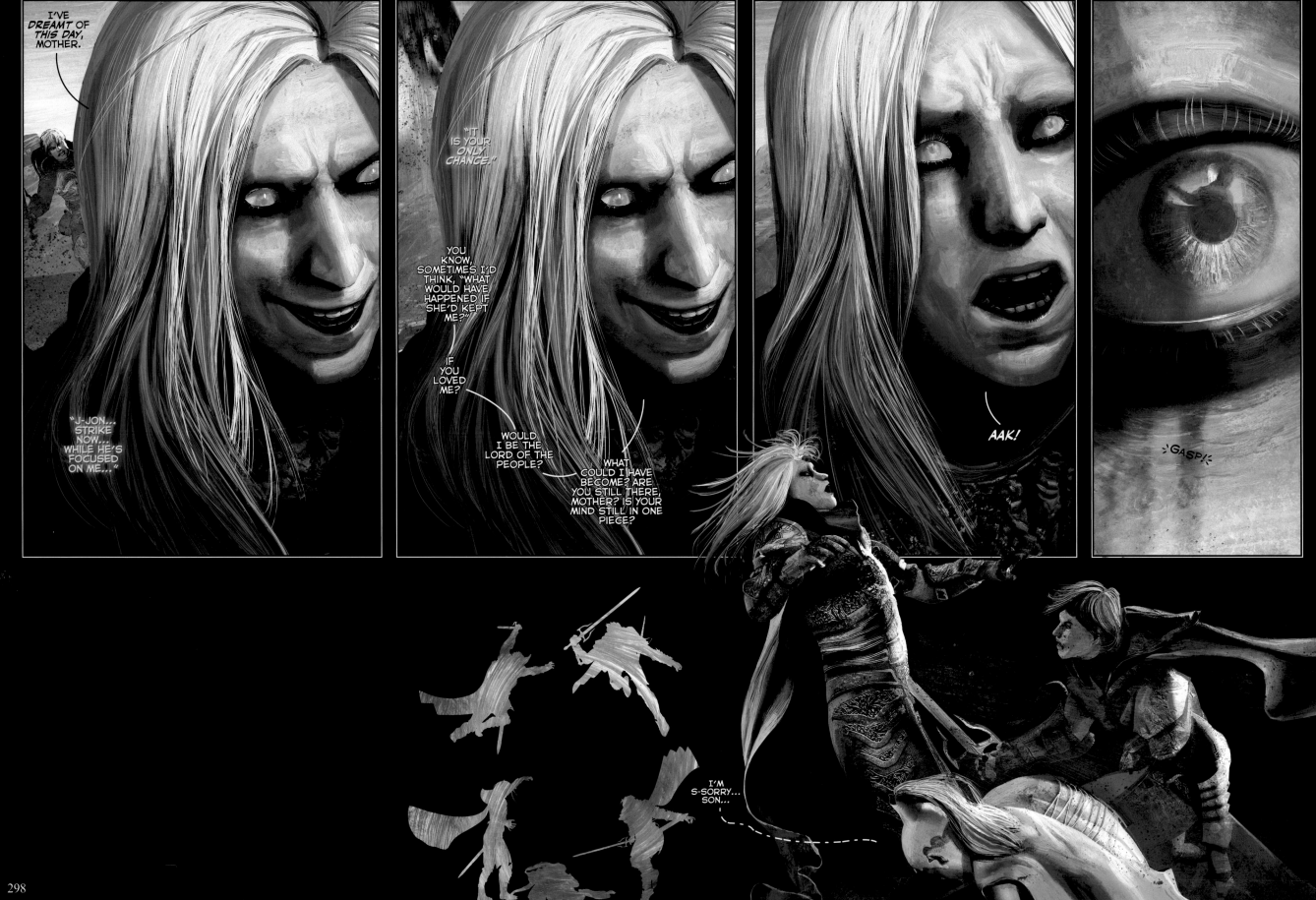

298

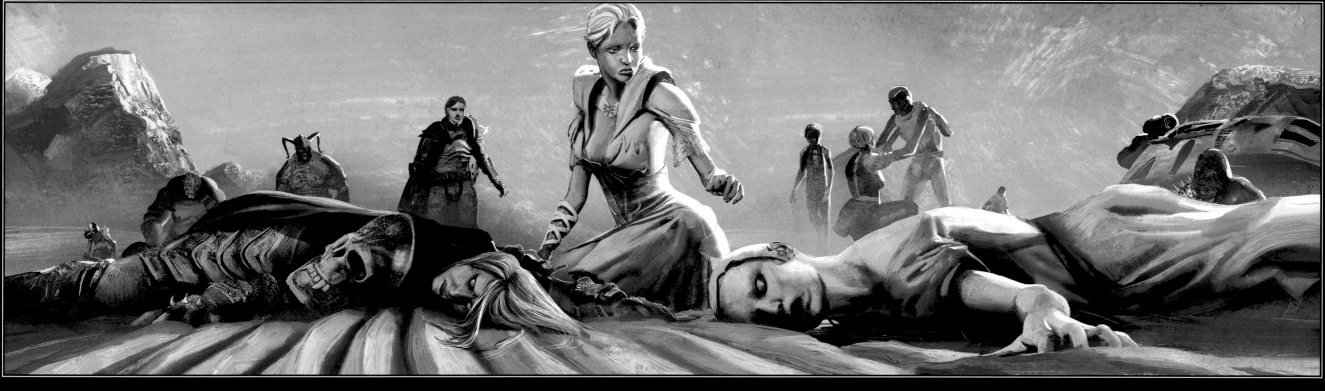

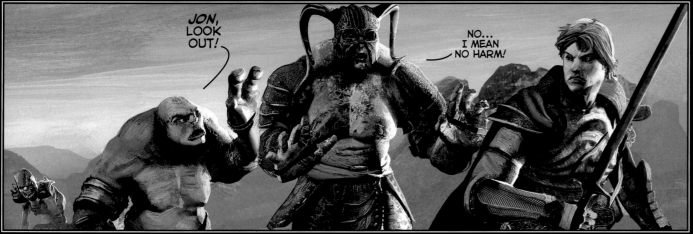

JON, LOOK OUT!

NO... I MEAN NO HARM!

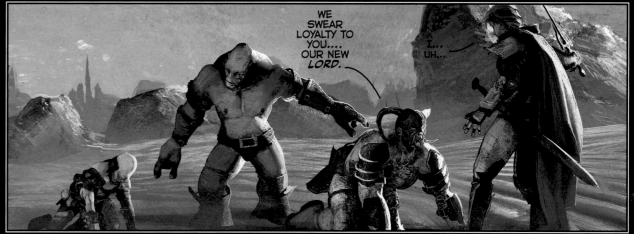

WE SWEAR LOYALTY TO YOU.... OUR NEW LORD.

I... UH...

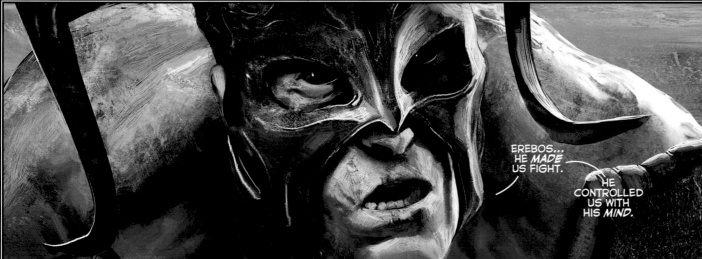

EREBOS... HE MADE US FIGHT.

HE CONTROLLED US WITH HIS MIND.

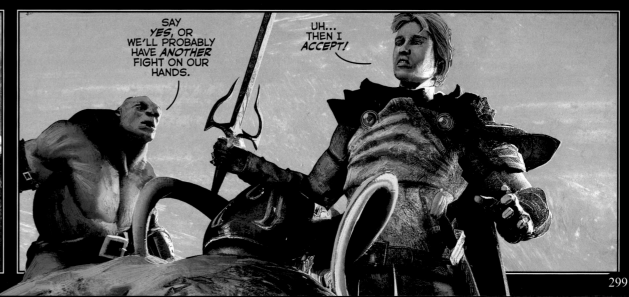

SAY YES, OR WE'LL PROBABLY HAVE ANOTHER FIGHT ON OUR HANDS.

UH... THEN I ACCEPT!

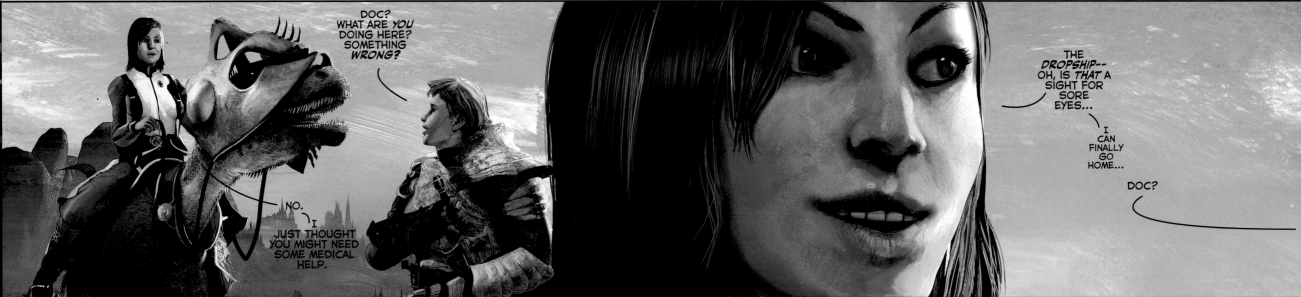

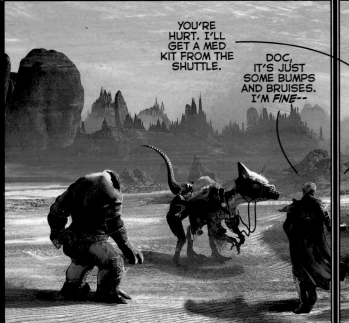

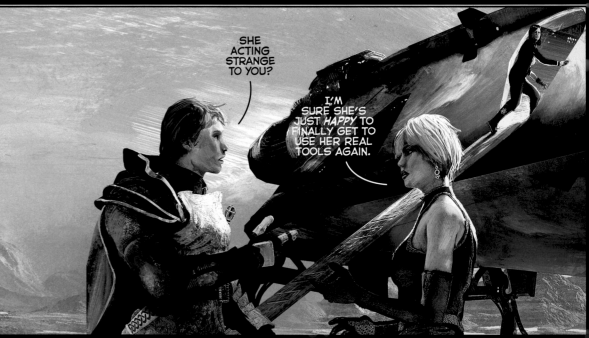

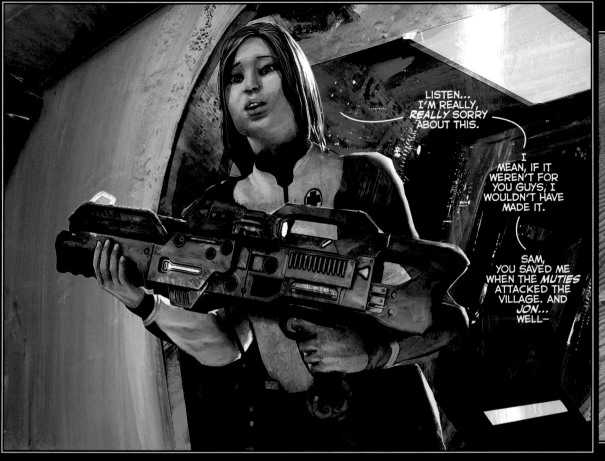

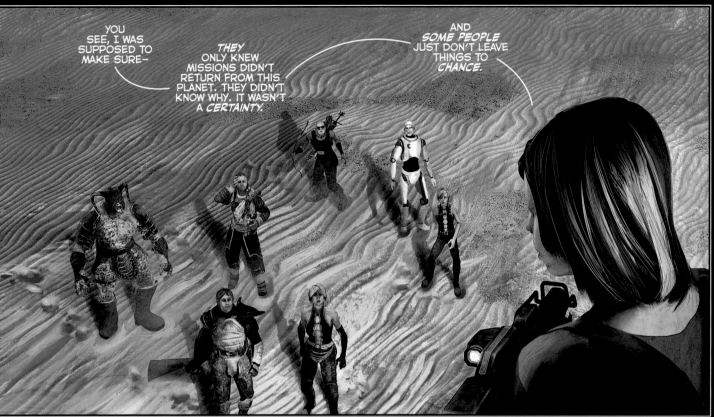

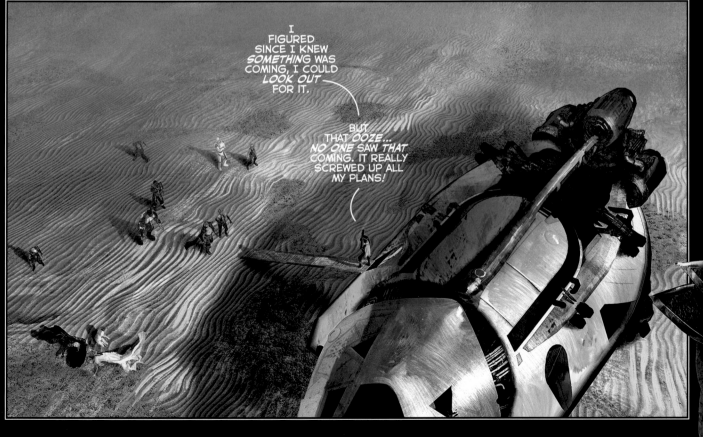

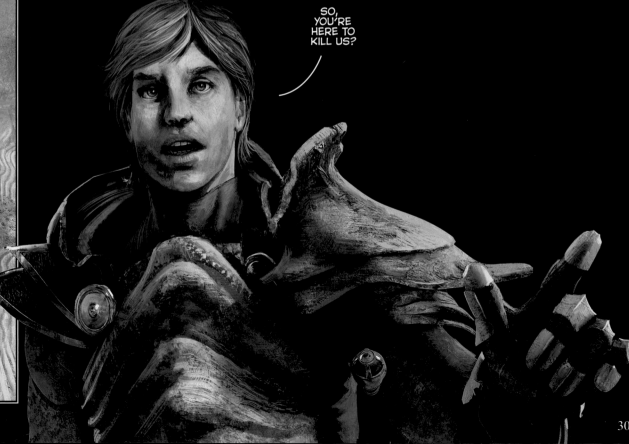

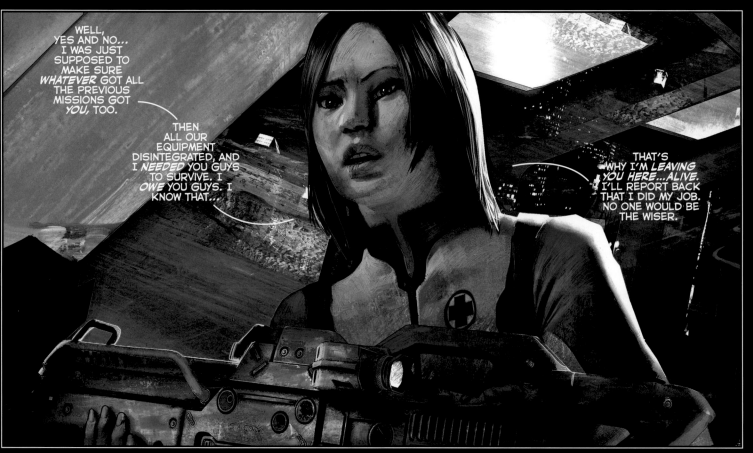

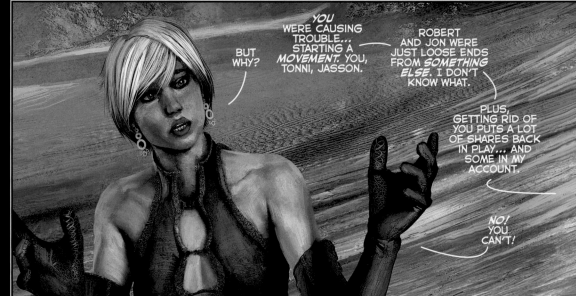

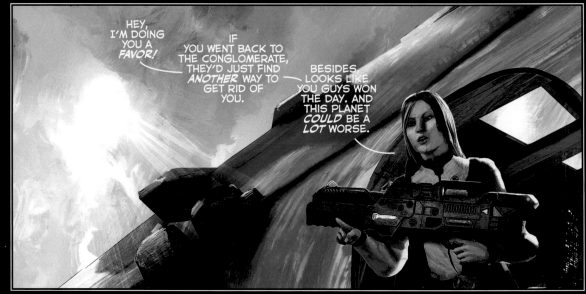

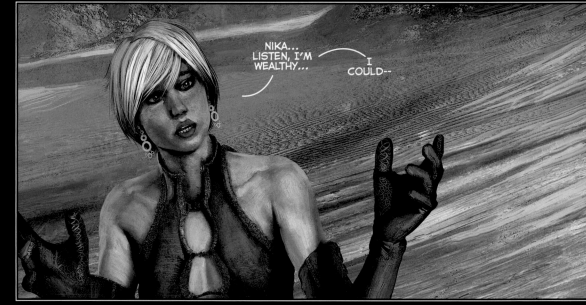

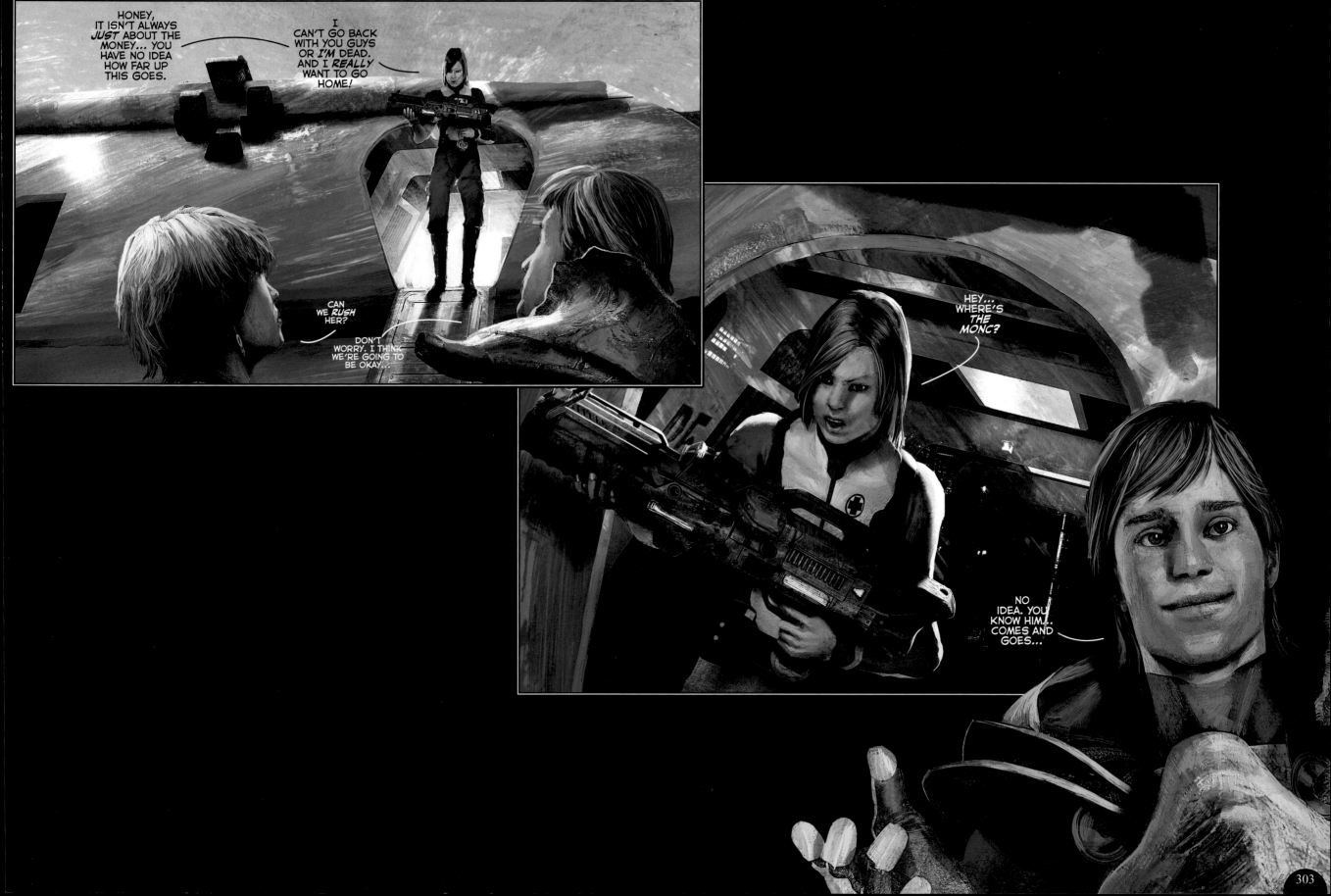

303

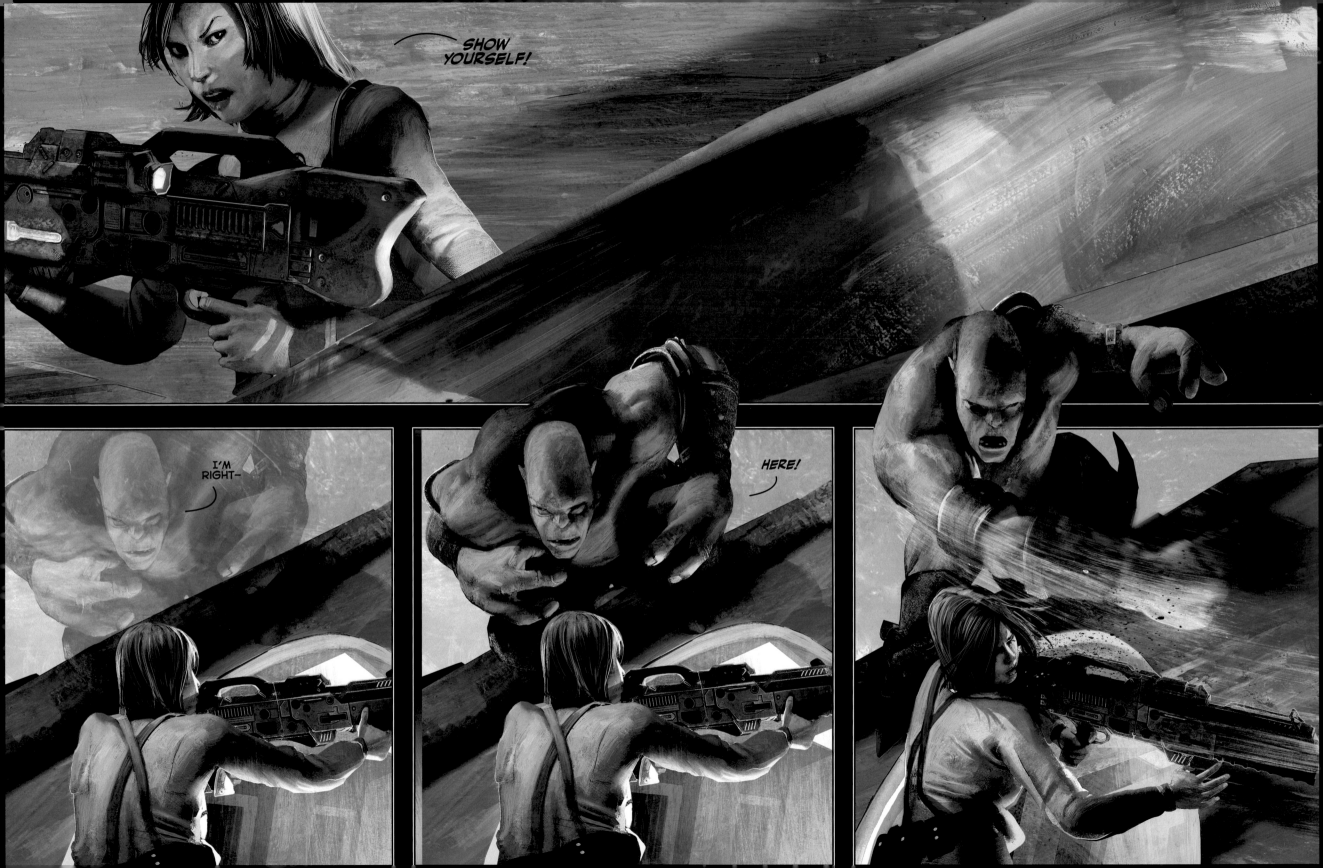

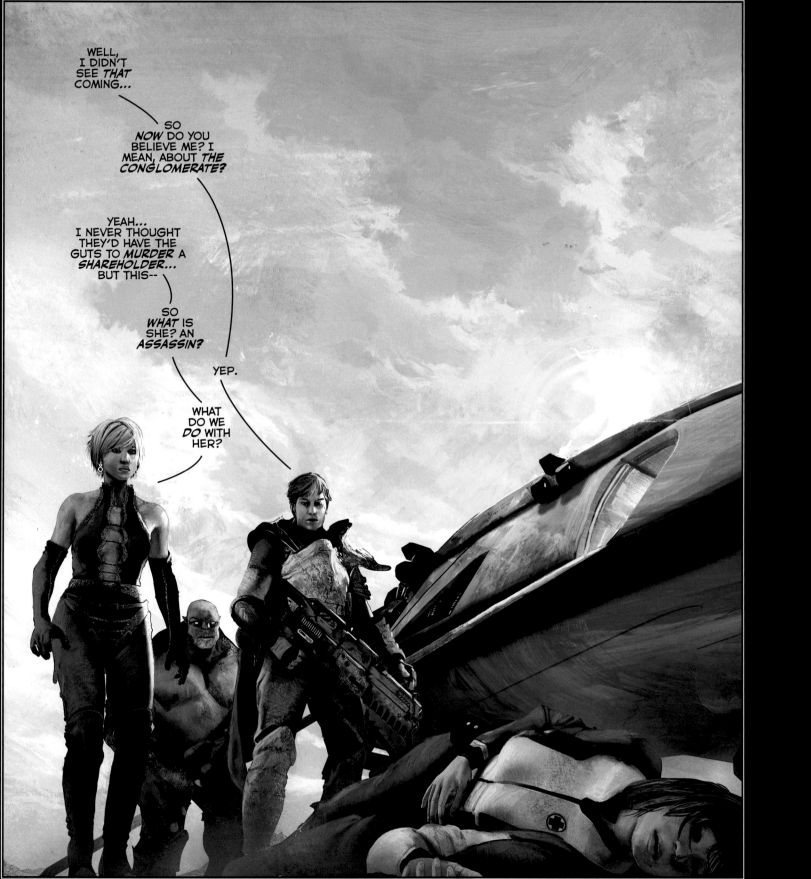

WE PUT HER IN THE SAME CELL I WAS IN WHEN I FIRST GOT HERE. TOLD HER WE STILL NEEDED A DOCTOR—AND IF SHE DID HER JOB, WE WOULDN'T DUMP HER SOMEPLACE PARTICULARLY NASTY ON THIS WORLD. SHE AGREED, OF COURSE. WHAT CHOICE DID SHE HAVE?

NOW SHE WAS THE ONE WHO WOULD NEVER LEAVE THIS PLANET.

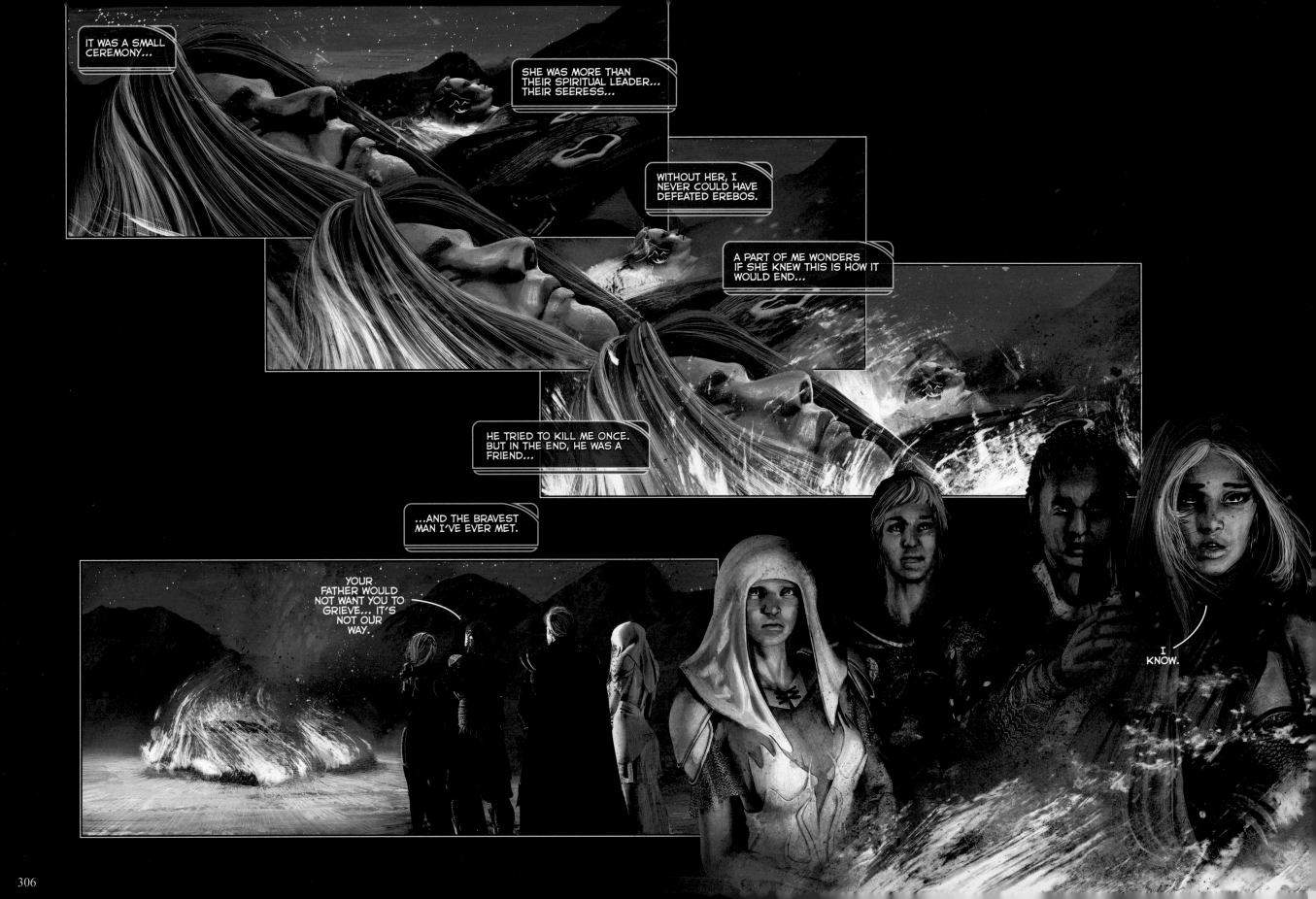

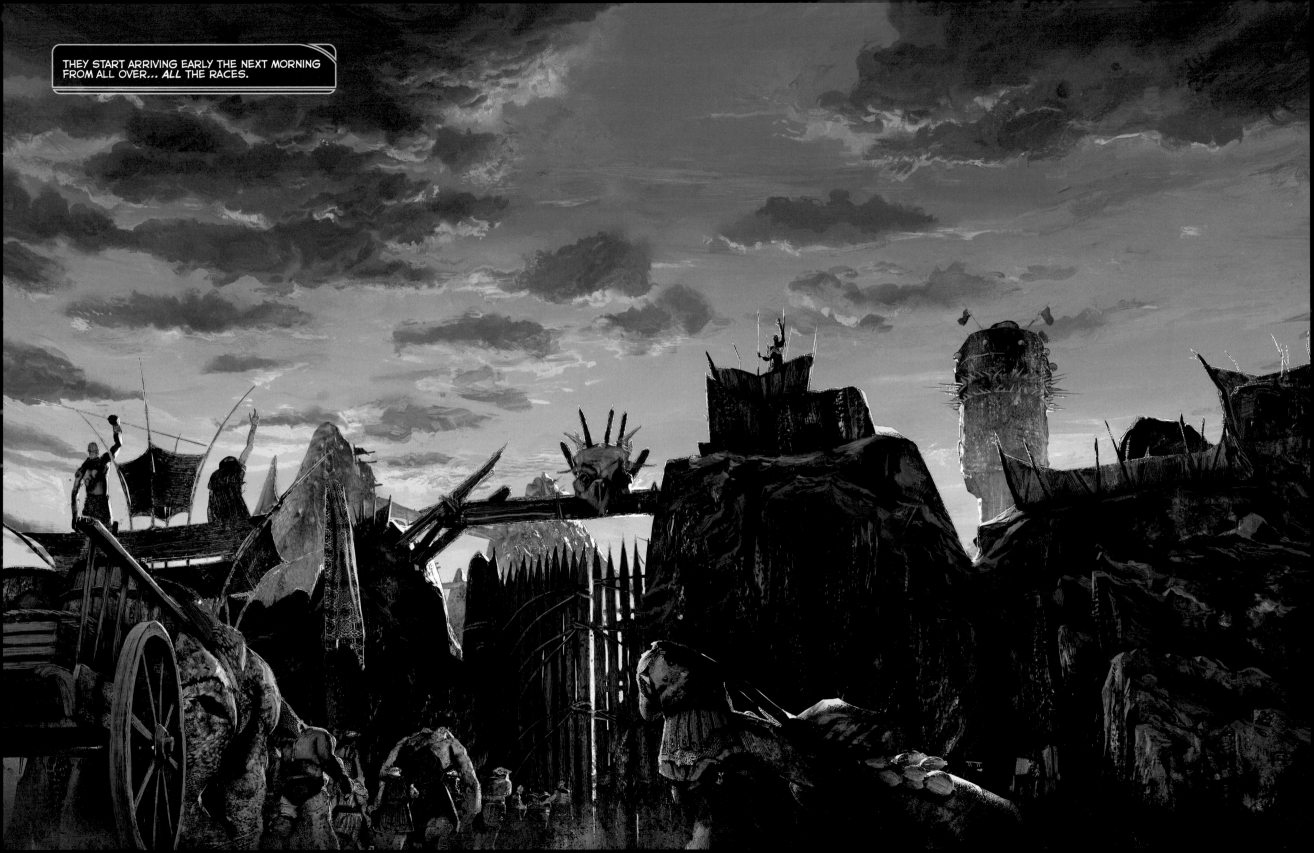

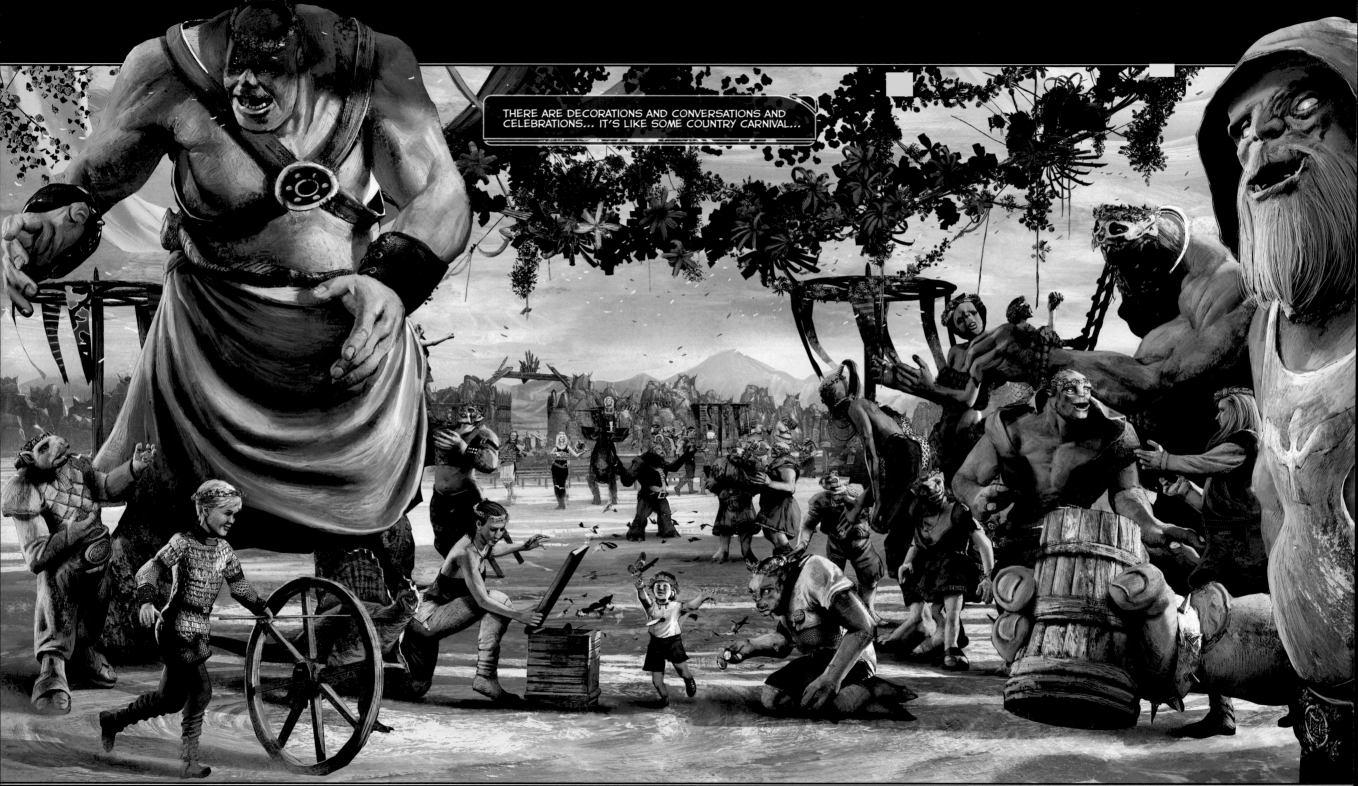

THERE ARE DECORATIONS AND CONVERSATIONS AND CELEBRATIONS... IT'S LIKE SOME COUNTRY CARNIVAL...

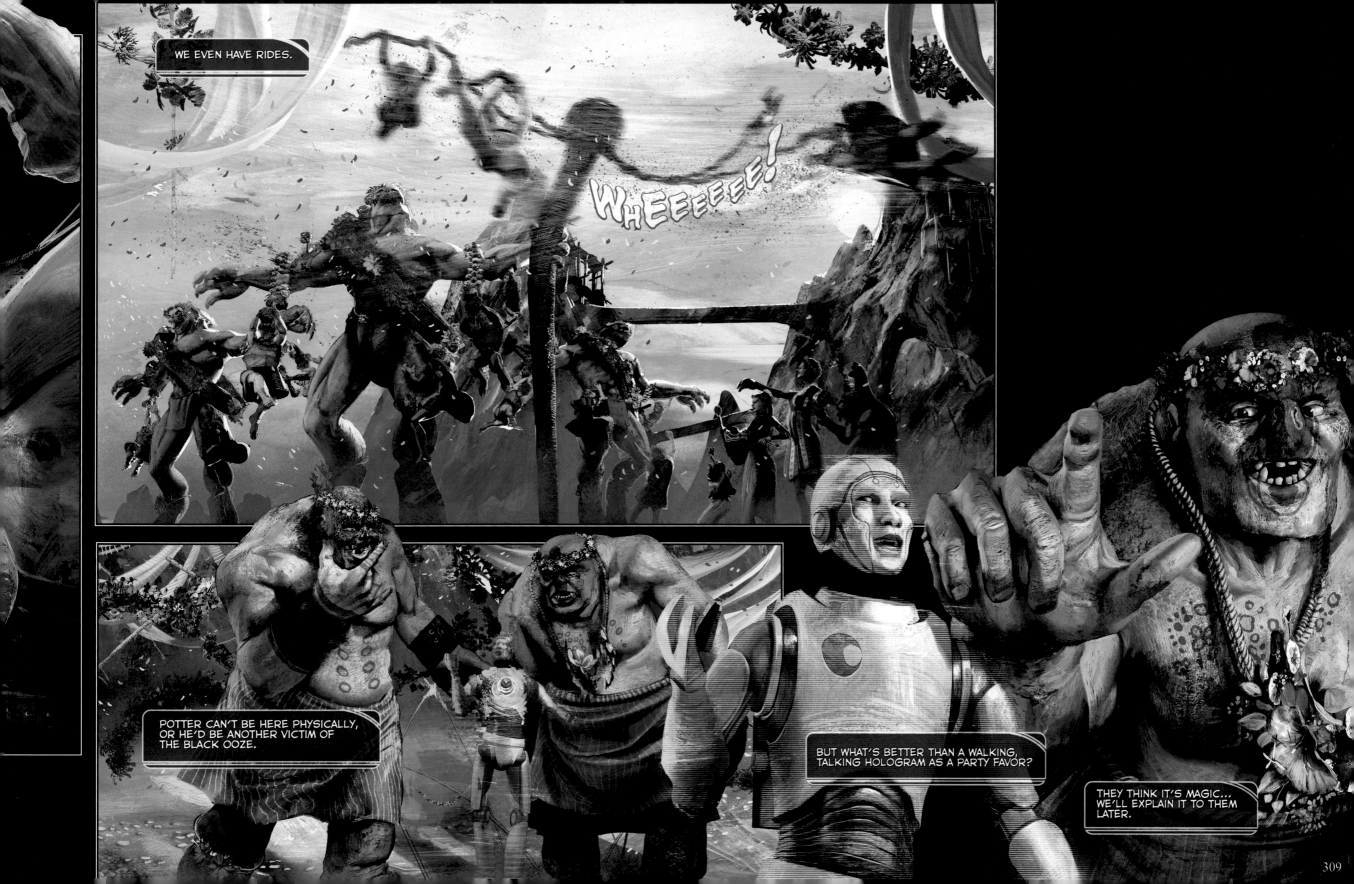

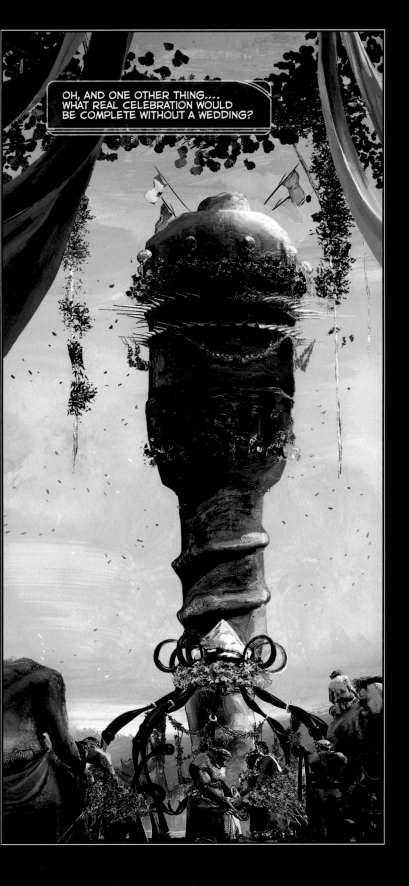

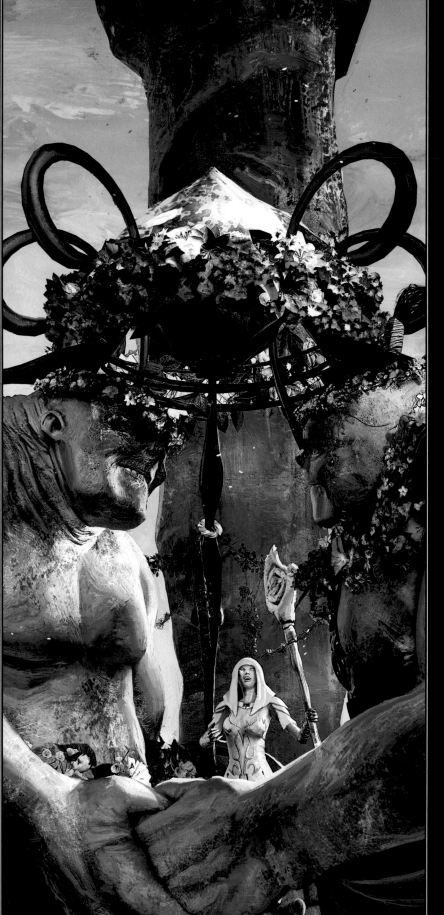

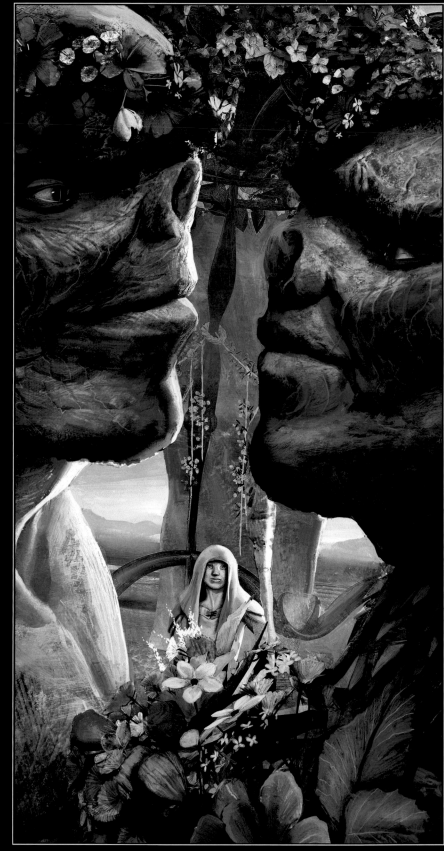

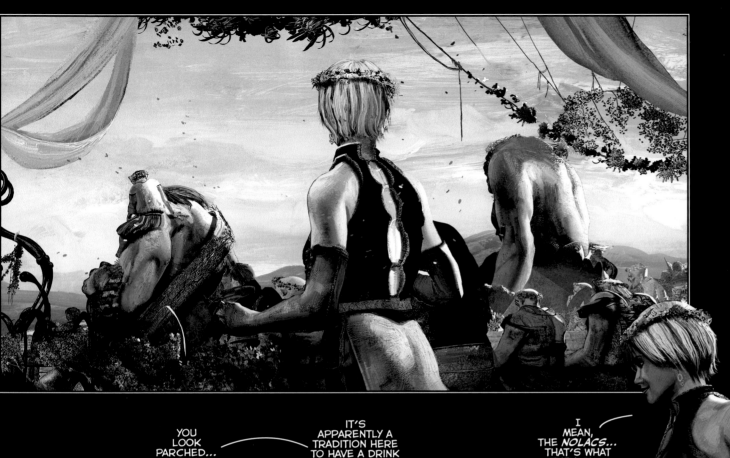

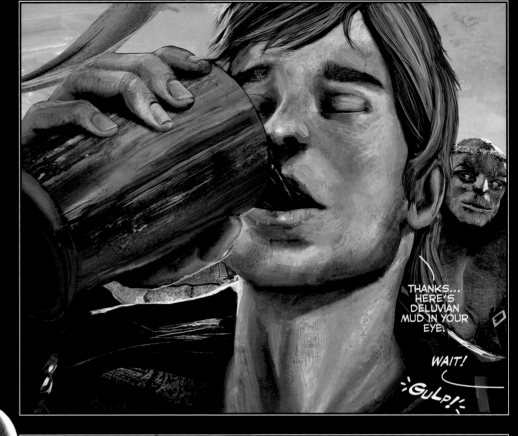

THANKS... HERE'S DELUVIAN MUD IN YOUR EYE.

WAIT!

:GULP!:

YOU LOOK PARCHED... TRY THIS.

IT'S APPARENTLY A TRADITION HERE TO HAVE A DRINK OR TWO DURING THE BONDING RITUAL.

DURING THE CEREMONY? I THINK I'M A BAD INFLUENCE ON YOU.

IT'S FROM THE STILLS OF THE CAVE DEMONS...

I MEAN, THE NOLACS... THAT'S WHAT THEY CALL THEMSELVES.

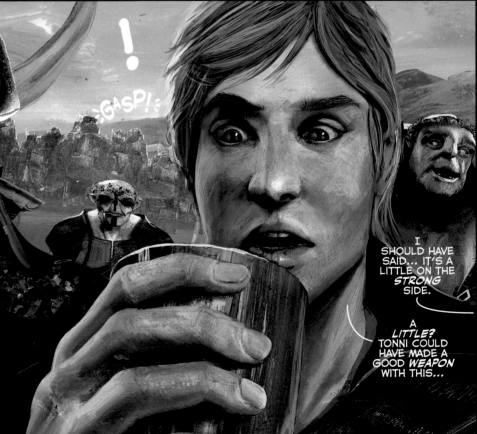

:GASP!:

!

I SHOULD HAVE SAID... IT'S A LITTLE ON THE STRONG SIDE.

A LITTLE? TONNI COULD HAVE MADE A GOOD WEAPON WITH THIS...

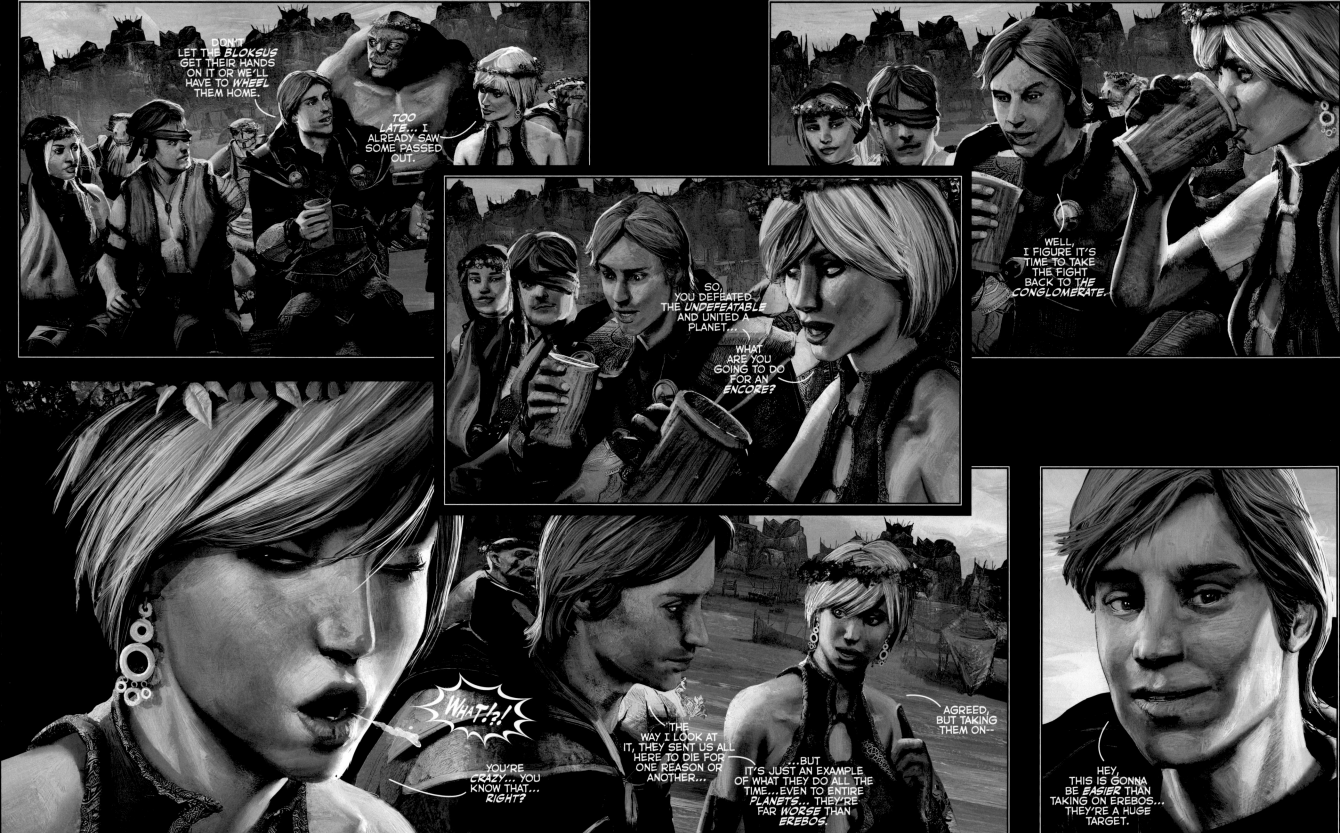

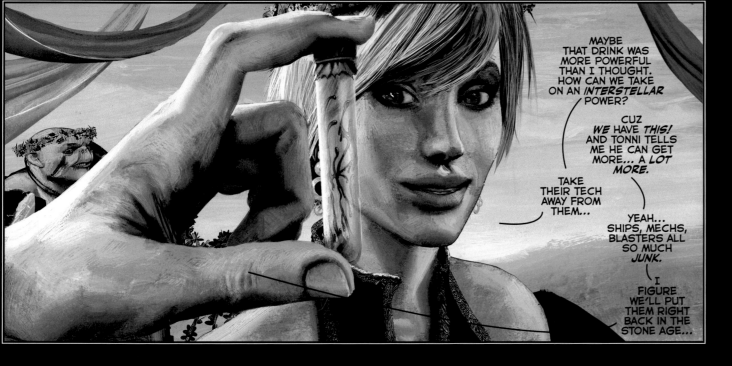

MAYBE THAT DRINK WAS MORE POWERFUL THAN I THOUGHT. HOW CAN WE TAKE ON AN *INTERSTELLAR* POWER?

CUZ *WE HAVE THIS!* AND TONNI TELLS ME HE CAN GET MORE... *A LOT MORE.*

TAKE THEIR TECH AWAY FROM THEM...

YEAH... SHIPS, MECHS, BLASTERS ALL SO MUCH *JUNK.*

I FIGURE WE'LL PUT THEM RIGHT BACK IN THE STONE AGE...

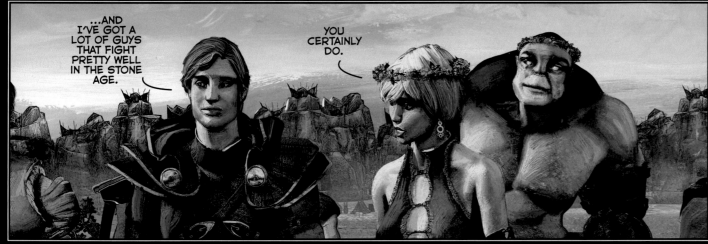

...AND I'VE GOT A LOT OF GUYS THAT FIGHT PRETTY WELL IN THE STONE AGE.

YOU CERTAINLY DO.

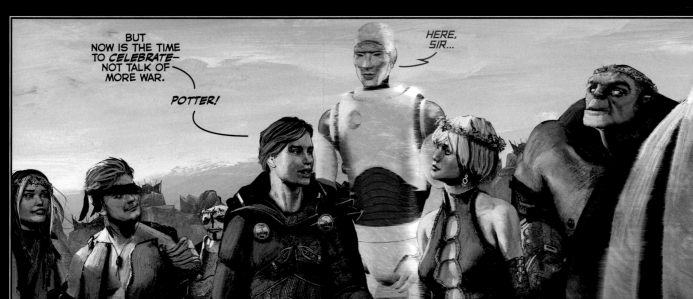

BUT NOW IS THE TIME TO *CELEBRATE*— NOT TALK OF MORE WAR.

POTTER!

HERE, SIR...

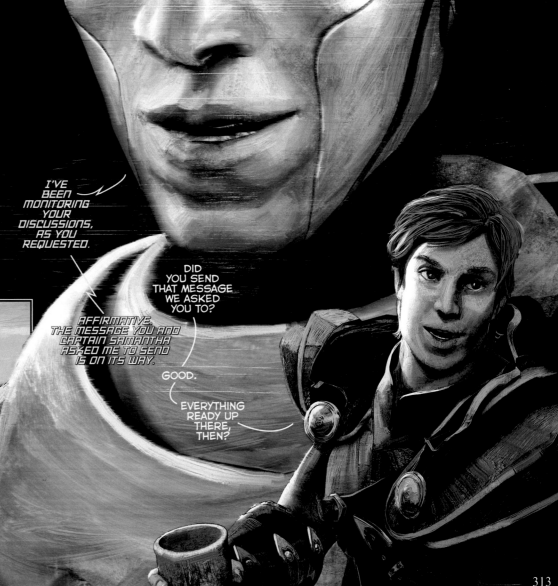

I'VE BEEN MONITORING YOUR DISCUSSIONS, AS YOU REQUESTED.

DID YOU SEND THAT MESSAGE WE ASKED YOU TO?

AFFIRMATIVE. THE MESSAGE YOU AND CAPTAIN SAMANTHA ASKED ME TO SEND IS ON ITS WAY.

GOOD.

EVERYTHING READY UP THERE, THEN?

313

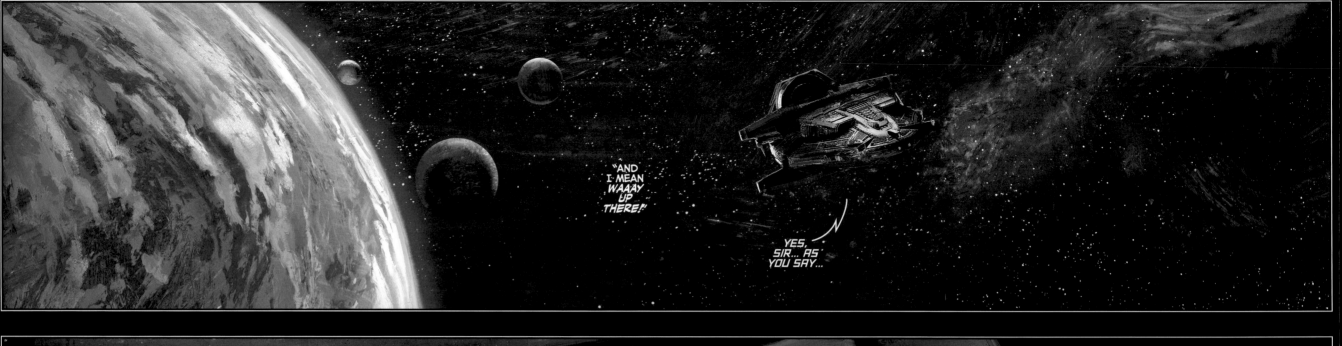

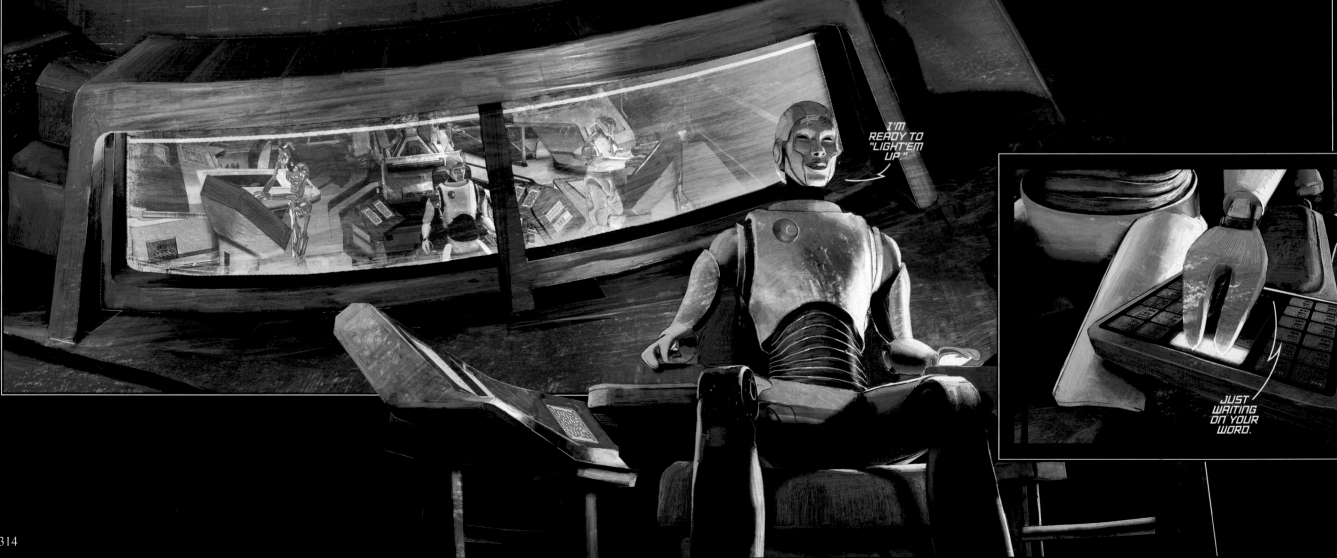

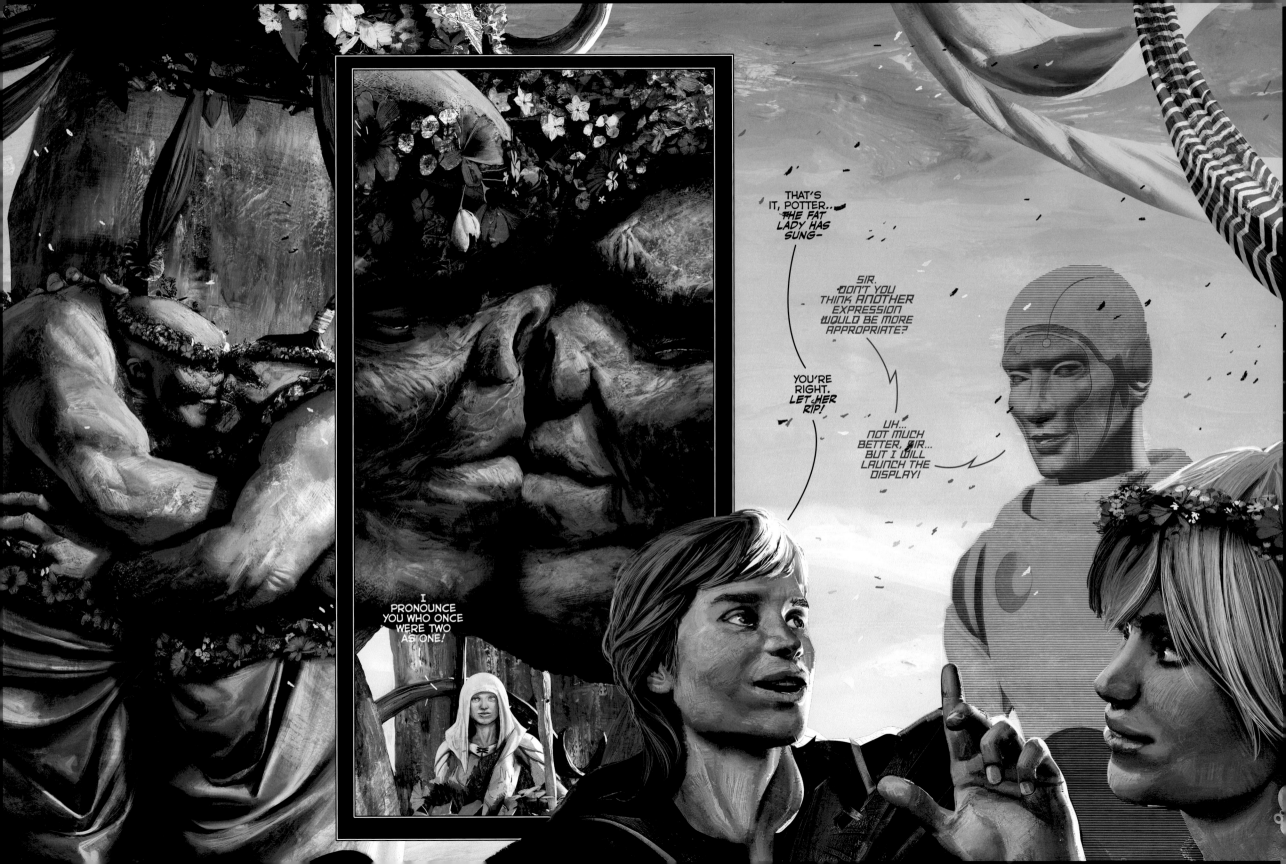

THZOOM!

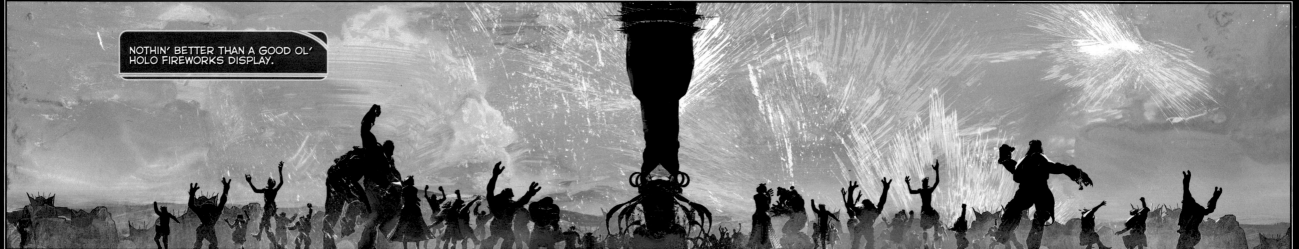

NOTHIN' BETTER THAN A GOOD OL' HOLO FIREWORKS DISPLAY.

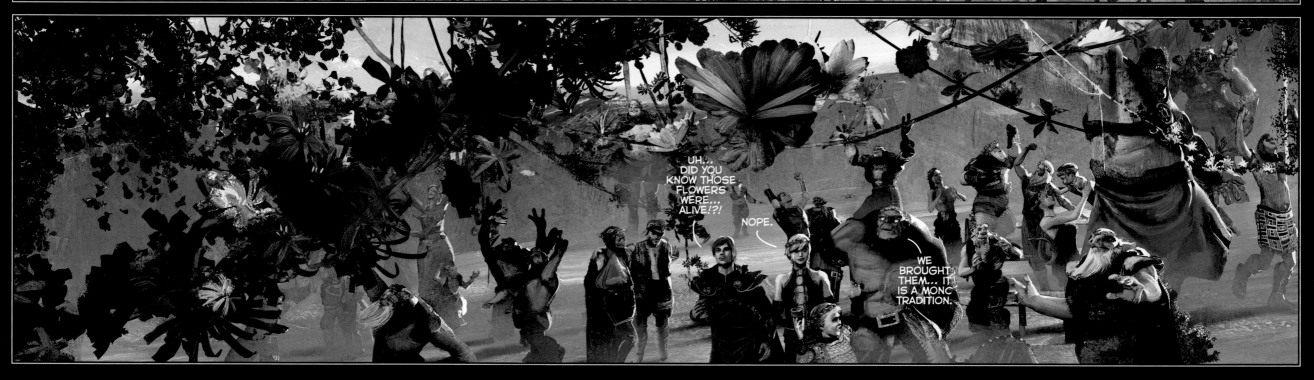

6

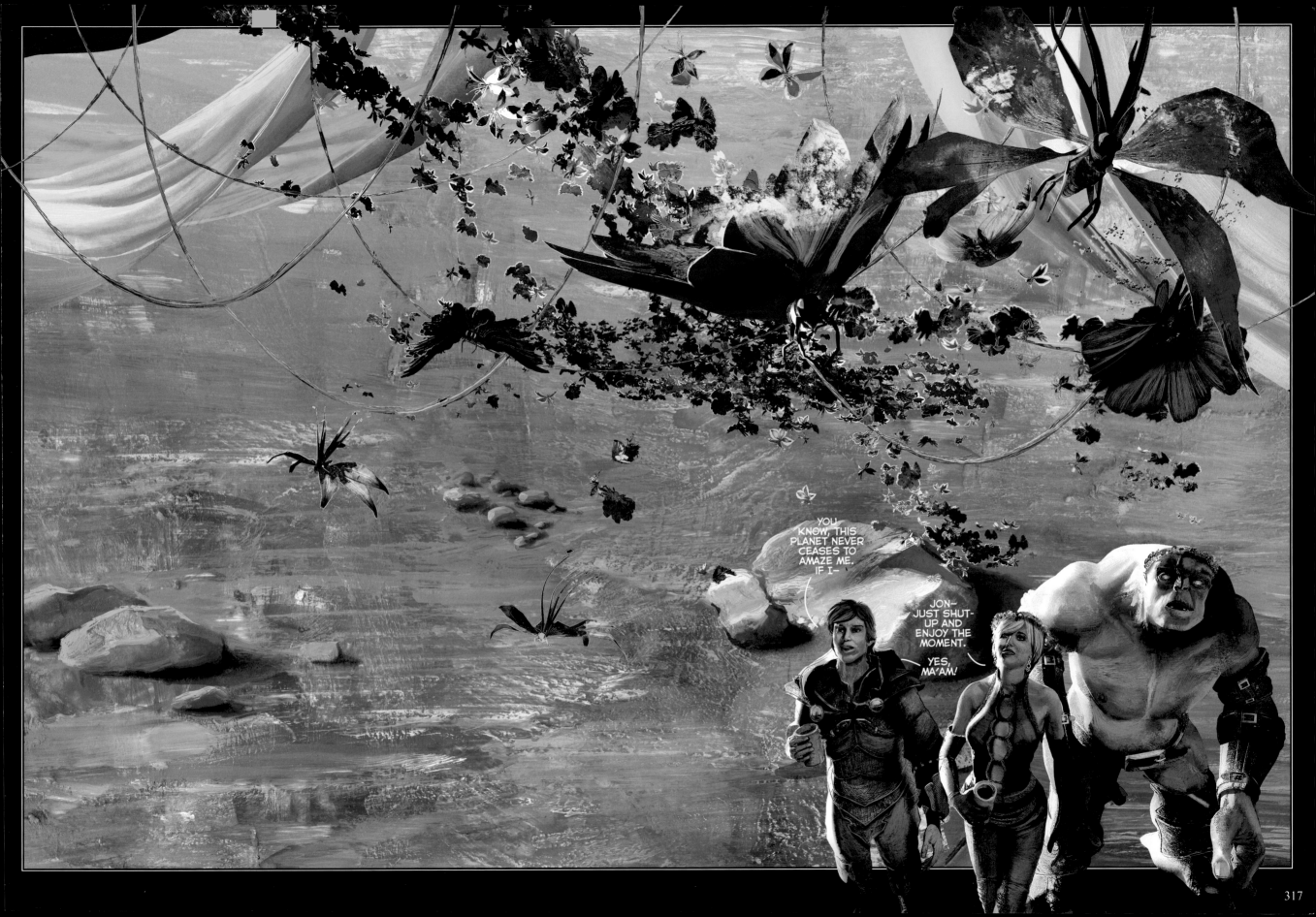

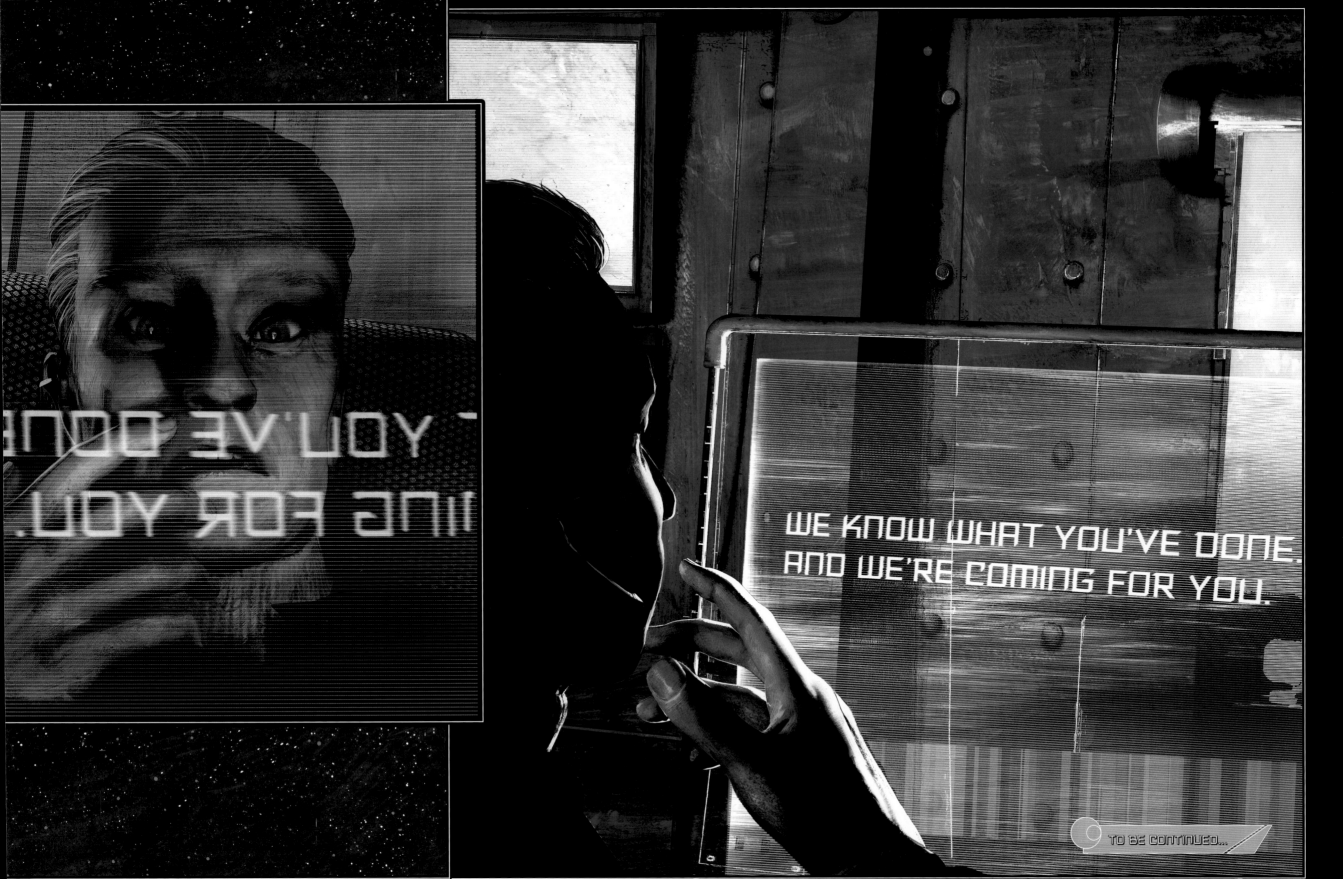

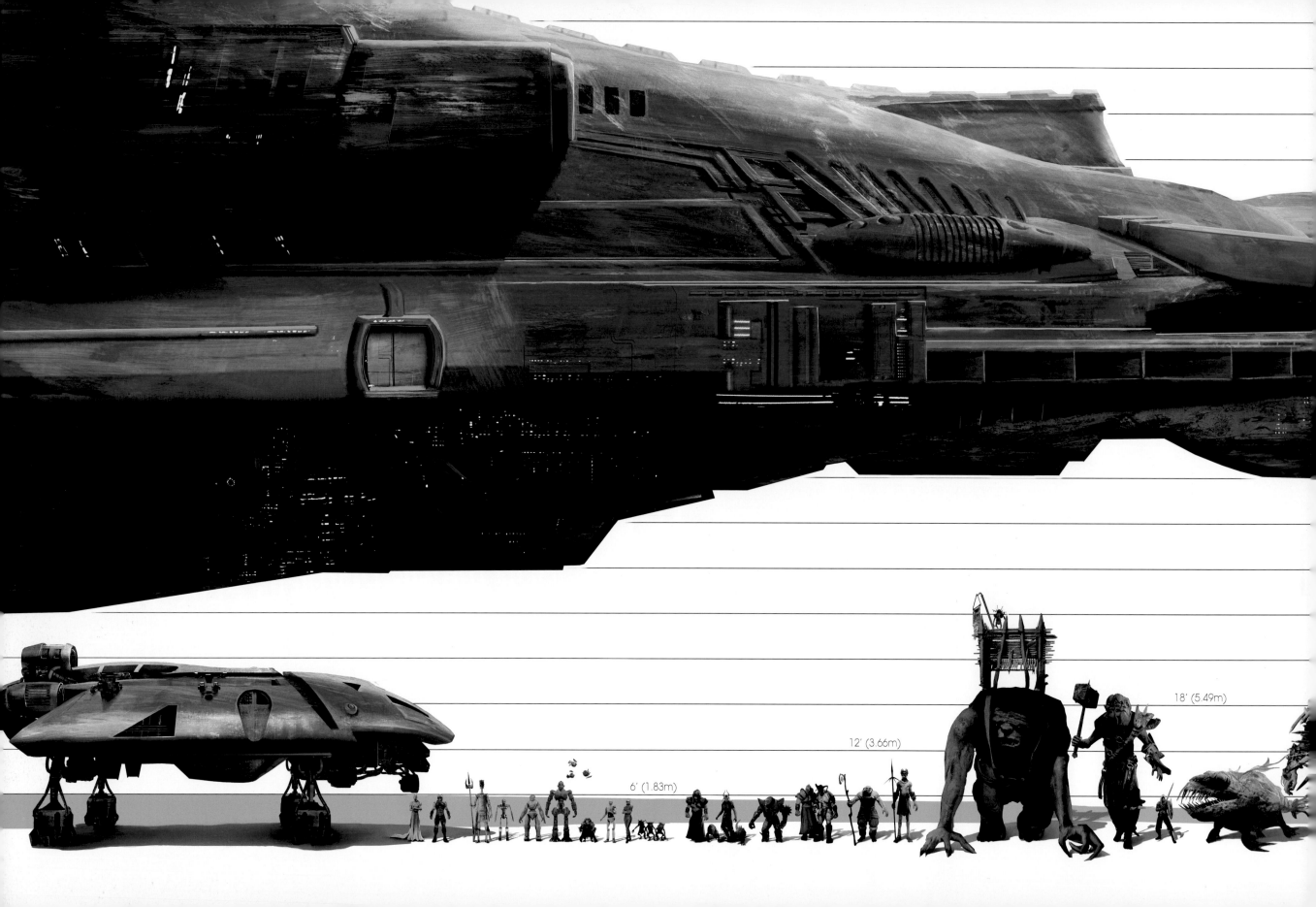

18' (5.49m)

12' (3.66m)

6' (1.83m)

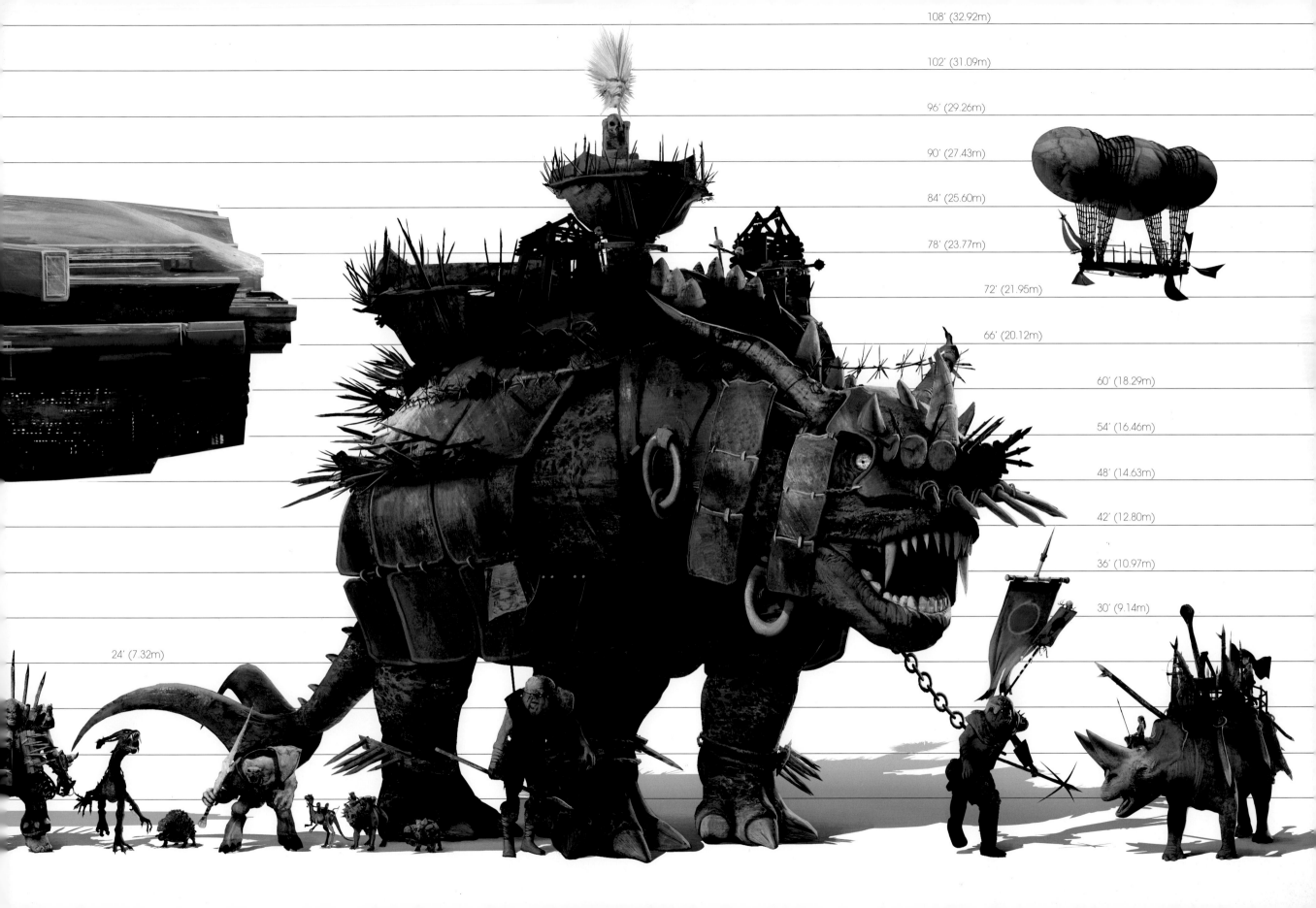

108' (32.92m)

102' (31.09m)

96' (29.26m)

90' (27.43m)

84' (25.60m)

78' (23.77m)

72' (21.95m)

66' (20.12m)

60' (18.29m)

54' (16.46m)

48' (14.63m)

42' (12.80m)

36' (10.97m)

30' (9.14m)

24' (7.32m)

322

EARTH & BEYOND: A TIMELINE...

2037:

2038:

2010: Private and public companies of governance step outside of usual lobbyists and move to more direct control of specific legislators in tune with their corporate agenda.

2012: Legislation to limit greenhouse gas emissions in US is defeated.

2039:

2015-2020: National militaries conclude last of major overt global operations. Private Military Companies (PMCs) displace most seize-and-hold and pacification actions.

2021-2024: Violence from local indigenous riots used to justify the quiet establishment of Global Rapid Response Forces (GRRF) program which codifies intelligence networks of INTERPOL with major PMCs, effectively becoming a military policing force with international jurisdiction and few legal restraints. GRRF funded by mega corps. Due to lingering operational security (OPSEC) concerns, American, Russian and Chinese security forces maintain separate intelligence/PMC entities under a variety of plausible deniability scenarios, typically hidden beneath layers of false corporate fronts. Figurehead politicians offer appropriate diversionary investigations maintaining this façade.

2040:

2041-2042:

2025: Global capitalism restructuring occurs with the full cooperation of member states, echoing the 2008-2009 economic meltdowns. Massive failure of sovereign wealth funds and debt-fueled economies lead member states to cast aside global stability for chaos. "Life management programs" incorporated into new framework of literal cradle-to-grave population control by wealthy surviving global mega corps steered by the shareholder elite. Media control becomes absolute and answerable to government oversight content committees.

2043:

2046:

2028: National sovereignty gives way to corporate control. Non-industrial nations undergo economic development as social/traditional fabric becomes monetized, diluted and removed as an obstacle to conformity. Politicians realize too late "company men" were controlling direction of events all along.

2051-2088:

2028-2038: The Decade of Deliverance. Most of the Third World raised to minimal consumption levels per "poverty as measured by early 20th century American standards." This benefitted profitability of mega corps that now had more markets to sell to.

2052:

2034: Century Genomic Nuclear Systems (CYGNUS) emerges as the first private company to achieve $1T market valuation. CYGNUS is only known to focus on cutting edge nuclear medicine and procedures for life extension (LEX) protocols. LEX protocols can potentially double the lifespan of select humans. CYGNUS's methods and clientele list are protected by newly ratified "Ghost" security protections, punishable by lifetime incarceration or death if leaked. "Specter" legislation derived as knee-jerk reaction to multinational financial Wikileaks debacle of 2011 and implemented in 2012. "Ghost" strengthens the measure by making disclosure a capital offense.

2052-2057:

2035: Shadow group responsible for the global capital restructuring of 2025 emerges as The Cooperative (known colloquially by some as "The Conglomerate"). Announcement of The Cooperative made at the close of the Beijing Economic Unification Summit (BEUS).

2036: Public disclosure of CYGNUS acquisition plans of Scientific Innovations Cooperative (SINC), created at the BEUS 2035 "to coordinate all technologies for the common good." Constitutes the first ever privatization of a global government entity. The merger effectively gives CYGNUS control of all critical technologies. Protests erupt around the world.

2060:

2061: MFTB primary systems brought online. Primary habitat geodesic dome ("Crimson Ark") atmospheric tests enter final stages before receiving human inhabitants. Construction for spaceway transfer infrastructure continues, including transport receipt/delivery ways, fueling and repair, passenger rest enclosures, underground power generation and aqua production/recycling facilities, etc.

2062: Rapidly increasing catastrophic global weather events wreak havoc on global economy and human living conditions.

2063: First humans arrive on Mars as CYGNUS takes direct operational control of the facility. Until raw resources could be excavated, MFTB's secondary goal was to become "Probe Central," creating more hives to launch to the stars and begin the process anew. Variations in magnetic fields on Mars versus Earth yields nMITES that can no longer self-replicate. The problem confounds scientists. Policy shift deems androids are to be used to build other androids and structures from traditionally mined materials. This is viewed by many as a technological reversal but necessary to continue the primary mission of the MFTB.

2089: Climate destabilization tipping points empirically reached. Massive, unprecedented shifts in weather patterns called "The Cataclysms" wreak absolute havoc on the surface of the Earth.

2091: Public works around the world begin construction of self-contained, Massive Domed Cities (MDCs) in anticipation of a worsening global situation. Various human bio-engineered survivability protocols develop (to save the species). The ensuing chaos of construction and planning gives ample cover for covert materials to be launched into orbit.

2094-2096: Pandemic outbreak of previously unseen spore in overcrowded MDCs, since labeled "s2094." (Euphemistically referred to as "the spore of ninety-four.") Direct death estimates approximately 4.2B with indirect deaths pushing the figure upwards of 5.7B. Breakdown of food production/delivery and the scarcity of medical services augment the final (ultimately unknown) body count. Wealthy citizens enter newly constructed, sterile MDCs as those less affluent and the truly poor migrate to makeshift underground enclaves. Some simply choose to brave whatever the unprotected surface world may bring than a guaranteed death.

2099: Human History Rescue Endeavor (HHRE Program) is adopted to physically relocate exposed/endangered, historically significant structures to an undisclosed location for long-term preservation until such time as the environment stabilizes enough for them to be returned to the surface. Objects too large to move have protection domes built around them (precursors to final MDC design). Relocation candidates include: Statue of Liberty (US), Eiffel Tower (France) and the Mamayev Monument (Russia). Containment candidates included: Mount Rushmore (US), Taj Mahal (India) and Hagia Sophia (Turkey).

2103: Massive, "World Ending" scenarios begin to occur. Throughout the chaos, the idea of corporate (rather than public) governance gains favor among global elites. Survival of the species cited as necessitating this change. As only the hyper-corporations had adequately prepared for the crisis, public support is nearly universal. Remaining puppet governments (and a handful of legitimately elected ones) are cast out by ballot and bullet alike. CYGNUS publicly dissolved.

THE CONGLOMERATE SUPPLANTS ALL GOVERNMENTS AND BECOMES THE SOLE RULING BODY OF THE WORLD.
The Conglomerate comes into being: August 14, 2103.

2103-2104: The Conglomerate moves quickly to distribute food, potable water, medicine, shelter and protection forces to as many locations as possible. By merging their PMCs with global defense forces, they are afforded an unprecedented, tightly controlled worldwide reach. Access to previously undisclosed satellite weapons platforms (SATWEP), some of which are brought online for the first time, allows The Conglomerate to defend even far flung "cooperative and valuable" populations of surviving humanity. Masses of the global population choose to assemble at Conglomerate-built "Continuity Camps" where supplies are known to first arrive.

2105: In late 2105, the entire Conglomerate leadership is relocated to a formerly American military installation on the dark side of the moon in order to avoid the environmental instability on the surface of Earth. Control of the facility had officially changed hands by way of Black Procurement Channels (BPC) in early 2053. Secrecy is maintained to minimize public panic and furor by an already skittish people. As MDCs rise on Earth to shelter the elite and those deemed "necessary personnel," the hyper-elite now live one step closer to the stars. Taking advantage of the lessened gravity and previously impossible to manufacture nano-materials, construction begins in earnest of Station-1.

2108: Former oceanic regions now desert and new settlement constructions release previously unseen bacteria. Pandemic races through two MDCs, killing all non-artificial entities. Estimated deaths: 280M. Radiological bombardment used to ensure sterilization. Resultant radiation clouds affect many not protected within other MDCs, but generally viewed as a calculated, necessary action by historians to ensure the virus' destruction. Older nuclear devices were utilized as they were locally available to the most affected regions. Neutron type weapons would have required dangerous transcontinental delivery through erratic atmospheric conditions.

2108-2118: Conglomerate dispatches mobile humanitarian teams to aid as many as possible with prosthetics and other synthetic organ replacements. Radiological and biologically resistant micro-populations (many cyborganic) begin to populate previously inhospitable regions. Nanomesh particle filters directly inserted into lungs save countless lives and create first wide scale organo-metallic populations.

2120: Station-1 (Conglomerate Space Station 1 or CSSTAT-1) brought online. Lunar outpost designated full materials R&D as Conglomerate operations and leadership functions are transferred to the first orbital nation. Station-1 is capable of supporting 1M people.

2121: Dr. Harry Kelheim coins "Galaxy Frequencies" (fg), making real for the first time the possibility of faster-than-light (FTL) travel. FTL engine designs remain elusive, but gateways targeting faraway systems begin design phase. Actual methodology based on highly classified manipulation of gravity waves as proposed in the 20th century.

2122-2124: Continued MDC population cycles and relocation efforts to Station-1 continue. Those who cannot afford either luxury are given the choice to risk global events as they unfold on the surface, or sent to now-vacated underwater bases (built in the mid- to late 21st century). These oceanic metropolises are known as Metrocean Habitats. Individuals could live in relative autonomy, but could not freely come to the surface nor rely on continued support unless a Conglomerate Administrator was installed to oversee internal governance.

2125: All humans are known by first name only, followed by a serial enumeration, henceforth known as a CYGNUS ID (CID). CIDs become mandatory in naming. (The CID is the precursor to The Conglomerate ID, also called the CID.)

2126: Wave Amplitude Resonance Projection (WARP) Gate (also called Kelheim Gate after the physicist responsible for system targeting calculation algorithms), begins construction in the outermost orbit of Earth. Gate construction is done en route to its final destination beyond Pluto. A next generation, nuclear-propelled mobile construction cage (and adjoining support structures) was created for the long-term project. Also on board were human oversight crews and thousands of construction robots (predecessors of the Robotic Gateway Construction Teams (RGCTs)).

2127:	AI-3 Directive passed, putting droid entities of minimal Class-3 intelligence in charge of human labor forces.

2154:

2128:	Station-2 (CSSTAT-2) brought online. Capacity crew complement is 5M and is the first orbital dry dock. Aside from Conglomerate managerial teams, all inhabitants are craftsmen necessary to the task of ship building (including scientists indulging in theoretical physics research). It is no secret The Conglomerate seeks faster-than-light (FTL) travel.

2157:

2159:

2132: Station-3 (CSSTAT-3) brought online. Sharing similar build features to CSSTAT-2, construction took place simultaneously, with its sister station using the economy of scale to keep overall costs under control. The focus of CSSTAT-3 is materials R&D believed to be too dangerous for terrestrial laboratories.

2133: First "starship" leaves dry dock after final assembly of segments built on Earth, the lunar station and small, makeshift orbiting platforms. Christened Conglomerate Space Vessel (CSV) Exodus in June of that same year. Exodus is immediately launched with full crew complement to the location of Kelheim Gate Source "Zero" (KGS-0) as final diagnostics of the gate are underway. Rumored mission was to destroy the Gate should it malfunction and pose a threat to the home system.

2161:

2163:

2134: First Kelheim Gate Source (KGS) is finished. As it serves as the epicenter of all Conglomerate intergalactic activities, it is dubbed "KGS Prime" (alternate names include: "KGS Alpha," "KGS-0," or simply "Alpha").

2136: The Conglomerate had long prepared for this day and readied massive resources from all Conglomerate-explored space (at a yet undisclosed expense) for KG construction droids and raw materials for the building of stabilization Kelheim Gate Terminuses (KGT) 1 and 2. Entry into KGS Prime takes place October 3, 2136. Successful droid pingbacks put into motion full KGT materials payload transfer. Target systems have planetoids of striking similarities to Old Earth's and are thus viewed as prime resource objectives by The Conglomerate. [For further information on FTL travel, please see FTL/WARP/Kelheim Gate supplemental.]

2165:

2150: KGT-1 is completed. Volunteer manned missions (called Jump Jockeys) enter in hopes of staking out claims in yet-uncharted regions of space, per Conglomerate agreements. Communication droids would accompany such missions and report back via subspace channels to assure compliance with said agreements. Tampering with or destroying a communication droid would be prosecuted as an assault on Conglomerate personnel, resulting in punishments therein; early version of the modern day Watcheye.

2166:

2167 to 2168:

2151: Space Marine mission (codename: Drakocyn) deployed to prevent rogue elements from entering the KGS and forestall the creation of potential black markets of materials acquired from destination systems. Drakocyn is the first true space military deployment of human defense forces. Practical control of such a large swath of space creates the need for a new strategic and tactical revisioning of terrestrial norms. Secret incubation project "Enforcer" is brought online to rapidly evolve the Space Marines into their ever-expanding role:

Space Marines assigned to maintain cross-gate system compliance fulfill their transition into the Enforcer Corps to better prepare for offworld operations.

2169:

2153: KGT-1 is cleared for full payloads (including humans). CSV Buccaneer Class (CSVB) vessels are among the first to enter, formally entrenching The Conglomerate in the business of inter-system excavation, resource procurement and management (REPROM). New ship construction and continuing technology advancements create a modern day "Gold Rush" (though all precious ores found on primary system planetoids are understood to be Conglomerate property). Entirely new economic models begin to develop beyond

2173:	Democratic Alliance of Planets ("The Alliance") is formed.
2175:	Tholeen Incident. Artificially created Enforcer prototypes escape their Conglomerate handlers. Exhibiting exceptional physical and mental superiority to their designers, their feigned obedience is discovered too late. Hardened core AI below the lab survives EMP discharge used to cut-off scientist communications with The Conglomerate and disables all transport vessels before self-destructing power grid, preventing the escape of the synthetic lifeforms (SYNs).
2175-2177:	Enforcers arrive to take back the base, only to be slaughtered by the alien tech derived clones. Killcard estimates were 100:1 in favor of the genetic morphs. EMP barrages from CSVH class ship brought on site to prevent any further offworld attempts (via captured shuttle vessels). Conglomerate authorizes second Omega Level Elimination, choosing to raze the entire world rather than risk their lethal creations getting offworld. GENE Threat Interrupt Code 1 (GENETIC-1) is written into law, forbidding the unnaturally adaptable, survivable human genome from being used as a template for future experimentation. Compliance failure triggers severe punishment.
2177:	CSVD Reliance (Dominus Class, CSVD-001), first of the Dominus Class dreadnaughts, arrives in-system on the last leg of its space trial. Next-generation WMD (including a high-penetration neutron scattercannon) are tested, including the playfully named "World Buster Bomb" (WBB). The WBB is rumored to be a "space-temporal shape charge" using a targeted, micro-disruption of the space-time continuum (temporary black hole) that "spits up" with enough kinetic force to destroy entire worlds. It is thought to be an energy discharge weapon of some sort rather than a conventional "bomb" as its name implies. Reliance is also exceptionally fast for its size, utilizing engine technologies gleaned from the Corishtani—[CLASSIFIED]
2178-2188:	Second rapid expansion of Conglomerate multi-galaxial holdings (internally referenced as "the Second Golden Age" of man). Presence of CSVD Reliance found to make future First Contact species pliable to favorable negotiation outcomes. During this same period, the Alliance (officially, "Democratic Alliance of Planets") have become the negotiating agents for outer rim contacts. Security guarantees or independent subsistence with the Alliance worlds often undermines (through careful legal maneuvers) Conglomerate goals.
2190:	Conglomerate enters diplomatic low-level warfare directly in what is grudgingly referred to as Alliance Space. The tagline: "Unified peace through unified space," becomes The Conglomerate mantra in Alliance spheres of influence. It is especially effective among the less affluent favoring stability to self-realized prosperity.
2214:	Sentient Values Act enacted by Conglomerate. Assigns individual value of species predicated on value of category and/or individual wealth (including mineral resources or technology assets). Rights and privileges are strictly accorded based on individual's status according to their category. [Fundamentally, this is a class system based solely on wealth, and wealth is measured exclusively in Conglomerate shares.]
2228-2237:	Integration efforts of Conglomerate financial network and installation of Conglomerate representatives of displaced, former Alliance government bodies unfolds. Several large transactions occur before CMOF is able to achieve full containment of all Alliance accounts suggesting a handful of "substantially wealthy" system outliers may exist. AI code hardened to monitor for suspect transactions indicating external wealth movement through Conglomerate financial systems.
2240-2343:	A time known as "The 103," thought to be the longest sustained period of "peaceful" growth in recorded history. Massive expansion of Conglomerate intergalaxial holdings and evolutionary ship developments occur during this time, as does the cumulative wealth and power of The Conglomerate. It is also called, "The Second Golden Age of Man."
2292:	Station-4 (CSSTAT-4), the first of the super massive space stations, is brought online. [CMS assets and general assembly of The Conglomerate will be relocated here in 2308.]
2398:	Syrhani'i terrorist group takes responsibility for outer Makton Peninsula raids.
2414:	Alliance War begins and ends in the same year with a major surprise attack by The Conglomerate on a wide swath of Alliance planets. Conglomerate officially dissolves Alliance guilds and political provisions while absorbing all Alliance holdings as restitution for war costs. Conglomerate is triumphant. GRA.2414a enacted to punish all living relations to would-be insurgents. GRA.2414a is considered one of the cruelest legislative acts of collective punishment ever committed by humans against humans.
2423:	Rogiran Treaty brings the first telepathic species into The Conglomerate. Their mind scanning abilities are of great interest to the CMSB's darkest branches of PARACOM. Many are placed on EXA administration bodies to give greater front-end information upon discovery of other lifeforms. Others are placed to work in concert with CMSB interrogation teams.
2427:	Makton Massacre, committed by known Syrhani'i operatives, elevates the threat conditions in the system. An emergency session of CMS results in legislative action PO.2010D.
2455:	Station-5 (CSSTAT-5) brought online using new materials from multiple systems and hardened data controls. Conglomerate operations and central command structure are all transferred to CSSTAT-5.
2456:	Conglomerate AI Act of 2456 grants Class IV or greater androids true personnel status with all the rights and privileges therein, including leadership positions over lesser ranking sentient organics.
2457:	Conglomerate streamlines system administration through the use of Watcheyes. Each Conglomerate Major Shareholder (CMS) is assigned a battery of these diplomatic representation droids (DRDs), ostensibly considered "extensions" of the actual CMS "in person." An assault of a DRD is considered an assault upon its owner (and subject to appropriate legal recourse).
2492:	Escalation of Syrhani'i (and those of like mind) violence against system assets and personnel answered with KILLOS and the quiet establishment of Enforcer Taskforce 343.
2500:	Following years of covert PARACOM infiltration of several terrorist cells, the 26th century opens with a multi-system, surgical offensive against the Syrhani'i and their supporters. The group's effectiveness and sphere of influence is reduced to their home system where they are relentlessly hunted. Other factions were terminated outright.
2501:	Considered the beginning of "the Third Golden Age of Man," marked by the sudden drop in non-alien related losses.
2519:	Multiple Kelheim Gates undergo final testing in preparation of full activation. Largest deployment of EXA forces sent to ensure security at KGTs.

2521: CSSTAT-4 and CSSTAT-5 undergo major retrofitting operations. CSSTAT-4 adopts the missions of scientific discovery and integration of captured technologies. CSSTAT-5 integrates surrounding, smaller work docks and supply entities into the superstructure (much of which becomes what is now the Lower Levels).

2523-2619: Multiple frontiers opened to Conglomerate exploration and acquisition. Some historians consider this period to be "The `Real' Third Golden Age of Man." Academic debates on the matter rage to this day, though without an accepted definition of what constitutes an "Age," any universally accepted conclusion is improbable.

2630: Deskarr Campaign and pacification efforts result in first true Conglomerate Deep Blue assets, strategies and tactics. Aquapilot-III categorization entered into CMSB pilot certification roles.

2648: CSSTAT-5 update adds dozens of square hectares of large, luxurious secure modular decks for CMS and distinguished patrons. Current reference to these additions is the "Upper City."

2651: Large scientific research mission sent to Essiv to study the Ula's "single communications" ability that appears to connect every life on the world into a singular, collective conscience able to affect every element of the biosphere. Considered the first, truly new form of life discovered since The Conglomerate's founding.

2712-2713: Sestus Prime Campaign.

2717: **THE PRESENT...**

CONGLOMERATE: GALACTIC EXPANSION

A brief summary of The Conglomerate expeditions into space...

Early Zero-G Success:

"It's said that July 20, 1969, signified man's first true journey outside the comforts of Earth. These were our first, dusty, childlike steps on the moon. The International Space Station was completed over budget and after countless delays in 2015. We achieved the first manned Mars colony in 2063, mere decades before the Cataclysms proved our calculations true, and our resolve absolute.

"This represents the advantage of a unified society. It is a society free from the directionless efforts of separate nations, quarrelling militaries, broken economies and fractured mindsets. This is the model we now bring with us to the future...and to the stars."

Filo Danguardia
Chief Science Officer, CCCR
Excerpted from the welcome speech at the opening
of the Eldybron Propulsion Studies Wing, 2107

With the disintegration of global nations and the rise of The Conglomerate as the solitary socioeconomic power, the advancements of technology experienced a kind of renaissance never before experienced in human history. By cultivating the brightest scientists, many of them possessing the knowledge of previously hyper-secretive military laboratories, The Conglomerate was able to direct an agenda that was impossible when competitive factions existed. The so-called *Frictionless Technological Imperative,* imbued with pure profit motivations over national security concerns, brought forth countless innovations that would ultimately save humanity.

Central to this new way of business was the birth of the first orbital materials lab (simply called "**Station-1**"). The weightlessness of space allowed for new, gravity-hindered composites and technologies to be developed and implemented. As Station-1 was located in orbit and outside the casual observational boundaries of the people below, several "controlling technologies" were also contrived and incorporated into the terrestrial population without their knowledge. The details of these programs remain classified to all but the uppermost tiers of Conglomerate operations and a handful of security apparatus personnel. As the world continued to destabilize, Station-1 quickly became home for The Conglomerate elite and governance.

The first major success of Station-1 endeavors was the manufacture and construction of **Station-2**. Station-2 represented The Conglomerate's first orbital dry dock. It was an achievement from which all future Conglomerate space operations would stem. Freed from gravitational impediments and having exclusive access to newly fabricated materials, segments of the prototype ship were brought to Station-2 for assembly from Earth, the lunar colony, and several free-standing orbital construction nodes. The **Exodus** was born in 2133 and entered history as humanity's first true space-borne vessel.

Exodus' primary use is recorded as a shuttle transport for resources and equipment to the **Mars Forward Transit Base (MFTB)**. Unofficial historical records mention a possible secondary function of the base as a monitoring and defense perimeter to the first **WARP (Kelheim) Gate's** activation. The model of **exploration/colonization (E/C)** was slowly distilled to preclude "inhabitable vessels" in favor of **Self-Replicating Exploratory Droids (S-REDs)** created for the sole purpose of finding resource-positive worlds and notifying The Conglomerate central command. This process rendered the massive financial investments predictable and accelerated The Conglomerate's return on investment. The division tasked with the everyday fiscal oversight of outworld E/C R&D eventually morphed into the **Extra-Solar System Mapping Initiative (ESSMI)** program.

Early manned efforts required a crude cryostatic technology to make the non-lightspeed travel somewhat more tolerable for those willing to risk it all for glory and profit. Fatalities upon reaching the destination were upwards of 80%. While deep sleep technologies have improved vastly, and are still necessary in some instances, the spirit of exploration and colonization owes its

start to these early pioneers. It lives on in a more literal sense with the ongoing **WARP gate** projects and the self-named **Jump Jockeys**.

FTL Travel

The breakthrough in faster-than-light (FTL) travel came when researchers discovered that each observable region of space (the more distant, the less precise) possessed a unique system frequency (f_g) which was based on the largest, most stable star(s) in the "target space." Earlier studies had found slight but demonstrable appearances of small particles that seemed to appear out of the ether to Conglomerate quantum aberration detection arrays suggesting the existence of a "tunneling" mechanism of some sort (since called *temporary micro-wormholes*). **Dr. Nomura Kensuke** and **Dr. Chaitanya Singh** devoted their studies to predicting the emergence of these tunnels in hopes of gaining the knowledge to artificially create them. In the meantime, a massive effort was underway by a separate branch of **Conglomerate Cosmos Catalogue & Research (CCCR)**, whose existence was based on the gamble that such research was paramount to eventual FTL travel.

The first executable WARP gate theories arose from Dr. Singh's astrophysics protégé, Harry Kelheim. As the Chief Science Assistant to Dr. Singh, Kelheim had unusually fluid access to the theoretical equations as well as the raw data and systems being gathered by the CCCR organization. Tackling the practical hurdles of FTL execution as something of a hobby, and much to the chagrin of his superiors, the first functional equations that married theory with available technologies to artificially create "directional wormholes" came to be through Kelheim's rebel brilliance. The overarching logic was to create a temporary singularity (the rudimentary applications having been studied since the 21st century's Large Hadron Collider experiments), then steady and direct the singularity at a predetermined target (f_g) long enough for transportation elements to enter the resulting gate. Target system frequency finally gave future travelers a set of destination coordinates. Gravitational wave theories of the past (originally set forth in the 20th century) could now be exploited with great accuracy (within a few years of the target celestial body). It is believed the use of "wormholes" for travelling these vast distances is derived from an artificial implementation of the Hoop Conjecture. The implication was staggering. Somehow, stable, "directed" black holes were being created at will by The Conglomerate. The truth of this, and much surrounding this field of study, is among the most guarded secrets of The Conglomerate. It is only known that Dr. Kelheim provided the necessary computations, meshing and resolving centuries of theoretical and astrophysics to bring about the world we enjoy today.

Several sub-departments sprang into existence to satisfy the accounting arms of The Conglomerate purely for the purpose of data harvesting. The cost of data acquisition and bureaucratic overhead was deemed a pittance in determining if a WARP gate to any particular destination made sense, rather than creating a non-profitable gate. As Director Romeo Dimput, liaison between science and economic factions once put it, "Return on investment before we leap... in this galaxy and *especially* outside of it."

The realization of WARP gate technology opened the doors to The Conglomerate's intergalactic spread, bringing with it a wealth of new resources from far-off regions of space. It also carried with it the price of an accidental encounter and eventual war with the **Corishtani**.

The Corishtani Conflict in Brief and its Subsequent Effect on Conglomerate Deep Space Operations:

The **Corishtani Conflict** (2161-2166):

Discovery of extraterrestrial life on a planet rich in several rare ores sought by The Conglomerate posed the first real test of corporate intergalactic politicking. The inhabitants of the world were a simple species (called only SBF-01), but sentient. Once communications were established with tribal leaders, it became clear they did not want anything to do with The Conglomerate. When The Conglomerate refused immediate withdrawal in hopes of further negotiations, a small band of SBF-01 attacked a perimeter observation camp. A science assistant was killed in the raid, though seemingly not by design. Seizing on the opportunity, the military complement eradicated the local population in its entirety, taking possession of the world and its riches on behalf of The Conglomerate. SBF-01 lifeforms were deemed a "clear and present danger to Conglomerate personnel" and were summarily hunted and eliminated with great prejudice.

Establishment of the mining network was proceeding according to plan when communications with the new outpost went dark (September, 2160). Subsequent droid scout missions revealed the mining colony had been destroyed by a far superior force and not by natural disaster. A new alien race, substantially more intelligent than the SBF-01, captured a scout ship and established a line of communication with The Conglomerate. They demanded to know what business The Conglomerate had with *their property*. This was The Conglomerate's first contact with the Corishtani Empire.

The Conglomerate, the quintessential corporate enterprise, saw the sophisticated weapons
of the Corishtani as an opportunity rather than a threat. Against council advice, the directors
of each Conglomerate arm decided shutting down the WARP gate would, while expensive, be
an effective safeguard against the Corishtani should events turn. They immediately dispatched
negotiation teams to prostrate themselves before "the superior power" and seek agreements for
technology transfers and resource sharing.

Initial overtures by Conglomerate and Corishtani teams began on a positive note, though
it became clear in hindsight the purpose for this congeniality was primarily to assess the other's
potential to resist invasion. Having never encountered any opposition beyond largely unarmed and
unsophisticated lifeforms, The Conglomerate representatives quickly discovered their counterparts
not only possessed clearly superior technology to their own, but shared their own vision of singular
domination over all they happened across.

The Corishtani formally announced their intentions when they seized control of the terminus
end of C2's primary WARP gate. This occurrence took place only *after* a diplomatic mission arrived
in Earth space to formalize what was billed as a mutually beneficial agreement. This would be the
first overt arrival of alien life to our corner of the universe.

In January of 2161, a small convoy of Corishtani frigates entered the Milky Way Galaxy's
outer perimeter, headed by a capital vessel and wide array of ship types previously unseen by
human eyes. If not for military sensor arrays placed in the region, the conflict would have likely
ended with a surprise attack in Sector Zero: Earth and Station-4 (the current hub of Conglomerate
efforts).

Upon detection, transport vessels were deployed to quickly stockpile smaller, forward
bases with 21st generation nuclear warheads (developed by The Conglomerate to expedite mining
operations) ahead of the approaching enemy. The "low-tech" nature of the weapons proved
something of a surprise to the Corishtani, who found their hulls breached by the raw kinetic force
and near star-like heat emanating from the core of the warhead detonations. The Conglomerate
had never before faced such a capable military force. It quickly became apparent the experience
was shared by the invaders.

The conflicts escalated and several of the system's planetary-based missile batteries were
destroyed. A vehicle specifically designed to repel an outworld assault was not to be found in the
hypercompany's inventory. The Conglomerate had come to a grim conclusion. They were facing
imminent collapse, and indeed, the very end of the human race. In a last ditch effort to save all they
had worked for, The Conglomerate set into motion a technological and production agenda unlike any
previously seen; far beyond in scope and breadth even those following the Cataclysms of Earth itself.

All Station and planetary assets were concentrated to a single end: survival of The Conglomerate.

It has since been estimated that with the full resources of The Conglomerate being utilized
in this manner, some three decades worth of military technological advances had taken place in
quantum computing, nano-machinery and advanced tactical operations against external systems
assault in just under 1.65 years. In the early days of the war, power conduits feeding the primary
gate were severed as a preventative measure against further incursion. The presence of the
"diplomatic" vessel was, it turned out, a cloaked "anchor" that allowed the Coristani to approximate
Earth's location to access by FTL travel mechanisms of their own. Once destroyed, the arrival
of new ships immediately ceased. Now cut off from their home systems, the existing Corishtani
engagements became more forceful as time wore on, despite tremendous advances in spaceborne
fighter craft and first-generation plasma and laser weapon sets deployed to stave them off. On the
ground, captured Conglomerate base assets were being turned against the waves of war fighters
assigned to take them back. These elite combat units, known as Enforcers (or Enforcer Corps),
suffered immeasurable casualties with each successful assault. The numbers were incrementally
worse when they failed.

Fortunes turned when The Conglomerate finished designing and put into emergency
production the USV Comminus class ships. As the first, truly robust space borne fighting and
delivery platform, Comminus bristled with weapons and defensive measures known to confound
Corishtani technology as well as stemming their reliance on an "overwhelming numbers" strategy.
A special operations division of the Enforcers had managed to navigate the gauntlet of Corishtani
forces and took a key factory of ship defensive armor on Jupiter's largest moon, Titan.

Located in a bunker-turned-hangar, the Enforcers stumbled upon an alien machine.
Scientists determined it was the Corishtani variant of the Kelheim/WARP technology. The design
was complex, but constructed of known elements. The power source, however, remained a mystery.
Enforcer volunteers prepared for what was widely accepted as a suicide mission. The machine
would be activated to send commandos to Corishtani space and attempt to infiltrate the strategic
hub of their operations.

Specialized USV Comminus ships were outfitted with additional propulsion and defensive
accoutrements not only to remain maneuverable in the upper atmosphere, but ensuring
the successful landing of ground forces when the war was taken into Corishtani space. Total
development cost to The Conglomerate remains, to this day, a zealously guarded secret. Academics
have hazarded periodic guesses, but with no way of knowing the extent of secret military operations
or subsequent planetary pacification expenses, even they admit the cost might best be estimated
"between improbable to impossible" credits.

Back in Earth space, Enforcer brigades reported increasing success reclaiming Conglomerate bases (and their weapons) as well as inflicting catastrophic losses against the Corishtani per asset lost. More importantly, Conglomerate Communications officers on board the "suicide mission" had broken the Corishtani military bands as well as the means to block them. They had also engineered a mechanism by which forged messages would be sent through the alien device to their homeworld. The lack of support for Corishtani forces and the full deployment of the Comminus platform successfully pressed the war back into Corishtani space within the second year of the war.

Much to The Conglomerate's delight, the Corishtani were not as sophisticated as once believed. Their technologies were roughly cannibalized assets seized as the Corishtani "scavengers" leapt from one system to the next, using sheer numbers to overwhelm smaller, less technically savvy worlds. The Conglomerate used the abysmal treatment by the Corishtani of enslaved species (savage even by Conglomerate standards) to encourage an underground alliance of systems to do what they could to support the much better focused, if enormously outnumbered, Conglomerate forces. Per the intelligence team's final transmission, the Corishtani did possess a massive, sophisticated, ground-based network on their homeworld. Through the careful financing of saboteurs within the Corishtani population itself (and its closest system allies), the network was softened enough to allow enough Comminus ships (and their Enforcer cargo) to reach the ground.

Once planetside, the Corishtani lacked the proper skills to meet The Conglomerate forces in trench warfare. Their adoption of a purely "outward" defensive posture suggested they never even considered that they might one day be invaded. This grave oversight would prove to be their undoing.

The Corishtani surrendered in December of 2166.

Using the near-extermination of the human species as a pretext, The Conglomerate quickly drafted and approved draconian measures to prevent the likelihood of even *perceived* enemies harboring such wild fantasies. As if to validate the threat, the Corishtani (even those who aided in The Conglomerate ultimately coming away the victor) were terminated wherever they were encountered. Their homeworld would be the first victim of an Omega Level Eradication, which called for the total destruction of all sentient life on the world. The resulting genocide of the Corishtani proved a popular action among the many races that fell under their rule for so long. Reeling from the fiscal turmoil the war had inflicted on The Conglomerate, its internal policy strategists were already hard at work to implement seemingly "finite" laws into a larger framework that would lead to their increased control of formerly Corishtani-owned space.

Business would quickly return to normal.

The governing policy of The Conglomerate when entering new space where sentient beings are detected is to do so with overwhelming force offering the native population the "choice" of joining The Conglomerate peacefully, or being subjugated by force, foregoing shares in "the one company."

CONGLOMERATE IDENTIFICATION NUMBER ASSIGNMENT (CID)

Introduction

A CID is the primary means of identification in Conglomerate society. The series of numbers is assigned based loosely on models prescribed by the Actuarial Congress of 2055. The project sought to fulfill the need for rapid identification in an exponentially rising population. The literal birth convention was abandoned in 2071, chiefly due to Mars Forward Transport Base (MFTB) and other in-transit births, which were difficult to confirm and, more importantly, led to difficulty calculating proper excise amounts. Cryogenic accommodations with robotic monitors were pushed into service to help slow further populous data integrity interruptions, as were additional safeguards in the Central Banking Ministry (CBM). The CBM was established as a transaction clearing house on Station-1 managing all Earth, Mars, Station and eventually, multi-galaxial commerce.

When The Conglomerate became the chief enabler of system life, the CBM created the CID which would encapsulate an individual's work type, guild association and relative value in Conglomerate shares. As a side note, the CID moniker was kept as a nod to the first institution which used the acronym (the "CYGNUS ID").

CIDs integrate Share Density Band (SDB) through the use of scientific notation standards (3-digits x Power of 10). This ensures an accurate measure of the citizen as well as maintaining format simplicity. The numbers are dynamic, and multi-system transaction framework update delays may occur with subspace interference of encrypted communications. Should one wonder why exponents are used in most CIDs, it bears remembering that The Conglomerate is a multi-system entity that incorporates hundreds of worlds and many sentient species who share in the company's long term vision.

Social prominence in Conglomerate Space is determined through share accumulation of Conglomerate stock.

Class C stocks, despite the "lower" letter designation, are considered the most valuable category of stock (sometimes called a "share density band" or SDB) with bylaw-derived voting and actionable rights many times those of other classes (A and B). Class C stocks are therefore held almost exclusively by **Board Members** and the **core Directorship**.

World leader signatories to the Charter may be gifted C stock for their cooperation in joining sustentative homeworlds and/or assets to The Conglomerate. World membership into Conglomerate management sometimes includes a Sovereign Shares Fund (SSF). This fund is dispersed to the local population as a way to ease the transformative nature of their new bond with The Conglomerate. Larger individual share concentrations increase one's standing in society and are directly indicative of their influence, or lack thereof, in system affairs. This status is reflected in the individual's Conglomerate ID (CID) enumeration immediately following the name. (Please see separate CID assignment document.)

The following summaries offer a broad explanation of share density bands (SDB) to assist Conglomerate citizenry in knowing their relative position and rights granted to the prescribed institution.

How to read a CID

There are several base formats of a CID. They are:

- TYPE I: "1-3-3" or "1-4-5" Enumeration Pattern
 - CMS designation
 - Format: 1 - (3 digits) – (3 digits) or 1 – (4 digits) – (5 digits)
 - Example: 1-234-567 or 1-2345-67890

- TYPE II: "3-4-4" Enumeration Pattern
 - Diplomatic/Primary Tower Directorship designation
 - Format: (3-digits)- (4 digits) – (4 digits)
 - Example: 123-4567-8901

- TYPE III: "4-4-4" Enumeration Pattern
 - Common designation
 - Format: (4 digits) – (4 digits) – (4 digits)
 - Example: 1234-5678-9012

- TYPE IV: "Menial "#-4-4" Enumeration Pattern (Where # = "Menial Level" 1 thru 4)
 - Format: 1111- (4 digits)- (4 digits):
 - Example: 1111-2345-6789

- TYPE E: Considered hybrid Type II with a "3-4-4" Enumeration Pattern
 - Conglomerate Military Services Bureau (CMSB) Enforcer-only use
 - Format: (3 digits) – (4 digits) – (4 digits)
 - Example: 123-4567-8901

Detailed examples can be found on the following page...

TYPE I.

The "1-" prefix is a format reserved for Conglomerate Majority Shareholders (CMS), also called "Level One" or "First" shareholders. The second series of three numbers should be thought of as having a decimal between the first and second of the series. (example: 234 = 2.34). The three digit suffix is a power of 10 (scientific notation). The whole of this number represents the number of C Class (exclusively) shares held by the individual. This enumeration is used for the uppermost tier of Conglomerate shareholders, including the Chairman and their immediate subordinates.

> Extended Example: 1-423-026 ("1-3-3" Enumeration Pattern)
> 1 = CMS/Director/Board Member
> 423-026 = 4.23×10^{26} shares of Class C stock

A second example: Conglomerate Director might have a share holdings designation: 1-100-012, or; 1.00×10^{12} shares of undiluted Class C stock

** Top tier CMS members all have a minimum double-digit "power of 10" block of C Class stock.

Executive CMS designations have a secondary classification where a mixture of C and B stock classes are held. These are described in the "1-2345-67890" (or "1-4-5") format. C Class stocks are described in powers equal to or greater than 5.

> Extended Example: 1-5676-26224 ("1-4-5")
> 1 = CMS/Director/Board Member
> 5676 = 5.67×10^6 Class C shares (* Note: Power of 10 is greater than 5)
> 26224 = 2.62×10^{24} Class B shares

TYPE II.

The three digit prefix indicates the position and industry where the person is stationed. A general break can be thought of as 100 to 199 in "leadership positions" and 200 to 299 in "council positions." A special block is also assigned from 300 to 350 for various ranks of the CMSB officers. Occupations of all kinds are assigned higher resolution classification digits accordingly. The prefix determines if the following eight numbers refer to C/B mix of stocks or a B/A mixture. C Class stock does not exceed a factor of more than 4 in Type II CIDs. Type II CID assignees are sometimes called "Level Two" or "Second" shareholders.

> Extended Example A: 113-2283-6105 ("3-4-4" Enumeration Pattern)
> 113 = Conglomerate Energy Systems (thus classifying the next eight numbers as C/B shares)
> 2283 = 2.28×10^3 Class C shares (* Note: Power of 10 is smaller than 5)
> 6105 = 6.10×10^5 Class B shares

> Extended Example B: 248-6059-9312
> 248 = Municipal Agricultural Consulate (thus classifying the next eight numbers as B/A shares)
> 6059 = 6.05×10^9 Class B shares
> 9312 = 9.31×10^2 Class A shares

TYPE III.

The first four prefix digits can be thought of as a two-digit profession denominator immediately followed by a two-digit guild association code. The following 8 digits are always Class B and Class A share indicators. The majority of Conglomerate citizens will bear a Type III CID. Due to the commonality of this CID, there are no references of stock "Levels" associated with it. They are simply referred to as "shareholders" in most official documentation.

> Extended Example: 4215-0325-2169
> 42 = Pilot (commercial), 15 = Aeronauts (Pilots & Fighter Craft Aviators Guild)
> 0325 = 325 Class B shares
> 2169 = 2169 Class A shares

* Power of 10 exponents can be integrated into the CID code if hyper-saturation of A or B Class stocks reach appropriate density.

TYPE IV.

The quadruple 1 ("1111") designation is reserved for the Menial class exclusively. As Menials are unable to join guilds nor possess Conglomerate shares, there is no need to define vocation nor associations therein. Some measure of confusion might occur as the lowest Menial (Menial Class 4) bears the "1111" prefix, and the uppermost Menial (Menial Class 1) is "4444". Similarly, Apprentices are prefixed "3333" and Provisionals are "2222". Ensuing digits represent literal credit holdings.

> Extended Example: 2222-5210-2401 ("4-4-4" Enumeration Pattern)
> 2222 = Provisional (able to support 3+ other Menials)
> 5210-2401 = Total net worth 521,024.01 Credits

TYPE E. (also called "Type II.5" or "Type II. Hybrid")

Enforcers, by virtue of their role in the success of The Conglomerate, enjoy certain advantages by answering the call to service. Members of the Enforcer Corps bear Type II ("3-4-4") or a unique, Type E ("3-4-4") designation until share density warrants escalation to Type II. Enforcer Type II CIDs are held to a B/A mix of shares. Officers of higher rank (General/Admiral or above, usually prefixed with 195 or 196) are understood to be C/B stocks, and are the exception rather than the rule.

Type E is a temporary assignment where a prefix identifier (340 for new enlistees) supplants the four digit Menial prefix, but no shares have yet been earned. The ensuing numbers remain their individual credit count until their service warrants payment in Conglomerate A shares. Credits have no value except in the Lower Levels amongst the Menial population and some distant outposts.

> Extended Example: 340-6983-6493
> 340 = Enforcer (enlisted/cadet)
> 6983-6493 = Total net worth 698,364.93 Credits

CONGLOMERATE SOCIAL ORDER SUMMARY

SUMMARY:

For a proper introduction to the Conglomerate social order, please refer to the Conglomerate ID (CID) document. A brief overview of some primary social strata are described in the following:

MENIALS:

The base common class citizenry , Menials comprise the foundational layer of Conglomerate society.

Today, the term Menial is used to categorize anyone, citizen or not, lacking any substantive Conglomerate shares. Most possess so-called "Class D" shares which only carry their face value in credits and are used accordingly. Menials have created a sub-caste system among themselves, from First Class to Fourth Class (lowest tier, often lacking even a single certificate). Most exist to simply exist. It should be noted that D stocks do not rise in value nor are they beneficiaries to periodic share buybacks. They are simply an alternative currency used by Menials for their day to day transactions. Conversion of any other type of share to D stock is strictly prohibited and any attempt to do so is investigated aggressively to prevent black market formation.

Menial CIDs are, therefore, not reflective of Share Density Band (SDB). Instead, the quadruple digit prefixes (1111, 2222, 3333 and 4444) are used to identify a Menial's class and their total credit worth. The number of actual credit fluctuations rarely changes even amongst the legions of Menials known to inhabit Conglomerate space. It is suspected that D stocks, undeposited ("wild") credits and/or rogue currencies may be in circulation. The Conglomerate monetary grid is a closed system and is responsible for assigning and monitoring any CID changes. It is therefore impossible for CID promotions to occur by way of illegal currencies without being flagged.

MENIAL CLASS 4:

Lowest category of Menial. Comprise the bulk of sub-robotic labor force.

MENIAL CLASS 3: Nucleite

Menial capable of supporting 3+ other Menials. The term Nucleite was selected as a dual descriptor combining the "nuclear family" of Menials, and that working with "hot" (radioactive) devices of some sort is the first level of employment that provides the means to do so.

MENIAL CLASS 2: Apprentice

Menial who has won the attention of a Servician (Menial Class 1) and is being taught a trade under their mentor.

MENIAL CLASS 1: Servician

Menial with a marketable skill or skills for which others are willing to pay. These include basic sanitization, repair and medical services. It is largely due to the Servician class that the Menial population is a self-sustaining entity that does not divert Conglomerate social resources.

ROBOTS / ROBOTIC ASSISTANTS:

Robots and robotic assistants were originally brought into service to streamline and improve the consistency of labor-intensive manufacturing sectors. Advanced models were tasked with providing supportive functions to high level executives who could afford them. As the Conglomerate economic engine spread offworld, the need for trustworthy administrative personnel to oversee system perimeter activities became increasingly critical. Outer-rim caches of industry were simply too distant for those on Station-1 to control directly. AI had improved dramatically in recent decades, and so the AI-3 Directive was passed.

AI-3 is the minimal level of AI necessary for sound decision making based on Conglomerate guiding principles. The AI-3Directive placed this class of android above all Menial classes, effectively stripping humans of most managerial and day-to-day administrative tasks.

The Conglomerate views the AI-3 Directive as the lynchpin to its incredible growth in the handful of centuries since its founding.

CLASS I: Repetitive Automaton (RAUT)

Simple robotics used for repetitive tasks, typically in the manufacturing sectors.

CLASS II: Human Controlled Robotic Servant (HUROB)

Specialized android assistants programmed for specific tasks and directed by human controller.

CLASS III: (CAT-3, "CATegory 3")

AI-3 enabled evaluation engine robot capable of executing complex administrative tasks.

CLASS IV: Quantum-Intelligence Self-Realized Robot (QISRR; Phonetically Known As "Kaiser")

Human-approximate decision engine hard coded with Conglomerate guiding principles. First class of service androids recognized as full crew member.

CLASS VI: "Ikasu"

Advanced variant of the QISRR with sophisticated algorithms specifically developed for situational flexibility offered by human processes without the danger of electronic emotional volatility of previous human emulation models. Class VI Ikasu designate: Potter, is among the first production certified models placed in astroservices as a ranked officer/pilot.

SOCIAL CONTINUITY & ORDER (SOCOOR):

The division of Social Continuity and Order comprise the majority of administrative functions in everyday Conglomerate "city" life. From the issuance of marriage (**Office of Marital Affairs**), shuttlecraft (**Office of Aerotrans Licensing**) and sex permits (**Office of Sanctioned Reproduction**) to sustenance management (**Office of Nutritional Commodities**), waste disposal (**Office of Resource Reclamation**) and water production (**Office of Hydrovitae**), amongst countless others, these are the individuals who make the Conglomerate able to operate as a single entity. Every major Conglomerate city, colony or outpost has a base installation of SOCOOR to ensure a consistent experience regardless of one's physical location in Conglomerate space.

SECURITY POLICE:

Conglomerate Security Police are the necessary instrument of organic citizenry who have proven themselves worthy of basic legal enforcement over their social equals. Most Security Police personnel are Enforcer Academy dropouts, usually for lack of mental discipline rather than physical ability. The

Conglomerate views their use as a means to recoup expenditures made for basic boot camp. Membership into the Security Police is the lowest occupational level allowed to eventually purchase and acquire non-D Conglomerate stock. (Many of the Security Police are dropouts from the Enforcer Corps, which is viewed as the true primary stepping stone to Conglomerate share ownership.)

The most disciplined ranks of the Security Police are sometimes granted responsibilities within corporate structures. These much sought after posts are known as Eagle Watch security detail. Eagle Watch includes director office security as well as personal protection duties.

PATROLMAN (or "Streetwalker," as recruits are often labeled)
Boot camp graduates put on active duty. Sometimes called "streetwalkers" by superiors.

DETECTIVE (or "Investigator")
Personnel authorized to conduct preventative incarcerations and case pursuits beyond simple/immediate citation duties. Class A stock acquisition and superb conduct are mandatory to achieve Detective status.

CONSTABLE
Director of affairs for micro-sector municipality. District "top cop."

CHIEF
Regional administrative officer, typically supervising 10-30 districts, depending on population.

COMMISSIONER
Top human authority within Security Police overseeing 15-25 regions.

AGENT
Primary Conglomerate oversight personnel of Security Police forces charged with internal affairs/anti-corruption efforts. While human Agents are known to exist, most are CAT-3 or QISSR robotic entities randomly assigned by regional judiciary centers or transferred as needed on a case-by-case basis.

MEDIA & INFORMATION ENGINEERS:

The information and marketing (media) units of Conglomerate society are considered among the most valuable of the non-CMS populations. The direct correlation of their efforts and the value of products (and thus, overall valuation of Conglomerate shares) is undeniable and their celebrity is well deserved. Several subsectors exist in this group including:

REPORTERS
On-site resource and chief information gathering unit (human and mechanized sources can both be referred to as reporters).

NEWSMEN
Sometimes called Information Direction Officers for their guidance of Reporters in the field.

EDITORS
Primary filtering agents of raw data as collected from Newsmen.

HEADLINERS
Public face of media operations to Conglomerate society, reviewed and trained internally by the Media Consumption Bureau based on physical attractiveness and on-camera believability.

ENTERTAINERS:

Entertainers are often tapped by their Media & Information Engineer associates in order to endorse an array of products. Celebrity is among the most socially lucrative currencies available and is rewarded in kind though Conglomerate shares. Among the many subtypes of Entertainers are: **Players** (athletes), **Sonicians** (singers), **Thespians** (actors) and **Vendibles**. Vendibles are a separate class of the Entertainers who exhibit unusually positive commercial valuation. They are typically multi-disciplined individuals.

ARTISTS:

The arts continue to thrive, even in the hyper-technical worlds in which we now live. Organic creations (and beyond) that "touch the soul" are sought by many Conglomerate citizens, and their efforts are rewarded accordingly. Subclasses of the Artists include, but are not limited to; **Painters**, **Sculptors**, **Proseans** (writers), **Performans** (live performers) and **Manipulationists**. The Manipulationist Movement harkens back to nanotech's infancy when material handling (and indeed, the materials themselves) were fabricated through direct, artificial atomic rearrangement.

ENFORCERS:

The Enforcer Corps is the premiere military organization of the Conglomerate. Highly trained and armed with the most advanced equipment from Conglomerate R&D, Enforcers are charged with a number of functions. Of these, three are key to Conglomerate expansion: system peacekeeping, hostile suppression and First Contact missions. Despite deep penetration by robots and androids in every facet of life, the Enforcer Corps have remained remarkably "organic." Cybernetic enhancements are typical, but ultimate control is maintained by the human imbued with such upgrade "kits."

It should be noted that only humans are tapped for Enforcer service, though other species diplomats and even the occasional QISSR have been known to take temporary command of an Enforcer brigade. This is a demonstration of Conglomerate faith in its fighting force.

ENFORCER CLASS 1: Cadet
New recruits must undergo rigorous mental and physical tests before being accepted into the program. Should the individual succeed, they are made Class 1 Enforcers.

ENFORCER CLASS 2: Combat Engineer
The Class 2 Enforcer is one who has seen field combat for at least three (3) of at least five (5) years of service. They are seasoned combat veterans with firsthand experience on the front lines.

ENFORCER CLASS 3: Officer
Class 3 Enforcers are those selected based on demonstrable leadership and decision making capabilities under fire. They are considered the best among Class 2 candidates and are sent to strategic and tactical augmentation instruction. Candidates who successfully complete this training return as commissioned officers and are installed into leadership and planning positions.

ENFORCER CLASS 4: Divisional Commander
The Class 4 Enforcer is the first level of multi-brigade command. Enforcers who have attained this rank are involved in strategic planning as well as tactical execution.

ENFORCER CLASS 5: Special Operations

Class 5 operatives are a special division of the Enforcer corps developed for clandestine objectives. Missions are designated from the CMS Directorate (or higher) and typically managed by a committee level chairman who reports to the Board. Class 5 Enforcers are the elite among the elite and are known to utilize yet-undisclosed technologies (both offensive and defensive) with far reaching intelligence network access that they may successfully complete their missions. The selection process for Special Operations remains classified, known only to the Paramilitary Committee (sometimes called Paramilitary Command; PARACOM) responsible for their coordination.

OVERSEER:

PARACOM-assigned special liaison between Conglomerate leadership and the Enforcer hierarchy. Generally filled by a diplomatic entity or temporary military promotion on a case-by-case basis.

MEDICALS:

For all the wealth of Conglomerate citizens, the imperative for wealth and those who possess it is to live and spend it. As such, the Medicals are a prized component of society. The poet Icthacerium may have put it best when he said, *"Time is money and life is time. Tell me how, then, one does not celebrate the Medicals and their miracles!"*

MEDICAL ASSISTANT:

General practitioner servicing the medical needs of Conglomerate society.

FIELD MEDIC:

Enforcer Medic, typically deployed to regions of conflict.

FIELD DOCTOR/SURGEON:

Enforcer advanced, massive-trauma specialist, also mission deployed.

ENFORCER MAINTENANCE TECHNICIAN:

Field Doctor/Surgeons who have had amplified training in cyborganics installation and repair.

PRIVATE PRACTICE MEDIC:

Typically a highly trained, experienced Medic who has taken on a handful of upper tier clients on a private practice basis. All medical credentialing and records remain a part of the Conglomerate Medical Bureau's master database, however, that the health of the citizenry can be maintained.

BIOSPECIOLOGIST (BIOSPEC):

Variable degreed specialty based on knowledge of multi-species anatomy and treatment, typically assigned to diplomatic missions.

BIOSPECIOLOGIST- TACTICAL (BIO-TAC):

Special category Enforcer-assigned medical expert for First Encounter data provisioning of species attributes and countermeasure development.

TECHNICIANS:

The innovative heart of cutting-edge Conglomerate science, Technicians can be found in all SDBs. Generally split into three distinct branches (Inorganic, Organic and Cyborganic), each carries out a necessary role in the Conglomerate's ongoing growth.

INORGANIC ENGINEERING:

In lighter SDBs, they can be **Robotic Repairmen** of varying skill levels. Advanced Technicians range from **Space Asset Maintenance** to **Station Masters** and **Artificial Intelligence Advancements**. Coding experts are also loosely categorized into this group. **Tactical War Mechanics Development** and the **Advanced Propulsion Consortium** are two of the highest funded brackets of Conglomerate R&D for obvious reasons, but are also under the most pressure to show concrete results to justify their continued financing. Chief among this Consortium is the study of **Manipulative Physics** and **Nanotech Specialization**, each pouring their discoveries into **Materials Creation Sciences**. **Applied Theoretical Engineering** (ATEN) is the all-encompassing think tank of the various disciplines of the Inorganic Engineering SDB.

ORGANIC ENGINEERING:

Human and **Multi-Species Specializations** range from LEX research to seeking information useful to the BIO-TACs deployed to the front lines. Theoretical and radical treatment venues are investigated at length within this technical division, the discoveries of which can find their way to the Medicals. Organic Technicians are often involved in First Contact missions analyzing not only the target sentients of the world, but the world dynamics and composition itself. The sub-divisions of the Organic Technicians are as diverse as there are lifeforms in the known universe. The duty of cataloging alien lifeforms falls under the direction of the Species Categorization Group.

CYBORGANIC ENGINEERING:

Those who have achieved a deep knowledge of both inorganic and organic disciplines can be invited by system wide **Achievement Monitors** to join the elite of this SDB: the **Cyborganics Analytical Group** (CYAN Group, or simply "CYAN"). While varying levels of cybernetic systems knowledge can be found in all SDBs, the CYAN Group is tasked with the delicate work of bringing formerly theoretical or "best case scenario" organometallic and subparticle flesh-to-composite (F2C) discoveries to reality. CYAN Group is responsible for most humans no longer being 100% organic even at birth. For example, medical nanites proactively eliminating disease elements can remain in the infant for several months following their departure from the womb. They are generally looked upon as the future designers, literally mapping humankind's next series of evolutions directly.

DIPLOMATI:

Diplomatic corps in Conglomerate society, both human and other species. Positions vary by sphere of responsibility and constitute the core legislative arm of the Conglomerate. Key positions include:

MESSENGER

Unofficial diplomatic contact through any viable channels, employed where political volatility of an open relationship with the Conglomerate remains unpredictable.

LIAISON

Official Conglomerate representative to *non*-incorporated Conglomerate world governments or other "parties of interest." The two main types of liaisons are civilian and military.

REGULATOR

Conglomerate assignee with *official duties within non-incorporated governments*. Generally utilized during transition into Conglomerate oversight and integration efforts of system law.

ADMINISTRATOR

Chief officer on-world upon incorporation. Embassy chief of staff position.

REPRESENTATIVE

Off-world agents of the Conglomerate granted diplomatic privileges through any embassy throughout occupied space.

OFFICIAL

Direct Conglomerate agent installed into native governments (by treaty or other negotiated settlement). Oftentimes becomes the main conduit in all Conglomerate dealings on behalf of the world in question. Considered an extra-embassy entity despite Conglomerate citizenship status.

AMBASSADOR

CMS appointed official, frequently used as a reward for non-CMS political services rendered. Largely ceremonial, but when necessary, carries the full weight and import of the Conglomerate government.

MERCHANTS:

If the Technicians are the neural net of the Conglomerate conscience, the Merchants are its blood vessels, shuttling and shunting the financial lifeblood that makes the Conglomerate's existence possible. Reaching out to the outermost regions of Conglomerate space, they channel the resources and credits back to the Station-5 and its unified control. The individuals allowed to partake of this activity are allowed to amass an affluence few could dream was even possible. Not surprisingly, the bulk of merchants are former Conglomerate directors (or higher) who have the personal resources to fund such ventures independently, but with the Conglomerate's blessing. All Merchants are carefully screened and monitored in their actions to avoid potential rival micro-economies from springing to life. They enjoy all the perks of their wealth, but are constrained in their political influence of governing law. This is the Conglomerate's loosely imitated version of a wealth "separation of powers."

CONGLOMERATE MAJOR SHAREHOLDERS (CMS):

The highest tier SDB is the Conglomerate Major Shareholder (CMS). They can be easily identified by the "1-" prefix of their CID. CMS are the executives of the major Conglomerate profit arteries. To the masses of Conglomerate-run space, the CMS hierarchy represents the "nobility" which oversees all aspects of life. Membership is typically related in some way to the: **Conglomerate Ministry of Finance** (CMOF), **Conglomerate Communications Corporation** (COMCOR), **Conglomerate Energy Department** (CEND).

GLOSSARY

A

A'raf: Erebos' stronghold. Greek for *partition*, referencing a wall between Hell and Paradise where its inhabitants escaped Hell, but whose acts in life keep them captive.

Advance Planetary Negotiations Committee (APNC): Group of high-level Conglomerate personnel who seek to change The Conglomerate's profit-first culture in exchange for mutually respectful resource negotiations that retain the native species' core rights as sentient beings. Currently in trial phase as an official committee candidate within The Conglomerate.

Advanced Kinetic Incidence Enforcement (A.K.I.E. Company): Spin-off entity of Stillwater Weaponsmithy providing community-level services.

Agent: Security Police: Internal investigations/anti-corruption division. Typically CAT-3 or QISSR robot, but post is sometimes filled by a human.

AI Act of 2456: [See *Artificial Intelligence 2456 Directive*]

AI-2456 Directive: [See *Artificial Intelligence 2456 Directive*]

AI-3 Directive: [See *Artificial Intelligence 3 Directive*]

AKIE: [See *Advanced Kinetic Incidence Enforcement Company*]

ALICE: [See *Artificial LIfeform Cloned Entity*]

Alien Threat Assessment Chart (ATAC): Enforcer mandatory competence handbook of basic alien lifeform types known to The Conglomerate. Sometimes called "Compendium" rather than "Chart" (whose name was retained as a historic nod to the original format.

Alliance Environmental Study Vessel (AESV): Class of Alliance vessels used to transport laboratory, sensory and analysis equipment and personnel to survey planetary habitability for colonization.

Alliance, the: [See *Democratic Alliance of Planets*]

Alpha Priority: Prioritization of a mission viewed as essential to Conglomerate survival and expansion.

Amnatshi: Cuttlefish-like creature from which the tattoo ink used by The People is drawn.

Antriax: Legendary blind warrior of The People said to fight solely with senses honed through the pursuit of The One to replace his sight.

A.O.: [See *Artificial Organism*] After Antriax in alphabetical order?

Aodh: Daughter of Caderyn. First Blade of the Red Clan. Celtic for *fire*. [See *Tonni's Journal*]

APNC: [See *Advance Planetary Negotiations Committee*]

Apprentice: Menial (Class 2) under the mentorship of a Servician (Menial Class 1).

Artificial Intelligence 3 Directive: Implemented in the early 22nd century (October 10, 2127) put, for the first time, robotic entities in positions overseeing human subordinates. AI units carry a mandatory Class 3 level intelligence in order to fulfill such duties. Class 3, CAT-3 and AI-3 are used interchangeably today.

Artificial Intelligence 2456 Directive: Also called the "AI Act of 2456" or "AI-2456 Directive," the policy gave artificial lifeforms of adequate ranking full crew/officer status.

Artificial Lifeform Cloned Entity (ALICE): First and only known human A.O. entity.

Artificial Organism (A.O.): Differentiation from A.I. (Artificial Intelligence) is the goal of organically replicating a self-proficient entity "cybernetic construct." The A.O. seeks to replicate nature rather than enhance it. (First known human A.O. was known as "ALICE," and a replicant of the then CYGNUS CEO's daughter. Her dissolution resulted in a general ban on human A.O. experiments.) Artificial Intelligence (A.I.) focuses on the "thinking computer."

ATAC: [See *Alien Threat Assessment Chart*]

Audrium: Ore mined in G2 world designate 110872-K ("Kamorahs"). Strongest naturally occurring material known. Extremely resilient to artificial shaping, with a molecular structure so complex even nano-forging processes require great lengths of time to manipulate it without compromising its properties. Recently rendered "shapeable," albeit at great expense.

Aurora Type: "Typical" space station designation encompassing life support, self-sustenance and artificial environments for long-term (multi-year) residence.

B

BADSYS: [See *Biomechanically Assisted Drive SYStem*]

Bal'ka: Maj of the Moncs. [See *Tonni's Journal*]

Battle Lord: Title bequeathed to the most capable of The People who have passed the test administered by Dagda. Responsible for the battle-readiness of the Clans as a whole.

Battle Screen: Secretive PARACOM full-body "enhanced Enforcer" program.

BCL: [See *Blood Credit List*]

Bethenia: Location of Alliance of Democratic Planets, UIS headquarters.

BIOGRM: [See *BIOlogical GRowth Materials*]

Biological Growth Materials (BIOGRM): The resulting materials fabricated by organisms rather than through man-made means. The single-piece compartments of some CSSTATs and CSVs are the direct result of this technology. Nanotechnology has largely displaced BIOGRM, but the technique is still in use for colonization missions where artificial power sources may be detrimental to the resources sought. Viral battery fabrication is a primary extension of BIOGRM (using native viruses), which allows power units to be made without the use of dangerous chemicals.

Biomechanically Assisted Drive System (BADSYS): Phonetically referred to as the "Bad Sis" among Enforcer ranks, the system is an integrated feedback and assistance mechanism which provides the wearer with an "enhanced" physical presence. FORCE armors and heavy construction suits each use variants of the BADSYS. In both cases, the technology seeks to marry augmented power applications to the finely tuned human nervous system.

BIOSPEC: [See *BIOSPECiologist*]

Biospeciologist (BIOSPEC): Organic medical specialist of various alien races.

Biospeciologist-Tactical or Biospeciologist: Tactical (BIO-TAC): Biospeciologist of target alien races with an organic weaponization focus.

BIOSYN: [See *BIO-Synthetic lifeform* or *SYN*]

Bio-Synthetic lifeform (BIOSYN): Artificial (laboratory directed) lifeform. The practice of creating human BIOSYNs was outlawed following the Tholeen Incident.

BIO-TAC: [See *BIOspeciologist-TACtical*]

Black Procurement Channels: Intra-governmental transactions of publicly funded innovations to the private sector bypassing all civilian accounting mechanisms.

Blank Slate: Codename for secret BIOSYN laboratory bearing callsign "Tholeen." Project for human cloning of Enforcers using Corishtani technology gone terribly awry. Practice since banned. [See *Tholeen Incident*]

Bloksus: Staunch sentient and, kilo-for-kilo, the strongest on Anomaly, valued for their prodigious lifting ability. [See *Tonni's Journal*]

Blood Credit List (BCL): Conglomerate's official "Most Wanted" list. Apprehension or termination of the bounty is exchanged for payment. Bounty hunters value the BCL's high-pay, no-questions-asked policy.

Bottle Rocket Nuke (BRN): Colloquial Enforcer reference to grenade-sized neutron ordinance.

BPC: [See *Black Procurement Channels*]

Breeds: Humanoid form on Anomaly. Very little is known about this group. [See *Tonni's Journal*]

BRN: Bottle Rocket Nuke

Bug Bullet: 8.32mm magnetically launched incendiary shell (MLIS) developed and first used against the Cliks on Sestus Prime.

Bugarrhea: Slang (military). First used in the Sestus Prime engagement as a reference to the endless flow of Cliks "…spewing from every cave and goddamn orifice of this ass of a planet…"

Bureau of Intergalactic Affairs: Regarded as the political arm of the Alliance. Their Diplomatic Corps were seen as the antithesis of thought and action to the UIS (United Intelligence Services) [as were the State Department and Pentagon of the former United States of America]; theoretically on the same side, but with vastly different views as to what solutions would be effective against common problems. [See *Diplomatic Corps* and *UIS*]

C

Cadaver Coat: [See *Vital STATistic Suit*]

Caderyn: Battle Leader of The People from the Red Clan. Celtic for *battle king*. [See *Tonni's Journal*]

Cadmael: Brother of Caderyn, leader of the Green Clan. Celtic for *war chieftain*.

Captain Nova: Popular holovid series featuring a swashbuckling adventurer and his unlikely crew.

CAT-3: Class 3 (AI-3 systems-enabled) androids. First level of "thinking" machines.

Cataclysms, the (2089): Several tipping points reached, setting off a global cascade of massive natural disasters.

Catastrophic Cellular Incoherence (CCI): The inability of an Artificial Organism to reliably regenerate cellular structures, resulting in death. Does not occur in nature and is the only known "tell" of an AO from its biological original.

CBM: [See *Central Banking Ministry*]

CCCR: [See *Conglomerate Cosmos Catalogue & Research*]

CCF: [See *Civilian Control Firearm*]

CCI: [See *Catastrophic Cellular Incoherence*]

CDS: [See *Continuity Disruption Sphere*]

CEND: [See Conglomerate ENergy DEpartment]

Central Banking Ministry (CBM): Division of core financial operations of Conglomerate government. Administered by the Conglomerate Ministry of Finance (CMOF), which is the top fiscal body in Conglomerate space.

Century Genomic Nuclear Systems (CYGNUS): Until The Conglomerate, the single most successful corporate entity in human history, specializing in nuclear medicine and life-extension sciences (LEX).

CEPC: [See *Conglomerate Energy Permanence Committee*]

Chairman, the: The largest shareholder of The Conglomerate with nearly dictatorial powers in all matters over Conglomerate-controlled space.

Charter, the: [See *Conglomerate Primary Charter of Space Exploration and Systems Governance*]

Chief: Security Police: Regional administrative officer.

CID: [See *Conglomerate ID*; also used in reference to the *CYGNUS ID*]

Civilian Control Firearm (CCF): Non-Enforcer category use firearms employed by civilian jurisdictional law departments.

Clan: Sub-societal grouping within The People.

Cliks: Native species of Sestus Prime. Extinct by Omega Level Eradication protocol. [See ATAC]

CMOF: [See *Conglomerate Ministry of Finance*]

CMSB: [See *Conglomerate Military Service Bureau*]

COAX: [See *Correctional Operand Analysis eXplorer*]

Cold PJs: [See *Vital STATistic Suit*]

Column of Challenges: Massive tree trunk to which combatants are bound in a ceremonial fight to the death. Combatants include the Battle Leader of The People and the one issuing the challenge to their authority.

Combat Troop Transport Ship (CTTS). Class of Alliance vessels used to transport troops and matériel assets to frontline positions.

COMCOR: [See *Conglomerate COMmunications CORporation*]

Command Medal of Valor: Awarded by CMSB for "services of exceptional valor to the CMSB and the people under its guardianship." Recipients are often immortalized as heroes of war.

Commissioner: Security Police: top administrative officer, assigned 15-25 regions.

Conglomerate, the: System overseer based on the simple, universal pursuit of profit and system unification. The Conglomerate is the evolutionary result of Old Earth's industrial revolution (19th century) applied to the multi-world, multi-species reality of today. The formation of The Conglomerate is credited with the single longest period of peace ever recorded. Despite this remarkable feat, there remain pockets of malcontents who question whether such peace was worth the high price paid through the loss of individual freedoms.

The Conglomerate is the single, unified authority for all aspects of system life, responsible for its governance, defense, expansion and profitability. At the core of this entity are the flagship enterprises from which The Conglomerate's influence spiders outward to the furthest reaches of controlled space. These foundational hubs are: Conglomerate Communications Corporation (COMCOR), Conglomerate Energy Department (CEND), Conglomerate Ministry of Finance (CMOF) and the increasingly influential Conglomerate Military Service Bureau (CMSB), which is responsible for overall system stability as well as acquisition. Each "hub" is a collective of mega-corporations specializing in a particular, operational sphere of influence but acting in accordance with their umbrella cooperative.

With the exception of the CMSB, the Board of Directors of The Conglomerate proper is elected from the CEO pool of these respective companies.

The Chairman of The Conglomerate therefore possesses, by any definition, near dictatorial powers over all of explored space through the tightly centralized nature of the bureaucracy and wealth management procedures.

Conglomerate Communications Corporation (COMCOR): Often referred to as "Conglomerate Communications." Top Conglomerate administrative body responsible for all interspatial and intergalaxial communications technology development, implementation and governance.

Conglomerate Cosmos Catalogue & Research (CCCR): Academically accessible information deemed not to be a security risk, typically drawn from the E/C R&D raw data.

Conglomerate Energy Department (CEND): Often referred to as "Conglomerate Energy." Top administrative body overseeing all energy resource management and policy execution across incorporated space.

Conglomerate Energy Permanence Committee (CEPC): Directorial level committee of Conglomerate Energy overseeing technological reviews and, based on such findings, recommending policies that can be exploited to increase efficiencies in current technologies or reclaim otherwise "wasted" energy (or byproducts) for further use.

Conglomerate Founding Charter of Space Exploration and Systems Governance ("The Charter" or "Charter"): Codified mandate by The Conglomerate to justify its constant, unceasing push to expand its physical borders in the name of "self-sufficiency, unity and safety for all under its rule." All worlds under the Charter or entered under The Conglomerate's administrative hand are subject to these rules and regulations.

Conglomerate Historical Preservation Collection: Old Earth monuments relocated to CSSTs in order to prevent their destruction on the surface.

Conglomerate ID (CID): Official Conglomerate citizen enumeration. [See separate CID explanation document]

Conglomerate Military Service Bureau (CMSB): Office charged with Enforcer Corps readiness, deployment and overall system stability.

Conglomerate Ministry of Finance (CMOF): Often referred to as "Conglomerate Finance." Top administrative body with oversight of all financial transactions. Its primary enforcement is executed through the Central Banking Ministry (CBM).

Conglomerate Space Station (CSSTAT): Massive, orbital platforms of centralized Conglomerate control and governance throughout known space.

Conglomerate Space Vehicle (CSV): Universal acronym for all space borne vehicles manufactured for CMSB purposes.

Conglomerate War Archive: Archaeological wing of the CMSB and maintained by the War College.

Conglomerate War College: Early Conglomerate training facilities on Stations and worlds responsible for the recruitment and training of Enforcer officers. While many such "War Colleges" exist, the term generally refers to the central academic ministry located at the perimeter of KGS-1.

Conservatorium, the: Located on CSSTAT-4, the Conservatorium is the single largest botanical preserve of its kind, containing all known plant life from the Earth, many species of which have since become extinct in the wild. While many are fully matured samples, the vast majority remain in suspended (unmodified), seed form.

Constable: Security Police: district lead.

Continuity Camps: Conglomerate resource clusters offering food, shelter and protection during the Cataclysms.

Continuity Distortion Sphere (CDS): Corishtani munitions type with the ability to create controlled, momentary points of dimensional instability resulting in massive physical damage. The design was reverse engineered and originally utilized in World Zeroing missions.

Controlled Burn: Term used in the early 21st century for involuntary population reduction, including stealth birth control and sterilizations (through food/medications/vaccinations) and wars fabricated for this explicit purpose.

Cooperative, the: Pre-Conglomerate corporate unification entity established in 2025.

Corishtani Conflict (2161-2166): First Conglomerate experience with an opposition force of greater capability than its own. Eventual victory over Corishtani yields a wealth of previously unknown technologies. [See FTL and Corishtani Conflict document]

Corona Type: Designation for automated (or manned) monitoring orbital space asset(s), as early warning outposts.

Correctional Operand Analysis Explorer (COAX): Sensor laden, forward drones sent in prior to any major shipment entering a Kelheim Gate to ensure maximum cargo survivability. Small, naturally occurring deviations in f_g are returned to the KGS and the updated algorithms uploaded into Gate and ship navigation computers. Also used in pioneer missions in the creation of new Gates.

Counsel, the: Governing body of the Alliance.

CQC: Close Quarters Combat.

Crimson Ark: Reference to main geodesic dome of MFTB.

CSSTAT: [See *Conglomerate Space STATion*]

CSSTAT-1: Brought online in 2120. Served as the first true standalone orbital hub of Conglomerate power. Component pieces were assembled on Earth, the lunar colonies and in orbit.

CSSTAT-2: Brought online in 2128. First dedicated space vessel dry dock.

CSSTAT-3: Brought online in 2132. Built concurrently with CSSTAT-2 with a functional emphasis on materials R&D. New EM shielding and nanite research rules created after the Solaris of 2148, which killed dozens of research subjects when in vitro nanites reduced individuals to "grey goo."

CSSTAT-4: Brought online in 2292. CMS general assembly assets transferred in 2308. The retrofitting operation of 2521 transformed CSSTAT-4 into the master science R&D location for The Conglomerate as well as harboring the Conservatorium.

CSSTAT-5: Brought online in 2455. Superstructure constructed in segments to literally house and centralize all Conglomerate power. Retrofitting operation of 2521 integrated most surrounding "work docks" and other "floaters" into the superstructure. 2648 build cycle added new, more luxurious and inherently secure decks, bringing the station to its current specifications.

CSV: [See *Conglomerate Space Vehicle*] Typically followed by additional letter delineating specific vessel purpose.

CSV Buccaneer Class (CSVB): Standard transport vessel type of The Conglomerate economy.

CSV Dominus Class (CSVD): Massive capital class vessel type created by The Conglomerate to impose its will across the stars.

CSV Herald Class (CSVH): Capital fleet vessel type used as a command platform and housing smaller assets in conflict.

CSV Impetus Class (CSVI): Modernized Comminus vessel. Fast attack, heavily armed vessel type designed to put Enforcer troops planetside as quickly as possible.

CSV Nitor Class (CSVN): Transport vessel type working specifically in some function for The Conglomerate's military.

CSV Vertos Class (CSVV): Missile destroyer and incursion vehicle type. Most modular and functionally flexible with POD system.

CYAN Group: [See *CYborganic ANalytical Group*]

Cyborganic Analytical Group (CYAN Group): Upper SDB of Technician (engineering) class and responsible for mankind's "future evolution."

CYGNUS: [See *CenturY Genomic NUclear Systems*] Move before Cygnus ID.

CYGNUS ID: First official recorded use of the [Single Name] [Patient Enumeration] format to identify LEX clients. The current CID (*Conglomerate ID*) is loosely based on this concept but incorporates share density band information.

D

Dagda: Oracle/Seer of The People, and believed to be a direct descendant of Dlotinus, exhibiting a number of his healing and prophetic abilities. The People possess a warrior-based social order, but Dagda is their spiritual leader. [See *Tonni's Journal*]

Damage-on-Site (DOS): Military jargon for qualitative damage assessment inflicted to the target.

DAMP: [See *Debris Annihilation Machine Pod*]

Daral 1-8958-69362: Executive VP of Conglomerate Communications and among the most powerful officers of The Conglomerate. [See *Conglomerate Personnel Entry*]

Debris Annihilation Machine Pods (DAMPs): Low-energy pulse lasers designed to remove space borne elements (typically satellites or small asteroid masses).

Decade of Deliverance (2028-2038): Period of unparalleled elevation of global living conditions.

Deep Sleep Cryostasis (DSC): The use of high-resolution bio-crystallization which allows for the near absolute suspension of organic metabolic systems without damaging delicate cellular structures. [See *Nova Cold Sleep Chamber*]

Democratic Alliance of Planets, the: During its heyday, viewed as the counterbalance to The Conglomerate's influence. Several treaties allowed for a non-intrusive understanding for several centuries until The Conglomerate unilaterally launched a full scale invasion which crushed the Alliance.

Desolation, the: Reference to the expansive, hostile, arid region of Anomaly. Dlotinus was believed to have spent a great deal of time in the Desolation, after which he relayed the Prophecy of The One.

Detective: Security Police: Investigations authorized.

Developmental Sustenance (Program): DEVSUS is a tertiary branch of the Conglomerate Energy Permanence Committee (CEPC) which is dedicated to reducing the need for the discovery, excavation and transport of ever-increasing resources needed by The Conglomerate. DEVSUS focuses on "wasted energy reclamation" rather than the harnessing of more nebulous (and less predictable) forces such as artificially created gravity wells.

DEVSUS: [See *DEVelopmental SUStenance (Program)*]

Dimensium: Primary material of the catalytic cocktail used to initiate the fusion reactions at the heart of modern day space propulsion. The use of Dimensium revolutionized space travel, replacing nuclear-type engines of the past.

Diplomati: Division of Conglomerate society concerned with diplomatic matters, both domestic and interspatial.

Diplomatic Corps, the ("Diplomats"): [See *Bureau of Inter-Galactic Affairs*]

Diplomatic Representation Droid (DRD): [See *Watcheye*]

Direct Neural Advertising (DNAd): Lower social orders of Conglomerate space, in hopes of elevating their post in life, often accept biotech "upgrades," thus accepting DNAds (pronounced, "*dee-en-ads*"). The implant additions are so named because eluding one is as likely as sidestepping one's own genetic code. DNAds run within REM sleep cycles and allow advertisers to subconsciously position their products to leech

any residual income from the recipient before they can actually ascend in rank. As the upgrades are cost prohibitive, this is often the only way many can access higher-paying jobs that require them. Preliminary code and hardware designs were patented by Fruit Tech Corporation of the latter 21st century.

Disruptive RAdiation GeOrganic Neutralization (DRAGON): New generation of space platform beam weapon which can target a single genetic code (species) or clear entire geographic locations of all life.

Dlotinus: Author of the Logicisms and the Prophecy of The One. Many believe he was a healer as well as a seer, able to foretell events and the coming of The One. [See *Tonni's Journal*]

DNAd: [See *Direct Neural Advertising*]

DOS: [See *Damage-on-Site*]

DRAGON: [See *Disruptive RAdiation GeOrganic Neutralization*]

DRD: [See *Watcheye*]

Dreamlearning: [See *Passive Neural Education Process*]

Drogduni: Massive, hulking beast used by Muties in combat. [See *Tonni's Journal*]

Duya: Traditional heavy robes worn by the Teana. [See *Tonni's Journal*]

E

Eagle Watch: Premiere Security Police assignment at building/office entry points of Conglomerate directors. The term is thought to originate from Old World references to former US Presidential security detail (by the Secret Service). It is a tongue-in-cheek reference as the wealth and power of the lowest Conglomerate Director far exceeds those of any past world leader by many fold.

E/C: Abbreviation for "exploration" and/or "colonization" assignments.

E/C R&D: Exploration/Colonization Research and Development.

ECHELON-7: Top level of secrecy for UIS operations.

EEV: [See *Electronic Emotional Volatility*]

Electronic Emotional Volatility (EEV): Advanced human parallel processing units (Gen 4+ androids) could sometimes emulate human emotions; typically anger, rage, jealousy and greed. EEV-identified androids are required by law to be disassembled and their SLA units melted.

Emergency Medical Intervention Stimulus (EMIS): Variable "remote medical" emergency treatments such as de-fib, temperature control and brain stimulus that can be administered through clothing equipped to deliver such treatments. These include the V-STAT suit and FORCE armor "underarmor" elements.

EMIS: [See *Emergency Medical Intervention Stimulus*]

Enforcer: Combat engineer of the Conglomerate Military Service Bureau (CMSB).

Erebus: Leader of the Kindred believed to be responsible for consolidating their gains over the past decade with unrivaled violence and guile. [See *Tonni's Journal*]

ESSMI: [See *Extra-Solar System Mapping Initiative*]

Llahlok: Also called the Llahlok Runner, it is a bipedal lizard used by Muties to patrol A'rar. Large horns are actually acoustic channeling structures, giving them a keen sense of hearing. [See *Tonni's Journal*]

EXA: [See *EXploratory Armada*]

Exodus: First ship delivered from Station-2 dry dock. Considered the first true space borne vessel (2133).

Exploratory Armada (EXA): Forward battle group exploratory force.

Extra-Solar System Mapping Initiative: Formerly the E/C R&D branch of early Conglomerate space exploration, the ESSMI was tasked with the fiscal oversight and coordination of new world resource discovery efforts. The mapping responsibility is a cooperative venture with the CMSB, as mapping even non-resource-positive worlds contributed useful tactical information and conventional star mapping data to be stored for possible future exploitation.

F

F2C: [See *Flesh-to-Composite Sciences*]

Faster-than-Light: General reference to speed/travel faster than the speed of light (299,792,458 m/sec in an ideal vacuum).

f_g: "Galaxy frequency," effectively serving as a target "address" for the WARP Gates to focus on, typically derived from the nearest-to-target, stable star/system. This allows the two ends (source/terminus) to stabilize the resulting temporary corridor between them. Calculation of f_g is credited to Dr. Harry Kelheim.

Firemaster (Fire Control): Advanced rate-of-fire computational assistant which can modulate weapon output based on clip/chambered munitions, sending realtime updates to targeting computations in the Enforcer's helmet com.

First Age of Man, the: Broadly defined as human history through 2239. Sometimes called "The First Golden Age of Man" as a nod to significant species advancements during that time.

First Blade: Clan leader of The People, usually the most capable warrior, also assigned to represent the entire Clan in council gatherings.

First Golden Age of Man, the: [See *First Age of Man*]

Flesh-to-Composite Sciences (F2C): Organometallic evolutionary studies. Advanced knowledge required for entry into the CYAN Group.

Floating Parks Initiative: Conservation program seeking to replicate small public natural preserves within CSSTATs.

FNDV: [See *Forward Negotiation Diplomatic Vehicle*]

FORCE Armor: [See *FORward Combat Enforcer Armor*]

Forward Combat Enforcer (FORCE) **Armor**: General term given to Enforcer impact armor. In military journals, can also be used to indicate level classification of the armor. *Example*: FORCE-10 armor is seen as generally superior in protective qualities to FORCE-9 grade armor.

Forward Negotiation Diplomatic Vehicle (FNDV): Modified, smaller versions of NITOR classification vessels designed for diplomatic missions.

Forward Unit Extended Length (FUEL) ***Clip***: Standard Combat Munitions Clip(SCMC) type with expanded load capacity.

Frictionless Technical Imperative: Replacement of national security concerns with pure profit motivations, minimizing conflicting or overlapping research and development cycles.

FTL: [See *Faster-than-Light*]

FUEL Clip: [See *Forward Unit Extended Length* Clip]

Fugly Duckling: Colloquial reference to the MOWAG.

G

Galactic Stability Accord of 2154 (GSA.2154): A part of The Conglomerate Primary Charter of Space Exploration and Systems Governance providing added text in 2154 featuring the compulsory use of Enforcers to purge those who would threaten the "general stability of the world, system or overall needs and desires as defined by its people and Conglomerate magistrates." All-encompassing edict for system exploration and expansion.

GATCO: [See *GAte Traffic Coordination Office*]

Gate Satellite Emitter (GSE): Devices which allow a Kelheim Gate to form.

Gate Traffic Coordination Office (GATCO): Gate systems and operations oversight body.

Gatecrasher (situation): During WARP Gate construction, where RGCT units exhibit coding errors detrimental to the Gate's completion. Human intervention in the form of Jump Jockeys are often employed at this point to maintain future shipping schedules.

GEES: [See *Genetically Enhanced Elite Soldier Program*]

GENE Threat Interrupt Code 1 (GENETIC-1): Called the "absolute rule of human genomes," GENETIC-1 all experimentation to create hybridized lifeforms from a human gene template because of its unnaturally high adaptability and survival instinct. Those discovered to attempt such experiments are typically imprisoned for life and their work destroyed. GENETIC-1 came into existence shortly after the Tholeen Incident in 2175-2177. [See *Tholeen Incident*]

Genesis (Torpedo): Matter-antimatter torpedo with an estimated payload of 170.8MT TNT. Preferred (most economical) method of planetoid extinction. Advanced kill format of the "World Buster Bomb."

Genetic Negotiations: A term coined by Tonni 131-4564-8828, Genetic Negotiations is the exploratory practice of studying native lifeforms prior to the opening of formal negotiations to assess potential molecular and evolutionary needs of the population. Helping to fulfill species' nutritional needs, for example, has been found to reduce the overall expense of final treaties as well as fostering trust. Detractors cite the time required to conduct such studies as reason enough to end the program.

Genetic Responsibility Act of 2414 (GRA.2414a): Amendment attached to the Treaty of Jarrus VIII, officially putting an end to space borne hostilities between The Conglomerate and the Alliance homeworld after which the treaty was named. Absolute surrender was the term, and the unilateral addition of GRA.2414a gave the Enforcers responsible for securing Alliance worlds the authority to track and terminate any relative of the members of the populist resistance, up to two generations older or younger. Considered among the most draconian of laws, even by Conglomerate standards, it was designed to reduce the likelihood of future insurrections. The poet, Icthacerium said of the law, "*You who would stand mightily to Conglomerate ire bear the heavy burden that you are not only your brother's keeper, but that of your grandparents and your grandchildren yet to be born, and everything between.*"

Genetically Enhanced Elite Soldier Program (GEES): UIS covert attempt to produce combat troops through the highly illegal practice of manipulating human embryos at birth and through development.

Ghost (Protection): Strengthening of *Specter* privacy legislation designed to make sharing, sales or exposing of LEX protocols or LEX clientele list a capital offense.

Ghronk: Gigantus freed by Jon from imprisonment by The People. [See *Tonni's Journal*]

Gigantus: Massive, peaceful sentient species of Anomaly. [See *Tonni's Journal*]

Global Rapid Response Forces (GRRF): Merging of domestic/international intelligence networks and private military corporation units superseding most legal hurdles of force incursion missions.

Global Resource Control Initiative (GRCI 2025): Technical policy reference to the worldwide capitalist system realignment of 2025.

Go-Juice: Illegal liquor often abused by Menials and other denizens of the Lower Levels.

Golo: Reference to "magic" or other powers of "mystic origins" practiced by the Teana. [See *Tonni's Journal*]

GRA.2414a: [See *Genetic Responsibility Act of 2414*]

GRCI: [See *Global Resource Control Initiative*]

Green Devils, the: Reference to the Second Enforcers, Fifth Battalion ("Two-Five"). Decorated heroes of the Corishtani War.

GRRF: [See *Global Rapid Response Forces*]

GSA.2154: [See *Galactic Stability Accord of 2154*]

GSE: [See *Gate Satellite Emiter*]

Guilds: Generic term for large membership special interests groups with some collective bargaining powers with The Conglomerate. *Enforcers* and *GATCO* agents are expressly forbidden from guild membership due to their critical roles in system stability.

H

Haberschtein Advanced Warships: [See *Haberschtein Shipyards*]

Haberschtein Shipyards: Premiere defense contractor with The Conglomerate responsible for several early science vessels and most modern day warship designs. Came into favor with the CSV Comminus Class fast attack craft instrumental in defeating the Corishtani. Station-3 is maintained by the company.

Hamtakoon Ridge: Favorite hunting grounds of the Kasakir in the wild. [See *Tonni's Journal*]

HELL: [See *High-Energy Landstrike Lasers*]

Helmet Integrated 3D "Yankee" Shooting System (HIYSS): Known as the "Hiss System," HIYSS is the current state-of-the-art combat defense unification asset which marries all raw and processed telemetry and allows it to be functionally displayed to the warfighter.

HHRE: [See *Human History Rescue Endeavor*]

Hibernation Hips: Term used for fatty deposits that can accumulate on an individual while in long term cryostasis. Also called "Thaw Thighs."

High-Energy Landstrike Lasers (HELL): Used for space borne combat as well as land based targets, the HELL system is the carefully coordinated use of several smaller output lasers to achieve the desired chain reaction (and effect) on the target. The system is therefore highly configurable and power output varies widely from one ship class to the next. The operational power required to fire a single HELL unit is estimated at 0.87 GW.

HIYSS: [See *Helmet Integrated 3D "Yankee" Shooting System*]

Human History Rescue Endeavor (HHRE): Global effort to rescue and preserve significant Old World histories, landmarks and other defining elements of mankind's existence. Spoken word and literary works were rapidly digitized while actual monument relocations were handled under the auspices of the HHRE. The idea for what would become the Conglomerate Historical Preservation Collection was first proposed during this undertaking as applicable technologies matured.

Human-controlled Robotic Servant (HUROBS): Class 2 designated robots primarily tasked with direct assistance to a human controller. Basic AI processors. Secretarial and nurse droids fall into this category.

HUROBS: [See *HUman-controlled ROBotic Servant*]

Hydropermanence: Creation and/or discovery of necessary water to provide a naturally habitable world for humans without the need for biomodification or external equipment.

I

IBH: [See *Internet Black Hole event*]

Icthacerium: Political philosopher and poet of early Conglomerate expansion. No actual records exist of this individual, but recent writings suggest they still live (or their identity has been assumed by another).

Ihsos Pass: Location of Mutie ambush of Moncs, believed to have been executed by Damianos (of "the Twins," under Erebos). [See *Tonni's Journal*]

Ikasu: Gen-6 "preemptive thinking" android closest to human thought without Electronic Emotional Volatility (EEV). Prototype with few operational units. Uses an advanced Stochastic Logic Algorithm and built without realistic "skinning" to easily identify them in public. [See *Potter, Stochastic Logic Algorithm*]

Impact Armor: [See *FORward Combat Enforcer Armor*]

Internet Black Hole Event (2041-2042): Mysterious severing of all digital communications, excepting a handful of major military networks, during which nuclear action was believed to have occurred. This has never been proven and is largely dismissed as urban legend.

J

Jericho Pharmaceuticals: [See *Jeri-Soda Company*]

Jeri-Soda Company: Formerly Jericho Pharmaceuticals, now the most successful beverage company across multiple systems (having created a taste profile that appeals to a myriad of species).

Jon 1111-6983-64934: Former leader of First Enforcers, Third Battalion (aka: "The One-Three," or "Steel Bane"). Blamed for the disaster of Sestus Prime and demoted to Menial Class 4 thereafter. [See *Conglomerate Personnel Entry*]

Jump Jockey: Effectively a WARP Gate (Kelheim Gate) "test pilot." The first humans who volunteered to travel through stabilized (Kelheim Gate Terminal) travel corridors had an 80% chance of fatality. These "high-risk for high-pay" human volunteers traverse a PGC to repair and oversee RGCT units that are suspected of coding errors. While they are rarely used, becoming a Jump Jockey is one of the few ways a lower caste sector can accumulate enough Conglomerate shares to reach the next level of social acceptance. It therefore enjoys a very well-stocked pool of volunteers.

K

Kaiser: [See *QISRR*]

Kelheim Gate: [See *Wave Amplitude Resonance Projection Gates*]

Kelheim Gate Source (KGS): Start point of stabilized inter-galaxial corridor.

Kelheim Gate Terminus (KGT): Endpoint of stabilized inter-galaxial corridor.

Kelheim, Harry: Theoretical physicist and Conglomerate Cosmos Catalogue & Research researcher credited for deriving f_g, which eventually led to stabilized wormhole travel.

Kerebos: Also called "Three Faces." Species on Anomaly. [See *Tonni's Journal*]

KG: Kelheim Gate. Kelheim Gate "Source" points are designated: KGS. Kelheim Gate "Terminus" points are designated: *KGT*.

KGS: [See *Kelheim Gate Source*]

KGT: [See *Kelheim Gate Terminus*]

KILLOS: Kill-on-Sight

Kindred, the: Vicious sentient species on Anomaly. Called "Muties" by all non-Kindred races. [See *Tonni's Journal*]

L

Law, the: Rules of governance of The People, based on the Logicisms of Dlotinus. Considered the highest principles by which to live and die. Lack of adherence could be punishable by death, though exile is often used instead.

Level One (Shareholder): Common language reference to Conglomerate executive level shareholders bearing the "1-" prefix in their CID (Type I. CID). Level One shareholders are the wealthiest in Conglomerate society. [See *Conglomerate ID*]

Level Two (Shareholder): Common language reference to second tier shareholders bearing Type II. CIDs. [See *Conglomerate ID*]

LEX Protocols: Life Extension sciences. CYGNUS was at the cutting edge of this research category.

Logicisms, the: Rules set forth by Dlotinus codifying the beliefs and practices of those seeking The One. Most followers justify Dlotinus (and his fabled abilities) as a faith-based personality/metaphor.

Long-cell: Long-term power source/battery, usually nuclear or matter-antimatter in nature.

Lower Levels: Generic term used for all CSSTAT Menial habitats.

M

MACODAX: [See *MAster COnglomerate DAtamatriX*]

Macula Type: Designation given to "cloaked" orbital space asset(s) which typically serve military purposes.

MAGBOOT: [See *MAGnetic BOOT*]

Magi: Class V android with modular appendages and "human reality" processing to closely emulate human behaviors and nuances. Some have silicon skins to further the illusion. PARACOM is thought to have used Magi androids in some black ops.

Magnetic Boot (MAGBOOT): "Magnetic" is something of a misnomer today as many composites are stronger than any naturally occurring metal, but lacking the metallic properties once exploited by the original MAGBOOTs. The name remains as a matter of convenient reference for any boot with "stickiness" to the material to which it is meant to adhere to.

Magnetically Launched Incendiary Shell (MLIS): Specialized munitions designed to deliver various time-delayed charges via the portable railgun (PRG) platform. The 8.32mm is considered the standard of this type.

Main Travel Corridor (MTC): WARP Gate destinations where f_g is very stable, or fluctuates in a predictable manner. MTCs comprise the main shipping lanes of Conglomerate interstellar commerce.

Maj: Roughly defined as a war chief (Monc), though it also carries political weight within the Council of Elders.

Makton Massacre: Unprovoked terrorist murder of hostages in the Makton Peninsula in 2427 resulting in the ongoing KILLOS statute on all Syrhani'i to this day.

Makton Peninsula: Syrhani'i rogue system currently engaged in low-level war with Conglomerate.

Mark of The One, the: Spiral symbol used in literature and structural markings to represent The One.

Mars Forward Transit Base (MFTB): First Mars colony and strategic entryway to Conglomerate space. Served as primary hub of resource transactions and transport.

Massive Domed City (MDC): Enclosed, hermetically sealed, self-sustaining metropolises constructed in haste during the Cataclysms.

Massive Kinetic Damage (MKD): Critical physical damage sustained from traumatic forces (typically used in context of field medicine).

Master: Lifelong Noviate who is elevated to a teaching capacity after exhibiting an understanding and practical use of the Logicisms. Some exhibit supernatural abilities not typically observed by their non-Master peers. [See *Tonni's Journal*]

Master Conglomerate Datamatrix (MACODAX): The main repository of all publicly accessible information available to Conglomerate controlled space and its inhabitants. Access varies by serviceable rank of individual.

Mating Permit: Authorization from appropriate SOCOOR entity granting permission for Menial couples to consummate.

MCD: [See *Master Conglomerate Database*]

MD/I: [See *Missile Destroyer/Infiltrator*]

MDC: [See *Massive Domed City*]

MFTB: [See *Mars Forward Transit Base*]

Missile Destroyer/Infiltrator (MD/I): Conglomerate Space Vehicle class categorization used to describe offensive vessels specialized to deliver massive munitions and Enforcer platoons to forward battle positions on a system level. CSV Verto is the primary reference when speaking of current generation MD/Is.

Missile Launch Control Deck (MLCD): POD format fire-and-guidance controls used to coordinate maximum firing rates and simultaneous strike precision of multiple missiles. Primary command issuance still derived from the bridge, but can be rerouted to a surrounding command vessel or pre-authorized MLCD in the event of its incapacitation.

MKD: [See *Massive Kinetic Damage*]

MLCD: [See *Missile Launch Control Deck*]

MLIS: [See *Magnetically Launched Incendiary Shell*]

Moncs: Denizens of Anomaly with active camouflaging abilities. Mortal enemies of The People. [See *Tonni's Journal*]

MOWAG: Massive Ordinance WAr Gun

MTC: [See *Main Travel Corridor*]

Muties: [See *Kindred, the*]

N

N(e)utrition Corporation: Manufacturer of *Synthet-o-Meal*.

Nanolectronics: Reference to the discipline of nano circuit electro-mechanical engineering.

Nano-Mesh: Self-sealing fabric (of various construction) that will patch itself in the event of a breach or tear. Depending on type and purpose of the mesh, active fibers will utilize various materials to execute the

seal. In most cases, repair tendrils will "pull and stitch" when broken fibers make contact. In life-threatening situations (e.g., high radiation, massive breach), the mesh can be coded to use *any* materials to repair itself... including matter from the wearer.

Nano-selection: Nanomachines inserted into Menials, usually without their knowledge, that activate to terminate pregnancy if the fetus is deemed unlikely to be a viable addition to the cheap human labor force.

Nanotech Materials Inventory Terraformation Sand (nMITES): Nanotech granules (sometimes called "sand") coded for limited-life fabrication of requisite materials on site. Used heavily for terraforming.

Nika 322-2933-6775: Highly decorated Conglomerate science officer. [See *Conglomerate Personnel Entry*]

nMITES: [See *Nanotech Materials Inventory TErraformation Sand*]

Northrealm: Large, imposing mountain region. Believed to be the primary habitat of the Bloksus. [See *Tonni's Journal*]

NOVA Sleep Chamber: Current model of cryostatic chambers employed for lengthy travel. [See *Deep Sleep Cryostasis*]

Noviates: True believers/followers of the Logicisms, usually studying under a Master. [See *Tonni's Journal*]

Nucleite: Term for Menial (Class 3).

O

Office of Special Projects and Science (OSPS): The OSPS functioned openly as the health and services branch of the Alliance government. The UIS operated a covert program under this umbrella that dealt with questionable weapons programs in hopes of discovering the means to combat Conglomerate Enforcer ranks.

Old Planet: Conversational reference to the Earth. Also called *Old World*. Can be used as both a noun and an adjective.

Old World: [See *Old Planet*]

Omega: Conglomerate military classification for planet-wide policy or action. *Examples*: Omega Level Eradication is the extermination of all life possible on the target world. Omega Level Evacuation would refer to the relocation of all primary lifeforms of a planet.

OPSEC: Operational Security

OPTI: [See *Optical PNEP Transition Instruction*]

Optical PNEP Transition Instruction (OPTI): Variant of the Passive Neural Education Process (PNEP) accessed directly through optical cortex stimulation. Especially useful for linguistic immersion as it allows for both verbal and written knowledge elements.

Orlak: Granatosian High Council [See ATAC]

OSPS: [See *Office of Special Projects and Science*]

P

P'neh: Slow Walker practice of "no wasted movement" derived as a survival mechanism. [See *Tonni's Journal*]

PARACOM: [See *PARAmilitary COMmand*]

Paramilitary Command (PARACOM): CMSB office assigned to the administration of the Enforcer Class 5 divisions. Sometimes called the *Paramilitary Committee* in diplomatic circles.

Paramilitary Committee: [See *Paramilitary Command*]

Passive Neural Education Process (PNEP): Process for basic knowledge accumulation transmitted directly into the brain through indirect cortical stimulation during REM sleep. Advanced programs use detailed neural maps for proper stimulation by simple nanomachines or through direct electrode stimulation. Menials who attempt to acquire PNEP technology are usually only allowed the chemical variant of the system (early prototype) which carries the risk of severe side effects. Advantage of PNEP is that all data is retained organically and does not require external power or data access.

Path of Dlotinu, the: The literal retracing of what is believed to have been Dlotinus' journey in his seeking of The One. It is used as a pilgrimage for the deeply devoted.

Patrolman: Cadet level member of the Security Police (also known as "Streetwalkers").

pDim: "Dimensium precursor" material

People, The: The most human-like species of Anomaly, geared for combat. Their advanced intelligence allows them to work socially and militarily as a cohesive unit even against superior numbers. [See *Tonni's Journal*]

Peter 1-8646-98375: VP Conglomerate Energy. Father of Samantha [See *Conglomerate Personnel Entry*]

PFR: [See *Plasma Fusion Round*]

PGC: [See *Provisional Galaxial Corridor*]

Physical Reconfiguration Construction (PRECON): Exercise of using nanites to convert current construction materials into newly required materials and structures (thus eliminating the need to import additional materials). A cost-savings windfall, it is exceptionally difficult in practice and is currently considered exploratory technology beyond room-sized reconfigurations.

Pioneer Operation: Manned expansion efforts into previously unexplored systems.

Plasma Fusion Rounds (PFRs): Standard plasma-tipped projectile munitions.

PO: [See *Protectorate Order*]

POD: [See *Portable Operational Deck*]

Portable Operational Deck (POD): Modular design of some ships (such as the CSV Vertos class) which allow for entire flight decks, missile storage and/or launch controls and even Enforcer barracks to be easily swapped in and out of the same housing.

Portable Railgun (PRG): Standardized weapons platform using magnetically accelerated munitions.

Post Conflict Survey (POSTCON): Post action debrief and accounting of Enforcer engagements.

POSTCON: [See *POST CONflict Survey*]

POTTER: Ikasu android and certified special missions pilot status.

PRECON: [See *Physical REconfiguration CONstruction*]

PRG: [See *Portable RailGun*]

Prophecy of The One: The most well-known (and least believed) prophecy of Dlotinus which spoke of an "all-uniting" savior who would bring peace to Anomaly and whose actions would reverberate across the cosmos. [See *Tonni's Journal*]

Protectorate Order (PO): Highest security directive regarding the defense of Conglomerate trade routes. Compulsory adherence across Conglomerate space.

Provisional Galaxial Corridor (PGC): Single-point (source only) WARP Gate creating the first entry pathway to a new f_g. Because the resulting corridor is not stable on both ends (the destination Gate having not yet been constructed) the PGC is the most fleeting and unpredictable of all Gate types.

Q

QISRR: [See *Quantum-Intelligence Self-Realized Robot*]

Quantum-Intelligence Self-Realized Robot (QISRR): Class 4 robot that is self-aware and given full authority as a crew member or staff. Also known phonetically as "Kaiser."

Quin: Legendary (if notorious) multi-system bounty hunter. [See *Conglomerate Personnel Entry*]

R

Raffas: Early cryostasis mission gone awry due to unforeseen circumstances and resulting cellular collapse and death of the crew. N(e)utrition Corporation developed Synthet-o-Meal to help protect cellular integrity with minor flight plan (or technological) glitches.

Rapid-Deployment Decoy Drones (RD³): Defensive drones meant to confuse and encourage enemy ordinance to strike them, leaving targeted vessel(s) unharmed.

RAUT: [See *Repetitive AUTomaton*]

RD³: [See *Rapid-Deployment Decoy Drones*]

Reaper (Torpedo): Matter-antimatter torpedo with an estimated payload of 50.2MT TNT.

Reflex Station (REFSTAT): Enforcer fast-response support and supply depot.

REFSTAT: [See *REFlex STATion*]

Repetitive Automaton (RAUT): Class 1 robot used for repetitive tasks such as product assembly.

REPROM: Resource Procurement & Management

Resource Positive/Negative: General assessment of new world during preliminary procurement operations, which will largely determine how (and how much) The Conglomerate will process the world.

RGCT: [See *Robotic Gateway Construction Teams*]

Robert 341-1421-8483: Conglomerate Intelligence Services and former member of Steel Bane. [See *Conglomerate Personnel Entry*]

Robotic Gateway Construction Teams (RGCT): Specialized droids developed specifically for the purpose of building the terminal gate (KGT) of a PGC.

Rules of First Contact: (Enforcers) Three Directives for Enforcer-led, First Contact: "Contain and pacify," "For the good of all, not just our own" and "Violence dealt where violence received."

S

s2094: Also called the "Spore of 2094" or the "Spore of '94" was the viral pandemic that swept across the human populations of Earth between 2094 and 2096. An estimated 5.7B (a substantial swath of all human life at the time) was extinguished given its high transmission factor and lack of natural or medical defenses. It vanished almost as rapidly as it appeared in much the same way variants of the poxvirus have been known to do.

SAB: [See *Stabilized Atmospheric Band*]

SAFE: [See *Ship Armor Force Effectiveness*]

Samantha 1-9287-97632: Stepdaughter of Peter. CMS-level citizen using her clout to try to enact change of Conglomerate First Contact missions policy from a violence-first to a mutual negotiations format. Goes by "Sam" with her friends. [See *Conglomerate Personnel Entry*]

Sarilliam G.: [See *Sarilliam Gratificia*]

Sarilliam Gratificia: "Dirty nanite" powder injested/inhaled by addicts for its varied, sometimes lethal effects to the pleasure centers of the brain.

SATWEP: Satellite Weapons Platform

Scientific Innovations Cooperative (SINC): Pre-Conglomerate silicon research behemoth.

SCMC: Standard Combat Munitions Clip

SDB: Share Density Band

Sea Merchants: Mysterious traders who approach the Desolation periodically on water craft from the southwest. [See *Tonni's Journal*]

SECCOM: [See *SECurity COMmittee*]

Second Age of Man, the: Sometimes called "The 103," or "The Second Golden Age of Man." A historic reference encompassing the years 2240 to 2343.

Second Golden Age of Man, the: [See *Second Age of Man*]

Security Committee (SECCOM): Quadrennial security-focused gathering of ranking "hot spot" field commanders to a CSM audience requesting far-reaching policy changes/adjustments.

Security Data Transmission (SEDATR) *Module*: Module providing security agent digital scanner and pipeline to the MACODAX to fulfill their law enforcement duties.

Security Police: Domestic peacekeeping law enforcement personnel.

SEDATR: [See *SEcurity DAta TRansmission* Module]

Self-Replicating Exploratory Droid: Primary exploration entity used to maximize earliest possible discovery time of resource-positive worlds. Artificial lifeform replacement of human-centered exploration models of previous centuries.

Sentient Values Accord Act: Conglomerate actuarial assessment of sentient world resources and population. Established in 2214.

Shake-and-Bake: Enforcer slang for close air support. Refers to the explicit use of high-yield conventional (non-nuclear/non-focused energy) munitions with thunderous detonation ("shake") followed by the literal burning of the enemy ("bake"). A far advanced cousin of thermobaric bombs of the past.

Shakifrit Treaty: Agreement between Moncs and The People for immediate cessation of hostilities where either might be ambushed by Kindred in the area. Architects of the treaty are Dagda and Urz. [See *Tonni's Journal*]

Share Density Band: Concentration (and types) of Conglomerate stock held by the individual.

SHIELD: [See *Spectral HIgh-Energy Laser Defense Grid*]

Ship Armor Force Effectiveness (SAFE): CSV armor rating given to various construction materials.

Siege of Titan-5 (2163): Live technology capture by Second Enforcers, Fifth Battalion (the "Two-Five" aka, "Green Devils") at Titan-5. Considered by many to be turning point of the Corishtani Conflict. Sometimes called "Siege 2-5-5."

SINC: [See Scientific INnovations Cooperative]

Skinning: Term used for the application of realistic organic "shells" (skinning) for androids.

SLA: [See *Stochastic Logic Algorithm*]

Sledder: Nitor class transport vessel that is *not* a part of the Conglomerate military.

Social Continuity & Order (SOCOOR): Massive Conglomerate bureau charged with most day-to-day life administrative tasks for the citizenry.

SOCOOR: [Pronounced, *soh-kohr*; See *SOcial COntinuity & ORder*]

Sovereign Shares Fund (SSF): Gifted shares to an entire world's population upon entry into Conglomerate Space (if so negotiated by the world's leadership). Dispersal of the SSF is at the discretion of the local government and not through Conglomerate channels.

Space Transit Surgery Board (STSB): Regulatory body responsible for general biological safety standards and protocol for space travel (with a focus on surgical procedures and cryogenic emergencies).

Species F-33-A: PARACOM codename reference to Cliks. [See *Cliks*]

Species Mandate H: "Species Mandate - Human" legislation used to isolate position by genotype species (specification - human). Created in response to attempted infiltration of Enforcers by Syrhani'i.

Specter (Protections): Massive privacy overhaul legislation meant to vastly increase punishments for Wikileaks-style divulging of information. Agreement is internationally adopted.

Spectral High Energy Laser Defense Grid (SHIELD): Two-stage, rapid output multi-spectrum focused energy device. Stage One scans inbound ordinance (cycling through available spectrum) determining the most likely frequencies to penetrate and destroy the target. Stage Two transitions output to that single frequency into a high-energy kill discharge. The SHIELD subsystems are uniquely separated from those of the HELL batteries, though some overlapping effect is possible should one or the other be rendered inoperable (i.e., SHIELD units used for offensive, or HELL used for (slower, extended range) defensive purposes).

Spectrum Pharmaceuticals: Manufacturers of Vitas (the "Magic Bullet" pill).

Spore of 2094: [See s2094]

S-RED: [See *Self-Replicating Exploratory Droid*]

SSB: [See *Strategic Security Base*]

SSF: [See *Sovereign Shares Fund*]

SSGO: [See *Systems Security Grid Office*]

Stabilized Atmospheric Band (SAB): Mechanical process (using ocean salinity and direct air current controls) used to create "safe havens" on Earth's surface. Due to CMS involvement, radiation scrubbers are also plentiful in such areas.

Station-5: CSSTAT-5. Largest of Conglomerate space stations. Workplace and generally accepted "hub of Conglomerate power." Unofficial "center" of the Milky Way galaxy, effectively replacing the Earth on official astrocharts.

Steel Bane: Military handle of the First Enforcers, Third Battalion. Decorated SPECOPS Enforcer unit until the Sestus Prime incident which resulted in its disbandment and severe disciplinary action for its commanding officer.

Stochastic Logic Algorithm (SLA): Amplification android AI software allowing for low-levels of "operational predictability" and extended analytical processes. Currently at Gen-6 and installed in Ikasu androids.

STRATAC: [See *STRAtegic Tactical Armor Coating*]

Strategic Security Base (SSB): Small, militarized zones used as housing and supply depots for Enforcers.

Strategic Tactical Armor Coating (STRATAC): General reference to current iteration of advanced aramid compounds (artificial fibers) used in the construction of combat defense armors and accessories.

Streetwalker: Term used by Security Police veterans referring to new recruits. [See *Patrolman*]

SYN: [See *SYNthetic Lifeform*]

Synthetic Lifeform (SYN): General expression for all synthetic lifeforms, but typically used in the context of

Systems Security Grid Office (SSGO): System military security bureau of the CMSB.

T

T-343: [See *Taskforce 343*]

Taskforce 343 (T-343): Dedicated Enforcer groups assigned to the full time enforcement of the KILLOS order of Syrhani'i within infested systems.

TDR: Troop Deployment & Retrieval

Teana: "Mystics" of Anomaly. [See *Tonni's Journal*]

Technicia Scientia Award: Highest civilian math and science award serving as an "admissions grant" to enter The Conglomerate's technical hierarchy. One of the few positions attainable by merit alone.

Tel'Forae: Mysterious forest home and stronghold of the Moncs.

Terrain Operations Portable Camp (TOP Camp): Modular base camp system. Also called a "Base-in-a-Box" or "B'n'B" by Enforcers.

Thanatos River: Large river of molten lava serving as a defensive moat around A'Raf.

Third Age of Man, the: Sometimes called the "Third Golden Age of Man." Historical reference for the years 2501 to the present.

Third Golden Age of Man, the: [See *Third Age of Man*]

Tholeen Incident (2175-2177): General description of the Tholeen Human Hyper-Genome Experiments where highly-adaptable, violent human hybrids broke free of their scientist keepers and took over the base. Conglomerate warships conducted an Omega-Level Eradication to destroy all life on the planet rather than risk their creations leaving the surface. GENETIC-1 was codified shortly thereafter, prohibiting all human genetic manipulations. [See *Genetic ENtity Exemplar Threat Code 1*] To date, it is believed the Tholeen Incident was the largest single loss of Conglomerate treasure caused by humans. The total loss of human life is second only to the Corishtani Conflict.

Three Faces: [See *Kerebos*]

Tonni 131-4564-8828: Terrestrial Scientist, Class VI, whose research has been critical to Samantha's mission to change Conglomerate First Contact policies. [See *Conglomerate Personnel Entry*]

TOP Camp: [See *Terrain Operations Portable Camp*]

Treaty of Jarrus VIII (2414): Ceasefire accord which subjugated the Alliance homeworld of Jarrus VIII and all worlds that had joined in its challenge of Conglomerate rule. In exchange for unconditional surrender, The Conglomerate allowed the world and its population to escape termination. Considered the historical end of the Democratic Alliance of Planets.

TRICOM: [See *TRIple-COMpound*]

Triple-Compound (TRICOM): Classified triple component fissile reagents for current high-potency explosives. The TRICOM warhead is the most devastating, non-radiological missile-type in the current Conglomerate armory. Its exact components, manufacture, power and detonation reactions are zealously guarded.

U-Z

UIS: [See *United Intelligence Services*]

Unified peace through unified space: Famous Conglomerate marketing slogan in Alliance space during the 2190s at the heart of a public relations battle for rapidly expanding territories.

United Intelligence Services (UIS): Intelligence branch of the Alliance, accountable only to the Counsel and responsible for "black operations" against The Conglomerate, including espionage, catalytic attacks and other "plausible deniability" functions.

Upper City: Generic term for all CSSTAT's uppermost 25% of decks comprising the most desirable living spaces.

Urz: Monc Master seeking The One. Dagda's Monc counterpart and key conduit to the Shakifrit Treaty. [See *Tonni's Journal*]

Vector C: Wormhole vector discovered leading to Corishtani homeworld.

Vital Statistics (V-STAT) *Suit*: Also known as "Cold PJ's," the V-STAT suit was designed to increase survivability of cryogenic entrants during GATE travel as well as conventional long-arm flights.

Vitas: Molecular level "mobile lab" capable of identifying and repairing cellular damage. Considered to be the "Magic Bullet" pill (until recent advancements in nanosurgeries). Produced exclusively by Spectrum Pharmaceuticals.

V-STAT Suit: [See *Vital STATistic Suit*]

WARP Gates: [See *Wave Amplitude Resonance Projection Gates* and *Kelheim Gates*]

Watcheye(s): Small, long-cell powered, anti-gravity orbs that serve as the eyes and ears of Conglomerate high executives when they cannot be present in person (such as in multiple locations in several systems). Deliberately tampering, hacking or inflicting harm on a Watcheye is prosecuted as if the physical owner was assaulted and is a capital offense in all but the rarest situations.

Wave Amplitude Resonance Projection (WARP) Gates: Conglomerate-developed, wormhole creation and stabilization technologies allowing for travel and exploration of far off galaxies. WARP Gates are the very arteries allowing The Conglomerate to conduct its intergalactic commerce and exert its influence accordingly. WARP Gates are often referred to as *Kelheim Gates* (or KG) in honor of the man responsible for unlocking key calculations leading to practical extra-galaxial travel. Source gates are suffixed with an "S" following the gate number (example; KGS-2). Terminus nodes are suffixed with a "T" following the gate number (example; KGT-2).

WBB: [See *World Buster Bomb*]

World Buster Bomb (WBB): Prototype matter-antimatter munitions and predecessor to the Genesis Torpedo.

World Zeroing: Omega Level Eradication order.

Zero-G Science (Z-Science): Experiments for the classical sciences offworld where the constraints of gravity can be sidestepped.

Z-Science: [See "*Zero-G Science*"]

Excerpts from Tonni's Journal on Anomaly

Persons of interest,
Plotinus + the Theology of The One

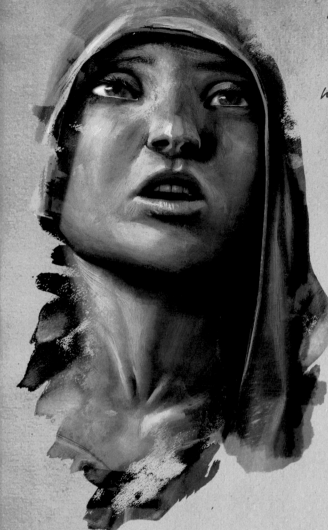

AINE
(awn-yay)

Race: The People
Etymology: Celtic for "queen of fairies / radiance"
Age: Unknown
Occupation: Priestess (daughter of Dagda)

Aine, daughter of Dagda, is as much a mystery as is her mother. Records of her birth are shrouded with as many conflicting stories as there are opinions on who fathered her. Dagda was not known to have taken a husband, or even seek the comforts of a man. Some have even speculated she was adopted by the elder Seer. A practicing Master under her mother's tutelage, she has cultivated a lesser, if rapidly growing, prophetic eye. Much of her time is spent in meditation. She is a healer and nurse following any major conflict The People engage in.

Aine possesses a disarming way about her, making it nearly impossible to stay tense in her company. This is in stark contrast to Dagda's presence, which is assertive to the point of chilling. Aine claims her "bedside manner," as I call it, is due to her seeking of The One. In so doing, her spirit is nearly a palpable force bringing with it an unusual sense of calm and well-being. To discount her matriarch's hand in this gentle influence is folly. Dagda recognized Aine's healing skills early and sought to nurture them with her own vast knowledge of the arts. Aine, in turn, would teach them to Noviates whenever possible. The alchemy of medicinals, insofar as more complex herbal remedies are known here, is the second duty of the Green Clan. Battle readiness is first, as it is with all Clans.

Aine is known to meet with any who genuinely seek to learn the healing arts. I have to admit a level of doubt as to her chemical efficacy being anything other than...supernatural. She has plucked the seemingly mortally wounded from death's embrace with curious regularity, though she cannot raise the dead. Her expansive knowledge of plant extracts has nevertheless provided the means to overcome ailments of all sorts, as well as avoiding poisoning to begin with.

The Conglomerate BioMED would be greatly enhanced by the variety of phytochemicals of this world. Synthetics and nanotechs are wonderful, but there is something to be said for the holistic approach. I'd all but forgotten that food...real food...is mankind's first medicine cabinet. Not some nutrition pill from Infinius Pharmaco.

Truthfully, I'd forgotten what food even tasted like until my synthetics were destroyed shortly after our arrival. It was like tasting everything...anything...for the very first time... No. That's not right. It was the first time I tasted real food...not some distillate, capsule or artificially produced analog meant to give a false sensation. While I had no idea what it was I was eating half the time, I enjoyed every morsel, even when it tasted...actually tasted...bad.

Aodh is the firebrand daughter of Caderyn and the second in command (First Blade) of the Red Clan as her father performs his duties as Battle Lord on behalf of The People.

Any who may have doubted her place or lineage need only see her in battle to understand she was given nothing, and earned everything. Aodh swears absolute fealty to Caderyn as both Battle Lord and father. She defends his honor with every deadly arc of her blade. She wields words that cut just as deeply against those who would dare think to do otherwise.

It is not known if Aodh will ascend to Battle Lord given her temperament. The elders are far from discounting the possibility, as Caderyn has no sons. More significantly, few are as skilled in battle as she. Aodh herself has expressed no interest in leading The People save to rid the world of the Muties and the Moncs.

The unusual coloration of Aodh's hair has been a contentious point of gossip among many of The People. Clans seldom married outside their extended circles until Caderyn challenged generations-old tribal laws as he rebuilt the Red. Inter-clan pairings were previously used to satisfy honor of some past wrong, or as a bonding gesture between Clans. Barring these conditions, those who did were often the subject of ridicule or the lowering of rank to the rest of The People. This tradition was strictly adhered to by the Red Clan until the tragic ambush.

The accepted narrative of Aodh is: Caderyn deliberately took a wife from another Clan (who had joined in his call to reconstitute the Red) so that their daughter would serve as a living, breathing reminder of how The People must always look past their sense of pride in favor of the whole. True or not, Aodh has lived under this story since her birth. The identity of her mother remains unknown to all but Caderyn. Perhaps this is at the root of her "anger issues." I'm told Dagda knows for certain, but nobody is so daring as to take her to task on the matter. Not even Aodh herself.

Many of The People adhere to the purist ways of old Clan rituals. Such individuals view this "outbreeding" as Caderyn's selfish drive to return the Red Clan to its former glory. They viewed his open call to the Clans as a way to steal the most capable among them. The unifying effect this act alone has created bears evidence to the contrary. Inter-clan relationships were also cemented in unforeseen ways, where merit became the primary arbiter of one's post rather than birth. Most regard the Battle Lord (and his hot headed daughter) with unconditional respect. They represent the future of The People as a whole.

AODH
(aid)

Race: The People
Etymology: Celtic for "fire"
Age: Unknown
Occupation: Caderyn's daughter and First Blade of the Red Clan

BAL'KA
(balk-uh)

Race: Monc
Etymology: n/a
Age: Unknown
Occupation: Third Maj (approximates to "Battle Elder")

Bal'ka is among the best trained Maj alive, having mastered the "moving camouflage" ability to devastating ends. Bal'ka was heading a broad circumference patrol around the Tel Mar Dunes when his party was engaged by an unusually large cluster of Muties. One of the Muties, recognizing the Monc, realized the prize they had chanced upon. Bal'ka's freedom from the Muties came when The People laid a trap of their own and eliminated his keepers.

As a new prisoner of his sworn enemy, his life was only extended until the coming dawn.

Bal'ka's capture was a tremendous loss to the Monc tribes both for his weapon-wielding skills which few could equal, and more importantly, the precious experience he could no longer share with the younger generations. Urz shared that the Maj are a rarity in an otherwise democratic Monc society. To become a Maj, a Monc warrior would not only exhibit competency on the battlefield, but also earn the faith and loyalty of those they lead. It is the only post where these two qualifications must be met before assuming a role so vital to their survival. It is also for these reasons they carry an unusual level of influence within the Elder Council...many of whom were past Maj themselves.

As the most skilled Maj, Bal'ka's clout within the Elder Council is substantial. He is their chief protector and engineer of many safeguards that have kept his people relatively safe in the dangerous Tel'Forae. Even The People are not known to explore the massive forests beyond where the light can immediately penetrate the high canopies, and then, only to acquire raw materials (such as wood) or smaller animals. Bal'ka is rumored to have abilities beyond his already impressive dossier, though none would elaborate. Least of all, Bal'ka himself, who is arguably the most amicable of his people.

Caderyn is the latest in a long line of Clan Chiefs in his family. The youngest son of four, he and his immediate elder brother, Cadmael ("war chieftain"), were the only survivors of a savage Monc ambush which nearly destroyed the Red Clan. It was a battle which claimed, among countless others, the Battle Lord of The People: Caderyn's father, Caedmon ("wise warrior"). The Red Clan had long established itself as the most proficient among The People, exercising a level of warrior doctrine none could match. Historically fractious clans spent generations fighting among themselves, but ultimately unified in the cause of survival against common foes, be they Monc or the Muties. Red Clan rose to prominence as The People's first line defenders. This relationship, born of convenience, eventually led to specializations within each Clan to benefit The People as a society.

Red Clan was consumed by the fight, and Caderyn became the driving force behind the Red. They directed the society with a focus on survival through rigorous physical training, refinement of war strategy, and most notably, spiritual strength through the seeking of The One. Among the Moncs and other enemies of the Clans, their blood red banners were a grim prelude of events that would soon follow.

Having witnessed the slaughter of his friends and family, an inner strength and controlled rage has guided Caderyn's actions since that fateful day. Caderyn is consumed in the study and practice of warfare and leads by bold, but never brash, example. His talents are not limited to the sword. Among the first lessons he took away from the ambush was the need for projectile weapons that could be fired from atop one's mount. The short bow was the result of this epiphany, and a new dimension of war was unleashed. He is also a surprisingly private individual with regards to his past. Dagda, on the other hand, felt the recording of Caderyn's history was integral to the future of The People. Much of what I put here is based on her words.

I'm told Caderyn was the youngest ever to become Battle Lord. He was universally accepted as the most capable warrior, and a Battle Lord's son, at that. Cadmael departed the Red Clan and joined the Green Clan, known for its studies of the healing arts, where he quickly ascended to its leadership. Many felt he turned his back on his warrior bloodline, though they stopped short of labeling him a coward. This was due less to what they believed about the elder brother than the respect they held for Caderyn. Cadmael is rumored to harbor a measure of jealousy towards his younger brother and his countless successes after being thrust into power. The nature of the relationship between the two is best described as "amicably tense." Beyond that, I will never press...
Following the Red's slaughter, Caderyn set about rebuilding their devastated numbers. The handful of survivors from that ominous day was bolstered by anyone from the other Clans who would commit their lives to the highest study of battle. Several elders saw this invitation as political maneuver to create a fighting force that would be above question or challenge...a danger to their own influence in matters concerning The People as a whole. If all the best fighters were Red, then surely they could never be displaced. Wise beyond his years, Caderyn moved quickly and ended several tribal laws to allow socially embraced cross-clan marriages to be embraced socially and encouraging a sharing of knowledge between clans previously unheard of. It was political, yes, but necessary in Caderyn's mind. He recognized that the strength of The People lay...in its People. Not the individual. Even he is rumored to have taken a wife outside of the Red, though exactly who and from which Clan remains a mystery. Stubborn suspicions remain in some circles, but Caderyn demands more of his own daughter than anyone save himself. This burden placed on his child dispels any lingering fears of favoritism (or nepotism) and, if anything, garners a level of sympathy for Aodh. Any further aspersions died as quickly in The People's hearts and minds as his enemies fell on the field.
Dagda suspects the mystery surrounding the nature of Caderyn's wife was maintained to prevent one Clan or another from feeling superior to the rest. These first steps moved The People towards unification in previously impossible fashion, and they have flourished for it.

By dissolving inter-clan barriers, the Red Clan emerged from his efforts far deadlier in combat than the one his father had led. More importantly, the other Clans rallied tightly around this "new" Red Clan as its members were drawn from the warriors of all Clans, equally represented and respected. Caderyn was not only the youngest to become Battle Lord, but also the most talented to ever assume the post. He may have been elevated as a matter of honor, but has held the post by sheer will, wisdom and skill.
By all accounts he is considered a fair ruler with The Law at the core of all his decisions. Caderyn has earned every victory against his enemies, and perhaps more strikingly, the unconditional respect of his own people.

CADERYN
(cad-er-in)

Race:
The People

Etymology:
Celtic for
"battle lord"

Age: Unknown

Occupation:
Chief of the
Red Clan and
Chosen Battle
Lord of
The People

GHRONK
(gronk)

Race: Gigantus Etymology: n/a
Age: Unknown Occupation: Slave (to Muties)

Ghronk, as with most of his kind, is a kind and gentle soul. His race is all too often captured and enslaved by the Muties for hard labor...or worse. Fact is, they are often captured by numerous races for that same purpose. The People have lent some measure of humanity to their treatment, though to call them less than a slave depends on one's definition of the term. Ghronk has become a favorite target of Mogg given how the latter delights in the substantial size difference and exerting absolute control over the formidable Gigantus. For all his monstrous size and hardened appearance, Ghronk would not step on a blade of grass if he thought it might feel pain.

We first ran into Ghronk as fellow travelers (read: slaves to the Muties) upon our arrival on Anomaly. It was handily the least pleasant experience of my life, though it reminded us all that things are not always what they seem on this world...or in most places, for that matter. The very mission which stranded us here, for example...

Our "freedom" was purchased at the business end of Caderyn's blade, and it is through this event I've come to commit these thoughts to writing. Ghronk often speaks of his mate, Matta. He does so with a heart that is without doubt far heavier than his substantial physical bulk. I'm sure they are a lovely couple and it is my hope they will one day be reunited.

Gigantus take on a single mate for life and rarely seek another even if their mate passes. It is a remarkable practice, especially to us. Marriage under The Conglomerate has become trivial, a means of wealth transference mechanism and little more. In many cases, a Gigantus' mate is captured but kept close in order to coerce the other (usually the male) into willful work. Ghronk is different in that he's physically separated from Matta yet still adheres to the "rules of capture" rather than going into a rage and seeking his mate as is typical of his kind.

With the exception of The People and Muties, few possess the weapons or numbers to down an infuriated Gigantus. None can do so without suffering substantial losses of their own.

58

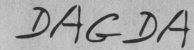

DAGDA

Race: The People
Etymology: Celtic for "god of knowledge and magic"
Age: Unknown
Occupation: Seer of The People

Dagda, to whom I owe much for her sharing of The People's history, holds a very special place in this world. She is the eldest Master in the teachings of The One among The People and is considered their spiritual leader. She is revered, respected and in some cases, rightly feared. Whereas the Battle Lord's rule is to enforce its people's laws, Dagda is both teacher and interpreter of The Law.

Her powers of prophecy have guided those over whom she watches through many difficult years and proven her abilities are not the blind adoption of faith or philosophy. Among such predictions was that of the Crying Skies, where the lower basins of the region were flooded for three straight years. Because of her premonition, The People had already relocated to an area several spans higher than their ancestral valleys, easily surviving what would otherwise have been a catastrophe. (I have confirmed this event with other elders of The People...and I think Dagda knows I did. It is by her good graces I continue to pen these words without any ill retribution for my investigative "trust but verify" mindset...) There are many other storied visions Dagda had shared to the benefit of The People including that of Desolation's Reach (where severe droughts expanded the desert across once fertile lands). The tale of Trakax's Betrayal is legendary. Dagda faced the Maj Council alone to warn them of their leader's secret attempts for a Mutie alliance. The truth eventually surfaced and Trakax was executed. The resulting Shakifrit Treaty called for the immediate cessation of hostilities between Moncs and The People if Muties are found in the area. Their gift for the ambush of greatly weakened forces was a very real concern. It also left no one unattended to conspire with the Muties.

The idea of a full blown melee, stopping to cooperatively hunt the offending Muties, then returning to destroying one another is...difficult to fathom. I have seen it happen twice with my own eyes before Jon convinced them to lay down their arms for good. It would seem honor is stronger than hate with these peoples...

The most intriguing of Dagda's recent prophecies are those that speak of a savior who will come to The People and whose actions on this world will reverberate across the stars like ripples in a lake. Based on her actions, we figure she meant Jon...though exactly how we'll return to the stars remains a mystery. It also brings on a deep sense of home sickness. The extent of Dagda's abilities as both healer and seer are unknown, even to Dagda herself.

All of the sentient races we've encountered on Anomaly have followers of The One except the Muties. Among each is a Dagda-like figure that teaches about The One, but does not necessarily carry the same respect she does. Such prevalence of the same philosophies almost makes me believe this Dlotinus did walk the deserts of this angry planet...

Masters who have achieved the power of prophecy are easy to identify by their dual colored eyes. The actual change and colors vary, but the clear irises tend to take on a tincture of cloudy, somewhat metallic quality when channeling their powers. I'm told it is a physical manifestation of "peering into a realm not of our own." Whatever the reasoning, the physical manifestation is well documented in each race's history, and sought among the young that their training can begin as early as possible.

Dagda is present at all council proceedings where her blessings and direction are sought. Her words are carefully weighed before any action is taken, and she speaks bluntly to avoid any "misunderstandings" or "advantageous interpretations" not in the interest of the greater good. If Caderyn is the fist and sword of The People, Dagda is akin to its soul and knowledge. Rumors exist of her ability to "kill with a gaze." Dagda herself laughed softly and dismissed such talk as superstitious gossip. I personally would not doubt it, but have no desire to find out. Dagda's chuckle is as disconcerting as her silent glare when irritated... After all, the woman rarely so much as cracks a smile.

Race: Unknown
Etymology: Greek for "darkness / mythical offspring of Chaos"
Age: Unknown
Occupation: Leader of Kindred ("Muties" to all outside Kindred society)

EREBOS
(err-eh-bose)

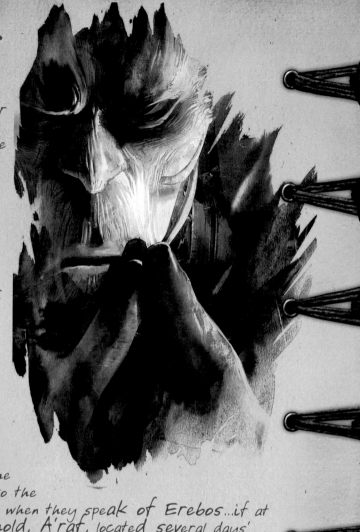

The Kindred ("Muties" to the rest of us) appear to have developed within the same time span as the other races we've cataloged. They defy conventional species homogeneity with a physiological diversity that flies in the face of accepted genetic limiters. Interspecies breeding, forced or otherwise, rarely results in viable offspring...much less non-sterile offspring. The Muties are the majority shareholder of this world's collected hatred, and their numbers were said to be in decline until an estimated two decades before our arrival. A new central figure was thought to have taken leadership over the previously leaderless Muties... one who has found the means to coordinate an otherwise fragmented society. That leader now has a name: Erebos.

Erebos eluded detection for many seasons, but the sudden streak of Mutie battle victories hinted at a "directed intelligence" among them. Someone capable of galvanizing mass coordinated action from the usually violent, individual efforts of the Mutie hordes. Dozens lost their lives trying to discover the identity of the person (or persons) responsible for the dangerous rise of the Mutie threat. A savagely beaten Monc spy captured by The People revealed this new leader as "Erebos." This information led to one of a few diplomatic exchanges between the Moncs and The People in recent memory as both sides took unusually high casualties at the hands of Mutie packs led by Erebos... Packs now swelling in size and confidence. The Shakifrit Treaty, completed through Dagda and the Monc Seer, Urz, gave both sides an honorable means to cease hostilities between themselves and eliminate Muties who may be lying in wait to ambush the weakened victor. That Erebos attempted (but failed) to strike an alliance with the Monc Maj (war chief), Trakax, was seen as a major turning point in the ongoing conflict.

What was once a purely physical enemy had become an intellectual one as well. Dagda sadly mused at the irony of an increased Mutie threat saving both People and Monc lives. She thought it should have been up to the warriors to see the futility of their feud through seeking The One. Mutie prisoners display absolute fear when they speak of Erebos...if at all... Most are unable to even utter the name, as if he were somehow able to affect them from his stronghold, A'raf, located several days' travel away. Muties have even taken their own lives rather than beg for mercy or face capture. Whoever...or whatever... Erebos is, they clearly rule through mortal terror. Another disturbing rumor is that he can kill with his mind.

At one time, this might have been written off as a Mutie falsehood. Dagda warned not to discount these stories out of hand. Jon has since shared some parts of his visions during his test to become Battle Lord. He claims to have "seen" Erebos, and could sense a power in him that makes the skin crawl. He felt he could sense Erebos' mind reaching out to him. Seems the Muties have good reason to fear and obey. How do you stop something that can kill you with a thought? Is a being that can do such a thing even mortal?

A final bit of data for your consideration...
While I cannot prove it (the forensic evidence is decades gone and my lab equipment lightyears away), my attempts to chronicle the recent histories of Anomaly have brought to mind a dark possibility. Erebos may have played a role in the Monc ambush from Caderyn's youth. This is not something I have shared with anyone at this time, nor will I until there is evidence to prove or disprove what, at face value, both sides would find sheer lunacy at face value. The concurrent timing of events... The approximate first appearance of Erebos. The rise of the Kindred. The Monc ambush at Ihsos Pass...

If I've learned nothing else during our time on Anomaly, it is that the highly improbable oftentimes proves the most probable.

Race: Kindred Etymology: n/a Age: Unknown
Occupation: Slavemaster

Muties by nature enjoy the thrill of the hunt and savor the messy destruction of their enemy (and sometimes, one another). However, there are times when slaves are taken as a labor force or objects of entertainment. The two terms are sometimes interchangeable. The one called on to humiliate and break the will of such unlucky individuals is a Mutie known as Mogg.

Mogg's legendary cowardice has relegated him to the role of "nursemaid" (albeit a cruel one) to prisoners of war. Despite the authority over those under his watch, he is viewed as little more than an irritant by those who take up the blade against the enemy... Not just the weakened leftovers of a crushed enemy.

Mogg will immediately retreat when a clear numerical advantage is not apparent. On more than one occasion, he has been the sole survivor of carefully laid ambushes set by the other races. He has rightly earned the nickname, "The Sandsnake," for his ability to elude death or capture. This knack for survivability is the only quality about him that gets any respect. It is nearly mythical.

Captured Muties, while terrified to speak of Erebos or the Twins, will rage endlessly against Mogg or being forced to obey him. A common theme: serving under Mogg is a fast track to one's pointless demise. An interesting thought considering a Mutie's frequent disregard for personal safety. Periodic contact with the Seamerchants to the west has raised suspicions that Mogg may be at the center of a vast slave trade. Is Mogg truly as stupid as he first appears? Erebos is said to have Mogg on a short leash, which makes this unlikely. But as I'm fond of saying, what is highly unlikely here on Anomaly is just as likely.

Truth, however, is a commodity that is in rare supply. At least there is something of home in that regard!

MOGG

The theology of The One is among the most deceptively simple philosophies I have ever come across in my travels.

On the surface it could seemingly be distilled down to the strong help the weak...almost idyllically chivalric...a truly enlightened view.

But I must preface this opinion by saying that I never think of any philosophy or religion unless I'm in REAL trouble. - TONNI

Dlotinus and the Origin of the Theology of The One

History:

Dagda; a Master from Dlotinus' own bloodline, is the powerful spiritual leader of The People. She also appears to possess other, less defined abilities, many of which are something of a mystery, even to her. The following are my attempts to transcribe the oral history of The One to writing as she and her Monc counterpart, Urz, shared the following...

As told by Dagda and Urz...

Some 300 summers before the first year of Caderyn's rule, a mystic seer and philosopher was born to The People. His name was Dlotinus.

Dlotinus was the first born son of Euederyn, the Battle Leader of his day, and whose reputation Caderyn seeks to emulate. As it is said, Dlotinus' mind would frequently wander, seemingly incapable of paying attention to the tasks set before him. He was nevertheless victorious in all the fierce contests of war skills which are the hallmark of The People.

As a young warrior, Dlotinus was a most extraordinary man even among his extraordinary peers. He was an inspired warrior who effortlessly married tactics with his physical gifts, and an equally capable leader. Personal conflicts among his Clan could be resolved with words as quickly as his sword in a battle with the Kindred. His unusual, carefree style

and sense of humor perfectly balanced his terrifying ferocity in the war arts. He was a man who was equally beloved and feared, depending on which half of him one had to face.

Dlotinus possessed an incredible battle intuition, seemingly able to read the mind of the enemy itself, and was thus virtually invincible when leading Clan warriors under his charge into battle. This skill brought with it great glory. He did not merely survive overwhelming odds in the blood stained fields of his enemies, but claimed frequent victories over superior forces. Dlotinus was born with a flair for mathematics and science and had a keen awareness of the natural world around him. He was constantly fashioning mechanisms to be used in daily life as well as implements of war... and he did so always with an eye to maintaining the careful order that nature had provided.
Many in his Clan assumed that he would one day become Battle Leader of The People. Few dared hold any notions to the contrary.

During his lifetime, as it is now, life for all races was a state of constant warfare, and oftentimes, internal battles within each race. Hostilities raged over territory and resources as much as glory or vengeance. Alliances forged with other races and clans shifted on the seas of sand depending on the current threats felt by one party from another. This year's enemy could well be next year's ally and vice versa. Past animosities or friendships, depending on the conflict, would have to be set aside in order to survive the day.
While life is typically defined as the living and eventual death of a being, life for The People is defined by living and dying in combat. There is no greater honor.

In the midst of a particularly brutal campaign against the Kindred, Dlotinus found himself separated from his Clan, stranded and lost in what has come to be known as "the Desolation." When he emerged from the bleak, unforgiving desert weeks later, he did so a very different man. What event or events changed him, and why he was changed, has been lost to the mists of time. Whatever the experience, it would eventually shift the world in which he dwelled as surely as the summer monsoons and its floods reshape the valley floors. Dlotinus returned to his people, laid down his weapons and turned his back to violence. Only for self-defense or to save another whose life was threatened by aggressors would glimmers of the powerful warrior inside his calm exterior surface.
Dlotinus announced he had found a new calling. He proclaimed himself a teacher, a healer and a seeker of the great truths of our existence. He then set forth much of the doctrine of the philosophy of The One: a belief and way of life followed by adherents to this day. Dlotinus claimed to have learned this dogma from finding The One in himself.

The once-warrior believed that all races can and must somehow follow and find The One. Should their efforts prove successful, the outcome would be peace and cooperation among all the People of this world... A stark contrast to the constant ebb and flow of spilled blood by the carnage of war.

Philosopher, Teacher, Healer, Warrior and Seer:

 Dlotinus wrote over many years a series of internal debates called "the Logicisms." These writings defined ethical behavior as an integral component in the search for The One. The tomes were destroyed shortly after his death by rulers of the time, opposed to the philosophy Dlotinus espoused in his later years. Those among his followers who had read the original texts took what they remembered and, in an effort to avoid execution or exile, turned his writings into an oral history; a teaching tool that has been passed down from generation to generation through a multitude of cultures, all seeking The One.

 Dlotinus was also known to be a very knowledgeable and skilled healer. As such, his services were sought wherever he journeyed, and he offered whatever comfort he could for no compensation and without judgment upon those he would aid. This unique ability allowed him to freely travel among all races-- even where his teachings were neither accepted nor welcome. It was this mission, and oftentimes the healing of a sworn enemy, that irritated various Clan elders to no end. Dlotinus made his pilgrimages freely and predictably. Many races who were enslaved by the more battle-tested species viewed his periodic arrivals with great celebration. Dlotinus spread his philosophies to all who would listen, lending calm words and comfort even to those who vociferously spurned his teachings. While opposing attitudes were loud, many found themselves dwelling on his words in private. Some even opened their hearts to receiving his message.

Of all his many talents, be it warrior, philosopher or healer, Dlotinus is best remembered for his gift as a powerful seer. Many of his prophecies came to pass during his lifetime, with others taking place decades, and in some cases, centuries after his death. Such predictions included future rulers, dramatic climatic events, and even his own departure from this world into the next. He rightly predicted that only a slight minority within the various races would embrace The One in his lifetime, but these were all the seeds of change he sought to plant, for they were across all races. Not just his own. They were the Moncs and The People, the Bloksus and the Gigantus, the Breeds and the Slow Walkers... Many followers were enemies. Sworn blood rivals who, for the first time, dared to consider an existence of peace on this world.

A walking stick crowned with a large swirl representing the inward path one must follow in order to find true Enlightenment became the symbol of The One. This staff was Dlotinus' constant companion during his travels. The stick itself was fabricated from a material said to be harder than steel and lighter than wood. It also served as a weapon if the need arose.

Of his many predictions, the most profound spoke of great changes wrought by a messiah or "Chosen One" sometime after his passing. This man or woman would vastly affect the lives of everyone on this world at a future time of untold chaos and despair. The Chosen One would unite many of the races and followers of The One and lead them to enlightenment...or complete annihilation. "Which," he is said to have mused, "depends on the will of those who would

follow." But without this great leader's help, he claimed, the destruction of The People and many other races was all but assured. If the savior could forge a peace among enemies, its effect would be so vast "the whole of the stars would burn with renewed purpose." While all followers of The One learn of this prophecy, only a slim few believe it might one day come true. Most considered it to be a metaphor or inspirational challenge to reach out to more followers and proselytize... Few truly believed it to be the foretelling of an actual event. Countless followers turned away from Dlotinus' teachings because this prophecy alone struck them as utterly absurd.

Dlotinus' teachings were not shared or embraced by many of the leaders of the races of his era. Tribal elders and even Clan leaders among The People generally resisted any change to the status quo. Peace was not a prize that could be won without first destroying one's enemy. It was not the result of making blood brothers of those who had previously spilled the blood of one's friends and family...and less so at the reveries of an old philosopher who was once the most feared warrior of the lands. While many races recognized him as a great and wise man, Dlotinus was equally viewed by many as a doddering old fool. They respected him and welcomed him as a healer, but few were willing to change their ways because of the teachings that accompanied the tending of wounds and illness.

Followers of The One greet one another by making this symbol in the air...

True Believers:

Small caches of individuals from each of the races dedicate their lives to following the path set forth by Dlotinus. These individuals are known as Noviates. Noviates fully adopt his teachings and integrate them into every element of their lives. As they learn more of The One and travel the path to its discovery, some Noviates become Initiates. The most devoted and knowledgeable of followers, those who have meditated and lived according to the teachings, come to a greater understanding of The One. Such individuals, many of whom begin to exhibit other worldly powers such as prophecy or healing, came to be known as Masters.

Many such Masters grew to become influential and powerful among their own people. Countless others were destroyed within their societies out of fear or ignorance. Unfortunately, once one became a Master it was very difficult to conceal the fact, since by seeking The One they cultivated great power...power which would sometimes manifest or reveal themselves to those seeking their end.

Over time, the Masters adopted the role of "teacher" almost exclusively. While a rarity, some Masters successfully enter the political realm with their beliefs before them for all to see. When leadership roles fell to the Masters, those of that society inevitably became new Followers. One of the few races that have done so completely is The People.

Passing of Dlotinus:

The death of Dlotinus, like much of his life, is shrouded in mystery. He is purported to have lived over 100 summers with little change in his physical appearance or mental prowess. The tangibility of his life has all but vanished today as many followers of the philosophy believe Dlotinus to be more of a legend than a man who once walked the same earth they now tread upon.

All that is known of Dlotinus' death is that he was traveling with, and living among, the Moncs at the time of his disappearance. He was never seen or heard from by The People again.

The leaders of The People blamed his death on the Moncs. The Moncs claimed then, as they do today, that he simply disappeared. The People's accusation is, in the Monc's eyes, an unforgivable insult. This dispute was among those that led to the wars and enmity which endure between these races to this day.

The existence of followers of The One within different races is seldom known, or even considered, as social contact is typically limited to killing one another. It remains curious that despite Dlotinus' success in spreading the philosophy of The One among the races, they fail to realize the existence of like-minded individuals within the other groups. This unawareness, many have argued, was by way of some grand design.

The Logicisms...

During his lifetime, Dlotinus codified a number of internal debates on the Theology of The One into a manuscript known as The Logicisms. After his disappearance, The Logicisms was destroyed by the political powers of the day as its self-empowering content was considered dangerous to their rule as it was accepted, and therefore seditious. Years later, a handful of pages from The Logicisms surfaced and remains to this day the only excerpt of the original manuscript.

In this passage, Dlotinus moderates a debate on the Way to The One between the Followers' two primary philosophical schools of thought: the Determinists, represented by Karmon, and the Believers, represented by Backteel.

Dlotinus: In our last debate, we discussed the Philosophy of The One and concluded that The One is the source of everything in the Universe. Everything emanates from and ultimately returns to The One. So the question today is—what is the Way to The One?

Karmon: Based on your teachings and your life's example, I believe that the Way to The One lies in a life of righteous action and self-examination. Together, ethical conduct and meaningful introspection lead to the purification of the soul and represent the true Way to The One.

Dlotinus: If this is indeed the case, Karmon, how does one know what constitutes "ethical conduct" and "meaningful introspection"? Aren't these practices inherently subjective?

Karmon: I believe that the objective precept for ethical behavior is the avoidance of harm. All living organisms in the Cosmos are part of the Great Chain of Being, from the smallest of mice to the most intelligent, self-realized of the races. Killing any living organism is an attack on the Environment while destroying the Environment is an attack on all living creatures. Realizing and honoring the intricate interconnections of all living beings while contemplating the possible harmful consequences of each action—this is the essence of the Theology of The One.

Backteel: I respectfully disagree with Karmon. I don't believe that the Way can be found through action or reflection. The path to The One can only be traversed by faith in The One. The Way to The One lies neither in the actions of one's hands nor in the thoughts of one's mind. Instead, it resides in the devotion of one's heart.

Dlotinus: If this is indeed true, Backteel, how does one know what to believe and what to have faith in? What is the object of devotion in the Way to The One?

Backteel: There is no object of devotion because objectifying and conceptualizing The One necessarily limits it. The One is all-encompassing and all-pervasive; it is beyond words and language, beyond description and signification. Karmon's process of defining ethical behavior and self-examination is paradoxical and self-negating as he relies on duality in order to understand singularity. Just as an animal cannot comprehend science, I believe that the Followers cannot intellectualize The One. We will only find the Way to The One by dispelling our academic skepticism and taking a leap of faith.

Karmon: Backteel knows not of what he speaks! Unlike an animal, we have the gifts of analytical reasoning and critical examination. When we use these mental faculties, it becomes clear that we cannot attain The One without hard work and self-awareness. We must define our path, describe our process and envision our success in order for us to attain The One. If we do not articulate our goal, we cannot move forward and we risk meandering aimlessly throughout life.

Backteel: Karmon is so blinded by the destination that he does not see the journey! We cannot define the path; we can only walk it. The beauty is in the walking and it is more important how we walk than where we go. We must walk with faith, humility and devotion, and only then can we ever feel the true nature of The One. Just as we have faith that the process is the goal, we must similarly have faith that the Way is The One.

Dlotinus: Karmon and Backteel! In your descriptions of the Way to The One, you are both right and wrong; you are neither right nor wrong. Once you understand this, you will see the Way to The One.

Karmon: How is it possible that we are both right and wrong? And that we are neither right nor wrong? That doesn't make any sense. Only one of us can be on the right path, which means the other one is a heretic!

Dlotinus: There are many paths to the top of the mountain, and means and methods that are not found on any path, but they all lead to the same place. Because the Followers share the same, ultimate goal, there is no heresy within The One. Our liberation is dependent upon the liberation of others for we cannot be free if others are oppressed. We must proactively and conscientiously work towards everyone's salvation as that is the only path to our own salvation.

Backteel: Will you teach us how to achieve liberation? Will you illuminate the darkness around us? Will you show us the Way to The One?
We humbly await your instruction!

Dlotinus: The One resides inside you and only you can reveal The One within. I am only a guide on this journey and I will not be by your side for much longer... Therefore, you must walk your own path, just as I have walked mine.

Karmon: Why do you say you will not be with us? Please do not abandon us, Dlotinus!

Backteel: We are lost without you!

Dlotinus: We can't always control our fate, and mine has already been determined. But remember that even after I depart, another will eventually come...and they will lead the Followers to worlds we cannot even imagine to exist today...

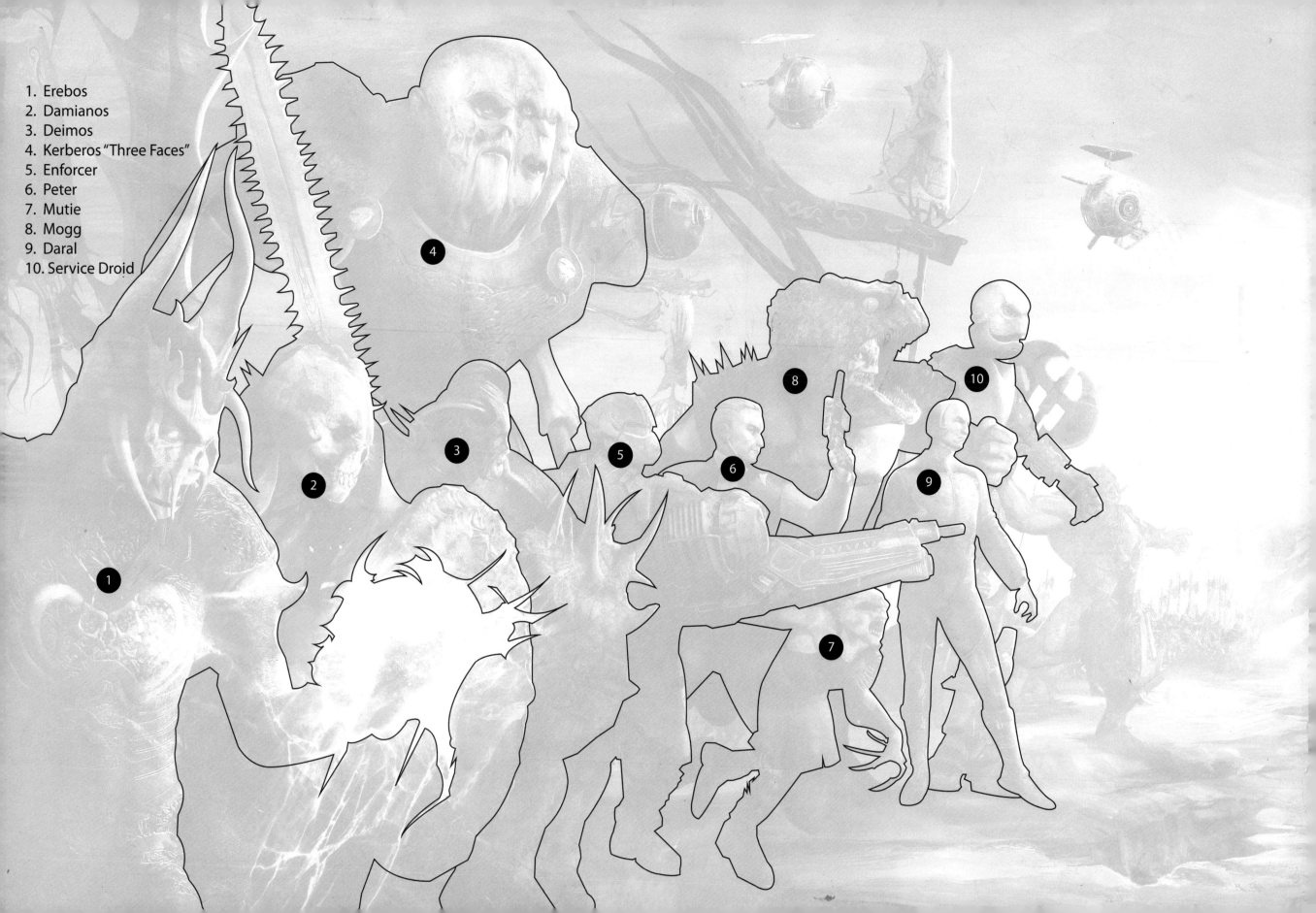

1. Erebos
2. Damianos
3. Deimos
4. Kerberos "Three Faces"
5. Enforcer
6. Peter
7. Mutie
8. Mogg
9. Daral
10. Service Droid